de Kooning

de Kooning

An American Master

Mark Stevens and
Annalyn Swan

Alfred A. Knopf · New York 2004

This Is a Borzoi Book Published by Alfred A. Knopf

www.aaknopf.com

All works by Willem de Kooning © The Willem de Kooning
Foundation/ Artist Rights Society (ARS), New York

Knopf, Borzoi Books, and the colophon are registered trademarks of
Random House, Inc.

Library of Congress Cataloging-in-Publication Data

Stevens, Mark [date]
de Kooning : an American master / Mark Stevens and Annalyn Swan.
p. cm.
Includes bibliographical references and index.
ISBN 1-4000-4175-9
1. De Kooning, Willem, 1904–97. 2. Artist—United States—
Biography. I. Swan, Annalyn. II. Title.
N6537.D43S74 2004
709'.2—dc22

[B] 2004048297

Manufactured in the United States of America

First Edition

To Emmy, Pippa, and our families

Contents

Contents

Acknowledgments

This book, a decade in the making, could not have been written without the help of many people, beginning with de Kooning's immediate family. Lisa de Kooning provided assistance whenever called upon, adding the unique, sometimes wry perspective of the daughter of a celebrated father. De Kooning's wife, Elaine, died before we began our research, but her brother, Conrad Fried, and sister, Marjorie Luyckx, provided much information about this remarkable woman's history, motivation, and character. They were also acute observers of de Kooning himself. Lisa's mother, Joan Ward, responded to innumerable questions over many years with patience, good cheer, and insight, and gave us access to much valuable information; her ongoing assistance and encouragement were key to the book. Without exception, the other women with whom de Kooning had serious, long-term relationships—notably Virginia (Nini) Diaz, Ruth Kligman, Susan Brockman, and Emilie Kilgore—aided the authors in important ways. Each was determined to help us understand a fascinating and nuanced man. In particular, Emilie Kilgore not only conveyed to the authors the character of her relationship with de Kooning but also showed us portions of the many remarkable love letters that he wrote to her.

The book has benefited from a succession of strong editors. Charles Michener and Deborah Futter were early and enthusiastic supporters of the project. At Random House, Katie Hall did a superb job of editing the manuscript, providing it with the kind of illuminating attention that, one sometimes hears, is no longer found in the publishing world. After Katie Hall left Random House, Erroll McDonald was instrumental in bringing the book to Knopf, as was our agent, Molly Friedrich, who has watched over the project for many years and offered unstinting support. At Knopf, Shelley Wanger gave us many valuable suggestions and firmly, patiently, and deftly shepherded the book through to publication. She exhibited, at all times, an unflagging commitment to the highest possible standards. Iris Weinstein, Ken Schneider, and Roméo Enriquez each gave the book much thoughtful attention.

Acknowledgments

We owe a number of critics and scholars special thanks. Thomas B. Hess and Harold Rosenberg were the artist's earliest and most influential critics. Today, the scholarship of the art historian Judith Wolfe is essential to any understanding of de Kooning's early years; the authors thank her for her generosity and support. Sally Yard, Richard Shiff, Judith Zilczer, Robert Storr, Gary Garrels, Lynne Cooke, and Diane Waldman have each conducted important research into de Kooning's life and art that we have drawn upon. The authors are also grateful to David Sylvester and Peter Schjeldahl, both of whom have brought a special liveliness and insight to their frequent writing upon de Kooning's art. The scholar and author Hayden Herrera put her graduate paper on John Graham at our disposal, which was helpful not only about Graham but also about de Kooning and Arshile Gorky. Like everyone interested in this period, the authors owe a particular debt to the treasure chest known as The Archives of American Art, Smithsonian Institution. We are also grateful to the former *Newsweek* editor Maynard Parker, who gave us access to valuable unpublished background files. At The Willem de Kooning Foundation, David Roger Anthony and Amy Schichtel were consistently patient, helpful, and informative. We are grateful to them as well as to the Artists Rights Society for their help in acquiring art for the book.

In Holland, several individuals assisted us in our research. In the early stages, René Dessing did background reporting. Until her death, Dr. Hanneke Peters helped guide the authors through the Dutch archives and sources; subsequently, the writer and artist Hendrik van Leeuwen provided invaluable help in conducting follow-up interviewing with the de Kooning family and in translating personal letters. We are also grateful to Mark Lynton for translating numerous articles for us. Among the de Kooning family in Holland, the artist's half-brother Leendert proved very helpful, as did the children of de Kooning's half-brother Jacobus Lassooy, especially his daughter Cornelia (Cory) Hendrika Maria. The artist's nephew, Antonie Breedveld, and Mr. and Mrs. Henk Hoffman, his second cousin and wife, gave us the family's perspective on de Kooning's youth. Jan and Monique Gidding were important sources on Gidding & Zonen, and Mr. R. van Bergen and Ms. Nora Schadee of the Historical Museum of Rotterdam brought to life for the authors turn-of-the-century Rotterdam. With regard to the last years of de Kooning's life, when the artist suffered from an Alzheimer's-like disease, Dr. Donald Douglas of Lenox Hill Hospital in New York provided essential information on dementias. We are also grateful to Dr. Anna Fels for giving us access to the medical library at New York Hospital/Cornell Medical Center.

This book depends, above all, upon dozens of interviews with people who knew de Kooning well. The authors are grateful to all of them. Several who submitted to more than one interview—and, in some cases, to extensive interviewing over many years—deserve particular thanks. The painter Joop Sanders, like de Kooning a Dutch-American, provided a wonderfully subtle perspective on his fellow immigrant and upon the downtown world of the 1940s and 1950s. Tom Ferrara, who lived and worked with de Kooning from 1980 to 1987, provided essential information from that period. The authors value his friendship and support. John Eastman and his father Lee—both students of the artist's character in addition to serving as his lawyers—were unfailingly helpful about his financial and legal history. The authors are also very grateful to the following for the time and information they provided: L. Alcopley, Mary Abbott, Molly Barnes, Jim Bohary, Nicholas Carone, Robert Chapman, Robert Dash, Pepe del Negro, Michael Goldberg, Bernard Krisher, Joan Levy, Mera McAlister, Priscilla Morgan, Pat Passlof and Milton Resnick, David Porter, Heidi Raebeck, Florence Rubenfeld, Esteban Vicente, Michael Wright, and David Young. Among the "old-timers," as de Kooning called them, we were fortunate enough to interview at length Leonard Bocour, Rudy Burckhardt, Herzl Emanuel, Tully Filmus, Liesl Jonas, Ibram and Ernestine Lassaw, and Joseph Solman, whose recollections and insights, dating back to the 1930s, were remarkable.

For occasional help in research, the authors wish to thank Danielle Clemons, Lisa Greissinger, and Jennifer Doll. The photo researcher Erica Ackerberg was indefatigable in finding photos and artwork and unscrambling difficulties when they arose. Among those who generously provided us with photos we would like particularly to thank Judith Wolfe, Joan Ward, Conrad Fried, Marjorie Luyckx, Emilie Kilgore, Antonie Breedveld, Jan and Monique Gidding, Liesl Jonas, The Charles Campbell Gallery in San Francisco, and jan van der donk—rare books, inc., in New York. Various friends offered particular help over the years, notably Jean Strouse and Jonathan Galassi, as well as Ann Banks, Carol Hill, Diane McWhorter, Ellen Pall, Laura Shapiro, and Elizabeth Stone. The photographer and writer John Gruen made available to us his extensive interviews from the period, for which we are very grateful.

Biographies provide, at best, only a glancing kind of truth. It should go without saying that all failures of fact, emphasis, and insight belong to the authors alone.

Introduction

On July 18, 1926, the British freighter SS *Shelley* weighed anchor in Rotterdam, the great port of the Netherlands. It steamed downriver along the string of docks lining the Nieuwe Maas River, into the Nieuwe Waterweg (the Rotterdam Seaway) and past the Hook of Holland, the prow of land jutting out from the lowlands into the North Sea. Then it pushed into the open water. The voyage to North America took twelve days. Hidden deep inside the ship, near the immense furnaces of the engine room, was a twenty-two-year-old stowaway named Willem de Kooning.

Like many poor immigrants before him, de Kooning embarked for the New World with nothing but his wits. He had little money and could not speak English. "I knew one word," he later joked. " 'Yes.' " He was about five foot seven, a tightly wound young man with the stocky build of a sailor. The expression on his face was often genial, wry, and offbeat; but his eyes could also quickly turn cold. As the freighter crossed the ocean, de Kooning dreamed of a country vastly larger than Holland, a mythical land of skyscrapers and easy money—a place that was home to movie stars, jazz musicians, cowboys and Indians, and those long-legged girls holding tennis rackets that he saw in the magazine advertisements.

His first glimpse of America, the Virginia port of Newport News, was a disappointment. He did not pretend otherwise. "What I saw was a sort of Holland," he said. "Lowlands, just like back home. What the hell did I want to go to America for?" Perhaps there would be no escaping the Old World, after all. But a few days later came the reassuring shock, the revelatory image that told him America would become his true home. He was walking with several Dutchmen, at rush hour on a summer morning, through a ferry station that linked New Jersey and New York City. The commuters were stopping in front of a man pouring coffee into a long line of cups. In Holland, the man would have carefully raised the pot between cups in order not to waste a single drop. Here, he never once lifted the pot. "He just poured fast to fill it up fast, no matter what spilled out, and I said, 'Boy, that's America!' "

Introduction

From the dark passage by ship to the eventual acclaim, de Kooning's life invokes the greatest of the classic American stories—that of the immigrant who crosses the ocean in search of a better world. His long life, with roots deep in the nineteenth century, stretches across most of the twentieth, and embodies many archetypal American themes. He knows poverty, success, and failure. He is a loner. He reinvents himself. He becomes a star. At the same time, his emigration to America parallels another cultural passage: the coming of age of American art. Most critics believed, during the 1950s, that the center of art was moving from Paris to New York, and they wrote about the "triumph" and "heroism" of de Kooning and his contemporaries.

For de Kooning, the late 1940s and '50s in particular, represented an extraordinary series of intoxications—in art, in love, and in fame. During this period he developed no fewer than four major and distinct styles of painting. Each was irreducibly personal, yet each also reflected important currents in the evolving American culture of the time. Any one of these styles might have served another artist for a lifetime. His success manifested itself in the common coin of the second half of the twentieth century—celebrity. After Jackson Pollock's death in 1956, de Kooning became the first art world superstar; walking with him through Greenwich Village in New York was, in the words of the writer Lionel Abel, like "being with a movie star." Heads turned. Strangers stopped him on the street. For many painters and poets in the Village during the late 1950s, he was the model of the major modern artist.

De Kooning suited an art world then being transformed by fashion and international attention. Like Picasso, he never disappointed a camera. He had unruly light hair and a face that many found both masculine and beautiful. And he had a certain way about him, a kind of existential charm that excited New York in the 1950s, when artists and intellectuals liked to discuss the most important subjects in a raspy, tough-guy manner. De Kooning spoke a homemade language, a slightly skewed English with a Dutch accent that was steeped in shoptalk and the American slang that he cherished, but also rich in cryptic allusions and philosophical quips. In a typical instance, much appreciated by poets and readers of existentialism, he quoted the Bible: "In da beginning was da void." Or perhaps it was, "In the beginning was the word." Or perhaps it was both.

To both gossips and intellectuals, de Kooning appeared to be a textbook case for Freudian analysis, so fashionable at the time. Not only was he often blocked and subject to anxiety attacks, but all the world seemed to know that he had titanic problems with his mother. He was famously unable to stay with one woman for long, which made him a constant

source of rumor and titillation; and his marriage to Elaine Fried, in her own right a popular and powerful figure in the art world, unraveled throughout the late 1940s and early 1950s. And yet, to the delight of Freudians, he could never quite end his marriage. To this day, many people consider his *Women* paintings of the early 1950s the work of a misogynist.

De Kooning suffered, too, in a way that appealed to a growing audience for art. He actually did "live on the edge" in a period in which despair and self-destruction were often presented as a dark romance. The heroic artist, it was thought, must undergo agonies of the spirit; alcoholism was considered a burden of genius. At the height of his success, de Kooning seemed to step into yet another American fable, that of the man devoured by his own success. He became a down-and-dirty drunk who sometimes slept in the gutter. Students from Yale would visit the Cedar Tavern, the famous bar of the downtown New York artists, to observe and admire his boozing and womanizing. He made a gorgeous wreck. After success in New York nearly broke him, he moved to Long Island and was haunted by the cruel cliché that there are no second acts in American lives.

Even his "failure" marked a cultural passage. Beginning at the height of his fame in the 1950s and increasingly thereafter, de Kooning was regarded with condescension by many important critics and artists. He painted his best work, it was widely thought, in the late forties. Then his powers of composition began to erode, even if his hand could still astonish. At a certain point, the personal touch of a painter, especially the unironic hand, became an embarrassment to sophisticated taste. It seemed to represent a naive, outmoded clinging to individuality and to various romantic aspirations, such as genius or authenticity. It also seemed to reflect the old European tradition of painting at a time when many artists sought other ways besides painting to depict the contemporary world. The safely dead Pollock became the sainted American master while the still living immigrant was suddenly the too-European, too-romantic, too-stylish artist against whom subsequent pop, conceptual, and minimal artists defined themselves. The romantic aura of de Kooning began to look, to many artists and critics of the 1960s and '70s, like showbiz boilerplate.

His last years, too, developed a symbolic import. During the 1980s, still younger artists began to reconsider his later work. Many feared that, with de Kooning, the spark and know-how were leaving painting forever. Some began to look back with longing to the 1950s, when, they thought, painting and poetry seemed large-minded and not the preserve of critics and professors. At the same time, the revival of de Kooning's reputation in

many quarters reflected something corny and starstruck, a desire for an elegiac doff of the cap to an old man who was the last of his kind. The tawdry fascination with de Kooning's life and estate during his decline into Alzheimer's-like dementia not only cheapened his last years, but was also characteristic of the vulgar, gossipy nature of the art world in the 1980s.

All this represented the public life of de Kooning in American culture. There was another de Kooning, of course, related to but different from the emblematic figure: the painter who spent his days alone, pacing anxiously before the canvas, often destroying his creations, and always struggling to renew his work. This de Kooning also illuminated the great American themes, but intimately, from within. He was always saying farewell in his art, always moving and changing, the eternal immigrant who ceaselessly reinvented himself on the canvas. ("You have to change to stay the same," he liked to say.) His celebrated brushstroke was a Whitmanesque song of the self. It had a similar rolling and rhetorical energy, a desire for both heroic scale and personal detail. It seemed to represent not just art but a way of being. The passionate personality of his strokes could seem impossibly, almost naively, ambitious, as if the artist's newfound "I" could encompass the world.

In one important respect, however, de Kooning's romance of the self differed from Whitman's, and also from that of Jackson Pollock, another painter often likened to the poet. De Kooning could never quite let go of the Old World. He could not forget what it meant not to spill a single drop of coffee, even as he fell in love with the exuberance of America. Other great Dutch artists before him had longed for lush foreign places. Others had appreciated the exotic, exfoliating self, and rendered the floating anxiety of the individual before the material world. But few were as ambivalent as de Kooning. He was, as a friend said, "forever in doubt." His doubt was embodied—boldly, poetically—in the characteristic hook of his brushstroke. The initial push of the brush suggested a bravura release, but then came the sudden kink as the hand twisted back upon itself or broke in a new direction. Like many Dutchmen, moreover, he refused to give up the knotty human scale. He did not want his paintings, he said, to be wider than his outstretched arms—and he never yielded (at significant cost to his reputation) the human measure to the mythic American reach of Rothko, Still, Newman, and Pollock. He could not easily forget the past, and, like other immigrants caught between cultures, he particularly distrusted talk of transcendence and purity. Purists necessarily abandoned part of the world, and he wanted to keep everything at hand, from Marilyn to Mondrian.

It was his ambivalent nature that led de Kooning to honor the paradoxes and contradictions of his era and to retain many valuable qualities of art—and, more generally, of sensibility—that were being abandoned during his lifetime. What were called failings in the 1960s and '70s have sometimes come to look like virtues that he protected. As one of the last great romantics, de Kooning held onto the "I" during a period when intellectuals began to question the authority of "the self." He did not fear high style when critics thought only the raw was sublime, or passion when they preferred irony. (He laid on the paint just when many were insisting upon minimal means.) Despite his love for the grand style of an artist like Rubens, he also cherished the rude vitality found in the art of the Low Countries. If art or life began to seem too fine, he did not mind aggressively celebrating the vulgar. His art offers as much criticism of America by way of Europe as criticism of Europe by way of America.

Every immigrant is broken, sometimes beautifully. De Kooning remained a man forever in between, suffused with private longings, regret, loneliness, and melancholy. Holding onto paradox was, among other things, a way to let nothing go. Was he American or European? Cruel or kind? Spontaneous or calculated? An admirer of high or low culture? Devoted to the past or the present? A radical or a conservative? A hater or a lover of women? A man of the city or the country? Whatever was said of de Kooning, the opposite often seemed no less true. And yet, toward the end of his painting life, de Kooning increasingly sought to move beyond— or before—such paradoxes. In the 1970s, he seemed to immerse himself in the primal springs of art. At a time when critics questioned whether painting had a future and abstruse theory dominated discussion, de Kooning joyously returned to the first and most visceral of human sensations, that of touch. His work in the seventies brought a new feeling for the physical body into painting, refreshing the tradition of the pastoral in Western art. Then, at the very end, he shed the heaviness of the corporeal world, floating his brushstroke in the air as if to say good-bye one last time.

In the early sixties, de Kooning settled on the watery eastern end of Long Island, partly because it reminded him of Holland. He built a studio there much like a ship and, when healthy, would bicycle across the sandy flats to the shoreline. He liked to stare at the water; "it reflects," he said, "while you are reflecting." The aging painter would sometimes ask his daughter, Lisa, "You see that?" and point to the miraculous and constantly shifting effects of light and color. And then, still staring at the water, he would raise his painting hand and, with his thumb and one finger, draw the line across the horizon, releasing his breath in a gentle "Sssssss. . . ."

Holland

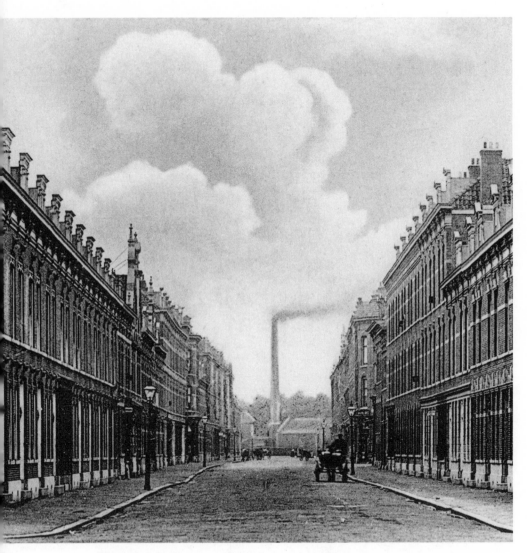

Zaagmolenstraat in Rotterdam Noord, where de Kooning was born

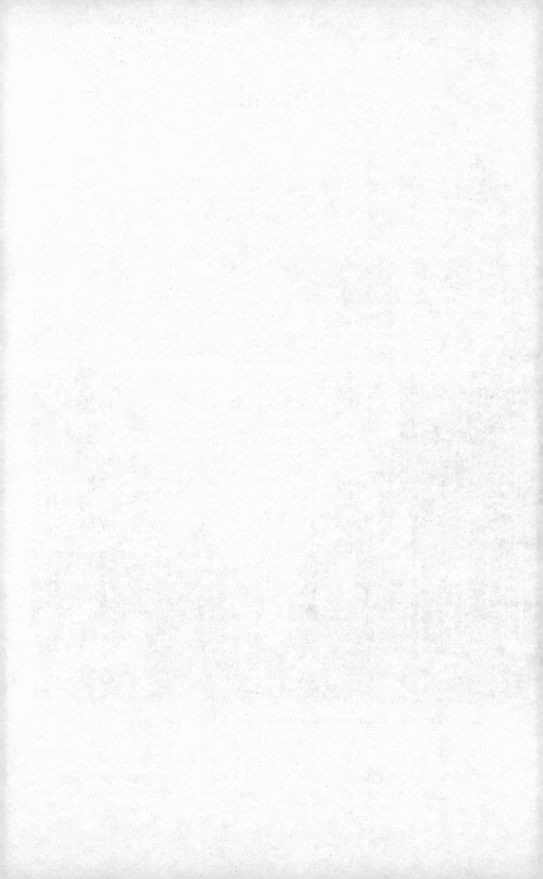

1. Hard Beginnings

My mother was a tyrant and Willem was stubborn.
—Marie van Meurs–de Kooning, de Kooning's sister

In Rotterdam, the boys often gathered near the harbor, playing games and picking up pocket money running errands for the dockworkers. They trailed behind the gangs of foreign sailors and watched the eccentrics who loitered around the docks. The Schiedamsedijk district—filled with bars, dance halls, street musicians, and prostitutes—was nearby. So were the shops of the Jewish Quarter, which kept unconventional hours and possessed the allure of another culture. Around the docks there was always some excitement. Rules of every kind were being broken—or so a boy could hope.

Willem de Kooning was one of the boys who haunted the waterfront. Among the largest and most modern in the world, the harbor was Rotterdam's heart, a pulsing, vital, rude area that in the good years of the early twentieth century worked around the clock. It was a place of both mystery and hard labor, of constant traffic between the practical and the exotic. Cranes broke the line of the horizon. Ships arrived from faraway places. Strange words hung in the air. Here, de Kooning began to develop a taste for the flux and hurly-burly of the modern world. Change, modernity, and the sea came together in his mind.

Even more important, the harbor was an open promise. If de Kooning relished the human energy of the docks, his imagination also required the sea, his first and most constant muse, just beyond. "There is something about being in touch with the sea that makes me feel good," he would later tell the critic Harold Rosenberg. "That's where most of my paintings come from, even when I made them in New York." The child whom his mother and sister called "Wim" would watch the ships by the hour. He liked the way "the air mirrored the water" and enjoyed the rippling give-and-take of color and light between the sky above and the sea below. When he was only four, according to his older sister, Marie, he surprised his family by drawing a big *toom* (his word for "boat") on the wallpaper, the first "de Kooning" on record. Early on, the sea also became synonymous with freedom—from poverty and a too-tidy, often smothering country that, like many Protestant cultures, made a point of individuality

while encouraging conformity. And freedom, too, from a suffocating family torn by furious arguments and harsh beatings.

De Kooning means "the king" in Dutch. There was nothing royal, however, about de Kooning's background. He was born on April 24, 1904, on the ground floor of a house that still stands at Zaagmolenstraat 13, a thoroughfare in the working-class district of Rotterdam Noord (North Rotterdam). The city of his birth was a place of tension and impermanence, at once modern and premodern. In the Rotterdam of de Kooning's youth, workers bought produce from peasants who came to the market wearing traditional costume and wooden shoes. It was a city in which tradition was constantly challenged by the new.

Until 1850, Rotterdam was a quiet provincial port twenty-three miles upriver from the North Sea. In the second half of the nineteenth century, however, it became the Dutch city that welcomed the future, a place of gritty and dynamic vitality. It was the first Dutch city to have electricity. It was also the least snobbish city in Holland. In contrast to Amsterdam, which retained a strong feeling for tradition and decorum, Rotterdam was more than willing to tear down the past in order to adapt to the demands of industry. In the 1860s, Rotterdam boldly filled in the river after which it was named, the Rotte, because it was too small to handle modern shipping. It used the space to run a railway to the water. In 1874, the city constructed modern shipping facilities. The rapidly developing German industries of the Rhineland, in need of a port, then sent their goods down the Rhine to Rotterdam. In 1890 the Nieuw Waterweg—the New Waterway, or Rotterdam Seaway—connected Rotterdam directly to open water; before that, ships had to traverse a series of difficult channels. The city became an economic power. The harbor defined the city's character, regulated its rhythms, and its unending activity turned night into day; the flow of traffic determined how well, or how poorly, Rotterdammers would eat.

At midcentury, the city had a population of fifty thousand. During the next twenty-five years, the number of inhabitants tripled. By the turn of the century, around the time de Kooning was born, Rotterdam's population was over 300,000, and the city was the fastest growing in Holland. North Rotterdam, where de Kooning mostly grew up, was developed by speculators to house the rapidly expanding working-class population. A shabby, cramped district of endless-seeming rowhouses, North Rotterdam lay just north and east of the city center. Like other poor districts of the city, including huge areas of working-class housing south of central Rot-

terdam, it was home to an itinerant population of sailors, stevedores, and peasants. Many such peasants, driven from the land by cheap grain imported from North America, clumped together in colonies within the city. Thousands of poor immigrants making their way to America from Germany and eastern Europe poured into the city by train, before booking passage on the Holland-America line.

Despite the ceaseless change, Rotterdam remained fairly stable. A small number of shipbuilders and wealthy families—many of them original Rotterdammers—dominated the city. Laborers, economically insecure and often desperate for work, were reluctant to risk their jobs by challenging authority. Although the Dutch have often prided themselves on being less class conscious than the English or the French, the Holland of de Kooning's youth, like the industrializing Midlands of England or the Wales of the young D. H. Lawrence, was a stratified society in which advancement was difficult and the wounds of class sharp. De Kooning's ancestors were mostly servants, laborers, and craftsmen. His paternal great-grandfather, Cornelis de Kooning, was a shipbuilder from Woerden, a small river town about twenty-five miles northwest of Rotterdam. Born in 1810 or 1811, Cornelis moved from Woerden to Delfshaven, a coastal town west of Rotterdam where his son Willem—named after Cornelis's father—was born in 1838. Sometime in the 1840s, Cornelis moved to Rotterdam to work in the city's burgeoning shipbuilding business. He settled at Vinstraat 2 with his wife, Anna Catharina Jacoba Jurgens, his son Willem, and his daughter Jacoba.

In 1850, Cornelis died at the age of thirty-nine or forty, leaving his wife and children on their own. For the next ten years, his wife supported her family by working as a maid. At the time of her husband's death, Willem—the grandfather after whom de Kooning would be named—was twelve years old and still in school. His education ended soon afterward. (It was the custom until well after the turn of the century for working-class children to leave school at twelve, then be apprenticed in various crafts.) Like his father, Willem worked in the shipyards. In 1865 he married Maria van Ladenstijn, who had been a maid. They had ten children, four of them boys. Among them was de Kooning's father, Leendert.

Leendert was born in Rotterdam on February 10, 1876, and grew into an ambitious but also stiff and emotionally withdrawn man. His face was shuttered—a vein of selfishness, according to family lore, ran through the de Koonings. He began his working life selling flowers, first from a cart and then at a flower stand at the railroad station. In 1896, the year he turned twenty, he started a small company with his oldest brother that bottled and distributed beer to pubs. Eventually he went off on his own,

establishing a beer-bottling and -distribution business in a modest building at Vledhoekstraat 26 in North Rotterdam, not far from a large new Heineken brewery. He appeared stable and was earning a little money. If he was very reserved, that was hardly unusual in Holland, and might have even appeared romantic in a handsome man in his early twenties. In 1897 or 1898, his eye settled upon Cornelia Nobel, who was everything Leendert was not—fiery, impetuous, caustic, and outspoken. In turn-of-the-century Rotterdam, Leendert's ambitious and frugal nature would make him seem an excellent match for a working-class girl like Cornelia Nobel.

Cornelia's family had lived in Schiedam, a town adjacent to western Rotterdam, since at least the eighteenth century. In 1873, Cornelia's mother—also named Cornelia—had married Christiaan Gerardus Nobel, a packing-case maker and carpenter. The couple settled at Rotterdamsedijk 47A, in a small lane in Schiedam, where Nobel made barrels and cases to hold the cheap gin for which Schiedam was known. The marriage produced nine children, five of whom died young. Three of the surviving children were girls. (The lone son, de Kooning's uncle, Chris Nobel, was the first in the family to set out for America. He settled in Brooklyn, where de Kooning sometimes visited him after coming to New York.) Cornelia was born on March 3, 1877. Even as a child she was considered formidable. She possessed, as her relatives said diplomatically, a "temperament."

Small and slim, Cornelia had black hair, dark eyes, and a figure in which she took great pride. She was a restless young woman, constantly on edge, with a sharp temper and wicked tongue. She rarely laughed. Acquaintances consistently thought of her as being much taller and bigger than she was, a "masterful woman who dominated the entire family," in the words of Jacobus "Koos" Lassooy, her third surviving child and the offspring of a later second marriage. Everyone in her family found her difficult. Henk Hofman, a cousin of de Kooning's, said that even his mother—Cornelia's sister—could not bear her for long. A woman who demanded center stage throughout her life, Cornelia was histrionic by nature; an interest in performing seems to have run in her family. She sang in her youth, according to family history, and did some amateur acting once her children were grown. Her relatives credited her with taste—which may have been a way of saying she was socially ambitious and put on airs. She was also "very quick," according to members of her family, and spoke rapid-fire Dutch with "a heavy" Rotterdam accent.

As an adolescent, Cornelia left her family in August 1894 and went to the town of Haarlem, probably to work as a maid. It was a bold step: Haarlem was about fifty miles from Rotterdam, a significant distance in that era. But Cornelia returned to Schiedam the following year, at the end of

October 1895, perhaps because she was ill-suited to the role of a servant. Two possibilities were open to a woman in her position. She could marry, or she could work in menial jobs. She was a pretty young woman, and her flair and dramatic personality no doubt proved a charming and interesting challenge to young men. In September 1898, she became pregnant with Leendert's child. Such an occurrence was not unusual, either for the period or the couple's social class. If pregnancy out of wedlock was not condoned, neither was it forcefully condemned. Few young men could afford to support a family; members of the Dutch working class often married late. As a result, it was not surprising that the young engaged in sex outside

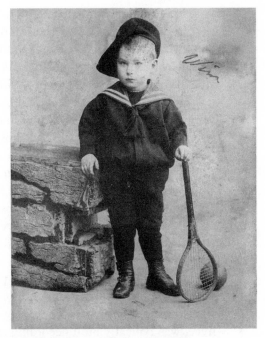

A formal portrait of de Kooning as a young child

of marriage or that, in the days before birth control, young women often became pregnant. Rotterdam was a city full of people at loose ends in which traditional sexual mores were more respected than followed.

Nonetheless, a man was still expected to take responsibility for a woman he impregnated. The couple was married on December 22, 1898, in Schiedam. Leendert was twenty-two, Cornelia twenty-one. No one knows whether their marriage was strongly desired or merely the result of a brief sexual encounter. What is certain, however, is that the young couple immediately came under intense personal pressure. In 1899, six months after the wedding, de Kooning's older sister, Marie, was born. Twin girls—Adriana and Cornelia—soon followed, in 1901, but they died days after their birth. Then came another daughter, Cornelia, in 1902, who died when she was eight months old. Willem de Kooning—the fifth child, but only the second to survive—was born in 1904, on April 24. By then, Cornelia had spent virtually all of her married life pregnant, either taking care of infants or burying them. She did so in a neighborhood where every day was a struggle: de Kooning's family was part of a great mass of people hanging on week by week, trying to find their way in a newly evolving society.

Her husband had little energy to give to his family. Still in his twenties, he was working hard to establish his own business, hiring several employees to help him bottle beer for Heineken and other breweries. He also delivered the beer by means of dog and pony carts from his Vledhoekstraat concern to pubs throughout the district. Soon he expanded his business to bottle and distribute Elko lemonade as well. At the time of Willem's birth, the de Koonings lived on Zaagmolenstraat, where the houses were slightly larger than those on the neighboring side streets—a subtle mark of Leendert's rise in the world. But the house itself was anything but fancy. In de Kooning's neighborhood, a man was rich if he owned a bicycle. (It was not unusual in the Rotterdam of 1910 for a man to walk two hours each way to work.) Most money was spent on necessities, though workers often blew their paychecks in the pubs—the only spots of warmth and brightness in the dank darkness of a Rotterdam winter, when the wind swept in from the North Sea. Meat was usually eaten once a week, on Sundays. The staple was potatoes flavored with lard from the butcher's shop.

Housing for workers, including the house where the de Koonings lived, was typically built according to the same plan. An apartment consisted of two small rooms, one used as a parlor and the other as a kitchen and gathering spot for the family. In between the two rooms was an even smaller and windowless half-room—essentially a passageway—which served as a communal bedroom. On each side of the passageway there was a sleeping alcove, one for the parents and the other for the children; as many as three or four children might share a bed. Water came from a cold-water tap on the landing that was used by the two families sharing the floor. They also used a common toilet, located in a closet on the landing, which contained a bucket that was emptied manually. Since heat cost money, people were often cold. The de Koonings probably used a coal stove. Those still poorer relied on small cooking stoves to take the chill off the day; coins were inserted into a meter that turned on the gas. Baths were typically taken once a week at most, either at a public bath or at home, where each member of the family used the same tub of heated water. The hot water was purchased at the local grocery store and then hauled back home and up the steps to the apartment. Since washing clothes was difficult and expensive—it required buying hot water or hiring a laundress—clothes were rarely clean. Bedclothes, cumbersome and hard to dry, were almost never washed.

The most telling aspect of life in North Rotterdam was the ceaseless movement of families from apartment to apartment. A family typically rented half a floor of a tenement and paid rent weekly. If the apartment

became dirty or a better deal was advertised elsewhere, the family would move. Freshly painted walls, for example, might lure a family to a new home. Sometimes landlords would offer a week or two, or even a month, of free rent to attract tenants. Moving was no problem, since few people had any furniture or possessions to speak of. What little they had was loaded into a pushcart and hauled to the new location. From 1899 to 1904, the year Willem was born, Leendert and Cornelia lived in seven different apartments.

Given the harshness of working-class life, tension naturally ran high in many families. Leendert and Cornelia were no exception—except, perhaps, in the degree of their hostility. Six years into their marriage, all the charm had left the relationship. The young couple had buried three children and were living in cramped quarters with a five-year-old and a baby. Money was short for an entrepreneur who wanted to expand his business. Under enormous pressure to make his bottling business work, Leendert chafed at the burdens of family life and disliked returning home to an angry wife and small, squalling children. The couple now seemed grossly mismatched by temperament: the husband was stiff and silent, the wife opinionated and volatile. That they began fighting bitterly is not surprising. That their marriage unraveled legally, however, was much more unusual. In the early 1900s, divorce was fairly rare in Holland. (Typically, couples who were unhappy together lived apart while remaining legally married.) More remarkable still, Leendert, rather than Cornelia, initiated the legal proceedings. It was far more common for a wife—usually abandoned or beaten by her husband—to file for divorce. But on February 20, 1906, as Willem neared his second birthday, Leendert began separation proceedings. The official reasons he cited were ill treatment and cruelty.

A man in Leendert's position did not lightly file for divorce: his action suggests that the marriage was especially difficult and probably violent. Cornelia had an explosive temper and often flew into screaming rages. Years later, Leendert described her as "hysterical." Cornelia was also known to lash out physically. Beyond slapping her children, she probably also struck her emotionally distant husband. He may have struck back. In any case, shouting and possibly hitting, along with the terrifying loss of control these actions imply—in a tiny apartment, in front of children— were probably more than a reserved man with ambitions to get along in the world could bear. Adding to the tension was an incident in which Leendert was briefly jailed for not having a proper license for a delivery cart. When he returned home after his release, he found that Cornelia had sold many of his factory furnishings. Her explanation was that she had needed money to feed her children, but doing this was a blatant affront to

his authority. On April 21, three days before de Kooning's second birthday and two months after Leendert filed his charges, Cornelia responded by filing a similar request for divorce on the grounds of adultery, ill treatment, insults, and—highly improbable in Leendert's case—extravagance. This last charge no doubt reflected Cornelia's belief that Leendert neglected his wife and children by spending his money on himself and his business.

After filing the papers, Cornelia moved out of the house on Zaagmolenstraat, taking her seven-year-old daughter and two-year-old son to a house on Josephstraat in West Rotterdam. Shortly afterward, she and the children moved back to North Rotterdam, this time to a small two-story house at Ooievaarstraat 17. Her new apartment was a step down in class from the one on Zaagmolenstraat. During the proceedings, Leendert was ordered to pay ten guilders a week to his wife and children. But once the divorce became final, on January 7—almost a year after Leendert initiated the proceedings—the alimony and child support he was required to pay was cut in half, to only five guilders a week. Cornelia's standard of living fell precipitously. She began to take in washing and started moving to ever smaller and shabbier houses. In February, the court took up the question of child custody. According to the legend that has grown up about de Kooning's early years, often repeated in brief biographical accounts in museum catalogs, the court awarded custody of Willem to his father and of Marie to his mother. His mother, according to this account, then began to fight for custody of Willem, finally kidnapping him and eventually winning him back in a legal battle.

The official divorce documents prove otherwise, stating that custody of both children was awarded to the mother from the beginning, with co-guardianship assigned to Cornelia's father, Christiaan Gerardus Nobel. Cornelia and her two children settled together after the divorce at Rietvankstraat 34, in still another section of North Rotterdam. Far from being a mother deprived of one of her children, Cornelia subsequently sent the small boy to his father. The reason was that she decided to remarry. According to the Dutch records, de Kooning moved to his father's house just five days before Cornelia married Jacobus Lassooy, on April 8, 1908. For most of his fourth year, de Kooning stayed with his father while his sister remained with Cornelia and her new husband. About to embark on her second marriage, Cornelia may have felt that an unruly four-year-old son from her first marriage would hinder the establishment of a new household in a way that his older and more pliant sister would not. During the period when de Kooning lived with his father, however, Cornelia frequently visited the places where he was playing, now and then scoop-

ing him up and taking him home with her. De Kooning remembered those occasions as acutely embarrassing; the unscheduled visits probably caused tension between the households. In any case, Cornelia's guilt over giving up her son probably explains the origin of the false story that the court assigned custody of Willem to his father. Unable to acknowledge to her children why they were separated, she instead blamed their father and the court, transforming herself into a heroic mother by telling them that she "kidnapped" Willem and fought a custody battle to get him back. In later years, de Kooning himself seemed uncertain what had happened. It is likely that, as with most children of bitter divorces, he did not want to know.

On November 25, 1908, seven months after de Kooning switched households, his father was also remarried, to Neeltje Johanna Been, who was ten years younger than Leendert. According to family accounts, she lived for her husband and ignored her children. (Her own son, de Kooning's half brother Leendert, described his relationship with his mother as "nonexistent" and said his parents "did not show us love.") Both de Kooning and his sister actively disliked their stepmother, and blamed her for increasing their distance from their father. One month into her new marriage with Leendert, she became pregnant. Two months later, Leendert sent Willem back to his mother, probably for the same reason that Cornelia originally gave him up: to protect a new marriage. De Kooning was not yet five years old. In his short life, he had known little but change and instability, a bewildering succession of households, parents, and small cold rooms lit by hot flashes of anger.

De Kooning himself rarely spoke of his childhood. In America, like many of his fellow immigrants, de Kooning would resolutely put his early life behind him and, when asked about his years in North Rotterdam, become unexpectedly reticent, deflecting the question or stating that he was "not one to go down memory lane." He would say, "I tried to avoid thinking of this aspect [Holland] of my life. In this way I protected myself from my own feelings." But the emotional tenor of his childhood nevertheless emerges from the Dutch records and the description by other people of his parents, together with the few memories he did mention. De Kooning remembered his childhood as one of great loneliness. Even before he could speak, he knew the angry voices and icy silences of two parents who detested each other. He felt the skittish energy of the mother, the distant remove of the father, the melancholy of the beloved older sister. He watched his father leave the house for good when he was almost two years old, and at the age of four suffered a cruel abandonment when his mother sent him away to an unknown house without his older sister. (Yet she

would regularly surprise and confuse the child by appearing by his side, emotional, seductive, and full of fight.) He spent a few months with a remote father until a new woman appeared who did not want him. Then he was sent once more to his mother—and a new stepfather.

Cornelia regularly beat her children. De Kooning told friends that she would have screaming fits and hit them with wooden shoes. For his part, Koos, de Kooning's half brother, said he was beaten and bruised every day of his life—or, as he put it, "shown the four corners of the room," a Dutch expression that describes being severely slapped around and beaten up. To physical beatings, Cornelia added powerful psychological punishments. She sometimes locked de Kooning in a closet. Once, she herself hid in a closet and then jumped out at him holding a knife. All his life he would fear constriction and love the idea of "breaking out" of boxes of style or habit: he would insist upon the convulsive truth of eruption and release. At the same time, he would become a master of indirection, "glimpsing" an intense reality rather than facing it directly—the preference, perhaps, of a child who must often flinch. The most telling story de Kooning told about his early life seemingly has nothing to do with his parents, but may represent the fear and desperate claustrophobia of a small child. He was playing with marbles on the street outside his house when one fell into the sewer. An older boy obligingly removed the grate so that Willem could retrieve the marble. But before the little boy could climb back out, the older boy replaced the grate and walked away, leaving him trapped. Because he could not swim, he panicked; he would never escape, or would perhaps be swept into the subterranean labyrinth. An old woman saved him, but de Kooning never forgot either the horror of the imprisonment or the indignity of the rescue.

For all her faults, Cornelia was a great "performer" in her private dramas. Her second husband, an extremely passive man, did not engage in fights with her. The full force of her personality was instead turned upon her spirited son. She regularly enjoyed with him the dark pleasures of the long, drawn-out, and knock-down battle. Marie observed, admiringly, that de Kooning was "stubborn" and unyielding. The passionate back-and-forth struggle would become an essential feature of de Kooning's later painting, as would his respect for the bravura gesture. De Kooning had no choice but to fight his mother: she would otherwise have consumed him completely, as she did his sister and her second husband. A grandchild of Cornelia's once recalled that she had *no* maternal feelings and "would not let herself be kissed so that the skin actually touched. She conveyed the message that 'I won't let myself be kissed by anyone, even my son.' "

If de Kooning's mother dominated him, his father remained relent-

lessly distant—which is no less wounding to a child. Even during the year de Kooning spent with him, Leendert had little contact with his son. He was gruff and authoritarian. As a small child, de Kooning once asked his father for the equivalent of a "dime." He was told no. "What would it have cost him [emotionally]," de Kooning once asked, "for him to give it to me?" Leendert treated his second family of children much the same way, refusing to have breakfast with his son and namesake, although they worked together at his beer and bottling business. In later years, Leendert demonstrated no desire to keep up with his first born daughter, Marie. So tenuous did their connection become that once, while both were picking up food in a war relief effort in the 1940s, Leendert failed to recognize her. De Kooning's own emotional distance from his father continued well into adulthood. Decades later, in a letter to his sister, de Kooning wrote that their father had all but abandoned them: "He was a stranger again . . . he forgot that the children must have something from BOTH the father and the mother." Yet Leendert was far from being a cipher in his son's life. De Kooning retained two powerful memories from his early childhood, each of which conveys a palpable masculinity. He would never forget, de Kooning said, the stamping of the hooves as the horses or ponies pulled his father's beer and lemonade wagons. And he would always remember his impressive, but forbiddingly high, starched collars—and wanted to get their feel into his painting.

Despite the harsh circumstances of his upbringing, de Kooning did find moments of escape and release. The earliest were with his sister, Marie. Though five years apart in age, the two children turned to each other for solace. Without his gentle sister, who loved him and provided some of the maternal feeling that his mother withheld, the boy's situation would have been incalculably worse. (Years later, de Kooning wrote Marie thanking her for her early kindness to him: "I will never forget that during my grown-up [sic] period, you were always there to protect me.") The children probably shared a bed and could together create a refuge in moments of loneliness. The bed was a safe haven for de Kooning, who all his life had difficulty getting up in the morning. He remembered his mother repeatedly snapping out one of his nicknames, "Wimpy—get up! Wimpy—get up!" and dreaming of the day when he would be able to stay in bed as long as he wished.

Marie and Willem were fortunate in one respect. Their mother had found, the second time around, exactly the sort of husband she could live with—a sweet, simple person. Jacobus Lassooy was an easy man to like and passed through life making few demands. He brought a measure of peace and quiet to the family, becoming a benign influence in an otherwise

explosive household. Although not very close to his stepfather, de Kooning in later years spoke more affectionately of Lassooy than of his own father or mother. Lassooy was tall—much taller than de Kooning's mother—and had dark, curly hair. "He was good-looking but not very interesting," said the wife of de Kooning's cousin, Henk Hofman. He had been a sailor on steamships. By the time of his marriage to Cornelia in 1908, he had become a *koffiehuishouder* (café licensee, or "coffeehouse keeper"). He seemed to change jobs with the seasons. In the six years following his marriage to Cornelia, he worked at five different ones—that of coffeehouse keeper, life-insurance agent, harbor controller, coffeehouse keeper again, and docker. The family changed apartments just as frequently. Between the ages of four and thirteen, de Kooning moved an astonishing twelve times. The only benefit was that several of the moves brought him closer to the harbor life that he loved.

As Willem grew older, he began to explore the city with friends. One of his happiest memories is reminiscent of a Dutch genre scene. He was part of a group of boys who, in winter, would cut down saplings near one of the canals in Holland and then, using them as fulcrums, joyfully whip themselves back and forth across the ice—an image of ecstatic release. The young de Kooning was also an occasional daredevil. Hofman remembered that he would perform dangerous stunts outside his aunt's house during family visits. One time he dangled precariously from a high church wall, delighting in the other children's fear. At the turn of the century, most games were played either on the canals or in the streets, since there were few parks and playgrounds. Street games, such as leapfrog, were highly organized, each with set rules. The young de Kooning was also beginning to draw—everywhere, and on all surfaces. His half brother Koos remembered Willem drawing boats and workhorses pulling wagons, perhaps those his father used.

De Kooning and his friends congregated around the cattle market near Zaagmolenstraat where country people in traditional costume brought cattle to be slaughtered. And, of course, they flocked to the harbor. De Kooning remembered one particular moment when he was very young—perhaps just seven or eight—and stood alone looking at the water. He became certain, he said, he would do something important in his life.

I t was at school that he first heard encouraging words from an adult. And it was there that he first met figures of authority who held out a promise of better things to come. Many teachers in Rotterdam's schools were idealistic social democrats who strongly believed in education as a means

of advancement—an ethic they worked to instill in their pupils. Most children went to school for the mandatory six years and, at the age of twelve, most then left school—usually apprenticed into a trade, just as Willem's grandfather had been sixty years before. De Kooning may well have begun school as late as eight years old. And he likely changed schools often as a result of his family's many moves. But little is known about his elementary schooling. None of de Kooning's school records survived the 1940 Nazi blitz of Rotterdam, which destroyed almost the entire downtown and harbor area of the city. In later years, he would sometimes point to students of fourteen or fifteen and remark, wistfully, that he had not gotten even that far. Throughout his life, de Kooning maintained an exag-

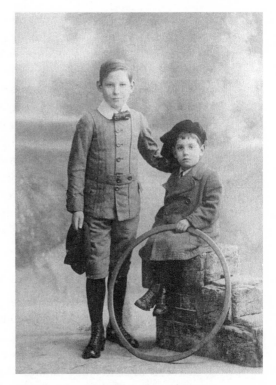

De Kooning with his younger half-brother, Koos

gerated respect for a university education. He was especially attracted to philosophers and novelists with a philosophical or intellectual bent, particularly admiring Kierkegaard, Wittgenstein, and Dostoevsky.

The schools in Rotterdam were organized around social class, with the poorest families sending their children to free neighborhood schools, each designated by a number. More affluent families placed their children in grammar schools that charged a small tuition. Still wealthier families chose more costly schools. In each case, the teaching was roughly the same; the differences among schools were more a matter of social standing than of education. De Kooning's would have contained six grades or forms. Each was probably attended by 100 to 150 pupils. School began at nine o'clock. The children sat on wooden benches, two to a bench, doing their lessons. The curriculum was strict and old-fashioned. The pupils studied reading, writing, arithmetic, geography, and history. There was a short midmorning recess, and, in the middle of the day, an hour and a half break, during which many children returned home for lunch. In the afternoon,

the teaching of the core curriculum resumed. Recitation and memorization were important. So was singing. The singing was done in unison, as in the army, to teach the students teamwork and instill discipline.

De Kooning flourished in this structured environment. "At twelve, I was a very good pupil," de Kooning told the journalist Gaby Rodgers in 1978. "I had two friends, and the three of us were always at the top of the class." The remark was telling. It suggested that de Kooning, whatever his difficulties with his parents, was competitive and already working for success in the outside world, as represented by the school. There was one history teacher in particular who inspired in de Kooning a feeling for the expansive possibilities of life and art. He would enter the classroom and then remain absolutely quiet for a full minute. Then he would announce, "Five thousand years ago . . ." According to Conrad Fried, de Kooning's brother-in-law,

> This made a terrific impression on Bill—what people were doing five thousand years earlier when they lived in what became Holland. The same teacher encouraged de Kooning to draw as much as he wanted. When he was a boy, he liked to use his fingers in the paint a little bit, particularly his thumb. He'd make a line and push it. It would make one of those de Kooning smudges that he still did until he was ninety. So this same teacher told Bill, "See that guy sitting over there? You go over and see what he's doing." So Bill did that. The kid was drawing loose. Bill was drawing tight. He got to talking to that other kid, and the kid told him that the teacher had told *him* the same thing—go see what Bill had been doing.

In later years, casual acquaintances of de Kooning's often emphasized—with the delight of those who cherish the idea that Einstein forgot to wear socks—his humble and unworldly manner, and amiable wit. This was not a false face. De Kooning was sometimes like that, but he was never simply an innocent. Those who knew him best were equally impressed by the intensity of his ambition, his knowledge of the direction in which the world was moving, and the lengths to which he would sometimes go to conceal his ambition from others. A marvelous-looking boy, with a shock of light reddish-brown hair and a pixie brightness around his eye, de Kooning early in life learned to divert anger, mute threats, and deflect competition. He never had much small talk, either as a child or man, but he could call upon a certain form of bonhomie, the conviviality of one who can be welcoming without giving much away. He was remarkably good at defusing tension, a talent developed in a household filled

with strife. (Later, friends recalled that he could step between two men arguing in a bar and soon have everyone laughing together.) "De Kooning had the social ability of somebody who has a restaurant or bar," said Joop Sanders, an artist and friend who was also born in Holland. "He had an innkeeper's mentality: you like everybody and get along with everybody."

During his school years, de Kooning's family continued to struggle. On May 8, 1912, Marie and Willem's half brother Koos (Jacobus Johannes Lassooy) was born. De Kooning was eight. His stepfather, it soon became clear, was as hapless as he was handsome. Shortly after his marriage he developed lung problems and suffered increasing illness for the rest of his life. "He wasn't a jolly fellow," said Cornelia's grandson and de Kooning's nephew, Antonie Breedveld. "But I blame it on the sickness. What I heard about him was that he was always in pain." Cornelia took in laundry and cleaned houses when her husband was not working. During World War I the family's economic—and personal—plight worsened. At some point in 1914 or 1915, de Kooning's stepfather had decided to return to running a pub himself rather than renting his spirits license to someone else. Rotterdam was a hard-drinking city—it was known as the drinking capital of Holland—and only a limited number of alcohol licenses were available. As such, they were valuable. Lassooy rented a pub at Linker Rottekade 120 and moved the family into the apartment above the bar.

In Rotterdam, the pubs ranged from tiny storefronts with a stand-up bar that served just one thing, shots of the local gin, to larger establishments that offered bar meals and a greater selection of spirits. Lassooy's pub was of the latter type, bigger than many and better stocked. It was therefore more taxing to operate and staff. The hours were grueling—from nine a.m. until one or two in the morning—and the patrons rowdy. A typical pub was a dark and dingy brown and reeked of smoke. Decoration was minimal. The bar itself was not large; most patrons leaned against the walls or sat in the window. Workers would go to their local pub almost daily for a lunch or supper of pea soup and hard-boiled eggs, swigged down with a glass or two of gin. Since the working day often began at six a.m., the first customers came in for soup at around nine in the morning. Cornelia routinely got up at four a.m. to make that day's soup, eggs, and meat rolls—all heavily salted, to encourage more drinking. "The mother was always busy in the bar; there was not much time for the children," said Joop Sanders.

In 1915, de Kooning's sixteen-year-old sister, Marie, desperate to escape from under her mother's hand, took the time-honored way out for a working-class girl: she became pregnant. The man who impregnated her showed no interest in marrying her, which probably increased the tension

in the household. Only on April 26, 1916, seventeen days before she gave birth to a son, Antonie, did Marie succeed in marrying the child's father, Dirk Breedveld. Perhaps the most significant fact about Marie's wedding was not that it was late or rushed, but that her own father did not attend. Eight years and three children into his second marriage, de Kooning's father was almost completely estranged from Marie and Willem.

That same year, as twelve-year-old Willem was finishing his elementary schooling, new financial troubles beset the family. Lassooy's decision to return to the bar business proved spectacularly ill-timed. Running a working-class bar in a city already overflowing with bars was difficult under the best of circumstances. During the war years, when money became scarce, it became even harder. Holland remained neutral and was spared the horrors of battle, but it suffered terrible economic privation. Rotterdam, as a port with strong economic ties to Germany, was especially vulnerable. During the German advance in 1914, most young Dutchmen were mobilized, depriving their families of income and Rotterdam of a sizable portion of its drinkers. Their departure was followed by a massive influx of poor refugees from Belgium, exacerbating food shortages in Holland. Meat and dairy products were being sold to the military or the export market, which created huge profits for speculators but left the working class barely above starvation level. The economic slump deepened when Germany began its blockade of the North Sea, effectively shutting down the port. By 1917, only a trickle of ships was reaching Rotterdam. Shortages worsened. The population began digging peat, an ancient and smoky source of energy, when supplies of coal ran out. There was not even fuel enough to brew beer. The widespread misery produced riots and civil unrest. Soup kitchens opened and handouts began, but these only took the edge off the widespread hunger. On one occasion, after Rotterdam officials confiscated goods from black marketeers, the local people hijacked the carts. At times, the rioting became so violent that the army was sent into the city to restore order.

Not surprisingly, Rotterdam seethed with radical politics. (During the left-leaning days of the 1930s, de Kooning recalled having seen it all before—the huge demonstrations, the crowds chanting "Red, Bread.") One of the few people in Rotterdam who did flourish during the war years was de Kooning's father, whose delivery carts carried lemonade to the troop trains. De Kooning's stepfather was not so lucky. By January 1916, Lassooy was having trouble paying the rent on his bar. In May 1917, with money growing tighter and fewer customers able to afford even the cheap local gin, Lassooy declared bankruptcy. After the bankruptcy proceedings, he was left with only ten guilders a week—the result of renting his liquor

license to a friend—for himself and his family to live on. With few job prospects and a family to support, Lassooy now listed his job as "laborer." He was probably, for the most part, unemployed.

Ten years after Cornelia's second marriage, then, de Kooning's family had almost fallen out of the working class and was living on the margins of society. How poor the family was can be seen from the borderline malnourishment that de Kooning suffered. (He was ten years old when the hostilities began and fourteen when they ended.) For the rest of his life, de Kooning was plagued with dental problems, the legacy of too little healthy food and dental care in his youth. He always claimed that he would have been several inches taller if he had had a proper diet. Like many people in Holland, de Kooning's family lived mainly on potatoes and turnips during the war.

In the hard year of 1916, while the pub was failing and his sister was pregnant, Willem was still too young to escape. But another door was opening for him. His teachers had noticed his gift for drawing and encouraged his mother to steer him toward a job as a craftsman. Once de Kooning finished primary school in 1916, his stepfather began to take him around to local establishments that might make use of his talents. Luckily for both Willem and the whole family, given their precarious position, he was hired as an apprentice at the important decorating firm of Gidding & Zonen (Gidding and Sons). The location at Aert van Nesstraat 130 was ideal, not too far from the family's latest apartment. Better yet, Giddings was an enlightened business run by two brothers who took a paternal interest in their employees. It was the start of de Kooning's life among artists—and the beginning of his farewell to his family.

2. New Worlds

You have to start, over and over again.

To a twelve-year-old working-class boy, the Gidding firm represented another world, an imposing and often dazzling one of money, class, style, and power. As a child, de Kooning knew this world only from the outside, glimpsed through the windows of the fancy downtown shops or sensed in the unfamiliar manners and accents of the prosperous Dutch who lived elsewhere in the city. At the Gidding firm, he was just another talented apprentice who might eventually make a useful worker. But de Kooning was also making his first important "emigration," just as he entered adolescence, toward a new life that promised more than just getting by.

The Gidding headquarters was located in the heart of fashionable Rotterdam, just off the Coolvest, the canal that passed through the center of the city. Originally a haven for sailors, the Coolvest area had become more respectable with the booming business of the port and the construction, in 1911, of the imposing new city hall. By the late nineteenth century, banks and expensive stores lined the street parallel to the canal. (The actual canal would be filled in between 1913 and 1922 and become a grand boulevard renamed the Coolsingel.) The area also attracted artists. The city's arts and technical sciences academy—the Academie van Beeldende Kunsten en Technische Wetenschappen, known simply as the "Academie"—had been located on the Coolvest since 1873. Nearby were a number of decorating and arts-related businesses, including the Gidding firm.

The company specialized in "everything to do with elegant decoration," as one family member put it. The firm not only served wealthy Rotterdammers, but also created the interiors of restaurants, theaters, and ships; its craftsmen made mosaics and stained glass and designed carpets, textiles, and furniture. While only one of many decorating firms in the city, it was particularly successful; Gidding employed more than one hundred people year-round at its headquarters. During summer, the busiest period for decorating and building, that number increased to around two hundred, as more workers were hired to execute the designs prepared by the two Gidding brothers or the firm's other master designers. Part of the influential arts and crafts movement that flourished in Europe in the latter decades of the nineteenth century and the first thirty years of the

twentieth, the firm had been founded by Johannes Gidding (1859–1914), a painter of still lifes, who studied at the Rotterdam academy, and established close family ties to that institution. His brothers Marinus and Jacobus also studied there, as did his sons Jacobus and Johannes—known respectively as "Jaap" and "Jan." After their father died, his sons succeeded him as the co-heads of the firm.

A good-humored and rather preoccupied pair, Jaap and Jan were only twenty-nine and twenty-five respectively when de Kooning joined the firm. They were better suited to art than to business and, at the headquarters on Aert van Nesstraat, left the making of money to others. Of the two brothers, Jaap was the better-known and more important artist. His horizons stretched well beyond Rotterdam and Holland, whose art world remained provincial by German or French standards. After leaving the academy in 1905, Jaap spent four years in Munich and traveled to Italy and Paris. There he became entranced by art nouveau, the style that was still the rage throughout most of Europe. He was especially taken by the expressionistic glasswork of the symbolist artist Johan Thorn Prikker. He was also influenced by the highly colored art nouveau theater designs of Fritz Erler. A well-off young man like Jaap, sensitive to fashion and aware

A workshop at the decorating firm of Gidding and Sons, where de Kooning was an apprentice. The Gidding brothers are seated at the table.

that his own country was somewhat behind the times, was easily swept up by what the English artist Walter Crane once called "that strange decorative disease." An ornamental style known for its curling line, dense patterns, and exotic flora and fauna, art nouveau was an expression of the lush, fin-de-siècle imagination of Europe. Its French name came from the Parisian shop La Maison de l'Art Nouveau, founded in 1895 by Samuel Bing as a showcase for the emerging style. (In Germany and Scandinavia the movement was called Jugendstil, after the Munich magazine *Jugend*, which disseminated its ideas. A more restrained Dutch version that developed in Amsterdam was called Nieuwe Kunst.) In part a reaction to the backward-looking designers of nineteenth-century Europe, who continually recycled rococo, classical, and Renaissance ideas, art nouveau instead emphasized the exotic, be it a symbolist fantasy of the snaky unconscious or a far-flung evocation of Persian, Indonesian, or Japanese design.

Though frequently effete and overripe, art nouveau was arguably the first widespread modern movement in the decorative arts. In some of its manifestations, the style developed a strong utopian spirit that challenged the bourgeois focus upon the individual. Many of its followers believed that the decorative arts were as important as the fine arts of painting and sculpture; the work of an anonymous craftsman, emerging from the ancient guild tradition of Europe, was as culturally significant as that of the solitary painter. The modern elevation of good craftsmanship into an almost religious ideal had begun earlier, with William Morris and the arts and crafts movement in Victorian England. It also owed much to the emergence of architecture—usually the presiding art in any utopian quest to remake the world—as a center of modern design in the late nineteenth century. In Holland, the architect Hendrik Petrus Berlage (1856–1934) was particularly influential in the formation of Dutch art nouveau and the later, stripped-down successors to the movement, the utopian Bauhaus and De Stijl schools. Like the Victorians Morris and John Ruskin, Berlage believed that art should promote and serve social harmony, remaking the world in all its parts. It was an idea that remained popular throughout the early decades of the century and would influence de Kooning for a time. If Jaap Gidding created beautiful surroundings for wealthy clients, he also designed tapestries, carpets, and glassware for mass production.

At the time de Kooning went to work at the Gidding firm, art nouveau's sweet hothouse breath was everywhere—in the ornate stained-glass creations of Louis Comfort Tiffany, in theater murals, in furniture, in the posters on city walls. Jaap Gidding himself had only recently returned from Paris and Munich and was eager to transmit the excitement

of the movement to his earnest, business-obsessed city. A late enthusiast of the style, he was working in a place that would not necessarily know that art nouveau was beginning to fall out of fashion elsewhere. (Gidding also adapted to changing tastes, later incorporating Art Deco elements into his designs.) For the interior of the renowned Tuschinski Theater in Amsterdam, Jaap created a lush orientalist fantasy of a carpet that had a central design in the form of an eagle. Many other designs executed by Jaap were steeped in an exotic orientalism. A frieze that he created for a pavilion in the Dutch town of Scheveningen was an *Arabian Nights* fantasia of gazelles, peacocks, stars, and entwining boughs.

In Rotterdam, during the early years of the century, the Giddings were regarded as important tastemakers. Visiting artists from other parts of Holland and from abroad regularly stopped by to see the latest creations of the firm. "If you said 'I work at the Giddings,' you were prized," according to a descendant of the brothers. A surviving photograph from the period conveys the self-confidence of the enterprise. Dressed in dark suits and white shirts, each with the requisite high, starched collar of the era, the two brothers are posed at an outsized drafting table. Around them are piled long rolls of drafting paper and various drawing implements. Huge swaths of paper cover the walls. Behind the brothers, ten smock-clad assistants—old-fashioned easels in hand—sit or stand before the walls, prepared to enlarge the ornate designs sketched by the brothers for a restaurant, theater, or ship.

Six days a week, the twelve-year-old de Kooning left his claustrophobic household, entered the Giddings' structured workshop, and immersed himself in the sweet business of fantasy. He loved the sounds of the shop, as craftsmen worked on wood with fine saws, hammers, and files, and he relished the smell of the glues and paints. He stared with awe at the great but carefully organized supply of materials—the benches, pencils, easels, papers, tools. He admired the way that working drawings were created to transfer an image onto a wall. For the first year or two, an apprentice typically worked on-site at a project of the firm's, doing errands and helping mix paint and grind pigments. De Kooning later recalled working in hotel lobbies and at the firm's leaded-glass studio as well. The work was often laborious; de Kooning would never forget the rigors of grinding red pigment. But he loved the elaborate process, the doing of the thing. His first experience with art was tactile and sensuous: a matter of using his hands, making the paint, knowing art from the inside out. At the Gidding firm, de Kooning first fell in love with what is sometimes called the "cuisine" of painting, by which is meant not just an artist-chef's passion for the making of sauces—the artful mixing of the paint on palette or canvas—but

an appreciation for the physical life of the kitchen-studio with its varied rituals. To the end of his life he would remain fascinated with the creation of paints, and he once said, as if to suggest that there was nothing about his medium he did not relish, that he loved to watch paint dry on a wall.

In this respect, de Kooning's beginnings differed from those of many later artists, who grew up when becoming an artist was considered more a matter of temperament than of know-how. De Kooning began by learning the hows rather than the whys. His hand led his mind; and he always retained a fundamental sense of solidarity with artisans. Although he also hungered for philosophical talk, as a highly intelligent man will who does not get his fill of it when young, de Kooning regarded anyone who talked too fancily about "art" with a kind of native suspicion, akin to that of the peasant who watches a city man set up as a farmer. At Gidding, among the craftsmen, not much fuss was made about the higher issues of "art." That was left to the firm's designers and to the Gidding brothers themselves. Before anything else, art was work. As de Kooning said of his Gidding years, "I got a lot of training but also a lot of cleaning up for everybody."

De Kooning was expected to arrive by seven a.m. He worked every day except Sunday, and did not finish until six or seven p.m. About eight months after he joined the firm, his day was shortened from twelve to eight hours, the discovery having been made, as de Kooning recollected with amusement, that workers accomplished just as much in the shorter period as in the longer. Still, the workweek remained six days. De Kooning's later strong work ethic and willingness to endure poverty—his friends marveled at his stamina and concentration—probably owed something to the discipline of the Gidding years. In 1916, his pay was one guilder a day. His mother took what he earned and gave him an allowance, the usual practice of the time. However, apprentices were also fed meals, which must have pleased Cornelia, since it meant one less mouth to feed and the workshop quickly became an alternative home for the boy. For the rest of his life, de Kooning would regard "the studio" as his real home and other artists as his true family. At the Gidding firm, paternal craftsmen took the time to teach him their various crafts. The head decorator of the firm, Jan Schenk, paid special attention to de Kooning, who acknowledged learning much from him. Even Jan and Jaap Gidding encouraged the young apprentice, passing on to him old tubes of paint to use at home and giving him flowers for still-life painting. (As early as 1916, de Kooning painted a precocious still life with a decorative backdrop.) De Kooning learned lettering, marbling, and graining as well as how to paint decorative designs with fine-precision lines using a three- or four-inch-long "liner" brush.

His talent soon caught the eye of his superiors, who gave him tasks beyond the capabilities of most people his age, such as making preliminary drawings. When he was only thirteen, he painted angels over some doorways and took great pride in the result. De Kooning would never profess much interest as a mature artist in the exotic curlicues and dense patterns of art nouveau or the related, feverish imagination of symbolism, but they probably affected him more than he knew. His lifelong passion for the sensuous curve—for bravura arabesques of the hand—may owe something to the sinuous lines that filled his eyes at the Gidding firm; and his unashamed celebration of painterly richness, especially the whipped-up surfaces and strange pastel tonalities in his art, may stem partly from the hothouse cultivations of the time. More than any particular style, however, Gidding gave de Kooning the faith that, in the studio at least, the world could be transformed. When the craftsmen scrapped something that looked perfect to his boyish eyes, such as a beautiful rectangular block of wood, he would often ask them if he could save it. Every morning he left a pinched family and walked into a world where he could paint angels.

Only one year after de Kooning joined the firm, Jaap Gidding urged him to enroll in the Academie van Beeldende Kunsten en Technische Wetenschappen in Rotterdam, the institution that along with the Gidding dominated de Kooning's adolescence. It was the custom for the brothers to encourage promising apprentices to attend the academy, which was located nearby on the Coolsingel, across from the Boymans Museum, which housed the city's art collection. It was, de Kooning later recalled, an "honor" to be asked to enroll. The Gidding brothers, in addition to having attended the academy, were well-known benefactors of the institution. (In the academy's yearbook, Jaap Gidding is listed first as a "member," and then, from 1923 to 1945, on its board.) The Giddings themselves often paid all or part of the tuition for their apprentices, who highly valued the imprimatur of the academy. A number of important artists had also studied there. Among the more recent was the painter Kees van Dongen (1877–1968), who emerged around 1905 as a member of the Fauves in Paris. In general, an apprentice worked for the Gidding brothers for some time before being asked to attend the academy. The gifted de Kooning was a notable exception. By the fall of 1917, he was already enrolled in the *handteekenen,* or drawing, program, in the academy's arts division.

For a boy with no previous contact with fine art, the academy would have seemed daunting at first. Every day, upon leaving work in the early evening, de Kooning walked the short distance to the academy's for-

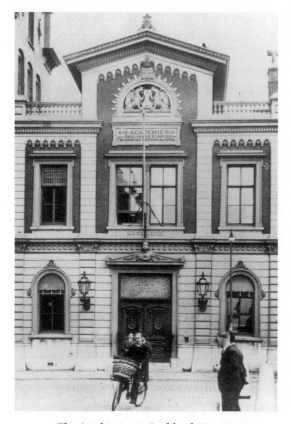

The Academie van Beeldende Kunsten en Technische Wetenschappen in Rotterdam, which de Kooning entered in 1916, at the age of twelve

midable neoclassical building, where he worked until about ten. Inside were two floors of formally proportioned classrooms. The long corridors had imposing Romanesque arches, seemingly laden with the important dust of art history. Copies of classical statuary lined the walls. Inside the classrooms, still lifes of teapots and jugs were arranged on tables for students to copy in a manner that Rembrandt himself might have recognized. The academy was a door to even wider possibilities than those offered by the Gidding brothers. It served as the only higher education de Kooning ever knew. At the academy, de Kooning attended lectures, met local intellectuals and artists, and perhaps even dreamed of becoming an artist himself, as unlikely as that prospect was for a boy of his background.

In later years, de Kooning sometimes referred to the academy in Rotterdam as the "Royal Academy," and much has been written about his study there that conveys the impression that the academy was an august and aristocratic place where de Kooning received the kind of classical training—all but lost to the twentieth century—that might have pleased Raphael. There is only some truth to this. Certainly de Kooning acquired a strong foundation for his art at the academy. As he told the *New York Times* near the end of his life, gesturing toward his paintings of the early 1980s, "Classical training frees you to do this." At the same time, the academy was actually one of the most modern institutions in Rotterdam, a place that stressed the practical as well as the theoretical and devoted much of its energy to training workers for modern industry. If

a young Rotterdammer wanted to be an electrician or a plumber, he would take classes at the academy. At an early age, de Kooning found embodied in the academy that difficult mixture of the traditional and the modern that would become one keystone of his sensibility.

The academy's origins were similar to those of many others in Europe. During the Enlightenment, cities throughout Europe had established academies modeled on a Renaissance ideal. In contrast to the local guilds, which for centuries had taught the applied arts to apprentices, these schools were typically dedicated to "pure" learning. Art was an end in itself, not a means to an end. Classical art, especially from Greece, was revered. Students copied classical works, carefully analyzing the laws of perspective and proportion; the academies treated classical art much as Enlightenment intellectuals regarded Nature, as an almost divine expression of rational laws. But Holland remained at heart a practical country whose main business was to promote more business. In 1818, when a royal decree was issued that forced Rotterdam to provide training in the fundamentals of art and architecture to tradespeople, the city began what amounted to an outreach program for Rotterdam's growing working class. A further effort in 1851 by the Ministry of Interior Affairs resulted in the merging of Rotterdam's original high-toned drawing society with two working-class institutions—an industrial sciences school and an architectural drawing school. The result was the academy that de Kooning knew. Its soul was thus curiously divided; in one room students might be copying a classical bust, in another learning how to build engines.

The academy offered two different courses of study. One was the more prestigious day course for the sons of wealthier families. "The boys who went to the day classes had many more possibilities," a classmate of de Kooning's said. "For us it was difficult since we worked during the daytime and every night from six till ten including Saturday evenings we had to go to the academy." But the larger evening program was the heart of the institution, which in de Kooning's day served as a de facto secondary school for the city's poorer classes. The academy placed particular emphasis on technical subjects such as architecture and mechanical construction. Within the arts themselves, there was a division for decorative and applied arts and a smaller one for plastic or fine arts, which included the drawing curriculum. Surprisingly, the latter, while offering the most traditional instruction in the school, was not the preserve of wealthy dilettantes. In 1916–17, the year before de Kooning enrolled in the drawing course, there were 164 students in the division, only 16 of whom were fine

arts painters or sculptors. The rest included 63 housepainters, 8 stucco workers, and a piano and organ maker.

The curriculum of the plastic and fine arts division was originally based upon the principles of classical French eighteenth-century academic art instruction, but also included architectural drawing and the history of architecture. Sometimes, a project would combine both a "high art" approach and a practical guild technique. As de Kooning later told the art critic Thomas B. Hess—for years the managing editor of *ArtNews* and one of de Kooning's strongest supporters—a still-life arrangement at the academy would be approached as an exercise in foreshortening, modeling, and the rendering of light and shadow. These were all classical art exercises. At the same time, the finishing was done with minute conté crayon dots to create a seamless, trompe l'oeil effect. The latter, said de Kooning, was a guild "secret." At the center of the program was eight years of training in drawing, which explains why many working-class boys in the applied arts were also enrolled in *handteekenen*. (Oil painting was not taught in de Kooning's division.) The student's own imagination or creative spark mattered little: inspiration, it was thought, could not be taught. What mattered were the fundamentals—of composition, of organization, of technique—as well as the practical goal of preparing students for a career in applied arts.

The first-year studies, de Kooning later said, focused on lettering and copying inscriptions. In the next two years, students progressed to copying increasingly complex geometric designs and drawing three-dimensional wire and plaster models, a process that culminated in a simple still life. The more advanced students used a "liner" brush—an angled brush that could create a fine line—which became an important tool of de Kooning's in later years. In the fourth year, the course of study included training in perspective as well as drawing more complex still-life arrangements and parts of the human face. Hess described the process of still-life drawing at the academy in this way:

> After the outlines were settled on the paper in faint charcoal lines, the still-life was modeled carefully, facet by facet, with conte crayon, the transitions and elisions expressed in gentle smudges and wipes of stompe or chamois. Each move had to be checked against the model. The students had to train themselves to keep their eyes at fixed levels and angles and at the same distance from the still-life and from the paper, and to reassume the identical position day after day. . . . Great care had to be taken to keep the skin of the paper intact. A bit too much rubbing and the fibers would come unstuck, making areas where the

charcoal would become too shiny and black. When the volumes were finally established the whole sheet was carefully rubbed and stomped to give an even layer of pigment across the surface—like a veil of black stretched over the white skin of the paper.

The fourth-year drawings at the academy were done with a superfine number one drawing pencil. (Years later, when the artist Pat Passlof studied informally with de Kooning, he asked her to use a fine 6H pencil.) The method of shadowing he learned, in which students smudged the fine lines with their fingers, influenced him throughout his career. The most advanced students at the academy—those in the fifth through eighth years—progressed to copying classical busts. Then they made more complete anatomical drawings from live models and studied the depiction of hands, feet, and torso. Only in the final years did they draw from live models. Each student's approach was the same, varying only in degree of technical prowess. Standards were absolute: everyone knew, de Kooning later said, who the best were. Teaching methods were as rigid as the curriculum. Once a class began, no student could speak. Each sat hunched at his easel for the duration of the three-hour class—reduced from the four-hour classes of de Kooning's initial year. "We had to work very minutely," a student said. "Sometimes we were busy with three or four square centimeters during one whole evening." A single drawing routinely took three to six months to complete. Drawing classes were, as de Kooning said, "very classical."

The supreme arbiter of the program, the very model of the old-fashioned pedagogue, was Johannes Gerardus Heyberg. Born in 1869, he had himself studied in the academy's night division from 1882 to 1887. Although he would regularly exhibit his paintings (mostly sober scenes of the daily lives of soldiers) in Dutch and international exhibitions, he was first and foremost a teacher. In 1892 he was appointed to the faculty after serving as a temporary teacher for one year. For the next forty-two years, until his retirement in 1934, he ran the drawing department as if it were the last redoubt of true art in the battle against the philistines of change. He himself gave up painting in his early forties because he disliked the direction of modern art. Heyberg required each drawing to be rendered with exquisite exactitude; each object was to be observed as precisely as possible within its environment. De Kooning later recalled that Heyberg was extremely strict. "No one could say anything during his classes, and great care had to be taken to avoid soiling the paper." To Hess, de Kooning conjured up an image of students gathered around a still-life object in the amphitheater of the school, each working assiduously in silence as

Heyberg exhorted them, "Draw without ideas! Draw what you see, not what you think!" De Kooning, Hess observed, often followed that advice.

Despite the institution's daunting appearance and his long days—first at Gidding and then at the academy—de Kooning did well in his early years at the school. Many in the student body came from the same social class as he did, which put him at ease, and Heyberg was not as imposing as he might have wished to be. He seemed outdated, even slightly comical. "Heyberg was a big man with a strange little beard," said one of his students. "He seemed to be a combination between a Russian and a skipper and he had funny eyes and a high voice." In short, Heyberg presented a perfect figure both to learn from and to rebel against, the latter being almost as important to a young artist as the former. A fellow student in the drawing classes remembered de Kooning as very quiet and modest; but he also remembered him as a singularly disciplined student "who worked more concentratedly than we did." De Kooning himself recalled that he was the best pupil in Heyberg's class. There is no reason to doubt him, for he mastered the curriculum while many others did not. Of the seventeen who began with de Kooning, only fourteen completed the first year's course; of those, only ten were advanced to the next grade or level. By his fourth year, de Kooning said, only four students were left from his original group. The others either quit or were not promoted.

Although Heyberg struggled mightily to maintain hallowed traditions, the modern world constantly intruded upon both the academy and its students. Not only had World War I shut down Rotterdam almost completely, but the city was also beset by disease and poverty. The deadly epidemic of influenza that ripped through the weakened populations of the United States and then Europe and beyond after World War I—in the end as many as fifteen million people died worldwide—also killed many in Holland. Then in his second year at the academy, de Kooning was probably still too young to understand the kind of disgust with both art and society that many artists experienced during and after the war, an attitude that led to the Dada movement's absurdist attack on all settled conventions. But he was perhaps old enough to sense that neither the Gidding brothers nor the *handteekenen* program at the academy would wield the same authority after the war as before it.

The authority of Cornelia also began to wane as her son grew into adolescence, although she remained as domineering as ever. Economic adversity did not improve her temperament. "Bill's mother had a very

rough life, working all the time, always working, working," said Antonie Breedveld. "Money wasn't in the street in those times." Whenever she wanted him to do something, de Kooning remembered, she would spit out his name repeatedly: "*Willem, Willem, Willem.*" His half brother Koos recalled harsh bickerings and constant domestic battles between his mother and her older son. During this period, the quarrels probably changed character, for Cornelia could not intimidate or beat a stubborn adolescent as easily as she could a child. De Kooning also missed Marie, his sister and confidante. As she moved into the adult world, he felt left behind, and consequently more restless. His mother took some pride in his artistic gifts, mainly because the Gidding firm was a prestigious place to work and because he now brought in some money. Her children certainly understood the necessity of working, and de Kooning spoke matter-of-factly about giving his wages to his mother. But she had no patience for moodiness or dreamy vagueness.

Not surprisingly, de Kooning began to slip away from home more frequently. Just down the street from the entrance to the academy lay the modern world of the Coolsingel. "I worked hard and long but still I went to the Coolsingel," de Kooning said. "Here many pimps and other obscure figures wandered around." If de Kooning loved the harbor as a boy, he was now able to explore its charms in a more grown-up way. The ships began to return to the port just as he entered adolescence, awakening the harbor and street life of Rotterdam. At its southern end the Coolsingel ran directly into a large square with a fountain that was the traditional heart of the city. In the neighborhood there was much to attract a rebellious young man. Just off the square, for example, was the Jewish Quarter—the Bompius—where many members of the Dutch Reformed Church went on Sundays to buy bread and supplies. As a young man, de Kooning gravitated to this district, making Jewish friends. He may have found in Rotterdam's Jews a reflection of his own sense of himself as both an insider and an outsider in Rotterdam, one who did not quite fit in. Beyond the square was the Schiedamsedijk, the quarter where most artists, poets, and musicians lived. And not far from there was the tough Katendrecht, the port's red-light district. The adolescent de Kooning loved the area's mix of sailors and businessmen, pimps and fishmongers, Jews and Gentiles, respectable citizens and confidence men. In a port, something unexpected might occur at any moment. He could happen upon foreigners, organ grinders, beggars, oddballs, and grandiloquent spouters of nonsense. He talked often of one particular character, Black Max, whom he remembered as "a very tall and thin man who made beautiful music with his mouth organ."

Sometimes he performed for me in Dutch a poem by the American Walt Whitman. I still remember how this started, "Lay her down and look at a blade of grass." I thought this was beautiful and it could be possible that this poem had some influence on my decision to go to America.

He reveled in watching the prostitutes who worked the district. In Katendrecht, as in the more famous red-light district of Amsterdam, the women sat framed in tiny lit windows facing the street. Years later de Kooning told his brother-in-law, Conrad Fried, that the prostitutes would titillate potential customers by flashing their breasts for a fraction of a second. "Bill would say, 'How do you like that? They wouldn't show you anything and then give you this flash.'" That provocative flash, said Fried, was the basis of de Kooning's later description of his art as a "slipping glimpse"—an attempt to capture in paint those quick, oblique but illuminating moments that the eye registers almost subliminally. "He would make this gesture of moving his hand across his chest," said his brother-in-law. "He thought that that glimpse was much more enticing [than a longer view]. In other words, if you took a good look at something, you might not be interested at all. But because it was only a glimpse, you want more."

At night, de Kooning walked for hours through the city streets. Sometimes, he would look up at the grand houses of the wealthy Rotterdammers and, he said, feel overcome by his isolation from the warm circle of wealth and comfort. He would pass by the Gidding firm and chafe at its here-to-serve-the-rich spirit. He wondered what relevance either the Gidding brothers or a teacher like Heyberg could have for his future. By the age of sixteen he could see that the Giddings were themselves sometimes treated with condescension by advanced artists in the city, who might well have arched an eyebrow when the young apprentice told them where he worked. Art nouveau would not long survive World War I; the Giddings' ornate work, designed for the prewar world, appeared too frivolous for a darkly shadowed century.

By chance, the Nazi blitz in 1940 spared a few Gidding archives. One of the surviving photographs shows four workers taking a break while on the job. An older figure, clearly the man in charge at the site, is surrounded by three young apprentices. Sitting in the front, cross-legged with his hands clasped across the knees, is a young man who may well have been de Kooning. Probably taken in 1920, not long before he left the firm, the photograph shows a young man with strong features and a clear-eyed gaze. He has a thick thatch of fair hair and his mouth is partly open, as if

he has just made a wry remark to the photographer. There is something else about the picture as well, a cool self-assuredness in the tilt of the head and the expression of the face. Graham Greene once remarked that a sliver of ice lies in the heart of every important artist. De Kooning was often warm and generous, but he did not allow himself to become trapped for long by sentiment.

He was now roughly the age his sister had been when she left home, and some of his contemporaries were already setting off on their own. His new friends seemed to lead a more exciting life on the kaleidoscopic street than that of a conscientious apprentice. One day, he had a terrible argument with his mother. She hit him smartly across the face. Instead of flinching, he laughed in defiance. Then she knocked him across the room, kicking him when he fell to the floor. He kept laughing—he would not let himself cry—in order to provoke her further. In the late spring of 1920, not long after his sixteenth birthday and the conclusion of his third year at the academy, de Kooning demonstrated for the first time that he possessed the toughness required to make his own way, which for him meant the capacity to be ruthless in cutting himself free of entanglements. He left his mother's house. And he left his job with the Giddings.

It was a leap into the marvelously open spaces of uncertainty. He joined his sister in Amsterdam. For a few weeks? Permanently? He didn't know yet. "At sixteen," he said later, "I stopped work and became a bohemian." From the child's love for ships that sailed on the sea, to the boy's appreciation of the new worlds discovered at school, to the young adolescent's entry into the plush milieu of Gidding, de Kooning was constantly keeping his eye on the less certain but also liberating future, one that left behind the felt obligation or imposed responsibility. De Kooning left the Gidding firm when his future, like his past, began to seem inescapable. It was his first declaration of independence, a statement of how he intended to live his life and a portent of his emigration to America.

3. Breaking Away

I read somewhere that Rubens said students should not draw from life,
but draw from all the great classic casts. Then you really get the measure
of them, you really know what to do. And then, put in your own dimples.
Isn't that marvelous?

It took a remarkable amount of self-assurance, along with the foolhardi-
ness that is the right of every sixteen-year-old, to walk away in 1920
from the Gidding firm. Not only were most workers in North Rotter-
dam in difficult straits at the best of times, but the war years had left the
city's working class traumatized, angry, and desperately worried about the
future. Even a low-paying job at a decorating firm would have seemed
preferable to a fly-by-night job in a pub or the hard labor of a dockworker.
And if he had just been patient, de Kooning was talented enough to have
moved rapidly ahead and soon gained a well-paying job as an artisan.

It was natural that de Kooning, after leaving his mother, would turn to
Marie for help. Like Cornelia, Marie was vigorous, decisive, and strong-
featured, with a commanding voice. Unlike her mother, however, she was
also sweet-natured. She often told her son Antonie that she "raised him in
freedom," contrasting her liberal approach with Cornelia's tyranny. Five
years older than her brother, she willingly served as both big sister and
mother. Even when he was not living with her, de Kooning, after 1920,
often went to Marie for money and food—and, especially, emotional sup-
port—in his early years of independence.

In late fall of 1919, Marie, her husband Dirk Breedveld, and their two-
year-old son, Antonie, moved to Amsterdam. They settled at Rozengracht
44, a bustling commercial street that was the main shopping area of the
Jordaan, a working-class district. Crowded and energetic, the Jordaan,
which lay just beyond the last grand canal of Amsterdam, was a center of
social activism and change in Holland. Protest marches and strikes were a
part of its regular rhythm; the country's oldest subsidized housing was
begun there, largely as a result of successful protests. In this colorful,
teeming, independent-minded district, in which 83,000 people were
crowded together into a pocket-size space, Marie established herself as a
seamstress—a *coupouse*—a job she continued to have for the rest of her

life. Her husband worked as a freelance window display man and, at other times, as a traveling salesman.

During warm days, de Kooning roamed the canals. He also babysat his nephew and, most importantly, accompanied his brother-in-law, who knew something about art, to the city's museums. There, he studied the old masters, in particular the Rembrandts at the Rijksmuseum, and looked closely at the more recent work, such as the paintings of the Dutch symbolist Jan Toorop (1858–1928), which were displayed at the Stedelijk Museum. De Kooning came to two difficult conclusions during his time in Amsterdam. He learned that, in Dutch terms, he was a dyed-in-the-wool Rotterdammer. If Rotterdam was the most forward-looking city in Holland—it was sometimes called the New York of the Netherlands—Amsterdam looked back to the seventeenth century, when the Dutch dominated the shipping and commerce of Europe. In recent years, the city, with the exception of the feisty Jordaan, had settled into a quiet and refined way of life. Amsterdam was home to the intelligentsia and many skilled artisans. It had the air of a place that proudly chooses to align itself with the elegant past, the present being unworthy of comparison. This did not suit de Kooning. All his life, he preferred the vitally impure to a refined pedigree.

De Kooning also came to realize he could not live full-time with his sister. There was little room to spare in the Breedveld household, including emotional room. The young couple, forced to marry at a young age, were not getting along and would soon separate. Where was Marie's sixteen-year-old brother to go? He returned to Rotterdam. The next two years were spent in a kind of limbo, as de Kooning scouted for freelance jobs in the commercial art world and tried to figure out how and where to live. Cornelia was still aghast at her son's decision to give up a fancy job at a well-respected establishment. (She relished connections to the upper classes—she later bragged that Koos worked as the headwaiter at an exclusive yachting club patronized by ship owners and other wealthy citizens.) Until around 1923 or 1924, de Kooning continued to live at home only sporadically, his mother's criticism regularly driving him to stay with friends or find some other place to sleep.

Once back in Rotterdam, de Kooning, at loose ends, signed up for his fourth year at the academy. He was probably on a state scholarship or subsidy to the school. While most academy records were destroyed in the 1940 bombing, including prize and scholarship awards, de Kooning listed a "State Academy Award" in an early biographical statement that he prepared for the 1939 World's Fair in New York. It was in his fourth year at

the academy, when he was sixteen or just seventeen, that de Kooning completed his first major work of art to survive. Entitled *Dish with Jugs* and now at the Metropolitan Museum in New York, it was a crayon and conté drawing dated 1921. It was an exceptionally proficient example of work done at the academy. It seemed created less by the individual hand of de Kooning than by the great tradition of European still lifes. The twentieth century barely touched the picture. Like Matisse's first work—a Chardinesque still life—it did not predict the artist's future course. Another early work that survived in photographs was memorable both for its technical skill and for the feeling it conveyed. Executed in charcoal on cardboard and preserved for years by Marie, it was a beautifully detailed rendering of one of de Kooning's early girlfriends. (Her name is now lost.) The first known image of a de Kooning woman, she gazed to one side in half profile, the eyes dreamy, the mouth slightly ajar, the cheek delicately shadowed. Over her high forehead floated a band of diaphanous material.

Beyond the doors of the academy, de Kooning experimented in different styles. Impressionism continued to be popular during his youth, as, indeed, were the earlier, bucolic landscapes of the French Barbizon school. (But no impressionist or Barbizon-inspired dabblings by de Kooning survive.) The style that had the most impact upon him was symbolism. With its often morbid presentation of sexuality and its melancholy, narcissistic spirit, symbolism had a natural appeal—then as now—for poetic and moody adolescents. It also had many links to art nouveau, which was familiar to de Kooning from his work with the Giddings. According to his friend Joop Sanders, de Kooning particularly liked Toorop, an important figure in art nouveau who, during the 1890s, joined the symbolist movement. Toorop's heightened emotional pitch, curling linear style, and grandiloquent allegories impressed many people of his time, though his work has not worn particularly well over the years. Sanders, who grew up in Amsterdam before emigrating to New York, remembered seeing many Toorop postcards and posters in the city.

Antonie Breedveld also recalled several lost pictures of a melodramatic and essentially symbolist style. One, an allegory about the ravages of venereal disease, depicted Bosch-like figures being vomited from an open mouth. Another called *The Kiss*, which survives, showed a woman and youth so utterly absorbed in a kiss they appear lost in each other. Another was a group of four lyrical drawings, done in colored ink or pastels, called *The Four Seasons. Woman and Tree* depicted three sleeping nude women who are bound into a willow tree that seems to imprison their forms while an owl flies somewhat ominously near the horizon. While not the works of a mature artist, these pictures foreshadowed

remarkably well de Kooning's principal obsessions: the Bosch-like picture adumbrated the vein of sexual satire and anxiety tinged with revulsion from sex that can be found in some later works; *The Kiss* has an Oedipally charged subject; *Woman and Tree* was at once claustrophobic and sensual; and *The Four Seasons* foreshadowed the earthy, lyrical abandon of the painter who would fall in love with the Long Island landscape.

But it would be a great mistake, one that many art historians are prone to make when discussing an artist's early work, to suppose that during this period de Kooning had any particularly strong or clear idea of his direction. He was not the kind of artist who develops early—the kind, that is, who seems to have one urgent thing to say and says it from the beginning. De Kooning's

The Kiss, 1925, an early symbolist-inspired work, pencil and conté on paper, 19″ × 14″

art matured late, for his sensibility was complex and ambiguous, and too fraught with buried emotion to yield important early art. He was not even eighteen, moreover, and no one in his life was urging him to become a serious artist. To a Dutch working-class boy who needed to make money in order to eat, any desire to be an artist seemed tinged with fantasy. It was something far away that other people did.

As he cast about for paying jobs, de Kooning found something far more important: a mentor who opened his eyes to the modern world. Bernard Romein, only ten years older than de Kooning, was a freelance designer whose main client was Cohn Donnay & Co., Warenhuis, a large department store located on Korte Hoogstraat, the most elegant shopping street in the city. Owned by some of the wealthiest Jews in Rotterdam, Cohn Donnay was stocked with elegant furniture and fabrics, most of them imported from France and Belgium. Like most bourgeois department

stores, it was very conscious of its image and made money by selling a sense of style. The store employed artists to decorate its ornate interior and imposing exterior. They also painted cards for the "show carts," the movable carts of items that were on sale. De Kooning applied for a job working under Romein. One of several applicants, he was chosen because he was polite and had "no chip on my shoulder."

At Cohn Donnay, Romein gave his young employee a measure of creative freedom. Much of de Kooning's work for the store consisted of making the humdrum signs for the show carts. During one Christmas season, however, de Kooning was permitted to turn the entire entrance of the store into a giant Negro head, from which radiated enormous swaths of fabric. (Zwarte Piet [Black Peter], a character in Dutch popular culture, is St. Nicholas's helper.) Spectacularly large and bold, the display could be seen blocks away. In order to enter the store, shoppers had to pass through Black Piet's head. According to de Kooning's nephew, it made quite an impression on de Kooning's family, as well as, presumably, the worthy matrons and burghers of the city. "Big his work has always been," said Breedveld.

But it was Romein himself, not the work done for the store, that profoundly affected de Kooning. Although he made little of lasting value during his life, Romein was one of those essential figures, often overlooked by history, who send out sparks that light other fires. He was an inspirer, a talker, perhaps a bit of a fake, a man who enthusiastically—but not stupidly—embraced the spirit of his time. Romein stood for the present rather than the past. He was not beholden to the Giddings, the academy, or art nouveau. He seemed to know everyone and see everything. In the early 1920s, he was painting in a symbolist-inspired style. In the later twenties, he adopted a more geometric look, which owed much to Mondrian and constructivism as well as to the earlier style of analytic cubism. Art deco would become important to him: he designed some handsome deco calendars in 1930–31 and several Bauhaus-style monuments for Rotterdam in the late twenties, including one in 1929 for Wilton's Shipbuilding Yards. As de Kooning described him to the art historian Judith Wolfe: "He wasn't like a terrific painter, he wasn't in that direction, you see. . . . He had a lot of, how can I say it, like a lot of things up his sleeves, you know. He wasn't smart alecky. . . . He was quite influenced by different schools but it wasn't because he didn't know what to do, he just wanted to take a good look at everything."

In later years, when mentioning the most important influences in his early life, de Kooning always put Romein first. From Romein, he learned the "most of all." Until he met him, de Kooning said, "It was all very

classical. Perspective, portrait, landscape. Everything. I was good, very good. I thought that's what I would be. Until Bernard Romein, my boss among the commercial artists, pointed out Mondrian and Frank Lloyd Wright to me. I didn't know what overcame me. It was a shock that that [Mondrian] could be art. That it could be wholly different from just painting a little pot. I had no idea." Romein, de Kooning said, was "a commercial artist but much more. A true artist, a rebel. He acquainted me with the work of the greats." Both Romein and de Kooning had grown up in the tough milieu of North Rotterdam and had flourished at the academy, which may partly explain why Romein took de Kooning under his wing.

The Cohn Donnay & Co., Warenhuis department store, where de Kooning worked with his mentor, Bernard Romein

It amused him to teach the younger man the ways of the world. De Kooning told Judith Wolfe, "He thought I was a crackpot, no, not a crackpot, but he couldn't help laughing. . . . I [was] not refined, you know what I mean."

Romein brought his protégé into the ongoing conversation that circulates around art. Everything, old and new, was open for discussion. Everyone, including a working-class kid like de Kooning, had a responsibility to engage his time; one must not look backward, locked into Heyberg's vision of art as an embattled Parnassus. Romein encouraged de Kooning to read the quintessential modern authors, such as Dostoevsky. He challenged him to open his imagination to the ideas and styles that succeeded symbolism. Holland, in the early 1920s, remained an artistic backwater. Even the Dutchman Piet Mondrian and the De Stijl group were little known and less honored. That did not, of course, bother Romein. He knew

the work and philosophy of De Stijl intimately, and he made certain that de Kooning did too.

The architects, designers, and artists of De Stijl believed in a universal, functional style that seemed the antithesis of the heady excess of art nouveau. The movement eventually came to be symbolized by streamlined wood and tubular steel furniture and by Mondrian's austere, "neoplastic" grid paintings. Its fundamental precept, that craft and design were as important as, if not more important than, fine art—a carrying forward of Berlage's earlier vision—would help define the thinking of an entire generation of European artists. Romein quickly saw both the aesthetic and functional appeal of this new Dutch movement. He was also extremely interested in the Bauhaus movement, established in Germany in 1919 by the architect Walter Gropius, which would become synonymous with modernism. At the same time, Romein was fully conversant with the German expressionist group Die Brücke, which had been formed in 1905. It did not matter that Die Brücke was so different from De Stijl; Romein was not a man of petty consistency. Although de Kooning later said that he did not follow avant-garde movements while in Holland, some were so prevalent as to be almost unavoidable. In Rotterdam, for example, de Kooning probably knew the work of the local Dutch modernist group called De Branding, which put on local exhibitions and exhibited at the Stedelijk Museum in Amsterdam.

Although Romein made de Kooning's academic training appear hopelessly old-fashioned, he urged him to remain at the academy. (He himself had gone through at least six years of the eight in the drawing program.) Apart from the technical training it provided, the academy also had many links to what was new and exciting in Rotterdam's artistic and intellectual life. Although de Kooning had had no advanced formal schooling, he was able to give himself an informal degree in art history by, in effect, talking to the teachers, reading books in the institution's library, and attending the evening lectures sponsored by the academy. Typically, the speakers were prominent architects, painters, and art historians. The art history lectures extended from Byzantine mosaics and Gothic paintings to nineteenth-century romantic art. An expert on Hindu art spoke. Contemporary art was not excluded—Berlage lectured. There were also talks on Gustav Klimt and the Wiener Werkstätte movement in Austria. Held either in the local hospital auditorium across the Coolsingel from the academy, or in the nearby Café Boneski, the lectures were usually followed by long hours of discussion and socializing in the nearby pubs.

After working with Romein, de Kooning's ambition became more complicated. Until then, the boyish student dabbled with the idea of being

a painter. In the 1920s, however, he grew equally interested in what might be called commercial art in the higher sense—that is, in the De Stijl and Bauhaus view that easel painters were becoming outmoded and that what mattered now was designing objects and environments for this new industrializing world. De Kooning could continue to make paintings on the side or at night, as Romein did, while working during the day as a commercial artist. For the next decade, de Kooning would follow this model.

There were many reasons, beyond simple admiration for Romein, for de Kooning to adopt this approach. During the 1920s, he simply could not find a "way" of being a traditional artist—either practically or philosophically. He still believed in the lofty ideal impressed upon him at the academy of the "good picture." But this no longer seemed modern. Neither did Toorop's symbolism. If Mondrian represented what it meant to be modern, moreover, was there a place left for an artist with de Kooning's messier, more romantic and impulsive sensibility? "I thought Mondrian was phenomenal," de Kooning said. "He made paintings that were wholly new, that didn't exist." But de Kooning once observed that it took him a long time to sort out the two influences—one could almost call them opposite poles—of let-loose expressionism and tautly reserved De Stijl. Until the late 1950s, in fact, his art (and life) would display a constant, flickering tension between restraint and release. His greatest works would gain much of their elusive ambiguity from seeming both impulsive and reserved, open and secretive.

What did seem modern, and relevant, was commercial art. De Kooning's growing interest in this "higher" commercial art was heightened by a second powerful role model who, along with Bernard Romein, also worked in the decorative and applied arts. In 1918, Jacob Jongert, a new teacher with a new outlook, was appointed head of the decorative arts faculty at the Rotterdam academy. Originally from a small town north of Amsterdam, Jongert had studied applied arts, a newly developing field, and then become the assistant of Richard N. Roland Holst, a well-known mural painter. Holst, a symbolist, imparted to the young Jongert an interest not only in William Morris and the Pre-Raphaelites but, at the opposite remove, a taste for leftist politics. Prior to joining the academy, Jongert taught design and craft to young women in Amsterdam for seven years. He was initially influenced by art nouveau or Nieuwe Kunst, but his perspective began to change when, in the summer of 1914, he visited Cologne and saw an international exhibit of German applied arts called the Deutsche Werkbund Exhibition. He was struck by the imaginative use of design for everyday packaging: "gingerbread, cigars, lamps and electrical articles . . . What lay before us was a terrain that in Holland was not

yet broached; but with such a great country preceding, we must surely follow."

Over the next few years, Jongert led the way in the use of strikingly bold, simple advertising designs in Holland. Just as De Stijl and Bauhaus preached the integration of "high" and "low" art and the importance of function defining form, so Jongert believed that no separation should exist between fine art and commerce. He articulated his position in an article in *Wendingen*, a Dutch arts magazine in which he proclaimed that advertising was "all-powerful." Along with his teaching position, he became the chief graphic artist of the local Van Nelle tea company, designing posters and packaging. After 1923 his designs developed a geometric look, with cubist and expressionist overtones. For example, in 1926 he redesigned the academy's old art nouveau–style logo, making it look cleaner and more streamlined. He and his students contributed work, which was well received, to the enormously important Arts Décoratifs show in Paris in 1925, which helped launch art deco. Jongert also tried to appoint a Bauhaus artist to the faculty. De Kooning himself developed an abiding admiration for great signs, and there were times in his life when he wanted his painting to have their directness.

In de Kooning's years at the academy, Jongert was an invigorating catalyst of change and ferment—someone who, like Bernard Romein, was deeply committed to the art of his time. For many, this new way of looking at art amounted to a revolution, especially, perhaps, for those students in *handteekenen* whose education seemed weighed down by the past. The craftsmen of the Giddings era also believed in the importance of the decorative arts, but there remained something precious in their vision and they looked back to ancient guild traditions. The new proponents of the decorative arts were fiercely of the future. Suddenly it was the decorative arts, formerly a more practical but less prestigious division, that was the exciting place to be at the academy. There was no longer any stigma attached to being a commercial artist. Many at the academy, not just de Kooning, became entranced by De Stijl—or at least its commercial version. According to de Kooning:

> At the academy in Rotterdam we were all under the influence of de Stijl. This was in the early twenties. We weren't at all interested in pure art, or in the person who earned his living being an artist. The Stijl group obviously encouraged our feelings. A modern artist, according to them, was not at all somebody who painted nice paintings. In fact, if he was really modern he didn't paint at all. He wasn't an artist. He was an

expert, a designer for example or somebody in publicity. And so I didn't have a wish at all to become a painter.

Suddenly, the old-fashioned idea of a painter as someone in a smock, palette in hand, seemed absurd to many ambitious young artists. "We used to call that 'good for men with beards,' " de Kooning said, alluding to the school of genteel, impressionist-style painters who continued to work in Holland almost a half century after Manet and Monet came to prominence in Paris. Mondrian, de Kooning once told the art historian Sally Yard, "became the greatest lay-out man in the universe." Such a view of his work, de Kooning went on to explain, would not have offended Mondrian himself:

He wouldn't mind it—he was very social-conscience. Early on as students we all knew Mondrian. I was at a young age influenced with sign-making. Because of Mondrian, a sign didn't have to be symmetrical like a sheet of music. Or like Beethoven was symmetrical. It could be asymmetrical. This also saved a lot of time. You could just lay something out—it didn't have to be measured out so perfectly.

Not surprisingly, de Kooning drifted further away from the academy the older he became. Although not listed in official academy annual reports after being promoted in 1921 to the fifth form, the evidence suggests that he did attend at least part of the fifth, which often took students two years to complete. But his vagabond life made the academic routine onerous. One of his closest friends at the school was Carmine Bennedeti "Benno" Randolfi, who was a year ahead of de Kooning. Benno's family often gave de Kooning a place to stay between his comings and goings at his mother's house—and even, during this period, put him up for as long as half a year at various apartments of the extended family. As their name suggests, the Randolfis did not seem the least bit Dutch to de Kooning. They were a florid, southern Mediterranean clan. Benno's father, Giovanni, had been born in Picinisco, Italy, and walked to Holland with two sisters as a teenager. The Randolfis lived gypsy-like on their wits and talent, selling balloons and ices in the summer and performing as street musicians for the strollers on the Coolsingel. Giovanni Randolfi traveled around town with an out-of-tune street organ mounted on a wagon that played crazily off-pitch tunes. "When they played ordinary songs with that instrument," de Kooning said, "it sounded as if it were a composition of Stravinsky."

The café on the Coolsingel where students from the academy often met

De Kooning was friends with not just Benno but the entire family. Sometimes he stayed with Benno's brother Vito—where, at one address, he left behind a painted door as a present, a custom he would continue later in the United States. He also knew Franz, Benno's brother; Franz's wife's brother, Leo Cohan, would one day help him get to America. The Randolfis provided de Kooning with a home, and they could not have been more different from his own family. They were a warm, generous, and unconventional family that thought nothing of taking in a homeless teenager for weeks on end. Their loose, free-floating spirit attracted him. They made the foreign appealing. When Giovanni had made enough money to support his family for a while, he would simply stop working until he needed money again. Later, de Kooning would tell Benno that the happiest time of his life was when he was sixteen or seventeen and lived with the Randolfis.

If Rotterdam could not claim a bohemian underworld like that of Paris—with its garrets, cafés, and Beaux-Arts balls—its art world was nonetheless radical by Dutch standards. And Rotterdam itself, as an international port, was more open than most Dutch cities to unconventional

ways of life. Much of de Kooning's free time was spent at one of two pubs, located on the Coolsingel, which were the focal point of the local art scene. He and some of his fellow students went there after night classes; anyone over fourteen could drink legally. Some of the academy's younger teachers also went to the pubs, and the two groups mingled until long past midnight, talking and drinking. The latest imports from America were fashionable—the movies, the jazz, and the free-kicking new dance called the Charleston. Some tony nightclubs opened around the Coolsingel; dozens of seedier establishments beckoned from the side streets. The sober Dutch middle class disliked jazz because it seemed disreputable, making it all the more appealing to de Kooning's generation. The Dutch middle class also frowned upon American dancing, which was considered indecent. Perhaps it was inevitable, given his increasing independence, that de Kooning would chafe at being a student at the academy. Wasn't the Charleston a truer and more passionate reflection of the modern world than the academy? Shouldn't his life have more to do with jazz and less to do with perspective? Sometime around 1922 or 1923, when de Kooning was in his late teens, he upended his life again, walking away from the school, just as he had his job at Gidding. He might return, he might not; he wasn't sure. While he would continue to work sometimes as a commercial artist, he wanted nothing to tie him down.

4. An American Dream

There were cowboys and Indians, you know; it was romantic.

A s a boy, de Kooning was enchanted by the American flag. He loved its resemblance to a shield when used in its heraldic form: it seemed romantic, medieval, declarative. A kind of painting. He noticed the ships docked in the harbor bound for America. Occasionally, someone he knew would simply vanish. "Gone to America," people would say. Why? "To get rich." Streams of immigrants from northern Europe, exotic to a child and speaking unknown languages, were boarding steamers bound for New York.

"I had an uncle who was a seaman with the Holland-America line," de Kooning said. "He used to tell me stories about America and once gave me an American football." As an adolescent, de Kooning became fascinated with American pop culture. He loved jazz, Hollywood movies, photographs of girls in magazine advertisements. He would joke that he wanted to meet Constance Bennett and become "rich and famous." When compared with the cramped conditions of his own family and country, the open spaces of America—reflected in the New York skyline, the Western frontier of the movies, and the rhythmic grandeur of Walt Whitman's poetry—seemed magically inviting. Many of the glowing oranges that appeared in the city after the war came from America.

America also appeared quintessentially modern to a young artist like de Kooning. It was "the land of the future." It was not a place for artists, at least not in the old-fashioned sense. It was a place still being built. In America, architects particularly mattered, especially the designers of skyscrapers. Even as a child, de Kooning imagined leaving Holland—boarding a ship and simply vanishing. He dreamed of America the way other children dream of running away with the circus. Something in Dutch culture generally yearned for other cultures and the open sea; for centuries, Holland sent young men to faraway places as seamen, traders, and expatriates. Not only had some famous Dutch artists emigrated, such as van Gogh and Mondrian, but artists who remained sometimes dreamed of distant worlds, like Rembrandt, who dressed up his subjects in exotic clothing from far away.

Still, like most Dutchmen, de Kooning was also an ambivalent person with some conservative instincts. His sister was in Holland. How could he abandon her, in the early 1920s, to an unreliable husband and a demanding mother? Besides, he was doing fairly well. To an eighteen-year-old newly on his own and accustomed to little, a small amount of money was fortune enough. Although de Kooning no longer worked exclusively with Romein, his mentor helped him find commercial work and remained a source of continuing inspiration. De Kooning was collaborating on paintings with Benno Randolfi, designing movie posters, and doing window displays and lettering. He was busy enough.

As he approached the age of twenty, however, de Kooning became increasingly frustrated with both his surroundings and the direction his life was taking. Holland remained largely indifferent to the new. If anything, the culture was openly hostile to change. Despite the reverence accorded Mondrian by Romein and many others, much of the art world in the Netherlands treated him as a joke. His contributions to a Stedelijk Museum show of 1909 in Amsterdam had been attacked, and he had been snubbed by the socialites and patrons of the city, who invited him to their salons only rarely. In December 1911, Mondrian left Holland for Paris, where he felt more comfortable, spending over two years there. (He left Holland for good in 1919.) More important, as the shock of the war receded, the hope that art and commerce would together transform Rotterdam began to fade in de Kooning's milieu. During the 1920s, some conservative designers reacted against the functional forms and linear look of the De Stijl movement. Barely had the new look established itself, in short, than old-fashioned art nouveau made a comeback.

To sophisticated young artists like Romein—committed to the modern and aware of what was going on in other countries—it was often demoralizing to live in a small country that actively discouraged change and quickly returned to the discredited styles of the past. No doubt Romein, more a man of the world than de Kooning, often expressed reservations about the Netherlands as a place for an artist to live. He himself would leave Rotterdam five years after de Kooning, going first to Delft and then to Ireland. In any case, de Kooning needed little encouragement to reject his surroundings. He could be a lively, witty, and seductive young man, with a gift for the wry or brilliantly slanted observation. But he also remained a man of northern Europe, with a deep and abiding current of alienation and melancholy. After Romein urged him to read Dostoevsky, de Kooning wandered the streets of Rotterdam feeling, he said, like Raskolnikov in *Crime and Punishment*—an outsider, destined to be

alone. By now, he only occasionally saw his parents. In April 1921, Cornelia and her family had left the center of town, moving back up to the North Rotterdam neighborhood where Willem was born. It was inconvenient to de Kooning's downtown haunts, and he needed little excuse to spend most of his time elsewhere. Cornelia, proud of her son's progress at the academy, no doubt rebuked him for not staying there. When he came to visit, they argued—and he would quickly leave.

De Kooning's estrangement from his father was also important. The younger de Kooning frequently sought out figures of authority and made somewhat older and wiser men into mentors—men who seemed to know how to live in the world. While still in Holland during the 1920s, however, he also made several efforts to establish a more serious relationship with his father. According to his half brother Leendert, de Kooning visited his father at his shop on Vledhoekstraat. The main purpose of such visits was typically to ask for money, but de Kooning hoped to make other connections as well. Sometimes, de Kooning stopped by the family's home and brought with him small drawings. One was an exquisitely rendered drawing of a garbageman. Perhaps father and son pretended that the gifts of money were the purchase price for works of art. (After de Kooning left, his father would put away the art in a large cupboard.) De Kooning's father responded to the efforts of his son, a young artist obviously seeking acceptance of himself as an artist, with grudging praise, at best.

Of more consequence to the father was his son's disreputable appearance. Leendert once saw his mother sewing a new corduroy suit for de Kooning, in an attempt to make the family bohemian more presentable. The meetings were doubtless agonizing for both father and son, the words artificial and the spaces filled with painful silences. Each man was reserved. A veil of unexpressed emotion—of history unacknowledged—hung between them. Several years later, after he was already in America, the young de Kooning decided to write both his stiff father and his easygoing stepfather, rebuking his father, whom he had once admired, and apologizing to his stepfather, whom he had slighted. Their responses fascinated him, for their two letters were virtually interchangeable. "They both said, basically, 'That's life,' " recalled Tom Ferrara, de Kooning's assistant in the 1980s. That his father, in particular, accepted his son's anger suggests that the older de Kooning was a man more paralyzed than unfeeling.

In the spring of 1923, when he was nineteen, de Kooning was almost drafted, a fact that probably did not increase his desire to stay in Holland. He was summoned for a medical examination on May 3, 1923, and pronounced fit to serve in the military. At that point, he was not enrolled at

the academy. He did, however, manage to avoid being drafted by getting himself labeled an "extraordinary conscript," which meant that he did not have to serve. According to family lore, both Cornelia and Leendert pulled strings and worked connections to get de Kooning exempted. A more likely explanation, since neither parent was important enough to pull strings, is that de Kooning's father bought him out of the draft. It was then legal to hire a substitute recruit for one hundred or so guilders, who would serve out the required tour of duty.

Increasingly weary of Rotterdam, de Kooning visited Brussels occasionally in the early and mid-twenties, each time for several days. Although such trips were always a bit risky, as de Kooning did not buy a ticket and had no official travel documents, they were a favorite antidote among young Dutch artists to the provincial spirit at home. The capital of neighboring Belgium was not very far away—just two hours by train from Rotterdam—and one could speak Dutch there and be understood by the inhabitants, who spoke Flemish. Brussels was far more cosmopolitan than either Rotterdam or Amsterdam, and its reputation in the arts was much higher; it was sometimes called the "little Paris." It had been particularly important since the days of art nouveau, when the Belgian artist and designer Henry van de Velde brought the English arts and crafts movement to the continent. Brussels and nearby Antwerp outstripped even Paris in their devotion to the style. The architect Victor Horta filled entire areas of both cities with houses rich in ornate balconies, leaded glass, and carved decorations.

Sometime around the spring of 1924, when he was twenty and at loose ends with nothing much to do in Rotterdam, de Kooning left the city for a longer stay—a half year or so—in Brussels and possibly Antwerp. "I can't remember whether I went there [Brussels] to see any art," de Kooning said later. "Because it was also connected with my wish to go to the United States, a sort of test of how long I could stay away from home. I found I could manage it for quite a long time." This time he made the trip with both Benno Randolfi and Willem (Wimpy) Klop, another friend from the academy. At first the trio worked at anything and everything, from painting outdoor advertisements to playing music, to make ends meet. On many occasions, de Kooning and his friends went hungry. (He once said that he could tolerate anything about poverty except the hunger.) Later, he described doing "all sorts of jobs, and after three months of crazy work I couldn't even buy one pair of socks."

At some point, however, their luck changed. De Kooning answered an advertisement in the newspaper *Le Soir* for a "painter-decorator" position and was lucky enough to find jobs—plus room and board—for himself and

Wimpy at the van Genechten firm, a family decorating business that was much like Giddings. (Benno did not stay with them; he may have returned to his family in Rotterdam.) The van Genechten firm specialized in decorating houses, doing stained glass, and restoring old paintings. Like the Gidding firm, the van Genechten establishment was run by the two sons of the founder, Georges and Florent. For the next six months or so Willem and Wimpy lived in a large third-floor atelier in the van Genechten household at 66 Rue Vandernoot, in a residential part of Brussels, painting impressionist-style landscapes that were sold through the local department stores.

None of the landscapes that the two painted jointly was signed, and all of them have been lost. While staying in the van Genechten household, however, de Kooning undertook one special painting, a portrait of Renée, the toddler daughter of Marguerite Lemmens, sister of Georges and Florent. In the portrait, the little girl was dressed in red and held a doll with a ruffled collar and a green stick body. The portrait reflected de Kooning's lack of academic training in oil painting. It was more a drawing than a painting; drawing would remain the foundation of de Kooning's later paintings as well. According to the art historian Judith Wolfe, who studied de Kooning's Belgian work in detail, the painting was done on top of an underdrawing that defined the face and hands and remained visible to the eye; later, de Kooning would often leave traces of his process visible in the finished work. The generous use of oil paint in rendering the child's skin was also characteristic of de Kooning's later depiction of the body. And here, as later, de Kooning wrestled with the rendering of hands and shoulders.

In its reliance on line, de Kooning's portrait was closely related to a portfolio of cartoon-like drawings that he created while in Belgium. De Kooning did not consider the drawings fine art; he hoped to show them around in order to get work as a commercial draftsman. In particular, he was already thinking of taking the sketchbook with him to America to serve as an introduction to advertising agencies and other commercial venues; this was especially important since he would not be able to talk his way into commissions, given his inability to speak English. Despite their commercial purpose, the drawings did reflect several of de Kooning's passions. All his life, he loved cartoons; in his mature art, a strong caricatural strain would erupt in many drawings and paintings of women, and he was always willing to rattle the precincts of high art with Flemish vulgarity. In an interview with Charlotte Willard in 1969, de Kooning said, "I have a lot of the cartoonist in me," and he identified with both cartoonists and sign painters because of their technical skills: "I admire cartoonists

and really good sign painters," de Kooning said in 1967, while in the midst of a period of painting that included both cartoon-like figures and an "in your face" boldness that de Kooning said was patterned on the direct, visceral message of signs.

Cartoons and illustrations played a major role in the political and social commentary of Holland in the 1920s, and illustrators were highly regarded. (They were also paid well, which would not have escaped de Kooning.) In his teens, de Kooning admired an illustrator named Piet van der Hem, who had gone to Paris after studying at the Rijksacademie in Amsterdam and had come under the influence of Henri de Toulouse-Lautrec. After returning to Holland, van der Hem drew and painted street life in the Jordaan neighborhood of Amsterdam. As de Kooning told Judith Wolfe about van der Hem's drawing, "To be able to do that, boy, you have to be very good." Van der Hem was part of a long tradition of Dutch artists and illustrators inspired by café and street life—in particular by the Parisian scene, whose decadent, demimonde feeling had been captured so memorably in the paintings and posters of Toulouse-Lautrec and in the lithographs of Théophile-Alexandre Steinlen, a Swiss illustrator whom de Kooning admired. Kees van Dongen, the eminent recent graduate of the Rotterdam academy who was celebrated mainly for his society portraits, had painted Parisian night and street life earlier in his career. In addition, particularly in de Kooning's day, artists and illustrators were fascinated with the darker side of street life—prostitutes, pimps, and beggars. Jan Toorop painted prostitutes and pimps; his daughter, Charley Toorop, did closely observed paintings of tramps and beggars. Both traditions—scenes of ordinary street life and of the demimonde—were reflected in the forty-one sketches made by de Kooning in Brussels. They were populated with flower sellers, shoppers in the city market, and a few male dandies and drunks. Some depicted women at tables in cafés, as observed directly by de Kooning. As he told Judith Wolfe, "I used to roam around there, you know, and meet people, and there was this large café where you could sit outside." Ten of the drawings were devoted to children and adolescents and a few portrayed prostitutes and pimps. There was even a man playing a street organ, in the spirit of the elder Randolfi.

In the drawings of female figures, the subject was often an alluring young woman, as in a picture of a flower seller who casts a seductive, side-long glance. (She was juxtaposed with a large and older woman, an instance of de Kooning's interest in how women change over time.) As in symbolist paintings, the female figure could appear melancholy or worn out by the demands of the world. In his café drawings, de Kooning often captured a more hardened, world-weary aspect of women. One picture of

Balloons, c. 1924, a drawing from de Kooning's sketchbook, conté crayon and charcoal on paper, 10⁵/₈″ × 7¹/₈″

four children who have two balloons among them had an obvious personal resonance. The oldest child, a girl, appeared to be in early adolescence. She was casually walking with one large balloon. Beside her, a younger boy held the second balloon, delighted with his prize. Another much younger boy held the girl's hand: he was wailing because he did not have a balloon. A third boy, leaning against a tree, observed the scene with a frown. The image could depict an actual event in de Kooning's childhood: the trio could represent Marie, de Kooning himself, and the much younger Koos. Whatever its literal truth, however, its greatest interest lay as a parable about the emotional hunger of childhood. In a scene where a woman is the dominant figure, de Kooning passionately identified with the attitudes of all three boys. He could imagine the thrill of attaining his dreams, and the powerlessness of being denied gratification. Most tellingly, perhaps, he could adopt the perspective of the observer leaning against the tree—the artist who makes himself an outsider and appraises the unbalanced family.

Not much is known about what Willem and Wimpy did in Belgium when they were not working. In later years, beginning with his résumé for the 1939 World's Fair, de Kooning claimed to have attended, during this period, both the Brussels Academy and something called the "Van Schelling Design School" in Antwerp. But there is no record of de Kooning's attendance at the former—and no record of there being a Van Schelling school at all. Just as de Kooning or his admirers in later years inflated the time he spent at the academy in Rotterdam, so he may have embellished his résumé with an education in Brussels.

Although de Kooning already knew about expressionism, he first powerfully experienced the art of the German and Belgian expressionists in Brussels. Its volcanic beauty—the slashing way with the brush, the startling harmonies of color, the upwelling despair—impressed the reserved Dutch artist. He was especially taken with the work of Jan

Sluyters, a Dutch artist who lived in Belgium. "I wasn't at all sure what to do," he said. "The emotions in those works!" As his later art made clear, de Kooning had a strong subjective streak of his own; he once labeled himself, rather reluctantly, an expressionist. In general, the Dutch looked more to German than to French culture for inspiration, preferring that particular form of northern heat to the cooler, more classical French tradition.

In Brussels and Antwerp, de Kooning would also have looked at much more Flemish art than was available in Holland. And he particularly would have seen, at the Musée d'Art Ancien, many of the greatest works of Rubens, for whom he always declared much admiration. Rubens was an unabashed sensualist of the brush, a man of appetites who clearly relished the physical properties of his medium. Oddly enough, the baroque master probably conveyed to de Kooning something similar to that of the expressionist art that he was seeing—that is, to let go a little, to be less reserved and tight.

An air of mystery surrounds de Kooning's final year and a half in Rotterdam. He returned home in the late fall of 1924, or early in 1925, with few prospects. He floated on the edges of society, almost entirely at loose ends. For a time, he rented with Benno and Wimpy a tiny garret at Karrensteegstraat 14, on a narrow lane in the red-light district. He also briefly lived at another apartment on Kruisstratt, near the train station. Not far away, the raised Schiedamsedijk road and Katendrecht district overflowed with pubs and prostitutes who worked out of pocket-size rooms above the pubs. There were also many dance establishments in the area, the best-known being the Cosmopolitan, where the girls did the shimmy and the music of choice was jazz. As always for de Kooning, Schiedamsedijk's carnival atmosphere, with its stream of nationalities and jazzy beat, seemed exotic and desirable, an expression of life beyond the confines of the straight laced Netherlands.

At the age of twenty-two, de Kooning was a strikingly handsome young man. Some men and women in the 1920s and '30s would even call him "beautiful," remarking upon the beguiling eyes and the "face of an angel" (although others thought his looks improved as he aged). His features were even and strong, his light hair thick and glossy. He was short but not small, his body muscular, solid, and well proportioned. He reminded many people of a sailor. (Or, as the dancer-choreographer Merce Cunningham, who met de Kooning in the early forties, would put it, "He had that sort of *sturdy* look.") Not many people noticed the legacy of

poverty and childhood neglect—the bad teeth, which appeared almost transparent—since de Kooning did not have an open smile or a big laugh. A photograph taken in 1922 even revealed a flicker of the Wildean dandy: hair long and flowing, arm cocked on his waist, elbow jauntily akimbo, a narrow bow tie at his neck. Both the stance and the look were also those of a rebel; he seemed to be challenging the viewer to find fault. In his old age, de Kooning would say that the American protesters of the 1960s, with their "long hair and strong fists," reminded him of himself as a young man in Rotterdam.

During this period, de Kooning's family had little knowledge of what he was doing. Cornelia and her husband, after years of scraping around following the bankruptcy, had gone back into the pub business yet again; and once again the business was failing. In tacit acknowledgment of defeat, they left Rotterdam for Amsterdam in April 1926, where they stayed for the next seven months. Cornelia was not therefore in Rotterdam during her son's last days there. Marie and her husband had returned to Rotterdam in October 1924 but shortly afterward separated. Subsequently, Breedveld took a job as a waiter on a ship bound for America and never returned. He did not send money; indeed, he never even wrote a letter to his family. Marie and her son were forced to live with friends of hers. It was now all she could do to support herself and her young son. Her impoverished brother could not stay with her.

Most important of all, de Kooning no longer had a steady source of income: the Cohn Donnay store had run into financial difficulties and would soon be bought by another department store chain. Romein did not therefore have as much work to direct to his friends. At one point, de Kooning had to resort to living with vagrants, moneyless artists, and intellectuals on a barge tied up at the docks. Staying on barges, like living among the prostitutes on Karrensteegstraat, was common enough among Rotterdam's bohemians. Still, it suggested serious poverty. Feeling sorry for her brother, Marie regularly left food for him at the barge, which probably embarrassed him: he should not have had to depend upon his sister. But even Marie rarely saw de Kooning. She would drop off her care packages in the late afternoon and leave.

Whether or not de Kooning returned to the academy during those final months is not clear. Did he reenter the fifth form, drawing the human head and beginning anatomical studies, as he later suggested? (De Kooning told the art historian Sam Hunter that he had drawn Roman heads, which suggests that he took at least part of the fifth-year class.) In the fall of 1925, he may well have spent more time studying. In the first two accounts that he gave of his academy education, he claimed that he had

studied there for six years. Still, it is more likely that whatever finish he had put on his education was completed prior to the trip to Brussels, as his life was so rootless after his return. The city of Rotterdam noted in November 1925 that Willem was no longer a settled resident of the city.

De Kooning offered one final clue to his past on his 1939 résumé for the New York World's Fair, which mentioned that he had received a silver medal from the academy. While this medal, an important milestone, was awarded at the end of the eighth year to the student who submitted the most distinguished drawing in that year's juried competition, there were five smaller silver medals awarded at the end of the fifth form. It is possible that de Kooning won one of those, although it is equally possible that it was a false claim to embellish his record, just as were his claims of further study in Brussels. What is certain is that de Kooning did not complete all eight years of study at the academy. No less certain is that in 1925 and 1926 the academy had little more to offer de Kooning, since he was no longer particularly interested in increasing his technical skills. He did not want to be an artist like Heyberg.

Where should he go? Should he remain in Europe—the more conservative choice—or strike out for the America he had so often fantasized about? The two most popular European destinations for those seeking a sophisticated city or a distinguished art scene were Paris and Berlin. In the early twenties, Berlin seemed especially modern, not only in its art but in the way its bohemians lived. The city's sexual openness and brooding aura—its air of seeming at once young and jaded—was appealing to unorthodox sensibilities after the war. Without question, however, Paris remained the center of the art world. In 1926, one could see Matisse and Picasso at work. The influential Arts Décoratifs show had opened there the year before. The year 1925 also saw the first exposition in Paris of the strange, hallucinatory work of the surrealists and related artists, including Marcel Duchamp, Man Ray, and Yves Tanguy. One could also find traditional representational painters—in short, anything and everything. More than a hundred galleries in the city were active. The huge annual salons exhibited the work of a thousand artists at once. Paris offered young artists opportunities to exhibit, famous museums and schools, and, perhaps most important of all, other young artists. Rotterdam's own Kees van Dongen had made a great success of himself in Paris.

Yet de Kooning never considered going to France. The twenty-two-year-old did not yet see himself as a committed artist, so there was no obvious reason to go to Paris. "My only interest was in being an illustrator or something like that," he would later say. "I was a good housepainter. [Real] painting was a sideline." More important, he had not yet seen the

work of Picasso, Cézanne, and Matisse, who would all—especially Picasso—play important roles in de Kooning's development as an artist; that would come later, when he was already in America. He continued to share De Stijl's view that commercial art was just as important to the modern world as painting and sculpture, and he took a special interest in the sophisticated illustration that was then emanating from Germany, in particular Berlin. According to his future brother-in-law, Conrad Fried, he seriously considered moving there, "because they were doing more advanced commercial work."

To a Rotterdammer, however, leaving meant getting on a ship—not a train—and putting out to sea. The process was familiar to anyone in Rotterdam; countless ordinary people looking for work had already shipped out to America. In de Kooning's own family, two near relatives had made the trip: his uncle Nobel, who had settled in Brooklyn, and his brother-in-law. De Kooning tried to interest Benno Randolfi in going to the New World with him. But Benno, bound more closely to his family, declined. De Kooning then tried to get to America on his own. Unable to afford a ticket in steerage, the usual way of traveling to America, he applied for a job as a deckhand on the Holland-America line. The scheme failed. The hiring clerk, suspecting that de Kooning planned to jump ship as soon as he reached America, refused to consider him for a job. So de Kooning tried his luck sneaking aboard a series of ships as a stowaway. But these efforts all misfired. There would be a farewell party—and then de Kooning would be back the next day. "I had a lot of trouble getting [to America]," he said. "Every time I hid out on a ship, they found me, or the boat wasn't going anywhere."

In the end, it was Leo Cohan, the brother of Benno's sister-in-law, who succeeded in smuggling de Kooning out of Holland. Cohan had already been to New York and back, working as a waiter aboard merchant marine ships; for a while, he also had a job in New York. Now he wanted to return to America. But he needed to pay his union dues to get work on a ship. If de Kooning would pay the union dues for him, said Cohan, he would arrange for de Kooning to stow away aboard his next ship. The scheme struck de Kooning as far-fetched, but he went along with it, borrowing twenty-five guilders from his father, who wished him luck and told him not to come back for more. It was enough: de Kooning now had the money to cover Cohan's union dues. And then nothing happened. Cohan shipped out of town without de Kooning. Months passed without a word from him; de Kooning forgot about the plan. Then, suddenly, Cohan appeared early one morning. He was agitated and in a great hurry, having probably spent much time looking for a friend without a fixed address. The ship

Cohan had selected for de Kooning was docked in town, the British freighter SS *Shelley*. Leased for this trip by the General Coal Company, it was traveling from Trieste to the United States and had docked briefly in Rotterdam to pick up more cargo. Now or never, Leo told de Kooning. He himself had been hired as a waiter and planned to jump ship in Newport News, Virginia, the ship's destination in America. De Kooning could hide in the engine room. There was no time to lose, and no space for belongings; de Kooning didn't even bring the commercial portfolio that he regarded as his meal ticket in America.

Years later, when de Kooning returned to Holland for the first time, on the occasion of his 1968 retrospective, he still felt guilty about his hasty departure from Rotterdam. He did not seem particularly disturbed about abandoning his mother; it was his sister who concerned him. In 1968, he could not even bring himself to telephone in advance to make arrangements to see her. The reason, he told a reporter, was that his departure still aroused so much guilt in him. De Kooning abandoned—without even a kiss good-bye—the sister who was raising her child alone, who had been the solace of his childhood, who was a source of ongoing emotional support and even physical sustenance. And he abandoned her in almost exactly the same way her husband had the year before, by running off to America. De Kooning would always claim that he left behind a scribbled note for Marie, saying good-bye. But she never got it. One day he simply vanished. De Kooning had no time to alert his mother in Amsterdam either, and did not let his father know that the moment had at last come. On the morning of July 18, 1926, the SS *Shelley* weighed anchor.

The Immigrant

De Kooning in the late 1930s

5. First Impressions

I didn't think there were any artists in America.

L ook Bill, America!" With that shout from the sailors, de Kooning looked out over the water—and looked again. He saw "a sort of Holland, lowlands, just like back home," as he remembered it. No skyscrapers with glittering lights. No beckoning Statue of Liberty. Not only was he disappointed at his first glimpse of America, he was also apprehensive as the ship steamed into the Virginia port of Newport News on July 30. The voyage itself had been stressful. He found the English ship filthy and, for much of the trip, was forced to hide in the hot, dark engine room where the sailors—while never officially acknowledging his presence— gave him lots of work. "Look what needs doing here," they would say to the empty air, knowing that he would have to do what they suggested. Worse than the heat, filth, and fear of getting caught were the sexual advances of an older sailor who tried to take advantage of his vulnerable position. "When we were disembarking at Newport News, the chief engineer saw me and gave me a big smile," de Kooning said. "I think he knew I was on the boat all the time."

Once off the ship, de Kooning's early impressions of America were not very favorable. When Leo Cohan and some sailors took him to a barbershop, the barber recounted with great relish the details of a lynching. What sort of country, de Kooning wondered, was this America? He felt particularly uneasy because he knew no English, which forced him to rely completely upon friends. Cohan, as cheerful and optimistic as ever, proved a resourceful companion who helped steer de Kooning to New York without passing through the usual entry point for immigrants on Ellis Island—the obligatory first step for legal entrance into the United States by way of Manhattan. The passage of the Immigration Act of 1924 had sharply curtailed the flow of immigrants into America, and, while the new quotas were less restrictive for northern Europeans than for others, illegal immigrants like Cohan and de Kooning faced certain deportation from Ellis Island. Calling upon his network of Dutch friends, Cohan arranged to board a coast vessel carrying goods from Newport News to Boston. Throughout the next week, as they steamed up the eastern seaboard, de Kooning and Cohan stoked the engines and worked as fire-

men. Disembarking in Boston, they proceeded by train to Rhode Island, where, with a group of Dutch sailors, they boarded another coast vessel bound for the old South Street port at the tip of Manhattan. Although South Street had been the center of the city's harbor life from the colonial era through the nineteenth century, the shipping business had mostly moved by the 1920s to docks along the Hudson River on the West Side of Manhattan. South Street was a quiet back door into the city for those who wanted to avoid scrutiny.

"We had enough money to buy a ticket on a passenger boat," de Kooning remembered of the trip from Rhode Island, "with music and dancing, and early one morning I just walked off the ship and I couldn't believe it— I was free on the streets of New York." As at Newport News, he was not overwhelmed by his first impressions. De Kooning, who always relished the debunking observation, said about his first view of New York: "This I remember: no skyscrapers. They had disappeared in the fog." Their few possessions in hand, the group of Dutchmen headed purposefully uptown to Barclay Street, where they boarded one of the ferries connecting Manhattan to Hoboken, New Jersey, the town across the river where they planned to stay. This is probably when de Kooning saw the counterman recklessly pouring coffee into the row of cups and was suddenly seized by the difference between Holland and America—the first slow and deliberate, the other driven, haphazard, profligate.

Like most immigrants, de Kooning spent his early months in America swaddled among his own countrymen. Hoboken was the logical place for a Dutch stowaway to live during the first unsettling days, as Cohan, the impresario of their emigration, recognized. Once a sleepy river town and leafy retreat for New Yorkers eager to escape the summer heat, Hoboken had become by the 1920s an important shipping town with a population of about seventy thousand. Four ferries connected it with its huge neighbor. The ships of nine big oceangoing lines docked at its piers, including the Netherlands-American Steam Navigation Company, which attracted a number of Dutch settlers. By the time de Kooning arrived, the traditionally German flavor of Hoboken had almost disappeared, owing in part to a huge wave of Italian immigrants around the turn of the century. There remained a northern European overlay to the city, however, along with a liberal sprinkling of Dutch inhabitants. The first Dutch Reformed Church had been founded in 1850 and maintained a high profile in the local community, and the Holland Seaman's Home provided a welcoming refuge for Dutch, German, and Scandinavian sailors and immigrants. "My sailor friends knew the Dutch settlement there, and they brought me to the

Dutch Seaman's Home, a sort of boarding house," de Kooning said. "Thanks to them the landlady gave me three weeks' credit. It was a nice, very clean little house. I liked it quite well."

Located at 332 River Street, the Holland Seaman's Home was across the road from the docks lining the river and near the Lutheran Seaman's Mission. Just down River Street were the Holland bakery, the Holland Hotel, and a restaurant called Holland. Despite his desire to leave the Old World, de Kooning—who instantly dropped his Dutch name, Willem, in favor of the all-American "Bill"—found the traces of home comforting. Plenty of work was available. More than thirty painters and decorators worked in Hoboken in 1926, a number of them either German or Dutch immigrants. Their establishments bore such names as Braue and Scher-merhorn, Otto Burckhardt and Son, and Fred Schlegel. "Three days later I was a housepainter," de Kooning said, "and got nine dollars a day, a nice salary for that time."

For someone who with a few notable exceptions paid little attention to how he dressed, de Kooning showed a particular preoccupation with clothes during his early days in America: they represented both a badge of success and a symbol of a new identity. After only one week of work, de Kooning proudly remembered, "I could buy a new suit, black for Sundays, low-belt trousers, nice workmen's clothes, for I didn't want to be differ-ent. . . . I do like a fine suit and a nice tie." If in one week he could afford a suit, "In three weeks I could pay off my rent and had new underwear and socks." Like many immigrants, de Kooning also wanted to demonstrate his success to his family and maintain the legend of a land of riches. A photograph taken in 1926, and no doubt sent home to Holland, shows de Kooning and a Dutch friend on the ferry between New York and Hoboken. De Kooning is lolling back against the railing, clearly at ease with the camera, the world, and his relative prosperity. In contrast to his Dutch companion, who is dressed in a poorly fitting jacket and workingman's cap, de Kooning is handsomely turned out. His three-piece suit is elegant, his shirt collar starchily correct. On his head is a fedora, raked jauntily over his forehead and all but hiding his eyes.

De Kooning could get by without much English, though it was not always easy. In the beginning, he knew how to order only one thing in restaurants—a hamburger. (When he finally tried to order something else at the local restaurant, the waiter said, "Hamburger, right?" De Kooning meekly nodded.) On the job, he found he had much to learn about the way his new country operated, which often differed from the careful, artisanal manners of Holland. "I was impressed by the workers' efficiency and their

De Kooning at the Stevens Institute of Technology in Hoboken, before his move to Manhattan

tools," he said. "We worked without stopping for eight hours and used much larger and better brushes than those we had in Holland. I learned a great deal on how to mix pigment with water and oil." He was struck by the American willingness simply to slap new paint over old; in Holland, housepainters would strip a window down to the wood before repainting. He also tried his hand at sign painting, and came away with a high regard for the veterans with whom he worked. "Sign painting was difficult for me because they used other letters here," he said. "How the hell those old guys smoking their pipes did it, I don't know."

De Kooning soon found helpful and congenial Dutch friends. Leo Cohan, who worked as a cook in a restaurant in Hoboken, sometimes arranged for de Kooning to get free meals; between lodgings, de Kooning occasionally stayed in Cohan's rented room. A man named Wimpy Deruyter—a ship's mechanic who befriended de Kooning on the voyage to America—visited whenever he was back in town. De Kooning's keenest friendship, however, was with a Dutch singer named Bart van der Schelling. Well known for never keeping a job or having any money, Bart was big, charming, and exceedingly attractive to both men and women. (He would later fight in the Spanish Civil War and eventually became a naive, or "primitive," painter.) Like Leo Cohan, he remained close to de

Kooning for years: in the early thirties Bill and Bart spent so much time together they seemed like brothers.

On Sundays, de Kooning would go sightseeing with friends. Little remained of the rustic charm that had once brought New Yorkers across the river to Hoboken. Its main allure in the Prohibition era was its great number of speakeasies; a local poll taken in 1930 named Hoboken the "wettest" city in New Jersey. But there was some greenery in the area. Only steps from the Holland Seaman's Home was Hudson Square, which looked over the river. Just beyond lay the Stevens Institute of Technology, which was housed in a mansion on a promontory known as Castle Point. De Kooning went there often to look across the water at the city. With friends like Bart, Wimpy, and Leo—who sounded like a troupe of comics— de Kooning also began to explore New York. He felt comfortable with its kaleidoscopic jumble of ethnic groups, which recalled the mixing of Dutch and foreigners around the Rotterdam docks. He saw the poverty, too, which belied the myth of easy riches: the slums on the Lower East Side; the tenements with windowless inner rooms and public toilets on every other floor; the two-bit flophouses on the Bowery. (One day, he would come to love the photographs of Weegee—the great chronicler of the city's meaner streets.) But that was not the New York that caught his eye. The Roaring Twenties were one of the city's great decades. It thrived on too much money, not enough sleep, and worried cries from the rest of the country about "decadence." The WPA guide to the city, compiled as part of the 1930s Federal Writers' Project, perfectly captured the proudly self-conscious, rhetorical flair of the period:

All through the 1920s New York had been not only the symbol of America but the daemonic symbol of the modern—the fortunate giant in his youth, the world city whose past weighed least heavily upon its future. . . . It was a city infallible in finance, torrential in pace, unlimited in resource, hard as infrangible diamonds, forever leaping upon the moment beyond. "You can get away with anything," said Ellen Thatcher in John Dos Passos' *Manhattan Transfer*, "if you do it quick enough." Speed—with its dividend, sensation—became the master formula in every human activity and technique: Wall Street, dancing, crime, the theater, construction, even death.

What de Kooning thrilled to was the pop energy of the city, which was exotic to a Dutchman who grew up in the subdued culture of northern Europe. Here was freedom from the constraints of class, taste, and disapproving looks; here was a new kind of openness, an invitation to wonder.

One of the first places he visited was Coney Island, a masterpiece of rhinestone splendor that provided entertainment for New York's lower and middle classes. Cecil Beaton described it this way during the 1930s:

> Every Saturday and Sunday a million people go to bathe at Coney Island, reached by subway in half an hour. They stay until the electric bulbs silhouette the minarets, domes and turrets, illumine the skeletons of roller-coasters and the magnificent pleasure-palace of George C. Tilyou (the Barnum of Coney Island), which with its many columns and electrical splendour, resembles something from the Pan-American exposition of 1900. The passengers on the Cyclone rend the air with their concerted screams, so many muezzins calling the azan.

"I liked the sentimental side of the people," de Kooning said, "the girls, the houses on the avenues, and the skyscrapers." Not surprisingly, he relished Times Square. Perhaps it reminded him of the square at the foot of the Coolsingel in Rotterdam, where he had whiled away time with the Randolfis. Except it was bigger, more extravagant, crazier. Like the harbor of Rotterdam, Times Square was a crossroads populated by sailors, tourists, prostitutes, and pimps—and just about everyone in between. Times Square in 1926 was lined with movie houses, shooting galleries, and amusement arcades. At night, it shimmered with thousands of brightly colored electric lights. De Kooning had himself photographed amid the bustle of Times Square. He looked like a man at home.

Once de Kooning found his footing in America, Hoboken seemed too much like North Rotterdam. Crowded tenements, cold-water walk-ups, and communal backyard toilets or privies were the realities of working-class life in Hoboken; he had not left Rotterdam to move to a similarly depressed city across the ocean. More important, he missed living in a bohemian milieu. It was one thing to be a workingman living among artists or people like the Randolfis who flourished on the margins of society. It was quite another to be a workingman among workers. On Sundays, a friend with an old car sometimes drove him to Storm King, a high promontory of land up the Hudson with sweeping views down the river. "We would stand by the parapet and look at the view of the city," de Kooning said. "It used to scare me to death. I would say to myself, 'There's no art here. You came to the wrong place.' " Although he visited the galleries on Fifty-seventh Street, they mostly showed plummy European

paintings intended for conservative apartments on the Upper East Side. He saw nothing like Mondrian.

Leo Cohan urged de Kooning to move across the river. "I said to him, 'Bill, you mustn't hang around in Hoboken. You must go to Manhattan. There you'll find other artists.' " In Hoboken, de Kooning began to hear about a community in the city called Greenwich Village, where poets and painters were said to live. He determined its location—south of Fourteenth Street and north of Canal Street—and one day found himself amid the oddly angled streets and old brownstones. But he could not find "the Village" he had heard about. "There were just lots of Italians standing around on corners. Inside, you know, the Village was nice, but from the outside, you couldn't tell it was there—it was so quiet." Then, while still living in Hoboken, de Kooning met a Sicilian artist named Mirabaggo, who lived in the Village. When a barber whom Mirabaggo knew retired, he bought the empty barbershop and opened a coffeehouse decorated with plaster copies of Greek and Roman sculpture. De Kooning began to spend time there on weekends. Soon he was also going to Café Rienzi, another coffeehouse that opened shortly after Mirabaggo's. He began to discover old Village hangouts, such as the Pepper Pot, the MacDougal Tavern, and the Jumble Shop. All of them had been in varying degrees haunts of writers and artists since the 1890s. Of greatest importance to de Kooning, however, was the living presence of painters. "Here in Greenwich Village there was a strong tradition of painting and poetry," he said. "I had not known this, and it brought back memories of my interests when I was 14, 15 or 16 years old."

Now that he had located an American art world, de Kooning naturally wanted to join it. He made some drawings and illustrations to replace the portfolio that he had left behind in Belgium, and began to read the Help Wanted ads for commercial artists in the Manhattan newspapers, just as he had in Brussels. When one ran in the *New York World* he dropped off his portfolio at the stated address. To his dismay, the place was mobbed with applicants for the job. He had all but given up hope when a man appeared holding aloft a portfolio and shouting, "Where's de Kooning?" The American's pronunciation was jarring. In Dutch, de Kooning was pronounced with a hard "o"—as in Koning. In American, he was de Kooning.

The job was his. De Kooning was so pleased—his first triumph in America!—that he signed up immediately, no questions asked. "I didn't even ask them the salary because I thought if I made twelve dollars a day as a house painter [de Kooning variously described his Hoboken wages as nine or twelve dollars a day] I would make at least twenty dollars a day

being an artist." The elation abruptly ended after a week when he was handed twenty-five dollars. "I was so astonished I asked him if that was a day's pay," said de Kooning. "He said, 'No, that's for the whole week.' " De Kooning had learned the hard way that less skilled labor could pay more than an arts-related job and that life in America was not going to be easy. "It turned out to be quite different from what I thought," de Kooning said of America. "Nowhere near as luxurious as I imagined it."

Disgruntled, de Kooning spent the weekend wondering whether or not to return to housepainting in Hoboken. Cohan and other Dutch friends urged him to keep the new job. As Cohan sensed, art and the company of artists would finally prove far more important to his friend than a fatter paycheck. Although de Kooning by no means considered himself a serious painter—that would only come years later—he made an essential decision that weekend: he must at least live in the neighborhood of art. His hopes of making a fortune waned, but his interest in an American art world strengthened. A little more than a year after his arrival in Hoboken, de Kooning packed his few possessions, said good-bye to his sailor friends, and took the ferry into Manhattan.

6. Becoming an American

Of course, New York is really like a Byzantine city.

In 1927, a Russian émigré artist named Anton Refregier saw a promising advertisement in the *New York Times* for a job with a design and decorating firm. The ad called for a "modern artist" which, as Refregier later remembered, was then unheard of, since what public taste demanded was fake rococo paintings. Refregier applied and was hired at the firm of Eastman Brothers for $25 a week. "When I was hired, it was explained that one of my functions was to go up to a place on 49th Street and 6th Avenue, a rooming house, and wake up an artist who was *the* artist of the studio at that time and was quite essential for the project," Refregier said. "I did not particularly like this part of my job. I went there and knocked at the door and a rather gruff voice with a heavy Dutch accent answered and I said, 'Mr. de Kooning, it's time to get up.' "

Eastman Brothers—the firm that had hired de Kooning a few weeks earlier—was located close to the theater district, the source of much of its business. The firm had a florid and theatrical air; it was, as Refregier attested, "unique." The brothers Nathaniel and Irving Eastman had first opened for business in the early 1920s as purveyors of Russian arts and crafts. By the mid-twenties they had become an all-purpose design factory. Their firm filled the second floor of a building at 127 West Forty-seventh Street, in a neighborhood of old row houses that had been partly converted into commercial enterprises. At Eastman, different teams produced stage sets, decorated speakeasies, made stained-glass windows for synagogues, and did interior design and renovation. In keeping with their advertisement, Eastman also specialized in modern design, often in the newly fashionable art deco style. Within the firm, there was a definite hierarchy. The "artists" like de Kooning and Refregier made designs to scale, which artisans then enlarged and executed.

No doubt Eastman Brothers reminded de Kooning of earlier employers, such as Gidding and the van Genechten firm in Brussels, both of which were also run by pairs of brothers. But there was one important difference: the Eastman brothers were grand fakers rather than designers and craftsmen of the old school. "Instead of making real stained glass, for example, they made fake glass," said Tully Filmus, another Russian-born

artist who signed on for a project at Eastman Brothers in 1929 and worked with both de Kooning and Refregier. "Everything was theatrical, for show. They weren't respectable." The windows produced at Eastman Brothers for poorer synagogues were just glass with rich colors painted on the surface. "After we finished a glass window," said Filmus, "a man would come and do stippling to make it look like it was old glass." In the context of provincial America—and especially in the make-believe world of stage design—such forgeries were accepted without question. Refregier later said that he would routinely fake Boucher and Fragonard paintings for interior decorators, "which was done by either copying something that was available in the Metropolitan [Museum], or from photography. And then the interior decorator expected you to shellac the painting and then take a little bit of oil and raw umber and smear all over the thing," giving it the illusion of age. This form of craftsmanship paid well: $75 a painting was the going price. The fakes were often very good. One friend said de Kooning worked for a solid week on just one such panel for an Eastman project.

The brothers operated their business in a fly-by-night style. Employment was strictly freelance, even for prized designers like Refregier and de Kooning. When the brothers landed a new job, they would advertise in the paper and assemble a temporary crew. For the duration of the project the pay was reasonably good (for a commercial artist) and the nine-to-five workday was easy compared to what other firms demanded. Once the job was completed, however, the team was disbanded with no guarantee of future work. For those who sought security, it was an unsettling way of life. But de Kooning, never one to punch a clock, was already accustomed to this on-again, off-again style and generally preferred it. "It used to be terrific here," de Kooning told Martha Bourdrez, a fellow Dutch immigrant, in 1950. "No taxes, and one could easily freelance." His technical training at both the Gidding firm and the academy made him particularly valuable to the Eastmans. The job itself was a godsend during his early days in the city, giving him steady (if intermittent) work for three years, at a place where his lack of English was not a drawback. The Eastmans were probably not long off the boat themselves, and were accustomed to dealing with immigrants. The projects were often adventurous for the young artists. Refregier recalled with awe that, when the firm was decorating speakeasies in the late twenties, the gangsters behaved just as they did in the movies, with bodyguards protecting their backs.

Eastman Brothers gave de Kooning the opportunity to meet others like himself. Through the Eastman freelancers, he developed a circle of

friends in America who knew their way around art, a small but extremely supportive group of émigré artists. "Looking back," said Refregier, "those were wonderful days. Everybody, practically every artist of any reputation at one time or another worked in that studio." Much of the intellectual and artistic excitement of the period—otherwise a time of increasing provincialism in American culture—was centered in this émigré community. It was a world filled with Russians, Armenians, Greeks, and Italians, many of them trained in academies abroad. Most were highly intelligent. Almost all were poor. As outsiders thrown together in this strange new place, often speaking only rudimentary English, they possessed a strong common bond and maintained a wider, more worldly outlook than most American artists. "It was nice to be foreigners meeting in some new place," de Kooning said. "Of course, New York is really like a Byzantine city—it's very natural [to meet other foreigners] too."

Given Eastman Brothers' particular role as a clearinghouse for expatriate Russian artists, de Kooning developed strong early ties to the Russian network in New York. Foremost among his new acquaintances was Refregier, his designated watchdog, who soon knew de Kooning well enough to complain about the daily wake-up visits demanded by the firm. "Bill, for Christ's sake, don't put me in this position," Refregier would complain. "Can't you possibly get up by yourself?" (De Kooning continued to have trouble getting up all his life.) But he and Refregier still became close friends. A short, slender man with memorably warm eyes, "Ref" was affable and easygoing, a good mentor for a young immigrant finding his way. "He was more sociable than Bill," said Lewis Jacobs, a friend of the two artists from Eastman Brothers. "He had an easy manner—very gentle. And he spoke very good English."

Every artist de Kooning met had a story. For example, Refregier, born in Moscow to a Russian mother and a father whose French family had moved to Russia several generations before, left Russia when he was only fifteen, at about the time of the revolution. He went first to Munich and Paris, where he was apprenticed to a Russian sculptor named Vassilief. Then, at age eighteen, he set out for America with his mother. In his first years in the United States, Refregier scrambled to make money any way he could, from waiting tables in restaurants to making decorations for Coney Island. Somehow, he saved enough money to attend the Rhode Island School of Design, in Providence. Then, in the fall of 1925, he went to Manhattan, determined to become a mural painter. Instead, he was forced to settle for various commercial jobs, including painting murals in speakeasies. Refregier was only a year older than de Kooning, yet he had

seen much more of the world. He was also familiar with all the commercial art establishments of Manhattan, a world with its own rules and insiders' ways. De Kooning also formed fairly close ties with several other artists at Eastman Brothers. One was Tully Filmus, who had grown up in Philadelphia and studied art at the Pennsylvania Academy of Art. A slight, gentle-souled man, Filmus often painted remembered scenes of his early childhood in the *shtetls* of Russia. Another, more casual acquaintance of de Kooning's was Jacobs, a close friend of Tully's from Philadelphia who was briefly hired at Eastman Brothers after Refregier and de Kooning were already established there. Although Jacobs had studied art before coming to New York, he was less dedicated to painting than Filmus was and would eventually leave the field to become a filmmaker and an expert on independent films.

Were such people Americans? Did Eastman Brothers reflect the way Americans did business? And what did it mean, anyway, to be an American? De Kooning did not put such questions to himself in abstract terms, of course, but he responded warmly to the theatrical extravagance and impure mixtures of people and ideas that he found at Eastman Brothers. He was living much as he had in Holland, only more so, without the old rules and no pious respect for the past or its precedents. Eastman Brothers was a kind of crazy-mirror reflection of the sober life at Gidding, and the irregularity of his employment repeated his experience with Bernard Romein at Cohn Donnay—but with Russians sent to bang on his door in the morning. The showmanship, fakery, and "by the seat of your pants" style delighted the Dutchman. This was a place where you could remake yourself, and admire others who were doing the same.

Through Refregier and Filmus, de Kooning met David Burliuk, the first artist to make a significant impression on him in America and a Russian who particularly celebrated the flux of modern life. Flamboyant, effusive, and intoxicated by visionary ideas about the future, Burliuk had helped found the futurist movement in Russia prior to the revolution. (He had met Kazimir Malevich as early as 1905.) In New York, Burliuk continued to proselytize and treat whoever would listen to his recollections and revolutionary ardor. He and his wife, Marysua, maintained an informal salon at which artists would come to sip tea, talk, and listen to his grandiose pronouncements about what he called in his writing "AMERICA THE GREAT." In de Kooning's day, Burliuk was infatuated by the new technology of radio and its possibilities for transforming the world. Describing himself as "painter, poet, orator, actor and show-man," Burliuk considered himself the founder of the "radio movement," whose aim was to "unite all Radio-modernists" in the world. In 1926, he pub-

lished a manifesto on "Radio-Style," which he issued from the "Universal Camp of Radio-Modernists." America would lead this march of art into the future.

While Burliuk was something of a blowhard, he was also admired for his role in furthering progressive art and for his connection to Russian modernism. And the reserved de Kooning always loved outsize characters and extroverted visionaries. Burliuk's circle included, in addition to many Russians, a number of American painters. Joseph Stella was a regular in Burliuk's living room. Stella had spent three years, from 1909 to 1912, in Italy and France, where he befriended and was influenced by the leading futurists. An Italian American, he was a bohemian in good standing and one of the original Village artists; younger painters often referred to him as a kind of "papa." The young Japanese-American sculptor Isamu Noguchi, who had recently moved to the Village, also regularly visited the Burliuks' salons and may well have met de Kooning there. For both young artists, the salons offered an important first taste of the artistic and intellectual debate that would surround them in the next decade.

In the late twenties, de Kooning—who had often fantasized as an adolescent about glamorous American girls "in black nylon stockings"—found a girlfriend who fit seamlessly into the crazy-quilt pattern of his new life. Her name was Virginia, or "Nini," Diaz. She was a tightrope or wire walker in the ornate and slightly tawdry world of vaudeville. De Kooning made a romantic story of their meeting. One day, he said, he saw her performing at one of the vaudeville palaces that lined Broadway, not far from Eastman Brothers. At that time, the area around Times Square, especially the contiguous blocks up and down Broadway, was filled with movie houses that alternated short feature films with live vaudeville. De Kooning took only one look at her, he would say—at her striking hourglass figure, long and luxurious dark hair, and gamine-like charm—and knew that he was smitten. What Nini herself recalled was more prosaic. She said de Kooning never saw her perform, which was one of her regrets. Instead, she said, they met at the boarding house on West Forty-ninth Street, the one where Refregier would come knocking and where de Kooning was sharing a room with another artist. Nini and her sister Corinne, with whom she performed, had earlier moved into that same boarding house. When the landlady told her that the new artist tenants were having a party, Nini went and saw de Kooning with a tub full of beer and a crowd of people in his room. "I wasn't a drinking person," said Diaz. "But he was wonderful. We dated right away."

Born in New York City, Diaz had grown up in a circus family. Her mother and father were aerialists with the Barnum and Bailey Circus. Her

father had been born in Spain, her mother in France. Owing to her mother's French background, Nini spent six years in a boarding school in Paris before rejoining her parents and three siblings in America. At that point, her father was performing with the Ringling Brothers Circus; Nini also began to train as a performer. Eventually, she appeared with her siblings in a traveling act that took them from Chicago to Cuba to New York. "I was fourteen when I first performed," said Diaz. "Before that we trained. Five or six feet was as high as we ever went. It was not high-wire. I did fast cross-steps—a fast run on the wire." By the time that Nini and Corinne settled into the New York rooming house, however, their kind of act was losing popularity. "We got the last of vaudeville," she said. Her sister, already married and the mother of a child, was eager to leave the life, and for her own part, Nini was only too happy to scale back performing and take up with de Kooning. He had not been with another woman since Europe, said Diaz, and proved an ardent and devoted lover. Together, the couple moved in 1928 into a small, two-story building at 64 West Forty-sixth Street, and Diaz assumed his name—which was a common practice at the time for unmarried women. Their new home was somewhat shabby but convenient both to Eastman Brothers and to the theater district, where Diaz still occasionally performed. It was also inexpensive. "We were very poor," said Diaz. "One time I had been in Chicago years earlier, and while taking ballet lessons I had become engaged to this dancer. He gave me an engagement ring. Later on [Bill and I] lived on that ring. Whenever we needed it, Bill would hock it and get five dollars."

In many ways, Diaz was a perfect match for the young de Kooning. Like him, she straddled the worlds of Europe and America. Her first language was French, and her English, while better than his, was not polished. "I was the last of the children to learn English," said Diaz. She shared with him a certain old-fashioned European notion about the roles of the sexes: a woman should cook and clean and make a nice home for a man. "I took care of that boy like a prince," she said. "I saw there was a good dinner on the table. I cleaned. He could drink out of the toilet bowl." In her devotion to old-fashioned standards, she may well have reminded de Kooning of the Dutch in general and even, perhaps, of certain aspects of his own mother, who made a point of cleanliness. Even Nini's personality—outgoing, talkative, a "live wire," as Tully Filmus said—may have evoked Cornelia. "Nini was street-smart," said one early friend from the 1930s, Bea Reiner. "She understood life. She was capable of looking at someone and sizing them up."

And yet, if Diaz brought a certain familiarity to de Kooning—she could have knocked elbows and made her way in the streets of North Rot-

terdam—she also represented something more exotic. Circus performers were a favorite subject of European modernists. Not only Seurat and Picasso, but also many German expressionists were intrigued by clowns, acrobats, and tightrope walkers, who were often treated as surrogates for the modern artist. Circus performers operated apart from conventional society. They symbolized the exciting freedom and danger of living outside bourgeois constraints. At the same time, Diaz, who was hired as a movie extra at one point, was enough of an American flapper to satisfy de Kooning's desire for a sexy American girl. He loved movie stars like Mae West—whose 1926 Broadway show, *Sex*, was a *succès de scandale*—and the latest songs of Duke Ellington and Fats Waller. He was a great fan of American comics and was beginning to pepper his talk with such native American lingo as "hot potato," "smart cookie," "terrific," a trait that throughout his life endeared him to his friends.

De Kooning was so useful to the Eastmans that they invited him to accompany them on a long winter trip to Florida. The brothers drove de Kooning and Nini to and from Miami in their big Packard car. Once there, the Eastmans and de Kooning studied the architecture of Miami, developing ideas for stage sets, while Diaz sunbathed on the beach. The trip was a great success, except when de Kooning was bitten by a Portuguese man-of-war and became ill. Diaz said, "Bill never went back to a beach again." She was both right and wrong. There was only one thing that de Kooning, who hated swimming, feared more than the sea—and that was being away from it for too long.

In his struggle to become an American, de Kooning not only cultivated slang but also seldom spoke Dutch. No matter how accented his English, he refused to turn to his first language for help, even when speaking with Dutch acquaintances. He seemed to want to erase the Old World, not just put it behind him. He sometimes seemed melancholy, and his friends at Eastman Brothers found him somewhat remote. "I don't know if he was afraid his English wasn't good enough, but he never started a conversation," said Lew Jacobs. "He would reply, but it was only a word or two, not a sentence. Unless you were just kidding around. He had a great sense of humor." Both Jacobs and Tully Filmus remembered de Kooning wrapped in a kind of shy, humble, and friendly persona—a pose typical of a person in a foreign environment—that they never quite believed in. It was an image that would persist for years. A decade later, the painter Conrad Marca-Relli said, "He was like the Dutch Boy on the paint cans, blond and blue-eyed. He was like a little boy. He had a thick Dutch accent. He was a

very Chaplinesque character, that little immigrant. His whole manner was very humble. If he came into a room, he was awkward, like with his hat in his hand. And everything was 'beautiful,' 'wonderful.' "

At times, de Kooning's shy and friendly surface seemed to conceal a watchfulness, bordering on suspicion, that puzzled observers. His more sensitive friends rarely believed they were getting the whole man. "I always felt that his sense of humor was really a protective coating, that behind that was Bill," said Jacobs. "He was friendly on the outside but a closed person on the inside." It was only in art—or perhaps when he fell in love—that de Kooning revealed more of himself. De Kooning told no one at Eastman Brothers of any private ambitions, particularly those concerning the serious practice of art. Both Filmus and Jacobs regarded him as a designer and carpenter. "Bill was just trying to make ends meet," said Filmus. "He wasn't intending to be a 'painter' at that point. He thought of himself as a commercial artist." However, Nini Diaz said that from her first days with him in late 1927, not long after his move to Manhattan from Hoboken, de Kooning was obsessed with art. "Bill just wanted to be an artist," she said. "In Europe, his mama had sent him to learn how to make cabinets and such. But the drawings he used to do! He just did jobs so he could paint." According to Diaz, de Kooning subjected himself to unrelenting, merciless self-criticism. "Bill tore up everything," she said. One painting that she particularly loved—the subject was a nude, possibly Diaz herself, playing cards—ended up the way most of de Kooning's canvasses did. "He ripped that one to pieces."

As soon as he could afford to buy supplies, de Kooning began to paint and draw on the side, much as his mentor Bernard Romein did. Eastman Brothers was located only ten blocks south of the art galleries on Fifty-seventh Street, and de Kooning often spent his lunch hour at an exhibition. In 1927, he saw a show of Matisse's work at the Valentine Dudensing Gallery. The twenty-three-year-old commercial artist marveled at Matisse's command of composition and stood before one picture dazzled by a "beautiful cobalt violet." He remained for a few minutes and then rushed out to buy a tube of violet pigment, hurrying home to paint so that he could "keep that feeling" alive. The picture he began that afternoon, almost entirely in Matisse's manner and nothing like de Kooning's earlier academic works, was one of two still lifes de Kooning painted that year as a direct homage to Matisse.

Since there were few galleries in New York, a single show of modern art could have a tremendous impact on local artists. That was the only positive aspect to the paucity of modernist offerings in the city. In the late 1920s and early 1930s, a handful of art dealers on Fifty-seventh Street,

including those at the Valentine Dudensing and Pierre Matisse galleries (the latter owned by the son of Henri Matisse), occasionally displayed paintings by Miró, Matisse, Picasso, and the cubists. The Julien Levy Gallery represented surrealists, among them de Chirico, Miró, and Ernst. The J. B. Neumann Gallery showed the German expressionists, and Edith Halpert's Downtown Gallery on West Thirteenth Street showed Stuart Davis and other American modernists. Until 1930, however, the Metropolitan Museum of Art possessed no works by Cézanne or van Gogh and did not own a single work painted after 1900. The Museum of Modern Art and the Whitney Museum of American Art would not open until, respectively, 1929 and 1931. Only two pioneering art institutions in the 1920s helped inform the public about modern art. One was the Société Anonyme, which was located at 19 East Forty-seventh Street and exhibited abstract and avant-garde art. Katherine Dreier, a wealthy American artist and collector, created the Société with the help and advice of both Marcel Duchamp, whom she had met in 1916, and the Dada and surrealist photographer and artist Man Ray. The Société, which lasted from 1920 to 1950, sponsored lectures and traveling exhibitions and introduced the work of such artists as Klee and Malevich to America.

The second pioneering institution was the Gallatin Gallery of Living Art, a collection that Albert Gallatin displayed for years at New York University. Located on Washington Square in Greenwich Village, close to many artists' studios, it opened to the public in 1927 and contained important works by Picasso, Léger, and Mondrian, among others. Together, the Société Anonyme and the Gallatin Gallery helped define the narrow perimeters of modern art in New York, at least in an institutional sense. So limited was the New York art scene when compared with the vitality of Paris that the artist Ilya Bolotowsky once said that in one afternoon someone could cover the whole art world of the United States quite easily. By contrast, in the Paris of the late 1920s and '30s, numerous dealers, collectors, and critics were paying attention to art. "The whole life was attuned to it," said the artist Ludwig Sander.

If there was little enthusiasm in America for the European avant-garde, there was virtually none for the homegrown modernists. An observer in the late 1920s could be forgiven for supposing that America had not produced any significant modern painting whatsoever. Although American modernists of the preceding generation such as John Marin and Arthur Dove were included in the celebrated Armory Show of 1913, which contained everything from Marcel Duchamp's famous *Nude Descending a Staircase* to the gritty realism of the so-called Ash Can school, their work had little lasting impact. (The Ash Can school's graphic

vision of working-class life had, however, created a generation of followers.) In the late 1920s, illustrative American scene painting, together with a diluted version of the Ash Can realism, dominated American taste. The public and most artists remained suspicious of "imported" styles of art. It was one thing for the European avant-garde to paint in a new abstract or cubist fashion; it was another for Americans to do so.

And yet, the few American modernists could not just ignore developments abroad; doing so would only confirm their provincial status. Many tried to straddle the ocean, addressing American subjects in a modernist way, but earned little respect for doing so. "The Armory Show was a complete disaster to American art because it made people think that you'd got to do things in a certain style," said the artist Fairfield Porter, a representational painter who was also a first-rate critic. Porter despised the "have-to-paint-in-such-and-such-a-way" lectures of both the modernists and the nativist or moralizing artists. "American art was provincial before," he said. "And it became more provincial as a result of the Armory Show." To some degree, de Kooning was insulated from this demoralizing environment. For one thing, he concealed his ambitions and was accustomed to living in provincial places. For another, he had little choice about whether or not to be a modernist. He himself was a European who could hardly adopt the nativist style without appearing false and ingratiating, and was therefore free to follow without ideological distraction his modernist predilections. Tully Filmus, whose art would always remain rooted in childhood memories, said that in 1930 "Bill had been bitten by the modern bug. He either couldn't, or wouldn't, work in the academic tradition."

De Kooning's earliest known paintings in America attest to his budding modernism. He was particularly interested in painting small, fairly abstract still lifes that included egglike shapes that owed something both to Miró and Arp and to his classical training at the academy, where students were painstakingly taught to draw pure geometric forms. The pictures have a surrealist air of possibility and implication; the suggestion of birth, evoked by the eggs, may also have been appealing to an immigrant hoping to remake his life. The "eggs" are also rich in contrary meaning. On the one hand, they are still and delicate and poised; on the other, they call to mind cracking and breaking. They are metaphors about metamorphosis itself. The ever-changing oval would never leave de Kooning's art. As the critic Thomas Hess wrote:

> The egg: It appears in the earliest pictures as a still-life object whose ovals can fill a painting, as a village of huts, or a head. When it loses its identity as Egg, the oval remains insistently in faces, eyes, breasts, a

light-bulb on a table, a pure shape that might be a lamp globe or the top of a glass seen from an angle of an apple. At some point in this process the oval enters de Kooning's mind and eye as a possession that, just because of its ability to multiply meanings, can be used anywhere he wants to put it.

Even as he worked at Eastman Brothers, de Kooning drew obsessively, defining and redefining his ideas through his hand, as he would throughout his life. For de Kooning, drawing was almost as necessary as breathing. It was a way to stay in touch with the world; as the charcoal or pencil moved across the paper, it released some of his nervous energy. Drawing was also a way to continue working as an artist when there was not enough time, space, or money to paint. His drawings were uncompromisingly modern. At one point in the late 1920s, Diaz peddled them around corporate offices in midtown to try and make some money. She returned with almost $200. (Among the buyers was the owner of the company that made Van Heusen socks, who purchased several.) De Kooning, Diaz said, was thrilled with the money. When she told him that many people criticized the drawings for being "too far ahead of the times," however, de Kooning flew into a rage. "They're going to tell me how to work!" he shouted and began to bang things around. "When he went into a rage the furniture flew," said Diaz. "That one time was one of the first."

As a new immigrant struggling in New York to re-create himself, de Kooning began to construct a certain kind of physical environment around himself, one that appeared strangely innocent and almost new-born—and entirely modern. "The modern" was his passionate aspiration, although what "modern" meant for him personally still remained, in a deep sense, ill-defined. He knew better what was *not* modern than what was. What was not modern was Holland, Gidding, and fussy little rooms. He remembered too well a childhood of constantly moving from one pinched room to another. In his early apartments, he would place flat panels on the doors in order to conceal their decorative molding, which reminded him of the Old World. One time, said Filmus, he even tried to swaddle the ornate tin ceiling of his apartment with a huge bolt of clean white material. He worked for hours stretching and tacking up the cloth. Then the two artists went to lunch, only to find upon their return that the cloth had sagged in the middle and become an upended tent.

In 1929, de Kooning had an unexpected vision of how an artist might live. Through his Eastman connections, he met the Armenian artist and sculptor Raoul Hague, who had recently moved to Manhattan from Woodstock. Not only did Hague live in an unconventional part of town—

Chelsea, then mainly an industrial district rather than a residential area—
he also lived in one of the first artist "lofts," an industrial space without
interior walls that a few artist-pioneers were using for both working and
living quarters. (Hague himself got the idea from an older painter named
John Nichols, whose loft on Tenth Street Hague saw while delivering a
package to him from Woodstock.) Soon after meeting Hague, de Kooning
visited him on West Eighteenth Street in Chelsea, where the sculptor
lived on the top floor of a three-story converted carriage house between
Sixth and Seventh Avenues. On the ground floor was a taxicab company;
above that was a speakeasy. De Kooning climbed the stairs. As Hague
opened the door, a vast area of nearly raw space opened out before the
young artist. It seemed to go on forever, stretching ninety-five feet back
from the street and with no interior walls to break the plane. Light
streamed in from windows at each end and to one side. It was bright, airy,
enormous. It was a place to breathe freely. De Kooning, who had always
lived in small rooms—who loved the open sea but had never known the
psychic luxury of space—stood at the door, dazzled.

7. The $700 Music Machine

I can't see myself as an academic. I think of myself as a song-and-dance man.

By 1929, de Kooning had established what must have seemed an enviable new life. Three years after coming to America, the twenty-five-year-old had an American girlfriend, more or less steady employment, and enough money to make ends meet. "He always managed," said Diaz, "to find a dollar." He had many European friends and was increasingly involved in the local art world. He could be forgiven for thinking that the hardest days were behind him.

In the first five hours of trading on October 23, 1929, the stock market lost five billion dollars. The crash and subsequent economic paralysis ruined many prosperous Americans, but what would become known as the Depression was hardest on those who lived on the margins, among them immigrants and artists. Its full impact was not felt for a while, but almost immediately people began to retrench. It was in that spirit that de Kooning, who knew firsthand what an economic depression meant and sensed that design firms would now attract less business, began to scout around for work to buttress his freelance stints at Eastman Brothers. In particular, he spent more time as a carpenter. He had always been adept with his hands and had probably honed his carpentry skills at his Gidding job. His friends took advantage of his skill, often asking him to make furniture for them. He would soon become celebrated among artists for building simple but sturdy platform beds that had metal pipes for legs and rubber mattresses. He is widely credited with devising this bed, which eventually became common in the studios of New York.

De Kooning also sought more lucrative projects. As his Eastman work tapered off, he acquired two design commissions. One consisted of renovating the Manhattan apartment of a couple named Vladimir and Matty Erlingon. The second, larger project was the renovation of a luxuriously appointed penthouse on Fifty-seventh Street. Its owner, a real estate entrepreneur named Norman K. Winston, wanted to give a modern look to the conventional square layout. He could afford to do what he liked: he owned a building on Forty-ninth Street named after himself, and, according to Lew Jacobs, his wife "had a grand salon on the Riviera." Winston dressed the part of a wealthy man, wearing expensive suits and a showy

watch. He took an immediate liking to the affable Dutchman and his vaudeville girlfriend. Before work started, he often gave de Kooning and Nini a large breakfast. "He'd say, 'Now, Nini, there are fresh eggs,' " she said. "And I'd say, 'Yes, Mr. Winston.' " According to Jacobs, "Bill was redesigning the whole apartment. He was changing the whole shape, building a piece out here, adding a thing there." It took him months to complete the work. Tully Filmus, whom de Kooning showed around the apartment, recalled that Winston wanted a lowered ceiling. De Kooning then hung a square boxlike second ceiling under the original "so that it would look modern." To help him, de Kooning hired a skilled German cabinetmaker. De Kooning would create the designs and then give them to the cabinetmaker to execute, in much the same way that the designers at Gidding and Eastman Brothers worked with craftsmen. Sometimes, de Kooning bartered his skills. Already, his teeth—so neglected while he was growing up—were beginning to give him problems. They were riddled with cavities and discolored from smoking. De Kooning found a dentist, Dr. Rebecca Horowitz, who took care of him "in exchange," Diaz said, "for Bill fixing up her place. She had one of the first modern gorgeous studios." Diaz also brought in income by touring occasionally with Don Valeria, who had a wire act that he took on the road. When Valeria got a job through his agent, he would often call Nini or her sister to see if either would perform with him.

As the economic situation of the country deteriorated, de Kooning, no doubt prompted by Nini—who was tired of pawning her ring—began to look for a regular nine-to-five job. Sometime around the end of 1929 or early in 1930, he applied for what was considered a particularly plummy job during the Depression, working as a window-display designer for A. S. Beck, a prosperous chain of New York shoe stores. He probably heard about the job from Nini's brother-in-law, Eddie, who worked as a salesman for A. S. Beck and no doubt vouched for de Kooning. The firm hired him, along with a Russian artist named Roman Chatoff, at a starting salary of around twenty dollars a week. Every morning, de Kooning reported to the firm's headquarters at 139 Duane Street, where the window displays were designed. It was his first—and it would be his last—regular nine-to-five job. He had last worked full-time at Gidding. A steady job made him uneasy, arousing in him the constricting feelings of bourgeois respectability, lost freedom, and heavy responsibility that he would fear all his life.

Not long after joining A. S. Beck, de Kooning noticed an employee carrying a book into the shop and asked him what he was reading. It was a volume on Matisse. De Kooning was naturally interested; the two struck

With his close friend Robert Jonas, whom de Kooning met at A. S. Beck in the early 1930s

up a conversation. De Kooning invited the man, Robert Jonas, to visit Nini and him at home. It was the first of many visits. De Kooning and Jonas formed a strong bond, founded, in part, on similar childhoods. Jonas had grown up in Newark, New Jersey, in a family beset by emotional and financial problems. His father abandoned the family, forcing Jonas to support his mother and sister. Nonetheless, Jonas went to the Fawcett School of Design in Newark and later took night courses in Manhattan. His first passion remained art, but a tremor made it difficult for him to do design work, and so, after the stock market crash, he settled for a job at A. S. Beck operating saws and helping to construct window displays.

De Kooning relished Jonas's intellectual edge, and the two men would regularly spend the evening drinking tea, playing checkers, and arguing. In contrast to de Kooning's other friends, Jonas could entice him into conversation. Jonas even called him "a big talker." According to Jonas, de Kooning was already fascinated by abstraction and what little he had seen of cubism. "He came with a furious thrust towards being modern." Once, when Jonas asked him what he meant by "modern," de Kooning simply cited various art movements in Holland such as De Branding—the group of Dutch modernist painters in Rotterdam—and spoke at length about van Doesburg and Georges Vantongerloo, two of the founding members of De Stijl, as well as Frank Lloyd Wright. The two friends also discussed politics. De Kooning had already assumed the position of an outsider who observes politics from a distance; he instinctively recoiled from all con-

straints, including ideological ones. However, Jonas was a fervent but not rigid communist. "They never stopped talking, him and Jonas," said Diaz. "All about communism. And when they were finished, they just started in again."

A. S. Beck was a step down for de Kooning in terms of money and prestige, according to Jonas, but a step up in terms of security. It operated with a military-like precision. Within the larger shop a little studio hummed with carpenters, cabinetmakers, and painters, all engaged in creating displays for about fifty store windows. Nearby was an area with drawing boards where de Kooning and Chatoff worked, composing designs to be executed by the craftsmen. A small separate office was occupied by Harry Coopersmith, a letterer admired for his speed and facility. The shop manager, who was responsible for completing the displays on time, was a short and vigorous man named Louis Ross, who was fairly tolerant of the ways of artists, except when it came to work hours. Since neither of his resident artists was punctual, Ross kept after them to report by nine. First he would admonish Chatoff and then add, "You, too, Bill." The phrase "You, too, Bill" became an affectionate office joke directed at the quiet but friendly Dutchman.

De Kooning's new job was diverting if not especially challenging. Far from being a philistine company, A. S. Beck took great pride in its appearance. (The handsome facade for one of their stores, in an art deco style, can still be seen at 128 West Thirty-fourth Street.) In the shop on Duane Street, de Kooning worked with a mock storefront, a kind of lifesize dollhouse that allowed him to test various designs by playing with their visual elements. He could move things around to create new patterns, much as he had done in the earlier show carts at the department store in Rotterdam and also as he would do in his later paintings. Most window displays followed the same basic plan. A series of risers displaying shoes ascended toward one high central focus point where the most expensive shoe would be put. Salesmen concocted most of the ideas for a display, which de Kooning would then sketch out. They might feature artificial flowers or a classical bust or a glass panel upon which had been etched a fetching design, such as a beautiful young woman holding doves. De Kooning's designs were typically in the style of the French art deco designer Jean Dupas. Famous in the 1920s for his decorative murals, which often depicted languorous, stylized women, Dupas had an elegant touch often imitated on both sides of the Atlantic.

In the early 1930s, de Kooning's future at A. S. Beck seemed bright. The successor to Louis Ross was a man named Jack Goldberg, who immediately recognized de Kooning's talent and allowed him a degree of both

creative and emotional license. De Kooning felt secure enough at A. S. Beck to disagree occasionally not only with Goldberg but also with Jack Daniels, the president of the company, who took a liking to de Kooning. Should either man criticize his designs, de Kooning, ordinarily quiet, would storm out and say, "Fuck them." And then he would not return for a week, even if someone was sent to pound on his door. But such blowups were rare, as his designs usually met with high praise. De Kooning remembered one in particular. Although the salesmen usually proposed display ideas, de Kooning once came up with an idea, a slogan, and a design all by himself. The theme was "Stepping in Style with A. S. Beck." Pairs of shoes, arranged on a series of risers, stepped jauntily toward the customers. The salesmen were irritated that a mere artist came up with something like that, but the bosses loved it.

In the 1920s and '30s, when virtually no buildings were air-conditioned, artists and craftsmen in New York often took off much of the summer. Even the regularly employed frequently left for the summer months. Business was slow in June, July, and August, especially during the Depression. "Folks would put a sign on the wall, 'Will be back after Labor Day,' " said Leonard Bocour, who began making and selling paint to artists in 1932. The destination of choice for many artists fleeing the urban heat was the tiny, New England–style village of Woodstock, New York. Woodstock, which became an artist's colony well before the turn of the century, was ninety miles northwest of Manhattan and about a three-hour drive over the slow roads of the day. Set in rolling, densely wooded country, it was pretty—and, no less important to artists, affordable. The main street was lined with Victorian houses and small wooden buildings built in the 1880s. Cottages and studios dotted the countryside. De Kooning had gone there on a short visit in 1928 or 1929 to see a Dutch architect—most likely a friend of de Kooning's Eastman Brothers friend Anton Refregier.

In 1930, not long after he took his new job at A. S. Beck, the summer slowdown began. De Kooning wanted to spend more time at Woodstock and discussed the idea with Tully Filmus and Refregier, who also had time on their hands. The three decided to rent a house together and traveled to Woodstock to see what was available. "It was pouring the day we went to look at the houses," said Diaz. "All I heard coming from Bill was all this cursing in Dutch." They finally settled upon the so-called Smith House. For $200, they could have it for the entire season. In late May or early June, de Kooning and Diaz left for Woodstock with Refregier, Filmus, and Tully's wife, Joan. Located on the side of a small hill, the Smith House

turned out to be ideal—roomy and comfortable with a front porch that looked out over a nearby brook. Beyond the brook was a dip in the land that hid the road from view. Hills rose in the distance. The house was an easy walk from the center of Woodstock, but was separated from town by a little bridge. It seemed cozy and rural, as if it were in the middle of the country. Jonas visited. "And Bart van der Schelling [who rented a nearby cottage] was the cook and I took care of the house," said Nini. "We had the front room. And we had a ball."

If any one place was the center of the American realist school in the early 1930s, it was probably Woodstock, which particularly attracted landscape painters. Chief among its artists was Yasuo Kuniyoshi, a Japanese-born painter who had emigrated to America in 1906 at the age of thirteen. His strangely angled, almost naive-looking landscapes and figure paintings had won him a following by the early 1930s. Along with such realist painters as Eugene Speicher and Emil Ganso, Kuniyoshi presided over the Woodstock scene like a gentle Eastern presence. They were, in Bocour's words, "the big giants." The most discussed event of the Woodstock summer was the regular poker game the artists played.

The usual practice in Woodstock was to paint during the day and spend the evening with friends. But there were daytime get-togethers as well. Once, during one of their Woodstock summers, said Diaz—de Kooning spent part of at least three summers in Woodstock—there was a nudist party at a lake near their house. The men tied ribbons around their penises and pranced around. Nini was the first to strip and dive in, and the rest followed. De Kooning did not, however, since he could not swim. In the evening, the principal gathering place was the Nook, an outdoor restaurant and bar near the center of town. On the patio of the restaurant, a few steps down from the road, the art crowd would talk, eat, and drink, although during Prohibition the only legal drink was watered-down "three percent" beer. The life seemed both bohemian and sweet as artists whiled away the time in the lingering dusks of summer.

Like most Woodstock artists, Refregier and Filmus were fairly traditional painters. As immigrants, however, they were not comfortable with American scene painting. Filmus painted portraits along with remembered landscapes of Jewish life in Russia. Refregier was active politically and interested in art that conveyed a social message. (He would become a leading figure in the social realist movement of the 1930s, which maintained that art should further the class struggle and reveal the truth about the oppression of the masses.) For de Kooning, the realism of most Woodstock painters must have looked old-fashioned. But he was not a misfit there, and he was by nature tolerant of different styles. And who was he to

venture criticism? He himself had not yet found a satisfactory way of making art, and he destroyed most of his work from the early 1930s. To his friends in Woodstock, he was just another talented dauber half-dreaming of becoming an artist and experimenting with various approaches. In an unusually cheerful still life from around 1929 or 1930, he placed egg shapes on what appears to be a henhouse. The countryside, throughout his life, would help restore de Kooning's spirits.

One experiment in Woodstock represented a significant departure, however, from the still lifes and occasional abstractions that usually absorbed him. He began to try to piece together the figure of a man. De Kooning had had some, though not much, anatomical drawing at the acad-

Still-life, c. 1929, oil on canvas, 32 ⅛" × 24"

emy. Now he seemed to be trying to rebuild the figure from the ground up, as if he had learned nothing, without relying upon academic rules or techniques. He labored over how to depict hands, shoulders, and fabric convincingly, in what would prove to be early studies for the 1932 *Death of a Man*, his first significant picture (later destroyed) to include the male figure. None of the parts seemed to come together. He could not form a complete man. Perhaps that was a way of telling the truth, for he himself was neither a complete painter nor a complete American. He would struggle for days, Filmus said, just trying to paint the creases in the fabric of the clothes. He would sit in a corner bunching and rebunching a pair of trousers and studying the effect. "He worked on a large canvas, working on it and working on it," said Filmus, a pattern that whatever the subject or canvas at hand would recur again and again in de Kooning's life.

After the months away, de Kooning returned to New York from Woodstock in an increasingly restless mood. Nini was pregnant, and he wondered whether or not to marry her. The couple discussed the idea. "But I'd seen too much poverty," Nini said. "I didn't want to." Few people in their

milieu wanted to get married; fewer still desired children. She also considered de Kooning too much of a loner—and too interested in other women—to make a promising husband. That fall, Diaz had the first of three abortions that she would undergo during her years with de Kooning. Everyone in New York knew where to get an abortion, Diaz said, although the practice was illegal. She had few regrets about ending her pregnancies. "There was this wonderful Jewish doctor we went to. He was a marvelous man. My sister always went with me. Somehow we always got the money to do it." De Kooning seems to have regretted the abortions more than Nini did, but not enough to stop her. He had a special fondness for children, but feared the constraints they would place upon his life.

That fall, de Kooning and Diaz began moving among apartments, as de Kooning impatiently sought an environment where he would feel comfortable. Their first stop after they left their rundown place on West Forty-sixth Street was at 348 East Fifty-fifth Street, a fairly conventional apartment. It was located in a neighborhood near the Fifty-ninth Street Bridge that attracted people in arts and film, including Tully Filmus. At one point, Nini's mother also lived with the couple, an arrangement that de Kooning, who already craved privacy for his painting, must have barely tolerated. Immediately, de Kooning set about transforming the place. He made his own furniture, which was plain, geometrical, and without fuss. (He would do the same in future studios.) He built furniture into the walls in the Dutch manner, a telling symbol of stability in a life of flux.

By the latter part of 1932, however, de Kooning found life in the apartment on East Fifty-fifth Street suffocating. He already disliked working at a regular job, and it made matters worse to live in a middle-class way. Diaz said he found the apartment too conventional and the neighborhood too bourgeois. (If de Kooning would never be a political radical, he was also not prepared to become part of the conservative middle class.) Sometime that fall or early winter, he and Nini left the area. They ripped out de Kooning's built-in furniture, infuriating their landlady, and began edging their way downtown. Their first stop was an apartment on West Forty-fourth Street. But they were robbed there, and soon made plans to leave when de Kooning heard about a place that needed to be renovated in Greenwich Village. "We got it for free because Bill was rebuilding the top floor," said Diaz. "It had a nice bathroom and a little kitchenette and one big room."

The new apartment was on the southwest corner of Fifth Avenue and Eighth Street, only steps from Washington Square Park. Located in a striking old mansion known as the Marble House, it was a single, comfortably large, and open space on the fourth and top floor. It resembled Hague's loft

more than a traditional apartment, and it thrilled de Kooning. Here at last was an open space where he could both live and work. For the rest of his life, the "studio" where he painted would remain his essential home—the center of both his nights and his days. De Kooning kept the space in the Marble House spare. One friend called it "the tidiest, neatest place I've ever seen." It had white walls and a frame bed covered with a gray army blanket. The floors were painted gray enamel, and there was no mess and splatter from his easel. The only decoration was a few green plants.

The new loft brought de Kooning closer to the bohemian Village, where he already spent much of his time. He was becoming especially interested in jazz, which embodied the freedom, lusty life, and expansive spirit of America. It was an outsider's music emblematic of the modern city. Like his fellow Dutch émigré, the austere Mondrian, who was also drawn to jazz during his years in America, de Kooning relished its high-voltage energy and unconventional syncopation. De Kooning was an artist who understood the tension between control and release and loved the sail-away fantasy of individual solos. He appreciated the blue melancholy, too. It was in those years after he moved to the Village that de Kooning developed his lasting fondness for the jazz of Louis Armstrong, Bix Beiderbecke, Fats Waller, and Count Basie.

With friends such as Jonas, de Kooning would often go to George's on Bedford Street in the Village, a tiny diner-restaurant that also had a room in back where customers could listen to trios and combos over a nickel glass of beer. Saturday nights were especially lively. According to the artist Milton Resnick, "On Saturday night you'd get some singer who was being tried out. That [practice] started there because all these artists knew what was good." On the rare occasion when someone was flush with money, a group might go to the downtown Café Society, where Billie Holiday and other jazz greats performed. At Café Society, which attracted a wealthier crowd, a beer at the bar cost fifty cents. Sometimes, a group of friends would take the subway to Harlem to hear the latest work. De Kooning was fascinated by the life there, according to the artist David Margolis, who would sometimes take him to the famous Savoy Ballroom to see the dancing.

If de Kooning in the early thirties celebrated music of great vigor and pizzazz, his own art was by contrast deathly mournful and wan. He experimented with both figurative and abstract ways of working, as he would throughout his life, and looked carefully at many different artists, in particular de Chirico and Miró. But he was also obviously affected, like many of his contemporaries, by the despair of the Depression. The pall over the larger culture was palpable. Five million Americans were out of work in

1930; the number doubled to ten million by 1931; in 1932 it reached fifteen million. Homeless migrants were everywhere. Bread lines, with long, shuffling strings of men in gray clothes, were ubiquitous. So were the pathetic apple peddlers on most corners—six thousand in New York City alone. In Manhattan, rows of shabby tin shacks stretched from Lexington Avenue on the east all the way to the East River and from Sixth Avenue on the west to the Hudson. The city's parks, ordinarily oases in the urban landscape, became the refuge of the dispossessed. The America that de Kooning jumped ship to find was vanishing in front of him.

And yet, even taking the Depression into account, de Kooning's art of the time was remarkably ashen. His egg shapes often look as bleak as unformed, featureless heads, and his figures appear drained of life. The destroyed picture from 1932, *Death of a Man*, depicted a kneeling, de Chirico–like figure dressed in heavy robes cradling a dead man's head. De Kooning later told the art historian Sally Yard, who did much original research on de Kooning's early work, that he wanted the picture to be "like a burial." Yard likened the mourning figure to a "guardian angel," a kind of guide to the next world. Or perhaps he was also a guide to the New World—a guardian angel in America. For what did an immigrant bury? Who did an immigrant mourn? Why would de Kooning paint a picture "like a burial"? Both figures in *Death of a Man* resemble the young de Kooning himself, suggesting that de Kooning was still mourning his past in Holland. Perhaps, in particular, he missed a father now essentially dead to him. He may also have been in mourning for himself, burying not just the boy left in Holland but the artist inside the man. De Kooning feared killing the artist within when he went to work making shoe displays; he could not be certain in the early thirties whether that artist was dead or alive, or whether his future in America was one of implicit promise or sad finality. Some of his friends noticed a certain delicacy about de Kooning during this period, a gentleness unlike the extravagance of the music he loved or the energy with which he would later be associated.

The dancer Marie Marchowsky, for example, sensed an abiding melancholy in de Kooning. She first met him in the fall of 1933 on a street corner near his apartment in the Marble House. She was sixteen years old and was accompanied by her friend Bea Reiner, whom Nini and de Kooning had befriended in Woodstock during the summer of 1932, on a visit there. (An aspiring actress, Reiner was babysitting in Woodstock in a house across from the Nook and, finding the scene tantalizing, often shared a drink with the light-haired Dutchman and the dark woman whom she took to be his Italian wife.) Marie was commuting into Manhattan from high school in the Bronx so she could study dance with

Martha Graham. There was a long period between when her school let out and the Graham class began. "Why don't you come and do your homework at my house?" de Kooning suggested. From the hours she whiled away at his place, Marchowsky remembered a painter "who was very gentle and very sweet. He had a very good sense of humor. His accent was there like now, but sometimes he would tell jokes. He was not an alcoholic. I later thought that his fame made him one."

Marchowsky also noted de Kooning's hunger for music. The music that he restlessly sought in jazz clubs and played incessantly at home gave vitality to his days and filled the empty

Detail from Death of a Man, *from the Depression years (now destroyed), c. 1932*

spaces of his art. Jazz accompanied his painting of "the burial," surrounding death with the rhythms of life—like a jazz funeral in New Orleans. Diaz also said de Kooning's days at the Marble House were full of sound. He liked classical music as well as jazz. In keeping with his modernist bent, he was particularly interested in Stravinsky during the period when he was thinking about "the burial." Among his favorite pieces was the thunderous *Symphony of Psalms*. He loved the scale of such music, the sensation of a great theme found and possessed. ("They had a wonderful subject," de Kooning once told Marie Marchowsky with a measure of envy about the *Symphony of Psalms* and other religious music—"God and all those angels up there.") But his favorite classical piece was *The Rite of Spring*, and he played it repeatedly. De Kooning, who could whistle and hum remarkably well, would even whistle Stravinsky to great effect. He probably found the *Rite of Spring*'s fiery celebration of modernity, especially its evocation of the difficulty of escaping the dying world and giving birth to the new, relevant to his own situation. He was having trouble giving birth to an art of his own that he could respect, and he was struggling to resurrect his life in the New World. Although de Kooning still regarded himself as a commercial artist rather than as a painter, Robert Jonas, who

saw him every day at A. S. Beck, shrewdly guessed that his friend was constantly, agonizingly, mulling the question of what direction his life should take. He was, speculated Jonas, "afraid of the vacuum of empty days. He'd have to face the problem, whether to make out in America or to devote himself to painting." Jonas recalled the almost painful gesture that de Kooning would regularly make about wanting to paint. "He'd say, he feels it down here, holding his stomach, meaning he had to paint."

In the early thirties, during the time when he was designing shoe displays, de Kooning made one astonishing, and symbolic, purchase. Just when the Depression was destroying the livelihood of millions of people, including that of many artists, de Kooning bought the best and most expensive record player money could buy—a miraculous machine that could summon "God and all those angels up there." Called a Capehart high-fidelity system, it was one of the first to change records automatically. It cost the then prodigious sum of $700, more than half de Kooning's annual salary at A. S. Beck; he got an advance to pay for it. With this purchase, de Kooning announced that he would not use the money he earned from his job to make himself conventionally respectable, even during the hard, early years of the Depression. He did not buy a house or a car, get married, have a baby, or stash away money against hard times. Instead, he professed himself sublimely irresponsible, a man nourished by music rather than the mundane realities. And yet, it was still *music* rather than art that prompted this expansive gesture, for he could not yet find a comparable fluency, vitality, or extravagance in art.

America was renowned for its unrepentant modernity: its machines, its jazz, its movie culture. With this purchase, de Kooning bought a vision of America and, ultimately, of himself. He'd made it in America. He'd achieved his purpose in emigrating. He could be certain no one he knew in Rotterdam owned such a marvel and that his Dutch family and friends would be astounded by it. But the music machine was also an avowal, a declaration that he was not a nine-to-five American. In a life in which it was a day-to-day struggle to get by, the player represented an homage to what's exceptional in the world, like a jazz solo that celebrated style and brilliant excess.

8. Three Brothers

The atmosphere was so beautiful that I got a little dizzy and when I came to,
I was bright enough to take the hint immediately.
—**De Kooning**, describing his first visit to Arshile Gorky's studio

I n the 1930s, de Kooning knew how to be modern. And he knew how to be a painter. But he did not know how to be a modern painter. Little in his early life gave him the confidence to put the pieces together. His mother was a fierce critic of everything he did. He was not university educated or fancy in the way of many European artists. His main success as a young man had come at the academy, where he was good at being an artist who was not modern, and in commercial art, where he was good at being modern but was not an artist. And now he was a Dutchman in America. How could a Dutchman possibly become a modern American artist, even if there *was* such a thing as a modern American artist?

If de Kooning were to become a committed painter rather than a commercial designer, he required not just mentors but also models of success in America, whose life and work spoke directly to de Kooning's own experience as an outsider. He had to see that an artist could invent himself, boldly and extravagantly, in the New World. Fortunately for de Kooning, he found not just one but three such self-made artists in those pivotal years. "I was lucky enough when I came to this country," de Kooning said, "to meet the three smartest guys on the scene: Gorky, Stuart Davis, and John Graham. They knew I had my own eyes, but I wasn't always looking in the right direction. I was certainly in need of a helping hand at times." De Kooning affectionately called the group "The Three Musketeers" and thought of them in roughly similar terms. They were essentially older brothers, figures of authority who could help give him direction and demonstrate that, yes, it was possible to be a modern painter in America.

Each was a larger-than-life artist of irreducible individuality. Each seemed partly made up, a figure of inspiring theatricality, wrapped in a forceful pose that challenged something bland, backward-looking, and provincial in American life. Of the three, Davis was the most removed from de Kooning because he was not an immigrant. He could not therefore provide the same personal model that the other two could. But Davis was actually a successful American modernist; and de Kooning, who never

became part of the Stieglitz circle, knew few such artists in the early thirties. In any case, the American painters around Stieglitz, such as Georgia O'Keeffe, Marsden Hartley, and Arthur Dove, took a visionary view of the American landscape that a visiting Dutchman could not easily assume.

Born in Philadelphia, Davis moved to New York in 1910 at the age of sixteen to study with Robert Henri, a leading realist painter. As a mature artist, however, Davis developed an increasingly modernist style. The first such change came after he saw the work of Gauguin and van Gogh at the Armory Show in 1913. He adapted their bold, expressive use of color to his own landscapes. In time, he began to study the early cubist works of Picasso and Braque, executing painted versions of their collages in the early 1920s. Davis looked to cubism when few Americans did, and he even visited Paris in 1928 and 1929. Early in the next decade, when de Kooning came to know him, he was transforming the later synthetic cubism of Picasso, Braque, and Gris into a distinctively American brand built around slangy pop symbols, such as a pack of Lucky Strikes. Davis loved jazz. He was interested in the urban pulse. De Kooning cherished his tough-guy way of talking and the gangster-like stance he affected; Davis, de Kooning said, would bark things like "Keep it scarce" out of the side of his mouth, which simply meant to keep something to oneself. It helped de Kooning to find an American who did not view European art defensively. Without apology, Davis could steep himself in Europe—the better to become American.

It was John Graham, however, who first impressed de Kooning with the possibility of being a modern artist in America. In April 1929, on a routine weekend visit to the art galleries, de Kooning happened upon the opening of a show of Graham's paintings at the Valentine Dudensing Gallery. Once there, de Kooning said, he saw a man of such polish and authority that he took him to be the art dealer rather than the artist. The man was "giving some women a hard time," de Kooning remembered. He had "a fantastic cynical attitude toward snooty ladies." The autocratic Graham was probably doing what he habitually did, which was command a crowd. Like de Kooning, Graham was an immigrant, but one who did not seem to have a doubt in the world. His life seemed too good to be true, and it was. His real name was Ivan Dabrowsky. Born in Kiev, the offspring of minor nobility on both his father's and his mother's side, Graham had grown up in a huge stone mansion surrounding a cobbled courtyard. He had studied law at the University of Kiev and attended a cavalry school. When Russia entered World War I, Graham, by his own account, joined the Czar's Guards and fought with such distinction that he earned a medal, the St. George's Cross. He also married, the first of five marriages.

(His first wife was later the surveyor of iconographic art for all of the Soviet Union.) During the revolution, Graham claimed to have fought as a counterrevolutionary and to have been briefly imprisoned before escaping to Warsaw. He subsequently rejoined the counterrevolutionaries during the Crimean uprising, he said, and when that revolution also collapsed, came to America. This was probably one of Graham's innumerable fabrications; or at least one of his highly colored memories. It is more likely that, in 1920, he simply fled west to Warsaw and then to America, leaving one wife behind and taking a second along with him.

Graham's projected "self," whether or not it was made up, was one of high romantic superiority and absolute commitment to modern art—qualities in short supply among American painters. Many artists appreciated the flamboyance of the fictions in which he enveloped himself, which had their own measure of truth. By virtue of both his erudition and his imperious manner, Graham elevated every occasion he attended. According to Ludwig Sander, "You always knew immediately when you walked into a room with Graham in it that he was the superior being in the room." Tall, with piercing eyes, strong Slavic bones, and a shaved head, Graham had the aspect of "an exotic Eastern priest," as the Graham scholar Hayden Herrera described him. He also had the ramrod-straight bearing of a cavalry officer and the well-developed physique of a wrestler that, as a narcissist of the first order, he was rarely reluctant to exhibit. He would doff his clothes at the slightest excuse. Few dared to challenge or even question Graham's grandiloquent pronouncements and embellishments of his past and present. He enjoyed suggesting, as if he were only half joking, that he was the son of Jupiter and a mortal woman. As he himself said, "I ask nothing of man, except an implicit obedience. When men criticize my work and attack me, I know how to answer in a most devastating way."

In the grim Depression years John Graham was a marvelous, otherworldly apparition. His bright singularity amid the collective gloom helped raise spirits. And his aristocratic airs, which included the wearing of exquisitely tailored Savile Row suits, were much too eccentric ever to threaten a man like de Kooning, who disliked ordinarily pretentious people. Graham was not the consort of "snooty ladies." Indeed, he took away the sting of class by turning his social affectations into a kind of playful, imperious art. (His greatest work of art was surely himself.) More important, he left the impression that *artists* were the true aristocrats. Graham, while a snob, finally admired only genius and could enjoy the company of artists whether or not they happened to dress well. He had become a serious student of art only in 1920, when he enrolled at the Art Students

League and studied with the American artist John Sloan, one of the prominent members of the Ash Can school. But he traveled back and forth to Paris frequently throughout the 1920s, where he kept up with the latest developments in art. Like Davis, he provided an invaluable link to France for his American friends. David Smith later said, "His annual trips to Paris kept us all apprised of abstract events, along with *Cahiers d'Art* and *Transition* [the two leading European art magazines of the time]." Graham would bring back copies of the two magazines, which covered the evolution of cubism and surrealism, to be pored over by his circle in New York.

There was no question where Graham's artistic sympathies lay. He was provocatively and absolutely confident that the modern road passed through Paris, and, in particular, the Paris of Pablo Picasso. Graham asserted that Picasso was the dominant master of the twentieth century. He also stressed the importance of surrealism, another fundamentally modern style that reflected new understandings about the unconscious and the workings of the mind. Graham admired Freud and Jung, and emphasized the liberating role that the unconscious played in the creation of art. (He was one of the first artists in America to advocate "automatic writing," a surrealist technique in which the artist found inspiration, and authority, in his own instincts rather than in tradition or society.) Graham's emphasis on the unconscious helped lay the groundwork for the later, highly expressive styles of both de Kooning and Jackson Pollock.

Unlike any other American artist at the time, Graham himself had won a measure of recognition in the Olympus that was Paris. His first one-man shows had taken place in Paris in 1928 and 1929, at the Galerie Zborowski. In 1929, Graham also had his first one-man shows in America, at the Valentine Dudensing Gallery in New York and the Phillips Collection in Washington, D.C. When few American artists even dreamed of having a gallery, Graham was represented on two continents. It hardly mattered that he was not a great painter or that his own work was heavily influenced by de Chirico and Picasso, among other contemporary European sources. His conversation, confidence, and example helped stimulate American artists, provoking them to be ambitious rather than provincial in outlook. Graham was such a mesmerizing speaker that Eleanor Ward—who later founded the well-known Stable Gallery—said he could "make you believe you saw angels." In conversation, Graham was that great rarity, a theorist about art in general and modernity in particular who was not also a bore. De Kooning had an abiding fondness for such people, so long as their ideas did not harden into dogma.

But the essential "brother" for de Kooning was Arshile Gorky. "If the bookkeepers think it necessary continuously to make sure of where

things and people come from, well, then, I come from 36 Union Square," wrote de Kooning, referring to Gorky's studio. It was Gorky who provided the critical model and the moral outlook that helped de Kooning decide how he would live his life. Art is a matter of character, not just style. De Kooning was trying to locate a way of being, to find the courage and conviction to become a modern painter in America. "I met a lot of artists—but then I met Gorky."

Their first meeting was inauspicious. In the casual way that artists had of dropping in unannounced at one another's studios, de Kooning went one evening in 1929 to visit Misha Reznikoff, a Russian artist whom he knew from Eastman Brothers. When he walked into Reznikoff's studio on Sixth Avenue, Gorky was already there. According to de Kooning, "He seemed to know his business, but there was something in his manner. We were almost in a fist fight." The circumstances of the quarrel are not known, but it is likely that Gorky began (as was his custom) to lecture the short Dutchman about art. The Dutchman was, after all, just a commercial artist. De Kooning—conscious of his training at the academy—would naturally bristle at any condescension. "[Gorky] always had the last word," de Kooning said. "He had melancholy. A terrific guy, terrific personality. But difficult. Oh, he was Armenian. Armenian."

There are two versions of precisely when this first meeting between Gorky and de Kooning took place, both of them suggested by de Kooning himself. In one, he was introduced to Gorky the same year he met John Graham, which was 1929. In the second, he moved the date ahead a year or two, to 1930 or 1931. Both versions are probably accurate in their way. De Kooning most likely did meet Gorky in 1929, but did not pursue the relationship because of the initial disagreement. If their first meeting was combative, the second was for de Kooning revelatory. He was walking near 36 Union Square when Gorky approached. Somewhat hesitantly, given their initial confrontation, de Kooning asked if he might visit Gorky sometime at his studio. "Why not now?" said Gorky. When de Kooning walked into the studio, he was overwhelmed and made "dizzy" by the atmosphere. "He had this extraordinary, extra-sensory perception," de Kooning later told Gorky's nephew, Karlen Mooradian, "this gift." De Kooning's epiphany in the studio was almost religious in character, as if he had finally reached the end of a pilgrimage. Here, he found the true metaphysics of art, where its principles were understood and its sacraments faithfully practiced. Certainly, Gorky, an Armenian who came from a land of religious passion and revered ritual, treated his studio as a

Gorky and de Kooning in Gorky's studio, 36 Union Square, around 1935

kind of sacred space. To begin with, it was quite unusual at that time to have a place outside one's apartment consecrated to nothing but the making of art. Stuart Davis said:

> he was the only artist I can recall who always had a real studio. Most, including myself, painted in their bedrooms or temporary makeshift quarters. In addition, he managed to keep these studios stocked with a supply of art materials worthy of a small retail store, and used them up with abandon and unconcern for cost in accord with his temperament. . . . In brief, he galloped around the Village like a mountain goat with his pauper peers and got off better than most.

Ethel Schwabacher, a student and friend of Gorky's, described the studio this way:

> [He scrubbed] the floor weekly so that it finally had the bleached tone of driftwood; the large palette on the table, under the frosted slanting window, was left in just the state of lowlustered sheen he liked best.

There was nothing haphazard about the piles of left-over or unused paint; there was no bit of material that he was indifferent to; the brushes, of which he had great quantities, bristle, camel's hair, of various sizes, round, flat, worn or new, were washed with soap and water after work; there were bottles of ink, pens, quill pens, crayons in profusion; a Greek head and hand, a porcelain fruit dish, a vase or so, stood or lay about; also a few art books, an old small phonograph and a half-dozen records of Russian songs. And on the wall, where he would certainly have liked to hang the paintings of his choice, were the nearest substitute he could afford—lifesize photographs of the works of Uccello and Ingres.

The great excitement of 36 Union Square lay in the feeling it evoked of work done there, work in progress, day and night, through long years of passionate, disciplined and dedicated effort.

De Kooning said that when he "came to" in the studio he was "bright enough to take the hint immediately." The hint was that a serious artist did not kid around. A serious artist made art the center of his life, treated it as a calling and sacrificed everything else to it. If he didn't, he was just an amateur. (Gorky, de Kooning knew, would not have lavished scarce resources upon a fancy record player.) The impact of Gorky's studio in 1932 lay in its atmosphere of absolute conviction. Having worked with the craftsmen at Gidding, de Kooning immediately recognized the reverence with which Gorky laid out his tools. "He went out of his mind with all those different types of brushes," said de Kooning. "I finally found brushes in his studio I didn't even know about." Gorky could deny art nothing; the tactile presence of the paint intoxicated him. "He used more paint than anyone. He outdid everybody." Many other painters and sculptors who came of age in the 1930s and '40s also attested to Gorky's inspirational effect. Max Schnitzler, an American painter and early friend of Gorky's and de Kooning's, called him the "driving force in those depression years" among painters. "He had that fire, that burning."

Using the same phrase as Schwabacher to emphasize the painter's dedication, de Kooning said, "He worked day and night, day and night." Gorky kept more than one hundred pictures stored in a separate room off the foyer and within easy reach so that he could rework an idea or see how he had earlier solved a problem. During their first meeting in the studio, de Kooning walked over to examine the current picture on Gorky's easel. It was a copy of a small painting by the Italian Renaissance artist Giovanni di Paolo at the Metropolitan Museum of Art. It depicted a man holding a hoop through which a bird flies. Gorky had been endlessly working

and reworking the image. De Kooning said that he, too, knew the painting, and he began to discuss it in detail. Gorky was surprised that de Kooning recognized the small, relatively obscure picture: perhaps the Dutchman was worth talking to.

Gorky was not much older than de Kooning. But he was a much older American, having arrived in the United States in 1920. Moreover, the harsh struggles and terrible suffering of his early life in Armenia gave him an ancient, fated air that he was not afraid to cultivate; he sometimes seemed to play the part of an Old Testament figure who happened to be in New York. Like Graham, Gorky not only invented a melodramatic persona, but his name as well. His real name was Vosdanik Adoian. He grew up near the shores of Lake Van in Armenia. Located between the vast Russian empire to the north and the Ottoman Empire to the west, Armenia had long been carved up between the two powers. In 1914, when Gorky was ten, the Turks entered World War I on the side of Germany and laid siege to the Armenians within their borders, claiming that they were traitors to the state. The Muslim Ottoman Empire had always been hostile to its Christian Armenian minority. This time, arguing that the Armenians would join with the Christian forces of Russia, the Turks attacked and shelled the Armenian cities and deported or massacred survivors. The persecution was so fierce that Henry Morganthau, the U.S. ambassador to the Ottoman Empire, wrote, ". . . the whole history of the human race contains no such horrible episode as this."

By 1915, the fighting had produced forced marches and near starvation throughout Armenia. Gorky's mother, Shushanik (or Shushan), died in his arms of starvation in 1919; she was only thirty-nine. Her death had a devastating effect upon both Gorky and his younger sister, Vartoosh. Not only were they now alone, they had also lost the person in the world dearest to them. Faced with fighting all around and no immediate family nearby, they decided to set out for America to join the rest of their family, who had already fled. Their father had emigrated in 1908 rather than be drafted into the Turkish army; their two older sisters had left in 1916 as the siege worsened. After traveling with a family friend to Tiflis, in Russian Georgia, the two children made their way first to Batum on the Black Sea and from there to Constantinople, where they set sail by way of Greece for America. After three days at Ellis Island, they headed to Watertown, Massachusetts, to live with their sister Akabi. Gorky had just turned sixteen. He would soon assume the name Arshile Gorky—Arshile was a form of the Armenian royal name "Arshak," and Gorky meant "bitterness" or "the bitter one" in Russian. The young Gorky then went to live with his father, whom he had not seen for twelve years, in Provi-

dence, Rhode Island. At the time de Kooning met him, Gorky had already been in the city for about five years—and on his own for nine. He was teaching at the Grand Central School of Art in Manhattan.

After their discussion in the studio, de Kooning often visited Gorky. "You find a fellow who's really good and you have a sense for it," he said. "It's hard to explain. It isn't technique, it's like a concert, just getting the right ideas." The two artists soon became close friends. By late 1932 or possibly early 1933, they seemed inseparable. "There was no doubt he was the boss," de Kooning told Karlen Mooradian. "It was his personality and I had to put up with it. He was the general. Like we would be walking and all of a sudden he would cross the street. So I would tell him, 'I wish you wouldn't do that Arshile, because you do that the right way and skip the car—but I run into it.' He always apologized, was very polite that way. He was kind of egocentric." When they walked down the street, the two artists made a slightly comical, Mutt and Jeff–like pair. On one side, a very tall and swarthy Armenian with a flamboyant air, drooping mustache, and long stride, and tagging along beside him, a sidekick, a short, fair Dutchman who looked like a sailor and appeared exceedingly modest and quiet. Perhaps some mutual friends perceived just how subtle their friendship was, and how marvelously deceptive the personality of each artist could actually be. The brash and overbearing Gorky would one day become the most tender, sensitive, and lyrical of artists; and his retiring companion would turn out to be, among other things, a master of the extravagant gesture and the ferocious assertion. In 1932, you might have guessed that Gorky would become de Kooning, and de Kooning Gorky.

All his life, except for a brief period in the forties when they saw less of each other, de Kooning talked about Gorky with deep affection and respect, saying, "I kind of gave in to him." This response was singular: de Kooning yielded to no other person during his life. Gorky was the only figure to whom he willingly "gave in," the only one who seemed indispensable to his evolution as an artist. Gorky was the essential alchemist in de Kooning's early life, the brother who possessed the secrets that lay beyond the academy doors:

> I had some training in Holland, quite a training, you know, the Academy. Gorky didn't have that at all. He came from no place. He came here when he was sixteen, from Tiflis in Georgia, with an Armenian upbringing. And for some mysterious reason, he knew lots more about painting, and art—he just knew it by nature—things I was supposed to know and feel and understand—he really did it better. He had an extraordinary gift for hitting the nail on the head.

Gorky helped teach de Kooning to be an artist, in both his approach to the world and his treatment of art history. De Kooning respected his deep, Old World melancholy, and his devil-may-care swagger and insouciance. The name Arshile Gorky was apt: Gorky *was* both royal and bitter. Isamu Noguchi said that Gorky "created this character Gorky. And he had the physique and the posture to carry it out and get away with it. Excepting that he was always, in a sense, playing a part, a role." But de Kooning admired Gorky's role-playing, sensing that, as with Graham, it enabled Gorky to become an authentic artist.

Like Graham, Gorky was autocratic—at least when it came to art. "If he looked at something and it was a lousy piece of art, he'd say it's lousy," said the sculptor Reuben Nakian, a first-generation American born of Armenian parents, and a close friend of Gorky's. "He spoke his mind because art was so corny and he was more advanced." In a group, Gorky was always "trying to think of a contrary aphorism," said the painter Joseph Solman. On one occasion, Solman said:

> About eight artists were sitting around in the Jumble Shop. Gorky was talking about Uccello. He was also a great fan of Ingres; he'd look at the biomorphic shapes in any Ingres painting. Anyway, he was talking about Uccello and I mentioned Piero della Francesca. Now I'm sure Gorky liked him just as much as I did. But simply because I mentioned him and I was younger and like an upstart Gorky said, "Piero della Francesca. He's an academician." I'm sure he said it for effect, just to put me in my place. He had a very dramatic manner.

Gorky, when de Kooning first knew him, had not yet found his mature style. He was still, in effect, putting himself through school at the Metropolitan Museum and the galleries. George McNeil, an artist who began to paint abstractly as early as the 1930s, remembered seeing Gorky at the Metropolitan regularly in 1929 and 1930, making drawings from sculpture. "We both worked in the rooms with the Greek casts," said McNeil. "Gorky was only eight years older than I was, but he impressed me as being a very much older man, and a very sure man. And a very dramatic figure. He dressed in a very long overcoat at that time, and he had a beard. He was wild-looking. He caused a furor in the Museum to a certain extent."

In the early 1930s, Gorky became a devoted disciple of Picasso. In his still lifes of the time, he copied Picasso's work in order to understand the master's art not just from outside but from within. Gorky's approach to Picasso had a great impact upon de Kooning. The decision to paint Picas-

sos, to make Picasso part of his studio, gave life to Graham's more abstract formulations about the painter, conveying a feeling of closeness, almost intimacy, to modern art. Gorky's rejection of originality as a goal—in this respect he resembled his cultural ancestors, the Byzantine icon painters—also deeply affected de Kooning. "Aha, so you have ideas of your own," Gorky told de Kooning when he first looked at his work. "Somehow," said de Kooning, "that didn't seem so good." Gorky was too ambitious to settle for small personal novelties. At once proud and humble, he would only work in the precincts of genius.

T. S. Eliot famously wrote, "Immature poets imitate; mature poets steal." Gorky hoped one day to steal. His intimate approach to tradition was a revelation to de Kooning. It helped him close—perhaps "heal" is the better word—a breach in his sensibility, leading him to reconcile his love for the past with his passion for the present. According to Harold Rosenberg, Gorky's challenging remark about "having your own ideas" transformed de Kooning's "entire attitude toward painting."

> If you had your own idea, that was it, you were stuck with it. The history of painting, however, contained endless inventions which the living painter could make his own. Even inventing a thing that had already been invented was an act of creation. De Kooning likes to call this "inventing the harpsichord"—the fact that we have the harpsichord, and even the piano that superseded it, does not prevent the invention that brought it into being from being legitimately repeated.

Throughout his life, de Kooning would celebrate a glorious and fecund "impurity" of outlook instead of something more restricting or "officially" modern. He would talk about even the oldest art as if it were made yesterday. From the academy in Rotterdam, de Kooning had gained an impression of the history of art as forbidding, an imposing edifice to which one might aspire after many years of humble apprenticeship. At the same time, he was taught that to be modern meant to reject the past. Gorky did not share these views. Art belonged not to history, Gorky thought, but to the present. What de Kooning found liberating was that Gorky treated past art as if it were *alive* and speaking to modern artists as if it were "news that stays news," in Ezra Pound's famous formulation. Gorky understood that the challenge for Americans—especially immigrants shorn of their countries—was to acquire the authority of a great tradition and not retreat into provincial ideas like nationalism and social justice or succumb to mere novelty. How was this tradition to be gained? Only, as Eliot suggested, with great labor.

Together, Gorky and de Kooning almost daily looked at and discussed art. After finishing at A. S. Beck for the day, de Kooning would drop by 36 Union Square to watch Gorky paint and continue their ongoing discussion of Picasso, Uccello, Ingres, and others. Often they would go to the restaurant Romany Marie's in the evening. On weekends, Gorky and de Kooning would ride uptown on the Third Avenue El, the elevated train that ran along Third Avenue, to see the latest shows of European work in the galleries along Fifty-seventh Street or to visit the Metropolitan Museum. The conversation between Gorky and de Kooning was mainly shoptalk, a discussion of the hows and whys of the visual—why Ingres placed a line there rather than here, what the Virgin's blue did in a picture, why Picasso flattened the space on one part of the canvas but not another. They were not afraid to criticize the greatest artists; even the best had weak moments. Analyzing the masters in this fashion fired both artists' imagination and ambition as they struggled to find their own voices; the painters of the past became colleagues and "contemporaries," which allowed them to think of joining their august circle without being awed into silence or timidity. (De Kooning later said that his goal as an artist was to create works that had a presence equal to that of the old-master paintings that he had seen in Holland—and at the Met and the Frick Collection, which he and Gorky visited after it opened in December 1935.) The artist Ludwig Sander said that Gorky would bump into someone on the street and immediately begin discussing his latest discovery: "He would pull out a couple of postcards of something he had just seen at a museum, and he would start telling you all kinds of things about how it related to Renaissance art." When particularly inspired—or if there were any attractive women around he might impress—Gorky gesticulated dramatically and spoke in an embarrassingly loud voice. "Being with Gorky was different than being with other artists who don't know how to converse or have any ideas about modern art," said Reuben Nakian. "You get ideas." The sculptor Herzl Emanuel said, "Gorky had an instinct for painting that was ferocious."

De Kooning admired the way Gorky kept changing, not only reworking individual pictures but also forever questioning his own evolving sensibility. De Kooning himself would become celebrated for the same attitude. In the mid-thirties, Gorky was slathering layer upon layer of paint on a canvas, each version reflecting his changing ideas about the work at hand. De Kooning recalled the transformation of one painting as it underwent a series of metamorphoses: "It was like a construction, to study it," de Kooning told Karlen Mooradian. "But [Gorky] had a peculiar way of torturing himself, coat after coat after coat of paint. And the paint-

ings became so thick." (Once, Gorky challenged him to pick up a certain painting. De Kooning, although strong, could hardly lift it off the floor.) Gorky conveyed the impression that art was full of intoxicating mysteries mastered only after long study. There was a kind of glory to be won in discovering and maintaining this sublime knowledge. De Kooning shared Gorky's love for the guild secrets of art, the how-tos of mixing and preparing. Gorky himself was loath to reveal his own discoveries. However, according to both Hess and Rosenberg, de Kooning sometimes helped Gorky. One day, after Gorky had become attracted to Miró, de Kooning found him cursing his inability to paint a long thin line. He was trying to do it with his "fat Rubens brushes," and de Kooning was amazed to learn that Gorky had never heard of the sign-painters' liner brush. Once he bought one, de Kooning remembers, Gorky spent the day in ecstasy painting long thin lines. De Kooning knew better than to ask Gorky where he got his magnificent art supplies or found his vast array of brushes; Gorky's reply, de Kooning said, would have inevitably been "Oh, some store." One time, the two were walking together down the Bowery, and they chanced upon a store selling decent paint at a surprisingly good price. De Kooning, highly enthusiastic, announced that he was going to go back home and get money to buy some. Gorky was noncommittal. When de Kooning returned to the store several hours later, however, every single tube of the paint was gone—purchased by Gorky.

Whether consciously or not, de Kooning absorbed many of the ideas of both Graham and Gorky. Raoul Hague said that Gorky in the early thirties often spoke of the cracks in the sidewalks as something that could interest and excite the eye. So did de Kooning, according to the poet and critic Edwin Denby, who became a close friend of de Kooning's in the mid-thirties. Graham was fascinated by the "edges" in painting—as, later, was de Kooning. Both Gorky and Graham emphasized the importance of "negative space," that part of the painting, often considered the background, that exists behind and around the central or positive image. De Kooning would often speak in later years of how "negative space" has its own power and how he sought a seamless image in which each received its due. Although the renowned art teacher Hans Hofmann defined negative space for many artists, de Kooning's own thinking about it went back to Graham and Gorky.

Their eventual fame makes it easy to forget how isolated de Kooning and Gorky were in the early 1930s, and how important it was that they found each other. Almost no one was interested in made-at-home mod-

ernism outside of the Graham-Gorky-Davis–de Kooning circle. Peter Agostini, one of the original Village inhabitants, later said of those times, "Nobody ran into anybody." He exaggerated somewhat, but it was de Kooning's great good fortune to find a milieu that encouraged and inspired him. In addition to Graham—the "éminence gris," as Isamu Noguchi called him—and Gorky and Davis, there was a sprinkling of younger artists who also found their way into this progressive circle, notably the sculptor David Smith. That, de Kooning later said, was the core group: "Early there was Smith and Davis, Graham and Gorky and de Kooning." On many nights in the early 1930s, Gorky, Graham, and Davis could be found, surrounded by attentive clusters of friends and disciples, at their two favorite Village haunts, both left over from the bohemian days of Greenwich Village at the turn of the century. Davis's was the Jumble Shop, a coffeehouse and restaurant on the corner of Eighth Street and MacDougal Alley near Washington Square Park, the heart of Greenwich Village. Twenty years earlier, the Jumble Shop had been the gathering place of Thomas Wolfe and other writers; half-scribbled notes by Wolfe still decorated the walls. The restaurant now welcomed a later generation of artists and writers. Just down Eighth Street from the new Whitney Museum, which opened in 1931 at 10 West Eighth Street, it mainly attracted the American realist painters, along with Davis (whom the Whitney had also recognized) and his little band of modernists.

Even more than the Jumble Shop, which Davis favored, it was Romany Marie's—and its patrons John Graham and Arshile Gorky—that attracted de Kooning and the other young modernists. Davis, for all of his love of the cubists, was a confirmed Yankee. Graham and Gorky, on the other hand, were very European. According to David Smith, "Romany Marie's was our hangout. In the early 1930s, we drank coffee and hung around New York like expatriates." Then located on a narrow Village side street called Minetta Lane, Romany Marie's was tiny, dark, and intimate. Throughout the 1920s and '30s it moved locations, always retaining its essential character. A previous version of the restaurant, at 133 Washington Place, had been memorialized by the Ash Can painter John Sloan in a painting called *Romany Marie's Garden*. A later version was in a basement on Grove Street. "It was a real Villagey place," said the artist Milton Resnick, who became a close friend of de Kooning's in the late 1930s. "It was a literary place, really, more than an arts place. Like old Village style." The restaurant was named after Romany Marie, its owner, who by the early 1930s had become a local legend. She was mannish and quite unattractive, but, like Gorky, made herself memorable. "Romany Marie was a rather intriguing personality, a strong personality," said the artist Dorothy

Dehner, who was then married to David Smith. "She was sort of a mother. She would sit around at different tables—never intrusively, but she'd sit with her customers, and go from one table to another." She cross-pollinated their conversations with gossip and tasty tidbits, reveling in intrigues and innuendoes. If the gossip wasn't good enough, she made some up. She also added spice to the mediocre food by telling the fortunes of her regular patrons. According to Noguchi, "A lot of people went down there. It was sort of a transfer of the Paris café life to New York. Romany Marie had a real function."

Within the modernist group there was a distinct pecking order. When Stuart Davis was around, for example, everyone deferred to him. Although they chafed at his position as the token American modernist accepted by the Whitney Museum, they also acknowledged his authority and seniority. When just Graham, Gorky, and de Kooning were present, however, Graham would assume command, which Gorky resented. The two were, in fact, rivals; there was rarely enough oxygen in one room for them both. When they were in the midst of one of their frequent fallings-out, said the artist Hedda Sterne, each missed no opportunity to run down the other behind his back. Graham, who had a malicious wit, was especially merciless in skewering Gorky. But when they met again, the tune would sometimes change miraculously, in the manner of two kings agreeing to a peace. "We must not talk this way about one another," they would say, embracing.

In the dark, cozy interiors of Romany Marie's and the Jumble Shop, with their pleasing echoes of an earlier bohemia, de Kooning's ideas about modern art were further sharpened. In the circle de Kooning frequented, Paris was sacred and the "Bible" was *Cahiers d'Art*. The discussions ranged widely. Picasso, in particular, was a brilliant, disturbing power from across the sea whose shadow seemed inescapable. For de Kooning as for his "brother" Gorky, Picasso was becoming the modern touchstone, the one indispensable artist—necessary, as Gorky put it, on almost a moral basis. The New York artists were haunted by his protean fecundity, his refusal to stand still or repeat himself. He embodied every aspect of the modern. After his early academic training in Spain, he became a master of figurative symbolist art, passing through the famous Blue and Rose Periods. His subsequent study of Cézanne and African tribal art helped stimulate his proto-cubist masterpiece *Les Desmoiselles d'Avignon*; then, working closely with Braque, he helped form cubism, which both Graham and Davis considered the definitive breakthrough of twentieth-century art. In their view, cubism was the face of modernity. Its variety of viewpoints, fragmented planes, crystalline structure, and use of contemporary

subject matter captured the tempo, texture, and space of contemporary life. But Picasso did not stop there. In the 1920s, he became a great surrealist. Picasso, in short, was the great modern fountain. Although the pictures de Kooning was making in his spare time during the early 1930s still owed more to other painters, such as Miró and de Chirico, than to Picasso, that would not always remain true. Picasso, owing partly to Graham's proselytizing, would eventually become de Kooning's greatest inspiration.

Often, talk would turn to the unconscious and Graham's interest in automatic writing. De Chirico's paintings, with their skewed perspectives and eerie stillness, were highly admired. According to Conrad Marca-Relli, who became friendly with de Kooning a few years later, Miró was also celebrated "because of his open form and open space." In the early 1930s, Cézanne remained an inspiration. How had he flattened the picture plane? How had the cubists taken his depiction of space still further? Matisse, Uccello, and especially Ingres, whom Graham and Gorky revered, were held up for admiration. Hours were spent over cigarettes and three percent beer discussing the mysteries of space, perspective, and illusion. How, in the end, did a painting trick the eye into believing that what it saw was real? And what was truly "real" anyway? De Kooning himself was also "passionate" at the time about the graphic, highly expressionistic painting of Chaim Soutine, the *shtetl* Jew then living in Paris. Soutine was best-known for roiling landscapes, depictions of bloody beef carcasses, and his astonishing, paint-laden brush; the impasto and surfaces were like nothing else in art. De Kooning told friends that he wished he could paint a picture that was like both Soutine and Ingres, a difficult combination to imagine and one that suggests how important it already was to de Kooning to welcome contradictory impulses.

The most abstract questions seemed endlessly interesting. Graham and Gorky both loved ambiguity; they felt that nothing was, or should be, certain about painting. Graham took the unknowable a step further, arguing that "dualism or a spirit of ambiguity or contradiction" underlay all of Western civilization. During these years de Kooning himself began to develop his distinctive way of talking about art. Its main characteristics were poetic elusiveness and joy in paradox. As Robert Jonas said, de Kooning loved ambiguity above all else. He liked, said Jonas, what couldn't be explained: "Gorky called it magic." Jonas remembered de Kooning's ability, in the 1930s, to argue and admire from every side. He could not be pinned down. When de Kooning talked, said Jonas, he started with solid propositions that became more and more abstract. "For instance, the word 'cubism.' Bill would define it. You could make notes. In a month, there would be volumes of notes. He had this dangling participle approach to

logic." It was simply that de Kooning liked to question everything continuously. He was beginning to see both art and life as constantly moving.

For de Kooning in the early thirties, Graham set the strange, almost quixotic tone. An air of idealism, bordering on fanaticism, surrounded him: either you were a believer, a prophet crying in the wilderness of bad contemporary art, or you were an infidel. To Graham's conviction was added Gorky's purity of purpose, his unerring eye, and his willingness to confront the greatness of Parisian painting. Between them, the two made a strong case against the prevailing spirit of American painting. De Kooning often took exception when critics later wrote that the 1930s were an infertile time in American art. "They weren't dead," was his invariable reply. "Everything happened early in the '30s. All of the influences were in place."

9. Downtown

Art is the thing you cannot make.

On May 1, 1934, Manhattan faced a rousing spectacle. For the past few years, the increasingly powerful Communist Party had been organizing vast May Day parades, much to the alarm of the conservatives. That year, the party outdid itself with what would prove to be its biggest demonstration of solidarity ever. The parade began at the tip of Manhattan, at the so-called Battery, and made its way up to Union Square at Fourteenth Street. The vanguard set off at two p.m. There were so many marchers—more than 100,000 by most reports—that the last, chanting and singing and waving banners, did not swing into view at Union Square until six-thirty p.m., a full four and a half hours later. There, a crowd that reached to the rooftops saluted them. The partying afterward continued for most of the night.

De Kooning and Gorky were there. And so were many other artists. By 1933, the painter Jack Tworkov said, most New York artists had been swept up by the powerful political surge to the left that characterized the Depression era. Money was short, success remote, but the scale of life seemed large; spirits downtown began to quicken, becoming less passive and bleak. The deepest questions about the human condition were routinely asked, as part of the daily round. Would Western civilization survive the crisis of capitalism? Was a new modern man being born? What was art's responsibility in a revolutionary era? To be young and an artist in the Greenwich Village of the 1930s was to be subject to a constant series of enthusiasms, as the conventions of politics, love, and art gave way to visions of another world.

By 1934, de Kooning's life in Manhattan had changed markedly. He still maintained close ties with Bart van der Schelling (who had become a roommate of Robert Jonas's) and with his Dutch friends from Hoboken and workmates at Eastman Brothers. He even continued to freelance occasionally for Eastman Brothers. But he was being drawn more and more into the downtown vortex of radical politics and bohemian life. In this milieu, an idealized view of personal freedom, rooted in the sublime self-ishness of romantic thought, often prevailed among artists, writers, and intellectuals. Malcolm Cowley described the ethos this way in his book

on the period, *Exile's Return*: "Each man's, each woman's purpose in life is to express himself, to realize his full individuality through creative work and beautiful living in beautiful surroundings." Marriage and conventional propriety belonged to the much-despised middle class, or, in the communist parlance taking hold in the early 1930s, to the "bourgeoisie." Many artists read the *Daily Worker*, the organ of the party, and *The World Tomorrow*, Norman Thomas's socialist paper. A growing group of independent Trotskyites, impatient with the follow-Moscow line of the Stalinists and more interested than conventional communists in an exploratory approach to literature and the arts, began paying particular attention to cultural life. (The magazine that would best represent this literary left was *Partisan Review*, which was founded in 1934.) It was from among intellectuals, including artists, that the Communist Party drew its most ardent supporters. To many of them, World War I and its aftermath decisively damned capitalism, with the greed, speculation, and social paranoia of the 1920s leading directly into the rise of fascism in the 1930s. "All the artists were communists," said the artist Dorothy Dehner. "They were the idealists."

Even among those who were not card-carrying communists, like Gorky and de Kooning, the prevailing sentiment was left-wing. According to Isamu Noguchi, artists were such pariahs in American society that they instinctively sided with anyone else perceived as an underdog. Communism had the added appeal of defining artists as workers, thus providing them the legitimacy that they sought but could not attain in American society. Even if they didn't fix plumbing or build houses for a living, many artists, including de Kooning, loved the notion of an honest day's work, done with one's hands, for an honest day's pay. Lawyers and bankers were parasites; workers built tangible assets, including art. They were honest and necessary. "Like they say, 'Are you for the communists?' " said the sculptor Peter Agostini. "Everybody says, 'Sure, why not?' Because everybody was broke and naturally we were working men. You see? So you all joined and everybody was a happy communist."

Just beyond the rarefied "beautiful atmosphere" that de Kooning found in Gorky's studio lay Union Square, the heart of left-wing thinking and communist politics in America. A crowded, four-block island of concrete and trees between Fourteenth and Eighteenth streets, and bounded by Broadway and Park Avenue, Union Square was an urban political theater, vibrant, shabby, and pulsing with opinions. The writer Alfred Kazin described a typical night at Union Square this way: "The place was boiling as usual, with crowds lined up at the frankfurter stands and gawking at the fur models who in a lighted corner window perched above the square

walked round and round like burlesque queens. . . . There was always a crowd in Union Square; the place itself felt like a crowd through which you had to keep pushing to get anywhere." Often Gorky and de Kooning, after a late night spent talking about painting, would stroll through the square and observe the scene—what Kazin described as an "eternally milling circle of radicals in argument."

By the mid-thirties, the Depression and political ferment were starting to mobilize American artists in a new way, bringing together individuals who had previously been isolated. In 1934, the College Art Association, which attempted to track artists nationwide, estimated that fourteen hundred were urgently in need of financial help. As the Depression deepened, some artists banded together in the belief that their common interests transcended their differences. Their first step was to persuade the city to allow open-air art shows in Washington Square, which was close to de Kooning's home in the Marble House on lower Fifth Avenue. All one had to do to participate was bring along a work and hang it on the fence. Artists also asked the major restaurants in the Village if they would display paintings on their walls. "This was the real beginning of the collective spirit," said the artist Burgoyne Diller.

But the most important change came with the founding in 1933 of the Artists' Union. One of its key organizers was de Kooning's close friend from A. S. Beck, Robert Jonas. From roughly 1931 to 1933, Jonas was a mainstay of the Workers International Relief, a communist-backed organization aimed at mobilizing the unemployed and lobbying for government assistance. In 1933, he and a few like-minded artists founded the Unemployed Artists' Union. Later known simply as the Artists' Union, it became by the mid-thirties a central focus of artistic life in New York. The headquarters was on Sixth Avenue between Ninth and Tenth Streets, close to Union Square and many downtown studios. Almost every artist belonged to the union, though not all were politically active. Communists dominated the union. According to the sculptor Herzl Emanuel, who knew de Kooning casually in those years, "The Artists' Union was the result of the organizing effort of the communists. And many of us were communists, including me. Why? Because the communists were tremendous fighters and very gifted organizers."

In addition, the Artists' Union provided downtown artists with a place to gather. "A lot of us wanted a base, a haven where we could get together and fight for our rights," said the artist Joseph Solman. For a while, Stuart Davis became so involved in the Artists' Union, editing its *Art Front* journal and serving as national chairman, that he had no time to be an artist. "Lots of work was done," Davis said wryly, "but little paint-

ing." One time, de Kooning helped Gorky build a memorable float for a parade organized by the union. "It was Gorky's idea," said Robert Jonas of the float, which was an abstract tower, made of painted cardboard, with a wooden skeleton and wires; it was so big that six people had to carry it. Compared to most artists, however, de Kooning gave little time to politics. Not only did he instinctively resist an ideology that told him what to do, but he shared the artisan's love for arcane know-hows, beautiful tools, and luscious materials, an attitude a socialist would dismiss as old-fashioned or even petit-bourgeois. John Graham was actually a more determined participant than de Kooning was, perhaps because he could not resist the pomp and pageantry of any parade, even a communist one. De Kooning loved to tell of one May Day parade when he saw the impeccably turned out, essentially royalist Graham marching among the ranks of the proletariat. Raising a beautifully gloved fist, his bearing militarily erect, Graham cried, "We want bread!"

In March 1934, while Nini was out of town on a vaudeville tour, de Kooning decided to give a party at his loft. This was not unusual. Despite a reputation for being quiet and unassuming, the young Dutchman often opened his loft to parties. In contrast to more serious painters during the early to middle years of the Depression, de Kooning was not then suffering any economic hardship. His steady work at A. S. Beck had dried up, probably because of Depression cutbacks and his own desire for more free time, but he continued to freelance regularly for the company and he made more than enough money to support himself and Nini. His celebrated music machine made his loft the best place for artists to dance outside of a dance hall. The parties themselves were informal. A few friends would drop by, bringing their own liquor if they wanted to drink, and often, friends of friends showed up. Among the strangers who showed up at this party was a group of five or six young women who lived on Thompson Street. Part of the downtown world of artists, dancers, and models, they roomed together in a railroad flat—a long, narrow apartment with several windowless inner rooms. "The place was a madhouse," said one friend, describing their life in the old, walk-up tenement. Most of the women were aspiring dancers who had studied, or were studying, with Martha Graham. But they also supported themselves by modeling for artists. "This was a hard-drinking crowd," said one participant. "They were always in search of a new party. It was a way of life that was very permissive."

Among them was a young woman from the Bronx named Juliet

Juliet Browner, after her move to California, photographed by Man Ray

Browner. The oldest of seven children, she had had a difficult childhood. Her mother, whose health had been undermined by a long string of pregnancies and miscarriages, was not strong enough to care for her children. Instead, she depended upon her eldest daughter to do much of the work raising her five younger brothers and one younger sister. Her father, "Doc" Browner, a pharmacist with whom Juliet was especially close, struggled to support his children and ailing wife, working long hours at Kostica's Pharmacy on Ninth Avenue in Manhattan. His salary barely covered the rent of the family's modest, two-bedroom apartment. Juliet helped out uncomplainingly. But when she was sixteen, she decided she had had enough, and set off on her own. (She would continue to return home, however, whenever her mother became ill and needed her.) She dropped out of Julia Richman High School in the Bronx and moved in with several old friends in Greenwich Village. There she began modeling for artists, among them both Graham and Gorky, and studying with a protégée of Martha Graham's named Lillian Ray.

Juliet's story was hardly remarkable. In the late 1920s and early '30s, the Village was filled with aspiring models and dancers looking for a break or a husband. However, Juliet Browner—sometimes known as Julie—was particularly beautiful. Like Nini, Juliet was petite and thin, almost bird-boned. But she was far prettier than Nini—prettier, indeed, than anyone in her circle. She had a cameo face, very white with delicate features, capped by thick, curly brown hair. Her figure was boyish but well developed. Even among the other models, all of whom were young and attractive, one friend remembered her as "outstanding." She also had a talent for dressing well, transforming clothing that she bought for fifty cents from the Salvation Army into festive party gowns. A photograph of Browner taken during those years shows her finely cut features and sharply planed cheekbones. "She was so pretty you can't imagine," said a friend. It was her

expression in this photograph, however, that was most memorable. She appeared at once innocent and otherworldly. One friend said that Juliet was even asked to pose for a sculpture of the boy Jesus, so beatific were her looks. "Juliet was so guileless and so vulnerable," said Bea Reiner, who was also a model at the time.

There was also another, more sensuous side to Juliet's beauty. She was not a great dancer, yet she knew how to handle her body and shape herself to music. As a child in the Bronx, she would wriggle and vamp to street chants. She also played the violin, and had a good sense of rhythm. After moving to the Village, Juliet, influenced by the flowing innovative style of Graham choreography, would often get up at downtown parties and begin improvising with other young dancers, always to a highly enthusiastic reception. The night of the party at de Kooning's was no different, except that the music was even better than usual because no one had to interrupt it in order to crank up an old-fashioned machine.

De Kooning loaded the Capehart turntable with records from his jazz collection. Then, as the evening wore on and the whiskey that some were drinking took effect, de Kooning put on Stravinsky's *Rite of Spring*. Twenty years after its riotous premiere in Paris, *Rite of Spring*, with its savage harmonies and sexual undertones, was still shocking, as it remains today for the unjaded. Juliet had never before heard it, and she was overwhelmed by its power. "I was so moved by the music I got up and danced until dawn," she said. One can imagine the effect upon de Kooning: a strikingly lovely girl, with a lithe and boyish body, giving herself to his favorite piece of music with abandon. Late that night, after the last of the guests staggered homeward, Juliet and Bill completed the seduction begun by the music. As Juliet put it, "After that I just stayed."

If de Kooning was enchanted by Browner's physical beauty and grace, she had many of the same feelings about him. Like Juliet, de Kooning was well proportioned, if not big, and in those years he was surprisingly fair. "Bill was rather delicate then," said one acquaintance of the time. "And very beautiful when he was young." In a photograph taken in the late 1930s, in which he stares directly at the camera, his features appear strong and even and his body trimly compact. His hair is thick. His gaze is at once stark and penetrating: perhaps he knew the effect upon others of a long-held look, when the eyes were light enough to seem bottomless. In recollections of de Kooning from the period, the word "angelic" recurs again and again. His manner reinforced the effect. "When you saw Bill, he was so beautiful and innocent-looking you always felt that if you had a ten-dollar bill handy you'd give it to him," said Joseph Solman. "He looked like that type in a French movie, a lovely helpless bohemian.

Everyone liked him because there was a quality about him that was naive, sweet, open, almost I would even say saintlike." Compared to the swaggering of many of the male artists, which had already begun in earnest in the thirties, de Kooning's gentleness appeared both unusual and seductive. Besides, there is something that appeals to many women about men who are not in hot pursuit; and by all accounts, de Kooning almost never aggressively chased women unless he was drinking, which began only much later in his life. He let women come to him.

Beneath de Kooning's sweet exterior, however, some acquaintances sensed a cool reserve. According to Bea Reiner, who knew both Juliet Browner and Nini Diaz, de Kooning struck her as a man who "wanted what he wanted when he wanted it." An even shrewder observer might have detected a measure of cruelty, a capacity to become quickly and frighteningly indifferent after the passion of the moment. Like many artists, de Kooning, finally, was less committed to any actual person than to a kind of beautiful dream or sensation of life that he nurtured within himself. Sometimes the outside world seemed to meet this internal standard. The glorious early days of a love affair were such a time. But the outside world typically became too ordinary, too demanding. He would not let it interfere with the artist's dream within. It did not take much to make de Kooning suspicious of a woman's motives. "I do know that Bill didn't want to get married," said the photographer Rudolph (Rudy) Burckhardt, who observed de Kooning's life firsthand after the two became neighbors, and then close friends, in the mid-thirties. Once, when Burckhardt was speaking affectionately about Juliet—admiring the sweet charm of her helpless, waiflike behavior—de Kooning snapped, "She uses that. She uses being charming." According to Burckhardt, whenever Juliet pressed Bill about their future, he would torment her by saying, "I'm not going to marry you. I'd rather marry Nini."

De Kooning's affair with Juliet did not greatly surprise their friends. Nini was not an ambitious artist in her own right and did not fit as smoothly into the downtown milieu as her beautiful rival did. Both Jonas and de Kooning also remained keenly interested in playing around, a widespread practice downtown. "Oh, the things that went on," Tully Filmus said. "It was all very bohemian." Nini resented any womanizing on de Kooning's part and was given to jealousy. Upon returning from trips with the circus, she would search the apartment for telltale signs of other women. One time, friends said, she destroyed a painting de Kooning had made of a nude model, thereby enraging de Kooning, who smashed his fist through a Sheetrock wall.

If Nini was susceptible to jealousy, de Kooning was quick to find a

relationship suffocating. He was ruthless to Diaz at the start of his affair with Juliet. Nini returned to New York from a two- or three-week-long tour of Canada the night of the party at which de Kooning met Juliet. She had been performing her wire act and had cabled de Kooning to say that she was on her way home. But then the fast car in which she was riding with her brother-in-law, Eddie, got them home several hours sooner than scheduled. When Nini arrived very late that night at the Marble House, she found it empty, with the air still thick with smoke, as if the last guests had just left. Diaz discovered that her douche bag, which hung in the bathroom, was wet, indicating that a woman had had sex—quite possibly, Diaz thought, with de Kooning.

Diaz, upset, hurried from the apartment to the tiny all-night café that she and de Kooning frequented. As soon as she walked in, said Diaz, she heard Tully Filmus warn de Kooning, "Here's Nini!" Seated with them was Juliet Browner, who turned around to look at Diaz and then said to de Kooning, "She's beautiful." By then, de Kooning was already so taken with Juliet that he could hardly see Diaz. That night, said Nini, she and de Kooning went home and talked and talked. "It was just like the movies," she said. De Kooning was smitten, and completely hard-hearted. He was determined to have Browner, who, said Diaz, was also more sexually accomplished and adventurous than she was. (One of Browner's talents, Diaz told friends, was for oral sex, which de Kooning had never before experienced.) Talking with male friends later, de Kooning would say, "Nini was nice. But oh, Juliet!"

Diaz had no choice but to move out of the Marble House to make way for Browner. On one level, she said, she did not mind the separation; de Kooning's moodiness and tension were affecting her health and may have given her an ulcer. De Kooning was working all the time, but was still destroying much of what he made. The hurt, said Diaz, was more "in the way it was done." De Kooning, however, was not completely uncaring. He helped her find a small apartment far downtown, moved her in, and gave her a few pieces of furniture to get her started. But she found her new life alone hard. She missed "all the beautiful music and looking out over Fifth Avenue."

That summer of 1934, as the heat of the city became uncomfortable, de Kooning once again left for Woodstock, this time with Juliet Browner. They took along enough clothes and art supplies for the whole summer. Before their departure, there was a touching scene at the train station. "Doc" Browner arrived with his daughter to meet de Kooning. Pumping Bill's hand, Browner said, "Take good care of my daughter." It was clear that Juliet thought the relationship was serious. De Kooning, who had no

such commitment in mind, was rattled. From what Doc Browner said, he confided to friends, it sounded as if they were getting married instead of simply vacationing together in Woodstock. Perhaps Juliet's desire for a commitment—only months after moving in with him—disturbed de Kooning and made him wish to send a signal that he was not, finally, available. Or perhaps he genuinely felt sorry for Nini, stuck in the hot city in her tiny apartment. In any case, he and Juliet were no sooner in Woodstock than de Kooning wrote to Diaz and invited her to join them. Eager to be part of de Kooning's life, even if not as his primary girlfriend, Diaz readily agreed and joined de Kooning and Juliet in an apartment in the heart of Woodstock. There, despite their complicated history, she and Browner soon became close friends. "I was very much taken with the little Juliet," said Diaz. The two would go swimming together—"Juliet swam like a fish," said Diaz—and Diaz would spend hours combing Juliet's hair.

Not surprisingly, de Kooning's ménage à trois did not go unnoticed. Most of his circle was astonished, particularly when Marie Marchowsky and a friend hitchhiked up to Woodstock at de Kooning's request and also moved in for a while. Shrugging their shoulders, however, de Kooning's friends merely said of the odd arrangement, "That's Bill. If anyone can make it work, he will." Once in Woodstock, Diaz and Browner stayed well into the winter. In August, de Kooning returned to the city. He had to give up his top-floor space in the Marble House, probably because the renovations were now complete and the landlord wanted a high rent. He moved into temporary quarters at 40 Union Square, near Gorky, in the apartment of a German architect named Mac Vogel, another member of the downtown crowd and a friend of Robert Jonas's. What Juliet did that autumn in the deserted summer colony is unclear. In her fearless fashion, however, Nini proceeded to pose for a local artist and become his lover, even though he was married. ("I gave him all the talent I had seen in Bill," she said.) The result, said Diaz, was a lovely portrait of her that the artist painted. When Juliet and Nini finally returned to Manhattan near the end of the year, Nini found that she had lost the sublet on her little apartment and had to relocate yet again, this time to Minetta Lane in the Village. She continued to find life without de Kooning hard. When Bea Reiner, who remembered her from the earlier Woodstock summer, moved into an apartment nearby, she thought Nini was still suffering terribly from the breakup. Reiner said that Diaz became rail thin and that her doctor put her on a regimen of beer to help her gain weight.

De Kooning, meanwhile, chose to move with Browner to a new part of town, West Twenty-first Street, in the center of Chelsea. It was there, five years earlier, that he had first glimpsed Raoul Hague's vast loft. Very dif-

ferent from the gracious area of lower Fifth Avenue where de Kooning had previously lived, Chelsea was an odd amalgam of elegance and ugliness. In its heyday, from the 1870s to the '90s, it had been the most fashionable part of town; Sixth Avenue had been known as the "Ladies' Mile," and was lined with opulent department stores. The first Grand Opera House was located on Eighth Avenue and Twenty-third Street, and fancy restaurants and ornate vaudeville palaces filled the area. By the mid-thirties, however, the stores and entertainment palaces had long since closed, becoming empty-eyed witnesses to an earlier prosperity. When de Kooning moved in, the side streets were lined with graceless loft buildings that contained small factories and manufacturing spaces. Each was four or five stories high—sometimes as tall as eight—and without much enlivening decoration, careful proportion, or, indeed, any redeeming architectural quality. The treeless streets, city canyons devoid of much light and space, were narrow. After dark, the area was deserted and grim. Few buildings were legitimate residences. Most were cold-water lofts, home to artists, dancers, and others too poor to rent apartments in residential neighborhoods. De Kooning's original apartment—a small loft space at 145 West Twenty-first Street in a five-story building that was indistinguishable from scores of similar buildings in the area—did not work out. He could not stand the smell of fresh bread constantly wafting upward from a bakery just beneath him. In a few weeks, he moved to a loft next door, at 143 West Twenty-first Street. Finding someplace new to live during the Depression was not difficult. A photograph of the street taken in the 1930s by Rudy Burckhardt showed "Loft to Let" signs on almost every building, and the street teemed with delivery trucks. Traces of an earlier era, before the lofts, could be seen in the rows of ornate, wrought-iron stoops that were never torn down.

Even after de Kooning's move to Chelsea with Juliet, Nini continued to be a significant part of his life. Sometimes, when Browner returned to the Bronx to take care of her ailing mother, de Kooning would visit Diaz and sleep with her. That spring of 1935, he had another powerful reason to remain close to Diaz. Nine years after leaving Holland, de Kooning had finally saved enough money to bring his mother to America. Cornelia believed—on the strength of what de Kooning had written to her—that Diaz and her son were married; she would even brag to friends that Wim was married to a world-famous dancer. Loath to tell her the truth, de Kooning devised an elaborate ruse. First, he found Diaz a new and bigger apartment, in which the paint from the renovation was barely dry, and then he moved back in with her for the duration of his mother's visit. "Bill was trying to make it look like everything was nice together," said Diaz.

De Kooning with his mother, Cornelia, and girlfriend Virginia Diaz at the newly built Rockefeller Center in 1935, on the first of Cornelia's two visits to the United States

The two presented themselves as a successful young couple living a conventional life as they took Cornelia around town. A photograph shows the three posing in their stiff Sunday best near the Atlas statue in the newly completed Fifth Avenue portion of Rockefeller Center. Diaz spent her days entertaining Cornelia, who would talk in rapid-fire Dutch with no regard for whether or not her listeners understood her. And Diaz spent her nights with de Kooning in the bedroom, while Cornelia slept on the couch in the living room.

Despite de Kooning's best efforts, however, Cornelia learned the truth about Juliet and Nini during her stay in New York. There followed the sort of histrionic scene that de Kooning had worked so hard to avoid. Cornelia wept and wept. When she subsequently learned about Nini's abortions, she became even more upset. Diaz tried to appease her by telling her that that was the way things happened in modern America. Cornelia, however, would have none of it. Doubtless she would have been even more upset to learn that de Kooning, during her visit, impregnated Nini once again. This time, the abortion would be performed not by Nini's regular doctor, but by a substitute, and with terrible results. For the next year, Diaz continued to bleed, becoming seriously anemic; later, she was unable to conceive a child.

That de Kooning was willing to create such an elaborate ruse about his private life indicated to what lengths he would contrive to go to avoid a confrontation with his mother. He knew that the tyrannical and morally conventional Cornelia would never approve of his life in New York, and he did not wish to quarrel with her about it. He also wanted her to believe that he was living a typically prosperous life in America. He was still, at

thirty years old, hiding from her. (This is also readily apparent from the cards he sent home over the years, filled with loving testimonials "to the best mother in the world" even as he complained bitterly about her.) Rather than let his mother into his actual life, and have to justify that life to her, he wore a disguise.

His juggled relationship with Nini and Juliet was also characteristic. At the apartment in Woodstock, de Kooning's friends witnessed a pattern of behavior that would often emerge in his personal life. Robert Jonas, a careful observer of others, noticed that de Kooning typically dealt with difficult relationships or choices by *not* dealing with them; he forced others to take action while he himself stood apart. "He doesn't commit himself," Jonas said. De Kooning often created around himself a kind of fraught irresolution, not surprising for a painter who would one day become known as a master of ambiguity. Almost never, for example, would de Kooning end an affair decisively. "Bill's life was very complicated because he never had one woman and then another woman," said Rudy Burckhardt, a wry observer of bohemian life in Chelsea. "It was all mixed up." According to Jonas, de Kooning's failure to act could itself be regarded as Machiavellian: he usually ended up with what he wanted and, Jonas said, would invariably make the selfish choice if he was actually forced to confront a situation.

In the mid-thirties, de Kooning seemed to others no more or less committed to art than he was to a particular lover. But here, too, he finally found a way to let others force his hand—and again in such a way that he achieved exactly what he wanted. On May 6, 1935, President Franklin D. Roosevelt announced the formation of the vast Works Progress Administration (WPA) public relief program, by far the biggest effort of his administration to get the unemployed back to work. As part of this gargantuan new project, there would be a Federal Arts Project, employing artists, dancers, actors, and writers. On August 2, the word flew through downtown New York that the Federal Arts Project was starting up that very day. All you had to do was to show up at the project headquarters with artwork in hand and sign on. "They were shouting with the excitement of children at a zoo," wrote May Rosenberg, the wife of Harold Rosenberg, who would become one of the most influential art critics of the New York school. "Hurry. Grab some paintings. Hurry! Grab anything you've got framed and come along."

For de Kooning, there was a catch. In order to join the WPA—as the artists always referred to the Federal Arts Project—you had to be impover-

ished. But de Kooning was actually quite prosperous; that summer, he was still working fairly regularly for A. S. Beck. Inspired by Gorky, however, de Kooning was edging closer and closer to the day when he would finally "declare" himself as a full-time artist. "The decision to take was: Was it worth it to put all my eggs in one basket, that kind of basket of art," he told the critic David Sylvester many years later. "I didn't know if I really was competent enough, if I felt it enough." Little by little, however, de Kooning was styling himself, in his own mind at least, as a full-time artist rather than a Sunday painter. He was beginning to reverse the old terms in which one worked for a living and then painted on the side. "It was a gradual development and it was really more of a psychological attitude: that it was better to say, 'No. I'm an artist. I have to do something on the side to make a living.' So I styled myself an artist and it was very difficult. But it was a much better state of mind." He was also helped by the support of his contemporaries—for de Kooning in the mid-thirties was beginning to gain an underground reputation. (Anyone with whom Gorky spent so much time naturally aroused interest.) The downtown artists also saw how hard de Kooning was working "on the side," and how ardently he struggled to find an independent style, constantly destroying his work rather than settling for mediocrity.

Still, it took the WPA to persuade a poor boy from Rotterdam to assume the financial risk. The WPA provided a regular paycheck just as A. S. Beck did. For several months during the summer and fall of 1935 de Kooning agonized over what to do. Then, in late 1935, he went to the display manager at A. S. Beck and told him that he was quitting his current project. The reason he gave was that he was not making enough money. Such a complaint, he decided, offered him a simpler exit than trying to explain that he wanted to be a serious artist. To de Kooning's astonishment, the manager offered to double his salary. "Then," de Kooning realized, "I knew that I *had* to quit." At the age of thirty-one, he had made his choice: he was now a full-time painter.

10. The WPA

I was reading Kierkegaard and I came across the phrase "To be purified
is to will one thing." It made me sick.

In contrast to Europe, which had a strong tradition of patronage, the
America of the 1930s regarded the arts as frivolous and often decadent—
and certainly not an essential part of national life. A presidential com-
mission reported in 1933, "For the overwhelming majority of the
American people the fine arts of painting and sculpture, in their non-
commercial, non-industrial forms, do not exist." During its five years of
life, the Federal Arts Project became a lightning rod for conservatives in
Congress and the press, who considered it the ultimate boondoggle.

Given this degree of enmity, it was extraordinary that President Roo-
sevelt backed the arts project—as well as its predecessors—as strongly as
he did. The government's earliest art-related project was the short-lived
Public Works of Art Project (PWAP), a predecessor to the WPA, which ben-
efited Gorky, among others. The PWAP was a tiny part of the much larger
Civil Works Administration, Roosevelt's first large-scale work-relief pro-
gram, which began operation in December 1933. The PWAP's intent was
to create art "of the best quality available" for public buildings. In the end,
the PWAP lasted only six months, but it established an important prece-
dent for subsidizing the arts along with other jobs. The next arts-related
work-relief program was the Section of Painting and Sculpture. Launched
in October 1934 and later known as the Section of Fine Arts, it was headed
by Edward Bruce, a businessman turned painter and supporter of the arts.
His idea was to continue to hire the best available artists, regardless of
their financial condition. More than a thousand murals were painted in
post offices and other government buildings through the auspices of the
two programs.

All of the early programs were preludes, however, to what would
prove the biggest, grandest, longest, and most far-reaching arts program
ever undertaken in the United States, the Federal Arts Project, which
came into being largely through the lobbying of Harry Hopkins, the head
of the WPA program and one of Roosevelt's closest advisors. Hopkins,
together with many others, opposed the idea of out-and-out welfare.
Instead, he believed in putting people back to work, then paying them for

their efforts—in his words, "ending the dole, expanding the rural rehabilitation projects, and giving other reliefers jobs on useful projects." Hopkins wanted such work efforts to extend to artists, and he refused to back down from this view even in the face of vehement criticism. "I think these things are good in life," he said about art, writing, and theater. "They are important." Largely as a result, when the WPA was announced in May 1935, one of its many subprograms was Federal Project Number One. A sizable $300 million was appropriated for the combined arts project, which covered theater, music, the visual arts, and writing. Museum curator Holger Cahill was put in charge of the visual arts program. He was an enlightened choice. Trained at the Newark Museum, he was familiar with many styles of art. And although he personally favored representational painting—the artists he most liked were the Mexican muralists—he knew better than to impose a single vision on art.

By August 1935, the arts project was ready to go forward. In New York, it was headed by Audrey McMahon, who, as director of the College Art Association, had already been helping many artists to find teaching jobs. By the middle of November, around eleven hundred New York artists were working on the WPA. Many went overnight from poverty to the stipulated salary of almost $24 a week. They could scarcely believe their good fortune. For the first time in years, they could afford decent meals, studios, and whiskey. "I can't begin to tell you how *rich* everybody was," said paint maker Leonard Bocour. Before being hired by the WPA, an artist first had to apply for Home Relief. Then, after gaining this proof of poverty, he or she could apply for the project and be transferred to its rolls. The Artists' Union proved tremendously valuable in this bureaucratic process by helping the artists establish indigency. If, along the way, an artist was fired or laid off, "we fought for them," said the painter Joseph Solman. But there were also sharp political tensions within the union, not least of which was the infighting between its two main communist sects. These tensions mirrored the larger division in the American left between Stalinists, who believed that all communists must answer to Moscow, and the Trotskyites, who were typically more literary and freethinking.

Despite their differences, the communists set the union's agenda, calling for art that depicted the class struggle and the fall of capitalism. They revered Diego Rivera and other left-wing Mexican mural painters. Modernist art that lacked a political message, such as cubism, was barely tolerated. "The modern artists were suffered," said George McNeil of himself and the other early abstract painters in the union, including Gorky and de Kooning. "They weren't completely ridiculed, but they were treated as aesthetes, as antisocial. They had to fight for everything at

that time." Fortunately for the small group of modernists, one division of the Federal Arts Project, that of mural painting, was not completely dominated by either communists or conservatives, even though both groups took a particular interest in such work. The division was headed by Burgoyne Diller, an abstract artist who was an elegant, dignified man with a scrupulous regard for the concerns of other artists. The first thing Diller did as a supervisor was to look for work for the modernists. It was an uphill struggle for abstract art, he later said: "[The authorities] felt that there was no place for it at the time because they felt that the project should be a popular program." However, Diller believed that at least a small percentage of mural projects could safely be apportioned to abstract artists: "I mean if I had ten jobs going, I could afford to start one that might be aesthetically a little questionable to some people."

Diller found a sympathetic listener in the early days of the project in an architect named William Lescaze, who had been commissioned to build a huge public housing project in the Williamsburg section of Brooklyn. According to Diller,

> We got together at one point and I told him that I thought that we had some fine abstract painters and they should have walls to work on. It struck me at the time . . . [that] we could probably have these abstract painters do things that would be very decorative, very colorful and probably people moving into this housing project might need that touch of color and decoration around, something to give a little life and gaiety to these rather bleak buildings.

Lescaze endorsed the idea and helped it win bureaucratic approval. "It culminated," said Diller, "in our having most of the men I had available at the time being assigned to jobs." Diller's division rapidly became synonymous with modernism in America. Stuart Davis designed one mural. Jan Matulka, who had taught at the Art Students League with Davis, designed another. McNeil was himself on the Williamsburg project. So were Ilya Bolotowsky and Balcombe Greene, two other early abstract artists.

Although de Kooning began on the easel project of the WPA, he soon joined his modernist colleagues in the mural division in Williamsburg. Each artist there worked in his own style designing what were called "decorative" murals—the code word that Diller devised in order to avoid the inflammatory word "abstract," which always aroused controversy. "They were rather special because these were the first abstract murals anywhere," said Bolotowsky. "There might have been one that Picasso did on the ceiling of Gertrude Stein's house, or maybe a couple more." De Koo-

ning's six months on the Williamsburg project did not result in any completed murals. A preparatory study for one work, however, showed an architectonic space influenced by Picasso's *The Studio,* a painting owned by the Museum of Modern Art; it also reflected the rounded biomorphic forms of Arp and Miró. The Williamsburg studies led to de Kooning's first inclusion in a museum show. Stung by criticism that it celebrated European art while turning a blind eye to innovative American work, the Museum of Modern Art mounted a show in the fall of 1936 called "New Horizons in American Art." The works were drawn from those executed during the first year of the WPA and were chosen by Holger Cahill—who knew Gorky's work, having written a short note on Gorky for the painter's first show at the Mellon Galleries in Philadelphia in 1934. Cahill included one of de Kooning's sketches for the Williamsburg project, in addition to works by Davis, Bolotowsky, Greene, Gorky, and McNeil. "I remember de Kooning's work was there, and mine too," said McNeil of the show. "There's a point which is very important and that is that de Kooning always had a peer position from the very beginning of modern art. He was always, as far as I know, respected as a tremendously important painter."

By the latter half of 1936, the Williamsburg project was winding down and Diller began casting about for other jobs for the modernists in his crew. It was then that Frederick Kiesler, a visionary architect and sculptor from Austria who had settled in New York in 1926 and become part of the downtown scene, came up with a novel suggestion. Why not have some WPA artists work on a mural with the celebrated French artist Fernand Léger? At the time, Léger, who was fascinated by America and considered New York the engine of the modern world, was making periodic trips across the Atlantic. Like Kiesler, he was an architect by training. His own style was based upon cubism, but he was by temperament open-minded about art and was far from being a "pure" painter. He loved to collaborate and had also worked on stage design, in the decorative arts, and even on films. He had taught a number of Americans studying art in Paris, and his static, monumental style of painting brought him widespread respect.

Not surprisingly, Diller endorsed the idea of a collaboration with an artist of Léger's stature. As a foreigner, Léger could not be hired onto the project outright; but he could be invited, owing to his prominence, to supervise the work of a group of WPA artists. "We decided that it would work if we could find a place where we could do a job that would employ a group of American artists that might take the same theme that he would take," said Diller. "In other words, if there were enough panels or positions for murals, that he could collaborate with them, and he could more or less establish a theme and then they could do whatever variations on

that theme that they pleased." Having interested Léger in collaborating for no payment on a WPA mural—a great coup in and of itself—Diller and Kiesler next set out to find an appropriate site. A natural location was the French Line pier on the Hudson River. Accordingly, they approached Monsieur de l'Enclet, the head of the French Line in America.

At the initial meeting, de l'Enclet proved coolly noncommittal to the idea, but Diller pushed ahead anyway. A small group of artists was selected to work with Léger. One was de Kooning, who was alerted to his new assignment by telegram. ("I didn't realize at first it was Léger I was working under," he said.) Among the others were Harry Bowden, a mural painter who later became a photographer, and the modernists George McNeil, Byron Browne, Ilya Bolotowsky, and Balcombe Greene. Mercedes Matter was both an assistant and the translator for the group. The daughter of the American painter Arthur Carles and an accomplished artist in her own right, Mercedes was married to Herbert Matter, a Swiss-born photographer who had studied with Léger in Paris. The couple put Herbert's studio, located in a penthouse apartment in the elegant East Side apartment complex known as Tudor City, at Léger's disposal. According to de Kooning, when Léger and his group of assistants first assembled in a WPA shop at Fifth Avenue and Thirty-ninth Street, "it was like meeting God." The American modernists revered Paris and its artists, above all those who, like Léger, had helped shape the evolution of cubism. Whatever awe was created by Léger's formidable reputation, however, was soon dispelled by the Frenchman's down-to-earth manner and appearance. "He looked like a longshoreman, a big man," said de Kooning. "His collar was frayed but clean. He wasn't like a great artist; there was nothing artistic about him." Léger's lack of pretense, together with his effort to treat assistants as equals, quickly endeared him to the Americans. "Léger became a human being for us the very first day," said de Kooning. "He wouldn't permit you to hold him in awe. We were supposed to submit our sketches for his criticism. I remember the first time we passed them all around the group. Léger just took a long look and without saying a word began to whistle. We all burst into laughter."

Léger's approach to the project was as methodical and workman-like as his appearance. First the group visited the pier together. Léger decided that he would decorate the exterior, while his assistants would each have a panel in the inner rooms. Next, he dispatched his helpers to the Museum of Natural History in order, de Kooning said, "to get ideas about the sea." Each was supposed to make a list of ordinary objects associated with the sea, which would then—according to Léger's practice at that time—be enlarged to dramatic proportions. With Léger, who did not

believe in too much intellectual art talk, everything seemed concrete and specific. For some, his working method was almost too practical. George McNeil was startled to discover that Léger worked like a commercial artist, cutting out shapes and pinning them on a wall to see how they worked together instead of yielding to hot bouts of inspiration. "He worked with cut paper and he was a completely matter-of-fact man about his work," said McNeil. "I remember being very, very shocked at seeing what he did. You know, it's as though you go to Parnassus and suddenly discover someone with a shopping list."

But de Kooning felt deeply reassured by Léger's methods. He, too, was suspicious of "fine art" and, as a trained commercial artist, naturally played with the pieces of a composition. "He worked like a sign painter and that was terrific," de Kooning told the art historian Irving Sandler, describing Léger's methods. "There was no mystery in how he did it. He made a little sketch and squared it off; after all, it was a mural. He made lots of sketches and threw them around on the floor and picked one out." Sometimes, Léger also used pigment right out of the tube without any mixing of colors on a palette. "He would make a figure yellow, outline it in black," said de Kooning. "He would shade flat, just like a child." All in all, Léger's methods could hardly be more direct—"no mystery in how he did it," as de Kooning put it. The only mystery was what made the finished result strong. Somehow, de Kooning said, Léger always picked just the right sketch from the ones strewn across the floor. He also possessed, said de Kooning, "a fantastically original way of looking at the world; he was like a builder." Each Léger work had a bulk, and a heft, that gave it monumentality.

For several months the assistants worked with their down-to-earth master. Communicating was often difficult, as everything had to be translated through Mercedes Matter. But the artists quickly grasped Léger's methods and his goal of melding the panels into a unified whole. Finally, all the preparatory sketches were ready; de Kooning's contribution was a rather static composition of wavy, biomorphic forms reminiscent of the sea. Diller made an appointment for himself and Léger to show all the sketches to the head of the French Line. Each WPA project required several layers of bureaucratic approval, in this case that of the steamship company, followed by the commissioner of docks and, finally, the Art Commission. (As Diller later said, it was ridiculous to think that the artists could be at work on communist propaganda, since the layers of scrutiny were so exhaustive.) When he and Léger were finally granted an audience with de l'Enclet, however, after being made to wait for quite some time, the head of the French Line took one look at Léger and

exploded in anger. According to Diller, "He said, 'I know that man,' and he started on a tirade in French." The gist of the rapid-fire French was that Léger was a communist—and worse. Finally, Diller picked up the sketches and said, "Well, Mr. de l'Enclet, thanks for your French courtesy." He and Léger walked out. The project was over. For the second time in his WPA mural career, de Kooning's work never progressed beyond the planning stage.

Even so, working with Léger inspired de Kooning. The Frenchman set an example. He radiated happiness about being an artist, despite the widespread melancholy of the Depression years, and he did not set himself above others, as if an important artist were an unreachable god. According to de Kooning, "He would look at his work in a very relaxed way, spread his arms, and say '*Bon.*' You got the feeling that to be an artist was as good as being anything else. This was a very healthy feeling." For the first time, moreover, a celebrated artist had praised his efforts. De Kooning, who had received small encouragement as an artist—even Gorky was too self-absorbed and critical to be helpful in that respect—turned the relationship into something intensely personal. Léger, he said, was "like my father; I loved him."

Because of the WPA, de Kooning's world, like that of most other artists, began to broaden. Artists saw one another regularly at the Federal Arts Project headquarters. They would gather on Friday afternoons at several bars to cash their weekly checks and attend meetings at the Artists' Union, followed by long discussions at the nearby Stewart's Cafeteria on Sixth Avenue and Eighth Street, two blocks from the union's headquarters. "After meetings at the union we'd go in for coffee and a sandwich or whatever and stay up to about two in the morning," said Joseph Solman. "We'd talk about the different phases of art, the shows of Picasso, de Chirico, Klee, the Whitney Museum. And we'd talk about the exciting shows that we saw around town." According to de Kooning, "The project was so good. It brought us all together in a friendly way." Many artists roomed together, creating an elaborate web of connections. Jonas, for example, lived in the mid 1930s with the painter Michael Loew, who would later (through Jonas) become a good friend of de Kooning's. Also living in the same apartment on Ninth Street were Lee Krasner, the painter and future wife of Jackson Pollock, and her boyfriend, an artist named Igor Pantuhoff. Before moving in with Mike Loew and Bob Jonas, Krasner and Pantuhoff had also roomed with Harold Rosenberg and his wife, May Tabak Rosenberg, in the West Village. Pantuhoff was a great early admirer of de Kooning's. A strikingly handsome White Russian with a manner almost as grand and flamboyant as John Graham's, he placed a study for

one of de Kooning's WPA murals on his studio wall. "You know, everybody was really aware of the value of other painters at that point," said the artist Fritz Bultman, one of Pantuhoff's friends. "There was no isolation."

This jelling of the art world in the thirties led to the formation of new groupings of modernists that served as a kind of support network for their members, all of whom were regarded with suspicion by the union and the communist rank and file. One such organization, established in 1935, was known as the "Ten." Its members included Joseph Solman, Ilya Bolotowsky, Mark Rothko, and Adolph Gottlieb. Bolotowsky was the only pure abstractionist in the group. The others, Solman said, were united by "a kind of mutual love of modern art and a kind of romantic expressionist feeling for modern art." Their style tended toward the abstract, and their favorites were the German expressionists, early Matisse, and Picasso. "We'd meet every two weeks at one studio or another and see the latest work and talk about it," said Solman. "And we gave each other a lot of courage." A second, more rigorously abstract group, the American Abstract Artists, began in 1936, mostly at the urging of a Mondrian acolyte named Harry Holtzman. (He later helped Mondrian emigrate to the United States in 1940.) Most of the AAA artists looked to Mondrian and the neo-plasticists or worked, according to Bolotowsky, in a "somewhat cubistic style." The AAA met weekly and quickly blossomed. Its meetings often carried over into the local cafeterias, where discussions would continue and the modernists in the AAA mingled with those in the Ten and with various independents. "So you can say that at some point around 1936, 1937, there was a very cohesive group of modern artists in New York centered around the AAA, and also in relation to the project," said George McNeil. "They had two common cores."

There was one other important meeting place for like-minded modernists: the school of the celebrated German teacher Hans Hofmann. After emigrating to America in 1932, Hofmann eventually founded schools in New York and Provincetown, Massachusetts. He had studied in Paris in the first decades of the century, and he had a rigorous, wide-ranging eye; he seemed equally interested in Matisse and cubism, for example, and found much to admire in Kandinsky and Klee. A large, jovial man who spoke in a heavily accented mixture of broken English and German, Hofmann, in addition to being a serious artist, was something of a showman and proselytizer. He was never happier than when lecturing, either formally or informally, at his school at 52 West Eighth Street. Hofmann brought two important ideas to America. The first was a respect, as the art critic Dore Ashton has suggested, for the "grammar of painting," a rigorous technical and formal understanding of visual meaning—apart

from the overt subject matter of a picture—that was often missing from American art. The second was a faith that art really mattered. According to the painter Larry Rivers, "He had his finger on the most important thing in an artist's life, which is the conviction that art has an existence and a glamorous one at that." His "imperturbably art-for-art's-sake urbanity," as Ashton put it, made the rhetoric of social realism sound shrill and tinny, and gave hope to the city's modernists.

It was the WPA, however, that made an art world possible. Its impact upon de Kooning and many other artists was incalculable. For the first time, American artists came together in substantial numbers, able to devote their full energies to art. By 1936, more than six thousand artists had joined the project. It was a scholarship for all. As Herzl Emanuel described it, "It was a period of tremendous discovery for people who had had no break in life up to that point." With the artists' newfound unity came a sense of confidence, possibility, and empowerment. Until that time, with the exception of isolated circles of friends like that of Gorky, Graham, and de Kooning, "there wasn't any art world," said McNeil. "That's the point. There wasn't any café life. There wasn't any center to go to. There was really nothing as far as a focus of modern art activity." For de Kooning and his friends, the 1930s could seem the best—as well as the worst—of times.

11. An Unfinished Artist

If the picture has a countenance, I keep it. If it hasn't, I throw it away.

In 1937, Congress, led by Texas conservative Martin Dies, began a crack-down on political radicals. At the regional level of the WPA, the military was placed in charge, with the result that artists were treated more like soldiers; they were required to work in an assigned office space or punch a clock to ensure that there was no freeloading. De Kooning never forgot one timekeeper: "He hated to climb all those stairs to check on me so I convinced him how unnecessary that was. I convinced him with an occasional gift he could drink. He was Irish, you know." By 1938, the House Committee on Un-American Activities began to look for card-carrying communists. Artists on the WPA came in for increasing scrutiny.

De Kooning, who remained fearful of deportation, decided to resign from the program rather than have his status questioned. His time on the WPA was short, only a year and a half; the Léger project was his last. Once he left, he could no longer depend upon the regular paycheck of $23.86 a week. And yet, when he was offered a good job in 1937 doing window displays in Philadelphia—easy work, with a grand salary of sixty dollars a week—he refused it. As he had promised himself, the art must now come first, the other jobs second. "That was a turning point in his life," said a friend of the time who had always seen de Kooning with money in his pocket, first from A. S. Beck and then from the WPA. "Then he became quite poor." During the harsh early years of the Depression, when many were desperate for work, de Kooning made out fine. Now, he could barely scrape by.

De Kooning was more isolated than many of his contemporaries, despite the newfound sense of solidarity among artists around him. The reason was not just that, as a foreigner, he felt he could not continue on the WPA. During the thirties, Gorky and de Kooning distinguished themselves by intentionally keeping their distance from every group, even those that supported modernists. They invariably insisted, that is, upon the singular self. They never became seriously involved in the Artists' Union, and only dabbled in politics. De Kooning was not indifferent to the downtrodden. "He did have sympathy for the average, ordinary, poor person," said Jonas. Herzl Emanuel recalled that when the civil war broke out in Spain, de

Kooning marched in protest along with the others. But de Kooning came to America having seen Marxism in action in Rotterdam, and he had no interest in joining a mass movement. Neither de Kooning nor Gorky could paint the party line. They could not tolerate the suffocating peer pressure of any group, however well-meaning. "We divorced politics from our art, although we were political," said de Kooning. Or, as Jonas said about Gorky, he sympathized with the union, but would not get more involved because of his deeper commitment to art. That viewpoint did little to endear Gorky and de Kooning to the great mass of believers who populated the union and painted in a social realist style. De Kooning never forgot how "rigid and doctrinaire" some of the artists at the union were, including men like the American social realist William Gropper.

The artist Barnett Newman, who in the thirties was also an independent—a libertarian who rejected all of the competing dogmas—later described the din of "Marxist, Leninist, Stalinist and Trotskyite" rhetoric as "so shrill it built an intellectual prison that locked one in tight. The only free voice one heard was one's own." Apart from the party line on art, de Kooning and Gorky also disliked the constant proselytizing of the faithful. "They were always greeting you as 'comrade,' " de Kooning said. "I didn't like that either." One time in the mid-thirties, he complained vehemently to his friends and Chelsea neighbors Rudy Burckhardt and Edwin Denby about the way in which the communists couched everything in political terms. "I remember him once saying, 'Vell, these people. They like a cup of coffee in the morning. So they say, "The people want coffee in the morning," ' " said Burckhardt. Denby remembered de Kooning struggling hard to maintain his independence: "Pressed to join a cause, 'That's your status quo,' he shouted. 'I'm not supporting anybody's status quo.' " With his outspoken opinions about the need to divorce art and politics, Gorky, in particular, attracted the anger of the more ardent proselytizers. On one occasion, when giving a talk at the Artists' Union (de Kooning was operating the slide projector), one of the union members got to his feet and began rudely denouncing Gorky and his ideas. What did all this have to do with the real purpose of art, the heckler demanded, which was to further the class struggle? Gorky drew himself up to his full six-foot-four height and said pityingly, "Proletariat art is poor art for poor people."

Gorky and de Kooning did not join the Ten, although their work suited its modernist outlook. Gorky also created a famous scene at the formation of the AAA, when more than thirty abstract artists assembled at Harry Holtzman's studio. Gorky began arguing that the group should be a kind of debating society about modern art, while most of the others, eager to show their work, instead wanted to form an exhibiting society.

"Gorky told us that the whole idea was silly because in art progress is always achieved by the great personalities," said Ilya Bolotowsky. "And all the rest serve as a kind of, what is it, floor mat for the great men." It was obvious from Gorky's argument that he saw himself as the great man in question. "He didn't put it quite that bluntly," said Bolotowsky. "But [he] admitted this was the idea." Not surprisingly, the rest did not concur. When they decided to proceed as an exhibiting group, Gorky announced that he would leave "if we didn't promise to behave," said Bolotowsky. And then there began a comically slow retreat. As Bolotowsky described it:

> It was Werner Drewes [who later went to the Midwest to teach] who said, "In that case, Gorky, you'd better leave." And Gorky said, "Yes. And I am leaving too." And Werner said, "Well, goodbye Gorky." And Gorky said, "I am leaving," and he started walking very slowly to the door of Holtzman's loft. And Werner Drewes said, "Goodbye, Gorky." Gorky came back and said, "I am going to leave if you don't behave." And Drewes said, "Goodbye, Gorky." So Gorky left, banged the door, then stuck his nose through and said, "I am leaving." Drewes said goodbye and everybody said goodbye. And Gorky banged the door and left.

De Kooning left with Gorky. According to many artists, de Kooning often seemed like Gorky's faithful, and silent, shadow. As Bolotowsky said, Gorky "used to be accompanied by a very modest fellow who never said a word; it was de Kooning, very shy, modest and unassuming." De Kooning's clothes and small stature added to the effect. "De Kooning always wore someone else's overcoat," said Joseph Solman. "It would be down to the sidewalk practically. Someone had given it to him." The general impression was of "a guy you'd be sorry for." In his quiet way, however, de Kooning was also making an important avowal. It would have been easier to stay with the catcalling crowd while Gorky grandstanded. Instead, de Kooning "voted" for Gorky's group of one. De Kooning made the avowal despite a deep and abiding uncertainty about who he himself was as an artist. Solman would regularly visit de Kooning's studio in the mid-thirties. "When he showed me his things he was always apologetic in a certain sense. He had a sort of innate modesty that was rather appealing. Even later the pictures looked unfinished. He'd say, 'I'm vorking on that.' He acted very indecisive about where he was going to go with the picture." And yet de Kooning was certain of one big thing. The picture he sought would not be found in a crowd.

In 1937, when de Kooning gave up his WPA job, he was newly alone

with his art. He had rarely worked as a solitary artist for an extended period of time; he had collaborated with others at the academy, at Giddings, at Eastman Brothers, at A. S. Beck, and in the WPA. Now, he was thrown entirely upon his own resources. Without the WPA, the poverty and isolation were often crushing. Gorky said of the years after the WPA, "If a human being managed to emerge from such a period, it could not be as a whole man and . . . there was no recovery from the blows and wounds of such a struggle to survive."

Turning inward, de Kooning once again tried to paint the male figure; or, to put it more precisely, he began struggling to piece together the fragments of a man. It was an old obsession, one that had engaged him in Woodstock in 1930, when Tully Filmus observed his fascination with male musculature and the play of light and shadow across creased fabric. In the largely unfinished and melancholy paintings of Depression-era men that now appeared and disappeared on his easel—they have been likened to T. S. Eliot's "hollow men"—de Kooning labored with compulsive determination over the smallest details of shoulders, hands, and clothing. Many of his male figures were based either upon photographs of himself or sketches he made while standing in front of the mirror. He would strip to the waist, flex his muscles, and watch the interplay among shoulders, neck, and arms. Although some of the figures bore a resemblance to de Kooning, the pictures are not "self-portraits" as the genre is usually understood. De Kooning had not yet decided how to paint a picture, let alone what to paint. The constant question of the last decade—who was he as a man and as an artist?—appeared no closer to being answered.

One day, de Kooning set about constructing a mannequin:

> I took my trousers, my work clothes. I made a mixture out of glue and water, dipped the pants in and dried them in front of the heater, and then of course I had to get out of them. I took them off—the pants looked so pathetic. I was so moved; I saw myself standing there. I felt so sorry for myself. Then I found a pair of shoes—from an excavation— they were covered with concrete, and put them under it. It looked so tragic that I was overcome with self-pity. Then I put on a jacket, and gloves. I made a little plaster head. I made drawings from it, and had it for years in my studio.

Every day, de Kooning would study this empty shell to see how he might animate it and fill "the vacuum of empty days" Jonas believed was troubling him. There appeared to be no hope of making a complete person or of creating a picture that integrated a man or artist into a whole-

seeming composition or environment. Neither the fracturing quality of cubism nor his experience in America provided a model for such a resolution. During his early days as a full-time painter, living among his incomplete men, de Kooning seemed almost monkish, an artist struggling ceaselessly with his own shadow. Never again would this quintessential painter of the female form pursue the male figure with such resolute consistency. In 1938, de Kooning made one of his greatest drawings, *Self-Portrait with an Imaginary Brother*, which was more finished in appearance than most of his contemporary paintings of men. He described the drawing—and the period in which it was made—as having an "atmosphere of being alone, kind of romantic." It portrayed two boys. The older brother held a book or drawing, the younger a ball. The older boy's free hand was close to the younger boy's, as if ready to provide a helping hand. Just as he committed himself fully to art, de Kooning chose to depict a small wide-eyed youth who seemed to stare without seeing and stood in a slightly awkward, ungainly way—he could almost have been blind—being guided by a more knowing, experienced big brother.

The picture, while not a literal description of de Kooning's life, was steeped in his personal struggles. As a child, de Kooning never had a worldly older brother to look after him. He had to make his way in America with little help. He also had to find himself as an artist. But here, he did have help. The drawing was, among other things, an homage to Gorky as his big brother and mentor in the New World. Gorky, like the older brother in the drawing, had a focused expression in his eyes and, typically, a book or drawing (rather than a childish ball) in his hand. Even the idea of depicting two figures, a favorite theme of de Kooning's, probably came from Gorky's autobiographical portrait of himself and his mother. Above all, de Kooning's drawing was suffused with Gorky's spirit as an artist. The figures seemed to emerge from the paper with delicate intensity. The lines themselves were a kind of becoming. Both boys resembled de Kooning himself.

While de Kooning's desire for "brothers" was fairly obvious, his search for an older or strong figure of authority was more subtle. There were no emotionally rich friendships with fatherly men during his early years in America and no portraits of older men. (Even Romein was more a brother than a father.) In the late 1930s, the distant Picasso, the master across the Atlantic, became the great masculine presence in de Kooning's art. And not just because he "influenced" de Kooning. Many others influenced de Kooning in the thirties, notably Miró, who continued to offer de Kooning a measure of freedom from the strictures of cubism and from the authority of Picasso. De Kooning even singled out Miró for special mention. "He

cut the Gordian knot," de Kooning said. "The idea of in and out, forward and backward. He didn't talk about it; he just did it." According to one friend, de Kooning was simply "nuts about Miró." "Those shapes [in de Kooning's early paintings] I think come from the great love that Gorky and he had for Picasso and Miró. Gorky was copying Picasso, but Bill was already finding a strange adumbration of abstraction all his own." The influence of Miró on de Kooning's painterly space, especially his abstract paintings, can be seen throughout the thirties, notably in two large works and two small ones completed in 1938.

But de Kooning's approach to composition, from the late thirties until the end of his life, was founded upon the cubist experiments of Picasso. Cubism paradoxically provided both a powerful implicit grid and an air of ambivalence—what de Kooning called the style's "unsure atmosphere of reflection." De Kooning also responded to a number of Picasso's various period styles. In his early pictures of men there were many direct references to the pre-cubist Picasso of around 1905, especially to his Pink Period. Later, de Kooning's fractured women reflected Picasso's cubist-inspired renderings of the female form. For most of his life, de Kooning would move back and forth along a continuum between more representational and more abstract styles while never quite abandoning the figure. It was a freedom, and commitment, that Picasso also insisted upon.

In the latter half of the thirties, as Gorky and de Kooning continued to talk about art as only working painters can, their conversation never strayed far from Picasso. They often stood in front of Picasso's paintings and analyzed how the forms worked structurally; they noted how Picasso brought together cubist and surrealist ideas, something both younger artists also did in their own ways. They saw more of Picasso than of any American artist, for Picasso's work often made the trip across the Atlantic—and not just through the reproductions in *Cahiers d'Art,* which American artists studied with rabbinical interest. In the thirties, when the art world was very small, the Museum of Modern Art and the galleries in New York consistently showed Picasso's art. In 1936, Alfred H. Barr Jr. organized "Cubism and Abstract Art" for MoMA, which included thirty-two works by Picasso dating from 1907 to 1929; at the same time, the Paul Rosenberg Gallery showed Picasso's recently completed work from 1934–35. *Cahiers d'Art* devoted a special issue to *Guernica,* painted in 1937 after Nazi planes bombed the Basque town into rubble; in 1937, Picasso also had three New York gallery shows. In 1938, MoMA organized "Picasso and Matisse," and the Valentine Dudensing Gallery exhibited twenty-one of his paintings. The New York apotheosis of Picasso occurred in 1939. Early in that year, ten works of Picasso's appeared in "Figure

Paintings," at the Marie Harriman Gallery, and the Perls Galleries showed "Picasso before 1910." Then, in May, the Valentine Dudensing Gallery exhibited *Guernica* and its studies. In November, Barr presented the astonishing "Picasso: Forty Years of His Art" at MoMA. This show included 362 works, among them *Guernica* and *Les Desmoiselles d'Avignon,* probably Picasso's most influential work, which the museum had acquired after two years of negotiation. It was an exhibit of shocking size for the era, especially one devoted to a living artist who continued to make new work.

In the impoverished and remote art world of New York City of that time, the impact of this succession of shows was enormous. *Guernica,* in particular, staggered many artists. Eleven feet high and twenty-five feet long and filled with indelible images of pain and suffering, it united modern form with social commentary, and made the arguments in the New York art world between politically inspired painters and modernists seem the petty factionalism of provincial artists. Already in 1937, John Graham had published his treatise *System and Dialectics of Art,* which, among other things, placed Picasso at the pinnacle of modern art. And, not surprisingly, de Kooning singled out the retrospective at MoMA as seminal to his development as an artist. But Picasso also provided something more subtle to an artist like de Kooning: an inspired form of being, a kind of metaphysical stance that fortified the latter's own sense of the artist's position in the modern world. Picasso's art was founded upon a powerful, romantic sense of "self." But this was an artist-self strong enough to sustain paradox; to change ceaselessly; to stay unmoored during a century of turmoil. He had authority, but also ambiguity. An immigrant in a foreign city, just as de Kooning was, Picasso was always "Picasso," even as he made and remade his art. With the exception of some of his cubist pictures, Picasso's "self" seemed to flow effortlessly from his hand, as naturally as a spring, creating an inimitable touch, space, and *écriture.* De Kooning would also develop one of the most personal hands in art, a symbol of ineradicable individuality in an often bleak mass culture.

Picasso confronted the past with a personal strength that sustained de Kooning's own deepest convictions. An artist who seemed to reject nothing, Picasso allowed not one but three histories to enter his art: his personal history; the history of his century, whose horror he faced in *Guernica* and whose characteristic space he explored in his cubist and surrealist works; and the history of art. This last was particularly reassuring to de Kooning and Gorky. Picasso was an authority who did not reject what came before. He could be a man of the present without abandoning the past. De Kooning would always retain this perspective, as many others

around him denounced "Europe" or made a fetish of the contemporary. "Everything is already in art, like a big bowl of soup," he once said. "And you just stick your hand in, and find something for you. But it was already there, like a stew." If de Kooning wanted to make use of the Pompeiian murals he saw at the Met, whose colors seemed mixed from blood and milk, he felt free to do so.

Picasso gave Gorky and de Kooning a form of permission: they could love and use the old masters in modern art. They could carry on a neo-romantic infatuation with Ingres and the Le Nain brothers, in particular, which proved essential in the formation of both artists' styles. (*Self-Portrait with an Imaginary Brother* owes much to the Le Nain brothers.) In the late thirties, Gorky and de Kooning would journey uptown to see two important works of Ingres newly on display in New York: his *The Comtesse d'Haussonville*, first shown at the Frick Collection in 1935; and his *Odalisque in Grisaille*, which the Metropolitan Museum bought in 1938 and immediately put on view. They borrowed Ingres's technique of making the canvas smooth and, importantly, the two great modern drafts-men steeped themselves in the eccentric life of Ingres's line, as it play-fully, sinuously, carved through space. In their work, Ingres's line would spring free from the duties of depiction.

As de Kooning well knew, Picasso came from a strong academic back-ground. The Spaniard's melancholy struggle with his inheritance during his Blue and Pink periods—and then his powerful eruption toward *Desmoiselles* and cubism—no doubt inspired the younger artist. In his own paintings of men in the thirties, de Kooning deliberately confronted his past academic training, hoping, like Picasso, to develop his own style. He could not cavalierly toss aside the past as if it were finished business; he could never throw away anything of value. Yet, there was now another, more modern, measure of man. And so, he would have to struggle to keep the academic and the modern in the same frame. In de Kooning's paint-ings of the late thirties, the academy seemed to break into polished mod-ern pieces. Often, the pose of the figure appeared as calculated as any in classical art, but also looked awkward, even goofy. The geometries could not hold; they seemed askew. De Kooning made beautiful puzzles of shoulders, forms, and contours, much as he had under Heyberg's thumb in Rotterdam, constantly revising, criticizing, rubbing out. Only now, noth-ing could be taken for granted: being modern meant that he must begin again at the beginning, despite what he had been taught. The essential par-adox of de Kooning's work in the late thirties, said Edwin Denby, was how sophisticated his understanding was of every style and artistic idea—but "on the other hand, his working idea at the time was to master the

plainest problems of painting. I often heard him say that he was beating his brains out about connecting a figure and a background."

There was one other essential Picasso permission: fiery sexual tension was a worthy subject. In contrast to many surrealists of the time, who were exquisitely, even daintily, dirty, Picasso's approach to sex was full of swagger and fight. He appeared engaged in a titanic struggle with the erotic muses, and he had many different sexual moods. In the late thirties, de Kooning, by contrast, seemed very nearly impotent and paralyzed. He brought none of the erotic release associated with his later work into his painting. But de Kooning was absorbing Picasso's art in ways that would only emerge later. There can be no doubt that the Spanish artist emboldened the younger artist erotically, setting an essential example of how an artist might figuratively touch a woman with the brush.

Of course, Picasso was also suffocating. Part of de Kooning's paralysis in the late thirties, part of his melancholy, certainly stemmed from the daunting example set by this imperious master from across the sea. According to Rudy Burckhardt, Picasso was regarded as "the one to beat." But how could one beat an artist who has done everything? How could one revolt against a father who personifies freedom? To a young artist who was struggling to define a "self," Picasso, so various in style but always inimitably himself, seemed to have his hand in every aspect of art, choking off possibility. Like their creator, de Kooning's men of the late thirties seemed mute and uncertain about how to move. Often, de Kooning would freeze up with doubt before a picture, unable to pick a way among the possibilities that lay before him. He tried to keep every painting unfinished for as long as possible—partly because he could never find a way out of a painting that satisfied him, and partly because he was already coming to believe in what a later assistant called "contradictory logic," in which the tension of opposites constitutes the truth of a painting. "No doctrine of style was settled at Bill's," Denby said. "He belligerently brought out the mysterious paradoxes left over. In any style he kept watching the action of the visual paradoxes of painting—the opposition of interchangeable centers, or a volume continued as a space, a value balancing a color." Denby described the life of a typical painting in this way:

> A new picture of his, a day or two after he had started it, had a striking, lively beauty.... But at that point Bill would look at his picture sharply, like a choreographer at a talented dancer, and say bitterly, "Too easy." A few days later the picture looked puzzled; where before there had been a quiet place for it to get its balance, now a lot was happening that belonged to some other image than the first. Soon the unfinished

second picture began to be pushed into by a third. After a while a series of rejected pictures lay one over the other. One day the accumulated paint was sandpapered down, leaving hints of contradictory outline in a jewellike haze of iridescence. . . . And then on the sandpapered surface Bill started to build up the picture over again.

De Kooning's struggles were heightened by his great ambition. If you were going to be a painter, Gorky always implied, you had to shoot for the stars. Or, as Denby observed, "After awhile one realized what it meant to him to be a painter. It didn't mean being one of the boys, making the scene or leading a movement; it meant meeting full force the professional standard set by the great Western painters old and new." Destroying his own work became a way of not settling for second best. "I destroyed almost all those paintings," de Kooning later told Selden Rodman. "I wish I hadn't. I was so modest then that I was vain. Some of them were good, a part of the real me. Just as Van Gogh's *Potato Eaters* [a great early painting of a family of peasants] is good, as good as anything he painted later in the 'true' Van Gogh style." The paintings that survived from the period did so mostly by chance: they were bought and removed from the studio before he destroyed them.

In the late thirties, de Kooning suffered from frequent fits of despondency. He told Burckhardt he was often lonely and depressed. As early as 1937, he was developing some of the nervous symptoms that later contributed to his alcoholism. He liked to work late into the night; but when his painting was not progressing well, he would become increasingly wound up and could not fall asleep. Ironically, in light of de Kooning's later alcoholism, Burckhardt suggested that he take a drink. "No, no, no," de Kooning would answer. "It doesn't do anything for me." Instead, when beset by his demons, de Kooning would pace the dark streets for most of the night, much as he had in Rotterdam, walking as far south as Battery Park at the southern tip of the city and then back. Often he went on these prowls alone, but friends occasionally accompanied him. Denby said: "I can hear his light, tense voice saying as we walked at night, 'I'm struggling with my picture, I'm beating my brains out, I'm stuck.' "

The soul-searching of the period was embodied in one poignant instance of personal invention: in 1937, perhaps inspired by the example of Gorky and Graham, de Kooning dropped the "de" from his name. Willem de Kooning suddenly became William Kooning in letters and in the references of some friends (including John Graham's spelling of his name in *Systems and Dialectics*). Apparently, even Bill de Kooning seemed too much "of" the Old World. A new and simpler all-American

artist, shorn of the "de," emerged. But the change in name did not last for long—at most a year or two. Perhaps de Kooning came to accept, even then, that it was his awkward fate to live between worlds.

Two Men Standing

Like many of his pictures from the period, *Two Men Standing* (circa 1938) contained a pair of figures—as if de Kooning must always try, for a second time, to capture the uncertain figure. Even his paintings of solitary men typically covered countless scraped-away versions. As in *Self-Portrait with an Imaginary Brother*, the man on the left was the more finished of the two, except for his hands, which were a blackened confusion of line. The man on the right was more ghostly, inhabiting his body less fully and naturally than his companion did. The legs of this second figure trailed off into insubstantial lines; his way of standing was posed and awkward, like that of a broken classical statue or a model asked to assume a difficult stance in a life class. He almost seemed to be an emanation of the more complete person. A wash of pink connected the figures.

This is a picture of a man trying to make a man. The draftsmanship goes in and out of focus. Nothing quite fits. Bodies do not settle into their place; parts do not come together. An arm looks ridiculous, de Kooning once said to Bob Jonas while standing before a painting—that shape it makes. The artist Milton Resnick once arrived at de Kooning's studio when he was scraping down a painting, modeled on a work of Picasso, of a woman who was balancing bread loaves on her head. "The trouble with a painting, you know, is that you can't get the legs under it," de Kooning told Resnick. "No matter what you do those legs are always sticking out of the plane." As a modern painter, de Kooning felt a double burden: the arm must not only look like an arm, but must also work "plastically" as an independent shape within the various related shapes of the painting. The laws of perspective tormented him; they presumed to fix forms in space. And he believed nothing was fixed. In particular, foreshortening drove him to despair. "He said vehemently that it made him sick to his stomach, not in other people's pictures, but when he did it himself," Denby recalled. John Graham, when visiting de Kooning's studio, would refuse to sit facing the easel—he found the problems on display too troubling.

The awkwardness of *Two Men Standing* is subtle, not inexpert. It evokes the struggle of a painter to find a form for a man, and a young artist

to find a place in the history of art. Its air is one of ritual mortification, meditation, and criticism. It has the color of blood and ashes. No luxury was allowed in the picture; at the time, de Kooning said he had "no idea" about how to paint hair. In *Two Men Standing*, something was struggling to be born, but the work was still very close in spirit to the paralysis and death of his "burial" art earlier in the decade. The expression in the face of each figure differs. The artist-figure on the left glares at the viewer (and at de Kooning) in a sharp and challenging way. His vaguer emanation to the right has an equally intense expression, but, in keeping with this figure's general lack of finish, one of his eyes is larger and blacker than the other. He seems to cry out for completion, as if to demand of his Pygmalion, "Make me, find me, place me." But this Pygmalion did not yet have the means. He literally did not have the hands. And perhaps that explains the challenging glare: he was asking de Kooning for hands. And all de Kooning could give him was a tangled and desperate-looking mass of scrawled and rubbed-out lines—a blackness so compressed it seems about to explode. A painter celebrated for touch could not depict a pair of hands. Eventually, de Kooning would reveal his "hand" figuratively, intimately—through the touch of the brush.

12. Friends and Lovers

Work as though every stroke might be your last.

In Chelsea, de Kooning's life filled with new friends. He still maintained his Dutch network from Hoboken, he sometimes saw his acquaintances from Eastman Brothers and A. S. Beck, and Gorky continued to be a central figure in his life. But the move with Juliet Browner to Chelsea changed his social as well as his physical environment. Foremost among his new friends were Rudy Burckhardt and Edwin Denby, who came to play significant roles in his life over the next few decades—not least in being two of his earliest champions and collectors. De Kooning first met them by chance several months after his move to West Twenty-first Street in early 1935. Juliet and de Kooning's black and white kitten, Marilee, had wandered through a window onto the fire escape next to Denby and Burckhardt's loft, located in the building next door to de Kooning's. When de Kooning came looking for the kitten, the three struck up a conversation. According to Burckhardt, "We'd been hearing loud hi-fi music drifting over: Flamenco, Louis Armstrong, Stravinsky's *Symphony of Psalms*. We began visiting."

Denby and Burckhardt were artist-intellectuals of the kind that appealed to de Kooning. Both had roots in the culture of northern Europe. Both were well educated, but showed no desire to live among the uptown swells. And their outlook was not limited to the art world; they were fluent in many other "languages," too. Edwin Denby had led a particularly unusual life. He was born in China, where his grandfather was minister to China (the equivalent of an ambassador today), and his father was a businessman in Tientsin. While Denby was still small, his father became consul general in Vienna, and Denby was educated in German schools. With the outbreak of World War I, the family returned to America. Denby never lost his fascination with European culture, however, and after three years at Harvard and one in Greenwich Village he returned to Europe for more than a decade. He studied modern dance in Vienna (and talked his way into meeting Sigmund Freud), and, while on a dance tour to Basel, met a young Swiss photographer and filmmaker named Rudolph Burckhardt. Eventually, after Denby returned to America, Burckhardt joined him there. Denby began writing a dance column for an influential magazine

about avant-garde music called *Modern Music.* Burckhardt was making short experimental films with music composed by Paul Bowles, the modernist composer and, later, writer.

The friendship among de Kooning, Denby, and Burckhardt was based not only on proximity, but also on a shared interest in related—but different—artistic worlds. Denby and Burckhardt were fascinated to observe, up close, the life of a serious painter. De Kooning, for his part, enjoyed their wide cultural purview. Denby and Burckhardt's far-flung circle encompassed what Denby later called "the three worlds—the dance world, the music world, and the painting world." Bowles was a great friend of Denby's. So, in the mid-thirties, was the composer Aaron Copland and the music critic and composer Virgil Thomson. In a few years, Merce Cunningham, the modern dancer and choreographer, and John Cage, the avant-garde composer, would also join the circle; Cunningham arrived in New York in 1939, and Cage in the early forties. It was an intellectually vivacious world, and one with gay overtones.

De Kooning was not a perfect fit, by any means, in this refined circle. For one thing, he never really enjoyed experimental music; he once complained to Burckhardt, after leaving a concert of Cage's music, that it was "just bips" and that he "liked Offenbach much better." For another, he was not always enamored of the homosexual manners of Denby's crowd, though de Kooning was not himself homophobic. But he was genuinely interested in such writers as James Joyce and Gertrude Stein, who were much discussed in Denby's loft. And he enjoyed dance. According to Milton Resnick, who became a friend of de Kooning's in the late thirties, "Bill was not a very cultured guy, but he liked the ballet."

Another circle of friends in Chelsea, drawn together by a serious love for music, met once a week or so in the apartment of a musician named Max Margulis, who lived at 300 West Twenty-third Street. A violinist and singing teacher, Margulis (known affectionately as "Max the owl" because of his thick glasses) was a man of diverse gifts. He was a boxer; he helped produce the fabled Blue Note jazz series; he was also, later on, an experimental photographer. "I think maybe this fellow who did our machines [record players] got us together," said Margulis, describing how he first met de Kooning. "He built a component system for us [hooking up the turntable to speakers]." Margulis owned all the newest records. "In those times there were not many records," he said. "A couple of Mozarts, a couple of Schuberts." The repertory at Max's was mostly classical, but, as Margulis noted, de Kooning also loved jazz: "He went to hear Louis Armstrong and all of those guys."

In 1936, while he was working for the WPA, de Kooning moved with

De Kooning in his loft on West Twenty-second Street, 1937

Browner one block north. Their new building, at 156 West Twenty-second Street, between Sixth and Seventh Avenues, was diagonally across from their previous loft. The building had been constructed, according to Burckhardt, as a loft space for small factories. Although de Kooning's new quarters were substantially bigger than his old ones on Twenty-first Street, there was a significant drawback. Whereas the first building had been designated as residential, the second was commercial, which meant that it was illegal to live there. And there was no hot water: each tenant had to heat his own. This loft, as spartan as its predecessor, was long and somewhat narrow, with white walls, gray linoleum tiles, and a few pieces of furniture that de Kooning built. "It was very spare, like he had been a pupil of Mies van der Rohe," said Joseph Solman. "There were a few chairs and a table, in simple biomorphic shapes." The overall feeling was one of quiet simplicity—"You might say ultramodern or Japanese. That's the way he liked it."

A photograph taken by Burckhardt in 1937 bears out Solman's memories. It is a picture of almost startling clarity. De Kooning, hands in pock-

ets and one leg canted to the side, stands near the back wall of his loft, his expression half welcoming, half quizzical. A door behind him leads to the fire escape that ran down the back of the building. To his right is a large window, its four rectangular panes of glass echoing the panes in the glass door. Against the back wall, between the window and the door, stands a single rectangular table. On top of it a slender rubber plant leans to one side. Visible in the foreground is the bottom of de Kooning's bed, neatly made and covered with a striped blanket. Everything is shipshape, orderly, and masculine; there is no trace of a woman's presence. In the reflected light, the floor appears gleaming and spotless. As long as he lived on Twenty-second Street, friends said, de Kooning would knock off work early on Saturdays in order to scrub down his loft. He loved a clean slate.

His life followed a fairly predictable pattern. Days began slowly. Like most other artists of the time, de Kooning routinely slept until ten or eleven in the morning. Several strong cups of coffee later, he began the day's work and painted late into the night, with a break for dinner. Often, a visitor would stop by. By the late 1930s, the artists' informal system of dropping in on each other's studios, to say hello and chat about works in progress, was an essential part of the day. Since nobody had a phone, visitors would announce themselves by yelling up to the open windows of the studio above. Sometimes de Kooning would stop painting around seven or eight p.m. and join Raoul Hague, who lived nearby, or another friend for dinner. De Kooning and Hague would go together to the local Syrian and Greek restaurants that Hague fancied, but almost always alone, since Hague, who later became a hermit, was deeply suspicious of strangers. Or de Kooning might meet Gorky and Graham for a night at Romany Marie's; these two friends rarely ventured north and west of the Village to visit de Kooning in Chelsea. On pleasant summer evenings, de Kooning and his friends might also join the crowds listening to the political speeches and debates at Union Square. Or they would congregate at Washington Square Park, a twenty-minute walk to the south. It was on one such evening that de Kooning, restlessly roaming the streets late at night, first met Mark Rothko, who rarely went to the artists' cafés:

> And so, one night in the park, it was late, wasn't a soul around. I walked around—thought I would sit a little bit on a bench. I was sitting way on the right side of the bench and kind of a husky man was on the left end of the bench, and I thought maybe I ought to move and sit on another bench. Maybe people would think we were a couple of old queers or something. I didn't know what I was thinking. We were just sitting there—wasn't a soul around. . . . And we just sat there until Mark said

something like it was a nice evening. And so I said, "Yes, a nice evening," and we got to talk.

I guess he must have asked me what I did. I said, "I'm a painter." He said, "Oh, you're a painter? I'm a painter, too." And he said, "What's your name?" I said, "I'm Bill de Kooning." I said, "Who are you?" He says, "I'm Rothko." I said, "Oh, for God's sake," and said it was very funny. Then we talked and a couple of days later he came to visit me in my studio.

As always, de Kooning befriended eccentrics with a powerfully idiosyncratic sense of self. One such figure, who often visited de Kooning in his loft or accompanied him to the local cafeteria, was a sculptor named Martin Craig who lived one floor below de Kooning on Twenty-second Street. The two shared an avid interest in surrealism. A chemist as well as an artist, Craig transformed his loft into something resembling a mad scientist's retreat, full of test tubes and welded, semi-abstract sculpture. "He and Bill were certainly more far-out than I was," said Solman. According to Herzl Emanuel, a friend of both de Kooning's and of Craig's, "Martin was very much involved in the modernist idea. But I think his main inspiration came from surrealist sources rather than cubist sources."

By far the most popular meeting place for local artists was the nearby Stewart's at Twenty-third Street and Seventh Avenue, which, along with the one near the Artists' Union headquarters at Sixth Avenue and Eighth Street, had become a regular hangout. Invariably there would be a group assembled there—most of whom had met one another through the WPA—lingering over nickel cups of coffee and discussing the state of art and the world. There were also two additional artist meeting places in the otherwise dark and deserted neighborhood. One was the Oasis Bar, across the street from Stewart's. The other was a Horn & Hardart Automat. Together, said Milton Resnick, the three places constituted "the center of the art world at that time."

For artists who painted alone all day, the late evenings at Stewart's offered a kind of vigorous release, a lively and ever-changing round of debate, jokes, and discovery. Hunched over in their chairs, cigarettes in hand, the regulars at Stewart's would pick apart the history of modern art, trying to understand what worked. Conversation kindled the hope of finding a new way into the history of art. Sometimes, the discussion would become very abstract, emphasizing, for example, the "process" of painting itself as an intrinsic good. Since there were few buyers, art seemed an end in itself. The properties of paint developed a kind of mystery that de Koo-

ning would one day joyfully celebrate. Resnick said a conversation about paint might go this way:

> There's a dimension that we don't understand. In other words, if you have a landscape or an interior you have a space. You can deal with it in terms of images or what-not. But you can't really understand what paint is doing. Paint is doing something that you ask it to do in order to get the nose on somebody's face. The paint also does something that isn't the nose on the face. What it does is fascinating. It's a new geography.

Often, after the cafeteria closed around one or two in the morning, the debaters would return to de Kooning's loft "and talk some more and make coffee," said Denby. "I remember," he added, "people talking intently and listening intently and then everybody burst out laughing and started off intent on another tack." Robert Jonas said that every artist would act as if he were the ultimate authority on the history of art in general and on cubism, futurism, and impressionism in particular.

Like de Kooning, many artists in Chelsea no longer worked for the WPA, and had to scrap around for money. The communal poverty helped establish a friendly camaraderie. There was no such thing as artistic rivalry. Nothing sold, and nobody was known, and nobody expected that to change. "There wasn't this terrible eagerness to make it," said the artist Ibram Lassaw. "It was beyond our imagination. In the thirties and forties artists didn't become artists because they thought that was a way of making a living. Without being self-conscious about it, we thought being an artist was a very noble thing, a way of life, almost like a religion. But we didn't say so in so many words, because that would be self-conscious." It was this camaraderie that led to de Kooning's first public recognition in America and to a welcome financial boost. Owing in part to his long friendship with Robert Jonas, de Kooning received a commission to design one of three murals for the Hall of Pharmacy at the World's Fair in New York, which was scheduled to open in April 1939. Earlier in the thirties, not long after de Kooning and Jonas began to work together at A. S. Beck, de Kooning happened to bump into Jonas and one of his best friends, Michael Loew. Like Jonas, Loew was very active politically; he would soon be one of the founders, and later a president, of the Artists' Union. At that first meeting, de Kooning was by chance carrying a red book with him that Loew, an ardent leftist, immediately recognized as Marx's *Das Kapital.* Loew was even more impressed when Jonas took him to de Kooning's studio. According to Loew's widow, Mildred, the two "formed a mutual admiration society."

The Hall of Pharmacy mural at the World's Fair, on which he collaborated with his friend the artist Michael Loew, 1939

Not long afterward, Loew began dating a sculptor named Beverly Woodner. Her brother, Ian, a graduate of Harvard's school of architecture, was so ambitious that he submitted several different designs for World's Fair projects under different names. When he won not just one but two commissions for buildings, he turned to Loew for help in decorating them. Knowing that he could not possibly complete two big jobs in the allotted time, Loew recommended de Kooning for one of them and brought the architect to de Kooning's studio. "You're right, Mike; he's good," said Woodner, and the deal was on. From late 1937 until early 1939, de Kooning divided his time between painting male figures and working on the mural. He answered to a Spaniard named Peixote. De Kooning later said of Peixote: "He accepted my work. I knew how to flatter him, how to handle him." The remark was telling, demonstrating that de Kooning could be manipulative when necessary. It was one of the few instances in his life (his handling of the Irishman who checked off artist-workers for the WPA is another) where he revealed in his own words the shrewdness that lay beneath his seeming innocence, as well as a workingman's ability to get his way with the boss.

In keeping with the grandiose theme of the World's Fair—how mankind would benefit from the technology of the future—the Hall of

Pharmacy was ambitious in scale and conception. Altogether, more than three hundred buildings would be built on the twelve-hundred-acre site in Queens at the astounding cost of $125 million to $150 million. The Hall of Pharmacy was allotted an auspicious location just off the Long Island Expressway, which skirted the fairgrounds. (Thousands upon thousands of motorists would have a panoramic view of the pavilion's curved wall and its brightly colored murals.) For de Kooning, the project was a welcome chance to gain public recognition—especially since his two WPA murals never got past the preparatory stage. He was asked to create a sketch that would be executed by professional muralists; two other sections of the mural were to be designed by Michael Loew and Stuyvesant van Veen. All together, the mural measured ninety-two feet long and twenty-nine feet high. The general subject was "Production," with the sun's power "streaming in brightly colored rays to the earth," wrote Loew in an official press release. As in his sketches for the WPA murals, de Kooning employed biomorphic forms reminiscent of Arp and Miró on his third of the mural. At one end of the image, a standing figure beckoned to a bird flying toward him. This bird, which may represent the scientific imagination, seemed to lead a long flowing mix of stylized imagery, evocative of both life-forms and scientific instruments, toward the figure. De Kooning enjoyed the project but was not a natural muralist. He was uncomfortable with the scale of the genre, which did not reflect his instinctive sense of the human dimension.

In addition to *Self-Portrait with an Imaginary Brother*, one other drawing from 1938 had a particularly personal meaning for de Kooning. Its subject was a pensive female nude created at a time when he was utterly absorbed in pictures of men. She could almost be an odalisque by Ingres, her head lying on one arm and her long and lean torso curving gently down to her legs. At the same time, de Kooning's emphasis upon the geometric structure of her body reflects his interest in cubism. Her face even seems presented from two different perspectives, as if midway through the drawing the artist, having begun in a fairly academic style, changed his point of view and adopted more openly cubist ideas. Despite the analytical detachment, both the drawing and the figure herself appear suffused in melancholy reverie. The model, of course, was Juliet. The drawing was the last of a series that de Kooning had begun when they met four years earlier. The earlier ones had been highly figurative; over time, however, the drawings followed de Kooning's evolution away from his academic training and toward a somewhat more geometric way of rendering the shapes of the body. Years later, Juliet described how he worked during this period, as he tried to puzzle out the figure: "He would take a long time to finish a drawing. He would think a lot. It took him more than a week to draw my eyes.

Reclining Nude *(Juliet Browner), circa 1938,*
pencil on paper, 10 $\frac{1}{4}$" × 12 $\frac{3}{4}$"

He wanted to draw them in the style of Leonardo, showing the outside of the eye as the inside. The part above the eye he wanted to draw without the skin around it. I remember him drawing on his knees."

Not until the forties did de Kooning make confrontational images of women. Instead, his women were either tightly drawn and realistic or evoked in an abstract flow of biomorphic ovals and loops. But the new drawing of Juliet seemed to reflect a distancing that was personal as well as aesthetic. By 1938, de Kooning had begun to tire of Juliet. He was never entirely faithful to her. Nini Diaz, for one, remained in the background. Once, Diaz even moved in with de Kooning and Juliet in their loft. On Christmas Eve of 1937, after a year and a half of performing—first in America in the WPA circus and then abroad with a vaudeville troupe that toured England, Sweden, and Germany—Nini arrived in New York with no money and nowhere to stay. And so she turned to de Kooning for help. For a while, she recalled, she slept in the same bed as Bill and Juliet with Nini on one side of Bill and Juliet on the other.

De Kooning's habit of vacillation in his relationships with women was underscored by this on-again, off-again affair with Diaz. He was still loath to make anything in a relationship final, conclusive, or complete; his life had to remain open-ended and unconfining. De Kooning, of course, had asked Diaz to leave in 1934 when he met Browner. But he never straightforwardly ended his relationship with her. While she was performing abroad, Diaz said, he even wrote her to propose marriage. In all likelihood, de Kooning did not really want to marry Diaz. His relationship with her may have been, in part, a way to protect himself from Browner's desire for more commitment just as, years later, he would not divorce Elaine de Kooning, partly because the marriage meant he did not have to marry anyone else. (Once in the late seventies, de Kooning asked his studio assistant, Tom Ferrara, if he had any plans to get married. Marriage, de Kooning said, was something everyone had to do *once.*)

It was Juliet's desire to be married, in fact, that led to the cooling of

her relationship with de Kooning. In later years, women who became involved with de Kooning remarked on his intense dislike of commitments, often blaming his formidable mother. "He resented any hold on him," said Joan Ward, the mother of de Kooning's daughter, Lisa. "Bill also had an intense distrust of women underneath." Juliet's neediness made the situation worse: a clinging vine is more charming in the early rather than the late stages of a love affair. She could sometimes seem too fragile, too delicate for the world. Still, de Kooning did not break off the relationship outright. Finally, Juliet accepted the inevitable, just as Nini had before her. Around the summer of 1938, she moved out of the loft on Twenty-second Street and into a room with Diaz, in a further twist of the unusual relationship among the three. But she was still "madly in love" with de Kooning. Elsa Walker, who had grown up with her in the Bronx and remained her best friend, suggested that she leave New York for an extended vacation. Why not go to California, suggested Elsa.

In 1940, Juliet did go to California—and never returned. It was there that she met the surrealist photographer Man Ray. The two were instantly attracted to each other; they set up house together after a matter of days and were married several years later. For Juliet, it was the necessary cure. (Earlier, her wistful letters home to friends had been filled with thoughts of Bill and of how much she missed their intense physical relationship.) De Kooning, by contrast, was relieved to have Juliet gone. He was particularly pleased to have his studio to himself. It is striking, in the reminiscences of those who knew de Kooning in the twenties and thirties, how peripheral the women in his life seemed. They were always there, but in the background; his friends could recall what they looked like, but little more. As long as a woman was attractive, it seems, any of a number of them could have been de Kooning's companion.

Once Juliet left, de Kooning, for the first time since moving from Hoboken to Manhattan, was a man without a woman. There was nothing unusual about this in the downtown milieu of painters. It was a singularly male environment, with the easygoing camaraderie of a group of men devoted to their work and keen to discuss it. Elaine de Kooning once commented wryly that for Bill "a woman is a woman is a woman." Sometimes, de Kooning would complain to Denby and Burckhardt that all women came with unwelcome strings attached. "These women," he told them. "You have to take them home at three a.m. Then you lose a day of work. And the next day there are these ashtrays with cigarette butts with lipstick on them." During the withdrawn period when he was painting his series of men, de Kooning, only half facetiously, joked that he was going to swear off women: "I tink I'm going to be queer."

13. Elaine

She had such beautiful hair.

I n the late fall of 1938, a twenty-year-old art student named Elaine Fried spotted de Kooning across a bar. "I thought he had seaman's eyes that seemed as if they were staring at very wide spaces all day," she later wrote. "He had an inhuman look—vacant, limpid, angelic." A few days later, a friend took her to his studio. "It was the cleanest place I ever saw in my life," she said. "It had painted grey floors, white walls, one table, one bed, four chairs, one easel, one fantastically good phonograph that cost $800 when he was only making twenty-two dollars a week, and one painting of a man on the easel." The effect upon her was "that this man was great."

Elaine de Kooning never got in the way of a good story. She was the sort of artist who refused, on principle, to let facts disturb a higher truth. Not surprisingly, her account of her early meetings with de Kooning has a heightened sound, as if she knew history would be listening: she immediately recognized his genius and they were, instantaneously, soulmates. *Of course.* There is no doubt that the attraction between them was intense, nor that she would become the most significant woman in de Kooning's adult life. But Elaine was also primed to admire de Kooning before she met him. On that day in the bar, what intrigued Elaine was not only de Kooning's appearance, but his already formidable reputation among the painters downtown.

Two years before, Robert Jonas—Elaine's boyfriend at the time—had taken her to an exhibit of the work of the American Abstract Artists. He told her that the two best artists in America were not in the show. Their names, he said, were Arshile Gorky and Bill de Kooning. Jonas was not alone in this view. By the late 1930s, de Kooning was already widely admired in the art world of New York. "Even before Elaine met him he attracted attention, though he didn't have any money and he didn't have any shows," said Ernestine Lassaw, the wife of the sculptor Ibram Lassaw and one of Elaine's oldest friends. His contemporaries respected his classical training; they respected even more his attempt to move beyond such training and become a modern painter. By the time she met

de Kooning, Elaine had become Milton Resnick's girlfriend. He was no less enthusiastic than Jonas when de Kooning's name came up—though Resnick himself had yet to meet him. "Bill is going to be the greatest painter in the country," he told her. This was high praise from Resnick, a judgmental artist who did not lightly make such pronouncements.

Elaine posing for de Kooning in 1938, the year they met

Close friends from their early days together disagreed about how much Elaine was influenced by her heart when falling in love, and how much by such assessments. She was a woman for whom love and ambition were intertwined in a marvelously complex way. "She once told me that she married Bill because someone told her that he would be the greatest painter," said the artist Hedda Sterne, who met the couple in 1942. "But I didn't believe her. She wasn't that calculating." Others were not so sure. According to the artist Janice Biala, who met the couple in 1940 and lived near them in Chelsea, "Elaine was on the make, you see, but not in the way that some people are who want to marry rich people. She was on the make in the intellectual world. She saw that de Kooning was somebody." Elaine's sister Marjorie Luyckx, who shared a room with her at the family's house in Brooklyn, took a more romantic view. She remembered her sister coming home the night she met de Kooning. Elaine's attraction to Bill, she said, "was pretty instantaneous."

On her first visit to his studio, de Kooning showed Elaine his work. There was no question about his feelings. Suddenly, the reserved de Kooning, who had never pursued a woman in his life, was madly in love. "There was nothing subtle about it," said Ernestine Lassaw. "He was *crazy* about her. He told everybody how much he liked her." The German photographer Ellen Auerbach was introduced to de Kooning not long after he met Elaine. "He was TERRIBLY in love," said Auerbach, who took some photographs in the late 1930s of the couple. It was Elaine who would

help inspire and provoke de Kooning to leave his exile among men—and come home to his greatest subject, the female figure.

Elaine Marie Fried was born in Brooklyn on March 12, 1918, a date that she decided, early in life, made her seem too old, so she chose to have been born, instead, in the year 1920. She was the first of four children from a singularly odd marriage. Her father, Charles Fried, came from a German family that settled during the nineteenth century near Livingston Manor, New York, in the Catskill Mountains. He grew up in a German-speaking enclave there. Eager to see more of the world, Fried left as a young man for New York City, where he got a job baking bread in Yorktown, then a heavily German area on the Upper East Side. He remained in the bakery business thereafter, becoming an accountant in the main office of the local Bond bread company in Brooklyn and finally the plant manager. He loved tending the garden behind the family's house at 2308 East Fourteenth Street in the Flatbush section of Brooklyn and was "very steadfast, very practical," said Luyckx. "Thank God; he was the practical angle in our lives." By contrast, Elaine's mother, Marie Fried, was a brilliant eccentric. Born Mary Ellen O'Brien, she came from "a very Irish household," according to Luyckx, and was "a dreamer, a reader, completely impractical." The artist Joop Sanders, who met de Kooning and Elaine in 1940 and became a family friend of the Frieds' soon afterward, described Marie this way:

> She was very eccentric, with all kinds of idiosyncrasies. Her makeup was like she had literally stuck her head in a barrel of flour. She had a snood net which was used then, and it all looked as if she slept in her clothes. You couldn't take her for more than ten minutes. But there was this very, very bright intelligence, self-educated, with these snatches of brilliance.

According to the painter Jane Freilicher, who grew up in Brooklyn near Elaine, "I remember seeing [Marie] and thinking, 'This is her mother?' I always thought Elaine was admirable not to be embarrassed about her mother because her appearance was so strange." In later years, Elaine began many stories with the wry remark, "Behind every artist is a mother." Marie Fried was a histrionic romantic who always wanted to live on a higher plane. She could not bear the thought of her extremely ordinary life married to a businessman baker in Brooklyn. She was fluent in French "and would say things like, 'Now we all have to learn the Greek alphabet,'" said Elaine's brother Conrad. "She was kooky—irresponsible

but extremely intelligent." Almost every weekend she would take her children to museums and libraries and even to the theater, less for their sake than to relieve her own anxieties and nurture her aspirations. She never considered whether or not the activities were suitable for her children. "She took us to Broadway plays that were way beyond us," said Luyckx. "Like *Macbeth*, with all the bloody descriptions and so forth. She didn't pull any punches." According to Ernestine Lassaw, "She studied all her life. She studied French, everything. But she didn't study her children very much."

In part, Marie's neglect of her children's basic needs stemmed from her own frustrated ambition. She had had four children in five years—first Elaine, then Conrad, Marjorie, and Peter. Having had the children, she seems to have felt little obligation to look after them. Often, according to her children, there was no food in the icebox. "She felt that she had missed half her life," said Lassaw, and so she channeled her energy into her own, often fanciful pursuits. At one point, for example, she resolved to play the mandolin and even had a blue instrument made especially for her use. But there was also a darker side to her neglect—one that her children, especially Elaine, tried to keep hidden later in their lives. At times, Marie was mentally unstable. Once, while the children were still very young, their mother was actually committed to Creedmore, a psychiatric institution in Queens. What triggered the institutionalization was a report to the authorities of child neglect from several neighbors. Her children appeared unkempt and malnourished. One, Conrad, even suffered from rickets. When the police came to her house, Marie went berserk and refused to leave. As one policeman held out a hand to her, Marie backed up to the stairs that led to the second floor of the house, grasping the banister. When they continued to insist that she go with them, she began kicking out at them with all of her might. "So they grabbed her and dragged her out screaming," said Conrad. The effect of this scene upon her children— Elaine was six years old—was profound. Conrad remembered cowering behind another woman as his mother was hauled away. Once she was diagnosed, Marie was committed to Creedmore for a year. A housekeeper stayed with the children. Marie would have been institutionalized for life had not Charles Fried felt a moral obligation to care for her. He vouched that he would do so for the rest of her life.

In such a household, the children naturally looked to their oldest sister for direction. Elaine, even as a child, had a take-charge personality, one strengthened by her special relationship with her mother. If Marie neglected her children's basic needs, she also focused enormous, if spo-

radic, attention upon Elaine. "Her mother adored Elaine," said Ernestine Lassaw. "The others were kind of . . . not as important." Marie would call Elaine "my Samson," assigning to her all of her own frustrated ambition and desire for power in the world. The selection of "Samson" as a term of endearment for a daughter was certainly eccentric, conveying the message that a woman must be masculine in outlook and could be destroyed by a Delilah-like femininity. According to Lassaw, "I think the mother liked the idea that Elaine was ambitious." As early as the age of seven or eight, Elaine was playing the part of mother-protector and ruler of her siblings. At home, she would make certain that there was something to eat and that the children stuck together. In exchange, they hurried to please her, even getting her coffee in the mornings. Elaine would continue over the years to be the benevolent dictator of her family, giving her siblings money when she had it or taking them on trips. The legacy of their childhood kept the four emotionally close throughout their lives, in the way of people who have undergone a crisis together. "I remember once at a party we were all in our late teens and early twenties and somebody asked the host who the two 'couples' were," said Marjorie. "It was us, the four of us. The host said, 'They're not married. They're brothers and sisters.' And the man said, 'Well, haven't they seen each other lately?' The host later told me about that, and I realized we did that at a number of parties."

Her mother's psychosis had a powerful effect upon Elaine. She willed herself into becoming the smart, funny, self-confident person that her mother and others expected her to be, just as the larger Fried family had expended enormous energy during their childhood years in attempting to maintain the illusion that they were just another happy family. And she flourished as a child, despite the shadow of her mother's problems. Coordinated and quick, both mentally and physically, Elaine rapidly extended her dominion beyond her siblings to the neighborhood. "My Samson" bested the local marble-shooting champion one memorable day, arriving home with his fanciest marbles as her trophy. Dinnertime conversations were feisty debates that Elaine was determined to win. "We didn't have conversation; we had arguments," she later said. Her competitiveness extended to art. "When I was five, I made drawings like all children," she said. "And when I was eight years old, my friends began to ask for my drawings. And so I began to have a little ego about it. There were a couple of other children whose drawings also other children would ask for. And I became competitive with them." When she was ten years old, she said, she noticed that Raphael had done a certain painting when he was thirteen. "Well," she thought to herself, "that gives me three years." According to her sister,

"She would draw all the time. We had a lot of art books in the house. She liked romantic subjects—the West—and she liked to draw animals."

In 1932, Elaine entered the local Erasmus Hall High School, an institution that held an exalted place among New York City's public schools. The second oldest secondary school in the country, it was founded as a private school in 1787 by the Dutch Reformed Church to serve the descendants of the Dutch farm families that had settled in the area. In 1896 it became a public school, and an imposing neo-gothic edifice crowned with Oxonian towers was built on Bedford Avenue, the central street of Flatbush. The vast complex, built around an inner courtyard, housed a stately library with heraldic stained-glass windows and an athletic wing with a swimming pool. In February 1934, it also housed a staggering 8,263 students, the result of the lack of jobs during the Depression. With no employment in sight, far more students than usual—most of them the children of Irish and Jewish immigrant families in the area—simply stayed on in school as long as possible. By the time Elaine entered high school, she was more physically fearless and competitive than ever. She excelled at sports. She was on the girls' champion baseball team, undefeated for her three seasons, and she was an outstanding hockey player. She also loved ballet, said her sister and, of course, art. "There was a wonderful art department and an art club. The Line, Mass and Color Club. It was run by a Miss Ragan." Elaine's grades were always high, her sister said, "all A's, always."

With her slim, agile body, striking reddish-brown hair, and lively manner, Elaine was already developing into the life of the party and the vivacious leader of her peers. "Elaine the fair, Elaine the lovable, Elaine the lily maid of Brooklyn," reads an admiring tribute in the Erasmus High yearbook. In January 1936, when Elaine graduated from the school (midyear graduations were then common), she knew that she was keenly interested in art and that she wanted to get out of Brooklyn. Like many artists and intellectuals born and raised across the Brooklyn Bridge, Elaine longed to make it in Manhattan, which she knew from the family trips to museums, libraries, and theaters. She enrolled that spring at Hunter College, the prestigious and demanding public college in Manhattan, but left soon after. She was unhappy, she later said, without a paintbrush in her hand. While college might be interesting, art was essential, and she believed she could not do both. That same spring she enrolled at the Leonardo da Vinci Art School, an old-fashioned Italian-style art school originally founded in a church on Tompkins Square on Manhattan's Lower East Side. (The founders, a family called the Piccirilli brothers, had

envisioned a place where the local Italian boys could go to keep out of trouble, "to keep them from becoming Mafias, I suppose," said Peter Agostini, who attended the school and became a casual friend of de Kooning's in the late thirties.) By the time Elaine entered Leonardo da Vinci, it had moved farther uptown, to Third Avenue and Thirty-fourth Street. Thanks to the WPA, a cadre of artists was assigned to the school to serve as teachers and supervisors.

One of Elaine's teachers for a still-life course was a young artist named Conrad Marca-Relli. A first-generation Italian American who would later become a good friend of de Kooning's, Marca-Relli had grown up in Boston, but from the age of seven to fourteen, he also frequently visited his relatives in Italy and studied there. Like de Kooning, he was a highly skilled draftsman. He, too, had been classically trained; he liked to use an extremely fine pencil and work over the same drawing for weeks. And he loved the old masters; it would prove to be one of many interests that he and de Kooning shared. But while Marca-Relli was important to Elaine as a teacher, it was de Kooning's old friend Robert Jonas, his deputy and the supervisor of the class, who in the late 1930s would transform Elaine's life. According to Jonas, Elaine arrived in class that fall carrying a thick book on schizophrenia. She did not know very much about art, he said, but she was very good-looking and very hip, as carrying around the book on mental disorders made clear; at the time, Freud was much discussed in enlightened avant-garde circles. (Jonas did not surmise that Elaine was also trying to understand her mother.) The two quickly became a couple, Jonas said. During this period, according to Jane Freilicher, "She seemed very dashing in a black trench coat and a beret. And she was very poised. She had very bright red hair as a young girl, in a pageboy. And she had a strange accent that didn't make sense geographically. I don't think it was affected, but it was definitely not Brooklyn. I remember when I met Rudy Burckhardt, he said, 'At last a girl from Brooklyn who has a Brooklyn accent!' "

Throughout 1936 and 1937, Elaine continued to live at home while commuting into the city to immerse herself in the art world. By the age of eighteen, she later said, she had already committed herself to being a serious artist, drawing all day long "and just completely being submerged in that activity." With Jonas as her guide, she made the rounds of gallery and museum shows and, when Marca-Relli organized a private class in a studio on Fifty-seventh Street, she began attending that as well. She also became politically active, representing the da Vinci School at meetings of the John Reed Club, which was trying to organize art students into an auxiliary Artists' Union. It was at one such meeting that Elaine met her

first serious boyfriend, Milton Resnick, who worked at the American Artists School on West Fourteenth Street and, like Elaine, represented his school at the meetings.

Like Elaine, Resnick was raised in Brooklyn. He had been born in Russia, to a Jewish family that emigrated to America in 1923, and studied drafting, lettering, and drawing at the Hebrew Technical Institute for several years. But he wanted to be a serious artist and began taking a night course in illustration at Pratt Institute and working at the American Artists School. His approach to art was passionate, romantic, and determined. "There were times I thought, 'If I don't stop, I'm going to die,' " said Resnick. "I don't know if there's anybody else who worked like I worked." Resnick ran the elevator at the school and painted in a storage room that he converted into a studio. "I had been living like a bum artist since I was seventeen years old, when I left home," said Resnick. "For two years I was living in a furnished room and spending all my time at the American Artists School."

Prompted by Resnick, Elaine left the da Vinci School for the American Artists School. "Everybody who was of interest in the art world came [to the American Artists School] either for lectures or talks," said Milton Resnick. "It was the center of the art world in a way, much more so than the Art Students' League [the more formal uptown academy, which was slow to embrace Picasso, Matisse, and modern art]." Stuart Davis taught there, as did the well-known social realist painters Moses and Rafael Soyer. Elaine supported herself by working as a model, sometimes in the nude. She also joined the Models' Union, the sister organization to the Artists' Union. She and Resnick moved into a loft together on Fourth Avenue and Twenty-ninth Street in Manhattan. Since Elaine still officially lived at home in Brooklyn and had to report to her mother about her overnight stays in the city, she invited Ernestine Lassaw, a classmate of Resnick's, to share the loft with her. Ernestine understood precisely what her role was: to provide cover for her nineteen-year-old friend. "She persuaded me to share a loft with Milton so she could have a place to come to in the city. It was a very dark, dismal place. Everybody who walked in got scared. It was in a business building, and it had been God knows what. It wasn't big; in fact, it wasn't big enough for all of us." Over the next few months, Elaine studied with a teacher named Milton Nibald and painted portraits and scenes of city life in a social realist style. She continued to dabble in politics and flirted with communism. At the time, the American Artists School was "the center of the American Communist Party," said

Resnick. Elaine attended a Workers Camp sponsored by the Party. "It wasn't so much communists as YCL'ers, the Young Communist League," said Marjorie Luyckx of the school. "None of us ever became communists. But we were all very young, and all the artists in those days were leftist."

Meanwhile, Lassaw, who was still serving as Elaine's cover, left the American Artists School and took a job as editor of a comics magazine. (But she continued to paint what were, for the times, quite radical nudes.) Sometime in 1938, Elaine, Milton, and Ernestine moved together to a roomier apartment on East Twenty-second Street between Broadway and Fifth Avenue, several blocks across town from de Kooning's loft on West Twenty-second Street in Chelsea. According to Ernestine Lassaw, Elaine, in contrast to many women artists of the period, approached art in an ambitious, competitive manner. She set up a studio in the new apartment and worked hard. At the same time, in the male-dominated world of the thirties, the way for most women to get ahead was through a relationship with a man. Resnick was a beginning artist without a reputation. De Kooning was a serious artist in his thirties and widely respected downtown—and, after all, not so much older.

N o one could have predicted the effect she would have upon de Kooning. "I don't think he had fallen in love with anyone before," said Lassaw. "[Women] had just sort of moved in on him and he accepted them. But I don't think he cared about them very much. He was very passive about it." Now, de Kooning seemed to lay siege to Elaine. He offered to give her drawing lessons. Discerning the importance to Elaine of her family, he made a point of meeting her brothers and sister and invited them to spend time in his studio. "He was so sweet," said Marjorie Luyckx. "He used to keep asking me to push her to marry him." As Elaine later made clear, she was just as eager to win his affection. But she played hard to get. "Bill was incredibly in love with her, but she didn't treat him very well at the beginning," said Rudy Burckhardt. "She was a great beauty. She would lean back on the couch and say, 'Bill. Cigarette.' And he would leap to get it." Elaine would sometimes brag to Ernestine that she was the best and most attractive model in New York; she was even voted "Most Beautiful Model" by the Artists' Union. She certainly had the romantic allure of the "lily maid of Brooklyn" described in the yearbook. "He thought she was adorable," said Joop Sanders. "He was crazy about her looks, and especially her hair, which was thick, a lustrous shade of reddish brown and curly."

It was Elaine's intoxicating vitality, however, that most attracted men and women alike. She always wanted to excel—to be the first, the funniest, the fastest—even when having fun. She was challenging and physically fearless. If someone dared her to leap off the top of an upright piano in the middle of a party, she would gladly oblige. If in later years she felt like joining a game of softball with the men, she would do so, running between the bases in high heels. "She was a daredevil," said Hedda Sterne. "She believed enormously in gestures without regret, and she delighted in her own spontaneity and exuberance." As Elaine herself put it, "I was a lot of fun. I mean a *lot* of fun." Soon after her visit to de Kooning's loft, Elaine began to distance herself from Resnick and started seeing de Kooning. Resnick was understandably upset. Not surprisingly, he could no longer live comfortably with Elaine and Ernestine, and so the two women moved to another apartment farther east on Twenty-second Street, at Avenue B. "She did sleep over in the apartment we had," said Ernestine, "but she was still living at home as far as her family was concerned." Elaine spent more and more time in Manhattan with de Kooning. He would frequently drop by their apartment to give Elaine and Ernestine lessons and critique their work.

Elaine soon began to study formally with de Kooning. Her studies were partly a cover story to account for the long hours that she spent with him. But she also regarded de Kooning as a serious teacher. "Being a student and dating were part of the same picture," said Lassaw. Aware of Elaine's interest in portraiture, de Kooning made a series of teaching drawings for her, showing figures in three-quarter and half profile, as well as heads portrayed at various angles. He also gave her drawing assignments and—just as he himself had done in Holland—asked her to practice the same exercise again and again and again. Even after she had mastered the subject at hand, he would rip up her latest drawing and make her repeat it. Elaine did not mind, since, despite her healthy ego as an artist, she considered de Kooning the master—a natural relationship given their fourteen-year difference in age. She also believed, unquestioningly, that he was a genius. "She felt that Bill was the greatest artist that she had ever met," said Ernestine. "And she'd met quite a few by that time."

Despite their student-master relationship, Elaine did not stand demurely in the background. Unlike Nini Diaz or Juliet Browner, she quickly became a significant figure in the world around de Kooning. She would accompany him to the Stewart's on Twenty-third Street, where, arms akimbo and cigarette lit, she would join the conversation. The men didn't seem to mind. They enjoyed her company. Elaine was bright, good with words, and pretty. She was also a regular in the late-night discussions

at de Kooning's loft that followed the closing of the cafeterias. Elaine's conquest of de Kooning's friends extended to Edwin Denby and Rudy Burckhardt. Eager to learn about music and dance, she soon joined Denby at the ballet and concerts. According to Burckhardt, she looked very glamorous on Denby's arm. De Kooning also introduced her to Gorky and Graham. (The contrast between the saturnine, eccentrically dressed Gorky and the cosmopolitan, beautifully turned-out Graham amused Elaine.) On a typical afternoon of the time, Elaine accompanied de Kooning, Gorky, and Hague to the Metropolitan Museum of Art. The four of them spent a lengthy time studying the Italian primitive and Renaissance art on view, with Gorky talking and gesticulating intensely. Afterward, they walked through Central Park—where, in earlier days, de Kooning, Jonas, and Gorky would occasionally paint "plein air" works—until they came to the lake. Although Elaine had to leave shortly to catch the subway to Brooklyn, they decided to rent a boat. All was tranquil until the moment, Hague said, when the infatuated de Kooning uncharacteristically lost his sense of humor, bristling with anger because he thought that Gorky and Hague were trying to look up Elaine's dress.

More politically engaged than de Kooning, Elaine brought a new political edge into his life. In the late-night discussions among friends at his loft, the talk would often turn toward the alarming news from abroad, especially the Spanish civil war. The events in Russia added to the air of darkness. In 1936, the infamous show trials had begun, in which high-ranking Bolsheviks suspected by Stalin of disloyalty were tried and executed. The trials, accompanied by vast purges of the army and an estimated nine to ten million other Russians, continued into 1937 and early 1938 and aroused grave doubts among many communists in America about the direction in which Russia was heading. There were also ominous signs of Germany's intention to dominate Europe. In March 1939, Germany entered Czechoslovakia, Europe began to mobilize, and the Spanish civil war ended in a crushing defeat for the Loyalists, as Franco's forces conquered Madrid. Two months later, Elaine accompanied de Kooning to see *Guernica* at the Valentine Dudensing Gallery. She later told the art writer Lee Hall, "We were stunned—really bowled over—by *Guernica*. Talk about passion. It was just pouring out of that enormous painting. Bill and I just stood before it—in awe, in wonder, and in a kind of terror. We didn't talk for a long time." Whereas de Kooning responded to *Guernica* mainly as art, Elaine also admired its political impact.

In the spring of 1939, an influential new museum opened in New York. At first called the Museum of Non-Objective Art, it would eventually become the Solomon R. Guggenheim Museum and was, as the art his-

torian Dore Ashton described it, "the child of the liaison between an infinitely wealthy collector, Mr. Solomon Guggenheim, and an infinitely eccentric devotee of certain expressionist brands of abstract art, the Baroness Hilla Rebay." Instead of lavishing his mistress with the customary jewels and clothes, Guggenheim, a copper baron, gave her art by, among others, Kandinsky, Klee, Chagall, and Arp. At first, the baroness displayed her collection in several art exhibitions. However, she wanted a more permanent showcase and asked her advisor, de Kooning's friend John Graham, to help her find one. The museum that Graham helped plan opened on June 1, 1939, with about 350 abstract works from the collection. It was housed in a former car showroom at 24 East Fifty-fourth Street, and was wildly strange for the period. Gray flannel covered the floor, the walls, and the windows. Since the baroness believed that viewers could best capture the essence of art while listening to great music, Bach was piped in to the gallery. Lilies scattered artfully about the museum scented the air. The baroness conducted herself like a Prussian field marshal, barking out orders and terrorizing the staff.

The new museum played a stimulating role in the education of New York's artists. It featured a kind of abstract art that was not prominently shown at the Museum of Modern Art and had been seen relatively little in the city. In particular, it provided a rich and detailed look at the work of Wassily Kandinsky (1866–1944), the Russian-born painter who possessed one of the great, founding eyes of modernism. (Some art historians believe he made the first purely abstract paintings.) Kandinsky's mysticism did not appeal to de Kooning, but he was immediately attracted to the painter's fluid handling of space and the ravishing, poetic implications of his abstract shapes. Gorky, however, was more deeply affected. De Kooning accompanied Gorky several times to see the exhibition. Both preferred the earlier paintings. During one trip, de Kooning said that the later Kandinsky works became lost in too much small busywork. Gorky responded, "Yeah, if it wasn't for that tiny Czechoslovakian design." As usual, de Kooning said, Gorky articulated the problem. "Gorky had this way of always coming out with the right answer," he said. "Everybody felt it, and he would say it."

And yet, the critical event of 1939 for de Kooning was not the stimulating confrontation with Kandinsky and Picasso but, rather, the private hours spent with Elaine. A new spirit began to course through his art. His palette seemed to stir, then awaken. In his dusky gray paintings of men there had always been a subdued, immanent rose. Now a blushy tint—perhaps the reflection of Elaine's hair as well as body—became bolder and more fleshy. Soon a powerful erupting pink would belong to de Kooning

the way a certain blue belonged to Matisse. (No other painter would ever bring such turbulent sexual force to what was traditionally considered a sweet, soft, and effeminate color.) De Kooning carried this new vision of pink into his life as well as his art. During his visits to Elaine and Ernestine's apartment, he began painting Elaine's room various shades of pink. "It was different tones of flesh," said Ernestine. "Different walls were different tones of flesh. I don't think he painted the ceiling, just the walls and the doors. It was very romantic. Just like his pink paintings."

In 1939, de Kooning made a pen drawing of Elaine's beautiful hair. In the past, he had found hair particularly difficult to depict. (Many of his men appeared almost bald.) Now, he no longer shied away from the subject. His art began to lose its air of poverty. He relished the luxury of his lover's hair—its dense dreamy fullness. How could he paint washed-out men, exiled in the gray Depression, when intoxicated by such fullness? Even the images of men that he continued to create, such as *The Glazier* (c. 1940) and *Standing Man* (c. 1942), contained rich reds and pinks. He asked Elaine and Marjorie to pose for him. Suddenly, he began to approach the figure in a looser way, one different from both his realistic and his biomorphic depictions. The most important work that he painted not long after meeting Elaine was *Seated Woman* (probably 1940), a picture influenced by Ingres that shows a woman facing the viewer. Her neck and exposed shoulders together made the kind of lyrical line—long and endlessly flowing—that Ingres revered. Her dress was low-cut and clinging; it evoked the tightly cinched dresses of the sixteenth century, in which arms, breasts, and shoulders were suggestively exposed. Her face, while blurred, was memorable for its strong and level-eyed gaze. And the hair was thick and lustrous. Held back by an ornament, it had an old-fashioned look, as if caught up in a snood. In contrast to the palette of his earlier paintings of men, the picture had the lush light of a jewel in a landscape. Its deep reds, yellows, and turquoises reflected both de Kooning's passion for Elaine and his love (shared with Gorky) for the richly colored Pompeiian murals in the Metropolitan Museum of Art. A fresh confidence and lyricism also entered his abstract painting at the end of the decade. *Seated Woman* was itself already fairly abstract, the figure flattened out against a background that, with its ambiguous rectangles and triangles, suggested but did not define an environment. Both the arms and the legs were depicted as shapes, not fully realized parts of the body.

As the thirties came to a close, de Kooning seemed on the verge of an exciting new period. He had been painting abstractions for at least a decade, leading to increasingly assured works; the World's Fair, with his mural on prominent display, opened on April 30, 1939, and some 600,000

people attended. And he was in love with Elaine, which led him to renew his figurative style and engage his natural subject, the female figure. He could be forgiven for imagining a brighter future. But success, in de Kooning's life, never came without surprises. He seemed to understand this; his impulsive brushstroke often kicked back upon itself. The war in Europe, only a distant rumble during the summer of 1939, would soon transform the character of his life in the provincial American art world.

14. Charmed Circles

The group instinct could be a good idea, but there is always some little dictator who wants to make his instinct the group instinct.

O n June 14, 1940, German soldiers marched triumphantly through the Arc de Triomphe and down the Champs-Elysées. Suddenly, as the art critic Harold Rosenberg wrote, World War II had "shut down the laboratory of the 20th century." Since the 1920s, American modernists had looked to Paris for the authoritative account of modern art. As the Germans celebrated victory after victory and America began preparing for war, a demoralizing air of disillusion settled over the downtown community. Before the war, many artists, poor as they were, had at least believed in the future. Now, according to the painter George McNeil, "All the fantasy in life came to an end." It was, as McNeil described it, "the best of times followed by the worst of times." Art seemed to matter little in the face of the terrible events abroad.

For de Kooning, the German offensive posed an additional threat since his family stood at risk. When the Germans invaded Belgium and the Netherlands in May 1940, they met with surprisingly strong resistance from the Dutch. To force a quick surrender, the Germans decided to make an example of a Dutch city. On May 14, they firebombed Rotterdam, incinerating the city center. Almost nothing was left standing. Rotterdammers said the scorched ground was still warm to the touch weeks later. Most communication with the outside world ended; de Kooning, like thousands of others, did not learn the fate of his relatives until after the war. This was a heavy burden. He had spent fifteen years erasing Rotterdam from his life. Now, history itself seemed to finish the job with monstrous cruelty. No doubt he felt painfully aware of his divided nationality—stranded, deracinated, safe.

Like other artists in the city, de Kooning found his own community eroding. The war would soon send many artists into the armed services or away from New York. There were no more magazines from Paris or stories from the lucky few who could visit France. By 1940, the WPA was almost dead, the camaraderie it had fostered fading. Disappointment in the failure of communism to transform the world and disgust with betrayals of principle by communist leaders—the non-aggression pact Stalin signed

with Hitler confirmed for many the doubts about the Soviet Union raised by the show trials—further depressed spirits. The isolation of American artists seemed almost complete, the hopes once aroused earlier in the thirties only made matters worse. Years later, the artist Adolph Gottlieb said that "a few painters were painting with a feeling of absolute desperation. The situation was so bad that I know I felt free to try anything no matter how absurd it seemed."

Into this unrelieved gloom suddenly came an unexpected sparkling. Starting in 1941, celebrated European artists fleeing the war—Marcel Duchamp, Marc Chagall, Jacques Lipchitz, Mondrian, and, most especially, the surrealists and their autocratic leader, André Breton—began arriving in America. This was a shock to local artists who were accustomed to traveling to Europe to search out important figures. The Europeans brought with them, in addition to their renown, continental ideas and prejudices. Cliquish, snobbish, and confident of their artistic supremacy, by turns inspiring and demoralizing, the surrealists at first pushed the Americans deeper into their gloom. Vanguard artists in New York were already familiar, of course, with the movement, and often saw surrealist art. The French-born art dealer Julien Levy had exhibited such work as early as 1932, and followed this original group show with exhibits devoted to Man Ray, Max Ernst, Salvador Dalí, Yves Tanguy, and Réné Magritte. In 1936, Levy also published a seminal book, *Surrealism*, which for the first time set forth in English the essential principles of the movement. The same year, the Museum of Modern Art mounted a huge show called "Fantastic Art, Dada and Surrealism."

In the early war years, however, surrealism developed a new, less familiar quality: an air of fashion. It was not the art itself that created this atmosphere, but rather the stylish arrival in New York in 1941, via the Pan American Clipper, of Peggy Guggenheim, the spoiled, eccentric patron from the celebrated mining family, and a girlfriend of the surrealists. (Solomon Guggenheim was her uncle; her father had gone down with the *Titanic*.) She had emigrated to Europe as a young woman and made a place for herself toward the end of the twenties in the brilliant expatriate world of Paris. There she developed a salon, entertaining Hemingway, Pound, and Gide, among many artists and literary figures, at her studio in the bohemian quarter of Montparnasse. Guggenheim was particularly attracted to the flamboyant behavior and desire to shock of the surrealists.

From Paris, Guggenheim went to London, where she opened a gallery in 1938 to exhibit the abstract art that Marcel Duchamp helped her collect. Her plans to open a museum, however, were scrapped as the international situation deteriorated. Rather than return directly to America,

which she found boring and bourgeois, Guggenheim instead went to Vichy France, where a group of surrealists, including Breton and Peggy's lover, Max Ernst, assembled in a villa near Marseilles. But the group was only biding time. One year after the fall of Paris, in July 1941, Guggenheim flew to New York with her entourage. At first, she seemed determined to replicate her Paris life in Manhattan. Her first step was to move into a huge town house on East Fifty-first Street overlooking the East River. The Beekman Place neighborhood, a cul-de-sac, was then the part of New York most like Paris and already filled with artists and musicians. Max Ernst, her soon-to-be (if briefly) husband, and the other surrealists gathered there, grumbling about their exile and playing the elaborate parlor games that the movement favored.

When not at this "headquarters of surrealism," as her house became known in the newspapers, the resident surrealists frequented local bistros such as Larré in the West Fifties. In the summer, they favored East Hampton, then a quiet village near the eastern tip of Long Island where many old line, WASPish families summered. What the surrealists did not do very often was mix with the natives. "Why bother?" seemed to be their attitude. Taking their direction from the imperious Breton, nicknamed "*le pape*" by his disciples, the surrealists regarded American culture as unsophisticated. As the critic Clement Greenberg later put it, the surrealist clique was made up of "terrible snobs." Unfortunately for those local artists not admitted into the charmed circle—and few were—the surrealists also wielded great power. To most Americans, any artists from Paris, even ones as eccentric and aloof as the surrealists, were more interesting than the local variety. Urged on by Guggenheim, the surrealists behaved with a panache and flair for publicity rarely seen in wartime New York. The two most talked-about events in the art world during the early forties were staged in rapid succession by the surrealist crowd. The first, an auction called the "First Papers of Surrealism," was held on October 14, 1942, at a graceful old house on Madison Avenue called the Whitelaw Reid mansion. Marcel Duchamp, the master of ceremonies and a devotee of chess, spun a web of string two miles long from column to column and painting to painting throughout the mansion's columned interior. His airy loops and fanciful connections—at once a nursery game for adults and a satirical depiction of art history—was accompanied by the sound of actual games being played in the formal ballroom: Duchamp paid a number of children to lend their playful chorus to the gamesmanship of making and selling of art.

The surrealists created a still more memorable spectacle six days later with the opening of Peggy Guggenheim's visionary gallery, Art of This Century. Located on the top floor of 30 West Fifty-seventh Street near the

other uptown galleries of Manhattan, the gallery, designed by Frederick Kiesler, was like nothing New York had ever seen. A leading proponent of avant-garde design, Kiesler created a completely nonlinear gallery. Made of canvas curtains attached to the floor and ceiling with strings, the walls billowed and curved, causing the viewer to lose any fixed feeling for space. There was not one conventional exhibition room, nor one conventionally displayed picture, to be found at Art of This Century. The paintings, none in frames, hung from floor-to-ceiling rope pulleys or were mounted on wooden arms that could be tilted and turned to any angle. The opening night was a triumph for Guggenheim. As Levy, whose own shows had been too early to gain widespread attention, later wrote, "[She] got here at a time when everything was ready to burst."

Not many observers except the local artists noted how few Americans were represented at either event. The opening show at Art of This Century, which Breton had helped select, was praised for its breadth of vision; it ranged in style from the abstract artists Mondrian and Malevich to Picasso and, predictably, the surrealists. But it included only one American, the painter John Ferren, who had spent much of the thirties in France and was continental enough to be an honorary member of the surrealist circle. Duchamp's "First Papers of Surrealism" had also tilted strongly toward Europe, for he invited only a handful of Americans to exhibit. One was William Baziotes, one of the earliest Americans to meet the surrealists and practice automatist techniques. The other Americans included young acolytes of Breton's—Robert Motherwell and the surrealist sculptor David Hare, who would be named the first editor of *VVV*, the surrealist publication that Breton launched in America.

The exclusiveness of the fashionable surrealist circle brought a fresh anxiety into the art world. Who was "in" and who was "out," who was at the center and who was on the margins, began to matter more than it had before. Not only were Graham, Gorky, and de Kooning initially ignored by the elegant interlopers, but they had to watch as a select few Americans were adopted by the Europeans. John Ferren had at least known many of the surrealists in Paris. The same could not be said for either David Hare or Robert Motherwell. A young intellectual who received his undergraduate degree at Stanford and then studied philosophy at Harvard and Columbia, Motherwell was a newcomer to the New York art world. He had been teaching at the University of Oregon. In 1940, however, he came east and became a pupil of the celebrated art historian Meyer Schapiro at Columbia. Motherwell, who had studied French literature and written on André Gide, began to engage the surrealists in conversation and debate, something few other American artists attempted. At best tolerated and at worst

mocked by the surrealists—Breton dubbed him *"le petit philosophe"*—Motherwell nonetheless flourished on the strength of his close association with the Europeans, becoming their useful young man.

Of course, the émigrés, not all of them surrealists, did occasionally cross paths with de Kooning and the other American artists who lived outside their circle. Many rented apartments in the Village, and Léger and Mondrian were sometimes seen walking the streets. (De Kooning once noticed Breton standing on Fifty-third Street making what looked like surreal hand movements; a butterfly had landed on his head in the middle of Manhattan.) Still, there was a big social distance between the two groups. The Europeans remained focused upon Fifty-seventh Street, where they gathered at Peggy Guggenheim's gallery, and Fifty-first Street, where she lived. Even being at the occasional party together did little to close the gap between the surrealists and other artists. At one party, de Kooning said wryly, "I tried to tell Miró of my admiration for his work in *English*. So you see, the contact was not such a thing." There was one essential exception, however—one surrealist who had an early and pronounced effect on Americans: Roberto Matta Echaurren (universally known as Matta). He had arrived in New York in 1939, before the great wave of émigrés. An ambitious Chilean who had joined the surrealists in Paris several years earlier, Matta had been a protégé of Breton's, and, like Breton, came from a background that respected elegance, intellectual airs, and a certain hauteur. But he had never been fully accepted by the French surrealists. In New York, he was more open to the Americans than the Europeans were. It helped that he was young—in his early thirties—and spoke excellent English. Julien Levy wrote of Matta's arrival:

> Matta burst on the New York scene as if he considered this country a sort of dark continent, his Africa, where he could trade dubious wares, charm the natives and entertain scintillating disillusions. He was chock full of premature optimism and impatient disappointment; believing ardently in almost everything and in absolutely nothing, as he believed ardently and painfully in himself, which was the same thing, everything and nothing.

Among de Kooning's friends, Gorky was most influenced by the arrival of the surrealists—and, in particular, by Matta. Both by background and temperament, Gorky was naturally attracted to surrealist whimsy and lyrical reverie. "Gorky had surrealism innate in him because of his Armenian background, independently of the Surrealists," said Robert Jonas. "They didn't implant it in him. Fantasies and dream images

have been present through the ages. And his Armenia abounded in them." It was only natural, then, that Gorky was eager to mix with the surrealists themselves. When Matta arrived in 1939, Gorky quickly gravitated to him. By 1941, the two had become very close friends, even though Gorky begrudged Matta his swift success in America. Gorky's lyrical landscapes of the early forties reflect Matta's influence. Matta urged him to be freer—to dilute his paint in order to achieve an airier, more extemporaneous effect and to use any accidental drips to spark improvisations.

De Kooning's relation to the surrealists was more ambivalent. In a variety of ways, the vogue for the style left him feeling more sharply isolated than ever. Any idea of a "club" or "circle" or "style" invariably made him feel deeply uncomfortable and alone. He particularly hated the European snobbery of the surrealists. Here was a group of wealthy, well-educated, and privileged Europeans bringing to the American art world the entitlements of class that de Kooning thought he had left behind in Europe—and then succeeding on a scale unimaginable to the artists in the Village and Chelsea. He and most other local artists remained outsiders looking through the window of the art world, outsiders in their own country, able only to dream of serious attention by the Museum of Modern Art or the prestigious galleries on Fifty-seventh Street. The surrealists were a pointed reminder to de Kooning that he remained caught between cultures.

The surrealists further isolated de Kooning in one other important respect. Whereas many Americans found a spiritual home in the surrealist realm of myth, symbol, and the "primitive," migrating in great numbers to this alluring place, de Kooning could not join them there. He always took an instinctively skeptical view of elevated talk about "myth" and the unconscious. He loved the physical world too much for this kind of skywriting; he was too passionately grounded to give himself fully to surrealist metaphysics. But all around him many others, such as Mark Rothko and a young Westerner named Jackson Pollock, who had previously been a regionalist follower of Thomas Hart Benton's, found themselves nourished by the tribal and unschooled art admired by the surrealists. Soon, Adolph Gottlieb and Barnett Newman would also begin to probe the mythical and primitive. Symbols of birth and the cosmos began to appear in paintings, the result of crossing surrealism's psychological emphasis with Carl Jung's theories of primordial creation. For many, the Jungian notion of archetypal images, in which mankind could tap into preconscious myth and magic, provided an escape from various increasingly stale styles.

Even if he could not join them fully, however, the surrealist example

still helped de Kooning immeasurably in the early forties. Despite his poor beginnings and reserved nature, de Kooning was a European with an eye for spectacle and glorious extravagance, characteristics rarely found outside of Hollywood in puritanical America, especially the penny-pinched America of the Depression. The hothouse surrealists were unembarrassed by spectacle, razzle-dazzle, and histrionic gestures. Despite Breton's dogmatic nature, moreover, the surrealists brought—through their physical presence, not just their imported precepts—an air of lush possibility into the depressed studios of New York. "Their being here was overpowering," said Ethel Baziotes, the wife of William Baziotes. "Its importance can't be overstated. These were fascinating men with highly perfected artistic ways. They had form, and the Americans were searching for form." They arrived just as de Kooning was struggling to free himself from many constraining inheritances. The academic training, the armature of cubism, the example of Picasso, the necessity for squinty-eyed control—these things did not lose their claim upon de Kooning, but their authority loosened, becoming less onerous and forbidding under the playful ministrations of surrealism. During the early forties, de Kooning reshuffled his deck and became a more eccentric artist, with a less relentless and more wandering eye, continuing to make both figurative and abstract works, including some odd pictures that closely resembled those of other artists, particularly Picasso and Gorky.

If the surrealist example encouraged de Kooning to open up, it also inspired him to focus ever more intently upon himself. What else did he have to depend upon? He could not hang onto a country, a social class, a settled tradition, a myth, a theory or even onto surrealism itself. He possessed only the quixotic authority of this elusive internal "self." And, paradoxically, the same surrealism that socially isolated him helped provide the tools he needed to create a vital personal style. Instead of emphasizing the history of art or the discipline of tradition, surrealism celebrated the idiosyncratic mark of the solitary individual. In the early forties, de Kooning increasingly released his brushstroke from the traditional responsibility to describe something else, such as a figure or a shape. The distinctive "handwriting" of his stroke carried more and more of the meaning in his work. The most assured pictures from the period were abstract paintings such as *The Wave* and *Matchbook*, in which de Kooning did not have to depict the outside world and could move fluidly with the brush.

But his "men" were, in their way, more telling. At the time that he painted *The Glazier*, in about 1940, de Kooning seemed interested in an otherworldly stillness beyond the usual Depression-era melancholy.

In *The Glazier*, the seated male figure sat facing the viewer, but his head was turned to the left, and his eyes stared off, remotely, into the middle distance. The figure emerged only partially from the plane of the wall behind him, adding to the dreamlike, hieratic quality of the painting. This visual echo from the ancient murals on view at the Met was strengthened by the patches of Pompeiian red on the torso of the seated man and by a classical amphora placed beside him on a richly veined slab reminiscent of ancient marble. And yet, despite its classical repose, the figure was also cut apart (as if by a diamond on glass) into various abstract forms. The torso and arms resembled geometric

The Glazier, *c. 1940, oil on canvas, 54" × 44"*

shapes more than parts of the body. One arm was missing completely; the other was handless; the face was simply an oval. In *Acrobat* (1942), as in *The Glazier*, the figure appeared to be breaking apart. Although the body and face remained highly descriptive, the figure inhabited an ambiguous space that de Kooning would one day call a "no-environment." Although the picture recalled Picasso's acrobats, de Kooning also seemed to be dreaming of a figure who could leap free, acrobatically, from the conventional lines of the body.

As de Kooning struggled with his art, Elaine served as his constant, lively admirer. The surrealists might have more fame, but, Elaine told him, he possessed more genius. This was a last, unexpected service that the Europeans performed for the Americans: the Europeans who appeared unreachable when viewed across the distant spaces of reputation and geography were not, up close, such titans after all. As George McNeil put it, "We saw that these men who had been mythical were ordinary human beings. And very practical human beings. The strange thing is they were quite young at that time, in their middle fifties." Not only that, but many of the surrealists were clumsy painters, however brilliant the ideas they

tossed quixotically into the air. Painters as gifted as de Kooning and Gorky immediately noted their pedestrian handling of paint and their rehash of various modern conventions. On one occasion, de Kooning later told the critic Lionel Abel, he was in a studio with Léger and the French painter Jean Hélion. "I looked at what I was doing and I said it's just as interesting as what they're doing. And it was, too." In short, the Europeans did not own the field. There was an opening for the eye—and the "I"—of an American painter.

De Kooning's internal drama did not pay the rent. Whatever the success of the uptown surrealists, life downtown grew increasingly onerous. Ten months after the Japanese attack on Pearl Harbor, on December 7, 1941, and America's entry into World War II, meat, coffee, butter, and leather for shoes were scarce. By December 1942, gas rationing had begun, soon to be followed by the rationing of shoes and of staples such as canned goods, coffee, and sugar. "With rationing and food stamps, sugar bowls from the Automat began to appear in artists' studios," Elaine told John Gruen. "Sugar for coffee and tea was a crucial staple—a major source of energy in diets that were skimpy elsewhere." De Kooning himself, an immigrant reluctant to confront the authorities, never talked about whether or not he tried to enlist during the period when many of his con- temporaries joined the military. Elaine, however, said de Kooning was deferred as an alien until, at the age of thirty-eight, he was no longer eligi- ble for military service. According to another account, de Kooning was turned away because of a bum knee, which he injured one night at a par- ticularly lively party on Twenty-second Street while doing the *kazatsky*, a Russian dance in which the men squat down and kick out with their legs. "We were jumping up and down and Bill chipped his knee," said Conrad Fried. "He of course was older." Unable to walk, de Kooning was told that he would have to have surgery. Frightened of the bespectacled doctor who was on duty that night at the emergency room—de Kooning told friends that the doctor sounded like a German interrogator in a movie about World War I—he fled the hospital and left the knee to heal on its own, with uneven results. In any case, he hardly yearned to become a soldier. If he made an attempt to enlist it was halfhearted.

The high-spirited Elaine, still in her mid-twenties, was willing to be poor, but not willing to give up the pleasures that money could bring. De Kooning, enamored, could not deny her anything. With no money coming in from the WPA or the World's Fair project, he was often nearly destitute. But he did attract a few collectors apart from Denby and Burckhardt.

Among the many refugees who came to New York during the European exodus of 1939 and 1940 was Janice Biala. Like many ambitious American writers and artists of her generation, Biala, who grew up in the Russian émigré world of Manhattan's Lower East Side, left for Paris in the thirties, where she became the last lover of English novelist Ford Madox Ford. Once back in New York, her younger brother, the painter Jack Tworkov, told her of his admiration for a little-known artist named Willem de Kooning. Tworkov had met de Kooning while working for the WPA around 1935. De Kooning didn't seem to be painting much then, according to Tworkov, "but toward the end of the thirties, [he] began to work a great deal and I began noticing it. At that time some of us began to think that he was a great artist, and we became friendly."

So glowing was the description of de Kooning that Biala immediately took an interest in the Dutchman's art. Soon, she met and married an artist named Alain (Daniel) Brustlein, whose cartoons regularly appeared in *The New Yorker*. "So when Alain and I were married, Alain said, 'Well, if [de Kooning's] as good as you say he is, and if I like his work, I'll buy one of his pictures,' " said Biala. "Because Alain was the millionaire of the group since he worked for *The New Yorker*. So sure enough we went over there to de Kooning's loft and he saw a picture [an abstract painting of 1938] that he liked and he bought it. This was probably in 1942." How important early patrons can be in an artist's life is often forgotten. In later years, Elaine made a distinction between early and later collectors of de Kooning. "The people who bought paintings then were not really collectors," she told the writer John Gruen. "They were closer to being patrons in that their primary aim was to keep the artists going rather than to acquire a work of art. Sometimes they didn't have very much more money than the artists whose work they supported." That was certainly true of Biala and her husband. Over the next seven years—before the Brustleins returned to Paris and their connection with de Kooning loosened—they purchased several more paintings. According to Biala, "We bought a number of pictures from de Kooning because he needed the money." De Kooning, she said, was "almost penniless." They did not behave as most collectors did, trying to get the best possible price. "We're not collectors. We paid him the regular price. We were the only people who did that, Bill told Alain. We bought *Woman* [a turquoise and pink painting of 1943 or 1944] and paid $700 for it, which at that time was a pretty good price." Similarly, Ellen and Walter Auerbach bought four small abstractions for ten dollars each. "We had very little," said Auerbach, "but he had even less." Denby and Burckhardt also helped support de Kooning; in the first half of the decade, they bought about ten paintings. Max Margulies, the

friend with the music machine, also bought at least one of de Kooning's early works, as did Milton Robinson, the husband of the dancer Marie Marchowsky. "Friends would bail him out by buying a painting," said Fried. "Bill would sell at any price. Whatever they had in their pocket."

Often, such "sales" were actually paintings that de Kooning "gave" to his friends when they loaned him money, so that he would not feel completely beholden to them. "Edwin and I would help him out with twenty dollars now and then, and he'd give us a small painting or a drawing, or we'd buy a bigger one for maybe $200," said Burckhardt, who lived on a family trust fund in those years. "But Bill worried about us, too: 'What are these two college kids going to do when their money runs out?'" Often, aware that de Kooning did not like to accept charity, Denby and Burckhardt made covert donations. One time, when money was especially tight—de Kooning was often three or four months behind in rent—Elaine found an envelope with $100 stuffed under the door. It came, she guessed, from Denby and Burckhardt. De Kooning so hated the idea of accepting charity that he could be cruel to his benefactors. A man named Harry Coopersmith, who had worked with de Kooning at A. S. Beck, bought an early painting but did not hang it. De Kooning believed that Coopersmith bought the picture as a favor without really liking it. The perceived slight rankled. Years later, after de Kooning became famous, he demanded to buy back the painting. "If you never liked it enough to hang it before," de Kooning told Coopersmith, "then you shouldn't have it now." Coopersmith was crushed.

De Kooning also let it be known that he was willing to paint portraits—a genre he disliked—which enabled some of his close friends to help without appearing to give him handouts. Several, including Rudy Burckhardt and Max Margulis, commissioned portraits. In Burckhardt's portrait, painted in 1939, he sat directly facing the viewer, with his arm resting on the edge of a table and his eyes staring slightly to the right. As in de Kooning's paintings of men, Burckhardt's clothing was realized in some detail while the face remained sketchy, giving the portrait an unfinished quality. De Kooning asked him to pose two or three times "and I wore a French blue suit which I brought back from Switzerland," according to Burckhardt. As for the unfinished face, Burckhardt said de Kooning had indeed painted it in originally, but in his usual way had grown dissatisfied, erasing it. He never finished it "just like Picasso with Gertrude Stein."

De Kooning regularly painted over his work in the early forties. "In those early years, Bill kept destroying everything he'd paint," Elaine told John Gruen. "You see, he'd get furious—and he'd be depressed and angry

with his work. There were always people around who thought Bill was absolutely fantastic and great. But Bill used to be extremely irritated at certain of these admirers—especially when they came around to his studio and watched him paint." Ellen Auerbach, who lived near de Kooning on West Twenty-first Street, said that throughout the early forties de Kooning would paint and repaint portraits of women to the point of obsession. "I remember once going in and Bill was painting over a canvas. I said, 'Bill, leave it. It's so beautiful.' And he said, 'I know. But when I was eighteen, I could paint just as good as now. Now I have to spend the rest of my life to know what I was doing.' " De Kooning's ongoing doubts were underscored by Biala's efforts to find him a gallery, which she thought would help him earn a living. Her own dealer was a handsome, prosperous-looking man named Georges Keller, whose Bignou Gallery showed mostly European artists. With work from Europe scarce during the war years, Keller invited a few American artists to join his gallery. He had never heard of de Kooning. "It took me years to get Keller to come down to see his painting," said Biala. "Then he did, and he was very impressed. He took two paintings and three drawings."

De Kooning, of course, professed delight with the turn of events. Keller even promised de Kooning a one-man show, which was a remarkable endorsement at the time. But then nothing happened: de Kooning never sent in enough work to sell or make up a show. "He was just content to be in the gallery," said Biala. "That's all." In the transitional years of the early forties, de Kooning, despite his poverty and lack of recognition, refused to be hurried in any way. The best Keller could do was include de Kooning in a quiet group exhibit of 1943 that, when compared with the splashy surrealist events of the previous year, amounted to little. Eventually, Biala reported that Keller got fed up: "He threw out the whole business and, partly because he liked me, he gave me the three drawings." De Kooning was singularly unconcerned by Keller's rebuff. He just shrugged and went on painting at his own pace.

De Kooning and Elaine got by in other ways. He continued to make furniture for other artists, as well as doing occasional freelance jobs for A. S. Beck. Elaine modeled and worked in a defense plant, Liquidometer, in Brooklyn, where she painted dials on instrument panels. But most of de Kooning's earnings during the late thirties and early forties came from commercial art. Many New York artists sought such work, although few admitted it in later years, preferring to imply that they would rather have starved. "Commercial success was something that Bill and Elaine both wanted and didn't want," said Joop Sanders. "They usually downplayed

the commercial work he was doing [in later years] because he was of course totally dedicated to being a serious artist." Still, de Kooning had fewer problems than many others in reconciling himself to commercial art. He was justly proud of the craft techniques, among them stenciling, marbleizing, gilding, and sign painting, that he learned in Holland. He continued to admire skilled artisans immensely, and he regarded the visual arts as a continuum, often finding the overlap between "high" and "low" enriching. In 1939, Conrad Marca-Relli remembered, de Kooning was working on a number of commercial projects. "Offers of commercial art were beginning to happen for certain artists without necessarily painting a commercial painting but using the image [to spin off into commercial work or attract interest]. I remember that de Kooning made a drawing of a woman with hair very much like an Ingres drawing. Very poetically beautiful. Then he started slowly getting little jobs to do." Marca-Relli was referring to de Kooning's drawings of Elaine, and to his first magazine assignment, four round cameo busts of young girls that appeared in the March 1940 issue of *Harper's Bazaar*. Each girl had a distinctive hairstyle, ranging from romantic curls to a shoulder-length *Alice in Wonderland* pageboy. Not surprisingly, the model was Elaine. She found it amusing that de Kooning, who had heretofore painted mostly balding heads, mastered the art of depicting good-looking hair when necessary.

The *Harper's Bazaar* drawings emerged from the last drawing that de Kooning would ever do in an academic, old-master style, a portrait of Elaine from 1940–41 in which she sat, wide-eyed, gazing at the viewer. She wore an old shirt of de Kooning's; the creases fell softly across her body. The features were finely modeled, her hair a mass of curls above the delicate, heart-shaped face. For once, the hands that so bedeviled de Kooning were perfectly realized and lay gracefully at her sides. A testament to de Kooning's tender feelings for Elaine in the first years of their relationship, the portrait was consummately drafted, progressing over three sittings of six hours each. As usual, de Kooning worked slowly and deliberately. Every stroke, once made, was reconsidered and in all likelihood changed. The process was so tortuous that de Kooning announced that he would not do any more such Ingresque "academic" drawings. "He said that if he kept this up he'd go crazy," said Burckhardt. While many contemporaries admired the drawing tremendously—"People always said, 'Look how he can draw,' " according to a friend—de Kooning himself grew to dislike the drawing. For one thing, he had always had trouble with likenesses. For another, Gorky, whose portraits were usually full-face, was disparaging, saying, "Too much profile." (Largely on the basis of this drawing, Gorky would later criticize de Kooning for

being more of a draftsman than a true artist.) Above all, de Kooning disliked attending to the world of surface appearances.

Tapping the lucrative magazine market fascinated Elaine, who had a flair for both journalism and promotion. She urged de Kooning, who was too shy to put himself forward, to work for magazines. Like several of de Kooning's money-making projects, the *Harper's Bazaar* drawings were commissioned through the auspices of Rudy Burckhardt,

De Kooning's Ingresque portrait of Elaine, c. 1940–41, pencil on paper, 12 ¹/₄" × 11 ⁷/₈"

probably at Elaine's suggestion. Burckhardt regularly sold photographs to Alexey Brodovitch, the art director of the magazine. Why not, thought Elaine and de Kooning, prepare a portfolio of fashion sketches that Burckhardt could show Brodovitch in order to get de Kooning some work as an illustrator? (De Kooning had intended to make similar use of the portfolio of drawings he did while in Belgium.) In the end, Brodovitch was not impressed by de Kooning's fashion portfolio, but did commission him to do the hairstyle sketches for a handsome fee of $75 per drawing. Elaine also decided to try fashion modeling, in addition to her poorly paid posing for art classes. The plan was for Burckhardt to photograph her and bring the pictures to the attention of *Harper's Bazaar.* Accordingly, she went to S. Klein, the clothing store on Union Square, and "purchased" a number of glamorous dresses, which she returned immediately after the shoot. (Burckhardt took pains to ensure that none of the tags showed on the clothes.) Despite his best efforts, however, Burckhardt could not interest the magazine in using Elaine as a model.

De Kooning was a poor businessman. He found it difficult to promote his work or break into the insular world of fashion. In particular, his heavily accented English made him ill at ease when talking to prospective clients. In the early forties, however, he met a man named Pierre Latishe, who proposed an unusual partnership. All his life de Kooning had a weak-

ness—which he relished—for hustlers who lived on the fringes of respectability. Latishe was French and "kind of a con man," according to Conrad Fried. Unable to make it as a commercial artist, Latishe, who knew how to smooth his way around the advertising agencies of New York, asked de Kooning to serve as his "hands." Latishe would find commissions; de Kooning would ghost the work; they would split the proceeds. Their clandestine collaboration lasted several years. Its strangest moment came when Latishe was commissioned to paint the portrait of a New York judge who was retiring from the bench. "That judge would come to Bill's studio, put on his robes and sit on this chair, and Pierre would be behind the easel," said Fried. "He would make believe that he was painting. He had told the judge that he could not see the portrait until it was finished. Meanwhile Bill would be hanging around"—de Kooning pretended to be Latishe's assistant—"and then, after he left, Bill would paint him from memory, through what he had observed."

At the time, Fried was often in the Twenty-second Street loft with de Kooning. He and his sister Marjorie both knew of Elaine's relationship with de Kooning; Marjorie occasionally modeled for de Kooning, and Conrad began to help around the studio and study informally with him. Two years younger than Elaine, Conrad had quit high school early and was working for a commercial arts studio named Traeger-Phillips on Forty-fourth Street. "Afterwards I would go to Bill's studio on Twenty-second Street for hours," said Conrad. "I was an apprentice there." Fried would lay out colors for de Kooning and do odd jobs. In return, de Kooning would critique Fried's drawings, encouraging him to abandon foreshortening and instead try to get everything on the surface. But he never imposed his own sensibility on the younger man.

> What Bill said was, "Conrad, you've got to find a Conradism." In other words, don't do it *his* way. Find your own way. And he would say, for instance, "Edges are what we see. It's between the edges that it's difficult. That's what Vermeer is good at." He'd say, "What we're going to do is go look at a Vermeer. See how he painted between the lines." So we'd go up to the Met. The Met was almost empty in those days. It was free and open and it was great to go with the artists because they would pick only one or two pictures to look at. Bill said, "If you go from picture to picture to picture you get all mixed up. So you say to yourself, 'What am I interested in?' and go look at that painting."

In addition to the magazine drawings, there were a number of advertising projects. "He tried to make a Ford logo and he failed," said Fried.

Conrad Fried, Elaine's brother, working in de Kooning's loft, early 1940s

"Then there was an advertising campaign in which Ford asked for a dozen views of America through the windshield. So Bill carefully laid out a windshield. Then he painted this winding road ahead and cows off to the side. Different scenes like that. He didn't win that one either." De Kooning was more successful doing a spot drawing for an advertisement for Model Tobacco: it appeared in the March 1, 1942 issue of *Life*. (He depicted a sailor holding a pipe, a jaunty man of the sea about to embark on another exciting adventure.) As a rule, de Kooning did not treat his commercial work cavalierly, but worked on such projects as hard as he did on his serious art. The actual process of preparing a commercial drawing was arduous. According to Fried, "If he did an illustration, this was his technique. He would take a piece of paper and make a careful pencil drawing of all the outlines. Then he would put shellac over it to cover it. That was transparent; you could see the drawing through it. Then he put sepia printer's ink over that. It's a technique; printer's ink never dries. Then they photographed it." The Model Tobacco ad proved particularly troublesome. Each time Latishe brought in a version, the art director found fault

An example of de Kooning's work in commercial illustration, an ad for Model Tobacco, Life, March 1942

with it. He finally put his criticism into words: the sailor looked too foreign. De Kooning, who had lived in the United States for more than fifteen years, could not adapt to the romantic, sugar-clean look of American commercial illustration. This time when Latishe returned with the drawing de Kooning lost his temper. The two had a fight. At one point, de Kooning pushed Latishe, who lost his balance and almost fell out one of the two big front windows in de Kooning's loft. When Edwin Denby dropped by later, de Kooning told him the story. "They're only interested in pretty-girl and pretty-boy pictures," complained de Kooning.

It was de Kooning's reluctance to draw "pretty-girl, pretty-boy pictures," said Fried, that hampered his career. Nonetheless, de Kooning continued to enter competitions. One drawing that Fried particularly recalled emerged from the nation's wartime mobilization in early 1942. "Outfits that made tanks or things like that would run ads in magazines. Bill made a drawing [for one such ad] which was really beautiful and which he worked on very hard. He made a landscape that went off into the distance. Over that landscape came an enormous soldier, high as the clouds. He had a clawlike hand digging into the foreground and a big, machine-gun-like thing in his other hand. It was monstrous, and done with a high degree of realism. But Bill never sold that. They didn't like it." Despite these commercial failures, de Kooning did have one success. A significant patron of the arts, the Container Corporation of America, established a corporate collection in 1937, the same year that IBM began its much-publicized sponsorship of artists. Among Container's earliest commissions were works by Léger,

Henry Moore, and the American realist Ben Shahn. In 1944, Container announced an open competition from which it would select works by American artists for its corporate collection. De Kooning entered, and in January 1945 his *The Netherlands* was one of the prizewinners in the competition. More closely related to his commercial illustrations than to his serious paintings of the time, *The Netherlands* was a painting of a Dutch town and the surrounding countryside. On the left, de Kooning placed a row of stately old houses along a canal. In the foreground, traders bustled about. In the bucolic scene beyond, boats sailed along canals and cows grazed in the fields. "I remember that when he worked on the competition, he was looking at Dutch postcards and doing a layout," said Sanders. While not a serious painting—it was probably intended to showcase his talent as an illustrator—*The Netherlands* had some visual interest. De Kooning employed a quirky bird's-eye perspective to render the town, as if the countryside were seen from a plane flying at rooftop level. The buildings thrust out at odd angles with hard, modern edges that offered a contrast to the work's generally old-fashioned air.

As a craftsman, de Kooning was fascinated by technical gadgets and know-how. He was one of the first painters to experiment with an opaque lens projector, used to project a drawing onto a larger canvas in order to see in magnified form how well it works at that scale. With the help of Fried, who was a scientist as well as an artist, he also began to explore the scientific visual properties of paint. (Some years later, Fried would invent a prototype reader for the bar code, the computer-generated labeling that appears on everything from fresh produce to high-fashion clothing.) "I remember talking about how warm colors seem to advance on the picture plane and cool colors recede," said Fried. "Bill was interested in this, so I made a device to show it. It was a tube some five inches in diameter and three or four feet long. There were two slots like tracks where you could mount color cards. By looking through the tube, there would be no reference except one color against another. You could measure the apparent distance from the eye."

De Kooning especially loved the tools of the trade. "He knew all the places on First Avenue," said Fried. "They are much cheaper than art store tools. He knew about rounds and flats and brights and dagger brushes." They were later employed by de Kooning in his painting, especially, said Elaine, the liner brush, whose original purpose was to do detail work on signs. (De Kooning would use one when he wanted the effect of drawing rather than painting a sharply defined stroke on the canvas.) He also liked the viscous, slow-drying ink of early-forties commercial drawings, which

allowed for many changes and had a tactile presence, both qualities that would become immensely important to his art.

Among his friends, de Kooning was probably the most knowledgeable about commercial art and the most inventive in using its methods to enrich painting. According to Sanders:

> He spoke about commercial art techniques and how he used them. Of course originally they were fine arts techniques, but they were much more used in commercial arts. Like using tracing paper and transferring with tracing paper [a technique that de Kooning would use heavily throughout the fifties and sixties]. And he used to do these things that they do in commercial art layouts—they cut out and do a sort of collage, a final pasteout. I remember him doing one thing when I was in his studio—drawing lipsticks. Kind of drawing them literally, in art deco style. He would make an arrangement by cutting them out and moving them around. That's something he also did a great deal of in his early paintings.

De Kooning never lost his respect for the craft that went into such work. In the final decade of his working life, the 1980s, he still recalled his admiration as a twenty-two-year-old in Hoboken for the sign painters who worked with such quick precision. He also respected artists whom others dismissed as "illustrators." (One of the last artists with whom he exchanged a work was Norman Rockwell.) But de Kooning also made a sharp distinction between his serious painting and his commercial work. He did not want anyone to confuse the two. In the late forties, when he first achieved some small recognition as a painter, de Kooning asked Fried to destroy his commercial illustrations because "they always come back to haunt you."

15. Home

Even abstract shapes must have a likeness.

I n the early 1940s, de Kooning began intently examining photographs of the great ballet dancer Vaslav Nijinsky with his neighbor, the dance critic Edwin Denby. What fascinated de Kooning was the uncanny perfection of Nijinsky's poses, especially in the photographs by Baron de Meyer. The dancer could create with his body a classical "line" as flowing, rhythmic, and composed as any found in Raphael or Ingres. Nijinsky also understood the expressive potential of the area between two bodies or forms, what painters sometimes call "negative" space. "The space between the figures becomes a firm body of air, a lucid statement of relationship," said Denby, "in the way intervening space does in the modern academy of Cézanne, Seurat, and Picasso."

De Kooning actually tried to assume Nijinsky's poses himself. He also asked Elaine, Denby, Rudy Burckhardt, and whoever else dropped by the studio, to copy them. The result was a period of slapstick hilarity and high-spirited mirth that lasted several days. Almost everyone could get a "piece" of the pose (the flair of a wrist, for example, or the curve of a torso), but no one could even begin to put together a full body before collapsing into laughter. So intrigued did Denby become by de Kooning's painterly references and interest in the problem that he wrote an essay in 1943, "Notes on Nijinsky Photographs," in which he observed:

> It is interesting to try oneself to assume the poses on the pictures, beginning with arms, shoulders, neck, and head. The flowing line they have is deceptive. It is an unbelievable strain to hold them. The plastic relationships turn out to be extremely complex. As the painter de Kooning, who knows the photographs well and many of whose ideas I am using in these notes, remarked: Nijinsky does just the opposite of what the body would naturally do. The plastic sense is similar to that of Michelangelo and Raphael.

De Kooning often dreamed of seamlessness, of an art at once classical and personal that flowed perfectly from the hand. He would have wished for a brush as fluent as Rubens's or an eye as clear as Raphael's. He would

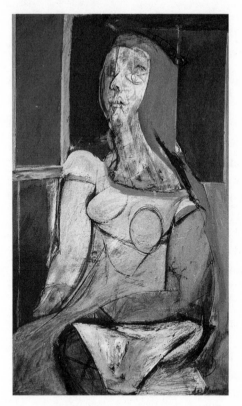

Queen of Hearts, *c. 1943–46, oil and charcoal on fiberboard, 46 ¹/₈″ × 27 ⁵/₈″*

have liked to be a Nijinsky of his art. He would never lose his admiration for such work. But de Kooning lived in an imperfect world of fragments. He had broken awkwardly and incompletely with his parents, especially his mother; he had uprooted himself from Holland and had become a self-taught American; he had moved back and forth between commercial and fine art; he had felt the different pulls of present and past; he had given himself to both cubism and surrealism, abstraction and the figure. Despite his classical fluency, he could not help but regard the canvas as fraught with difficulty. That he painted melancholy, thwarted men was hardly surprising.

As he matured, however, de Kooning began to grow into his paradoxical sensibility. Why couldn't an artist know and revere Nijinsky—and crack up, American-style, at the same time? (He would soon develop the courage to bring a note of manic hilarity into art.) During the first half of the forties, de Kooning began to find a metaphysical home—a place of pieces—in his adopted country. In this home of paradox, ambiguity, and yearning, he considered it less necessary to stand outside of himself, staring and wondering at the incomplete man on the easel. The male figure began to recede from his art. Instead, ardently in love with his American girlfriend, de Kooning moved passionately into his great subject—the female figure. The women beginning to appear in his art were often piecemeal and disturbing in appearance. Some were goggle-eyed (as were many of John Graham's portrayals of women) or chopped into awkward poses. In contrast to the men, however, the women were becoming increasingly tangible, in a tactile rather than representational way. Viewers could almost feel their forms in their own fingers. The women pulsed not only with pinks but also with earthy reds, greens, and ochers. *Queen of Hearts* (c. 1943–46) was ripe, almost tumescent in feeling: the lines could barely contain the swell of color. At the same time, the "abstract"

and "figurative" directions of de Kooning's art began coming together. As the female figures became increasingly abstract they also grew, paradoxically, more personal. Freed of literal representation, de Kooning, more and more, seemed to move "inside" the subject, the brushstroke becoming a hand moving with the flesh.

As de Kooning's art came together, Elaine left the bedroom on Avenue B that de Kooning had painted for her in a romantic spectrum of pinks. "She moved in with Bill, more or less," said Ernestine Lassaw. "But she still stayed in Brooklyn most of the time." According to Rudy Burckhardt, "On Twenty-second Street they were so much together that it was almost too much." Elaine quickly helped center de Kooning in the social world of downtown New York. She was not just a girlfriend, but an indefatigable promoter of his work. His name was always on her lips; she believed absolutely in his genius. "I just thought he was great," she later said. Because she was such good company—a woman who did not hang back but entered fully into the milieu of her lover—she added brilliance to a reputation that, downtown, continued to grow stronger and stronger. "Bill and Elaine were very sharp, very sophisticated," said Joop Sanders.

During the war years, de Kooning became an essential figure in New York's art world, no longer an outsider or dabbler but a kind of founding father for many other artists. In this world, de Kooning and Gorky were particularly admired for their seriousness of purpose. They did not take the distinction between art and life seriously—art manifestly *was* their life. "It was well-known that [de Kooning] and Gorky chose poverty rather than to compromise in their work," wrote Dore Ashton. "De Kooning's reputation for working slowly, scraping out, starting all over again, and never really finishing a painting, was legendary already in 1943." De Kooning and Gorky were also admired for their catholic taste, which made them a bridge between the different worlds of the downtown artists. Neither de Kooning nor Gorky had endorsed the pure abstraction of the American Abstract Artists, yet both had painted a series of geometric abstractions in the 1930s; and de Kooning still revered his fellow Dutchman Mondrian. Both admired classical draftsmanship, and de Kooning remained as fascinated with the human figure as any of the Italian artists in the Village. "In painting, Bill was one of the few who had inherited a tradition from the Old World," said Conrad Marca-Relli. "Bill and I used to talk until four a.m. We would talk about Titian, Piero della Francesca."

De Kooning was more accessible than the formidable Gorky to younger artists. "Gorky would come with his dogs," said the sculptor Philip Pavia, "but they wouldn't allow him in the cafeteria with the dogs, so we would go outside and talk with him." Younger artists gravitated to

de Kooning because of his knowledge, easy manner, and dedication. They particularly relished his brilliantly offhand way of talking about painting. He did not approach art as a critic, philosopher or art historian would. There was nothing dry or portentous in his language. He put an original spin on ideas, so they could be felt, not just thought. "He was the most marvelous speaker on art I've ever heard," said Joop Sanders.

> It's not only what Bill said about art, but how he said it [that made an impression]. He was not a great theoretician so much as that he made art very much a part of life. It was the way he would interweave art with general small talk. He would talk about technique, subject, the possibility of doing the figure, what abstraction meant, how abstract is abstraction, and isn't it always the figure? He was very humorous, and to the point.

Many other artists also marveled at de Kooning's ability to enliven art. One notable example was Fairfield Porter, who met de Kooning after moving permanently to New York from Chicago in 1939. Celebrated in later years for his landscapes and figurative paintings, Porter was a resolutely representational artist and never became part of de Kooning's modernist group. Nonetheless, he was captivated by de Kooning's talent, openness to history, and commitment to the poetry of form. In contrast to the teachers he had encountered in his academic training, said Porter, de Kooning was completely grounded in the specifics of painting. He would first talk about the savor of an individual picture and only then widen the discussion:

> I mean, if I told you the remarks that he made about a particular painting, and [the painting] isn't in the process of being made, it would sound banal. [But] it's only banal when it's separated from what you're doing. . . . He might say, for instance, that that tree up there, that apple tree, or the middle apple tree, he would say, "That's not the shadow for that grass." If you just hear that remark, you might think it's not the right shape, or you might think all kinds of things. He would mean something about it's not in where it's supposed to be. The reason it's not in where it's supposed to be is because you haven't yet found the right color and thickness of paint and all kinds of things like that. It's like somebody criticizing a college theme and saying, "You haven't found the right noun in this sentence or the right verb. You're using adjectives because you haven't found yet the right words."

De Kooning's popularity also stemmed from how generous and encouraging he was to other artists, no matter how different their styles were from his own, and how interested he always appeared in their work. Although he was sixteen years older than Joop Sanders, for example, and much better trained—"I had no art training at all except for, all in all, six months with George Grosz [at the Art Students League]," said Sanders—de Kooning never patronized him. "With Bill there was not the feeling of a generation gap," said Sanders, "which was one of the extraordinary things about him. All of the younger artists thought that. He never condescended to you." "He had this absolute genius," said the artist Hedda Sterne. "He would go to anybody's studio and never, never discourage anyone." Coupled with this interest in others' work was an intensity of focus that many people found irresistible. While de Kooning was visiting someone in the studio, no one else in the world seemed to matter, even though some among de Kooning's acquaintances always suspected that he would forget about them the moment he said good-bye. "Bill was the kind of person who, if you met him in the street, he would walk with you and the first thing you know he would come home with you," said Ernestine Lassaw. "He was very intense when he was with you. I think that was his great charm. He made you feel as though you were really something." Many artists wanted de Kooning to see what they were doing. "Bill was a magnet," said Lassaw. "Everybody sought him out."

Several years into the war, the small group of downtown artists who were left in New York—most had been drafted or had gone off to do war-related work—began once more to coalesce into a cohesive group. The closeness was more private and inward-looking than during the WPA era. The shrinking of the art world during the war years tended to bring together the remaining few, whatever their differences might be. It no longer seemed as important if a Village crowd was mostly figurative or a Chelsea group resolutely modernist. Social realism was fading, and surrealist ideas fostered idiosyncratic and experimental approaches to the making of art. Even the most conservative artists began to move in new directions. Still, there remained an important distinction between "uptown"—the émigré surrealists and their followers and patrons—and "downtown." The artists downtown, notably de Kooning, began to take a certain defensive pride in their exclusion from the more fashionable precincts of art. They were the "rejected Americans," as Pavia called the group.

American artists began to congregate at the Waldorf Cafeteria in the Village, on Sixth Avenue and Eighth Street. As long as an artist was

"downtown," he was welcome at the Waldorf. By 1943 and 1944, de Kooning was spending many evenings there, much as he had once gone to Stewart's Cafeteria in Chelsea. The routine was always the same. Usually the artists would settle in around eleven p.m. or midnight with a five-cent cup of coffee and stay until closing time. "You could drop in any time between noon and three in the morning and always find some artists deep in conversation," Elaine told John Gruen. Meeting at the Waldorf had originally been the idea of two well-known Village artists and characters, both regarded as "elders" by younger artists. One was Landes Lewitin, an Egyptian who had lived in Paris for eleven years in the 1930s and '40s. As a result, he considered himself an expert on the School of Paris. He was talkative and opinionated and "always making pronouncements," according to Elaine. Lewitin's counterpart was a Greek immigrant named Aristodimos Kaldis, a sly and rather feline man who was an amusingly poisonous gossip. De Kooning knew many of the artists at the Waldorf from the thirties, but there were also some new faces, including a sizable number from Little Italy, a part of the Village settled by Italian immigrants that for years had its own flourishing artistic community. "We'd all sit around a big table—eight or nine of us—and we'd have big discussions and big fights," Pavia told John Gruen, describing the early years of the Waldorf. "We'd fight about the Surrealists and French culture. Bill de Kooning talked about *his* Picasso, and Gorky talked about *his* Picasso." Lewitin treated Picasso as a god; Kaldis thought the greatest twentieth-century master was Matisse. "And Bill would always say that Michelangelo was the greatest living artist," said Pavia.

Parties were frequent. "Anything was an excuse for a party," said Marjorie Luyckx. "But everybody brought stuff to the parties. They were at all the artists' studios. And everybody was at those parties." Some of the jolliest, Luyckx said, took place at de Kooning's studio. Dancing was popular. The men would squat down and try to dance the *kazatsky*, a legacy from the thirties' obsession with Russia and communism. Elaine once bent over backward to pick up a handkerchief with her teeth. Such parties continued until the early hours of the morning, and then, said Luyckx, after everyone quieted down, de Kooning and Bart van der Schelling sang songs. "Bart had a deep baritone and sang professionally," said Luyckx. "And Bill had a beautiful singing voice. Bart would sing, and Bill would harmonize with this wonderful tenor." Often, led by Bart, who had fought in the Spanish civil war, they sang songs from the days of the Lincoln Brigade. But they also sang old Dutch songs. "It was enthralling," said Luyckx.

On other nights, there might be a performance of avant-garde music

or dance in someone's loft. As with art, there was a separate downtown world of music and dance, somewhat apart from the Classical world of the New York Philharmonic and the Metropolitan Opera. It was downtown that new music and dance (and poetry) had their first hearing. According to Elaine, artists served as the "built-in audience" for modern dancers, composers, and poets, which prompted a cross-fertilization among the arts. The performances were done on a shoestring and attended mostly by friends and supporters. Despite not liking avant-garde music, de Kooning regularly attended because, as he told friends, he believed that all modernists should rally behind one another. (It was at such a gathering in 1940 that Joop Sanders met his fellow immigrant de Kooning. The performance was one of music by Virgil Thomson, Aaron Copland, and William Schuman. When Sanders introduced himself to the striking woman seated next to him, she said, hearing his name, "Oh, is that Dutch? You have to meet my fiancé, who is also Dutch.") Merce Cunningham remembered de Kooning coming with Elaine to his early collaborations with John Cage; the first was in 1944. "I remember him saying once, something like, 'I like your dance.' With this kind of cutoff sense—the way he spoke," said Cunningham. "And of course Elaine was extraordinarily able to speak about dance. She was a great friend of Edwin's, and they went together to a great many performances." At one such performance, Denby encouraged Elaine to write her first dance review, which led in time to her well-received writing about art.

I n the spring of 1943, de Kooning very nearly stopped painting. It was not because he found his art discouraging, but because he had embarked upon the grandest carpentry project of his life. The loft immediately above his at 156 West Twenty-second Street had become vacant, and de Kooning decided to move in and overhaul it from top to bottom. The next six months, said Denby, would be "the only time during many years before or later that [Bill] put off painting for longer than a couple of days." Although de Kooning always cared about the space around him, only something momentous could take him away from his painting for so long.

De Kooning was building a home for Elaine and himself. They had decided to get married, and he wanted to give her the most comfortable and well-set-up living space he could provide as a wedding present. "He said, 'I'll build her the most beautiful house in the world,' " said Marjorie Luyckx. " 'It won't be the most expensive, but it'll be the most beautiful.' " Before, recalled Conrad Fried, "Bill had a birdbath and dishpan. He lived an impermanent life." In 1943, Bill and Elaine had been together for

four years. Although it had taken them that long to get to the point of marriage, "we really knew we always would," Elaine later told John Gruen. She had decided to get married to Bill "from the moment I first met him." De Kooning proposed, after a fashion, during an outing at Brooklyn's Sheepshead Bay, where Conrad belonged to a canoe club and kept a twenty-two-foot-long racing canoe. "Bill was terrified of the water, but I finagled him into the boat," Fried said. The two were maneuvering the craft into the water when Elaine arrived and changed into a skimpy bathing suit. "She was kind of a knockout," said her brother. "Bill looked at her and announced, 'We have to get married.' "

"Why bother to get married?" Conrad later asked him.

"When you meet someone you think you can't live without," answered de Kooning, "then you get married." In any case, de Kooning was already a de facto member of the Fried family; their marriage simply strengthened the familial connection. (Neither de Kooning nor Elaine considered children a reason for marriage.) In their early years together, he had regularly taken Elaine back to her home in Brooklyn late at night, complaining of the long and dreary round-trip ride on the subway. He knew both Marjorie and Conrad well, of course—Marjorie from frequent visits and occasional modeling at Twenty-second Street and Conrad from being his informal studio assistant. Gradually, de Kooning began to join the family on Sundays. At first, he dreaded meeting Elaine's father, Charlie Fried, and with good reason. Fried, a steady man with the conservative instincts of a good accountant, had his doubts about whether or not this Dutch artist who never seemed to make or have any money was the right match for his daughter. Whatever his reservations, however, he forever endeared himself to de Kooning at their first meeting. They first shook hands. There was a pause. The silence began to lengthen. Then Charlie Fried reached over and put an arm companionably around de Kooning's shoulders—something de Kooning's own father had never done.

De Kooning liked and admired Charlie Fried, and Charlie Fried reciprocated. It helped that Conrad vouched for de Kooning artistically. On his first visit to de Kooning's studio, the elder Fried had gestured to the paintings and asked Conrad, "Is he all right?" "He's all right, Dad," Conrad assured him. An old family photo showed Fried with his two sons, Conrad and Peter, and, standing next to Charlie, de Kooning, accorded the same status as a son. When the elder Fried had chores to do, he called upon de Kooning as well as upon Conrad or Peter, and they worked side by side in amiable silence. The two had much in common. Both were adept at making things with their hands, and their temperaments were similar. Each had a wry, offbeat sense of humor; each was handsome in a northern Euro-

pean way. In the fifties, when de Kooning heard that Charlie had died, he was devastated. According to Luyckx, "Bill said that he loved my father more than his own. He said when he died, the grief was greater." De Kooning's relationship with Elaine's mother was more ambiguous. Family members said Marie liked de Kooning. Once, while Elaine was away modeling at Bennington College in 1942 to make some money, Marie treated de Kooning and her younger son, Peter, to a day on the town in New York. Their first stop was at the pool of the Park Central Hotel (though de Kooning did not swim), followed by dinner and a movie. De Kooning duly wrote all the details to Elaine. "He said what a wonderful time he had had," said Luyckx. Others outside the family, however, remembered that Marie was not happy with Elaine's choice of a boyfriend and then husband. That was probably inevitable, given her boundless ambitions for Elaine. She expressed her reservations openly. "She didn't think so much of Bill," said Ernestine Lassaw. "When I married Ibram, she said, 'Ernestine, *you* have found your Prince Charming.' She didn't think Bill was such a great catch. He was so old [fourteen years older than Elaine]. And he had bad teeth. He got better-looking as time went on." According to Joop Sanders, "She absolutely loathed him. And it was reciprocal."

Whatever Marie's feelings, the relationship went forward. De Kooning and Elaine celebrated their engagement at a party at their loft on Twenty-second Street in 1942. And then de Kooning set to work in earnest renovating the loft upstairs. The top-floor space was big enough to serve as both the living and the working quarters for two artists. According to the previous tenant, Alexia Johnson, "The loft was just too large; it wasn't good for an apartment." There was heat until five or six p.m. each day provided by large radiators in the front and back, an amenity that many rough lofts of the time lacked. And there was a hot-water boiler in the kitchen. But there was no stove and no tub, and the overall condition of the loft was poor. "We moved out because there was too much work to be done," said Johnson. "There was no flooring, for example, only subflooring. It was a wooden floor, but it was unfinished and gray."

Each morning, after several cups of coffee and a few cigarettes, de Kooning climbed the stairs and took up where he had left off the night before. According to Denby, "He patched the walls, straightened the pipes, installed kitchen and bath, made painting racks, closets and tables; the floor he covered with heavy linoleum [used linoleum, which he bought from a defunct factory], painting it grey and the walls and ceiling white." The effect was spare but cheerful. On the north side, facing Twenty-second Street, there was a wall of big plate-glass windows. On the south side, at the back of the building, smaller windows let the sun stream

in. At the center of the loft, to crown his efforts, de Kooning built a free-standing bedroom that reminded Joop Sanders of a Dutch sleeping alcove. De Kooning may have intended the echo: the best moments of his childhood may well have been with his sister Marie in the private world of the alcove. The walls of this little room went up almost to the ceiling. It was open at the top and had two small, built-in windows, one facing the front of the studio and the other the kitchen. According to Denby, "The bed and bureau fitted into it." On the outside walls of the bedroom, de Kooning built handsome cabinets and closets. He essentially created a pocket of space for his private life, a room-within-a-room, that served as an intimate retreat from the main business of life, which was the making of art. Just as he had painted Elaine's bedroom a romantic pink for her earlier apartment on Avenue B, so de Kooning painted this alcove the same seashell color, very like the pinks he was then using in his paintings. To Denby, the effect was magical: a bedroom white on the outside and pink on the inside, which "seemed to float or be moored in the loft" like a ship in the sea of space.

Behind the sleeping alcove at the back of the studio was the kitchen, which had a folding table that de Kooning built so that it could be pushed flat against the wall; its retractable pipe legs would drop down when they wanted to eat. Despite the already grand scale of his loft, this "was to give them more space," said Luyckx. De Kooning wanted to interfere as little as possible with the openness of his studio. To one side, he placed a library–sitting area. "There was a leather armchair and a leather couch, as I remember," said Luyckx. "And in the wall [of the sleeping room] he put speakers, and he had the works of the phonograph [the great Capehart] in the arm of the couch so you could lift it up." Surrounding the couch and armchair were walls about three and a half feet high with built-in bookshelves. Elaine's work space was at the back, de Kooning's in the front, with the northern light. The whole, as Luyckx said, seemed immaculate. "You never saw a bit of dust. He also built the furniture into the floor. He said, 'I know she's not going to dust under it.'"

In contrast to the preparations, the wedding itself was routine. It took place on December 9th, 1943, "two days and two years after Pearl Harbor," as Elaine told John Gruen. The couple was married before a justice of the peace in the inelegant environs of city hall, only a short distance from the South Street port in lower Manhattan where de Kooning had first landed seventeen years before. The wedding party consisted of just three family members: Marjorie, Peter, and Charlie Fried. Bart van der Schelling served as best man. Also there were Alain Brustlein and his wife, Janice

Biala. Most other old friends were in uniform and far away from New York. Conrad Fried said, "I didn't go because I didn't think it was important. They were already living together." Noticeably absent was Elaine's mother. Her official explanation for the slight was that she considered Elaine too young to get married, although Elaine at twenty-five was hardly too young by the standards of the day. "Actually, the wedding was kind of bleak," Elaine told Gruen. "Afterwards, we went to a bar in the downtown district and we all had a drink. Oh, I guess it wasn't that bleak. It was kind of amusing. But it was not festive. I mean, nobody rolled out the red carpet for us." Janice Biala also recalled the day as somewhat melancholy, saying that it was she and her husband who wound up throwing a spontaneous, informal and extremely simple wedding lunch for the little party at a cafeteria. After lunch, the Brustleins said good-bye to the couple, who returned to the studio and, according to Elaine, "continued to work."

With Elaine shortly after their wedding on December 9, 1943

If Elaine found it strange to return directly to work on her wedding day, she never said so. That was the way of life on Twenty-second Street: every woman in de Kooning's life from Nini onward could attest that he was already married to his work. During the time when Elaine was commuting back and forth to Brooklyn, de Kooning's days were devoted to art, and they continued to be so after she moved in permanently. Typically, the couple rose late in the morning. Breakfast consisted mostly of very strong coffee, cut with the milk that they kept in winter on a window ledge; they did not have a refrigerator, an appliance that in the early forties was still a luxury. (So was a private phone, which de Kooning would not have until the early sixties.) Then the day's routine began with de Kooning moving to his end of the studio and Elaine to hers. Work was punctuated

by more cups of strong coffee, which de Kooning made by boiling the coffee as he had learned to do in Holland, and by many cigarettes. The two stayed at their easels until fairly late, taking a break only to go out for something to eat or to walk up to Times Square to see a movie. Often, however, de Kooning, who hated to stop working, began again after supper and pushed far into the night, leaving Elaine to go to a party or concert. "I remember very often walking by and seeing the lights on and going up," said Marjorie Luyckx. "In those studios, the heat used to go off after five o'clock because they were commercial buildings. Bill would be painting with his hat and coat on. Painting away, and whistling."

Pink Angels

Many pictures from the late thirties and early forties contained fiercely worked-over passages, such as the darkly smudged, almost wounded area around the hands of *Two Men* or the blurring of the neck in *Queen of Hearts.* These seemingly unfinished areas appeared full of sweat and frustration, as if de Kooning could not find a clear resolution of color and form. But such passages also had a turbulent beauty; and de Kooning retained them in the final image. Over time, he began to recognize that exactly *there,* at such points of eruption, tension, and ambivalence— where convention might see something unfinished—was the vitality he sought.

Until the mid-forties, de Kooning had struggled to contain movement and explosiveness and instead, like a Nijinsky pose, bring a sense of classical or academic stillness to his work. This often gave his art an air of suppression and tense paralysis. Focusing furiously upon what Elaine called the "figure related to rectangular form" finally left something overworked, bloodless, and sickly in his pictures of the men, while the effort to intensify his representation of women somehow led to surrealistic overreaching. In *Woman* of circa 1944, for example, the skin was a garish yellow-orange and the dress a smear of red. The breasts protruded suggestively, the eyes bulged out comically. Most noticeable of all, the fingers of the left hand were capped by feral red nails. And yet, for all the sexual innuendo and eye-popping palette, the woman remained strangely still.

In *Pink Lady* of the same year, however, the figure began to deliquesce. The viewer could make out a seated woman in an unmistakable pose: legs splayed apart, one side of her dress slit up to her crotch, her head thrown back. But she was also dissolving into a series of powerful and flu-

idly suggestive shapes. Curves that could be her arms, or those of a lover, swept around her body; her profile was seen, and seen again and again, in duplicate and wavy outlines. Heavy charcoal lines bit into her shoulders and thighs and veered off into the space around her. The effect was one of restless sexual energy, as if the parts of the body were thrown into perpetual motion. There was no central focus; the eye moved from one slipping fascination to the next. The boundaries in de Kooning's sensibility were beginning to break up. His art was developing a distinctive velocity.

This process culminated in *Pink Angels* (circa 1945), the work in which de Kooning comes into his own as a mature artist. (That de Kooning also saw *Pink Angels* in this light is suggested by photographs taken of his studio in 1946; to the right of his easel sits the painting, readily at hand for him to refer to.) In contrast to his earlier figurative pictures, the female body in *Pink Angels* seemed entirely present, visceral, and certain, but not in a literal way. The central image in the painting, a sensuous swath of pink, evoked a woman's hips and thighs. Swelling, curvilinear forms jerked and flowed across the canvas, spliced with vertical and horizontal lines reminiscent of the cubist grid. Ghostly images from rubbed-out versions could be seen, lending the inflection of memory to the sensation of erotic abandon. The picture moved with convulsive speed: the whiplash line erupted, and the color surged here and suddenly there. Between figure and ground there was no significant separation. De Kooning was no longer an artist who made a "positive" and a "negative" space, placing a figure into an environment. The environment was the figure, and the figure was the environment.

Although *Pink Angels* was painted in the present tense, it did not exclude the past. The high tradition of Western painting was no longer an authoritarian ideal, however, that constrained the urgings of the clamorous heart. Instead, the past lived in the present, surfacing as a kind of glimpse or a flicker in the scrubbed-out refinements, the Ingresque turn of line, or the care taken that the larger composition could still hold the eye. In fact, nothing seemed excluded or closed off. In the body of a woman, the larger world could also be discerned—city, country, water, land. During the late thirties and forties, de Kooning spoke admiringly of how Cézanne responded to Mallarmé's use of the multiple meanings of words; a table-cloth could also become a mountain. In *Pink Angels*, de Kooning suddenly seemed inside the paint. He gave up much that he revered to arrive at this sensation, including stillness and certainty; but, in doing so, he found his own way. Everything was now in flux.

In the mid-forties, as de Kooning set to work each day, he was no longer the sad, muted man depicted in the paintings of a few years before.

de Kooning

He was married to a beautiful American who considered him a genius. He had designed a radiant loft where he and his wife could both work and live. He had earned the support and respect of many other artists. Most important of all, he had found a place in art that suited him—a nomadic sort of home. Just as de Kooning came into focus as an artist and an American, however, he was shaken by a series of deep professional and personal disappointments. He did not change outwardly, and remained a charming regular at the cafeteria. But his eye darkened. He was forced back upon his earliest and most difficult intuitions about human nature, above all, that he was fundamentally alone, whatever relationships or beguilements the new world might offer. In the end, he could depend only upon himself.

Recognitions

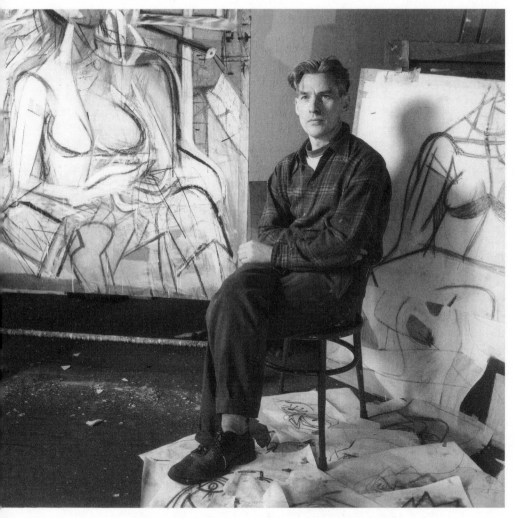

De Kooning in his studio on Fourth Avenue, 1946

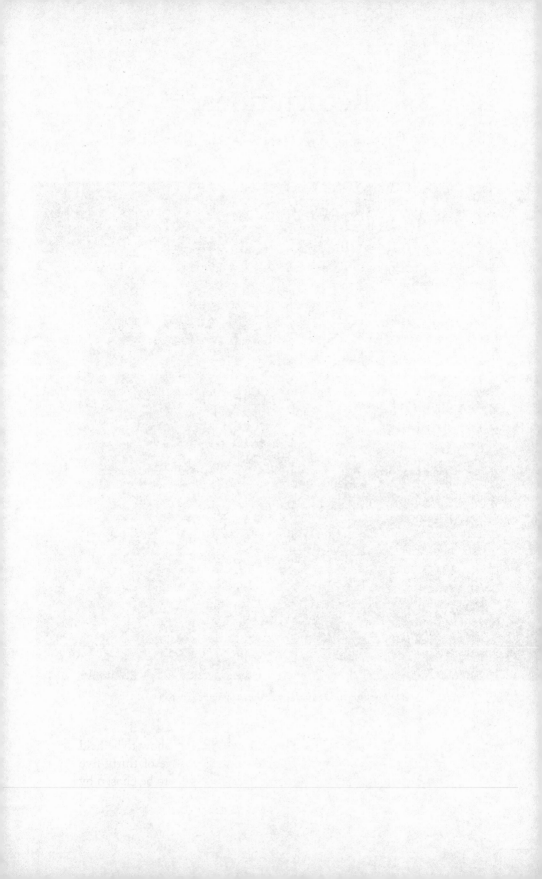

16. Missed Connections

I'm not poor. I'm broke.

De Kooning's difficulties began, paradoxically, before he was aware of them. While he was readying the loft for Elaine, Peggy Guggenheim, the doyenne of the fashionable art world, was once again changing what it meant to be a successful artist in New York. By the spring of 1943, she had begun to fall out with her circle of European surrealists. In March, her husband, Max Ernst, left her for a young American surrealist painter named Dorothea Tanning. Guggenheim also quarreled with André Breton. He had promised her free advertising in his journal, *VVV*, for a show at her gallery devoted to that journal's covers. When he reneged, Guggenheim angrily canceled the show. As her relationship with the Europeans worsened, she began to look elsewhere for inspiration—and discovered America.

During Guggenheim's infatuation with the surrealists, her intimates included only one American, Howard Putzel, a former art dealer from California. Now, Guggenheim increasingly turned for advice to Putzel, who became her new secretary, and to the artist Matta—who had himself been excluded from Ernst and Breton's inner circle and who was friendly with American artists. At the same time, James Johnson Sweeney, soon to be named the chairman of the department of painting and sculpture at the Museum of Modern Art, became a close if unofficial advisor. All three men pushed Guggenheim in the direction of young Americans. Of them, it was probably Putzel who most strongly championed their art. Although never as important to Guggenheim as Ernst or Breton, Putzel had been part of her circle since her days in Paris. In 1938, he had closed his gallery in Los Angeles, his taste for surrealism having proved too outlandish for Hollywood, and moved to Paris, where he became part of Guggenheim's entourage. After Guggenheim's quarrel with the surrealists, Putzel's campaign for American art began to prosper.

In the April 1943 issue of *Art Digest*, Guggenheim's Art of This Century advertised a juried "Spring Salon for Young Artists" show to be held the following month. Any American artist under the age of thirty-five could submit examples of his or her work. Finalists were to be chosen by a jury composed primarily of Americans, but including two celebrated

Europeans, Mondrian and Duchamp. After being excluded from Guggenheim's world, Americans were now being invited in, or at least given a chance to exhibit: a huge number came to Guggenheim's gallery bearing canvases. De Kooning, however, was not among them. The reason was not simply that he was too old for the competition; an exception would probably have been made for an artist with his underground reputation. Nor could his differences with the surrealist aesthetic fully explain his reticence: he could doubtless have found a painting that would have looked at home in Guggenheim's gallery. De Kooning's difficulty was largely social. Guggenheim awakened in him the class irritations of his youth in Rotterdam. He disliked seeing the fashionably rich gain power over art and artists. Who were these dilettantes to presume to judge the success or failure of painters who, working in cold-water flats, bet their lives on art?

Putzel actually did everything he could for de Kooning. Even before the juried show, he approached the painter directly about exhibiting his work at Art of This Century. But de Kooning resisted, politely telling Putzel that he was not comfortable with the surrealist style. Putzel even persuaded Guggenheim herself to visit de Kooning's studio in order to buy a painting for the gallery; in this way, he hoped to spark her interest in de Kooning's work. She arrived—yawning, inattentive, and snappish—in fashionable riding pants and announced: "I'm so hung over from last night's party." Then, after walking about the studio and riffling through de Kooning's paintings, she decided that one should be brought over to Art of This Century. De Kooning, who had remained silent during this performance, said brusquely, "It's not finished." Guggenheim hardly seemed to hear him, saying, "You can finish it and bring it over in two weeks." According to Rudy Burckhardt, "Bill made sure the painting was even less finished two weeks later."

Guggenheim's show of American art, which opened in May 1943, fascinated the art world of New York. It seemed to narrow the gap between the figurative surrealism of the Europeans—the approach preferred by Breton and his circle—and the more abstract styles practiced at home. Many artists, not just official surrealists, appeared to be using surrealism's interest in the unconscious as a starting point. "That show was the first big melting pot of Surrealism and of abstraction," Philip Pavia later told John Gruen. "It was a big transitional show. I think this was really the birth of New York as an art center, even with all those foreigners around." The show was important for another reason. It marked the emergence of Jackson Pollock, whom Howard Putzel had met the year before and immediately deemed a "genius." Born in Cody, Wyoming, and raised in, among other places, Chico, California, and Phoenix, Arizona, Pollock was an out-

sider even in the outsiders' world of downtown New York. Since moving to Manhattan in 1930, he had been a protégé of the regionalist painter Thomas Hart Benton and been drawn to the visual intensity of the militant Mexican muralist David Siqueiros, who had organized a politically charged workshop in New York. Such affiliations placed him outside de Kooning's modernist circle, which was oriented toward Europe. Shy and inarticulate, Pollock had kept to himself, living with his brothers and shunning the conversation that went on night after night during the 1930s in the downtown cafeterias.

Pollock was also much younger than the more established downtown artists. De Kooning was eight years his senior, while John Graham was more than a generation older. Nevertheless, it was John Graham who gave Pollock his first break. Graham considered Pollock "a kind of bumpkin, but with a profound talent," according to one friend of Graham's, the artist Ron Gorchov. He included Pollock in a show that he organized for the McMillen Gallery in January 1942 (which also included de Kooning). It was on the occasion of this show, which did not get much public attention, that de Kooning and many other downtown artists first met or became aware of Pollock. "Graham was very important, and he discovered Pollock," de Kooning later told the interviewer James Valliere. "The other critics came later—much later. Graham was a painter as well as a critic. It was hard for other artists to see what Pollock was doing—their work was so different from his. It's hard to see something that's different from your work. But Graham could see it."

Graham helped introduce Pollock to African art and to the work of Picasso, and he strengthened Pollock's faith in the unconscious. Pollock began to study the art of the surrealists. He became interested in William Baziotes and met Herbert and Mercedes Matter, the couple involved with de Kooning on the Léger project. The Matters were among the few people considered cosmopolitan enough in the New York art world to interest the surrealists. By late 1942, Pollock had begun to perform his own surrealist-inspired experiments. When Matta and Robert Motherwell tried to create their own distinctive brand of American surrealism, Pollock was included among the artists who met at Matta's to experiment and to play surrealist-inspired parlor games.

Pollock's second break had come in the summer of 1942, when he had been introduced to Putzel by the Los Angeles artist Reuben Kadish. Putzel soon began promoting Pollock's work to Guggenheim. Even so, she initially had little reaction either to the paintings that Putzel showed her or to Matta's concurring endorsement of his talent. Pollock almost did not make the cut for the "Spring Salon for Young Artists" show, even though

Putzel obligingly went to fetch Pollock's paintings rather than ask him to stand in line with the rest of the artists. On the day of the judging, Guggenheim told Mondrian that she loathed Pollock's *Stenographic Figure.* Instead of rejecting the painting, however, Mondrian paused, looked at it carefully, and then declared that it was among the more interesting works that he had seen in America. Guggenheim instantly recanted.

Mondrian's pronouncement was prescient. Among the artists on display in the "Spring Salon," Jackson Pollock was singled out for high praise by the critic of *The New Yorker,* Robert Coates, who announced, "We have a real discovery." Coates, like Pavia, thought American abstraction and European surrealism were enriching each other. Pollock's *Stenographic Figure* embodied, in his view, the coming together of the two major directions of art. For Pollock, the enthusiasm of Coates and the endorsement of Mondrian marked a turning point. As he later wrote to his brother Charles, "Things really broke with the showing of that painting." Putzel then pushed for a one-man show for Pollock and succeeded in getting Guggenheim to visit his studio. When Pollock arrived late for their rendezvous, he and Lee Krasner—then his girlfriend and later his wife—found Guggenheim enraged on the street outside the building. She harangued him for making her wait, as well as for making her needlessly climb five flights of stairs; she tended to treat all but the most celebrated artists as servants who should be grateful for her attention. It was all Pollock and Krasner could do to persuade Guggenheim to climb back up the steps and look at Pollock's work. Still, she dilly-dallied about exhibiting his art, worrying that doing so would symbolize an irrevocable turn away from European surrealism. She was uncertain whether to make such a bold statement. Although she had given the American artist Joseph Cornell a one-man show, Cornell, unlike Pollock, was regarded as an American surrealist in the European tradition. Guggenheim sent Marcel Duchamp to see Pollock's work. Like Mondrian, the laconic Duchamp did not rave; but neither did he condemn. That, along with the support of James Johnson Sweeney, finally convinced Guggenheim that Putzel was right.

Pollock's first one-man show opened on November 8, 1943. It was a landmark in the emergence of modern art in America. In the announcement of the show that appeared in *Art Digest,* Guggenheim praised Pollock as "one of the strongest and most interesting American painters." In the brief introduction to the exhibition catalog, Sweeney wrote that "what we need is more young men who paint from inner impulse without an ear to what the critic or spectator may feel"; and, while he faulted Pollock for lacking self-discipline, he called his talent "volcanic." Most

subsequent reviewers injected cautionary notes, just as Sweeney had done (much to Pollock's anger). The European surrealists publicly endorsed Pollock while privately treating his work with condescension. But the qualms hardly seemed to matter. Since he was shown at Guggenheim's gallery, almost all reviewers covered Pollock's show, including those at the *New York Times*, the *New York Sun*, *Partisan Review*, *The New Yorker*, and *The Nation*. Robert Coates reaffirmed his judgment that Pollock was "an authentic discovery."

Suddenly, there was fashionable buzz around an American artist. The Chicago Arts Club asked for the Pollock show. The San Francisco Museum of Art wanted a show of Pollock drawings. Sidney Janis, a former shirt manufacturer who had become a collector but not yet a dealer, included a Pollock in a traveling exhibition of "Abstract and Surrealist Art in the United States," which he organized in 1943. Alfred Barr, the director of the Museum of Modern Art, bought *She-Wolf*, one of the strongest paintings in the Art of This Century show—a sign that Pollock had serious support in the uptown art world of New York. Not least, Peggy Guggenheim became his official patron. She agreed to support him with a monthly stipend of $150, to be deducted at year's end along with an additional gallery commission from the sales of his paintings. Collectors soon began to flock to Pollock. One of the first was Jeanne Reynal, who bought Pollock's *The Magic Mirror* in 1944. A personal student and long-time supporter of Gorky's, Reynal was a prodigious collector of art and a well-known figure downtown. A talented mosaicist who "did Gorky in mosaics," according to Joop Sanders, she was fabulously wealthy by downtown standards. She entertained lavishly at her brownstone on West Eleventh Street in the Village, where a lovely aviary helped to keep the guests amused. "She was one of a group of women who were surrealist inspired," said Sanders. "They all wore Alexander Calder jewelry and Isadora Duncan sandals. And she was loaded from top to toe with silver jewelry from Santa Fe."

On the strength of his first show, Pollock began to circulate among wealthy patrons and collectors, who were eager to meet Guggenheim's American discovery. His success was confirmed by his second one-man show at Art of This Century in March 1945, from which Pollock emerged with a new supporter, the art critic Clement Greenberg, who would become one of the most powerful voices in American art. "Jackson Pollock's one-man show establishes him, in my opinion, as the strongest painter of his generation and perhaps the greatest one to appear since Miró," wrote the supremely confident Greenberg in *The Nation*. He added, "I cannot find strong enough words of praise." It was an extraordi-

nary triumph for someone who, just three years before, had been an unknown. No other young American had received anything remotely like Pollock's critical and commercial acclaim. That success was even more astonishing given how ill-suited he seemed to the polished world of Peggy Guggenheim and the art establishment. Pollock often became drunk or behaved outrageously. He threw up at one luncheon that Guggenheim arranged at the Chelsea Hotel to introduce him to collectors and, on another occasion, urinated into Guggenheim's fireplace during a party.

But it was already understood among some sophisticated collectors who were aware of surrealism and tribal art that "the artist" would now sometimes perform the part of modern savage. Especially one from Wyoming. The war years, moreover, were jingoistic; America was ready for a made-at-home genius. The *ArtNews* reviewer wrote of Pollock's first show, "[His] abstractions are free of Paris, and contain a disciplined American fury." It was a nationalistic note that would be sounded repeatedly about Pollock, one that initially excluded many of the other artists who would eventually be acclaimed as the upholders of American art but who came from immigrant families. Milton Resnick put it this way: "They had been waiting for the American glamour boy in art. . . . Who were they going to go to—a Dutchman, an Italian, a Jew, a Greek? Where's the American? He filled the bill."

In contrast to Pollock, de Kooning had nothing to show for a decade of serious work other than his inclusion in several group shows: John Graham's 1942 show at the McMillen Gallery, the group show at the Bignou Gallery in 1943, and two pioneering surveys of 1944. Of the latter, "A Painting Prophecy" was organized for a Washington, D.C., gallery by David Porter, a Chicago painter then serving in the War Department. Porter, ahead of his time in spotting talent, included works by de Kooning, Pollock, Rothko, Marca-Relli, and Gottlieb. The other was the "Abstract and Surrealist Art in the United States" exhibition organized by Sidney Janis that included a painting by Pollock. (It opened at the Mortimer Brandt Gallery in New York in November 1944 after traveling across America.) Janis selected many of the same artists that David Porter did, with the addition of a few more directly influenced by surrealism. De Kooning was also included in an autumn salon at Guggenheim's Art of This Century Gallery in October 1945. Compared to Pollock's *succès d'estime*, however, de Kooning's inclusion in these group shows was insignificant. By mid-decade, already forty years old, de Kooning had sold only one painting to a collector outside his downtown circle of friends and admirers. And that sale made him no happier than the ill-fated visit of Peggy Guggenheim. In 1943, Helena Rubenstein visited the group show at

the Bignou Gallery. The art dealer Georges Keller had included two de Koonings: *Pink Landscape,* circa 1938, and *Elegy,* from the following year. Rubenstein bought *Elegy* for $450, a significant sum for de Kooning. But she purchased it only as an afterthought. According to Joop Sanders, "Bill said that Rubenstein was buying the store, so to speak. She had bought one Renoir for $35,000. Bill's painting was, I think, $600. She said, 'What is that?' They said, 'It's a promising American painter named de Kooning.' So she said, '$600. Throw it in for $450.' Bill said to me, 'Christ, I've never seen that much for a painting. But the bitch. Renoir doesn't need it.' "

De Kooning did not begrudge Pollock his success. He saw in Pollock an original who deserved respect; Pollock's example would help inspire the creation of de Kooning's own great works of the late forties. "Pollock was the leader," de Kooning later said. "He was the painting cowboy, the first to get recognition. Peggy Guggenheim was crazy about him. She bought things from him during the war." De Kooning graciously added, "He had then come much further than I. I was still seeking my way." In de Kooning's eyes, Pollock, whatever his success uptown, remained an outsider who had paid his dues; he was a comrade, an *artist.* It was not Pollock but the world adopting Pollock that sent the hard message that de Kooning remembered too well from Rotterdam, that he was not part of the class that dominated art. Still, de Kooning could not be deeply wounded in this way. Like many proud people from poor families, he had long ago reversed the terms of rejection. If Guggenheim condescended to him, well, he would look down his nose at her. What troubled him more than any conventional exclusion from the world of privilege, what cut him to the quick, was a less expected and more intimate rejection by one of his own.

In the mid-forties, the artist in the world who was closest to him, Arshile Gorky, not only took up with the world of wealth and connection but dropped de Kooning. From the beginning, of course, Gorky took a greater interest than de Kooning did in surrealism. Gorky was already talking to the art dealer Julien Levy about surrealist ideas. He jumped at the chance to befriend Matta in the early forties and enjoyed discussing art with him, much as he once had with de Kooning. But Gorky, in the eyes of some New York artists, was not just artistically interested in the surrealists. He craved acceptance by the snobbish Europeans. Isamu Noguchi recalled that he introduced Gorky to Breton in about 1944, and that Gorky was ecstatic when *le pape* gave him his blessing. Noguchi said, "That was for him arriving." Despite his good fortune, Gorky did not offer de Kooning a helping hand. "He didn't share the pie," said Sanders. "Gorky was picked up by the surrealists, by Breton and all the elegant peo-

ple that Noguchi knew and did nothing to introduce them to anyone. . . . There was an awful lot of resentment there, although de Kooning respected Gorky greatly as a painter. Pollock was Guggenheim's baby, but she did buy Gorky, and he did move in the circles of Breton and all of those people." The group taken up by Howard Putzel became a clique. De Kooning could not help but contrast Gorky's new behavior with his fierce independence from cliques in the thirties. "He was going up the ladder," said Conrad Fried.

The new situation exposed some old tensions between the two painters. Gorky had always taken the dominant part in their relationship; de Kooning understood that Gorky could not do otherwise and still remain Gorky. What was acceptable when they were struggling together, however, became offensive when Gorky decided that he was too important to waste his time on de Kooning. Traditionally, Gorky would tease de Kooning in slyly hurtful ways. He knew just where to stick the hot needle. During the many years when de Kooning, like Gorky, was working to find himself as an artist, Gorky would generously compliment him for being a "great illustrator," the implication being that de Kooning's wealth of talent and academic training, which Gorky sometimes envied, could not alone make him an artist. Gorky would also make barbed comments about de Kooning's social background. In one brilliantly two-edged compliment, for example, he nicknamed de Kooning "Master Bill." (He even painted a portrait of de Kooning in 1937 with that title.) The name "Master Bill" acknowledged, once again, de Kooning's talent and European training, while simultaneously likening him to an apprentice learning a trade. The artist with the common name "Bill" would have immediately understood that Gorky was pointedly denying him the full formal majesty of the word "master," as it was reverentially applied by Gorky to the great artists of the European tradition. Instead, he was using the word condescendingly to mean a "boy of some standing," emphasizing his friend's immaturity as an artist.

Another serious wedge in the friendship between Gorky and de Kooning came with Gorky's marriage in 1941 to a woman from the uptown world. Agnes Magruder, the daughter of a naval commodore, had grown up in Boston and was as poised and self-assured as Gorky was brooding and suspicious. Ironically, she met Gorky early in 1941 through de Kooning. Agnes had been introduced to de Kooning by the woman who rented her a room on East Twenty-third Street. Not long after, de Kooning and Elaine invited Agnes to a party where Gorky would be, having first told her all about the Armenian artist. Gorky and Magruder fell deeply in love.

They were married in Virginia City, Nevada, that September after driving cross-country to San Francisco with Isamu Noguchi in search of prospective patrons. It was not Agnes Magruder herself, whom Gorky affectionately called "Mougouch," who separated Gorky from his old friends. Gorky himself did that. But his marriage transformed his circumstances. Agnes did not subscribe to the custom of Gorky's friends dropping in informally for dinner. "I can remember Agnes curling her mouth up and saying, 'De Kooning for supper again?' " said the artist V. V. Rankine, who married Agnes's brother, John Magruder, and lived for a short time with Agnes and Gorky. It also became socially awkward for the newly well-off Gorky to see his impoverished friends. His wife's family owned a farm in the horse country of Virginia, where Gorky and Mougouch spent increasing amounts of time, including the summer of 1943. The next year, they extended their stay in Virginia for nine months. Then, after only two months back in New York, they were off again for nine months, this time to the house in Connecticut of David Hare. Gorky's "going up the ladder" seemed to pay off in 1945, with Breton's blessing of his first one-man show at the Julien Lévy Gallery in an important essay titled, "The Eye-Spring: Arshile Gorky."

De Kooning's circumstances could hardly have been more different. In the latter years of the war, while Gorky lived in fine country houses and worked toward his one-man show, de Kooning was desperately poor and still without serious prospects as an artist. In contrast to Gorky, he had married a woman without money or social position, and he inhabited a world far removed from fashion and power. In the mid- to late forties, Elaine made almost no money. She had begun to paint self-portraits that she sometimes sold to friends; her sister bought a 1946 self-portrait for twenty dollars, which Elaine called "good money." With the encouragement of Edwin Denby, she also wrote short ballet reviews for the *New York Herald Tribune*, the newspaper to which Denby contributed. But that was more for the excitement than for the pittance earned. "In the mid-forties," Edwin Denby said, "de Kooning was poorer than ever." "That devastating poverty seemed the most important thing in our lives together," Elaine later recalled. As dedicated as the small downtown group could be, there was also an element of squalor about their lives. They slept in dingy, comfortless lofts, their days made ragged by the search for money. De Kooning couldn't afford to pay for electricity; instead, he later recalled, he was "stealing the landlord's light by using a long wire from the hall." "There were tragic things, if you think about it," said Conrad Fried. "A certain amount of suffering." Franz Kline, a downtown artist

who would become one of de Kooning's closest friends and a celebrated painter, once had so little to eat that his dog ate a bar of soap. According to Ludwig Sander, "We were really just like Bowery bums in a way."

De Kooning put a brave face on his circumstances. He loved to announce grandly, "I'm not poor. I'm broke," banishing any suggestion that he was mired in proletarian hopelessness. He had, he always made clear, chosen his condition. But he was often desperately anxious, walking away the nights in the streets of New York and continuing to suffer, sometimes, from heart palpitations; in the late forties, for the first time, he asked a doctor about his heart. At dark moments, he even dreamed of joining the crowd and becoming a middle-class American with a decent paycheck. According to Conrad Fried:

> Around 1946 or 1947, after Elaine was married to Bill, they used to come out and my father would bake a cake. One time it was income tax time. So Bill said, "Gee, I don't make out taxes and I'd like to." My father gave him a couple of 1040 forms and he set to work. There was this litany of tragically small sales and how he went to the doctor for heart palpitations and had wound up borrowing $100, which he regards as income! Typically he'd have sold a painting for $200. Finally my father said, "You don't owe enough to pay taxes." Then Bill started to pad up the amount to get to the point of paying tax. Then he would feel like a real citizen.

In the tough years of the Depression, Gorky's noble and extravagant persona, and his richness of soul, helped inspire de Kooning to endure the penury of an artist's life. The two friends even collaborated on projects, notably a mural for the Riviera Restaurant in New Jersey that they executed together in the late thirties. De Kooning always publicly acknowledged his debt to Gorky; Gorky never did the same for de Kooning, though de Kooning gave Gorky more than a few technical tips learned at the academy (including how to blow up drawings to mural size for the Riviera Restaurant). De Kooning's knowledgeable support helped maintain Gorky's spirit, confidence, and insight. They were together great draftsmen studying other great draftsmen; inevitably, each learned from the other's "line." Their mature art seemed to stem from a common root, then flower independently as each developed a personal hand and brushstroke: Gorky's was one of erotic whimsy and melancholy, de Kooning's was full of spit and American pizzazz. The *Garden in Sochi* series that Gorky completed in the mid-forties and de Kooning's new abstractions were kindred creations.

To see Gorky sail away into the world of privilege represented for de Kooning nothing less than the loss of his American brother. "There was a great friendship at one time," Sanders said, "but it was bitter enemies from then on." But bitter, it must be remembered, in the family way. De Kooning never stopped loving Gorky; and, after Gorky's death in 1948, he spoke of him only with respect and longing. Decades later, when de Kooning was celebrated, Gorky often stole into his thoughts. No artist came up more often in his conversation. None seemed so close at hand.

In 1945, de Kooning had lost a brother, and began to lose a wife as well. Despite the couple's early happiness, the first year of their marriage opened small but important seams in their relationship. Marriage demanded difficult adjustments on both their parts. After years of working alone, de Kooning found it exasperating to share his loft full time with another person. Elaine preferred to paint in silence; but her husband kept up a steady stream of whistling. "I hate to say this," Elaine told John Gruen, "but Bill whistled while he worked. You know, Mozart and Stravinsky. Bill could whistle these fantastic melodies. But I found it just a little, tiny bit irritating." Also, she said, their personal rhythms were different. De Kooning's was slow and deliberate, hers fast and furious. "Bill said my pace was like Gorky's—hacking away at the canvas." There were important temperamental differences. Elaine was vivacious; she loved a party and craved attention. De Kooning enjoyed giving or attending an occasional party, but was essentially a loner who relished the solitude of the studio. Even before marrying Elaine, de Kooning seems to have worried about those differences. He could not help entertaining some suspicions about her motives, or, probably, those of any woman wishing to claim him. Not long before the wedding, he shocked Janice Biala by confiding, "You know, I loved Elaine and if she had married me last year I would have been so happy. But now, I tink I've been had."

They were more together, in short, when they were sometimes apart. Being married certainly did nothing to change de Kooning's relentless focus upon work. Nor did it relieve his moodiness or assuage his anxiety. Gorky's "betrayal" only worsened his mood, as did the relentless poverty of the war years, when he had to seek commercial work even as Pollock and Gorky began to prosper. By the fall of 1945, his young and high-spirited wife was growing restive. The summer the war finally ended, Elaine longed for some escape from the grinding routine of her husband's days. A friend of Edwin Denby's, a handsome, charming young Irish American named Bill Hardy, who was a physicist with the Sperry Chemi-

cal Company in New York and circulated in the downtown world of artists, dancers, and musicians, proposed that Elaine sail to Provincetown with him that fall to crew his boat and celebrate the end of the war. Hardy was an avid sailor. Elaine gladly accepted. A bohemian lover of good times, she did not stop to think how her husband might feel about this adventure. Or, if she did, she decided that what she wanted took precedence. She stayed away well into early winter, with de Kooning paying a few visits to Provincetown. Although Elaine always insisted that her relationship with Hardy was platonic, de Kooning was nonetheless "pissed off," according to Ibram Lassaw, less about the sexual issue, perhaps, than about her prolonged absence.

No sooner did Elaine return that December than she and de Kooning were evicted from their loft on Twenty-second Street, losing what little they had in the way of a settled life. For de Kooning, the loft he so carefully crafted symbolized his love for Elaine and his hopes for their marriage. Now, suddenly, it would have to be abandoned. Several times in the past, when they were behind on the rent, they had barely escaped eviction. There were periods, said Elaine, when they were so poor that they had had to choose between cigarettes and supper. But this time the problem was not the rent. This time, fate itself seemed to conspire against them. The building was being sold; de Kooning's loft would be turned into storage space. Whatever tenant's lease they had was probably worthless. "We could have fought it, but we didn't," said Elaine. They had to get out.

Forced to move quickly, de Kooning asked Elaine's former boyfriend, Milton Resnick, for help. Whatever his initial feelings about losing Elaine, Resnick had become one of de Kooning's close friends in the late thirties and, before joining the military, lived near de Kooning in Chelsea. Having recently returned from four and a half dangerous years in the army, where he served as head of a reconnaissance unit, Resnick had rented a cold-water flat in a tenement building on Carmine Street in Greenwich Village, just off Sixth Avenue. The building was south of Eighth Street, about twenty blocks from where the de Koonings lived in Chelsea. It was in the middle of Little Italy, a district then populated mainly by immigrants. According to Resnick, de Kooning said, "We have to get out, and Elaine needs a place to stay. Why don't you let me have this place and we'll look for another for you?" Ever the good friend, Resnick agreed, even loaning de Kooning several hundred dollars from his army savings, which, Resnick said, de Kooning failed to repay.

The new apartment was a financial godsend. The rent was $18 a month rather than the $35 for Twenty-second Street. In every other respect, however, it represented a miserable comedown from their loft.

The space was tiny, just one and a half rooms. The kitchen and living room were combined and connected to a tiny bedroom, which had room only for a bed. There was no heat. The bathtub was in the kitchen next to the sink. The building itself was a roach-infested tenement that had not been fixed up in years. According to Conrad Fried, "The floor there was awful." A good floor was always important to de Kooning. Now, he and Fried took up the linoleum he had installed on Twenty-second Street, rolled it, and carried it on their shoulders down Sixth Avenue to Carmine Street. "Then we cut it up and fit it in the Carmine Street apartment," said Fried. Since de Kooning had no money and so much of his furniture was built in, the move was accomplished "without a truck or car," said Fried. "By carrying things. All his books. He put them in suitcases." The couple's sole purchase for their new home was practical: a used refrigerator, which de Kooning and Fried manhandled up the four flights of steps to the apartment. De Kooning was in the rear as they climbed the stairs. "We were juggling it up these narrow tenement stairs," said Fried, "and I heard him say, 'My life is in your hands.' " The Capehart phonograph, the magnificent splurge from de Kooning's early life, did not make the move. It had been destroyed when another tenant on Twenty-second Street was doing electrical work and failed to tell de Kooning that he was converting the power from alternating to direct current. "He switched the current and Bill's phonograph was on and it blew up," said Marjorie Luyckx.

The debacle with the Capehart, too, seemed a symbol of the larger state of de Kooning's affairs. His dreams of the good life had come crashing to an end. In just two years, he had gone from a beautifully crafted, bright, and cheerful loft, which he could fill with music with just a flip of a switch, to a dingy dungeon with barely enough room for one person, much less two. Carmine Street might well have reminded de Kooning of the precarious existence and constant moving that he had endured as a young boy in Rotterdam Noord. In any case, he had several times fixed up a living space for himself, only to be forced to move shortly thereafter. Now, he vowed never again to put such effort into any place he did not own. The loss of the loft, according to both Fried and Marjorie Luyckx, left him "heartbroken."

As difficult as it was to live in, their new mouse hole was almost unworkable as a shared studio. Elaine set up her easel in one corner, and de Kooning took the other. They had already been getting on each other's nerves painting at opposite ends of the big loft on Twenty-second Street. Now, on top of each other night and day, tension flared between them. If de Kooning was snappish and irritable before the move—if he often

regarded Elaine as a distraction—now he found the close quarters unbearable. He could not live without working. But even the solace afforded by solitary work, never mind success, was being denied him. According to Sanders, "There was a lot of conflict about who could work there and who couldn't." Nonetheless, de Kooning resolutely maintained his focus. At one point, he debated whether or not to solicit commissions for portraits; he had continued to draw occasional portraits during the forties as a way of supplementing his meager sales and supporting his purchases of paint. But he decided to break with this practice: no more portraits. One of the last to solicit one was an Austrian couple, the Kurzes, who had come to New York as refugees in 1940. Kurz wanted a portrait of his wife, and the two went to see the work of a number of downtown artists. They settled upon de Kooning, and, because he had no phone, went to Carmine Street to see him. Elaine met them at the door with the news that de Kooning was no longer doing portraits, but that she, Elaine, could draw one. The Kurzes declined.

During this period, de Kooning was well served by his dark, absurdist humor. He began to relish the unexpected eruptions that occurred in life and art. Conrad Fried was once walking through the Village with de Kooning when two cars collided. Much to Fried's surprise, de Kooning suddenly burst out laughing, enjoying the plight of the two drivers. "Look at that," he told Fried. "Those guys are not like us. They have everything going for them. But all of a sudden they're in the same shape as us." Another time, when de Kooning and his friends were partying, the lights suddenly winked out. People scurried about looking for candles and checking fuses. When the lights returned, someone asked de Kooning what he did in the darkness. Well, he said, he made faces. *Of course* he made faces. He grinned, he scowled, he glared. He twisted his features around.

Uptown, there was a luminous world of money, fashion, and success. Downtown, there was a lively world of friends with whom to pass away the nights. But, at any moment, the lights might go out. Then you were left to yourself—free to make faces in the dark.

17. A Quickening

*Of all movements I like cubism most. It had that wonderful unsure atmosphere
of reflection, a poetic frame where something could be possible,
where an artist could practice his intuition.*

In contrast to Europe, where even the victors lay exhausted and desti-
tute, the United States emerged from World War II with a renewed sense
of confidence. At the same time, the inescapable truths of the war—
especially the details emerging about the death camps—darkened the
imaginations of thoughtful people. Had the world reached an end or a
beginning? Extreme pessimism and extreme optimism suddenly appeared
equally justified. Not surprisingly, the scale of art in New York began to
change and expand; anything, artists began to feel, was possible. The sur-
realists returned to Paris, and the American servicemen came home, eager
to make up for three or four years of lost time.

Typically, the returning artists settled in the Village. In fact, the only
appealing aspect of de Kooning and Elaine's drab new apartment was its
location. With the return of the GIs, the scene at the Waldorf Cafeteria,
which was only a few blocks from their flat on Carmine Street, intensi-
fied. If the artists had once numbered seven or eight on any given evening,
now the tables were overflowing. Each night seemed more crowded than
the last. According to the sculptor Philip Pavia:

> It's hard to describe the evenings. But there was a real hunger. We all
> sought each other's company and it was practically daily; six out of
> seven nights of the week we all sat around and talked. . . . Droves of
> artists started coming into the cafeteria. Jack Tworkov, Milton
> Resnick—I can't name them all. Pretty soon we couldn't fit around the
> table. So we had about four tables. Sidney Janis [who would soon
> become a dealer] would come in, and [the architect Frederick] Kiesler.
> And John Graham would come in with complete contempt for all of us.
> He hated the cigarette smoke and he would hold his nose while he
> talked to us. Now this was the beginning of everything.

One of the returning soldier-artists was Ludwig Sander, a painter who
had lived on Third Street and been part of the downtown scene since the

early thirties. His rush to the Waldorf was typical: "My second night home, [Reuben] Nakian took me right to the cafeteria where everybody was, and I saw guys I knew from before." Sander remembered seeing de Kooning that night and "other faces that looked familiar from before the war." The list of new arrivals from the old days included Burgoyne Diller, de Kooning's original supervisor on the WPA. Another old friend from the WPA, Ibram Lassaw, instantly became a Waldorf regular. James Brooks, George McNeil, John Little, John Ferren—artists who had been around since the WPA days—began showing up. Even Jackson Pollock would drop by occasionally, or "make entrances," as the sculptor Peter Grippe said. "He'd tell us what a bunch of idiots we all were, and then he'd leave," said Pavia.

During the day, "most artists stayed in their studios," said Grippe. But when taking a break, an artist would typically head to Washington Square Park, which was filled with contemporaries out for a stroll and a chat. And at night, all of Eighth Street became "the playground of the downtown group," Pavia said. "We would leave the cafeteria and walk the length of Eighth Street back and forth." The result, said George McNeil, was "a tremendous ferment." With the Europeans mostly gone, moreover, there was no longer any necessity, as Pavia put it, for "fighting the uptown group mentally." Peggy Guggenheim returned to Europe in 1947; Art of This Century closed the same year. Freed from the shadow of Europe and buoyed by newcomers to the Waldorf, the Americans began to paint with fresh energy. The laboratory fervor resembled, according to McNeil, that found in the fauves and the cubists at the outset of the century. It was a coming together in new beginnings.

Despite their excitement, the Americans still kept an eye on Paris. Among several influential postwar shows was a Jean Dubuffet exhibit in 1947 at the Pierre Matisse Gallery. A cranky iconoclast, Dubuffet had only begun painting seriously in 1942, at the age of forty-one, after a career as a wine merchant. He departed radically from the traditions of the School of Paris. Called one of the first "anti-artists"—which, of course, is just another kind of artist—he would incorporate pebbles, shards of glass, and the detritus of modern life into paintings. Many evenings at the Waldorf were devoted to discussions of Dubuffet's skewed perspectives and bizarre, Dadaesque use of materials. "He was shaking the whole scene," said Pavia. "That distortion he had was crazier than Picasso's if you try to understand it." One of Dubuffet's chief supporters was de Kooning, who was also an admirer of the grand old man of Dada himself, Marcel Duchamp, whose iconoclastic work was on display in a major exhibition that year. Duchamp and Dubuffet were appealing not only because they

attempted to redefine art—which the New Yorkers also hoped to do—but because they mercilessly mocked conventional taste. De Kooning himself, always powerfully drawn to the impurities of life, relished this air of freedom. He called Duchamp "that one-man movement—for me a truly modern movement because it implies that each artist can do what he thinks he ought to."

Cézanne and Picasso were the subject of large postwar shows and both inspired much talk downtown. "Cézanne was very important, and much discussed, but not as much as Picasso, who was a monumental figure at that point," said Joop Sanders. "And those women, the sort of grids [that Picasso used], I think Bill's women might have been influenced by them. And also the use of the flat color." By 1946 and 1947, however, American artists were also beginning to question Picasso and the cubists. The revisionist view, buttressed by the wartime presence of the surrealists, was that cubism was a dry "modern academy," said John Ferren, that could imprison an artist's sensibility. "Cubism has its basis in drawing, and in planning," said George McNeil. "It foisted form upon painters. So I think in those years it was considered a kind of detriment or obstacle to going ahead with free painting." Casting about for something to replace the "awful shadow of the School of Paris," as Ferren described it, painters turned increasingly toward the subjective and personal, which again owed a debt to surrealism's emphasis on the subconscious. Sometimes, the painter's internal struggle to create the painting seemed almost as important as the end result. In the famous words of Harold Rosenberg, writing several years later, "What was to go on the canvas was not a picture but an event." Confidence grew that there was a new American art. Jack Tworkov put it this way:

> This emphasis and reliance on yourself, on not looking over the shoulders of others, or painting as if others were looking over your shoulder, became the main theme. And because there was this break with tradition, there was a real kind of effort to break with Europe, to break with Picasso, to break with Cubism, to break with Surrealism, or whatever.

As the downtown artists began to find one another, and themselves, they were in turn beginning to be discovered. It seemed almost miraculous, but a few homegrown critics and art dealers began to take a serious interest in work by Americans. Until the end of the war, the three leading "professional" journals of the day, the *Magazine of Art, ArtNews,* and *Art Digest,* had either ignored the New York painters or been critical of them. *The New Republic* also ignored art while extensively covering poetry,

film, and literature. But two small influential magazines, both with roots in the downtown Marxist world of the thirties, had begun to write about the emerging art scene during the war. *The Nation* had hired Clement Greenberg, then at *Partisan Review,* to be its critic, and *Partisan Review,* which had evolved into the most influential journal of politics, arts, and society among New York intellectuals, had also begun to review American painting. The *Partisan Review* group included many of the most distinguished writers and editors of the day, among them Philip Rahv, William Barrett, Mary McCarthy, Dwight Macdonald, and Delmore Schwartz. Its early pieces on art were written by James Johnson Sweeney, Peggy Guggenheim's advisor and the chairman of the painting and sculpture department at the Museum of Modern Art, and by Robert Motherwell, then an ambitious writer as well as artist.

In later years, much would be made of the role of the early critics in "discovering" the New York school. The expected procedure, as Lionel Abel wrote in *Intellectual Follies,* his memoir of the era, was that the avant-garde was first found by the little magazines. Mainstream journalists who read the little magazines would then sell the avant-garde to the mass public. The more important role of the early critics, however, was less mechanical than this suggests. To begin with, simply being noticed was enough to nourish the spirit of isolated artists unaccustomed to serious regard from anyone but friends. Just as important, the manner in which certain critics wrote gave what often seemed a useless existence making unwanted pictures an air of grand import.

The two main critics emerging from the left-wing milieu downtown were Clement Greenberg and Harold Rosenberg. Although they differed greatly in sensibility—they would eventually become fierce rivals—they shared a common grounding in the passionate politics of the thirties. They took up art criticism in the forties during a period of shattered ideals, when disappointment with the failure of the Soviet Union to sustain the dreams of Western Marxists was widespread. Not surprisingly, they brought into their views of art ideals and attitudes that politics could no longer sustain. They believed without question in a vanguard of revolutionary artists who must meet the demands of history, even if those artists were not themselves fully aware of what they were doing. They reveled in clashes, arguments, and hard-nosed judgments. Unsentimental about old Europe, they were prepared to believe that Europe's time was past and that the evolution of important art would cycle into a more modern society like the United States. They wrote as if History herself stood at their shoulder, promising artists her highest regard. Which hit the spot when you lived in a cold-water flat.

Greenberg had seemed destined to be a literary critic. The son of Lithuanian Jews, he was born in the Bronx and raised mainly in Brooklyn, with a brief period in Norfolk, Virginia. He was determined to leave both Brooklyn and the Old World Jewish community behind. After getting his A.B. degree at Syracuse University, he moved to Greenwich Village. Prematurely balding, with an egg-shaped head and a habit of lecturing rather than talking to others, Greenberg was first a writer and then an editor at *Partisan Review* for several years. (Philip Rahv, who, along with William Phillips, edited the magazine, later speculated that Greenberg saw too many literary critics around, and therefore turned to the understaffed world of art criticism.) Greenberg helped prepare himself for writing about art by attending a summer session at the Art Students League. He also went to lectures at Hans Hofmann's school and accompanied Lee Krasner, one of Hofmann's best pupils, as she made the rounds of the galleries. In 1944, he was named art critic of *The Nation*.

Even painters whom Greenberg supported often found him difficult, for he usually treated them with condescension. "All artists," he liked to say, "are bores." His views about what modernism demanded of an artist often seemed dogmatic, which is what de Kooning, in particular, disliked about him. And Greenberg never hesitated to pass judgment on an artist's work to his or her face. "That one's a mistake!" he would pronounce, pointing to an offending painting during a studio visit. His confidence seemed unshakable, his faith in his own pronouncements complete, his ambition for himself and his chosen artists fierce. A natural "agent provocateur," as Dore Ashton called him, he loved to make confrontational statements. "The future of American painting," he declared in the mid-forties, "depends on what [Motherwell], Baziotes, Pollock, and only a comparatively few others do from now on." Still, as most artists recognized, Greenberg was forcefully promoting American art. And his severity had a kind of beauty, for it honored seriousness of purpose and celebrated an elect who would enter the Pantheon of history.

The second important critic to emerge, and one who would later challenge Greenberg's position as the leading critic of the so-called New York school, was Harold Rosenberg, who knew most of the downtown artists, including de Kooning, from the WPA era. The *New York Times* critic Hilton Kramer later characterized him as "resourceful in polemic and sometimes dazzling in his style, with a sardonic humor that lived on easy terms with elaborate conceptual conceits, and justly celebrated as a phrasemaker." Rosenberg could intoxicate himself with his own words. He could not live without ideas and an audience to hear them. He was around six foot three, with one bad leg that added a distinctive cant to his

walk. (His friend Saul Steinberg, a short man, refused to talk to Rosenberg unless he sat down.) He had piercing eyes, a jutting nose, and flaring nostrils that he used to dramatic advantage in his endless debates. His friend Mary McCarthy described him like this:

> I compared him once—in a book review—to a pirate or buccaneer, I forget which. And there was certainly that in his appearance and voice—something of the Jolly Roger on the Spanish main. The bristling mustache and eyebrows, the great height, the game leg, the outthrust lip and surveying eye, as if commanding the scene from the focs'le. He gave an impression of total fearlessness and genial contempt for any craft that would seek to board him. This was by no means a false impression. Yet he was not a bellicose man—or even fierce, except in his independence. He was, in part, a humorist, and the ferocity of his look and voice had a hint of playfulness, as though he were casting himself jovially as King Herod in a pantomime ordering a massacre of innocents.

Unlike Greenberg, Rosenberg genuinely liked most artists, and was widely liked in turn. He was "one of the boys" in a way that Greenberg refused to be. In common with many downtown painters, he took a long time to find his way. He attended City College of New York and then earned a law degree from St. Lawrence University in 1927. After that, he abandoned the law and spent most of his time talking, reading, and writing poetry. He and his wife, May Tabak Rosenberg, lived in a rambling apartment in the West Village, where they rented out three rooms. Around 1936, Rosenberg also began to write about art, although not as seriously as he would in the 1950s. He contributed occasional reviews to *Art Front,* the publication of the Artists' Union, and was for a short time its editor. All of his articles took a fiery Trotskyite line. According to Ibram Lassaw, "He was looked up to by all the Trotskyites." During the WPA era, Rosenberg was briefly on the artists' project prior to joining the writers' program. (According to one story, he qualified by submitting several half-baked paintings on the theme of Pilgrims and Indians, supposing that this would impress the government officials.) It was during this period that de Kooning met Rosenberg, probably introduced by Ibram Lassaw. At the time, Lassaw shared a loft at 38 East Eighth Street with an artist named Max Spivak, who had been assigned to paint a large mural for the WPA and had been given two assistants. One of them was Rosenberg, who quickly established his intellectual credentials with the group by spending his time reading instead of painting. "Harold would be sitting in

an old Morris easy chair next to the great big pot-bellied stove," said Las-saw. "In those days, that's how we had to heat the space. He'd be reading. We didn't care. We knew he was a writer and respected his opinions. Every once in awhile he'd expostulate: 'Did you ever hear anything more stupid than this?' He'd be reading a book by Stalin. He was so anti-Stalinist." In 1938, Rosenberg landed a prestigious post in Washington as the national arts editor of the WPA's American Guide series. Four years later, *Trance Above the Streets*, a book of his poems, was published. However, it was not until the later forties and fifties, when he began to visit de Kooning's studio three or four times a week, that Rosenberg became a serious student of painting. Even then, few artists took his eye seriously, for Rosenberg saw ideas rather than pictures. But no one minded much, since his ideas were stimulating.

In the forties, the flicker of interest from art dealers was, if anything, more unexpected than the interest of critics. Before the mid-forties, the prestigious galleries on Fifty-seventh Street—notably Pierre Matisse and the Valentine Gallery (shortened from Valentine Dudensing)—handled only European masters, while a third important gallery, Marion Willard, mostly specialized in American painters of an earlier generation, such as Edward Hopper and Thomas Hart Benton. That left Julien Levy and Peggy Guggenheim's Art of This Century to support the surrealists and a sprinkling of Americans, and no one to focus upon the downtown artists. Then, in 1945 and 1946, three art dealers opened new galleries. One, Sam Kootz, was an affable, loquacious Southerner who had published a book in 1943 about modern art entitled *New Frontiers in American Painting*. He then assembled a huge exhibition of contemporary art for Macy's department store in New York. The exhibit included, among others, two paintings by Mark Rothko (offered for less than $200 apiece) and works by Bolotowsky and Carl Holty. Kootz also quietly began making plans for a gallery. Well before Peggy Guggenheim closed her gallery, Kootz was wooing some of her painters.

The second dealer to promote emerging American painters was Betty Parsons. Like Peggy Guggenheim, she came from a wealthy background. She was the daughter of a Wall Street broker and a Southern belle and made her debut in the society of Newport and Palm Beach. Not long afterward, she married a suitably wealthy husband, and her life seemed destined to revolve around parties and charities. But then, Parsons rebelled against expectations. Shedding both her spouse and her social life, she set sail for Paris to study art. It was obviously an auspicious time to do so. At the center of the American expatriate circle in Paris was Gertrude Stein, who knew such artists as Alexander Calder, Man Ray, and Isamu

Noguchi. Parsons, who was slim and fine-boned, with a flutey voice and a vague resemblance to Greta Garbo, fit in well. After returning to the United States in the early thirties, she spent some time in California before settling in New York, where she soon became involved in the arts. Initially, she painted and was a partner in a bookstore that also displayed some art. When the Wakefield Bookstore was bought by art dealer Mortimer Brandt, Parsons was placed in charge of the contemporary art section. It was there that she first showed work by, among others, Rothko, Gottlieb, and Ad Reinhardt. In 1946, she decided to open her own gallery. Since Guggenheim was closing Art of This Century, Parsons inherited Rothko as well as Pollock (who, as Peggy Guggenheim later wrote, no other dealer would touch). She also became the dealer of Barnett Newman and Clyfford Still. Newman functioned as her right-hand man, helping arrange many of her shows. With her society connections—she knew many of the benefactors of the Museum of Modern Art—and her faith in her artists, Parsons rapidly established herself as an important art dealer.

It was the third and least respectable of the trio of early dealers, Charles Egan, universally known as "Charlie," who would prove the most important to de Kooning and many other downtown artists. Egan had no money or position to recommend him; he survived through his wit and hustle. The son of a coal miner, he came from Scranton, Pennsylvania. His first job had been as a salesman in the art gallery of Wanamaker's department store. He was a heavy drinker without much head for business. He was "charming, handsome, aloof, and intimate at the same time," said Margo Stewart, a young artist whom Egan later recruited to help run his gallery. "There was a sense of mystery about him. A lot of people were suckers for Charlie. He could charm you." Egan was even known for suckering his own artists. Once, Stewart herself bought a de Kooning drawing from Egan and, when she told de Kooning of the purchase, "He said, 'What drawing?' Nobody knew what had been sold or not sold." But Egan was also genuinely and obsessively interested in contemporary art. While employed at the staid J. B. Neumann Gallery on Fifty-seventh Street, he was a regular at the Waldorf. "He told us he couldn't stand working there," said Milton Resnick. "He said, '[Neumann] won't let me talk. He said that I have to dress nice and if someone talks to me I'm supposed to look at my shoes.' And we said, 'Why don't you open up your own gallery?' He said, 'I'm broke.' We said, 'Find enough money to rent a place.' At that time rents weren't high. And he found a place four stories up on Fifty-seventh Street. It was a tiny little hole in the wall. He had no storage space, just a closet. He had a little extra square room. That was about all. And the artists fixed it up and painted it." According to Stewart,

"There was a little closet with a telephone and a chair, and a plywood desk attached to the wall. And he stored the paintings in the bathroom, in the bathtub."

Several artists helped Egan fix up his space on Fifty-seventh Street. Isamu Noguchi did the lighting, "a fantastic job," Stewart said, "for about seven dollars." Giorgio Cavallon, one of the Italian artists in the downtown group and a highly talented draftsman, also helped with the space, as did Milton Resnick and a few others. De Kooning and Franz Kline painted the walls. These artists had every right to expect Charlie to mount a show of their work—particularly de Kooning. It was well known that Egan virtually worshipped the painter and his art. "He was crazy for de Kooning's work and for de Kooning himself, and for years had talked about it and finally opened a gallery," said Janice Biala. "We all understood that he essentially opened it for Bill." Then the news came: Egan would open his new gallery with a show of gouaches by a Swiss-American artist named Otto Botto. De Kooning and his friends were dumbfounded. Otto Botto? "He was kind of a . . . he painted watercolors a la Picasso," said Resnick. "No one took it seriously. We just thought it was a laugh. Red-cheeked Otto Botto, who lived in New Jersey and used to come to the Waldorf just to show up and talk to everyone." When questioned about this choice, Egan pleaded poverty—with his usual charm. "Charlie said, 'You know, you guys, I'd never be able to sell your paintings. I'm broke, and I need to sell.'" The news could not, in any case, have surprised de Kooning very much. No serious critic had yet mentioned him.

Meanwhile, de Kooning was pushing forward from *Pink Angels*. In paintings from 1946 such as *Fire Island*, *Special Delivery*, and *Bill-Lee's Delight*, he created speedy, propulsive forms and continued to knit together the imagery so that the eye became less and less aware of the differences between figure and ground; often, he outlined the forms with bold charcoal lines drawn directly into the wet paint. Of the new works, the most important was *Judgment Day*. Despite its relatively small size, about twenty-two inches by twenty-eight and a half inches, it was a dramatic painting with extraordinarily dense imagery. Bloated, monsterlike shapes bearing a distant resemblance to the fantastical Flemish art of Bosch or Brueghel crowded the four corners of the painting, seemingly restrained there by strong vertical and horizontal lines pushed deep into the paint. De Kooning himself described the main forms as four angels guarding the Gates of Paradise; he seemed to present them from the perspective of an outsider who is excluded and still engaged in a hellish, ceaseless struggle to attain release. At the exact center de Kooning placed a small, shiny circle, like a peephole to paradise.

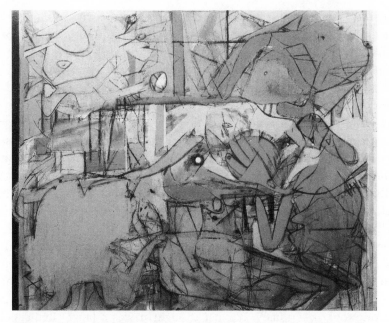

Judgment Day, 1946, oil and charcoal on paper, 22¹/₈″ × 28¹/₂″. The basis for a dance backdrop

In the spring of 1946, de Kooning used *Judgment Day* as the basis for a much larger work, a dance backdrop commissioned by his old friend Marie Marchowsky, who had founded her own dance company in 1940. Like so many of those who helped de Kooning, Marchowsky was a friend first and a collector second. She bought an early painting or two. She also commissioned a portrait in 1945 from Elaine—Elaine's first—for fifty dollars. She and her husband often invited de Kooning to dinner. On one such evening, Marchowsky was telling de Kooning about her latest project, a recital the following April at New York Times Hall. "We were talking, and my husband said, 'Why don't you do the backdrop?' " said Marchowsky. "My husband said he would pay. I told Bill what it was about, and he wanted to do it." The name of Marchowsky's work, which was twenty or so minutes long, was *Labyrinth*. True to her training as a Graham dancer, Marchowsky inclined toward psychological ballets. "As I look back, I was too young to do something so extravagant," said Marchowsky. "I was interested in Freud, and it was very pretentious, about the labyrinth of the mind. But when you're young, you'll tackle all kinds of things." For de Kooning, who was paid just fifty dollars, the huge seventeen-by-twenty-four-foot backdrop was an entertaining diversion that gave him the opportunity to work at a lavish scale.

Martin Craig, de Kooning's pal from Twenty-second Street and a good friend of Marie's, had already built the set for *Labyrinth* in Marchowsky's studio. Pressed for time, de Kooning decided to use *Judgment Day* for the backdrop. According to Resnick, "We had one day to do it and one night. I painted, and Bill mixed the colors. He had made a sketch with chalk, and then he had to make the colors. He had to cook fish glue. You had to melt it with water and cook it and then add those cheap hardware pigments to it and get it bright." The result was spectacular. "It was enormous, and it overwhelmed me with its brilliant colors," said Marchowsky. "I felt it was much too imposing for me." Three weeks later, she gave de Kooning a birthday party. He arrived in his usual ragged clothes, including cheap, paint-splattered pants. "Bill looked like a guy you'd be sorry for," said Joseph Solman. "We had drinks and congratulated him because she had used him for that ballet. But he sat in a corner like a guy you'd give a handout to."

De Kooning, cooped up with Elaine, found Carmine Street unbearable. Through the artists' grapevine, he heard of a studio for rent not too far away. A former storefront on the second floor at 85 Fourth Avenue, right across from Grace Church School, the studio was located on the east side of the Village between Tenth and Eleventh Streets. It had one large shoplike window that faced west over Fourth Avenue. The rent was steep but manageable—$35, the same as for the old loft on Twenty-second Street. According to Joop Sanders, de Kooning sold a painting around then that enabled him to pay the first few months' rent. It was only his desperate desire to escape, however, that led de Kooning to lease the studio. According to Conrad Fried, the space, while about a hundred feet long, was also "cold and dingy and decrepit." Exposed electrical lines snaked across the stamped-tin ceiling. The back resembled a cave and was illuminated only by naked light bulbs dangling from overhead. There was no heat. De Kooning had to lug five-gallon cans of kerosene upstairs to use in a stove that he installed. There was no hot water and only a shared bathroom in the hall outside. When, a year or so later, Jack Tworkov rented the unused space behind him, de Kooning only had to come up with $17.50 a month in rent. Helped by Conrad, he built a dividing wall with separate doors from the hallway into each space. But sound carried between the two rooms, and de Kooning was continually bothered by the sense of someone being on top of him. Anyone visiting Tworkov passed by de Kooning's open door.

Demoralized by his expulsion from Twenty-second Street, de Kooning, in contrast to his usual practice, did little to fix up the Fourth Avenue

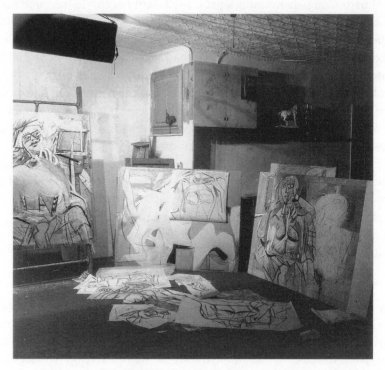

De Kooning's "cold and dingy" studio on Fourth Avenue, 1946

studio. Along the far wall, he built a kind of Dutch hutch, a wooden cabinet with two sizable compartments for storage behind double doors. Otherwise, he had only a table, a cheap spindle-backed chair, and, along the opposite wall from his easel, a cot. He placed a folding chair by the cot to hold his coffee cup and ashtray. That, plus a small bureau and table to hold his paints and brushes, was it. And the light was a problem. Instead of looking north, his space faced directly west over the street, forcing him to work in the hot and shadowed glare of the afternoon sunlight. De Kooning glazed the window to cut down on the glare and positioned his easel against the wall just to the window's right.

Still, the work did not come easily in this new studio. Despite his recent breakthrough in creating the flowing figural abstractions of *Pink Angels* and *Judgment Day,* de Kooning once more began veering back and forth between abstractions and more recognizable representations of women. (Throughout his life, he returned to the female figure as to eternally unfinished business.) A series of photographs taken by Harry Bowden in November 1946 showed his studio covered with large caricatural

images of the female form, few or none of which survive. In many of the "women" paintings that do survive from the late forties, the body seemed disrupted by latent narratives of feeling that a viewer cannot quite follow. In *Pink Lady (Study)* from 1948, which contained one fully realized but cubistically shattered woman and two partially rendered and ghostly images, the main figure's head rested sideways on her arm. Yet her head also floated, almost detached, from her neck and body. And the head of one of the ghostly figures was set upon the stark, geometric shape of a cone.

De Kooning's life in New York changed once he began working in his new studio. His home was no longer with Elaine on Carmine Street; his home was always where his easel was. He began to spend more and more time alone on Fourth Avenue, though he often returned to the apartment at night. With Elaine in

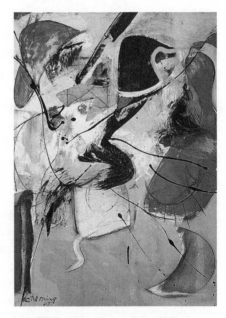

Untitled painting, *1947, from one of the darkest periods of his life, oil and charcoal on paperboard,* 29 ⅝" × 21 ⅝"

perpetual motion, going from parties to concerts to dance programs, what increasingly gave de Kooning emotional support was not his marriage but the community of artists around him. Not only did he regularly see his friends at the Waldorf, but he drew closer to the many artists who lived near the new studio. In one building at 52 East Ninth Street, for example, were John Ferren and his wife, Rae, also a painter. Below them were Conrad Marca-Relli and his wife, and above them was another Village regular, Franz Kline. Across the street were Milton Resnick and Hans Hofmann. "[Hofmann's] school was on Eighth Street, and he lived right across from us," said Rae Ferren. "Looking out our window, you could see his profile working. . . . You have to realize how small and intimate the Village was." Another group of artists was located a block north on Tenth Street. Many others were in the Sixth Avenue area south of the Waldorf.

It was during this period, when he was spending more time alone, that a close friendship developed between de Kooning and Franz Kline, one markedly different from de Kooning's earlier relationship with Gorky. De Kooning first met Kline at Conrad Marca-Relli's Sixth Avenue studio in the early forties. By the latter part of the decade, they became virtually

inseparable. Kline was gregarious, affable, and without pretensions. Like de Kooning, he loved American slang and offbeat humor. He had both a romantic temperament—as his dramatic abstractions would later show—and a feeling for the brawny places of the world, since he himself came from an industrialized coal-mining region of Pennsylvania. He did not engage in the intense, often grandiloquent theorizing that attracted many painters after the war. Indeed, he loved to give barroom speeches—with a twinkle in his eye—in which he unspooled long tangled threads of hifalutin art-nonsense. There was no need for de Kooning to defer to Kline, as there had been with Gorky, nor was there any reason to fear that Kline would snub de Kooning or begin to assume airs.

To many downtown artists, Kline seemed to be a happy-go-lucky misfit with few prospects. His greatest success to date had been in high school in Lehighton, Pennsylvania, where he was a natural athlete who earned high school letters in all three major sports: varsity football, basketball, and baseball. He was also a talented if conventional draftsman whose pen-and-ink cartoon drawings in the high school annual had been much admired by his teachers and classmates. After high school, Kline drifted along for four years, studying drawing in Boston as the Depression deepened. In 1935, he went to England (where his mother was born) in order to continue his training and, perhaps, find work; he hoped to emulate the great English illustrators. But he could not find jobs, partly because he was a foreigner. He returned to Pennsylvania and, like de Kooning, tried his hand at window-display work. But he hated it, and the store hated him. At the end of the thirties, he made his way to New York.

Once there, Kline settled into the anything-goes atmosphere of the Village, with its crazy-quilt collection of eccentrics, charmers, and drunks. To support himself, he supplemented the small trust fund of his English wife, Elizabeth Parsons, by turning out caricatures, portraits, and barroom murals. Kline's background differed dramatically from that of most of his contemporaries at the Waldorf, who had typically been through the WPA together. All were far more serious students of modern art than was Kline. No one could have predicted that he would soon abandon his figurative style and create the powerful black-and-white abstractions that would make him famous. In the late thirties, Kline's main interest was pen-and-ink drawing. He did not begin painting seriously in oils until 1940, when he started to depict conventional interiors and remembered landscapes of the coal-mining region where he was raised. "Franz and I worked on murals together," said the artist John Sheehan, an Irish-American drinking buddy. "I picked up one mural job from a nightclub, the Jungle Inn on Thompson Street. We also used to do portraits on

the street, on Fourth Street near the Pepper Pot nightclub. We'd pick up what we could in portraits and caricatures, at twenty-five or fifty cents apiece." Well into the forties, Kline still hoped to become an illustrator. "A lot of artists won't admit that they were interested in illustration," said Sheehan. "They like to give the impression that they started out with the new art movement that began in France."

Kline's best-known works during the Waldorf period, when de Kooning first became his close friend, were several large-scale murals—barroom scenes of acrobats, dancers, and half-naked women cavorting in dance halls—created for El Chico's, a Spanish nightclub on Sheridan Square. Kline never made any effort to disguise his admiration for the conservative English tradition of illustration, an eccentric expression of taste that de Kooning, who never scoffed at a background in commercial illustration, respected him for maintaining in the face of the snobbish condescension of other artists. In later years, de Kooning went out of his way to use his own connections to advance the career of his friend. He even wrote to the austere German émigré Josef Albers on Kline's behalf, after Albers became a distinguished academic at Yale. De Kooning's close friendship with Kline surprised some contemporaries. In the mid-forties, Kline was popular but not respected as an artist; he was not yet the beloved figure he became in the fifties. According to Joop Sanders, he was considered by most of the artists "a barroom character and a bad painter." What was de Kooning doing, some could not help wondering, spending so much time with Kline when he once stood with Gorky? Perhaps de Kooning, despite his legendary gifts, was losing his way or slipping into decline. Perhaps he would never finish enough paintings to put together a show. In fact, de Kooning saw the potential in Kline. More important, he found in the affable but soulful Kline—whose mentally ill wife caused him constant pain and difficulty—an ally who could help sustain him through the worst period of his life since his arrival in America twenty-one years earlier. De Kooning no longer needed a mentor. He required a steadfast friend.

18. The Bottom of the Well

If you are an artist the problem is to make a picture work
whether you are happy or not.

As the United States economy boomed after the war, and excitement mounted in the New York art world, de Kooning continued to move in the opposite direction: a downward spiral of poverty, emotional crisis, and sharpening feelings of failure and rejection. His life grew more rough and seedy. Not only did he refuse to renovate his new studio, he also made no effort to keep it clean. He gave up his Dutch, sailor-like ritual of a weekly scrubdown of the space, and, increasingly, seemed holed up by himself. On many evenings Elaine would stop by his studio and yell up from the street, asking him to join her at a party. He would stick his head out the window and reply, "No, I'm still working. You go on ahead and I'll come by later." But he rarely showed up, and would instead work through most of the night until he collapsed, exhausted, on his ratty studio cot.

A young artist named Mike Goldberg, who visited the studio several times in the late forties, remembered it as "grungy." Abandoned drawings, cigarette butts, paint smears, squashed tacks, filthy cans, and crumpled-up pieces of paper filled up the dark space. Old friends noticed the change: de Kooning was admired downtown for his tidiness and for liking a bright, spare studio with a beautiful floor. Although he was working hard in 1947, he completed too few pictures to make up a show. That had not mattered in the 1930s and early '40s, when almost no American artists were exhibiting; but now there were dealers and critics interested in American paintings. Why couldn't de Kooning exhibit? Why couldn't he do what other artists did? De Kooning was so poor that when Dorothy Miller of the Museum of Modern Art asked him to show her photographs of his work, he could not spare the nickel for the subway home after buying a ticket to the museum so that he could get to her office. Instead, he walked the forty or so blocks from midtown. He already knew, viscerally, what it meant to fail and become truly marginal—not marginal in the manner of an avant-garde intellectual who rues his alienation; marginal like a bum. "Before that, when he was living on Twenty-second Street, he was a Dutchman—so clean," said Conrad Marca-Relli. "This was a reversal." During another

very hard time—the period before he left Rotterdam for America—de Kooning had lived just a step away from the street. In Chelsea one morning at five a.m., as de Kooning walked with Denby and Burckhardt, Burckhardt wanted to photograph a bum in a doorway. But there wasn't a bum around. So de Kooning took up the challenge, and was so convincing in the role that a passing policeman asked Denby and Burckhardt if they wanted any help ridding themselves of this nuisance.

The suffering of his family during World War II, when Rotterdam was bombed into rubble, made de Kooning ashamed that he had not achieved a greater success in America. Unlike most immigrants who sent money back to the Old World once they established a foothold in the new, de Kooning had precious little for himself in the late forties, much less for his struggling family back in the Netherlands. Still, he tried. After the war, said de Kooning, he sent them "quite often parcels with the most bizarre gifts in them like coffee, tea, and strange stockings." In doing so he had the feeling that "I did something useful for them." But it was not much, and de Kooning knew it. In 1946, Joop Sanders returned to visit his family in Holland, but de Kooning did not have either the money or the inclination to do the same. Instead, he asked Sanders to look in on his mother and sister. "They were absolutely ecstatic that I came to say hello," said Sanders. "The sister was as wild about him as his mother was." At the time, the family actually seemed better established than when de Kooning had left. They were living in a working-class district, "a very staid neighborhood," said Sanders, near the center of town. Nothing critical was said about de Kooning, but his mother and sister must have wondered why Joop, another artist, could return home and their own Wim could not.

During this dark period in his life, de Kooning felt compelled to reach out to his father and justify his "failure" in America. In November 1946, he wrote a letter to Leendert in a laborious Dutch style that contains several spelling and grammatical errors. It is a son's attempt to try once more, in middle age and after a war, to win the support and respect of a remote and unsentimental father; to convey his "hopeless" ideas about art; and to explain why he chose art over making money in America.

> Dear Father,
>
> It's been more than twenty years since we saw each other. That's a long time. When the war was over I started on a letter to you and up to now it hasn't been possible for me to put it in the mail. There were ideas in it that looked hopeless. I was trying to explain my whole life to

you, but when I'd finished it I had the feeling I wasn't such a bad guy after all. Therefore I thought this evening, "You have to write to your father."

And so I won't try to hide behind sentimental ideas. I have an irresistible longing to see you again. There's one thing I want to say about myself, and that is that I'm still in love with the art of painting [he uses the formal anglicism *in liefde met* for "love" rather than *verliefd op*], and that's the reason I have been down-and-out most of the time [for "down-and-out" he uses a slang word of Yiddish origin, *gesjochten*, perhaps evoking his days in the bohemian Jewish quarter of Rotterdam] and so it wasn't that easy to come to Holland. But I've never done anything irregular, I've led a straight life. I want to let you know that you've always been with me. It is impossible for me to imagine you grown older. I am gray now. I can only remember you "as you were" in the small office. I can only remember you when you were alone. I say "je" because "u" is so far away [in referring to his father, de Kooning switches from the formal *u* to the informal *je* and *jou*]. I will try to come to Holland next year and maybe you will be able to find me an old loft to paint in. Ha . . . Ha. Really, father, the art of painting is very beautiful. I can remember you once telling me that when you were a young man you dreamt of having a great big business, but when you were older you wanted to be content with a small business, neat and proper. And with painting it is the same. If I will ever be a great painter is something for other people to find out. I am content to just be a painter. Now I am happily married to a beautiful woman and she sends you a big kiss.

I'm very glad I've written you and in my mind I embrace you. Your loving son, Willem

Either Elaine or de Kooning had the idea of including a kiss from Elaine: a lipstick smear, in the shape of a pair of lips, closes the letter. De Kooning explained, "This is the kiss Elaine sends and she says her lips are larger in reality." De Kooning also sent two photographs, one of himself and one of Elaine. They presented two people who, appearing anything but "down-and-out," embodied every expectation a Dutchman might have of success in America. De Kooning was well dressed and stood in a relaxed, cocky pose in his Twenty-second Street studio. Elaine sat, stylishly arranged, in a glamorous evening dress. (The picture of Elaine was no doubt one of the high-fashion photographs that Burckhardt took of her when they were hoping to cadge some modeling assignments.) On the back of Elaine's picture de Kooning wrote, "In the picture her hair seems

brown but in reality it is blond." It was an odd remark, since Elaine's hair was not naturally blond, but perhaps de Kooning thought his fair Dutch family would be more comfortable with the idea of a blond wife.

Leendert's response to this first letter does not survive. Later correspondence, however, suggests that he chided his son and encouraged him to abandon art for something more lucrative. De Kooning, probably irritated by this, did not answer his father until February 1948, when he was creating some of his most admired work but before he had had his first show. De Kooning wrote:

Dear Father,

Today is the tenth of February. It is your birthday. It is very late in the evening. I thought that maybe I could send a telegram but that was not to be. Of course I should have answered your last letter earlier and I feel very guilty. And also Henny's [his aunt's] letter. But believe me things are always very difficult for me here. There is of course no reason for experiencing difficulties in America. And especially now life is very good here. But when you are a painter, it is really outrageous. Yet, I blame no one. In the museums you can get it for free why buy it. Still that makes things very difficult for us painters. You can say, why don't you do something else. Well.—I'm laughing to myself. As difficult as our life may be you can't imagine what a good time we're having after all. At the same time it is a long never-ending beautiful story. And it is right now at this very moment I'm writing to you that I feel completely happy. Therefore, when I sent my wishes they can only be good. And of course my wife "sends you her love." And we wish dear aunt Nelly lots of happiness and Marie and Henny and Leo. I would love to come to Holland and I thought I might be able to in the spring but now it looks as if it won't be that easy. But possibly later. It looks as if I'm never going to be able to accomplish anything but you mustn't think that. Often I feel I can never prove myself. That is really the reason I never write. Well I'm saying "good night." It is late. And while I am going to bed I will think of the Zaagmolenstraat.

To this by turns defensive and affectionate letter, Leendert tried—not very successfully—to respond in a helpful way. His letter, which contains many misspellings, was the work of a man ill at ease in writing and in giving encouragement. He wrote that "I was glad you have not forgotten me and that you don't write much that is okay." He went on to say that, whatever his son's complaints, he should remember that life was much harder in Holland than in America: "where you are in America to other

people is the land of promises." Finally, Leendert chose to recognize not de Kooning's commitment but his impracticality:

> now the other matter that I'm going to write you mustn't get angry about and not swear at me this part too you have to see from my side—absorb it—well you are a painter and I am a businessman and trades-man. . . . You write me that you can get [art] for free in museums, well that is the same here I believe, because the people that are able to buy don't spend any money on that so you won't be able to get rid of your good works.

It was a harsh admonition. De Kooning would never be able to "get rid" of his good works, even if he succeeded in finishing and exhibiting them. In America, de Kooning increasingly regarded himself as a failure. In Holland, his father thought the same. After twenty years, not much had changed.

Of all the difficulties confronting de Kooning in 1947 and 1948, the most painful was the ongoing disintegration of his marriage. After the couple's move to Carmine Street, Elaine appeared as vivacious as ever. To the outside world, she was immensely charming and flattering to her husband. The couple gave parties together during which Elaine, a quick study with a pencil, would sketch amusing likenesses of their guests. But no matter how affectionately the couple behaved in public, their relationship worsened toward the end of the forties. De Kooning was proud of Elaine, but he increasingly resented her extroverted nature and her intrusions upon his time, space, and money. He began to think she cared more for her public appearance than for his private welfare. If de Kooning "dressed like a rag bag," as many friends recalled, Elaine loved to shop and took pride in her stylish looks. She found ways to spend money no matter how poor the couple was. Janice Biala once visited de Kooning at the couple's loft on Twenty-second Street, and he showed her the closet he built while renovating the loft. The closet, Biala said, was stuffed with clothes. Everything, with the exception of one suit, belonged to Elaine. On another occasion, she said, de Kooning came to see Biala and her husband after they bought a *Woman* painting.

> Bill asked us not to pay him at one blow. "When I need money, send me a check," he said. And so one day we had done that and I happened to meet him and Elaine at the Bignou Gallery and I said, "Did you get the

check?" And he looked at me in a very funny way and Elaine said, "Oh, there's a check?" Because Bill was afraid that any time she knew what money they had it would immediately be gone for clothes.

Elaine's spending was so heedless that her brother Conrad warned her that she could get both herself and de Kooning into serious trouble. It was no use, since Elaine could not stop shopping.

The sailing trip to Provincetown in the fall of 1945 with Bill Hardy— her treat to herself after the long, dreary years of war—was the first dramatic rift in their relationship. Ernestine Lassaw later saw it as "the beginning of the end." But that trip was not an isolated example of what de Kooning increasingly came to regard in the early years of their marriage as Elaine's supreme self-absorption. In 1945 or 1946, for example, he came down with strep throat. It was a particularly serious case, probably with complications, and he was put into Bellevue Hospital. His friends became extremely worried. But Elaine simply brushed it off. "There was nobody to feed him," said Janice Biala, "and so we all got together [to cook for him] and Elaine would boast that she came home at three in the morning and saw the duck that I had cooked for de Kooning and she ate it." While never a friend of Elaine's, Biala was not exaggerating. "As marvelous as she was to him when he was old, she was the worst when they first got married," said Joop Sanders. "What turned him off greatly was that he got very ill and went to Bellevue with strep throat and she absolutely didn't take care of him at all. She let him lie there without even visiting him. 'Oh, you know, Bill was at Bellevue,' she said." Nor did Elaine take particular interest in de Kooning's periods of intense anxiety, when he suffered heart palpitations and sometimes thought he would die. He deeply resented, and never forgot, her indifferences to his mental anguish. De Kooning later told Joan Ward that Elaine was "good to everyone but her family." By "family" he did not mean her brothers and sister but himself. Ernestine Lassaw said, "Elaine was always generous and loyal to her friends, but she did exactly what she wanted to do. She never pleased anyone but herself."

What had become clear as early as 1946 was that both Elaine and de Kooning were self-absorbed, yet each expected to be taken care of by the other. Elaine imagined herself as part of an extraordinary couple, a beautiful young painter married to a great artist whom the world revered. A great artist who expected her to be *marvelous* rather than conventional— a muse, not a housewife. But de Kooning, given his Dutch working-class background, imagined a traditional wife who would look after his needs. "Bill wanted an old-fashioned family setup," said Conrad Fried. "He

thought it would be nice to establish a separate studio from where you lived, and supper would be on the table when you came home. And they would have a child or two. And Elaine in no way was interested in having a child, or in cooking dinner." That de Kooning loved to eat well and heartily—throughout his life, he liked women who could put a meal on the table—never seemed to enter Elaine's mind. She could not be bothered with the kitchen or cooking food the way de Kooning liked. Ernestine Lassaw, who often fixed dinner for de Kooning after she and Ibram were married in 1944, said that de Kooning, for example, liked his potatoes dry, but that Elaine, on those few occasions when she made potatoes at all, invariably made them wet.

Elaine was even less interested in keeping house than in fixing meals. On Twenty-second Street, it was de Kooning and not Elaine who scrubbed the loft on Saturday afternoons. Nini Diaz, visiting once, was shocked by how filthy the bathroom was; no one seemed to have cleaned it in months. Similarly, Fried noticed how grimy the bedsheets became at Carmine Street. "They were gray, the color of cigarette ashes," he said. "They were particularly gray in the middle, in a large patch. Of course there was no washing machine and no money for a Chinese laundry. I said, 'Why not just put them in the bathtub and let them soak in some soap and rinse them out and take them up on the roof to hang?' Elaine nodded and then said, 'What do I hang them on?' " So Fried went to the roof, strung up a wire between the chimneys, and left Elaine laundering the sheets. Then, about six months later, he happened to look up from Seventh Avenue and saw some sheets hanging from the wire. "I thought, 'Oh, she's done it again,' " said Fried. But she hadn't: they were the same sheets. "She had never gone back and gotten them. And now they were *really* gray. It was my promotion that got her to do it in the first place. But she never had the will herself to do it and therefore never finished the job."

Fried also thought that the issue of whether or not to have children was a source of conflict. Sometimes de Kooning appeared dismayed by how circumscribed the lives of friends became when they had family. Once, during an outing in Central Park with Jack Tworkov, his wife, Wally, and their baby, the Tworkovs announced at four p.m. that they had to go home and feed the baby. How could you give up your life like that? de Kooning asked. But others remembered de Kooning saying that he wanted a child. According to Mildred Loew, the wife of de Kooning's early friend Michael Loew, de Kooning once joined Michael while he was watching the couple's baby. "Michael went to feed the baby and Bill said, 'No, let me,' " said Mildred. " 'Sure you know how?' asked Michael. 'Oh,

yeah.' Then Bill said, 'You know what, Mike? I think I'd like to have one of these.' " Much later, in the seventies, de Kooning told his assistants on Long Island how much he always wanted to have a child, especially a girl. He wanted a daughter, he said, so that she could grow up to be another Marilyn Monroe.

Elaine was less ambivalent on the subject. By many accounts, including that of her brother Conrad, Elaine was not interested in having children. She recognized that the responsibilities of motherhood might force her to give up her ambitions as an artist. In the mid-forties, Elaine had the first of several abortions, which were quite easily arranged in the New York of the period. What was embarrassing for de Kooning was that he had to borrow the money for the operation; even this most intimate of events was known to everyone. "Fortunately we were not in New York [at the time] or we would have had to pay for it," said Biala. "Elaine looked on us as a sort of *vache à lait* [a cow to be milked]. Somebody else paid for it, I don't remember who." Three decades later, after the advent of the modern women's liberation movement, Elaine's reluctance to be domestic, or become a mother, would have been viewed in a far different light. But in the late forties, even after the newfound independence that women won during the war years, most people still assumed that a wife would take care of the household. The downtown artists, fiercely dedicated to their work, often expected their spouses to support them as well. "What Elaine wanted was what he wanted, a studio and a career," said Conrad Fried. "This started a rift. It was a different basic philosophy of life." Their drama was echoed throughout American society, as women, emancipated by the war, were expected to resume the old ways.

As inevitably happens in an unraveling relationship, small irritants became the occasion for large angers. De Kooning, always a slow and groggy riser, would wake up in the mornings and know that Elaine was also awake beside him but that she was pretending to be asleep so that he would have to get up first and make the coffee. Sometimes he called her "the emergency girl," referring to her high-keyed behavior and her ability to make a big production out of anything. The artist Pat Passlof, who studied with de Kooning at one point in the late forties and also knew Elaine, said, "One of their first disagreements was because Bill expected meals and vacuum cleaners. Elaine was the wrong person to ask to do this. There were painful, vicious arguments. Elaine felt that she was an artist, and she didn't feel like sacrificing herself." In one fit of anger during an argument, de Kooning smashed his fist through a plywood wall, much as he had let his temper go with Nini and similarly smashed a wall in their apartment on Fifty-fifth Street.

Like most artists, De Kooning was morose and irritable when his work was going badly. It was also clear to Elaine that, finally, she did not matter to him as much as his art did. De Kooning refused to let being married change his life in any way: he did what he wanted when he wanted. "It was not one-sided, believe me," said Ernestine Lassaw. "If Bill went out with somebody to have a cup of coffee, he might never come home. He was an artist; he did what he pleased. And Elaine was not one either to sit there with the pot boiling and wait for someone to come home. They had no sense of fealty or whatever you might call it. It was just a mutual disability, as it were." As their relationship soured, they began to develop sexual problems. De Kooning loved to be in love; the jolt of a casual fling also appealed to him. He had no patience, however, for routine sex with a person who no longer entranced him. At such times, he withdrew sexually, becoming emotionally distant. Matters only worsened whenever a woman placed demands upon him or communicated any expectations. There were those over the years who speculated that Elaine eventually began to have affairs because of de Kooning's inability to satisfy her sexually. If so, the reason was not that he disliked sex, but that he was no longer in love.

Elaine also had a complex approach to sex, the result of the psychological burden she carried from her own troubled childhood. Throughout her youth, Elaine, her mother's "Samson," had been taught that she was special, as special as any man. And Elaine was determined to behave like a man, unless acting like a woman, such as taking de Kooning's name, served her ambitions. She was also determined to assume the privileges ordinarily accorded to men. Those privileges extended to sex. Like many men, she saw nothing wrong with playing the field. ("I live from the neck up," she said in the fifties, distinguishing between her real life—the life of the mind—and what she did with her body.) "She took on a male stance," said Mildred Loew, who visited the couple in Woodstock the summer before their marriage. Elaine also seems to have felt a measure of contempt for the men she emulated. She absorbed her mother's feelings of anger and distrust toward men, which were crystallized when her father allowed her mother to be institutionalized. For Elaine, playing the field became a way not only to be admired by men, but to give as good as she got. Once, not long after her marriage and well before she began to have affairs openly, she became ill at a party at their Twenty-second Street loft after drinking too much. At some point, de Kooning went solicitously into their freestanding bedroom to check on her condition, only to find her in bed with her old flame Robert Jonas. Enraged, he pulled Elaine out of the bed and cuffed her around, blaming her and not his old friend.

Elaine's dominating personality, troubled childhood, and often manic pace—she sometimes seemed to be trying to outdance her demons—made her a volatile young woman. That was part of her fascination. "She was a very, very complicated woman," said Joop Sanders. "She had some very old-fashioned ideas about men-women relationships. She felt she should be taken care of, but she had the feeling that men had it all, and that she was more of a man than anybody." With the exception of their closest friends, however, most of the 1940s art world thought the de Koonings had a strong if eccentric marriage. All her married life, moreover, Elaine would carefully craft an image of their relationship—"Bill and I"—that was intended for public consumption. This relationship, in which she and Bill remained soulmates whatever the passing distractions of love and sex might bring their way, was not just a facade: it always remained true for her. But it was much less true for her husband. Elaine had a brilliant gift for explaining away the cracks in her marriage; indeed, those cracks only seemed to make the marriage more interesting, deeper, even amusing, a credit to the fascinating couple called "Bill and Elaine." Of all the stories that Elaine would tell, the most delightful in this respect was her account of how, on Carmine Street, de Kooning once asked her to fix a proper dinner. "Fine," she replied. "I'll fix it tonight if you'll fix it tomorrow." De Kooning looked at her, thought a minute, and then said, "Vat ve need is a vife."

For a time, de Kooning assumed the role of the good husband in public, especially for the benefit of Elaine's parents. (He would also play the part for his own parents; his 1946 letter to his father suggests that his marriage is prospering.) But privately, de Kooning withdrew emotionally. As their relationship foundered, he made many drawings of women, often in pairs, as if the female figure were intrinsically unstable and women were capable of suddenly mutating into new and fierce guises. The most personally revealing painting of the period—an extremely rare instance of de Kooning depicting a man and a woman together—was probably completed in the winter of 1947–48, when de Kooning was distancing himself from Elaine. It presented a horrifying view of the relationship between the sexes. It would be foolhardy, of course, to reduce any de Kooning image to simple autobiography. Still, the picture suggests that de Kooning felt a woman could suck the life out of a man. The male figure resembled the de Kooningesque man found in many of the artist's drawings from the thirties and forties, when he often used himself as a model. Awkwardly dressed in a suit and tie, as if for public presentation, the folds of his suit shattered into cubist planes, this figure stood as stiffly as a mannequin mounted on a stick. (His wooden shape also evoked the Crucifixion, a

Untitled, *1947–8, oil on paper mounted on board,*
21″ × 16 ¹/₄″

theme that would later become of obsessive interest to de Kooning.) He stared outward, his gaze directed slightly above the viewer's head, with a pained and frozen expression. He appeared passive and detached, as if his life were finished. But the woman standing next to him—and a little in front—sparkled with evil energy. Fashionably dressed in a razor-angled outfit of bright colors, she was at once witchy and beautiful. Her large slanted eyes were those of a temptress who destroys her victims. Her sharp-toothed grin, a parody of a Hollywood star's dazzling smile, was that of a vampire vamping for her public, head tilted seductively to one side, right hand held coquettishly against her cheek, blondish hair thrown back.

A study for an important *Woman* of 1948, she is by far the most malevolent figure in de Kooning's oeuvre. (She makes his famously fierce *Woman I* of 1952 appear benign by comparison.) But her appearance was not the most disturbing aspect of the drawing. De Kooning placed, directly between the couple, a ghostly figure of unclear sex who seemed to emerge from the witchy woman's body, raising his or her arms balletically over the woman's head. This sketchy creature craned its own head toward the de Kooningesque man in the suit while its body twisted back toward the woman. The intent was ambiguous: the figure could be a siren beckoning the man to his doom; an interloper who, while seemingly friendly, steals away his woman; or an emanation from the woman herself who drains him of his life's blood. A purple line—a kind of proboscis—passes from the figure's head into the man's neck.

19. Darkness Radiant

In Genesis, it is said that in the beginning was the void and God acted upon it. For an artist that is clear enough. It is so mysterious that it takes away all the doubt. One is utterly lost in space forever.

For de Kooning, 1947 and 1948 were the landmark years when he began painting the "black-and-white" abstractions, which some critics consider his greatest works. No outsider can follow the winding, internal path that leads a man like de Kooning from despair to discovery, but the sensation of hitting bottom can sometimes stimulate an artist to abandon old commitments, embrace new ideas, and, finally, confront what must be said or acknowledged. De Kooning, when there seemed nothing left to lose, was helped by a profane, "damn the consequences" outlook in the art world of the time that encouraged doing whatever it took to make important art. An attitude best described—this being a period in American history that could still recoil in shock—as *fuck it.*

Pollock was the master of this outlook. It was Pollock who, more than any other American artist, seemed determined to do whatever it took to break free of all confining boundaries, including the traditional window of art. It was Pollock who sought to transcend, roughly if necessary, the dreary niceties of existence. No one described the *fuck it* of Pollock more generously than de Kooning himself, in an interview many years later with James T. Valliere in *Partisan Review.* De Kooning did not yet know Pollock well in 1947, and the stories he recounted probably occurred in the fifties, but Pollock already had an emblematic importance for many other artists in the late forties. What seemed boorishness to outsiders embodied for his contemporaries the joyful thrust of liberation—the gift for the big feeling—in an often straitlaced and provincial culture.

> A couple of times [Pollock] told me, "You know more, but I feel more."
> I was jealous of him—his talent. But he was a remarkable person. He'd
> do things that were so terrific. . . . He had this way of sizing up new peo-
> ple very quickly. We'd be sitting at a table and some young fellow would
> come in. Pollock wouldn't even look at him, he'd just nod his head—
> like a cowboy—as if to say, "fuck-off." That was his favorite expres-
> sion—"Fuck-off." It was really funny, he wouldn't even look at him. . . .

Franz Kline told me a story about one day when Pollock came by all dressed up. He was going to take Franz to lunch—they were going to a fancy place. Halfway through the meal Pollock noticed that Franz's glass was empty. He said, "Franz, have some more wine." He filled the glass and became so involved in watching the wine pour out of the bottle that he emptied the whole bottle. It covered the food, the table, everything. He said, "Franz, have some more wine." Like a child he thought it was a terrific idea—all that wine going all over. Then he took the four corners of the table cloth—picked it up and set it on the floor. In front of all those people! He put the goddamn thing on the floor—paid for it and they let him go. Wonderful that he could do that. Those waiters didn't take any shit and there was a guy at the door and everything. It was such an emotion—such life.

Another time we were at Franz's place. Fantastic. It was small, very warm and packed with people drinking. The windows were little panes of glass. Pollock looked at this guy and said, "You need a little more air," and he punched a window out with his fist. At the moment it was so delicious—so belligerent. Like children we broke all the windows. To do things like that. Terrific.

"Such joy," de Kooning said of Pollock, "such desperate joy." For a reserved man like de Kooning, the comparison of Pollock to a child was significant. Not only did it recall the emotional battles of de Kooning's own childhood, but it suggested release, freedom, letting go—particularly powerful feelings to a blocked and often paralyzed artist. In the late forties, moreover, Pollock's brooding nature, his "outsider's" temperament, and his inability to live in "the real world" suited the existentialist philosophy then becoming popular in New York. Punching out a window or putting a tablecloth on the ground (as Pollock did with a canvas) became existential "gestures," the acts of a free individual in a corrupt world. Part of the *fuck it* was not treating art as high-flown or precious. An American artist was not supposed to be a fancy European at a café. He painted whatever he wanted, however he wanted. "He freed us," de Kooning said simply to his old friend Tully Filmus.

De Kooning was so poor in the late forties that he often could not afford to buy paint. It was while he was with Kline that he probably adopted an elegantly *fuck it* solution to this problem: stop buying the expensive paints made for "art." Instead, the two artists went to a store on the Bowery for sign painters and letterers, where each purchased a five-gallon can of commercial black enamel paint and a five-gallon can of zinc white paint. (They did not buy any commercial colors because they knew

those would fade.) They also shared a ream of commercial artists' sign-board—actually heavy paper—that had been sized, or glue-coated, to iso-late the paint from the paper and prevent rot. In the next few years, as an inexpensive alternative to canvas, de Kooning would paint many works on cardboard or Masonite. With this approach to materials, de Kooning could use as much paint and "canvas" as he wanted. "On 4th Avenue I was painting in black and white a lot," de Kooning later said. "Not with a chip on my shoulder about it, but I needed a lot of paint and I wanted to get free of materials. I could get a gallon of black paint and a gallon of white paint, and I could go to town."

Of course, de Kooning did not begin painting his black-and-white pic-tures only because he couldn't afford other paint. If he had wanted expen-sive color paints, he would have certainly found a way to get them. And Picasso had already set a precedent for using Ripolin enamel and painting in black-and-white, a fact frequently discussed at the Waldorf. His use of "drips" and gobs of paint that accidentally fell from his brush, which he sometimes left on the canvas was another frequent topic of conversation. Joop Sanders recalled one dinner in the 1940s, not long after the war ended and people began to see Picasso's latest painting, at which "everybody was talking about the Ripolin. There is a seated woman by Picasso, I think in 1942, in which he uses enamel on plywood or Masonite and left the drips in. This was discussed at great length." (In one famously funny story that circulated downtown, someone asked Gorky—who had been painting smooth surfaces—what he was going to do now that his idol, Picasso, was dripping. Gorky drew himself up and replied haughtily, "If he drips, I drip.") And *Guernica*, of course, the most famous example of a black, white, and gray painting, still enthralled many artists.

The story that de Kooning turned to enamels because he could not afford other paint nevertheless contains, like many legends, an important element of truth. Throughout his life, de Kooning would regularly strip the fanciness from art, searching for a grittier expression that was not "artistic" and would not yield easily to a fluent brush. In the late forties—with his marriage coming apart, his wallet empty, his studio turning into a mess, his paintings unfinished—it seemed not only inexpensive but right to dip into a can of commercial enamel and start painting in black and white. An artist moves into black, according to Barnett Newman, to clear the ground for new approaches. De Kooning used black and white, Tom Hess believed, "to achieve a higher degree of ambiguity—of forms dissolving into their opposites—than ever before." There was no one explanation, of course, for his decision. De Kooning was an artist of intu-ition rather than reasons. But he kept the two original cans of enamel for

the rest of his life, making sure not to lose them whenever he changed studios. They became a symbol of what to do, a key, a support, a rabbit's foot. Sometimes, he would use the empty cans to prop up a picture.

The early pictures in the black-and-white series, probably made in late 1946 and still in oil rather than enamel, generally had a white background. Several contained mysterious black letters. In the past, when de Kooning began a picture, he sometimes sketched a letter, number, or word onto the empty canvas, which then became a small visual motif upon which to build the larger composition. This was something more than a trick. Trained as a letterer in Rotterdam, de Kooning mirrored his evolution as a painter whenever he worked like this, advancing from the mark of the artisan to that of the modern artist. As an immigrant not fluent in English, moreover, he probably enjoyed dissolving the form of language into the mysteries of art. Once he finally completed or abandoned the painting, there was usually nothing left of the original letter.

In a number of paintings of 1947, however, the letters remained prominently in place. *Zurich*, for example, contained a large Z O T in the right corner and about half a dozen letters strewn elsewhere. (A second painting, *ZOT*, of 1949, similarly contains the letters Z O T, this time in the bottom left corner.) In Zurich, the various letters, depicted at different depths, spaces, and scales, pulsed in the eye like the concatenating billboards of Times Square. They offered only fragments of language; even Z O T sounded like a piece of Dada nonsense, and, in Dutch, meant "foolish." The picture also contained an X—a letter used to cross out meaning or cancel a printer's plate—painted in white on a black ground, the reverse of the way de Kooning painted the other letters, which are black on white. At the time he painted *Zurich* de Kooning was having difficulty communicating with both his wife and his father, but the painting is not an especially grim comment upon ambiguity or the failure to connect. Instead, the fleshy life of de Kooning's brush intruded upon and reshaped the letters, mocking their formality and presumption of meaning and giving them a visual life apart from the verbal. Near the center of *Zurich*, there was a big thick swipe of paint—a playful cow's lick amid the slender skeins of black crisscrossing the surface.

As the black-and-white paintings progressed, fewer letters appeared and the series began to darken, notably in a turbulent work called *Light in August*. (The picture has usually been given a date of ca. 1946, which is probably mistaken for several reasons.) The first great picture in the series, *Light in August* was much larger than most of the earlier works,

more than four and a half feet high and three and a half feet across. The title was borrowed from the novel by William Faulkner—a writer much discussed in the late forties—and given to the picture well after it was painted. The protagonist of Faulkner's densely written book is Joe Christmas, a man with an invented name who is estranged from his mother, his father, and his culture. He is adopted, part white and part black, and cannot fully communicate with others or explain himself to the world. He finally murders his father, and is himself castrated and killed with a butcher knife.

Not surprisingly, the fate of an unlettered man, estranged from his parents in an unforgiving culture, spoke powerfully to de Kooning. He must have responded, as well, to the rhyme between his black-and-white palette and Faulker's black-and-white man. *Light in August,* a brooding picture evocative of a dark and primeval universe, glows with mysterious symbols: a black crescent, circles, what looks like a gate, glimpses of the body. Now that he was free of most colors, de Kooning became more spontaneous, almost drawing with his brush. The blackness itself began to seem like a glorious color; there was an element of rapture, an undeniable joy, in de Kooning's confrontation with his own darkness. In the lush volcanic blacks he found a metaphysical grandeur in his private despair.

According to the critic Harry Gaugh, "The black paintings have an x-ray quality, not only because of their darkness, but because in some places we see into things, but never clearly. Rather, an inconstant back lighting or reflected light fuses silhouettes and shadows." At the same time, the black and white do not define a separate "positive" or "negative" space; the surface fuses in a pulsing, often tumultuous rhythm. The forms themselves have a kind of living kick, a personal velocity across the space. Other painters called the surface an "activated field." In 1950, de Kooning said:

> I am always in the picture somewhere. The amount of space I use I am always in, I seem to move around in it, and there seems to be a time when I lose sight of what I wanted to do, and then I am out of it. If the picture has a countenance, I keep it. If it hasn't, I throw it away.

In January 1948, Betty Parsons presented a new exhibit of Jackson Pollock's art, a grouping that contained some of the artist's first drip paintings. The dominant colors in many of the Pollock pictures were also black and white. The show probably demoralized and exhilarated de Kooning in equal degree. He could not help contrasting his limited output to Pollock's prolific one; and yet, the early Pollock drip paintings, such as *Cathedral* and *Enchanted Forest,* celebrated a kind of flowing release, an escape from

Painting, 1948, enamel and oil on canvas, 42 ⁵/₈" x 56 ¹/₈". Acquired by the Museum of Modern Art, New York, not long after de Kooning's first one-man show

the endless questions, revisions, and doubts that were part of de Kooning's temperament. In the winter and spring of 1948, de Kooning suddenly broke free in his own way, creating a succession of "black" paintings that are among the most beautiful works of the twentieth century. Surrounded by the cans of cheap enamel, de Kooning, with the joy of a bum made rich, let go as never before, loading his brush and slathering on the paint and, as he put it, "going to town." During this burst, de Kooning made *Painting*, now in the Museum of Modern Art, *Village Square*, and *Dark Pond*. He also produced numerous drawings. He seemed entirely one with his art. Nothing was necessary in this work but the momentary movement of mood, thought, and allusion; no narrative need interrupt the play of consciousness.

Of course, de Kooning's way of being "inside" the painting had connections to surrealism and to the method that Pollock was developing. But de Kooning's approach was also fundamentally different. Whereas Pollock appeared transcendently free, de Kooning, while more spontaneous than before, still held onto the ambiguities and backward-coiling paradoxes of the self. When Pollock unrolled canvas on the ground, creating a kind of metaphysical boundlessness—like the ocean—he gave up the window and the mirror of the painter at the easel. He also gave up traditional brushwork. De Kooning loved water and the ocean, but he also feared them. He could not give up the mirror, the window, or the brush. The per-

sonality of the brush, in his hand, was the mark of the knotty, inescapable self.

In the black-and-whites, the shapes would abruptly shift in velocity and depth. Whipping lines ricocheted around the canvas. Images lost themselves in other images. The physical world was palpably present, both in the thick gritty surfaces and in the elliptical glimpses of a figure or landscape. A curve could evoke a shoulder or a road; a patch of gleaming blackness could suggest the rainy streets of New York at night. In de Kooning, a turn of mind was also a touch of mind, and thought always had body. Every painting seemed about to become another painting, and de Kooning actually created them through a literal process of metamorphosis. Even in the later black paintings, he usually began by first drawing a form or a letter in charcoal. Then he switched to black paint, often "drawing" images with a thin, long-bristled liner brush, a favorite of his because it could be both supple and precise. He often saw a shape that he wanted to save for later or move somewhere else in the picture. At that point, according to Joop Sanders, who often observed de Kooning painting in the forties, "he would trace [the form] in charcoal on tracing paper."

Once the image was preserved on the tracing paper, Sanders said, he might retrace it on the reverse side of the tracing paper. Then, when he placed the tracing paper on a painting and went over the lines on the front again with the charcoal, the charcoal lines on the back were transferred directly onto the paint. "When you take off the paper, you get an outline of the form," said Sanders. "Then he would paint the form another color or even use parts of the lines underneath to flatten out the shape so you get these structural lines of what was underneath. Which brings in a great deal of abstraction." Sometimes, de Kooning actually applied the tracery directly onto the canvas—transfer paper and all—using a glob of zinc white to hold it in place. Either way, numerous forms were discarded, moved, or saved. "He had these pieces lying all over the floor," said Sanders. "He would say, 'That looks interesting,' and cut it out and put it into something else and have that be a starting point." One painting in the series formed from another. The critic Tom Hess described the artist working in this way: "[De Kooning] will do drawings on transparent tracing paper, scatter them one on top of the other, study the composite drawing that appears on top, make a drawing from this, reverse it, tear it in half, and put it on top of still another drawing."

In the black-and-white paintings, everything seemed intertwined. Not only did figure and ground become one, but light was dark and dark was light. The abstract was figural. The great wonder was that such pictures did not become muddled or uncertain. Part of the reason was that, in

contrast to most surrealists, de Kooning still retained much of the cubist grid, which gave his compositions an underlying, tensile strength. But he used the structural strength of cubism toward un-cubist ends. In a discussion of the painting *Black Friday,* the art historian Sally Yard emphasized how its space differed from that found in cubist pictures:

> Despite his intent interest in Picasso, de Kooning's enlistment of black and white in no sense reiterates the Cubist narrowing of the palette to gray and dun tonalities . . . de Kooning discerned his way *beyond* Cubist space. For the Cubists, these paired hues operated as abstracted devices of light and shadow—ghosts of chiaroscuro, signs of three-dimensionality. In black and white de Kooning finally confounded the systematic, rational construction of space from perspective to *passage,* arriving at a space elastic enough in Black Friday to accommodate the compressed house shape at the upper left alongside the image of the artist's finger, and the abstracted anatomies at the lower right.

In the late forties, de Kooning was already resisting the growing fashion for reductive abstraction, which increasingly (as in the work of Rothko and Newman) removed many elements of traditional painting. In discussing one of his works from 1948, he said, "I'm not interested in 'abstracting' or taking things out or reducing painting. I paint this way because I can keep putting more and more things in it: drama, anger, pain, love, a figure, a horse, my ideas about space." Contraries should live together in the same mind; that was the space of truth. According to Yard, even "the abyss and the gates of Paradise defy separation."

Like de Kooning, many of the artists who would one day be called abstract expressionists found a more assured personal voice in 1947 and 1948. Those were the seminal years in the formation of the New York school, according to Clement Greenberg. Although Charlie Egan, de Kooning's putative dealer, had opened his gallery with shows of more sellable uptown artists, he was still keeping a close eye on de Kooning and his friends. According to Egan's then wife, Betsy Egan Duhrssen, "Charlie used to go down to Bill's studio early in the morning. Bill had a way of not letting people in when he was working. They'd take walks and talk. Charlie loved to talk about art." During the winter of 1947–48, Egan noticed that the famously blocked de Kooning was suddenly producing lots of black-and-white paintings; they were strewn around the studio. Egan

asked if he was ready for a one-man show. De Kooning agreed that, for once, he had finished enough paintings. Before de Kooning could change his mind, Egan scheduled an exhibit for several months in the future.

At one point, Egan met with Elaine and de Kooning in the apartment on Carmine Street to name the pictures. To what degree de Kooning himself thought up the titles remains uncertain. In general, de Kooning shied away from naming art, once observing, "I think that if an artist can always title his pictures, that means he is not always very clear." In this case, however, the strong likelihood is that he had some titles in mind. Not only did several allude to light and darkness, but some pictures—in addition to *Light in August*—invoked the powerful, despairing, and archetypal themes of family violence and sacrifice. *Orestes* referred to the son of Agamemnon and Clytemnestra, who, with the aid of his sister, avenged the murder of his father by killing his mother and her lover. And on Good Friday—a *Black Friday*—the emblematic "son" of Western culture was sacrificed.

De Kooning's first one-man exhibition opened on April 12, 1948, shortly before his forty-fourth birthday. It consisted of ten black-and-white paintings that he had finished during the past year. All were priced between $300 and $2,000. By even the modest commercial standards of the time, the show was a failure. It was originally scheduled to hang for one month, but when nothing sold Egan decided to keep fishing for business for another month. "Charlie Egan, in desperation, kept the show up through May and June until it became an embarrassment to Bill," said Elaine. "It made things seem more hopeless." Since money was scarce and neither Egan nor de Kooning was a good salesman, the exhibit was hardly promoted—just several small notices in the arts magazines and a few mailed announcements. There was no opening-night party, although the more aggressive dealers had begun that custom by the early forties. According to Elaine, "Nobody thought of going to the gallery on opening day, not even Bill." If de Kooning's first show made no impression on the public, however, its impact downtown was profound. By the late forties, de Kooning's reputation as a brilliant artist who destroyed most of his work was established. Suddenly, the artists who knew him only by reputation, or from the Waldorf, could judge his work for themselves. Artist after artist made the subway journey uptown to Egan's tiny, top-floor gallery at 63 East Fifty-seventh Street to examine the de Koonings. "Bill was acclaimed from the minute he started showing," said Jane Freilicher. Then part of a younger downtown artists' circle that revolved around Hans Hofmann's school, Freilicher, like her contemporaries, was keen to

see the much-vaunted black-and-white show. "He was already forty," she said. "Everybody was talking about him. I don't know if they sold, but he engendered great respect in everyone."

Since de Kooning was not known on Fifty-seventh Street, the main-stream press did not cover the show. The sole exception was Sam Hunter, whose review in the *New York Times* was not glowing:

> Curiously enough the artist seems to controvert his own aims by with-holding life from these forms at the crucial moment when they are about to emerge from their dense, seething web of automatic activity. This method of canceling out, contradiction, of maintaining an inter-minable fluidity either adds up to an impression of imprisonment with possible contemporary spiritual implications, or one of lugubrious vac-illation and paucity of motifs and content, according to your point of view.

Hunter's pessimism was far outweighed, however, by the tremendous enthusiasm of later magazine reviews. Covering the show for *ArtNews*, then the most important art magazine in the country, was a young writer named Renee Arb, who was just starting out as a critic. "Here," wrote Arb, "is virtuosity disguised by voluptuousness—the process of painting becomes the end. Technique is lavish and versatile; draftsmanship ele-gant and concise; the range of color seems as rich in black and white as in the brilliant hues." Arb's admiration was so fervent that Tom Hess, the managing editor of *ArtNews*, wanted to know half-jokingly if anything was going on between Arb and this unknown painter about whom she was raving. Were the two, asked Hess—who at that point knew nothing of de Kooning—having an affair?

Most important of all was Clement Greenberg's review of the show in *The Nation*. In later years, Greenberg turned against de Kooning. At the time of this first show, however, de Kooning's work provided an ideal illustration of some of Greenberg's favorite themes. He lauded de Kooning in his *Nation* review; four paintings were also reproduced in an illustrated piece in *Partisan Review* that Greenberg wrote that April titled "The Cri-sis of the Easel Painting." "Now, as if suddenly, we are introduced by William [sic] de Kooning's first show, at the Egan Gallery (through May 12) to one of the four or five most important painters in the country, and find it hard to believe that work of such distinction should come to our notice without having given preliminary signs of itself long before," Greenberg began. "He has saved one the trouble," Greenberg continued, "of repeating 'promising.' " In the rest of his *Nation* review, Greenberg

went on to praise de Kooning's draftsmanship and his distillation of color into black and white, which Greenberg took to be an effort to bring new forms to life in the post-cubist era. He also took pains to answer the reservations Sam Hunter expressed in the *New York Times*. Unlike Hunter, Greenberg recognized that ambiguity was a value de Kooning sought, and he gave any reservations he might have a positive slant: "The indeterminateness or ambiguity that characterizes some of de Kooning's pictures is caused, I believe, by his effort to suppress his facility. There is a deliberate renunciation of will in so far as it makes itself felt as skill, and there is also a refusal to work with ideas that are too clear." Greenberg ended his review with a flourish. "These very contradictions," he wrote, "are the source of the largeness and seriousness we recognize in this magnificent first show."

For de Kooning, the recognition was unprecedented. With this one show, as Greenberg suggested, he established himself as one of the most talented artists in the city. This came at a time, moreover, when Pollock's critical fortunes seemed to be waning. Pollock's exhibit three months earlier, which de Kooning admired, had proved to be a critical disaster. With the exception of Greenberg, not one critic liked Pollock's new drip paintings, and many artists also found them puzzling. Now that most of Pollock's supporters had returned to Europe, some Americans weren't certain that the painter, who had retreated to the springs on the eastern end of Long Island, was worth the trouble. Some art-world gossips and reputation adjusters began to wonder for the first time if de Kooning was destined to supplant the reigning champion.

While a *succès d'estime*, de Kooning's first show did nothing to help him financially. That May, with no prospects of making money elsewhere, he faced his usual summer dilemma. Not since their last visit to Woodstock in 1943 had de Kooning and Elaine spent any significant time outside the city. The couple longed to leave, both because the apartment and studio were stifling in the summer and because it was harder to cadge meals and rent money, and find odd jobs, with so many people gone. "We were looking forward to the summer with trepidation," Elaine wrote in a later article about the summer of 1948. "The previous four summers of our married life spent in the city had taught us that living hand-to-mouth, at which we were expert, was more difficult in July and August than during the rest of the year when 'something would happen.'"

Then de Kooning's luck changed, thanks to a chain of events put in motion by his friend from the Eastman Brothers era, Misha Reznikoff.

Shortly before the Egan show in April, Reznikoff, a perennial gadabout who knew everyone and kept abreast of the gossip, had been talking with the sculptor Peter Grippe and his wife, Florence. Since few artists had regular jobs, the Grippes—who had run the Atelier 17 printmaking studio in the Village since the celebrated British printmaker and artist Stanley William Hayter, its founder, had returned to France—were considered very successful. According to Peter Grippe, "Misha said, 'Bill is down and out. Can you do something for him?' " Grippe had known de Kooning's work since the WPA days. He also knew of de Kooning's much-vaunted inability to finish a painting. Feeling sorry for de Kooning, the Grippes invited him to breakfast. Not long afterward, Josef Albers, who knew the Grippes through the Atelier, told them he was having trouble finding faculty for the summer session at Black Mountain College in North Carolina. Albers had been head of the art department at Black Mountain, an experimental college that attracted many European émigrés, since the college's founding in 1933. He was now organizing its summer session. A string of eminent artists and critics had already turned down his offer of a summer appointment. Finally, Mark Tobey, the mystical, highly respected West Coast painter, agreed to teach painting. But then Tobey fell sick and withdrew, leaving Albers with no choice but to find a substitute.

The Grippes, who were already signed on for the summer, thought of de Kooning. "I know a painter who is starving," Grippe told Albers. "He doesn't have enough money to get out of town." He added that John Cage and Merce Cunningham, who were also scheduled to teach that summer, knew de Kooning and would vouch for him. Albers duly checked with Cage. "He said he'd like someone who was entirely different [from me]," said Cage. "I suggested de Kooning, partly because I knew he was different." De Kooning's recent show also recommended him. Two years earlier, Albers had himself exhibited with Charlie Egan, and he believed Egan knew who was important downtown. Still, after Tobey, Albers regarded de Kooning as a comedown. "Tobey was a big name," said Grippe. "Bill wasn't resolved as a painter." But de Kooning was a likely prospect and, more important, eager for the job.

The invitation to teach at Black Mountain was extended. De Kooning and Elaine—especially Elaine—were "overjoyed." Not only would they be out of the city from July 1 to August 25, the length of the summer session, but Black Mountain would also pay their train fare, their room and board, and $200 in salary. That amount easily covered the rent for their flat on Carmine Street and de Kooning's Fourth Avenue studio. According to Elaine, "At the end of June, in great good spirits, we packed our brushes,

paints, pads, jeans, bathing suits, one 'good' suit for Bill, and two dresses for me and took off for Asheville on an overnight train."

Black Mountain—an aptly named destination for a painter immersed in ambitious black paintings—was like nothing else in America in the late forties. It was more European, more offbeat, more radical than any college in the country. It had been founded by a band of renegade professors from Rollins College in Winter Park, Florida, who wanted Rollins to have an experimental curriculum. After being dismissed by Rollins over differences of opinion, the dissidents, headed by John Andrew Rice, a classics professor, went to Asheville, North Carolina, in the hill country of the western part of the state. There they rented the Blue Ridge Assembly buildings that belonged to the local YMCA and had traditionally been used only in the summer. Rural and remote—hundreds of miles from the nearest city—the site included a working farm that produced food for the college, and the faculty and students worked on the farm in the afternoons. "Black Mountain College combined elements of the progressive schools, farm schools, religious sects, and summer camps," wrote Mary Emma Harris in her history *The Arts at Black Mountain College.* "There was a strong sense of pioneering in the American tradition of building a 'log cabin college' out of nothing and of providing a good education without tremendous laboratories, expensive buildings, and stadiums."

By 1948, Black Mountain had moved from its initial quarters to a 726-acre site that was once a summer camp for girls. Rice was also gone, having resigned in 1940. If anything, however, Black Mountain had become even more radical. Its curriculum, which was unaccredited and did not lead to a degree, offered something more like a voyage of self-discovery than a traditional course of study. There were no bells, and no classes in the afternoons. Students were expected to help build new buildings and repair existing ones—even slaughter cattle. Despite Black Mountain's isolation, the college had become a magnet for European intellectuals, artists, and musicians displaced by Hitler. Amédée Ozenfant, a French purist painter who came to Black Mountain in 1944, called it "one of the new centers of German culture" in America. Albers, who had been recruited just as the celebrated Bauhaus was closed by the Nazis, was a zealous champion of abstract art; it is little wonder that Black Mountain "came to be identified with experimental art in America," as Harris wrote. To the rural, conservative southerners of the neighboring countryside, many of them fundamentalist Christians and nondrinkers (Black Mountain was in a "dry" county), the "large number of Jews, northerners and Germans" at the college contributed "to a general suspicion [in the nearby area]," wrote Harris. Isolated on their sprawling campus, the Black

The lake and dining hall at Black Mountain, the experimental college in North Carolina where de Kooning taught in the summer of 1948

Mountain faculty and students became increasingly inbred, their every squabble magnified by their inability to get away.

Into this strange, intense, sometimes stifling atmosphere came the de Koonings in late June 1948. Their overnight train ride from New York, sitting upright on hard seats the entire way, was an ordeal. Sometime during the night, a fight broke out in the middle of the car, and ten men moved forward to break it up. "Do they expect me to go?" said de Kooning, somewhat nervously, remaining seated. When they finally arrived at the campus, the isolation—"evocative of Faulkner's South"—seemed to their urban eyes both alien and, according to Elaine, "rather desolate." De Kooning's initial reaction to the South was not enthusiastic: "I feel like turning around and going home," he said. If Black Mountain appeared outlandish to de Kooning, he himself made an awkward fit with the other faculty members. He was a modernist who sometimes painted abstractly, but he also differed significantly from Albers, who believed in rigorous geometric abstraction; or from Buckminster Fuller, a visionary architect who had also signed on at the last minute; or from John Cage, who was abandoning traditional musical forms and sounds. In contrast to many around him, de Kooning maintained an unapologetic reverence for the past and seemed as interested in practice and craft as he was in spinning

the wheels of theory. One student, Pat Passlof, vividly recalled de Kooning's first talk to the faculty and students at Black Mountain. "Everyone who taught had to give a talk," said Passlof. His was called "Cézanne and the Color of Veronese." The audience included Kenneth Noland and Kenneth Snelson, who would become well-known artists, and, among the faculty, Buckminster Fuller, Merce Cunningham, and John Cage. "Bill had written this out beforehand, trying to explain the foundation he's standing on," said Passlof. It was hardly what the avant-gardists had expected. Most were deeply involved in Albers's color theories, in which he asked students to solve different problems by putting together colors in various ways, a method diametrically opposed to de Kooning's more classical conceptions of art training. "So here comes Bill, innocently talking about what was on his mind, and a lot of people were in a 'Burn the Museums' mode. This seemed out of place. They didn't like his paintings, either. But they liked him," said Passlof.

Any lingering hopes for de Kooning were dispelled during his first class. According to Gus Falk, another Black Mountain student:

> Finally this little Dutchman comes in, says how do you do, and starts setting up a still-life. He spent about two hours setting up this simple, simple little still-life. Backing up and looking through the window of his hands seeing how it was, changing it a little bit, finally we were wondering what he was doing. Not talking much. Finally he stops and finishes it and he looks around and he says, 'Vell, ve're going to spend all summer looking at this ting. On one piece of paper or one canvas and we're going to look at it until we get it exactly the way it is. Then we're going to keep working on it until we kill it. And then we're going to keep working on it until it comes back on its own.

At that point, there was a virtual rush for the door by the devotees of Albers. But Passlof had come to Black Mountain specifically to study with de Kooning. She had seen his show at the Egan Gallery and had been so moved that she had walked out of the art history department at Queens College in search of him. "De Kooning didn't teach anywhere, but I found the only school, Black Mountain College, whose faculty might be in his circle," she said. When Tobey had canceled, she felt "instantly" that de Kooning would be his replacement. She went down to the train station in Asheville to meet him. "Even though I had never seen him, I knew it was him," said Passlof. "He and Elaine arrived together. He was very beautiful— romantic-looking. I think he had a tremble to him, literally, that you could feel even if it wasn't visible. And sometimes it was visible."

Passlof and the other students who had signed up for his course assumed that de Kooning's teaching would be as radical as his paintings. "You know, we were going to express ourselves," said Falk. Instead, there was the talk about Cézanne and Veronese, and the impeccably crafted still life. Once the acolytes of Albers left the class, however, de Kooning proved to be much less doctrinaire than his few remaining students anticipated. Although he wanted them to work on one still life with a 6H pencil, just as he himself had learned to do in Holland, he could not play the tyrant for long. In her cow-stall studio—each student had a tiny painting space of his or her own in the converted barn and slept in a communal dormitory—Passlof painted abstractions for the rest of the summer. Gus Falk spent the time experimenting, even blowing up ink spots with de Kooning to study the results. There were no formal classes after the memorable first one. Instead, de Kooning visited each studio daily, giving "immoderate praise" to his students. According to Passlof, "He always said, 'Terrific. Terrific!' when he came into your studio."

Once their initial shock subsided over the strangeness of rural North Carolina, de Kooning and Elaine settled in quite happily at Black Mountain. Elaine, in particular, loved the time there. "She took every class in the place," said Passlof. There was dance with Merce Cunningham—Elaine's close friend, whom she had met through Edwin Denby—and color theory with Albers. Best of all, there were long lectures by Bucky Fuller, who, with his visionary blue eyes and irrepressible enthusiasm for the geometry of the universe, was considered by most people at Black Mountain a delightful nut. Fuller had arrived that June in an aluminum trailer packed with what he called his "magical world of mathematical models." Unlike de Kooning's opening lecture, which appalled many who attended, Fuller's first three-hour disquisition on "energetic" and "synergetic" geometry—in which he made mobile constructions from bobby pins and clothespins and, according to Elaine, "dazzled us with his complex theories of ecology, engineering, and technology"—fascinated listeners. Elaine liked to tell a story about Bucky and Bill:

> One day, [Fuller] held up two jagged, irregular lumps of metal. "If these are put together a certain way, they will form a perfect cube," Bucky explained. The two lumps were passed back and forth between the students for an hour and a half with much discussion of how and why they didn't fit. Then Bill wandered into the room. Bucky had a special regard for the intuitive approach of artists. "Let's see what someone from another discipline can do," Bucky said to the class and explained the problem to Bill, handing him the two lumps. Bill hefted them and stud-

ied each one separately and then snapped them together, forming the perfect cube on the first try. Bucky nodded approvingly, not at all surprised. But I was surprised. "How did you do it?" I asked Bill later. "Well, I figured all those smart engineering students had tried all the logical ways," he shrugged, "so I just looked for the least logical way."

Although the summer faculty was buffered for the most part from the political infighting that often marked the winter faculty, there was still, as Elaine later wrote, a "whiff of the open and veiled hostilities that provided a constant and oppressive undercurrent" to Black Mountain. There were factions and feuds, many of them exacerbated by Albers's inaccessibility and autocratic Germanic style. Unlike the other faculty members, who were assigned to cottages scattered near the student dormitories, Albers lived by himself in a cottage on top of the hill. And except for mealtimes, when everyone ate together in a dining hall by the lake, Albers kept apart. "Albers didn't mingle with us," said Florence Grippe. "If you were very special, he'd invite you to tea." De Kooning was regarded by some as an upstart with few formal credentials. "It's true that he was not very respected by the faculty," said Gus Falk. "I remember one faculty member talking down to Bill at a meal. This man was saying, 'You're not even an artist. You don't really show.' " However, Albers always backed de Kooning. "Albers was wonderful," said Falk. "Everyone asked him, 'Why did you invite de Kooning? He's the opposite from you.' And he answered, 'Any fool can see that's where the action is.' Albers had this talent for inviting people who were completely opposed. And respecting those people more than his own followers, who aped him."

To de Kooning, however, just being at Black Mountain was reward enough. "He walked around this rundown old camp, this lake with rattlesnakes all around it and a bunch of old stables for studios, and said, 'I've never been in a college before,' " said Pat Passlof. "He was full of wonder about these things. It was very endearing." Unlike most of the faculty, de Kooning was not averse to doing the same manual work the students did. Once, said Florence Grippe, "Albers decided the barns needed cleaning. He told everyone to clean the barns. I said, 'I'm not cleaning the barns. Let the students do it.' I said to Bill, 'We're not going to clean the barns. Buckminster isn't. Ames [Winslow Ames, director of the Springfield Art Museum in Missouri] isn't.' Bill said, 'Oh, I will. I don't mind.' "

In the gossipy, inbred faculty circle, one of the mysteries that summer was the nature of the relationship between de Kooning and Elaine, and where, to be exact, each one slept. In her later accounts of the summer,

De Kooning at Black Mountain, 1948

Elaine described living in a spare two-room faculty cottage furnished with nothing but a table and chairs and bed and bureau. While de Kooning might have worked there, others said that he seemed to be on his own, sleeping in one of the student areas. "Bill said, 'You know, I can't sleep. It [student noise] goes on all night,'" recalled the Grippes. "We said, 'Bill, go complain to Albers.' He said, 'I'm so grateful to be here that I'm afraid to say anything.'" Elaine, for her part, was most definitely not in the student dormitories or with her husband. When asked whether she was staying with de Kooning, Elaine said, "Oh, no, we're separated." Still, Gus Falk remembered thinking, "There was a love between them."

If their relationship was mysterious, their poverty was blatant. For most of the summer, de Kooning was, as usual, desperately short of money. There was soon nothing left of the $200 that Albers had sent him in New York. "What we learned is that Elaine took that money and spent it all on clothes," said the Grippes. "He had no money when he came down." While food and board were provided, the extras—including beer for the student and faculty parties—were not free, and de Kooning was forced to scrounge around for cash. But he was accustomed to being broke, so his situation did not seriously affect him. Nor—unlike Elaine—did he participate much in the Saturday-night parties. At one party, according to Gus Falk, "Elaine was dancing and Pat [Passlof] was dancing, and Bill and I weren't, and he said to me, 'Why aren't you dancing?'" When Falk explained that he'd rather sit on the edges and observe, de Kooning nodded and said, "Ah, you're like me. All you want to do is paint."

As a teacher, de Kooning was conscientious, not only seeing his students almost daily but also talking with them during meals. Otherwise he wanted to be left alone. His summer's work had begun badly; he had been blocked, said Elaine, because he "missed the sense of continuity in his New York studio." That only made him eager to work harder. At first he had taken up pastels, a marked change from his recent string of black-and-whites. Then, said Elaine, he finally taped a twenty-five-and-a-half-by-thirty-two-inch piece of cardboard to his easel and began painting with oil and enamels. The tiny bits of color included in *Black Friday* spread rapidly. "Flaming pinks and oranges and yellows would sweep across the paper in ever-changing forms, eventually crystallizing in an image that suddenly presented an identity," said Elaine. At that point, she said, other artists might have decided that a work was finished. But for de Kooning, it was only a beginning. "Time after time," she wrote, "I had the familiar but still painful experience of coming home to find an image I loved blasted away. This seemingly endless process was the method by which he had arrived at the paintings in his first show earlier that spring."

For de Kooning, the summer was marred by one tragic, deeply felt event: the suicide of Gorky. News of Gorky's death was slow to reach the isolated enclave of Black Mountain. The first reports came by mail several days after Gorky killed himself, on July 21. Two and a half years before, in January 1946, his studio in Sherman, Connecticut, had burned, destroying about thirty paintings and numerous books and drawings. Two months later, he had a colostomy to remove his rectum, which was cancerous. After that operation, he was forced to use a cumbersome external bag attached to an opening in his side to eliminate waste. Just when things seemed to be improving for him—his February 1948 show of new, more transparent paintings at the Julien Levy Gallery, while puzzling to some, was greeted favorably by Clement Greenberg—Gorky and Levy had a serious car accident. Gorky's neck was broken, his painting arm temporarily immobilized. For Gorky, life became hellish not only for himself, but for his family. In the middle of July, his wife took their two daughters and left the house. Gorky's suicide followed a few days later.

De Kooning knew nothing of what had happened until one student, V. V. Rankine, the sister-in-law of Gorky's wife, Agnes Magruder, opened her mail during the morning coffee break and began to read the newspaper report of Gorky's death that her mother had sent her. According to Pat Passlof, de Kooning "recoiled as if struck." He got up from the table, excused himself, and disappeared. That night, Passlof and Falk had invited de Kooning to spend the evening with them. After the news, however,

de Kooning could hardly talk. When the students went to get him, he opened the door and said that he couldn't come. For the next few days, little was seen of him. In his own way, he was saying farewell to the man who had most affected his own destiny. Whatever their differences, de Kooning remained immensely admiring of Gorky. "Were you influenced by Gorky?" Falk asked de Kooning that summer. De Kooning answered, "I insisted on it." A year later he felt obliged to write the following letter to *ArtNews:*

> Sir: In a piece on Arshile Gorky's memorial show—and it was a very little piece indeed—it was mentioned that I was one of his influences. Now that is plain silly. When, about fifteen years ago, I walked into Arshile's studio for the first time, the atmosphere was so beautiful that I got a little dizzy and when I came to, I was bright enough to take the hint immediately. If the bookkeepers think it necessary continuously to make sure of where things and people come from, well then, I come from 36 Union Square. It is incredible to me that other people live there now. I am glad that it is about impossible to get away from his powerful influence. As long as I keep it with myself I'll be doing all right. Sweet Arshile, bless your dear heart.

With the exception of Gorky's death, the summer of 1948 proved a "magical one" for many of the faculty and students, wrote Mary Emma Harris in her history of the college: "It marked the end of the dominance of the European artists at the college and the emergence of the young Americans, who were to be the creative leaders in the arts in the United States for the next twenty-five years." As the summer came to a conclusion, even de Kooning was caught up in several large group events that galvanized the campus. One was a performance of Erik Satie's lyric comedy *The Ruse of Medusa,* which crowned a week's worth of Satie performances by John Cage, Patsy Lynch Wood, and Richard Lippold that had been held every Monday, Wednesday, and Friday night. The role of Baron Medusa was played by Buckminster Fuller and that of Frisette, his daughter, by Elaine. In a photograph of the production, Elaine, dressed in white and carrying a bouquet, looked exquisite, her heart-shaped face, slender neck, and graceful posture perfect for the role of a fresh young girl. Merce Cunningham, increasingly interested in purely abstract movement rather than in the literary, psychological ballets of his mentor Martha Graham, danced in the production. De Kooning himself had a starring, if less public, role as the set designer. According to Elaine, he "transformed a huge

stodgy desk and two nondescript columns into magnificent pink and grey marble with a technique he had learned at a decorator's shop in Holland when he was sixteen years old."

The last day of the summer session was August 25. A few days later, de Kooning once again boarded the train, this time without Elaine, who decided to stay at Black Mountain for a while longer. But he was accompanied by Pat Passlof, who wanted to ride back to New York with him. On the train, Passlof asked him if he had any recommendations for good art schools in New York. "Why don't you study with me?" said de Kooning generously. He believed firmly that young painters should come to New York, get a studio, and start painting rather than go to college to learn art. That was what *real* painters did.

In his baggage, de Kooning carried the work that he and Elaine made over the summer. Elaine had produced a series of fifteen or so enamel paintings on wrapping paper. Their imagery and biomorphic shapes echoed the structure of de Kooning's black-and-white paintings, but lacked the tight calligraphy of his line or the dense and whirling energy of his forms. De Kooning produced only one unfinished and modestly sized painting, the same twenty-five-and-a-half-by-thirty-two-inch piece of cardboard that he had been working on since late July. (He was the only one to follow the suggestion he gave his students that they work all summer on a single composition.) However, that one painting, called *Asheville* and completed in New York, was important. Like the black-and-white works of the previous year, it was filled with hundreds of shapes and lines, boldly etched in glossy black enamel and careering across the canvas. Now, however, the bright, jewel-like hues that were edging into the earlier *Black Friday* splashed against the white background, becoming a shimmering visual feast of bright oranges, reds, greens, and yellows. Freed for a moment from dark urban dreams, de Kooning let his art melt into the landscape—as he would many times in the future, when the city wearied him and he sought to recharge his spirit.

Still, de Kooning was not about to abandon New York. Not long before the summer came to an end, Elaine and de Kooning were at one of the Black Mountain parties when de Kooning, tired of the merriment, suggested a walk. "I'm getting sick of crowds," he joked. The two of them—who had gone to more parties in two months in the country, Elaine later said, than they had in the previous five years in the city—left the festivities and went into the darkness outside. "After ten minutes on the moonlit road," said Elaine, "none of the lights from the school were visible to interfere with the vast, heavy, velvety blackness of the sky, nor did sounds

of laughter and music penetrate the almost terrifying hush." The two stood looking up at the sky, "enveloped," said Elaine, "by the awesome multiplicity of stars." It was a sight never seen in the city, where the reflected glare blanked out the stars and only a slice of sky was visible from a loft window. "Let's get back to the party," de Kooning said suddenly. "The universe gives me the creeps." It was time to return to New York.

20. Stepping Out

I always felt that the Greeks were hiding behind their columns.

In the fall of 1948, de Kooning's life changed in a subtle but profound way. He was no longer just "Bill," an inward-looking man accustomed to living in obscurity. Strangers and old friends alike sometimes regarded him differently now, for he was becoming someone to watch, an artist who might actually make it in America and, more surprising still, find a paying audience. "Between the two world wars, art was something one talked about but didn't buy," de Kooning would later say. "After World War II, the pendulum went alarmingly the other way." In October, the Museum of Modern Art, the center of the modernist establishment in America, formally recognized him. Its director, Alfred Barr, was growing interested in his work, although he disliked much contemporary American art, including that of Pollock. The autumn after the Egan show, MoMA bought the black-and-white work called *Painting* for $700. That same autumn, the Whitney Museum of American Art included *Mailbox* in its "Annual" show of American art, the first of what would be sixteen appearances by de Kooning in Whitney Annuals and Biennials.

De Kooning's emergence into public view was further advanced, shortly after the MoMA acquisition, when *Life* magazine convened a "roundtable" discussion of modern art in the penthouse of the Museum of Modern Art. "Fifteen distinguished critics and connoisseurs," wrote the editors, "undertake to clarify the strange art of today." The group of critics and experts assembled for the roundtable included Aldous Huxley, Clement Greenberg, and the art historian Meyer Schapiro. Also present were such establishment figures as James Johnson Sweeney, chairman of the department of painting and sculpture at the Museum of Modern Art, and Francis Henry Taylor, the director of the Metropolitan Museum in New York. The group sat for hours debating the value and meaning of modern art, focusing primarily upon famous European modernists, mainly Picasso, Matisse, Miró, Dalí, and Rouault. In the remarkably serious article that resulted, which ran for more than sixteen pages, *Life* also illustrated the work of what it called five "young American extremists," with de Kooning (represented by *Painting*), Pollock *(Cathedral)*, Adolph Gottlieb *(Vigil)*, William Baziotes *(The Dwarf)*, and

Theodore Stamos *(Sounds in the Rock)*. Both Sweeney and Greenberg greatly admired the de Kooning painting. *Life* wrote this about Greenberg's response:

> When the moderator inquired as to what Mr. DeKooning [sic] was trying to say, Mr. Greenberg replied that he thought Mr. DeKooning [sic] was wrestling with his fears, but that this overtone of foreboding and anxiety was not the most important aspect of the picture. "The emotion in that picture," continued Mr. Greenberg, "reminds me of all emotion. It is like a Beethoven quartet where you can't specify what the emotion is but are profoundly stirred nevertheless."

If the public still knew nothing about modern art—except, of course, that it hated it—*Life* could certainly recognize a developing story. Contemporary art, the editors sensed, was beginning to excite the public. For de Kooning, the money from MoMA mattered less than the signal the purchase sent to collectors. Not only was *Painting* the first and only de Kooning painting to sell from his first show the previous spring, but it could not have found a more prestigious buyer. The Museum of Modern Art was supported in large measure by the celebrated fortunes of such families as the Rockefellers and the Blisses, who often acquired new works with the intention of giving them to the museum. Any painting purchased by the museum or its patrons brought its creator the attention of New York's serious collectors. And the gallery scene was itself expanding. In the six years between 1940 and 1946, the number of galleries in Manhattan more than tripled, and sales were annually doubling and tripling. Most attention was still directed at European art, but it no longer seemed unreasonable to hope that interest in American art would increase.

Not only did younger artists notice the attention bestowed upon de Kooning by *Life* and the Museum of Modern Art, they also started to make an existential hero of the moody painter of black-and-white pictures. "By the time I knew his name he was already kind of a legend," said the artist and writer Louis Finkelstein, who moved into the midst of the artists' community around 1948. "There was a current of talk about him, a word of mouth. People who had missed the first Egan show were waiting for another de Kooning event." Even as his art moved into the mainstream, de Kooning seemed to retain the romance of his underground reputation. The young painters in the neighborhood noted how poor he remained and could not help admiring the conviction that sustained him. It was his devotion to hard work that turned Finkelstein into an admirer of de Kooning's before the two ever met. Finkelstein and a friend, having

rented a space on the opposite side of Fourth Avenue from de Kooning's studio, spent many nights listening to music and watching the unknown artist at work across the way. "He painted far into the night with an air of great seriousness," said Finkelstein. "He would go to the other side of his loft and stare fixated. Then suddenly he would come alive and then step back again. 'Whoever he is, he must be one of the most serious artists,' we said to each other." According to Betsy Egan Duhrssen, "Bill just worked. He worked and worked." No matter how late the discussions went at the Waldorf, no matter what tensions arose in his personal life, de Kooning continued to work with the relentless intensity of one who strives always to reach the unattainable.

Younger artists naturally compared the history of de Kooning and his generation to the struggle of the avant-garde in Europe. Perhaps de Kooning was himself the legendary genius in the garret. In the late forties, the European model of modernist struggle was being enhanced and romanticized by a wave of existential ideas moving into New York from the war-blackened continent. The bestiality of World War II and the onset of the cold war was bringing a dark—but also exciting—pessimism into intellectual life. The social optimism of Marxist intellectuals, eroded by harsh realities of history, could no longer attract many strong minds. However, many now turned inward and celebrated the individual who had the courage to face without fear a terminally absurd and corrupt society. The heroes were no longer Marx, Lenin, and Trotsky but, rather, Kierkegaard, Dostoevsky, Nietzsche and Freud, the great voices of isolation and the inner life. In particular, the French philosopher Jean-Paul Sartre, who raised nihilism and a sense of absurdity about human matters to the first principle of modern life, attracted attention. (The magnetic Sartre popularized existentialism through speaking engagements, including an appearance in 1948 at Carnegie Hall.) In the fall of 1947, Harold Rosenberg and Robert Motherwell together edited a magazine called *Possibilities*, part of a series of writings about contemporary art underwritten by the European booksellers Heinz Schultz and George Wittenborn. *Possibilities* was heavily influenced by existentialism and celebrated the inviolable "individuality" of the artist in a morally despicable society. As Rosenberg wrote, artists did not now speak as a group, as they often did in the thirties, but were making "an individual, sensual, psychic, and intellectual effort to live actively in the present." According to *ArtNews*'s Tom Hess, "The picture was no longer supposed to be Beautiful, but True—an accurate representation or equivalence of the artist's interior sensation and experience. If this meant that a painting had to look vulgar, battered, and clumsy—so much the better."

De Kooning's painting seemed to be a perfect reflection of existential thought. "Doubt," "alienation," "paradox," "ambiguity," "despair," the favored themes of the moment, were the very breath of his art; the black-and-white paintings in which the figure and ground eternally change places were masterpieces of uncertainty. It was becoming accepted that it was exactly de Kooning's doubt that gave his paintings much of their power: "I think the outstanding thing in his art is his doubt," said Joop Sanders, "his equivocating about it." At the same time, de Kooning's actual life also began to develop a powerful existential aura. It was obvious to de Kooning's contemporaries that nothing was fixed for this man. In an industrial society widely regarded as conformist and dehumanizing, de Kooning, with his beautifully broken English and Chaplinesque clothes, appeared distinctively and entirely himself, a homemade man. He was obviously not part of the great social machine. He lived on the margins as an outsider. Pat Passlof saw his poverty firsthand in the fall of 1948, when she moved into a loft on Tenth Street around the corner from de Kooning's Fourth Avenue studio and began to study with him. "There were no facilities in these people's lofts [communal toilets were in the halls] and not much heat," said Passlof. "So that as darkness came on it got colder and colder. Your choice was to go to bed or to go out." In one of the photographs taken by Harry Bowden in 1946 of the Fourth Avenue studio, de Kooning stood by his easel ready for action wearing a jacket and hat. His studio was obviously cold; he lacked the money to heat it properly.

Simply finding enough food to eat was an ongoing concern, just as it had been during the Depression. "I had this big cauldron," said Passlof. "I'd add each day's leftover food to it. People would stop by, and depending on who it was, I'd say, 'Are you hungry?' Once, I had a dozen people sitting on my floor." If there was any money at all, Elaine and de Kooning might eat at the Jefferson Diner, just down Sixth Avenue from the Waldorf, which advertised "home-cooked meals" and dished up "an excellent hamburger on toast for ten cents," according to the painter John Sheehan. A common technique for filling the stomach on particularly desperate days—one perfected by the crafty artist Aristodimos Kaldis—was to move very slowly through the line at the Automat wolfing down food from the plates arranged along the counter before reaching the cashier. "Eat, you sons of bitches, eat!" he would hiss at de Kooning and Elaine, all the while distracting the attendants, almost all of them Greek, with his banter. At the cashier, Kaldis would decorously pay for the one remaining plate on the tray.

Lofts were inexpensive around Ninth and Tenth streets, where artists clustered, because the neighborhood "belonged to the bums," said Passlof.

"That block—Tenth Street between Third and Fourth Avenues—was their headquarters. There were employment agencies where they occasionally found work, and they slept under people's staircases. There were also a lot of very cheap, empty lofts on Tenth because of the war. On opposite sides of the street were two metal-stamping factories. They had expanded into neighboring town houses during the 1940s, and then, when the war ended, little by little they had retrenched. So that a lot of lofts were empty and cheaper than anywhere else. And at one end the Third Avenue El was crashing and banging." Even so, de Kooning and his friends struggled to pay their rent and utility bills. They often tinkered with the Con Edison meters that recorded the amount of gas used. "Some of us had gas heaters and we all had different theories about how to make it read less," said Ibram Lassaw. "I remember Conrad Marca-Relli and Bill and me sitting around discussing this. My method was to unscrew the meter and turn the face to the wall. In that position, the wheel wouldn't turn. But you had to be careful not to have nothing there because that wouldn't make sense. We also had to be very careful not just to open the door when somebody knocked. It might be the meter reader from Con Edison. Once, Bill was in his studio on Twenty-second Street. There was a knock on the door and the meter was in the wrong position. So Bill said, 'Who dot?' The voice said, 'Con Edison.' Bill thought and paused a moment and said, 'Dat's all I want to know.' " The meter reader was left dumbfounded.

If de Kooning sold a painting for $200, said Marjorie Luyckx, "Elaine would take $100 and pay the rent for several months in advance. Then they would have $100 to pay for their cigarettes and paint and food. And they could relax, because the rent was always the most difficult sum to come up with." But there were many months when de Kooning sold nothing, and then he was forced to make the rounds of his friends, borrowing the rent money. "They were in dire straits during that whole period," said Joop Sanders. "Bill was one of the poorest," said the artist-scientist Alfred L. Copley—known downtown as "Al," short for his painting name, Alcopley—who became a downtown regular in the mid-forties. Once, Alcopley noticed that de Kooning did not even have a decent pair of shoes. "His shoes were falling apart. I had just bought new shoes the day before. I said, 'Put these on,' because it was dangerous for his health. So he put them on and said, 'Oh, they fit marvelously.' I said, 'You keep them.' Bill had it very difficult until . . . I think his fortune changed about 1950 or 1951."

A great artist without decent shoes . . . It was the sort of image that could capture the existential fancy of the late forties, especially if van Gogh's celebrated painting of a pair of old shoes came to mind. (And it probably would, for that earlier Dutch painter was one of the deities of

existentialism.] Another de Kooning story with existential overtones concerned a crime, a policeman, and an overcoat—a piece of clothing that, since Gogol, had a philosophical aura. On a cold winter evening, de Kooning and Elaine came upon a woman being mugged. De Kooning stepped in to help, the woman fled, and the mugger—furious at the interruption—demanded de Kooning's new overcoat. De Kooning handed him the coat and then continued walking with Elaine down the street. The man followed, muttering. When a policeman walked toward them, de Kooning edged closer to the mugger, and just nodded at the passing symbol of authority.

With every picture, de Kooning, in the spirit of Sisyphus, seemed to start anew, despite the difficulty. He himself likened each new painting to a kind of gamble with fate. "Every time I paint a picture I'm throwing the dice," he said. "I can't 'save' anything. That would be like doctoring it. It's a new game. It's not like playing poker where you can trade a card for another one; it's playing dice." De Kooning always insisted to younger artists that they play "the game" for keeps. Art, he said, was the only thing about which he didn't have a sense of humor. In the fall of 1948, he told Passlof she must return to the beginning, drawing the sort of painstaking still lifes that he himself made at the academy. "He said, 'If you want to be serious, this is what I think you should do,' " said Passlof. He set her up with an extra-fine 6H pencil. "The thing is, when you're working like that it's hard to change," said Passlof. "It's practically like working with an etching needle. He wanted that control." Like many others, she was inspired by what de Kooning said about art, which seemed at once poetic and practical. In a memoir of de Kooning, she wrote:

> Speaking of Ingres or Cézanne, he initiated me into the world of artists' concerns: finding and consolidating the picture plane; the role of movement, speed, and stillness in creating space; what paint does. Bill preferred to leave a door, a place in the plane to let you in—akin perhaps to the American Indian taboo against closing circumferences, although one is three-dimensional, the other two—a sort of asymptotic space.

As she came to know de Kooning better, Passlof also became aware of the tensions that were part of his character. Anger would sometimes whip out from behind the usually sweet demeanor. Wary of the "dizzying swings between enormous generosity and warmth and real viciousness," she said, "I was a little frightened of him." Sanders "always thought there was something very Dostoevskian about him, in that it was incalculable what would set him off from being a real prince to being a very nasty guy."

For younger artists, the Dostoevskian shadow only deepened de Kooning's appeal. It was a form of authenticity. Weren't many of the greatest artists similarly tormented? Any glimmerings of success, far from easing de Kooning's mind, only increased the pressures on him. Although he had decided to forgo commercial success in order to commit himself to art, his desire to be important and "make it" naturally lingered on, as his poignantly ambivalent letter to his father made clear. He once said that when taking the subway he was torn between feeling happy to be with the proletariat and thinking that, somehow, the bell rang louder when he, de Kooning, went through the turnstile.

Throughout 1948 and 1949, de Kooning continued to live mostly apart from Elaine. He would spend many nights at the Fourth Avenue studio; visits to the apartment on Carmine Street became increasingly irregular. The two places, neither of which had a telephone, were just far enough apart to make casual communication difficult. Elaine frequently did not know de Kooning's plans for the evening. Broke and unwilling to cook, she might eat nothing more than a wedge of Velveeta cheese and sardines for dinner. Her friends, aware of her straitened circumstances, frequently invited her out. Among them were Charlie Egan and his wife, Betsy Egan Duhrssen. De Kooning's art dealer idolized Elaine. She embodied his dreams of the artistic life. She seemed to him a beautiful free spirit, young and vivacious, the muse of a great painter whom he revered. (Egan, a notorious romantic with more than a streak of black Irish in him, read and quoted incessantly from James Joyce's *Finnegans Wake*.) At the same time, Elaine had an enterprising know-how that Egan lacked. Egan was "gorgeous and charming," but, according to his wife, he was also a phlegmatic man and a drinker. Elaine provided the dealer with both ideas and encouragement.

During the summer of 1948, while Elaine and de Kooning were at Black Mountain, Egan had met Duhrssen at an isolated beach on Martha's Vineyard and begun a passionate affair. She was smitten by Egan's mischievous Irish charm and the frank sexual ways of the artists' milieu. On that isolated beach in Martha's Vineyard, she said, no one wore clothes. "Charlie was there," she said. "He really had a beautiful body." Not long after they met, Egan proposed to her, but confessed that he would always carry the torch for another woman whom he could never possess. "There's one person I adore," he told her. "But she's very virginal. Lily pure. I will always love her." That he was referring to Elaine became apparent during the couple's honeymoon that September, when, according to Duhrssen,

"Charlie's brother called me Elaine and Charlie called me Elaine. This," said Duhrssen wryly, "was a pretty serious thing in my life."

In the fall of 1948, after returning to the city from Black Mountain, Elaine was surprised to hear of Egan's marriage. All her life, she was accustomed to dominating certain men and women who lacked her force of personality, gathering around her an extended family of admirers who looked to her to provide a measure of guidance and shape to their lives. Egan was one such man. Elaine had known, of course, that he worshipped her, but could hardly begrudge him his marriage after a whirlwind romance. Still, she was somewhat startled, and perhaps jealous, especially since the passion was gone from her own marriage. De Kooning no longer felt much sexual interest in her, a fact he confided to friends. Alone in her grim apartment on Carmine Street, Elaine was delighted to accept invitations to dinner at Duhrssen's East Side apartment, where Charlie moved after his marriage.

Duhrssen was an excellent cook and did not mind laboring over a hot plate to prepare dinner; many people did not yet have regular stoves. "She and Charlie would sit and have martinis while I was cooking, and she would discuss what he should do," said Duhrssen. "She told him how to dress and who to see. She was a regular general." At first, the evenings of martinis and beef bourguignon—Duhrssen's specialty—ended with friendship all around. With time, however, Duhrssen began to wonder about the nature of Elaine's marriage to de Kooning. "Elaine and Bill were living separately, and at that time there were doubts about whether Elaine was still married to Bill," she said. After dinner, Egan usually escorted Elaine downtown to Carmine Street. It was the gentlemanly thing to do. But he would not return for hours. "He'd say, 'I'm going to take Elaine home now,' and that's all I'd see of him until the next day," said Duhrssen. She knew that he might be in a bar somewhere, as Egan was a drinker who loved carousing with artists. But she could not help wondering whether or not he spent the night with Elaine. In January 1949, Duhrssen went to the opening of the second big show of Jackson Pollock's art at Betty Parsons's gallery. "It was full of huge, beautiful Pollocks, very overwhelming," she said. "Elaine and I encountered each other there. Our voices both shook. She knew what was going on and then I knew."

The affair became increasingly obvious. Egan once came back with lipstick on his undershirt. Another time, Duhrssen found a pair of Elaine's shoes at the gallery and confronted Charlie with the evidence. "I told him, 'I saw Elaine's shoes in the gallery.' And he said, 'They're my shoes.' And I said, 'But you don't wear high heels.' " De Kooning soon learned of the affair, according to Duhrssen, but appeared strangely indifferent. He

remained friends with Egan and attended events with Elaine, as if there were no triangle. His friends regarded this as an example of Village ethics: de Kooning did not believe in monogamy, and he himself enjoyed occasional one-night stands. As an artist celebrated in the small downtown circle of artists, he was beginning to attract women who wanted to sleep with a famous artist. Not long after his return from Black Mountain, for example, a woman who had been at the college with her husband came by de Kooning's studio and, after a few preliminaries, simply dropped her dress. Startled, de Kooning said, "Geez, you know, I'm friends with your husband." "Oh, Bill, don't be silly," was her answer. "What the hell was I supposed to do?" de Kooning later said with a shrug.

But then came a night when de Kooning's composure cracked, under almost farcical circumstances. A woman giving a big party at her new loft on West Broadway invited both the Egans and the de Koonings. "You were supposed to wear a crazy hat to the party," said Duhrssen. "She wanted to strip her wallpaper off and we were all supposed to help. She had two big steaming machines that you held against the wall. After awhile it was a pretty wild-looking scene, with all of these drunken people in wild hats." At a certain point during this party, Duhrssen realized, Charlie was nowhere to be seen. And neither was Elaine. "I heard Bill yelling upstairs. Elaine and Charlie were locked in the bedroom and Bill was beating on the door." His anger was provoked less by the affair itself, Duhrssen speculated, than by being cuckolded in public. "This was in front of everybody, of his friends."

Not many marriages could survive this kind of door-pounding embarrassment, not even among Village artists. The endurance of Elaine and de Kooning's was usually explained, among their friends, in one of two different ways. There were those who regarded it as a Machiavellian marriage of convenience, in which each party found the relationship politically useful. Others considered it a bohemian union in which two people continued to love each other but found their sexual amusement elsewhere. Both contrasting perspectives had a touch of the truth, but neither could adequately explain why Elaine and de Kooning stayed together during this period. While de Kooning wanted to succeed as an artist, he certainly was not calculating enough in the late forties to stay married simply because Elaine might further his career. And Elaine was not yet the power in the art world that she would one day become. As for the higher interpretation of their marriage, de Kooning, while a romantic lover, was not a sentimentalist. The idea of some large-minded "understanding," "love," or "union of souls" was exactly the sort of high-flown conception that he would regard as fancy-pants bunk. In the late forties, moreover, de Koo-

ning harbored an explosive rage, the kind that originated in suffocating working-class rooms. He was not sometimes irked at Elaine; he was sometimes fist-poundingly furious at her. His rage may even have spilled over into violence, the legacy of his childhood of physical beatings. In the heavy-drinking 1950s, he openly hit Elaine at parties more than once. He may also have done so in private arguments. Just how deep his anger went was shown much later when a researcher went to East Hampton and asked to talk to him about Charlie Egan. He refused, saying that he felt nothing but contempt for Egan.

Now middle aged, de Kooning had already had several long-term relationships with women that ended once the romance began to fade. Why should his relationship with Elaine be any different? There were no children or financial reasons to hold him. For her part, Elaine well knew that de Kooning was almost impossible to live with. In fact, he did not live with her. And she was a pretty young woman who sought relationships with other men. Why stay with him? There is only one explanation for the survival of the marriage. Both Elaine and de Kooning found something rewarding, something true to their sense of the world, in exactly what was murky, difficult, and powerfully unresolved in their relationship. Both were themselves the children of difficult marriages. Elaine's mother, who felt smothered and dreamed of living artistically, raised her favorite daughter as a surrogate who would live in a way that she herself could only dream of. In particular, Elaine must aspire to importance "in the arts." For almost every woman of that era, that meant—at least in part—being attached to an important man. At the same time, Elaine's mother, trusting no man, constantly told her little Samson both directly and by her own example that she must never lose herself in a man or a marriage. Elaine's mother deeply resented her conventional husband and constantly asserted herself; in the end, she left him. In her own marriage, Elaine met her mother's implicit expectations. She created a powerful identity in the arts while retaining her independence.

De Kooning's childhood experience of marriage was, of course, even more difficult than Elaine's. At a very early age the emotional texture of his life was rent by furious arguments. The divorce of his parents literally tore apart his life, sending him back and forth between his father and mother. Once he himself married, he might naturally be reluctant to face a divorce. On a deeper level, however, de Kooning was powerfully drawn to the fraught and unresolved, which was the emotional environment in which he grew up. In life as in art, he would often place himself in situations that were ambiguous, unfinished, indirect. He was rarely willing to decisively end a relationship. (He would never close the window in a

painting, either.) He never officially broke with Nini or Juliet, or, indeed, with other important lovers later in his life. He was a man who backed away, but stayed connected.

It is doubtful that de Kooning and Elaine spent much time discussing or clarifying their marriage. Even if Elaine had wanted to do so, de Kooning, according to other women in his life, had no patience whatsoever for stewing over the psychological intricacies of "a relationship." He was much too indirect a man to confront emotional problems in a straightforward manner. De Kooning's marriage in the late forties and early fifties followed the pattern of his other long-term relationships, devolving into a state of lingering tension. As de Kooning once admitted to Alcopley, "We have no life together but I'm psychologically attached to her." In contrast to Juliet and Nini, however, Elaine could not be driven away and did not leave when de Kooning became angry or stopped giving her sustained attention. Owing to the circumstances of her own background, she could enjoy both his charm—there were many good days, too—and tolerate his ambiguity, distance, and hostility. Over time, a marriage that de Kooning and Elaine retained for shadowy private reasons began to develop a public face—their friends still often referred to "Bill and Elaine"—that suited them. While living mostly apart, they would attend public functions as a couple and spend the summer together out of town. This gave Elaine the identity she sought. She remained absolutely committed to him as a painter and proud of her connection to what she was not afraid to call "genius," a devotion that de Kooning could not help but find flattering and useful. According to Hedda Sterne, "Every third or fourth sentence, she was saying something intelligent about Bill. She had an absolutely passionate faith in his work." De Kooning also took comfort in the legal connection. For one thing, being married protected him from the hopes of other women. He would often talk of marriage to subsequent lovers; but somehow a new marriage never came to pass. For another, being married gave him roots in America. Even though he had lived in New York for more than two decades, he was still not a citizen. What would a divorce mean for him legally? How would a Dutchman get one? Would they then deport him? His fears were unfounded, of course, but genuine in the way of all childish fears.

As her private relationship with de Kooning deteriorated, Elaine was herself beginning to push outward and develop a strong public profile of her own. In the early spring of 1948, *ArtNews* let it be known that it needed another reviewer. At the time, Elaine was not an established art critic. She had begun writing criticism as a lark, doing the occasional dance piece under the tutelage of Edwin Denby, who encouraged her to

continue. When the position opened at *ArtNews*, however, Elaine applied for it, competing against several more experienced writers. Her impressive combination of charm, talent, and familiarity with the downtown art world won her the job. "She knew everybody and about everybody," said Duhrssen. The same month that de Kooning had his first show, Elaine wrote her first review for *ArtNews*, which she laboriously typed on a cheap secondhand typewriter acquired for her new career. She was not working for the money—at the time, four dollars was the rate for a two-hundred-word review. A perfectionist who drove herself and everyone else crazy with her worries, Elaine found writing both arduous and painful. On one occasion, when writing a review of Reuben Nakian's first show in years, she had a particularly hard time condensing her ideas into the small two-hundred-word space. As she told John Gruen, "I went up to the *Art-News* office at five one evening, and announced that I had a few minor changes to make in the Nakian piece [which at that point was vastly over space]. I sat at a typewriter as the office emptied out until finally I realized I was all alone in the building." She was still there the next morning. When Tom Hess, the managing editor, arrived at nine, "He asked suspiciously, 'You haven't been here all night, have you?' I laughed wanly at this preposterous suggestion and fled without an answer."

In the late forties, *ArtNews* was the most influential art magazine in the country. Anyone who worked there would get to know Alfred Frankfurter, the editor, and, more important for the future of the American art world, Tom Hess, who was a strong candidate to run the magazine when Frankfurter retired. Born in Rye, New York, an affluent suburb of Manhattan, Hess spent part of his high school years in Switzerland before going to Yale. There, he studied art, literature, and history. That credential helped him get his first job, working at the Museum of Modern Art for Alfred Barr and Dorothy Miller. Then, after serving in the air force during the war, he took a staff job at *ArtNews* in 1946 as an associate editor. Well-educated, well-spoken, and well-connected—his wife, Audrey Stern, came from the family that founded Sears, Roebuck, and her money underwrote the couple's art collection—Hess had established himself as a powerful figure at the magazine by 1948. As it happened, he was not immediately drawn to de Kooning's work. After Renee Arb's rapturous review of the Egan show, Hess took a look but came away only partly convinced. In December 1948, reviewing the Whitney annual that included an example of de Kooning's work, Hess did not even discuss *Mailbox*, de Kooning's entry, until the end of his piece, and repeated the conventional reservations about de Kooning's ambiguity, which he said left the painting too open-ended.

Shortly after writing the Whitney review, however, Hess met de Kooning himself, no doubt through Elaine. The friendship between the two men was immediate. According to Rudy Burckhardt, it "was an instant love affair." In 1949, Hess was promoted to managing editor of *ArtNews*. His new position strengthened his standing as a leading art critic of contemporary art; in the small art world of the time, he naturally heard again and again how much other artists and critics, notably Clement Greenberg, admired the 1948 show of de Kooning's work. Not surprisingly, Hess began to reconsider his earlier reservations. Together with Harold Rosenberg, he would soon become an indefatigable champion of the painter.

In February 1949, de Kooning made his first public statement about his art. The previous fall, a group of intellectually minded artists—Robert Motherwell, David Hare, Mark Rothko, and William Baziotes, all of whom had been connected with Art of This Century—had founded the Subjects of the Artist School at 35 East Eighth Street. The school was intended to be a teaching institution, but its underlying purpose was to clarify the principles of an American avant-garde. Its founders hoped to propagate a new style of art. On Friday evenings, a guest speaker was usually invited to address a public session of the school. Not only painters but also other figures in the arts, such as Harold Rosenberg and John Cage, gave talks to an audience that typically numbered about 150 people. De Kooning was a natural choice to be such a speaker, especially after the attention he received the previous fall. At the time, de Kooning took a great interest in existentialism, particularly in the melancholy ruminations of Kierkegaard. According to Pat Passlof, Elaine would read passages of Kierkegaard, the nineteenth-century philosopher and theologian who was an important precursor to twentieth-century existentialism, to de Kooning, and "the ordinariness of Kierkegaard's heroes, or anti-heroes, appealed to Bill." Louis Finkelstein, who was much drawn to philosophy and psychology, also remembered de Kooning talking about "vat those Freudians think." De Kooning himself said of the impact of existentialism: "It was in the air. Without knowing too much about it, we were in touch with the mood."

De Kooning loved the atmosphere of ideas, though he recoiled from intellectual snobbery. He could almost feel ideas in the tips of his fingers: they actually made him want to paint. The painter Mary Abbott, who became a good friend of de Kooning's in the late forties, recalled his telling

her, "An artist is like a homespun philosopher." Meaning, said Abbott, that he has ideas that are really about living. It has to do with thinking about living. It means wondering about life. In other words, a painting is an adventure. It's not an end. It's not finished. The intensity of de Kooning's passion for ideas astonished Finkelstein, who believed he "read more than people thought he did. He was conversant with a number of philosophical ideas. Certainly he knew Kierkegaard and Wittgenstein by quotation. People were puzzled at the time by Sartre's argumentative techniques. But Bill was already handling them—not at all in an academic or scholarly way, but putting together ideas. He had a great gift for grasping ideas." Finkelstein first met de Kooning by chance. After hearing Jack Tworkov give a talk at the Pyramid Gallery, Finkelstein accompanied Tworkov back to his studio. As usual, de Kooning had left the door open to the stairwell.

> Jack immediately introduced me. Before you knew it, we were talking. I came back any number of times. . . . Tworkov spoke English better and had a degree from Columbia. I thought at first I was speaking to the more scholarly of the two. I had been reading [Alfred North] Whitehead for several years. Jack read a little and said, "I don't understand what this has to do with painting." But every time I opened up an argument with Bill about Whitehead he flew around the room. In those days de Kooning would talk a mile a minute. The striking thing was that Bill wanted to participate in every idea, whether historical or an argument about process or the unconscious. Of all those people, he was the most authentically exploratory.

Finkelstein was struck by how de Kooning liked to anchor the speculative in the specific. "He spoke of abstract ideas and concepts, but he was distinctive in frequently referring to specific works of art." It was a trait that Joop Sanders had also noted years before: others might spout lofty-sounding and often loosely defined ideas, but de Kooning would remain almost doggedly grounded, plucking the ideas from the air and relating them to specific painters and works of art. At one conversation among artists about Courbet's subject matter, Finkelstein remembered the talk drifting toward a broader discussion of realism. "Realism meant various things to various people," said Finkelstein. "Even Greenberg used it to mean anything. But Bill got up and said, 'If you want to use the word "realism," you have to say what it means, where it came from and who used it.' Any number of times he expressed his interest in getting things exactly as they were."

However much de Kooning loved such discussions, the prospect of writing down and delivering a formal "statement" to an audience made him apprehensive. Unlike the give-and-take of conversation, a formal speech seemed to tie art down, imprisoning the brush in the armature of theory and abstract ideas. (Even as a young man he had found the modern theories of De Stijl, for example, tyrannical.) Nonetheless, Elaine urged de Kooning to frame a public talk, to step onto the soapbox, and declare his principles. Hess and Rosenberg probably did the same. Always on the lookout for ways to advance de Kooning's reputation, Elaine did not want to leave the field of theory to Motherwell and the others: de Kooning must assert himself and participate in defining the new American art. Because de Kooning's English was imperfect, Elaine worked with him for several days, copying down his spoken observations. Then, much as he might put together the forms of a painting, de Kooning began to arrange the pieces of his thought.

"A Desperate View," a brief talk of five hundred words that de Kooning delivered at Subjects of the Artist, had an informal air. De Kooning began in a personal, almost backhanded way, as if he didn't want to appear grandly philosophical when using the word "desperate": "My interest in desperation lies only in that sometimes I find myself having become desperate." The talk itself was an aphoristic collage constructed of paradoxes. "An artist," de Kooning said, "is forced by others to paint out of his own free will. If you take the attitude that it is not possible to do something, you have to prove it by doing it." De Kooning used the Kierkegaardian notion of "trembling" to subvert the view that any one "idea" could ever claim art. For a moment, that trembling, which was itself only one idea, could paradoxically unite contrasting styles of art: "In art, one idea is as good as another. If one takes the idea of trembling, for instance, all of a sudden most of art starts to tremble. Michelangelo starts to tremble. El Greco starts to tremble. All the impressionists start to tremble. The Egyptians are trembling invisibly and so do Vermeer and Giacometti and all of a sudden, for the time being, Raphael is languid and nasty; Cézanne was always trembling but very precisely."

The talk did not proceed in a straight line, with a formal beginning or end, and its air of paradox and existential freedom assured that this manifesto, at least, would never presume to tell artists how they must paint in the present. Already in 1949, de Kooning was seeing attitudes develop among critics and artists that worried him. In "A Desperate View," he attacked the dictatorial spirit that often underlay the desire for a group "style" and denounced the Hegelian notion that art, for historical reasons, must "progress" in a certain direction: "Art should *not* have to be a cer-

tain way. . . . Style is a fraud. . . . It was a horrible idea of van Doesburg and Mondrian to try to force a style. The reactionary strength of power is that it keeps style and things going. . . . I think it is the most bourgeois idea to think one can make a style beforehand. To desire to make a style is an apology for one's anxiety."

De Kooning recognized the individual timidity that lay concealed in group declarations and uncritical celebrations of the new. He preferred lonely restlessness and anxiety to the comforts of the crowd. His sense of belonging came from identifying with the greater historical community of artists, past as well as present. He defended the messy impurity of history against the American predisposition to think that art, or life, could be made wholly new. "I think innovators come at the end of a period," he said in the talk. "Cézanne gave the finishing touches to Impressionism before he came face to face with his 'little sensation'."

> Whatever an artist's personal feelings are, as soon as an artist fills a certain area on the canvas or circumscribes it, he becomes historical. He acts from or upon other artists. . . . An artist is someone who makes art too. He did not invent it. How it started—"to hell with it." It is obvious that it has no progress. The idea of space is given him to change if he can. The subject matter in the abstract is *space*. He fills it with an attitude. The attitude never comes from himself alone. . . . You are with a group or movement because you cannot help it.

Although de Kooning wrote "A Desperate View" for an audience, he was also manifestly speaking to himself, and justifying the private choices he was then making in his art. The success he enjoyed with his black-and-white series, for example, would have led most painters to repeat and expand upon their success. However, de Kooning, while confident he would make more abstract pictures, refused to be certain about it. He would not sign on the dotted line, not proclaim, "I am now an abstract painter." Art, he wrote, did not "progress"—at least for him. In particular, he could not abandon his own past, notably his passion for representing the female figure. "She" receded from, but never left, his art of the late forties. Throughout this period, de Kooning, rather than work in an exclusively abstract idiom, occasionally struggled with more representational images of women or pairs of women. His abstractions, in turn, were filled with glimpses of the figure. He destroyed most of the more literal images. In 1948, however, he painted one sizable and astonishing picture of a woman. (The verso, also signed, was an abstract picture.) Despite some expressionist distortions, the face of *Woman* bore some resemblance to Elaine's. The

body, more undressed than most of his earlier images of women, protruded suggestively toward the viewer. The breasts had a voluptuous visual pop. Bold, black lines defined and forcefully caressed the body, cupping around one breast. A swath of bright pink, evoking a low-cut dress, was all the woman wears. She had a fierce, gleeful, come-hither grin. She was also literally starstruck, staring rapturously into a jagged star bursting with light in the upper left-hand corner of the canvas. (In the upper right-hand corner, the only calm part of the turbulent canvas, de Kooning sketched in the blank outlines of a house. It was a hint, perhaps, of domesticity

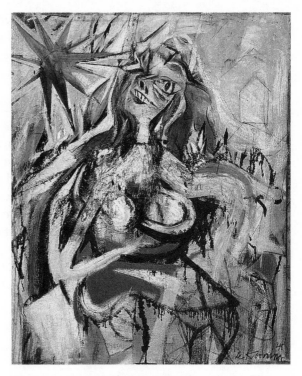

Woman, 1948, oil on enamel on fiberboard, 53 $\frac{5}{8}$" × 44 $\frac{5}{8}$".

lost in the city lights.) *Woman* possessed the sharp teeth, flaring nostrils, and prominent eyes that would characterize de Kooning's famous women of a few years later. In this painting, an American star—part camp, part vamp—made her entrance into de Kooning's art.

If de Kooning refused to give up the figure in the late forties, he also retained certain traditional artistic practices that those around him were rapidly abandoning. In particular, he continued to draw constantly. This, too, seemed old-fashioned, and a rebellion against the "progress" of the time. Few artists during the next decade would spend much time drawing, which seemed small and overly precious to a generation moving toward a rough-hewn American approach to art and toward images of vast scale. For de Kooning, however, drawing remained essential. It was his daily bread. De Kooning almost never made drawings merely as preparatory studies for paintings. They were always ends in themselves. In certain respects, even the black-and-white paintings could be seen as drawings in paint. In the late forties, as if to underscore the point, de Kooning created a series of very free drawings that both complemented and were indepen-

dent of the paintings of the period. Some were pen and ink; others used the same black enamel as the paintings. Most were done with a palette knife. In a few cases, de Kooning probably used an extremely flexible brush which he returned to again and again whenever he wanted to "throw" a whiplash line.

Of course, he also continued to paint ambitious abstract paintings. After delivering "A Desperate View," de Kooning, part of an increasingly confident downtown community, began moving toward the summary works of his black-and-white period. The titles of the last works in the series reflected the concerns he expressed in "A Desperate View." But he turned away from darkly romantic names, tinged with the grandeur of myth, such as *Light in August* or *Orestes*. Perhaps he thought art was becoming too high-flown, for he would shortly give very different titles, *Attic* and *Excavation*, to two of the greatest paintings in his oeuvre. He had no intention of slighting the essential clutter of existence. He had too much respect for what lay just out of sight, whether buried in the past or stored upstairs.

21. The Club

The Club was always misunderstood. We didn't want to have anything
to do with art. We just wanted to get a loft, instead of sitting
in those goddamned cafeterias.

In early August 1949, *Life* magazine published an article that would
reverberate through the American art world for the rest of the century.
Its dramatic headline was, "Jackson Pollock: Is He the Greatest Living
Painter in the United States?" The article, which referred to Pollock as
the "shining new phenomenon of American art," was accompanied by an
extraordinary photograph of the artist wearing paint-spattered overalls.
His arms were crossed defiantly. A cigarette hung from his lip. Posed in
front of a long horizontal work called *Summertime,* Pollock looked like
the dark, brooding angel of art: the painting flared out from him like
wings.

In the Springs, the workingman's part of East Hampton where Pollock
had moved four years before, people brought copies of the magazine to the
house where he and his wife, Lee Krasner, lived to congratulate them.
Copies circulated rapidly through the art world. The article itself was
actually fairly condescending. ("Finally, after days of brooding and doo-
dling, Pollock decides the painting is finished," *Life* reported, "a deduc-
tion few others are equipped to make." Elsewhere, Pollock was described
as "drooling" paint.) But the words hardly mattered. Something funda-
mental had changed in American culture when its largest mass magazine
presented an American artist in this romantic, tough-guy light. Existen-
tial ideas were being transformed into a popular romance. In the photo-
graph, Pollock could almost have been the French writer Albert Camus, a
Gauloise dangling from his lip; or, equally, the actor Marlon Brando play-
ing a working-class hero. Suddenly, a tongue-tied and difficult artist was
an American star. In the next decade, countless young artists would
dream of this defiant, cocky pose.

De Kooning probably saw the article after returning to New York,
with Elaine, from a month-long vacation in Provincetown, Massachu-
setts. A summer haven for artists since the turn of the century, Province-
town, on the northern tip of Cape Cod, was a place of handsome beaches,
low-ceilinged Cape Cod cottages, a quaint harbor road named Commer-

cial Street, and miles of isolated sand dunes. (In the late forties, artists were less likely than before to rent houses in Woodstock, which was hot and buggy, and East Hampton was not yet a magnet.) Hans Hofmann had founded his celebrated summer school in Provincetown in 1935; he and "Miz" Hofmann, his wife, were the unofficial heads of the artists' community. The town contained a number of small art galleries and several artists' bars, notably the Old Colony, where people would meet at sundown. Along the bay, artists could rent tiny studios, and inexpensive lodging was available throughout the town. De Kooning and Elaine rented part of the ground floor of a small cottage for July. Also on the ground floor was the painter Sue Mitchell, whose boyfriend at that time was Clement Greenberg. On the second floor was the son of the man who owned the Maeght Gallery.

It was in Provincetown, said Joop Sanders, that he first saw de Kooning drink heavily, and he sensed a new intensity in the partying spirit of the art world. De Kooning and Elaine had invited him up for a visit, which was dominated by one drunken and embarrassing escapade. Coming back to the house one day, Sanders found an exceedingly agitated Elaine at the door. Another artist had taken Bill to the beach after both became drunk drinking sherry. A big storm was forecast and she was worried that they might drown. She asked Sanders to find them.

> I caught up with them and they were unbelievably drunk and were still drinking. Bill's companion actually fell down and passed out. I said to Bill, "He's so big that we have to get him into the ocean to sober him up." The water was practically at the dunes because it was the hurricane. There was nobody to be seen, and we didn't have bathing suits with us, so Bill and I took our clothes off. We dragged him into the water and he started to sober up and said, "I'm going to kill myself"— and walks right into the waves. I got a stranglehold on him by the neck and Bill [who could not swim] was kind of prancing around in the water. I'm dragging him back to the beach and he flops down and we start to laugh. I'm looking down at him and then I look sideways and see these boots. There was this state trooper. He said, "You're under arrest for exposing yourselves where women and children could see you." The guy with us started to shadowbox with him. So there we were, resisting arrest and indecent exposure.

After the trooper took them back to Provincetown, they were thrown into separate cells to sober up. De Kooning—made nervous as always by

officialdom and conscious of his status as an immigrant—anticipated the worst. "Bill starts waking up from his drunk state," said Sanders, "and is saying, 'I always knew it. These bastards. I'm going back to Rotterdam. You're losing a good artist, etc. etc.' He was holding forth." Fortunately for both Sanders and de Kooning, the judge fined them only five dollars for indecent exposure and then let them go; nobody, of course, had seen them. But their friend was charged with the more serious crime of resisting arrest and his bail was set at forty dollars, which Hofmann lent him. By the next day, of course, the story of their arrest was all over Provincetown.

The Provincetown visit had one important impact upon de Kooning. The powerful sensations aroused in him by the sea—vital to him in Rotterdam, but rarely experienced on the streets of New York—entered his work that summer as a kind of brief counterpoint to the dark, existential brooding of his gritty urban paintings. One painting that resulted, *Sailcloth,* was a loosely knit and inviting color abstraction full of earthy flesh tones and windy, snapping sensations of line; it seemed serene when compared to his other work of the period. *Two Women on a Wharf,* in turn, was a strong, almost caricatural rendering of tourists in Provincetown; the blues, yellows, and pink-purples shimmered as if reflected off the water in a noonday sun. Both works anticipated de Kooning's emigration from city to country in the early sixties, when he settled in the Springs. There, he would often parody the prancing women of the Hamptons and celebrate the ebb and flow of the sea.

Once back in New York, de Kooning, of course, was thrust into the middle of the discussion of the *Life* article. He disliked the proletarian affectation of the famous photograph, sensing that something untrue was being sold to the public. "Look at him standing there," he told Milton Resnick. "He looks like some guy who works at a service station pumping gas." Nonetheless, the *Life* article marked the beginning of a growing excitement that would culminate in the next Pollock show in November. The artists downtown were starting to feel, not surprisingly, that the world was shifting under them. Not only was the mainstream taking an interest in the margins, but their traditional social life was changing. The old ways of meeting together at the Waldorf Cafeteria no longer seemed to work as well. First, the management began to give the artists a hard time. "They used to hound us," said Ludwig Sander, who had gone there almost every night since being discharged from the army in 1946. "You had to buy a second cup of coffee, you know, you had to have two nickels. And then they closed up the toilets. And you couldn't have more than four chairs at a table or something like that." The manager would complain if someone

moved over a chair from a neighboring table. Then some tough teamsters and a variety of petty criminals started to drift into the cafeteria. "The place was filled with pickpockets," said Sander. "It was much more of a reunion for the boys from Sing Sing." There were fights all the time: "These gorillas started making trouble," said de Kooning. "It wasn't good any more, hanging around the Waldorf." A bitter feud also erupted between Aristodimos Kaldis and Landes Lewitin, still the unofficial café kings. Previously, the two would preside together over the debate, but after their falling-out each tried to act as the head of the informal artists' group, refusing even to acknowledge the existence of the other.

As a result, a number of downtown artists began to look for an alternative, one modeled on the many Italian and Greek clubs that then dotted the Village. "We began to talk of our own place, our own club," said de Kooning. "We talked and we talked of it." Such talk derived, in part, from a nostalgia for the days when the larger world did not intrude upon the downtown artists. Belonging to a club was a way to withdraw for a moment from the "uptown" of *Life* and, more generally, from the public life of art; at the same time, it paradoxically reflected the downtown group's growing self-consciousness and ambition with regard to their formal position in the world. The same month that the article on Pollock appeared in *Life*, Franz Kline set in motion the creation of this new meeting place that would be called, laconically, "The Club," and would become a mirror for the promise and predicaments of American art.

With barfly affability, Kline struck up a conversation with a commercial artist from New Zealand at the Cedar Tavern, a blue-collar bar on University Place off Eighth Street that was just beginning to become popular with neighborhood artists. He learned that the New Zealander had a loft on Eighth Street that he would be giving up when he returned home. For $250 in "key money," Kline could have it. A handful of Waldorf regulars, including Kline and de Kooning, went to see the loft. Unfortunately, most of them had trouble paying their own thirty dollars or so a month in rent. Where would they find a fortune like $250? ("Bill," Ibram Lassaw told de Kooning at one of the planning meetings, "that jacket doesn't fit so good." "Vell, yours doesn't fit so good either," de Kooning answered. Both were wearing secondhand clothes.) "Some thought we might find another place for much less money, although none of us knew of one," recalled Alcopley. Besides, this particular loft had much in its favor. Located at 39 East Eighth Street, it was only two doors away from Studio 35, the successor to the Subject of the Artists School that Motherwell, Hare, and the others had founded the year before. It was also "close to the Cedar Bar, to which many of us went when we had the money," Alcopley said, "and

near a hamburger joint [Riker's] that was the least expensive eating place in this part of town." Shabby but usable, the space itself was the third floor of a small factory building with creaking wooden stairways. The loft had a fireplace, three windows facing Eighth Street, and one window at the back. A ticking factory occupied the same building, and the stairway was often snowy with feathers.

An urgent meeting was called after a second, larger group of artists went to inspect the space. Most of the core Village artists attended, including de Kooning and his close friends Kline, Joop Sanders, Milton Resnick, Alcopley, and Conrad Marca-Relli. The debate went back and forth. Should they take the space? Finally, after Philip Pavia, one of the few artists with some money, agreed to advance most of the $250 key money, they decided to rent it, and each contributed ten dollars. "We all were overjoyed," said Alcopley. Throughout September, the artists worked as a group to transform the space into a suitable gathering spot. They took down the partitions that the New Zealander had erected, leaving only two small walled-off areas in the back, one for the existing kitchen and the other as storage space for a few folding chairs and tables. They painted the walls and ceiling white, and they scrubbed and scoured. "There was a kitchen that we cleaned up like mad," said Ludwig Sander, the cook of the group. "In fact, there was a real professional restaurant stove in there. Bill de Kooning and myself boiled every part of it and put it back together." They bought wood for the fireplace, and Giorgio Cavallon, the most technically proficient of the group, installed a record player and speakers, all weighted with sand so that the old, creaking floor would not continually vibrate and affect the sound. In addition to the folding chairs, there was an assortment of secondhand furniture, including a couch, coffee tables, and lamps with amber-colored shades. "We had sort of comfortable furniture for awhile," said Sander, until Milton Resnick threw it all out: "He thought it was too bourgeois."

By the time the Club officially opened in October, the list of "charter members" had grown from the original ten or so to nineteen. But the atmosphere, at least initially, remained the same. Everything was low-key and informal. "None of us was for written rules," said Alcopley. There were, in fact, only two "rules." First, it was decreed that no women, communists, or homosexuals could be members of the Club; those three groups were deemed to be already too clubby, in an undesirable sense. (This rule was contested from the beginning, and later collapsed.) Secondly, any two charter members could blackball any future applicant for membership. In practice, that meant that it took only one charter member to blackball a newcomer, since Landes Lewitin, who

wanted the group to remain its original size, blackballed all prospective members on principle.

During the fall of 1949, the Club functioned as the artists originally intended, as a coffeehouse or café, with little purpose other than that of providing a friendly place to meet and chat. "The Club started out with the definite mission of being just a social club," said Conrad Marca-Relli. "We did not want any art, any culture. It's odd that it turned the other way. We were just looking for a place where we could have a cup of coffee and talk among ourselves as we did in the cafeteria about painting, about art." Wednesday nights were reserved for "board meetings," when the members attended to the mundane business of running the Club. Rosenberg, one of the earliest members who was not an artist, later told John Gruen how "hilarious" he found these meetings. "I mean, they used to just kill me because the main issue seemed always to be 'Who's going to sweep the floor,' 'Who's going to take care of making the coffee.' " Soon, however, these Wednesday nights evolved into periods of informal discussion. De Kooning would say, "Let's have discussions among the old-timers." Ludwig Sander might cook up a huge bowl of spaghetti or beef goulash or someone would bring sandwiches, and the twenty or twenty-five members would sit around and talk informally until the wee hours. "We'd drink coffee, hardly any hard liquor," said Pavia. Around three a.m. or so— the curfew was later set at three-fifteen—many of the group would go to Riker's, for food and more discussion. "The Club had a real pragmatic spirit about it," said Pavia. "We had an idea about getting somewhere."

Originally, the members of the Club came primarily from two different but compatible groups. One was made up of Mondrian-inspired artists, among them Ibram Lassaw and Harry Holtzman, who in the thirties had belonged to the American Abstract Artists. The second was the "Picasso men," as Pavia described the loosely knit group of painters that included de Kooning, Marca-Relli, Resnick, and Pavia himself. In essence, the two groups made up the old Waldorf crowd. What they had in common was less an ideology than a shared preference for cubism over surrealism; many artists still recoiled from the swanky surrealists who had dominated New York during the war years. The group was partly defined by what it was not: not uptown, not rich, and not closely connected to fashionable tastemakers. "The uptown group meant people who were showing already, who during the war years had got a gallery and were beginning to show, like Motherwell, Rothko, you know, people who were already uptown—Gottlieb," said Marca-Relli. "And we were downtown instead. Bill was with us and Franz and the others who were still the downtrod-

den." As Pavia said, "This Club was a real Eighth Street hard core, and the two artists who were the leaders, the two artists who came out of this who were absolutely Club-raised, were Bill de Kooning and Franz Kline."

De Kooning and Kline soon became the heart of the Club. All his life, de Kooning, who never forgot his working-class roots, felt a profound solidarity with artists who looked in from the outside. They were his adopted family. Given his wry humor and love of paradox, he enjoyed turning the tables on the snobs, creating a club of the outcast. Kline, in turn, was a natural clubman, an artist who loved to talk with friends and even appeared rather English and natty. As Marca-Relli put it, "He had a very beautiful personality. He always felt that he looked a little like Ronald Coleman [the dapper British actor]. In a sense he wanted to be that." By 1949, Kline and de Kooning had become even closer. If Gorky had been the admired older brother and Pollock was the family rival, Kline was the beloved brother about whom de Kooning felt no qualms. Inspired in part by de Kooning's black-and-white abstractions, Kline had recently abandoned his conventional figurative style and joined the avant-garde painters. It was de Kooning who originally helped Kline see the possibility of making large gestural abstractions from small, black-and-white drawings. Around 1948 or '49, de Kooning borrowed a Bell-Opticon projector to enlarge some sketches and lent it in turn to Kline. "Franz had noticed small areas of a painting as being especially interesting, and he wanted to enlarge them to be striking," recalled Conrad Fried.

In the fall of 1949, word quickly spread about this new meeting place where Kline and de Kooning and their circle gathered to talk away the night. A younger generation of artists, including Mike Goldberg, Louis Finkelstein, and a group that was studying with Hofmann, were living in the Village and were keen to interact with the "older" generation. Their interest suited the Club's founders, who were hard pressed financially. "There was a need to increase the membership, since we had to pay back the money Philip had advanced, as well as pay for the monthly rent and other expenses," said Alcopley. Soon, people were clamoring to join the Club. A second tier of "voting members" was added to the original charter members. And then there was a third tier, simply called "members." On membership questions, de Kooning was not an excluder. He saw to it that a number of his friends from the old days joined, including Alain Brustlein (Janice Biala's husband), Mike Loew, Misha Reznikoff, and later Elaine, who became one of the first female members.

Much to the dismay of many original members, the Club soon began to change. One night, William Barrett, who, besides being part of the *Par-*

tisan Review group, was a philosophy professor at New York University, had given an informal talk. The members invited him back and, although many were against having a formal "lecture" format, rows of chairs were set up to face the table at which he spoke. The era of formal Friday-night talks, interspersed with prearranged panels of five or six artists, had begun. Speakers during the next couple of years ranged from Father Lynch, a Jesuit priest, to Tom Hess, to the composer Edgard Varèse, to the philosopher Heinrich Blüecher. Joseph Campbell talked on "Myth and Creative Art," Kurt Seligmann on "Black Magic," and the Juilliard Quartet came and played experimental music by David Tudor.

Despite the divisions between uptown and downtown, the more established artists who lived uptown quickly realized that something vital was happening on Eighth Street, for the Club almost immediately became the intellectual center of the new painting, assuming the role that the more official Subjects of the Artist School had been designed to play. The uptowners, too, began to attend the Club. Barnett Newman became a member. Other new members included the critics Rosenberg, Hess, and Greenberg. "Soon museum directors, such as Alfred H. Barr Jr. of the Museum of Modern Art, came to several of our Friday evenings, as well as important collectors," wrote Alcopley in a memoir. "None of them was given any special treatment and they were eager to be guests of the artists of The Club." While the Club remained resolutely downtown in feeling, its ideology began to broaden as its membership grew. Downtown and uptown discovered that they had more in common than they had thought. "When we got the Club together we seemed to merge and we got to know each other more, and we met for the first time some of the painters we had heard about or had seen their shows but had never gotten to know," said Marca-Relli. "There began to be a real feeling of fraternity. It was like the project, only even more vitally so."

The Club helped concentrate the mind of American art and focus its aspirations. The visitors from uptown, especially intellectuals, musicians, and scholars, bolstered the confidence of the artists and helped spread the word in New York that American art was a valued part of the larger enterprise of serious culture. If *they* were interested in coming to a grubby downtown loft, well, then, maybe the poor guys in the dirty studios were doing something significant. On many Fridays, the topics discussed by the panels were nothing less than an attempt to define contemporary American art. Philip Pavia, who scheduled the panels, later pointed to two early ones that he considered seminal: one on German expressionism and another on abstract expressionism. For three or four critical years, at a time when many of the artists were developing their mature styles, the

Club created a stimulating public backdrop for private dreams. "The Club came along just at the right time," de Kooning said. "It was so important, getting together, arguing, thinking. I believe it helped take away our provincialism. And you just couldn't get rid of it until its time was past." The downtown artists were becoming confident that they represented the high Western tradition—that they were heirs of the great Europeans. William Barrett described an evening this way:

> A friend of a friend knew somebody at Juilliard, and shortly the Juilliard String Quartet were down to play at the Club. Nor was their playing perfunctory; in that informal atmosphere, they flung themselves at the music with extraordinary energy, and the meaning of "chamber" music seemed to take on some of its old dimension in that loft. There was a thunder of applause at the end, and Willem de Kooning leaped to his feet and presented the musicians with his latest opus, a lovely black-and-white wash drawing, amid a burst of more applause—this time for the picture itself.

Throughout the fall of 1949, as excitement began to gather around the Club, Jackson Pollock—who, by virtue of the *Life* article, was by far the most famous painter of them all—was conspicuously absent. Pollock, a shy man when he was not drinking, was uncomfortable with discussion and debate. Even so, everyone at the Club looked forward to his November show, and his drip paintings were much discussed. "I want you to know the Club didn't respect many artists," said Pavia, "especially the uptown club, but they did respect Jackson." Many artists felt that it was Pollock, more than de Kooning, who opened a new territory for art. "I think [Pollock's influence] was just phenomenal," said George McNeil, another early member of the Club. "I think it's almost a kind of mystical thing the way this guy opened up everything." As Marca-Relli saw it, Pollock had created a whole new way of painting abstractly: "In a sense, most of the painters came out of a conservative mold. To go abstract meant giving up a lot of things. The big dramatic push was from Jackson. Because Jackson, by pouring paint and making all-over canvas, reduced the possibility of anything figurative. It was dispersed."

Not surprisingly, when Pollock's show opened at Betty Parsons's gallery on Fifty-seventh Street on November 21, 1949, it was filled with artists who had come to see his latest work. The twenty-seven paintings on display, all "overlapping swirls and skeins of brilliant color," as Robert Coates described them in *The New Yorker*, ranged from a group of less expensive, small works that Pollock had created with an eye to

attracting new buyers, to several huge works of mural size. Apart from the paintings, what caught the attention of the artists was the character of the crowd. On one side were the artists themselves; on the other, well-dressed strangers. The two groups did not mingle. "Suddenly, there were people there we didn't know," said Pat Passlof, who was at the opening along with Milton Resnick and de Kooning and a crowd of other artists. "And they were wearing suits, and there were ladies with jewelry. These were people from somewhere else. And they were going around shaking hands; and none of us did this." At one point, Resnick turned to de Kooning and said, "What's going on here?" According to Passlof, "That's when Bill said, 'Look around. These are the big shots. Jackson has broken the ice.' " By the end of the show, eighteen of the twenty-seven paintings had been sold, and the critical reception was almost uniformly adulatory. The *Life* article had done the job of interesting American collectors in art—or at least in Pollock's art—as perhaps no other publication could have done.

As 1950 approached, a feeling akin to manifest destiny began to course through the art world. This was "the American century," the Luce magazines constantly trumpeted, and Americans had a heroic role to play in resisting totalitarianism and celebrating Western values. Buoyed by the new optimism, the downtown artists decided to stage a Christmas party for their children and friends at the Club. Most of the charter members spent several evenings creating one or two huge collages apiece. In the end, the collages—"daring and dazzling" to look at, according to Alcopley—covered almost every inch of the Club's walls and ceilings. The partying mood did not end after Christmas. The biggest day of all, New Year's 1950, was approaching. Bridge tables were covered with paper tablecloths and lined up in a long row for a communal dinner. The New Year's celebration began sedately. "It was well behaved," said Lutz Sander, one of the members in charge of the event. "Everybody was a little high but quiet, sort of glowing. It was a glowing more than anything else." After dinner, the dancing began.

And then it was midnight and 1950. And then it was morning, and still no one went home. Many artists simply broke for breakfast and a new bottle. The partying lasted for three days. Sometime during the marathon, Philip Pavia stood up and delivered a ringing proclamation. "This is the beginning of the next half century," he announced. "The first half of the century belonged to Paris. The next half century will be ours." De Kooning echoed the thought. "This is 1950," he said. "This is when it's going to happen."

Excavation

In the early spring of 1950, de Kooning began *Excavation,* one of the greatest paintings of the twentieth century and a work that even his harshest critics usually call a masterpiece. The euphoric confidence of the downtown artists probably played a part in its creation, for de Kooning was not a painter who ordinarily set out to create "a masterpiece" in a premeditated fashion. But with the charged talk of "an American century" filling the air—and with Pollock proposing a vast new space and the example of *Guernica* always present—how could an ambitious painter not seize the day?

Excavation was a brilliant act of summation at midcentury: the culminating work of the black-and-white series and a synthesis of the contrary passions animating painting during the first half of the twentieth century. De Kooning simultaneously seemed to be "excavating" modern art, Willem de Kooning, and New York City in 1950, and putting the scrambled pieces together convincingly. Joycean in its density and shifting inflections of meaning, *Excavation* seemed to draw from both high and low culture, past and present. It was one of the last examples of a voracious and all-encompassing modernism, a glancing portrait of the artist in which nothing was left out.

De Kooning completed little in the months leading up to *Excavation.* Its main antecedents—*ZOT* and *Attic*—were created in the spring of 1949, almost a full year before he began work on the picture. In *ZOT,* he reversed his palette, painting in black against a largely white background, which would also be the general scheme of *Excavation.* A luminous picture in which lines seemed to move through a foggy shimmer, *ZOT,* despite its wildly inventive calligraphy, was gentle and atmospheric. In *Attic,* however, de Kooning summoned the furies once again. It was his largest easel painting to date, at five foot one inch by six foot nine inches. Its size could hardly contain its explosive forms. The shapes, which often evoked sexual body parts, were flung and crushed together in what Tom Hess called a "savage rending." Indistinct images layered upon one another swirled up and around to the very edge of the canvas. In the middle left, one shape suggested a screaming mouth, possibly an echo of the screaming woman in *Guernica.* Touches of red amid the roiling chiaroscuro resembled smears of blood. And yet, the picture was exquisitely composed. According to Gus Falk, who sometimes dropped by his

former teacher's studio, *Attic* was the result of careful deliberation. "He made a drawing of it, to work on the parts where he felt there was a problem. He worked on that picture carefully. 'Maybe I could throw a line here,' he would say. He would erase parts, redraw it. In other words, he *did* it like Ingres. It was not throwing his guts on the wall."

During the long fallow period before *Excavation*, de Kooning, in keeping with his long-standing habit, would restlessly walk the streets at night trying to calm himself, looking particularly at the pavement when it was glistening wet. He was also attracted during this period to the "excavating" going on around him at building sites. In the economic boom of the postwar years, construction workers were repairing and extending subways and digging foundations for new buildings. De Kooning, like many other pedestrians at loose ends, enjoyed looking through the holes cut in the boards surrounding construction sites in order to get a glimpse of the excavation and the rising building. However, the first inkling for *Excavation* came from a movie, *Bitter Rice*, a work of Italian neorealism that was an art-house hit in 1950. De Kooning saw the movie in one of several theaters in Greenwich Village that regularly showed the foreign films then popular with the artists and intellectuals in New York. Produced by Dino de Laurentiis and directed by Giuseppe de Santis, *Bitter Rice* was a bleak story about women who worked in the rice fields of the Po Valley. Its star was Sylvana Mangano, a nineteen-year-old actress who helped establish the earthy Italian ideal later made famous by Sophia Loren and Gina Lollobrigida. Wearing a flimsy dress that hugged her curves, Mangano spent much of the movie in water-soaked rice paddies stooping over and working the wet ground. She would look up from her labor with a yearning at once existential and erotic.

De Kooning recalled being struck by the image of peasants using spades to turn over the rich wet earth of a rice field, which he saw as a kind of "excavation." His own hooking brushstroke did something similar, often turning up glinting forms in the loamy paint. And he was always attracted to the places where land and water meet, to powerful and earthy images of femininity, and to the muddy, physical sensuality of oil paint. The image of a beautiful woman knee-deep in earth and water would obviously excite his deepest sympathies. (Much of his drawing, painting, and sculpture after he moved to the Springs in 1963 would address similar subjects.) The images from *Bitter Rice* may also have aroused in de Kooning memories of the damp lowlands of Holland, where a spade would quickly turn up water and the problem of digging anything—from a grave to a foundation—fascinated the Dutch. He may even have recalled the

tender Rembrandt painting *Hendrickje Bathing* (1655), in which a woman standing in water shyly lifts her dress.

On the painting wall of his Fourth Avenue studio, de Kooning tacked a swath of unstretched canvas that was roughly eighty by one hundred inches, substantially larger than *Attic*. The cramped space made the scale of *Excavation* appear even larger than it was. The evolving painting actually appeared enormous, said Sanders, and de Kooning himself worried that it was too big, exceeding the human scale that felt instinctively right to him. He mostly used his customary black and white enamel housepaint, but also added the last of his small remaining supply of color paints; the palette knife unearthed glinting passages of color in the rich fields of white and black. As it developed, *Excavation* appeared palpably alive, its surface a kind of "skin" beneath which beat a pulse, the paint yielding to the brush as flesh does to the touch.

Excavation was first and foremost an excavation of desire. The body was always turning up in the paint, evocatively, but could never be held for long in the eye; the flesh could never be entirely possessed. Any more settled description of the body would have diminished the sensation of physical movement, such as the caress of the hand or a leap of the heart, that was also a vital part of desire. It would create an outsider's perspective on the body, which, after all, is not just a form locked in space but a flux of sensations. The brushstroke seemed to veer between love and hatred, suggesting how close those emotions could be; a "reaching toward" could become, with a flick of the wrist, a "recoiling from." The desires of the past could suddenly erupt into the present. There was nothing dead in de Kooning's archaeology. You could never entirely bury a lover or a mother.

Many other desires surfaced in *Excavation*. If the lover could never entirely possess the beloved, the immigrant could never fully claim his new country. De Kooning may have emigrated to the bright lights of America, but he was still driven to excavate a buried Europe. Nothing in the picture appeared conclusive; *Excavation* thrived upon the sensation of betwixt and between. The ceaseless sensation of movement also seemed to capture the dissonant social rhythms of the twentieth century, encompassing a time of displacement, movement, dislocation, exile, and longing for home. In "writing" himself, in short, de Kooning also began unconsciously to write his time. De Kooning in 1950 was one of those artists with a mysterious divining rod for what his culture must create in order to know itself.

In *Excavation*, de Kooning took upon himself the European clash of styles. For decades, the art of painting had seesawed between expression-

ist impulses and classical reserve, between the rational and the irrational. In particular, cubism and surrealism presented two contrasting alternatives, one depending upon geometry and the grid, the other upon the looser form of dreams. *Excavation* was a magisterial synthesis of these two claims on modern truth. To de Kooning's circle, cubism represented not only a certain way of organizing space, but also a responsibility to make a well-constructed picture; a painter should submit to the discipline of history and school the "self" through rigorous analysis of painters (such as the cubists) who perpetuated the tradition. Surrealism, by contrast, presented the "self" as a tradition of one. The surrealist found authority in private dreams rather than in any adherence to the past. In his black-and-white paintings and above all in *Excavation,* de Kooning created a powerfully poised style that integrated the rigorous detachment of cubist structure with the personal drive and spontaneity of surrealism. If the surrealist in de Kooning rattled the bars of cubism's cage, the cubist in him insisted upon order's measure. Few paintings in the history of art conveyed such respect for history, order, and tradition while still celebrating the spontaneity of the moment.

De Kooning gave his synthesis a strongly American character. *Excavation* had none of the monkish reserve of Parisian cubism, but seemed brash and pulsing, like a blinking sign in New York. A black and white city that glinted with occasional color, New York was itself a kind of synthesis of cubism and surrealism, a combination of strict grids and liberating gestures in which order and chaos, reserve and craziness, appeared locked in a tense balance. New York in 1950 was not the bland caricature later known as "the fifties." It celebrated the exaggerated self and the strut of personality. And yet, the city could also be cold and detached, a place of gritty grays and inhuman scale. That may be why de Kooning pushed himself beyond his habitual sense of scale in *Excavation.* Through his "allover" composition, the New York glimpsed in *Excavation* was both a vast backdrop and a personal place of spiky and intransigent pieces. The whites contained more streetlamp yellow than in some other de Kooning black-and-whites: there was soot in the glow.

No other American painting—not even Stuart Davis's pictures—conveyed with comparable force the jazzy syncopation of the city. The rhythmic line led the eye through the painting at different speeds. In the hooking stroke, there was a constant stop-start: quick turns, sudden open spaces, the passing note of recognition. Color slipped beguilingly across the eye and was lost. *Excavation* was a personal improvisation on the great abstract grid of modern urban life: the gestural line sometimes seemed to step forward from the rest of the painting, almost like a jazz

soloist. It was equally an homage to certain currents of pop vitality, especially the tough guy bravado and wry perspective of the American detective. De Kooning loved American movies and detective stories, and the lush moodiness of his black-and-whites owed something to film noir.

The restless casting about of line—and the tension between darks and lights and the fitful illuminations of color—also suggested the nervous play of existential thinking in 1950. In *Attic* and *Excavation*, it was possible to discern a deadpan existential reflection of heaven (the attic) and hell (the excavation of the basement) and a modernist echo of religious art, including glimpses of copes in *Attic* and, in *Excavation*, allusions to a Boschian hell. Yet there was a certain romantic grandeur to American pessimism that was different from anything found in Europe. The United States had suffered, but not as the Old World had. Money was flowing again. The ash-in-your-eye bleakness of New York in the Depression was lifting. American painters could contemplate great subjects, such as the fall of modern man, from a grand, almost baroque perspective.

Modern culture is often the study of fragments and lost wholes. An artist, to bring that study powerfully to life, must remember the whole the way the shard remembers the pot. In *Excavation*, something perfectly complete seemed to have shattered; but de Kooning had recast the pieces into something newly worthwhile. Not once in *Excavation* did the brushstroke seem to forget the larger composition. The picture pieced together the fragmentary, the broken, and the partially concealed. De Kooning's refusal to abandon the pieces—and the past—was what fundamentally distinguished *Excavation* from Pollock's drip paintings. In Pollock's work, the parts were subservient to the "all-over" image. His art left the past behind and rose above the quarrel between cubism and surrealism; it was a *transcendent* art. But de Kooning still composed a picture so that the gritty individual details mattered; they did not completely submit to the larger idea. De Kooning refused to transcend or escape the self in any larger sense. A self was too hard won, and too prized, especially for an immigrant.

De Kooning could have been forgiven for resting after *Excavation*. It would have been much simpler after years of struggle to spend the remainder of his life making versions of this grand synthesis. Many critics, friends, dealers, and artists urged this course upon him. Instead, as he brought *Excavation* to completion, de Kooning painted a small rectangle near the bottom of the painting. He described it as a "door," a way to leave. Then, at the age of forty-six, just when he first knew success, de Kooning figuratively "opened" that door and left his grand synthesis behind, forever abandoned, in order to begin again. He was once more at home, adrift.

An American Master

De Kooning at fifty-five

22. Coming of Age

It is a certain burden, this American-ness.

The 1950s became de Kooning's public decade. He could no longer avoid thinking out loud about what it meant to be "major" or "American" or "modern." He might still be poor, but his poverty was no longer obscure. Powerful figures outside the small group of downtown artists were now watching the painter with the odd Dutch name, inviting him to join the wider circles of taste, power, and success in American culture. *Excavation* aroused great expectations. The private man must become, willy-nilly, a public figure.

By 1950, the trailblazing was complete. De Kooning, Pollock, Rothko, Smith, Kline, and Still had each arrived at a mature style. And if, as de Kooning said, "Gorky was before the books"—well, now the time for the books had arrived. The time for marketing, celebrating, analyzing, and promoting. The time for ambitious young men. If "the next half century belongs to us," as revelers at the Club declared on New Year's Eve of 1950, then the unprecedented public success of Jackson Pollock should not remain an isolated phenomenon. The eternal question of the ambitious, "Why not me?" now asserted itself with increasing urgency in the studios of New York.

In the beginning, however, the question still surfaced as "Why not us?" as the group of artists around the Club began to press their claims upon American culture with a self-conscious confidence unimaginable even a year before. It was not the most successful or powerful artists in the community who took the lead. The founding figures were too old, too cranky, or too wounded from years of solitary struggle to play cultural politics with much success. Rothko, Newman, and Still, all in their mid-forties, were shy or imperious men who had difficulty getting along with others. Pollock and David Smith, respectively thirty-eight and forty-four years old, were alcoholics who lived outside New York. And Gorky was dead. De Kooning, at forty-six, was naturally put forward as a leader. But he was not even an American citizen, and, whatever the ambitions of Elaine, he did not like to shine a direct light upon his art or upon himself. For a man of de Kooning's temperament, serving as a public figure—as,

indeed, the emblematic New York artist of the fifties—would prove as personally challenging as the long years of neglect and poverty.

And so, others more fluent seized the day. Robert Motherwell, in particular, was the early artist-spokesman and theoretician for what would shortly become known as abstract expressionism. He was the movement's "young man in a hurry." There were other spokesmen in the late forties and early fifties, notably Clement Greenberg, but Greenberg was not an artist and lacked Motherwell's flair for promotion. Important proselytizers such as Hess and Rosenberg were only beginning to develop their voices. In 1950, Motherwell was thirty-five years old, a generation behind de Kooning and three years younger than Pollock. He had a private income, a college degree, and close connections to powerful tastemakers. He knew how to make the right friends and enemies and was socially adept in ways that the older, poorer artists could not hope to be.

If Motherwell was an intellectual, however, he wanted more than anything else to be a painter. He admired unpolished genius, as had the sophisticated Parisian surrealists he earlier befriended. The artists who most attracted him were those of the fewest words, laconic individuals who disliked talking about art, notably Jackson Pollock and David Smith. They were passionate, rough-hewn men who liked to drink, did not easily fit in, and lived far from sophisticated New York artists; in short, they were very unlike Motherwell himself. Many of the painters of the time were intensely suspicious of Motherwell's fluency, regarding him as a coddled rich boy who was horning in and putting words in their mouths. There was a story often told by such artists about the time Motherwell spoke for de Kooning, an act widely regarded as a kind of sacrilege. Fairfield Porter told it this way:

> De Kooning asked me to join [the Club]. . . . But they were all very patronizing to me, who the hell is he, because I wasn't an abstract expressionist. Except Bill who knew me, who wasn't that way. And I felt just the same towards them. I thought, "Who the hell are you? I'm really brighter than you think." One of the first things I heard there was a talk that Bill wrote out and he didn't want to give it because of his Dutch accent which he felt self-conscious about. So Motherwell read it. Motherwell introduced it by talking in this very patronizing way about really how good it is, you know, sort of patting Bill on the back. And his attitude sort of disgusted me. Because Bill has a connection with reality, a real connection with painting, and Motherwell just came out of a book and courses in philosophy at Columbia or something.

ABOVE: Still Life: Bowl, Pitcher, and Jug, *c. 1921. Conté crayon and charcoal on paper, 18$^1/_2$" × 24$^1/_4$". A student work from the Academie in Rotterdam*

BELOW: Self-portrait with Imaginary Brother, *c. 1938. Pencil on paper, 13$^1/_8$" × 10$^1/_4$". A drawing that reflects de Kooning's close relationship with his friend and mentor, Arshile Gorky*

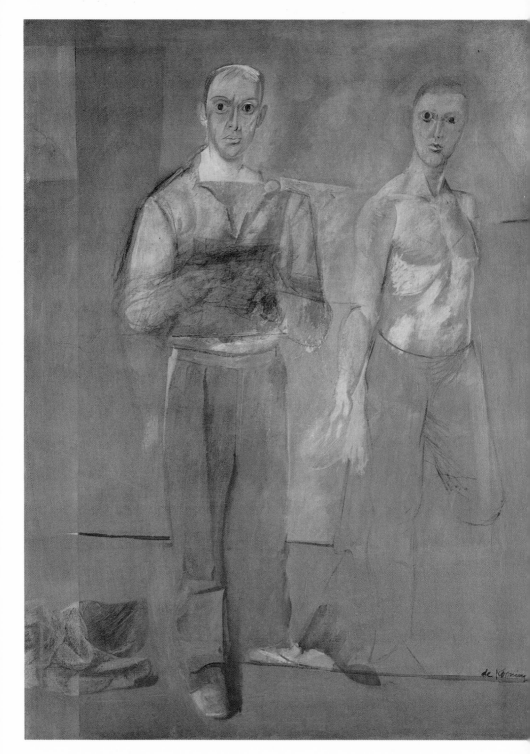

Two Men Standing, c. 1938. Oil and charcoal on canvas, $61\frac{1}{8}'' \times 45\frac{1}{8}''$. De Kooning
struggled for years to create an image of a man that satisfied him, constantly revising
and destroying his work in the process.

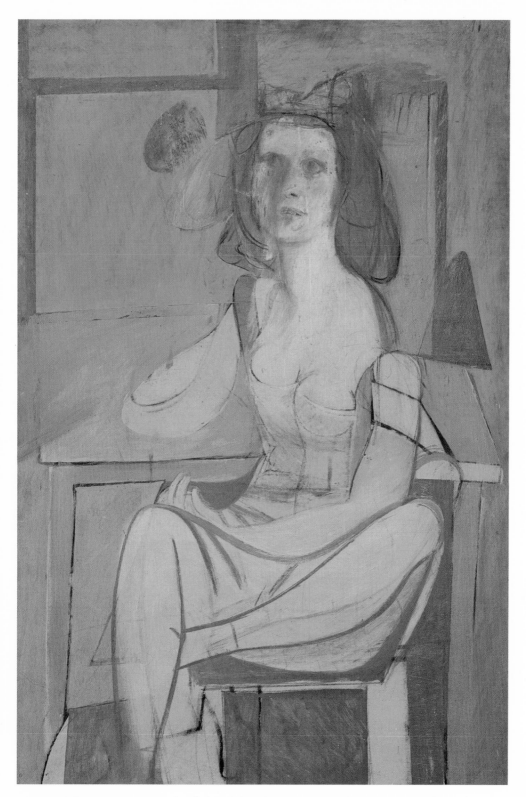

Seated Woman, c. 1940. Oil and charcoal on Masonite, 54″ × 36″. One of de Kooning's
first woman paintings

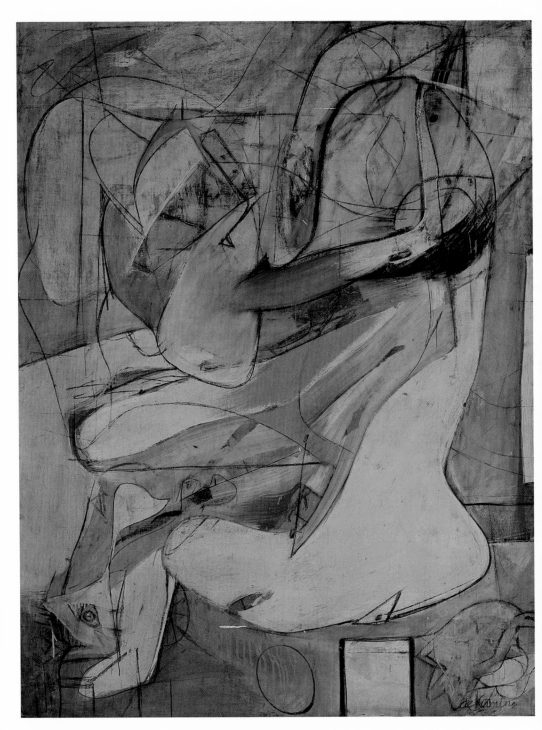

Pink Angels, *c. 1945. Oil and charcoal on canvas, 52" × 40". An early breakthrough
work of abstraction based on the female figure*

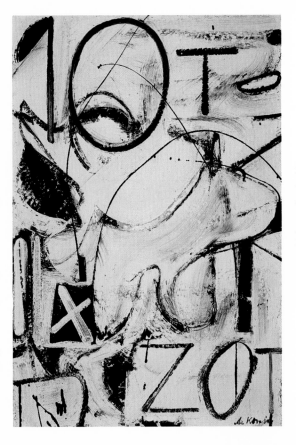

LEFT: Zurich, *1947. Oil and enamel on paper, mounted on fiberboard, 36" × 24⅛". An early example of the artist's great black-and-white series* BELOW: Black Friday, *1948. Oil and enamel on pressed-wood panel, 49¼" × 39"*

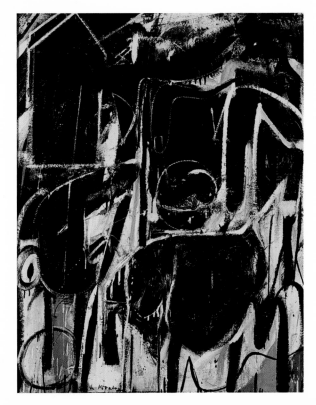

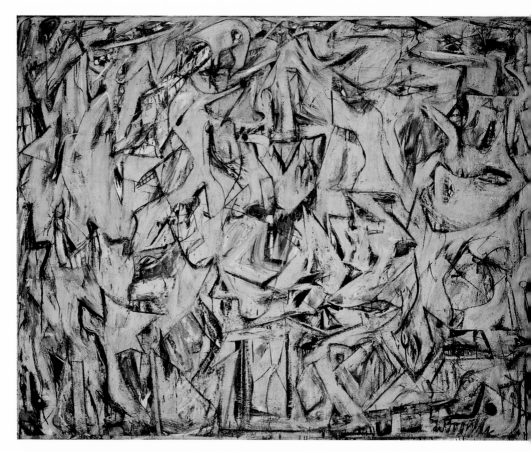

Excavation, 1950. Oil and enamel on canvas, 80⅛″ × 100⅛″. De Kooning's midcentury masterpiece

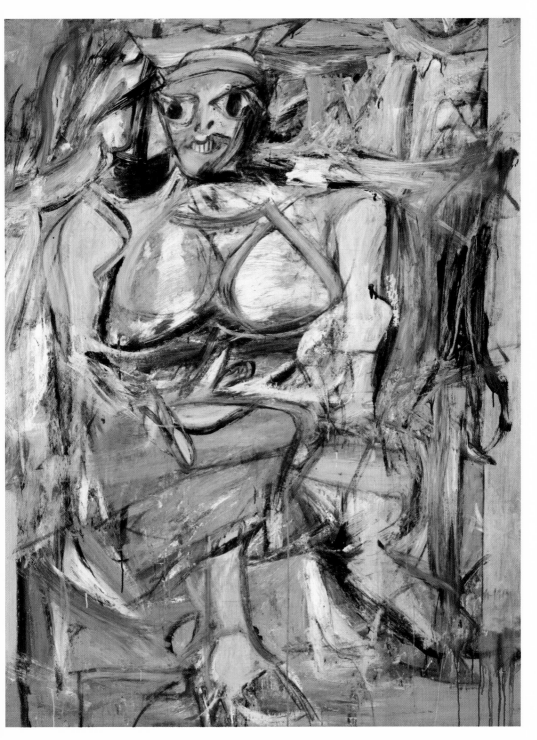

Woman I, *1950–52. Oil on canvas, 75⅞″ × 58″. An iconic work and still one of the most disturbing images of a woman in the history of art*

Easter Monday, *1955–56. Oil and newspaper transfer on canvas, 96$\frac{1}{4}$" × 73$\frac{7}{8}$". An example of de Kooning's bravura style of the mid-fifties*

Ruth's Zowie, *1957. Oil on canvas, 80¹/₄" × 70¹/₈". De Kooning developed an intensely personal brushstroke in the mid-fifties that many New York painters emulated.*

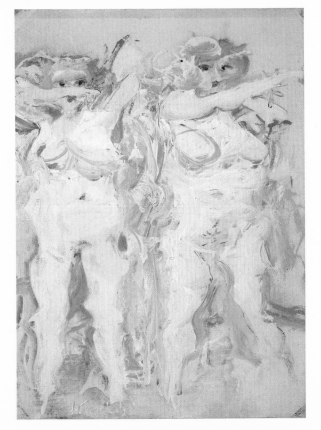

ABOVE: Pastorale, *1963. Oil on canvas, 70" × 80". In the early sixties de Kooning dreamed of moving to Long Island and developing a new style of landscape painting.*
RIGHT: Clam Diggers, *1963. Oil on paper on composition board, 20$\frac{1}{4}$" × 14$\frac{1}{2}$". Painted soon after de Kooning moved to the Springs*

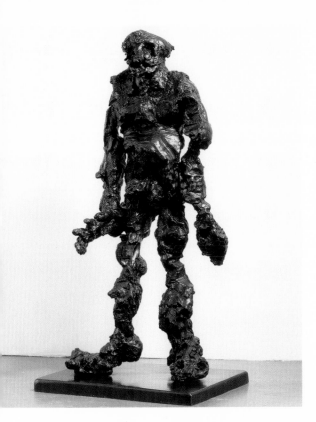

LEFT: Clamdigger, *1972.*
Bronze, 57$\frac{1}{2}$" × 24$\frac{1}{2}$" × 21".
During his brief turn to
sculpture, de Kooning created
a series of primordial-looking
figures.
BELOW: *. . . Whose Name Was*
Writ in Water, *1975. Oil on*
canvas, 76$\frac{3}{4}$" × 87$\frac{3}{4}$". An early
work from de Kooning's great
series of late landscapes

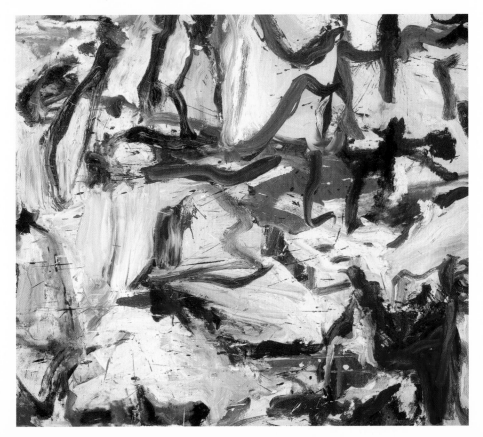

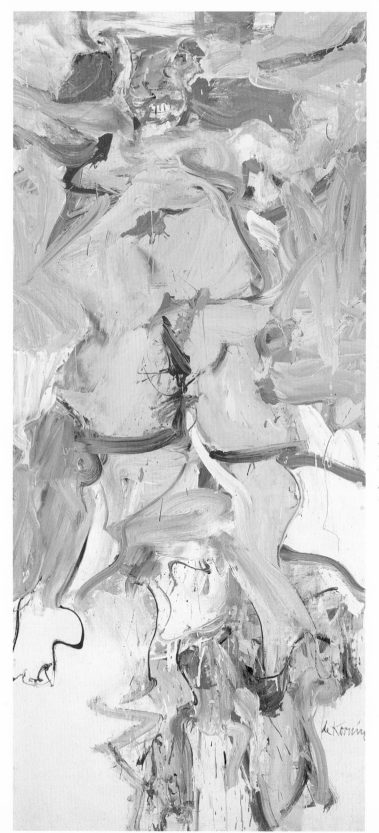

Woman, Sag
Harbor, *1964.*
Oil and
charcoal on
wood, 80″ × 36″.
Another
frightening
idol, a relative
of Woman I,
painted on
a door

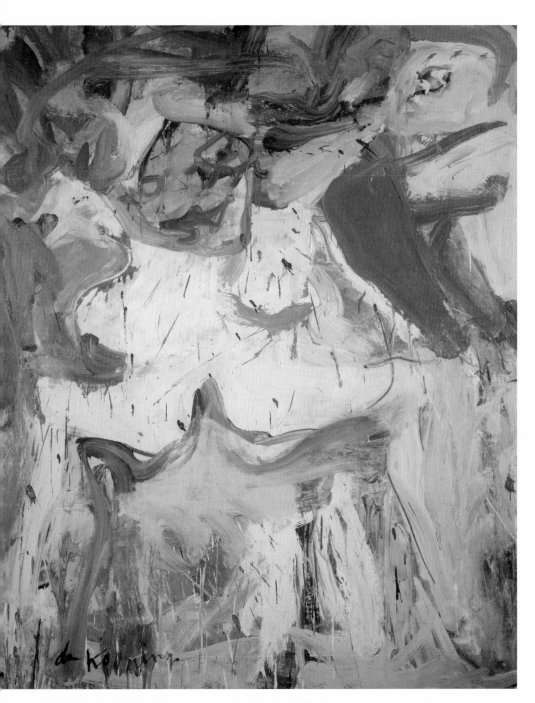

The Visit, *1966–67. Oil on canvas, 60″ × 48″. Among de Kooning's most sexually*
confrontational works

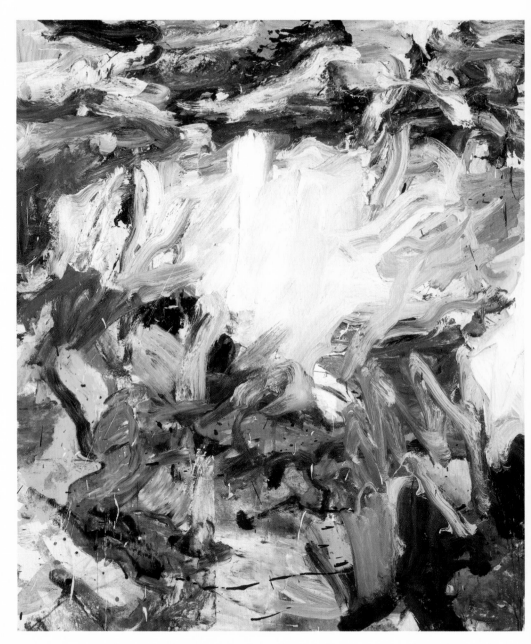

Untitled V, *1977. Oil on canvas, 79¹/₂″ × 69¹/₄″. De Kooning's rapturous late style*

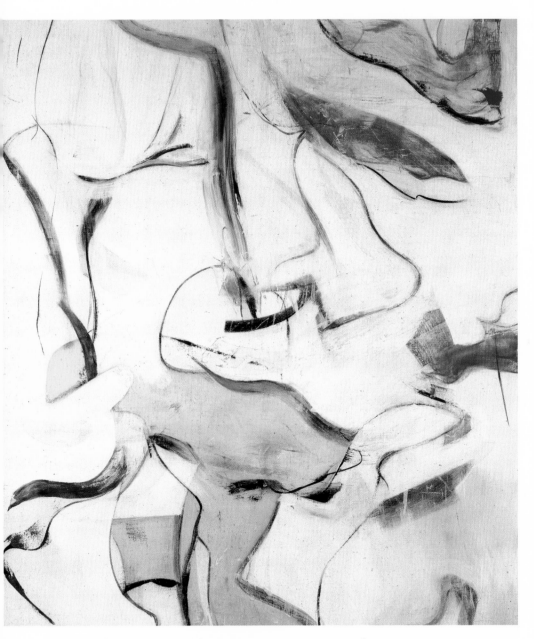

Morning: The Springs, *1983*. *Oil on canvas, 77″ × 88″. A new simplicity came into
de Kooning's work in the early eighties.*

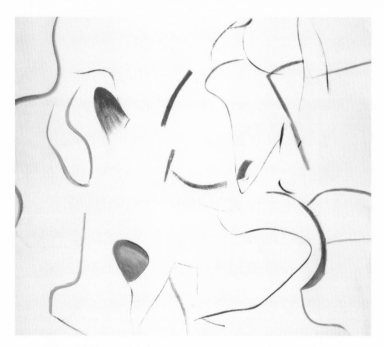

ABOVE: Untitled, *1984. Oil on canvas, 77" × 88". As he aged, de Kooning began to empty out his art.*

BELOW: Garden in Delft, *1987. Oil on canvas, 80" × 70". A bold work from de Kooning's last years, when his Alzheimer's-like dementia was becoming more pronounced*

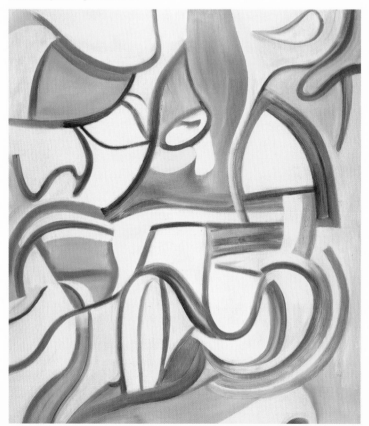

Few painters thought much of Motherwell's art—he usually won more praise from writers than from painters—but they could not deny his intelligence or organizing skills. By 1950, Motherwell recognized that the surrealism of André Breton was a spent force in America. Something else was happening. But what was it? Aware of the vivid history of modernism in Europe, Motherwell naturally thought New York, like Paris, should possess the quarrels, movements, and manifestoes that were a mark of cultural significance; certainly the movement should have a name, as the impressionists or the cubists did. But it was no easy matter to find either a name or a unifying theme for the group. The work of a de Kooning had little in common stylistically with that of a Barnett Newman. What could possibly bring together a Still and a Reinhardt, a Rothko and a Pollock? Moreover, the artists downtown were knotty individuals who did not necessarily like the idea of groups.

In April 1950, Motherwell and Ad Reinhardt helped organize a three-day symposium of artists at Studio 35. Its purpose was to frame a movement. The conference was ostentatiously closed to the public. The business at hand was too serious for amateurs and philistines, who would merely distract the avant-garde with ill-informed questions. However, one established figure, Alfred Barr, was invited to participate. The presence of the director of the Museum of Modern Art and a man long associated with European modernism was an important nod toward power. It was also a symbol of the participants' desire for recognition. During the conference, Motherwell and Barr, acting almost as art historians, repeatedly prodded the artists to define what they were doing and to make conscious what had heretofore remained vague or in the process of forming—in short, to transform themselves into a movement. Motherwell, for example, would ask questions like, "What then exactly constitutes the basis of our community?"

A stenographer recorded the conversation, which was subsequently edited by Motherwell, Reinhardt, and Bernard Karpel, the Museum of Modern Art's librarian, and published as *Modern Artists in America*. In the end, while the conference settled little, it powerfully reinforced the conviction in the studios that a significant group was taking public form. The self-conscious talk also began to divide the downtown artists, however, disturbing those who treasured the old community and feared that publicity seekers would displace artists. Should it matter who was in and who was out, who belonged and who didn't? Success brought distinction, but also cruel distinctions. One of de Kooning's closest friends, Milton Resnick, thought de Kooning himself began to sell out during these private-public conversations:

Ad Reinhardt and Motherwell had decided to have a group of artists and call them the New York school. The first meetings were held at Ad Reinhardt's studio somewhere near NYU. There were like twenty people there. [Motherwell] said, "There's no use having a New York school unless we know who you are." Motherwell was a banker's son with a lot of influence at the Museum of Modern Art. He had power and connections. At that meeting, I couldn't believe it. I thought it was crazy to suggest that we could be a New York school. Publicity and whatnot. The character of the meeting was that we all had to express our ideas and what we thought so that we could get to know each other more. I wasn't saying much because I was thinking, "This is a lot of shit." But I did say something and Motherwell said, "Milton, I couldn't have said that better myself." That was the last straw. That son-of-a-bitch college boy thinks he knows something.

So when we left I felt as if Bill and I were of the same mind. It didn't occur to me that there was something going on in Bill's mind—that he saw opportunity. And I said, "That's the first time I heard about the pot of gold and the rainbow and the gold is right there to begin with." So Bill said, "You're just a fucking nihilist. You don't want to be in." We were standing in front of the Cedar Bar. And I said, "You go in. I'm not going in with you." That was the first time we saw differently.

Resnick was right that de Kooning wanted to be a successful painter in America. But de Kooning also issued a memorable warning when Barr challenged the group to come up with a name:

Alfred Barr: What is the most acceptable name for our direction or movement? (It has been called Abstract-Expressionist, Abstract-Symbolist, Intra-Subjectivist, etc.)

David Smith: I don't think we do have unity on the name.

Ralph Rosenborg: We should have a name through the years.

Smith: Names are usually given to groups by people who don't understand them or don't like them.

Barr: We should have a name for which we can blame artists—for once in history! . . .

Motherwell: In relation to the question of a name here are three names: Abstract-Expressionist; Abstract-Symbolist; Abstract-Objectionist.

James Brooks: A more accurate name would be "direct" art. It doesn't sound very good, but in terms of meaning, abstraction is involved in it.

Bradley Walker Tomlin: Brooks also remarked that the word "concrete" is meaningful; it must be pointed out that people have argued very strongly for that word. "Non-objective" is a vile translation.

Barnett Newman: I would offer "Self-evident" because the image is concrete.

De Kooning: It is disastrous to name ourselves.

During the three-day gathering at Studio 35 the painter Adolph Gottlieb suggested responding forcefully as a group to the Metropolitan Museum of Art's recent decision to include no judges sympathetic to abstract art on the panel of its juried show "American Art Today, 1950." The snub was a godsend to the downtown artists: the museum performed to perfection the part of stuffy, blinkered fool, evoking the famous failure of the bourgeois Salon in Paris to include many of the great modernists. The artists around the Club could now, in turn, play the part of the slighted impressionists. They wrote an "open letter," intended to be widely disseminated, to the president of the Metropolitan Museum of Art. Dated May 20, 1950, and reported two days later on the front page of the *New York Times* under the headline "18 Painters Boycott Metropolitan: Charge 'Hostility to Advanced Art,'" the letter began, "The undersigned painters reject the monster national exhibition to be held at the Metropolitan Museum of Art next December, and will not submit work to its jury." The artists patronized the Metropolitan—the presumable guardian of eternal values—by offering its leaders a history lesson: "We draw to the attention of those gentlemen the historical fact that, for roughly a hundred years, only advanced art has made any consequential contribution to civilization." The group also picketed the museum, attracting further attention. Five years before, the artists would have accepted rejection from the Metropolian as a matter of course.

No sooner did de Kooning complete *Excavation* in May 1950 than Alfred Barr selected the painting—together with works by John Marin, Jackson Pollock, and Arshile Gorky—to represent the United States at the Venice Biennale that year. Well aware of the developing brouhaha over the show at the Met, Barr, like the protesting artists, saw a wonderful opportunity to distinguish his own museum from the fuddy-duddies uptown, and he came down forcefully on the side of the insurgents. In the June 1950 issue of *ArtNews*, he called the painters whom he selected "three of the younger leaders" of a "predominant vanguard." This dramatic assertion of taste—which was what his Biennale selection and *ArtNews* article amounted to—was a call to arms for American modernism. Explaining his picks in *ArtNews*, Barr wrote:

The spirit of painting after World War II seems by contrast [to the spirit of painting after World War I] much bolder—at least in those countries where cultural freedom still survives. There are, it is true, reconsiderations of meticulous realism or romantic scenery, but everywhere in the United States as well as in Western Europe many strong young artists and a number of talented old men are engaged in renewed exploration and adventure. In America several names have been used to describe this predominant vanguard: "symbolic abstraction," "abstract expressionism," "subjectivism," "abstract surrealism."

Despite his gracious acknowledgment of other groups, Barr, as the most important institutional tastemaker in his field, did not hedge his bet upon what American art truly mattered. He did not select one abstract expressionist, one meticulous realist, and one painter of romantic scenery. He picked the three most admired abstract expressionists. (By contrast, Alfred Frankfurter, the other American judge for the Biennale and the editor of *ArtNews*, invited Hyman Bloom, Rico Lebrun, and Lee Gatch, artists now largely forgotten.) Barr, like Clement Greenberg, also granted recent American art the same status as the contemporary School of Paris. It was a remarkable act by a man who retained strong ties to French modernism and had heretofore taken only a dutiful interest in American painting. Barr's selections sent a powerful signal to the art world, telegraphing the crossover of abstract expressionism from the studio to the museum. It was one thing for intellectuals like Clement Greenberg and Thomas Hess to champion these artists in small magazines or for the editors at *Life*, eager to play up the notoriety of artists, to ask of Jackson Pollock, "Is he the greatest living painter in the United States?" It was another for Alfred Barr to put his own reputation on the line.

At the Biennale, where Peggy Guggenheim was also showing her collection of Pollocks at her villa, Barr's selection caused much comment, not all of it favorable. The most astute response came from the great Italian still-life painter Giorgio Morandi, who recognized in Gorky and de Kooning sensibilities formed in the European tradition. But Pollock's work, he said, was "something entirely new." De Kooning himself was much too poor to think of making the trip to Venice. But the selection was a moving form of recognition. An impoverished Dutch immigrant representing America in the palaces of Europe! This was a delightful irony for a man with de Kooning's turn of mind. And he was deeply gratified by the company. Still, he sold almost nothing in New York. Egan could not even find a buyer for *Excavation*, a painting that not only went to the Biennale but would also be featured in an exhibition at the Museum of Modern Art

called "Abstract Painting and Sculpture in America" that opened the following January.

Life sensed the shift in established taste. That fall, the magazine, which had followed the actions of the avant-garde with bemused interest since its feature on Pollock, decided to publish a piece on the opening of the controversial exhibition of American art at the Metropolitan Museum of Art—by including a picture of the excluded protesters. Jackson Pollock and James Brooks hurried in from Long Island to make the shoot. The picture was published under the headline "The Irascibles," the name taken from an earlier editorial in the *Herald Tribune* that criticized the protesters. Nina Leen's picture, which portrayed fifteen of the original eighteen painters who signed the letter to the Met, was highly theatrical. The artists, arranged like a still *Life*, stared into space, their expressions serious, skeptical, demanding. Not one smiled. Each wore a coat and tie, except for the sole woman, Hedda Sterne. Each looked posed. Jackson Pollock, *Life*'s favorite, was in the center of the frame, carefully positioned and looking over his shoulder. De Kooning stood in the upper left, hair slicked back, staring intently. Together, the artists seemed to embody their headline, "The Irascibles," a name that was itself a dramatic piece of public relations that brought to mind every cliché about the struggle between the avant-garde and bourgeois society.

The success of *Excavation* led to one utterly unexpected form of recognition for de Kooning: an invitation to teach in the Ivy League. In the fall of 1950, after the Biennale, Josef Albers asked de Kooning to come to Yale as the "visiting critic in painting at the School of Fine Arts and Architecture." Albers had become head of the design department at Yale in 1950 after leaving Black Mountain the year before. He knew de Kooning from Black Mountain and from vacations in Provincetown. Although the two men differed in both sensibility and temperament, each recognized in the other the mature commitment of the serious artist. And Albers, despite his professorial manner, found Yale stodgy and wanted to expose his students to vanguard artists. Surprised at the invitation, de Kooning asked Albers what made him think that he, de Kooning, was qualified to teach at an august institution like Yale. Albers replied that the main reason was that de Kooning "was sitting on his own behind." De Kooning accepted the job for the paycheck—he was paid $1,600 for his teaching stint—and because it was hard to say no to Albers. He also understood that the job symbolized the new respect accorded his work. Still, the Ivy League and de Kooning made an unlikely fit. (It was perhaps his experience at Yale that led him, later in life, to say, "I can't see myself as an academic. I think of myself as a song-and-dance man.") At the first meeting of

de Kooning's class, the students mistook the middle-aged guy in old clothes for the janitor, not suspecting that this was Professor de Kooning.

Many students, veterans of World War II attending Yale on the GI Bill, were not especially committed or talented. De Kooning thought that they were wasting their time; he sometimes became exasperated by their amateurish efforts. The air of privilege at Yale also occasionally irked him. "You think because your father is rich," he told one student, "culture is going to stick to your ass." He asked Albers, "These guys are so lousy. Why don't you flunk them?" Albers replied, "If they were plumbers or carpenters I would. But they're just painters. They can't do any harm to anyone."

De Kooning retained a poor boy's interest in, and anxiety around, an institution like Yale, at once admiring and recoiling from its *gravitas*. In a letter to Albers the following year, he said he had "developed so large a sentiment for the place" and "I imagine that is partly because I never got anything like that in my own youth. Will you, if I am not speaking out of terms, give my regards to Dean Sawyer?" But de Kooning displayed little real passion for formal instruction. For all that he admired craft, he disliked a rules-driven approach to art. And he himself was always struggling with his academic background. His European training distinguished him from his American contemporaries in ways that sometimes made him uneasy. At the same time, his years at the academy inevitably made the course of study in New Haven appear, by contrast, not quite serious. Albers asked him to continue teaching, but de Kooning declined. (His friends took particular delight in his Dutch pronunciation of "Yale," which sounded very much like "jail.") De Kooning instead tried to persuade Albers to hire Franz Kline, who needed the money. Remembering the comment about "sitting on your own behind," he wrote Albers:

> Well, from that point of view and the way you must mean it, for you know I didn't come out of thin air, Franz Kline then is sure sitting on his own behind. He also, like you did and I did went thru the mill and is not a "Johny [sic] come lately." He also has a remarkable personality and will put a lot of life in the students.

De Kooning continued to live in New York while teaching, taking the train to New Haven twice a week. He performed his duties conscientiously, not only giving his students formal criticism of their work but also providing them with some idea of what was demanded of a serious artist. He was popular; few students had studied with a teacher so unlike a professor; Albers himself referred to the room where de Kooning taught

as "the genius shop." A number of Yale men began following de Kooning to the Cedar Tavern, where they would join in the partying and play with the idea of becoming a hard-drinking artist—another indication that, in America, art was becoming increasingly fashionable.

In June 1950, not long after sending *Excavation* to Venice, de Kooning placed two seven-foot-high sheets of paper on the painting wall of his Fourth Avenue studio and began the drawings that would lead to one of the most disturbing and storied paintings in American art, *Woman I.* Abandoning the abstract style of *Excavation*—just as he was first tasting some small degree of success, at the age of forty-seven—took courage. It was at once a declaration of independence and a romantic assertion that, in art, the inner voice must prevail.

At the time, Clement Greenberg was arguing, with intellectual force, that history demanded abstraction of a major artist. That was where freshness and discovery lay. Figurative painting was now inevitably minor, Greenberg believed, for it repeated the past and did not powerfully claim the new visual territory available to the artists who worked in the abstract tradition. Many artists whom de Kooning knew, among them Rothko, Newman, and Reinhardt, also believed that serious painting was now abstract. But from his earliest days, de Kooning instinctively recoiled from any external demand or expectation: he would allow no woman, no institution, no club, and no philosophy to give him marching orders. He would certainly not allow anyone to tell him he could not paint the subject closest to his heart, the figure.

As always, de Kooning's "return to the figure" represented a return to something that he had never left—and, for that matter, would never leave. Given the historical evolution toward abstraction, however, it was natural that many people in 1950 thought that de Kooning had "progressed" toward abstract art, moving from his figurative style to the black-and-white abstractions. Yet, even during the black-and-white period, he continued to draw and occasionally paint the figure, and his oeuvre as a whole represents an ongoing, rhythmic tension between figuration and abstraction. In 1950, he simply took up unfinished business.

With *Woman I,* de Kooning, emboldened by his abstract works, reopened his attack on half-buried problems, both formal and emotional. While painting *Excavation,* he had become fascinated with Mesopotamian figures, themselves excavated from the distant past, and with other ancient deities. "I had seen a picture of a Mexican goddess," he said, "to whom hearts were sacrificed." Such an image seemed to him contem-

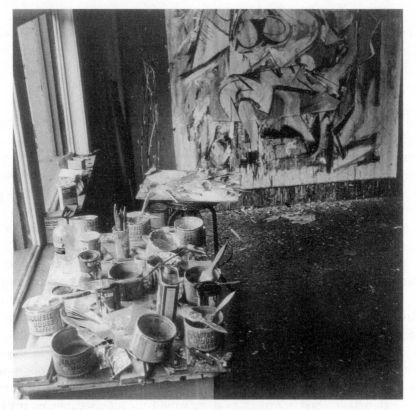

De Kooning's painting wall, Fourth Avenue studio, 1950

porary as well as ancient, a powerful Everywoman of many guises. Following upon the great success of *Excavation,* de Kooning became haunted by her shifting countenance. She could be open-ended and mysterious, from ancient Mesopotamia and also modern Hollywood. She could owe something to Picasso's women but also reflect the symbolist deities that filled the art of de Kooning's youth, muses who often absorbed and possessed men. She could be mother and wife, monster and lover, a creature at once earthbound and hallucinatory, grotesque, cruel, monumental, cartoonish, and funny—a contemporary goddess who could possess the viewer, but could not, in turn, be possessed.

With such an ambitious and phantasmal figure in mind, de Kooning perhaps hoped he could do with the figure what he had done in *Excavation,* animating the entire canvas and creating a detailed but "seamless" work without the "hot spots" that he complained sometimes stopped the eye in a painting. The figure had always troubled him in the past, always forced him to stop-start and suffer over its various ill-fitting pieces. Now,

as he began this new picture, he approached the figure somewhat differently, treating it as an architectural structure into which he could freely move, much as Pollock was said to get "inside" his drip paintings as he rhythmically swung the ribbons of paint onto the canvas. Perhaps, too, de Kooning could at last escape from his own teachers: his women of the forties still remained in thrall to Picasso.

Although de Kooning began by making large working drawings of a seated woman, he was soon confronting the canvas without preparation. "I always started out with the idea of a young person, a beautiful woman," he said. "I noticed them change. Somebody would step out—a middle-aged woman. I didn't mean to make them such monsters." Over the months, this one particular canvas became a kind of dark mirror-mirror upon the wall. He could never be sure what image would daily form, staring back with challenging doubts and questions. He would struggle with his *Woman I* long into the evening, often working in the nude on hot summer nights and pacing back and forth, studying the image for long periods and then striding purposely forward with the brush, searching for the startlingly fresh image that would have the exclamatory "of course" of an image painted in one quick surge of inspiration.

Despite his hopes, *Woman I*, like his earlier figures, came to him in pieces. If he liked one section that he thought did not work with the rest of the composition, for example, he continued his practice of using charcoal to trace its forms onto thin paper, which he would then attach to a different part of the canvas to see how it looked. Or he might retain the tracing for later use. Sometimes he would paint over the attached tracing, experimenting with the color and form. The image became an ever-moving, kaleidoscopic puzzle that he could not stop or put back together again. At first, he found nothing unusual in this, since it echoed his work of the thirties and forties, when he also completed few figurative paintings. But the one new and disturbing element in his current predicament was his public persona. De Kooning was a painter who had produced a widely acknowledged masterpiece that was sent to represent the United States in Venice. History was now hurrying him along, expecting great things—not some morbid struggle with a bizarre-looking female figure. He felt watched, and he disliked the feeling. The struggle with *Woman I* stretched into the fall of 1950, as the photo of "The Irascibles" appeared in *Life* and he taught at Yale, and extended into the spring of 1951.

Still alone and poor in his Fourth Avenue studio, de Kooning remembered very well the bleak days of the forties when his marriage was breaking up and his art seemed to have dead-ended. In public, he might now be an increasingly celebrated artist, but in private he was just a blocked

painter wrestling with a frightening, crazy-looking woman. People were beginning to talk. Perhaps he was just, in the slang of the time, a one-note-Johnny. On some evenings, de Kooning would linger over a beer at the Club or the Cedar. But he disliked being asked how work was going and often spent the evening alone with his one constantly changing mistress. He could still depend upon close friends, however, to support his quixotic effort to paint the figure. Tom Hess and Elaine remained devoted believers, as did many painters, notably Franz Kline.

Perhaps his greatest support, however, came from an artist de Kooning never knew. In the fall of 1950, just when de Kooning was beginning his "woman" struggle in earnest, the Museum of Modern Art mounted a large Chaim Soutine retrospective, which included the artist's landscapes, portraits, and depictions of carcasses. It was the first substantial show in America of the painter's work. It appeared just before the MoMA show "Abstract Art in America" that reviewed abstraction in the New World and gave a prominent place to *Excavation*. De Kooning was more impressed with the challenging figurative art of Soutine—a man from Old Europe—than he was with the American abstractions. *Excavation* may have made de Kooning an art world insider, but what moved him in 1950 was the example of a Jewish outsider who tenaciously clung to the figure against the strictures of two different religions, Judaism and modernism. If Picasso was an autocrat with whom de Kooning must struggle, Soutine was a predecessor whom he could admire without reservation.

Born in a *shtetl* near Minsk, Soutine, like van Gogh, grew up in pinched rooms under the thin gray skies of northern Europe, and then made heated paintings with swirling colors and pungent surfaces. Like van Gogh, he was desperately poor for years and a rootless wanderer who never quite fit in. De Kooning was also a poor European from the north who left home to seek another light; he, too, made heated paintings with a lush and animated surface; he, too, aspired to transform paint into a kind of flesh. In modernist New York, de Kooning drew courage from the abiding devotion of Soutine, an emblematic outsider, to the great tradition of Western old master painting, especially his regard for the Dutch masters Rembrandt and van Gogh. In his paintings of animal carcasses, a contemporary version of Rembrandt's beef carcass, Soutine seemed to probe (and to read prophetically, as the ancient soothsayers did) the guts of modern existence. No less than Soutine, de Kooning, in *Woman I*, hoped to bring a modern fire to art without abandoning what came before.

De Kooning also responded, passionately, to Soutine's difficulty. In contrast to van Gogh, a popular favorite, Soutine was not beloved. There was something grotesque about his twisted figures, something rude and

over the top about his surfaces. De Kooning relished the seeming awkwardness of Soutine, just as he enjoyed the rudeness of Flemish painting, elements essential to *Woman I*. Soutine helped give de Kooning the fortitude to make art that disappointed taste and stood outside the fashion of the time. But Soutine could not paint the picture for de Kooning. And the months continued to pass. Almost every day he would use a sharpened spatula to scrape away most of the figure, flinging the dead paint onto newspapers strewn over the floor. (He would attack the picture in this way whenever the worked-over paint lost its freshness and became what he called "rotten.") "He was in torment about the women," said Joop Sanders. "It happened many times that he just threw the painting on the floor." People began to compare de Kooning to Frenhofer, the artist in Balzac's *The Unknown Masterpiece*. Frenhofer, in Balzac's telling the most gifted artist of his time, was so absorbed by the possibility of perfection that he could not complete a whole painting, just small bits of a figure—notably the foot of a beautiful woman.

Others were less flattering in their comparisons. Clement Greenberg paid a visit to de Kooning's studio and offered no encouragement whatsoever, telling the painter that it was folly for the artist who painted *Excavation* to return to the figure; no major painter aware of the historical direction of serious art would paint such images. Greenberg's air of certainty infuriated de Kooning and many others he told of the visit. It seemed that the critic was trying to abridge the hard-won freedom of the downtown painters to do as they pleased, a freedom that was life itself to a man with de Kooning's background and character. In the end, Greenberg's visit strengthened de Kooning's determination to make a figurative painting, but the learned critic's confidence could not help but gnaw at de Kooning, sharpening his own private doubts about his work. Sometimes, de Kooning found a measure of humor or absurdity in his block, telling Hess, "The *Woman* became compulsive in the sense of not being able to get hold of it—it really is very funny to get stuck with a woman's knees, for instance. You say, 'What the hell am I going to do with that now?'; it's really ridiculous . . . I wouldn't know what to do with the rest, with the hands, maybe, or some gesture." The Fourth Avenue studio became as dirty as it had been during his darkest days in the forties, with drawings and paper strewn carelessly about; a filthy bedsheet lay crumpled on the cot. As before, de Kooning's friends noticed the mess because ordinarily he was tidy, so Dutch in the way he mopped his floors once a week and laid out his clean brushes in neat rows. Now, the only thing that looked fresh in his studio was the toothpaste smile on his idol, which he clipped out from a magazine and fixed on the unstable image.

His heart palpitations worsened. Sometimes, he thought that he was dying. One night he rushed over to the studio of Conrad Marca-Relli and pounded on the door. "He woke me up about two in the morning and said, 'Jesus Christ, I think I'm going to die. I can't stop.' The doctor had told him, 'You've got to calm yourself. You're overanxious. This whole idea of painting a figure and destroying it . . . this is doing something to you.' Here is this man who, don't forget, could draw like Ingres and could paint with the sweet quality of any master. And yet he had to cut it off, destroy it all, slap it off, all these violent strokes." A doctor de Kooning once consulted about the palpitations had ordered him to stop running around the block to release tension and try instead to relax and live with his anxiety. But this only made de Kooning fear that running around the block would give him a heart attack. In desperation, he asked Alcopley—whom he knew to be a scientist as well as an artist—for advice. Alcohol widens the arteries around the heart, Alcopley told him, thereby improving the circulation of the blood. Why not have a drink to calm down?

De Kooning rarely drank in the thirties and forties. At the Cedar Tavern in 1951 and 1952, he typically lingered over one or two beers, and when Harold Rosenberg brought a bottle to the studio to juice up the afternoon's talk, Rosenberg himself drank most of it. Now, de Kooning brought a bottle of whiskey into his Fourth Avenue studio. He would nip at the bottle when his heart began racing. The whiskey sometimes helped, loosening the knot in his chest. Sometimes, he also prescribed alcohol for his other main health problem—his difficulty getting going in the morning. A taste in the morning was a traditional home remedy, and in that era was generally regarded as harmless. It helped him, de Kooning said, "sneak" into the day. In this mild and medicinal fashion began the desperate story of de Kooning's alcoholism. In the future, when friends said drinking would kill him, de Kooning would sometimes respond by asking, "How do you know? Maybe drinking saved my life."

23. Bitch Goddess

An artist is forced by others to paint out of his own free will.

In April 1951, de Kooning had his second exhibition at the Egan Gallery. There was little new work to show: since completing *Excavation* almost a year before, he had done almost nothing but paint and repaint what would become *Woman I*. But Egan still hoped to capitalize on de Kooning's growing reputation by presenting the unsold black-and-white paintings from the forties and a number of smaller works on paper. Yet there were few buyers for even the most inexpensive pictures. Egan extended the show. By that June, only three drawings and one small and one medium-size painting had been sold. It was a harsh letdown. De Kooning had other reasons, of course, to find Charlie Egan exasperating: Egan's very public affair with Elaine in 1948 was not something that de Kooning, with his traditional view of how a wife should behave, could easily forgive; and the affair with Elaine broke up Egan's marriage to his wife, Betsy Duhrssen, whom de Kooning liked.

De Kooning also believed that Egan was cheating him financially. A poor businessman under the best of circumstances, Egan was under constant pressure to pay the gallery rent. His alcoholism represented a further drain on his resources. "Bill didn't get his money," said Duhrssen. "Charlie would sell something [of de Kooning's] and then the money would go to the rent or to drinks. . . . Well, Bill was starving. He ate at the Automat. Elaine claimed that sometimes he just ate catsup." When Egan became engaged to Duhrssen in 1948 he dissuaded her mother from spending $1,000 on a wedding present of a fancy record player, instead asking her to buy the couple a work of art from the gallery. His fiancée selected a great black-and-white from the 1948 show, *Light in August*. Duhrssen's mother paid $750, with Egan proclaiming that he would accept no "commission." He kept his word to his mother-in-law, but de Kooning himself never saw a penny. The dealer did not even bother to write up a bill of sale. (Egan was so bored with recordkeeping that, in a fit of ebullient housecleaning in the early fifties, he dumped the file cabinets he kept in the gallery bathroom onto the street.) Egan was an amateur in an area—contemporary art—that would soon yield to professionals.

After the failure of de Kooning's second show at Egan, Elaine, and perhaps Tom Hess, encouraged de Kooning to change galleries. In the spring of 1951, during or shortly after his show at Egan's, de Kooning began to think about approaching Sidney Janis, the art dealer who, along with his occasional assistant Leo Castelli, recognized more clearly than most the changing shape of the art world. Born in Buffalo in 1896, Janis was neither an artist-dealer like Betty Parsons nor a man who lived among artists like Egan. He was instead a Jewish businessman with a passion for dancing and art. A short, trim man with a dapper taste in clothes who liked to take his wife, Harriet, dancing at Roseland, the midtown dance hall, Janis had founded M'Lord Shirts Company in 1925 and used the money he made in that business to collect art, mostly that of well-known French modernists. His business continued to do well during the Depression, and, in 1938, having already assembled a strong art collection, he retired from business. With Harriet, he devoted his time to collecting and writing popularizing books on modern art, such as *They Taught Themselves, Abstract and Surrealist Art in America,* and *Picasso: Recent Years.* Such books earned little, and in 1948 Janis decided to combine his interest in art and business and open a gallery. He took over the space then occupied by the Sam Kootz Gallery, next to Betty Parsons at 15 East Fifty-seventh. Recognizing the potential in the American market, he soon brought a new verve to the selling of art in New York. Janis believed that art could be shrewdly marketed and that stylistic innovations in art, as in shirts, could bring a high return if they became fashionable. His background as an outsider in American society proved a great advantage, for he was less vulnerable than others to the European snobbery and museum hush typical of most art dealing; he was also not ashamed to make money or to demonstrate a business acumen well beyond the more amateurish dealers, such as Egan and Betty Parsons, who were closely associated with the downtown American artists.

Janis made certain to begin with a splash. In the spring of 1948, he opened with a substantial show of works by Fernand Léger, having first gone to France to talk to the painter and his dealer, Daniel-Henry Kahnweiler, to ensure that he could get impressive pieces. He followed up with shows of work by famous Europeans. To collectors, this schedule "announced" that Janis's gallery would be top of the line, for he identified himself with the biggest names in European painting. Yet Janis remained interested in new American work. During the years when he had his shirt manufacturing business, he often visited studios downtown; he had first met de Kooning in Gorky's studio as far back as the early thirties. Some-

times, he spent an evening at the Waldorf cafeteria with artists. He was also on the acquisitions advisory committee of the Museum of Modern Art and, in 1943, supported the purchase of Jackson Pollock's *She-Wolf.* A year after Gorky's death, in 1948, the painter's widow, Agnes, decided to leave the Julien Levy Gallery—then the premier showcase of surrealism in the city—and take Gorky's estate to Janis.

The great challenge for a businessman like Janis lay in creating a vital market for American art. Janis liked betting on unknown or undervalued artists whom he admired; and he understood from his own reading and from his collecting of Mondrian that fashions in art changed over time. But America was still widely regarded as much more provincial than Europe. How could he persuade a wealthy American to buy a Pollock or a Gorky instead of a work by Miró, Matisse, or Picasso—let alone a landscape by Monet? How could Americans be put on the same footing? Janis's initial marketing ploy was clever: he juxtaposed European and American artists. In the autumn of 1950, Janis, working with Leo Castelli, then a young man on the fringes of the art world, staged a show called "Young Painters in the U.S. and France." It was not happenstance that "U.S." came before "France." The show paired artists: de Kooning's *Woman* from 1949–50 was juxtaposed with Jean Dubuffet's *L'Homme au chapeau bleu* from 1950. Pollock was paired with Lanskoy, Rothko with de Staël, Kline with Soulages, and so on. The underlying purpose of the exhibit, which followed by only a few months Barr's showing of American art at the Venice Biennale and the Irascibles' attack upon the Metropolitan Museum of Art, was to demonstrate that the New Yorkers could stand with the Parisians and even, perhaps, best them. A second way to convince collectors to buy American art was to create talk—and ride the wave of publicity set in motion by the articles in *Life.* Janis could not have anticipated the powerful part that fashionable enthusiasms would eventually come to play in the postwar art world, but he recognized the potential of gossip and talk, as did Castelli.

In the spring of 1951, a number of downtown artists noticed a large and empty storefront space at 60 East Ninth Street, not far from the Club and the Cedar. Few artists had yet had an individual gallery show, but the ambitious group feeling—the "Why not me? Why not us?" mood—was growing stronger and stronger. No one is certain who first proposed organizing a collective show in the Ninth Street space; Conrad Marca-Relli, Franz Kline, Jean Steubing, Milton Resnick, and John Ferren were all early supporters of the idea. "The charter members of the Club met to discuss it," said Ludwig Sander. "And since they had a policy against exhibitions

Leo [Castelli] volunteered to run it." The storefront was immediately rented for two months at fifty dollars a month. Club members cleaned it up, painted the walls white, and put up partitions to increase wall space. The word went out: artists would be represented by one work apiece. Soon, they began to arrive with paintings under their arms. Marca-Relli was the one most directly in charge of organizing the show, an almost impossible task, and some political resentments soon surfaced. The uptown dealer Sam Kootz, for example, did not wish "his" artists—such as Gottlieb, Baziotes, and Motherwell—to show among the lesser figures downtown. Motherwell, however, did join the exhibition.

While Castelli was never exactly in charge, his smooth approach and unfailing good manners made him a useful diplomat. He was hard to shout at, and he could get along with both downtown and uptown. In 1951, most downtown artists knew "Leo," who always seemed to be around, but few could describe what he actually did beyond organizing an occasional show and collecting modestly. Like Janis, Castelli understood the place of art in the Old World—he was a European—but also sensed the potential in his adopted country. Somehow, Castelli managed to get the show hung. Almost seventy artists were included, many of them little known. Franz Kline designed the poster. From start to finish, slapping together the show took less than two weeks. It was considered especially important to include a work by de Kooning, since he was already the leading light of the downtown lofts. Unfortunately, de Kooning had no new work at hand. And so, he walked over with a *Woman* from 1949–50, a surprise to many viewers, who anticipated a black-and-white picture in the tradition of *Excavation*.

Although the show was hardly noticed in the press, it became a fashionable event, as Castelli probably anticipated. For the opening, a banner was stretched across Ninth Street, and a bare bulb hung from the second floor on a flagpole socket. "And that night the cars that arrived!" said Sander. "The cabs that came! It was like, you know, the old newsreel pictures from a movie opening in Grauman's Chinese Theatre in Hollywood [with] people getting out in evening clothes." Alfred Barr, for one, was stunned by the number of unfamiliar artists who were included. It confirmed for him and many others that what was happening in New York represented "a movement" and "a scene." It was a historical phenomenon, in short, rather than just the expression of a few solitary and eccentric American voices. After the opening, Castelli took Barr to the Cedar and wrote down the names of the artists on the back of a photograph of the installation. Abstract expressionist art would not begin selling well until the late fifties, but for Janis and others watching the art market, the Ninth

Street show was a bellwether reminiscent of the Salon des Refusés, when the nineteenth-century impressionists thumbed their noses at the official salon. Together with a series of powerful public statements—the Biennale in Venice, the Irascibles' attack upon the Metropolitan, and the celebration of American modernism at MoMA—the Ninth Street show represented the jelling of a style. People talked. And in art, money often follows talk. Janis would not immediately begin signing up contemporary American artists, but he watched the scene closely.

The excitement generated by the show only emphasized, in de Kooning's mind, how amateurish his current exhibition at Egan's looked. It did not stand out as something fresh and bold; it merely demonstrated, publicly, that he had nothing new to exhibit. Sidney Janis and Leo Castelli, by contrast, were making a strong case for American art. So de Kooning put on a jacket and tie and visited Janis that spring, casually mentioning to him that he no longer had a gallery and was thinking about what to do. (He always chose to dress the part when he went uptown; he thought it was "corny" to affect a bohemian look.) According to Janis, "I said we'd be delighted to take him on." De Kooning did not officially join the gallery until 1953, at the time of his first show there. "In fact," Janis told John Gruen, "de Kooning was the first one we took on of the New York School painters." But the two men almost certainly worked out an informal understanding in the spring of 1951, for Janis immediately began advancing de Kooning money for the purchase of painting supplies. There was no better way to his heart: de Kooning might accept living on catsup, but considered it intolerable to starve his palette. During the summer of 1951 Janis wrote de Kooning twice from Europe, where he and Harriet were vacationing and buying art, to ensure that de Kooning had adequate materials.

De Kooning found Janis a relief after Egan. Not only was he an organized businessman, but his money had the right origins—de Kooning always preferred a self-made man. And, as in Rotterdam, de Kooning had a particular fondness for tough-minded Jewish outsiders, identifying with their struggle on the edge of society and their prickly humor, which often ridiculed social pretension. It pleased him that Janis liked art because he liked it, not because he went to the right schools. In some respects, Janis may even have reminded de Kooning of his own, money-sharp father. It could hardly fail to please him, too, that Janis represented the estate of Arshile Gorky.

That spring and summer, the Art Institute of Chicago began trying to reach de Kooning to discuss *Excavation*. A letter arrived inviting him to submit the picture to its juried exhibition and competition in the fall of

1951. The show was called the "60th Annual American Exhibition: Painting and Sculpture at the Art Institute of Chicago," and had a prize of $4,000. De Kooning ignored the letter; answering mail was never one of his strengths, and Chicago was nothing more than a vague "out there" to an immigrant from Holland who identified himself as a New Yorker. Despite his *succès d'éstime* with the picture, he had no faith that he could sell it. Not only had the extended Egan show failed to produce much, but no one in New York was offering to buy *Excavation,* the most ambitious work of his life. How could Chicago know better?

"What do they think I'm going to do?" de Kooning complained to Conrad Fried. "Pack up the painting and ship it to Chicago and get it shipped back and told you got an honorable mention? So to hell with it." Then a second letter arrived at his studio. De Kooning ignored that, too. Finally, a representative from the Art Institute personally knocked on de Kooning's studio door and, according to Fried, promised in so many words that *Excavation* would be awarded the first prize. "That changed everything," said Fried. "We packed it up and sent it off." Chicago, in 1951, seemed further away than Venice, but the jury that fall, which included Hans Hofmann, awarded *Excavation* the first prize. Katherine Kuh, a curator at the Art Institute, immediately set out to buy the picture for the museum. She ran into great resistance, but ultimately succeeded.

When the check for the prize money arrived, de Kooning went to a bank and asked for cash. He had to wait several days for the check to clear, but eventually walked out of the bank with the entire four thousand in his pocket, by far the most money he had ever seen in his life. He was almost forty-eight years old and had just received his first serious paycheck. A friend told him that he shouldn't walk around with that kind of money, but must instead open a checking account. De Kooning confessed that he did not know how to write a check. Moreover, he showed no interest in learning. Only money jingling in the pocket could make a poor boy feel rich. Until the end of his life, de Kooning maintained no faith in the abstract numbers on a bank statement and believed in putting the gold under the mattress. (Those cataloguing de Kooning's estate after his death found $5,000 taped to the bottom of a drawer.) His friend nonetheless prevailed upon him to be sensible, and the two men opened his first bank account.

In the period when the Fourth Avenue studio was de Kooning's cave—not long after his separation from Elaine, when he was painting the black-and-whites and then *Woman I*—he was drawn to a winsome young

woman named Mary Abbott. She brought a kind of youthful optimism into an especially dark period. She was everything the figure in *Woman I* was not. She appeared wonderfully crisp, bright, and fresh. Not only that, but she was a sensible girl who asked nothing of de Kooning, something that could not be said for either Elaine or the devouring figure in *Woman I.* It was in 1948 or 1949 that David Hare introduced de Kooning to Abbott on the street. She was from a prominent family—her great-granduncle was Henry Adams, and she had come out as a debutante at the socially prestigious Colony Club in New York City—but she had left that all behind and chose to live downtown in a cold-water flat at 88 Tenth Street. Mark Rothko, Barnett Newman, and David Hare all took a special interest in her, encouraging her to hone her talents at school and become a serious painter.

Abbott had just separated from her husband. Sometimes, to help make ends meet, she modeled for *Vogue*. Before she met de Kooning, she took classes at the Art Students League. In the late 1940s and early '50s, Abbott, then in her late twenties, was much too reserved and stylish a woman to chase after a well-known older artist. And she never did. Instead, de Kooning gently pursued her. He liked her polish, she thought. Since there was no heat in her studio on Tenth Street, he would bring her kerosene to ensure that she stayed warm. Their affair continued on and off until the mid-fifties, and their friendship lasted for decades. Sometimes he would drop in to visit her, and sometimes she would come by to see him: "That's more the way it was then. There were no dinners. There wasn't money for that. Then later we went to the Cedar Bar. I didn't study with Bill. I was just with him." She would also occasionally see him during summers on Long Island, after she had remarried and had a house in Southampton.

De Kooning always loved talking to Abbott, who was an eager listener. He would tell her that "an artist is like a homespun philosopher," meaning, she thought, that "he has ideas that are really about living and then he concentrates them. It has to do with thinking about living. It means wondering about life. A real philosopher's system is the last part that comes. It's a way, not any end. It's never finished." Abbott liked his manner.

> It wasn't gallant, not the pulling-out-chairs kind of manners. But pleasant, polite. Until he got drunk. He was very good-looking, very attractive. And he was very warm. Certainly not cold or disinterested. Not with me, he wasn't. He had great charm without putting it on. Just natural charm. And magnetic. Very quiet, but magnetic. He was brighter

than the others were, and quieter about it. Didn't knock you down the way Pollock did, but he was very much a man. Not passive at all . . . I didn't like Pollock much. When he was sober he didn't talk, and when he was drunk Bill had to keep pulling him off of me. One evening I was at a dinner at the Rosenbergs' and I was smoking and I offered one to Pollock. "Would you like one of these?" And he said, very pretentiously, "I only smoke canvas."

According to Abbott, Bill talked "in a funny kind of way. Broken sentences, but very much to the point. Art was the center of his life, and that was it." She was deeply taken by his openness to others. "I think he may have liked the idea of my background. But that was one thing about Bill. He liked all kinds of people. I remember one time we were sitting at the Cedar and there were a bunch of businessmen. Redneck types. I thought that they were baiting him, but he was answering them. Later, he said, 'You don't understand.' He was engaging with them because they were a different kind of person. He didn't close things off in either people or painting. That was part of his greatness." One moment he'd be talking to the businessmen, the next discussing Massacio or Fra Angelico.

She was no less taken by his devotion to process and craft—to the many techniques he developed for painting wet on wet, keeping a painting fresh, and getting the texture and viscosity of the paint right: "He was controlling the drip." In the period after the black-and-whites, when he was moving into color, she also watched him compose charts and records of how he arrived at certain colors. "He had a chart showing each mixture that he made. Exactly what he'd mixed in each bowl." Nothing impressed her more, however, than how hard he would look at a painting. "He really studied it for a long time. Maybe more than anyone else. 'What do you think?' he'd say about a painting. I'd say, 'I think it looks good.' He'd go, 'Eh? I don't know about that.' He was always in doubt. He always had a chair and would sit for hours looking. Even when you were there he was looking."

About Elaine, de Kooning would just tell her, "Vell, she wouldn't be a housewife." In contrast to Elaine, Abbott did not badger him, something de Kooning had rarely encountered in a woman. She understood from the first that he would see other women when he wanted to. (She herself would see other men.) She could cook, too. Twice he asked her to marry him. He said, "I want to marry you because you're such a good cook. But then you couldn't paint as much." She believed at the time that he was almost serious and that, had she responded warmly, he might have gone

through with it. But she didn't react strongly to his proposals, and such moments passed. "I had the idea that Elaine—I thought very well of Elaine—I had the idea that she wasn't divorcing him because of the trouble he could get in. But maybe I'm being idealistic." Perhaps she also sensed the cost and likely outcome of a long-term relationship with de Kooning. He was older, he would first have to divorce Elaine, he was from a very different background—and he loved painting more than he loved her.

For de Kooning, there was nothing like a young lovely woman with admiration in her eyes to restore, momentarily, the confidence of a middle-aged painter. Abbott herself, though she sensed the unresolved anger in de Kooning, was impressed by how much he genuinely liked women, despite the successive images that appeared on the canvas of *Woman I*. She was also struck by how varied the women were that he was attracted to in his life: "What he liked is everything. So long as women were good-looking." But a woman like Abbott was not what de Kooning was wrestling with in *Woman I*. No one can know exactly why an artist does not finish a painting, but de Kooning's difficulty with *Woman I* lay mainly with excavating an image that satisfied his feeling for a buried truth. A polished figure of perfect proportions made him "nauseous," as he said of his earlier Ingresque drawings of Elaine. A veneer of platonic perfection, whether conveyed to a poor student at the academy or presented by a mother, a wife, or a toothpaste smile, heightened sensations of exclusion and, more important, betrayed the private reality that lay concealed within the figure. He told Hess that he hoped to render "the intimate proportions" of anatomy rather than its unmoving "artistic proportions"—to capture the felt, in other words, not just the seen. The body was more than its form.

Struggling with *Woman I* felt true to de Kooning, whether or not it yielded a successful picture. He believed in fighting his way into intimacy with an image; the broken, convulsive, and awkward must be conveyed, if the truth was to be served. De Kooning also insisted upon contradictory meanings. How was he to convey the many aspects of, for example, a mouth? A mouth meant far more than a realistic depiction of two lips and a hole could reveal. A mouth was nourishment, smiles, frowns, sex, teeth, whispers, and shouts. It told lies and truths. It was inside and outside, a lipstick pose and a revelation. Viewed this way, a mouth was an almost impossible thing to get right. And so de Kooning snipped out the toothpaste smiles from advertisements and placed them upon the canvas, a recognition, in part, of how prettily mouths can lie. But the cutouts were

also a way to silence a form that was all questions. De Kooning was well aware that people would be quick to interpret his difficulty with mouths, given surrealism's fascination with castration and the *vagina dentata.*

> I cut out a lot of mouths. First of all, I thought everything ought to have a mouth. Maybe it was like a pun. Maybe it's sexual. But whatever it is, I used to cut out a lot of mouths and then I painted those figures and then I put the mouth more or less in the place where it was supposed to be. It always turned out to be very beautiful and it helped me immensely to have this rare thing. I don't know why I did it with the mouth. Maybe the grin—it's rather like the Mesopotamian idols, they always stand up straight, looking to the sky with this smile, like they were just astonished about the forces of nature you feel, not about problems they had with one another. That I was very conscious of—the smile was something to hang onto.

De Kooning also had great difficulty depicting the figure's hands, much as he had in the 1930s and '40s. As with the mouth, his problem was not one of competence, but of feeling. After the eyes and mouth, the hands were the most expressive parts of the body. They could both wound and love; and de Kooning was no stranger to either a vicious tongue or hand. The hands in his women of the period were often clawlike, as threatening as the *vagina dentata* or the cold public smile, but they did not represent the full meaning of touch in the actual painting. His own brush was so full of touch—often loving touch—that the feeling of "hand" in the paintings was invariably ambiguous. The body, too, could not appear dry or abstracted, if it were to convey "intimate" rather than artistic proportions. De Kooning told Hess, "I like a nice, juicy, greasy surface." To create that surface, de Kooning used a medium of turpentine, stand oil, and damar varnish. (The unusual medium, together with the constant scraping down of the painting, made *Woman I* a physically unstable painting that no longer looks the way it did in the 1950s; it has kept on "moving," literally aging with time.) He struggled to keep the entire canvas wet and "alive," so that he could work with the full image. When he stopped painting, he would press newspaper onto the image to keep the oil wet.

Perhaps the painting would also feel untrue to de Kooning if it did not reflect his fought-over feelings about success, glamour, and celebrity. One of the guises of *Woman I* was the bitch goddess success, a devouring American idol who must be propitiated. Another was the movie star or celebrity. Still another was the hussy who offends a community's stan-

dards. De Kooning felt obliged as a leader of the downtown group to assert his right to represent the despised figure as radically as possible. He did so in words no less than paint. During the three years when de Kooning was struggling and blocked—the period when abstract expressionism jelled as a recognized style—he gave three talks that, taken together, represent an avowal of artistic faith. In the period when he could not find his way, he did his talking.

The statement of 1949—"A Desperate View"—had reflected his thoughts about the black-and-white paintings in particular, but the next two were an implicit defense of *Woman I.* They were composed when he had no idea whether or not he would succeed with his return to the figure; they were his answer to the whispers in the art world and his declaration of independence from, on the one hand, the views of Clement Greenberg and, on the other, the mysticism of Newman. He gave "The Renaissance and Order" at Studio 35 in 1950, just as he was warming up to begin *Woman I.* "What Abstract Art Means to Me" followed in February 1951— in the midst of his struggle with the painting—at a symposium organized by the Museum of Modern Art on the occasion of its show "Abstract Art in America." In both, de Kooning challenged powerful prejudices then developing in the art world. Art, he thought, was becoming too intellectually abstract and immaterial, losing touch with both man and the visceral world—and, in a deeper sense, with the Western tradition. The first sentence of "The Renaissance and Order" is "In the Renaissance, when people—outside of being hung or crucified—couldn't die in the sky yet, the ideas a painter had always took place on earth." In the essay, de Kooning, then laying in the figure on his own canvas, chose to celebrate the earthiness of the Renaissance artist:

He could never become completely detached. He could not get man out of his mind. . . . Flesh was very important to a painter then. Both the church and the state recognized it. The interest in the difference of textures—between silk, wood, velvet, glass, marble—was there *only in relation to flesh.* Flesh was the reason why oil painting was invented.

He contrasted this earthbound perspective with the "Oriental idea of beauty," which is that "it isn't here. It is in a state of not being here. It is absent. That is why it is so good. It is the same thing I don't like in Suprematism, Purism and non-objectivity." He might have added that he also didn't like it very much in the vast, open color fields of Barnett Newman and Mark Rothko, who often spoke of art as a form of transcendence. De Kooning had little patience with the platonic. He admired the Renais-

sance artist partly because he wasn't "continuously occupied with the petulant possibilities of what 'mankind' ought to do." De Kooning preferred a peasant's measure of man, distrusting the fancy talk of those who would not dirty their hands. He was content to locate the world in the space traced out by his own outstretched arms.

The Western outlook was, de Kooning believed, nothing to apologize for or to progress past: "When I think of painting today, I find myself always thinking of that part which is connected with the Renaissance. It is the vulgarity and fleshy part of it which seems to make it particularly Western. Well, you could say, 'Why should it be Western?' Well, I'm not saying it should."

Nonetheless, he argued for an ongoing connection to an ancient, man-centered Western approach to art. It was an implied rebuke from an artist born in Europe to those who emphasized the radical newness of present-day American art and gloried in a "boundless" American space.

> There is a train track in the history of art that goes way back to Mesopotamia. It skips the whole Orient, the Mayas and American Indians. Duchamp is on it. Cézanne is on it. Picasso and the Cubists are on it. Giacometti, Mondrian and so many, many more—whole civilizations. Like I say, it goes way in and back to Mesopotamia for maybe 5,000 years, so there is no sense in calling out names. . . . But I have some feeling about all these people—millions of them—on this enormous track, way into history. They had a peculiar way of measuring. They seemed to measure with a length similar to their own height. For that reason they could imagine themselves in almost any proportions. That is why I think Giacometti's figures are like real people.

De Kooning distrusted the hubris of artists and critics who spoke of reordering both art and the world. Here, too, his attitude reflected an Old World skepticism about America's originality and arrogant, can-do faith.

> The attitude that nature is chaotic and that the artist puts order into it is a very absurd point of view, I think. All that we can hope for is to put some order into ourselves. When a man ploughs his field at the right time, it means just that. . . . Insofar as we understand the universe—if it can be understood—our doings must have some desire for order in them; but from the point of view of the universe, they must be very grotesque.

A year later, when the Museum of Modern Art asked de Kooning to speak on abstract art, the invitation struck him as a kind of black

joke. After all, he had now been plowing the same figurative field for almost a year without success and at the worst possible time, as more and more artists became "abstract." *Excavation* might be featured in MoMA's show, but de Kooning himself particularly disliked ideological or theoretical talk about abstraction and did not believe in what many people meant by "abstract art." "What Abstract Art Means to Me" continued the themes presented in "The Renaissance and Order," but was less oblique in its attack upon the art world's faith in abstraction.

De Kooning thought the word "abstract" belonged to the people who conversed about art, those more interested in philosophy, politics, and art history than in painting. It was "talking," he wrote, "that has put 'Art' into painting. Nothing is positive about art except that it is a word." He particularly sought to distinguish between two kinds of "abstract." On the one hand, there was the mysterious, elusive quality of any great picture, whatever its content; a quality alluded to by such vague words as "lyrical" or "sublime." De Kooning called this the "nothing" part in a painting, "the part that was not painted but that was there because of the things in the picture which were painted." De Kooning loved this quality wherever he found it:

> Some painters liked to paint things already chosen by others, and after being abstract about them, were called Classicists. Others wanted to select the things themselves and, after being abstract about them, were called Romanticists. Of course, they got mixed up with one another a lot, too. Anyhow, at that time, they were not abstract about something that was already abstract.

What he objected to were those modernists, notably Greenberg, who he believed turned the abstract into a program, creating theories and inventing "an esthetic beforehand,"

> that "nothing" which was always recognized as a particular something—and as something particular—they generalized, with their bookkeeping minds, into circles and squares. They had the innocent idea that the "something" existed "in spite of" and not "because of" and that this something was the only thing that truly mattered.

De Kooning detested the idea of deductively reducing painting to form, or reaching for some higher purity. He even disagreed with critics who thought that cubism abstracted form or reduced art to essentials. He

admired cubism, he said, because "it didn't want to get rid of what went before. Instead it added something to it." De Kooning recoiled from those modernists who sought to "free art from itself. Until then, Art meant everything that was in it and not what you could take out of it." According to de Kooning, "The question, as [such modernists] saw it, was not so much what you *could* paint but rather you could *not* paint." Obviously, the man struggling with *Woman I* was in no mood to take orders from theorists. "The group instinct could be a good idea," he wrote, "but there is always some little dictator who wants to make his instinct the group instinct."

> Spiritually I am wherever my spirit allows me to be, and that is not necessarily in the future. I have no nostalgia, however. If I am confronted with one of those small Mesopotamian figures, I have no nostalgia for it but, instead, I may get into a state of anxiety. Art never seems to make me peaceful or pure. I always seem to be wrapped in the melodrama of vulgarity. I do not think of inside or outside—or of art in general—as a situation of comfort. I know there is a terrific idea there somewhere, but whenever I want to get into it, I get a feeling of apathy and want to lie down and go to sleep. Some painters, including myself, do not care what chair they are sitting on. It does not even have to be a comfortable one. They are too nervous to find out where they ought to sit. They do not want to "sit in style."

"Sit in style," which suggests aristocratic comfort, also sounds like "sit in judgment." He liked neither perspective. He liked no better the idea, frequently argued in the fifties, that the rise of science led inexorably toward abstract art. As in "The Renaissance and Order," he argued for a different measure:

> That space of science—the space of the physicists—I am truly bored with by now. Their lenses are so thick that seen through them, the space gets more and more melancholy. There seems to be no end to the misery of the scientist's space. All that it contains is billions and billions of hunks of matter, hot or cold, floating around in darkness according to a great design of aimlessness. The stars I think about, if I could fly, I could reach in a few old-fashioned days. But physicists' stars I use as buttons, buttoning up curtains of emptiness. If I stretch my arms next to the rest of myself and wonder where my fingers are—that is all the space I need as a painter.

De Kooning ended "The Renaissance and Order" with a parable about a village idiot obsessed with measuring things. "What Abstract Art Means to Me" concluded, in turn, with a parable about abstraction.

> About twenty-four years ago, I knew a man in Hoboken, a German who used to visit us in the Dutch Seaman's Home. As far as he could remember, he was always hungry in Europe. He found a place in Hoboken where bread was sold a few days old—all kinds of bread: French bread, German bread, Italian bread, Dutch bread, Greek bread, American bread and particularly Russian black bread. He bought big stacks of it for very little money, and let it get good and hard and then he crumpled it and spread it on the floor in his flat and walked on it as on a soft carpet. I lost sight of him, but found out many years later that one of the other fellows met him again around 86th street. He had become some kind of a Jugend Bund leader and took boys and girls to Bear Mountain on Sundays. He is still alive but quite old and is now a Communist. I could never figure him out, but now when I think of him, all that I can remember is that he had a very abstract look on his face.

Not surprisingly, a picture as fraught with ambitious complication as *Woman I* did not easily resolve into a good and tidy painting. That was de Kooning's final, great difficulty with *Woman I:* he knew what a "resolved" painting looked like, but his feeling for the truth did not allow for such resolutions. In January or February 1952, more than a year and a half after he began the picture, de Kooning almost found an image that satisfied him. And yet, not quite. "There followed a few hours of violent disaffection," said Hess. In the end, de Kooning angrily ripped *Woman I* off the frame and left it in the hallway by his door, with a stack of old cardboard and odds and ends of wood. He seemed finally to have accepted failure in that one picture. He did not abandon the struggle, however, or return to abstraction. Instead, he began three other *Woman* pictures.

Later that year, the art historian Meyer Schapiro walked up the stairs of de Kooning's Fourth Avenue studio and knocked on the door. While such a visit was not unheard of—Schapiro, like many writers, critics, and painters in Greenwich Village, sometimes made studio visits—it was also not routine. Schapiro, a busy scholar who taught at Columbia University, was not a close friend of de Kooning's and did not frequent the Cedar or make the rounds of the studios the way Harold Rosenberg did. However,

among serious artists, Schapiro was the most respected art historian of the time. He was famously learned, maintaining interests ranging from the Romanesque to abstract art, and a celebrated lecturer who could bring art vividly to life. What distinguished him downtown, though, was that he was not a worthy drudge locked in the academy. Schapiro was passionately *modern*, his mind steeped in the issues of his time. Not only did he know his Marx and Freud, he sympathized deeply with the spiritual, moral, and aesthetic challenges faced by individual artists in Western culture, of whatever time period.

One of Schapiro's passions was van Gogh. In essays about the struggling Dutch painter, who had left Holland to go to France, Schapiro repeatedly described Vincent's art as an "avowal." He could hardly fail to sympathize with the predicaments of another tormented Dutch immigrant who, far from home, was struggling with his demons and creating storms in the paint. It may be that Hess, Motherwell, or Elaine suggested that Schapiro visit de Kooning's studio, with the hope that the scholar would provide some words of encouragement. But Schapiro himself had doubtless heard of de Kooning's difficulty in finishing *Woman I*, for he already respected both de Kooning's art and his turn of mind.

De Kooning, as was his habit, offered his guest a cup of boiled and very strong coffee. During their talk, the scholar brought up the abandoned canvas. "Let's talk about this," he said, encouraging de Kooning to bring the picture back into the studio. What exactly Schapiro said is not known, though he remembered telling de Kooning that he thought the painting was fine the way it was. But Schapiro was a brilliant teacher who was famously inspiring when he lectured. No doubt his eyes lit up, his words began to flow, and the room around him seemed to swell with possibilities. Schapiro's spirited conversation in front of the picture probably gave de Kooning the reassurance no one else around the painter had been able to provide. In contrast to the critics of the period, engaged in the battles of the day, Schapiro was a scholar whose vision encompassed both the past and the present. If he approved of de Kooning's eccentric *Woman I*, then perhaps the picture would not have to stand ashamed before history, as some painters and critics said. Perhaps its tensions were not just outlandish or embarrassing or unresolved. Perhaps its spit-in-the-eye "imperfections" were part of its power. Perhaps it was even an important "avowal" in the tradition of van Gogh. Schapiro distrusted highly aestheticized approaches to art, preferring artists whose work erupted into form out of personal necessity. If Soutine gave courage to de Kooning at the outset of his struggle with *Woman I*, no one was better positioned than Schapiro to embolden de Kooning at the end.

Schapiro's spring visit lifted the darkness around de Kooning. He put *Woman I* back on his painting frame, made some further changes, and declared it finished in mid-June 1952. He had been blocked for three years. He began work on the three other *Women* with renewed conviction, able to complete them rapidly now that he could accept their character.

Nothing better suggested the sudden brightening of mood than de Kooning's decision to abandon the studio on Fourth Avenue. The old space was steeped in struggle, pain, and exhaustion. It was there that he had passed the cruel war years when his marriage unraveled and poverty pressed upon him; there that his heart raced out of control as he created his black-and-white style and searched for his fearsome *Woman.* He recoiled from its dinginess and disliked sharing a porous wall with another painter. With *Woman I* completed, he could uproot himself once again and start afresh. (The sale of *Excavation* also momentarily enriched him.) He often visited the painter Esteban Vicente, who had moved into a nearby studio at 88 East Tenth Street the year before, and de Kooning asked him to let him know if something became available in the building. Vicente, like de Kooning, was an immigrant (from Spain) who shared de Kooning's Old World training and respect for tradition. Mary Abbott had also once lived in that row of houses.

De Kooning liked the neighborhood. Fourth Avenue was crowded with used book shops and browsing intellectuals: on the northeast corner of Fourth Avenue and Tenth Street was a large used bookstore, and on the southeast a dive called the Terrific Bar—"terrific" was one of his favorite American words. There was also a German restaurant and a Polish saloon. A couple of what the painter Mike Goldberg called "bum's bars" occupied the ground floor and basements of the walkups; no doubt de Kooning liked that the block "belonged to the bums," as Pat Passlof put it. When the space on the top floor across from Vicente became available, de Kooning decided to rent it.

In the same period, Leo Castelli and his wife, Ileana Sonnabend, invited de Kooning and Elaine to spend several weeks with them in their large old shingled house on Jericho Road on the outskirts of East Hampton, a village on the eastern end of Long Island that was an elegant summer retreat for New Yorkers. De Kooning and Elaine now lived separately, but had no difficulty with a temporary arrangement of this kind; they remained married, still saw each other frequently at social events, and sometimes went places as a couple. The invitation from Castelli was another indication of de Kooning's acceptance in the art world, and it gave Elaine and de Kooning the chance to visit a place where increasing num-

bers of New York artists and writers were settling in the summer. Pollock lived year-round in the Springs, a few miles from East Hampton; Rosenberg, Motherwell, and many others were nearby. Besides, a Dutchman who loved the water and had grown up in a flat landscape near the sea would naturally like the eastern end of Long Island: there were even windmills in the area.

De Kooning set up a studio on a screened porch. "Since he wanted quiet and isolation," said Castelli, "he made a wall to separate his studio from the rest of the house." Elaine worked in a more open part of the porch, moving inside whenever it rained. (During one period of bad weather, she painted a portrait of Castelli.) Now that *Woman I* was complete—perhaps—de Kooning was eager to begin work on other pictures in the series. He did not want to lose his focus and kept to himself during the day, refusing invitations to join the crowd that went to the beach. Instead, when he was restless, he would bicycle around the area, a typically Dutch practice. Castelli said de Kooning completed little while he was in East Hampton. He mostly spent his time drawing and making what Hess called "relaxed, light-hearted pastels." But he still worked very hard, and the summer in East Hampton was probably responsible for giving some of the *Women* a country air. His palette began to lighten, with more pastel hues, and the paint became somewhat more watery. One famous image from the series, *Woman and Bicycle*, contains hints of water. In any case, de Kooning, wherever he happened to be living, was always ready to bring the sea into a picture. He told Rosenberg:

> *Woman I*, for instance, reminded me very much of my childhood, being in Holland and near all that water. Nobody saw that particularly, except Joop Sanders. He started singing a little Dutch song. I said, "Why do you sing that song?" Then he said, "Well, it looks like she is sitting there." The song had to do with a brook. It was a gag and he was laughing, but he could see it. . . . It's just like she is sitting on one of those canals there in the countryside." In Rotterdam you could walk for about 20 minutes and be in the open country.

Although de Kooning loved the Long Island landscape, he recoiled from the polished, old-money atmosphere of East Hampton. It reminded him of the wealthy families in Rotterdam who controlled the business of art. Once, when he was riding his bicycle, a woman waved him over and asked him if he was her neighbor's "man." When de Kooning said no, the woman nonetheless ordered him to tell his employer that if his dogs kept

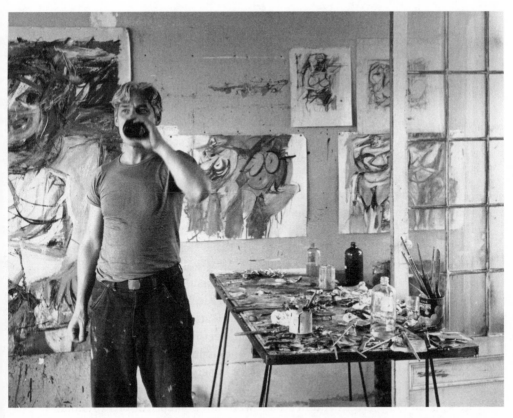

At work on the porch of Leo Castelli's house in East Hampton in the summer of 1953

bothering her cats she'd call the police. (De Kooning later said he never wanted to live in a place where people had "a man.") De Kooning preferred the Springs, a working-class hamlet just beyond East Hampton where Pollock lived in a small house: he felt comfortable in this simpler area near the sea.

On summer nights the Castelli house filled with friends and laughter. Artists in the area often came for drinks and dinner. So did a mixture of others, including writers, collectors, and even some of the wealthy people in the Hamptons who did not have a direct connection to art. This social mixture was something new for de Kooning. His world had been composed almost entirely of working artists. Even the Cedar, in 1952, was populated mostly by downtown artists. (The outsiders who came to drink with artists had not yet arrived.) Although de Kooning had never felt comfortable around socially ambitious or prominent people in America,

he discovered, now, that he had more than enough status to fascinate people who were not members of his world. At the Castelli dinner parties, de Kooning sometimes said little, in itself interesting to outsiders. What was this painter, who spent all day on the porch creating strange images of women, thinking? De Kooning found that it was not necessary to carry on a polite conversation. No one expected him to. Besides, Elaine could talk enough for them both. When de Kooning did talk, he would often light upon something—and send it spinning in some unexpected direction. The guests were not always sure what he meant, but they loved the surprise of it.

A regular guest at the Castelli house was Harold Rosenberg, who had a summer cottage in the Springs. Although Rosenberg had known de Kooning for many years and had visited his studio, the two men were not particularly close during the thirties and forties. Rosenberg directed most of his early critical work toward Gorky, Pollock, Baziotes, and Hofmann. During that summer, however, the friendship between Rosenberg and de Kooning deepened, in part because de Kooning loved eccentric, outsize characters. The two men's conversational styles were complementary. Rosenberg loved to propound, lecture, and, in his nasal and high-pitched voice, just talk, talk, talk the night away; de Kooning's darting way with the elliptical or unexpected observation would, in turn, pop any gathering pretension and stimulate Rosenberg into creating fresh castles in the air. Serious intellectuals were often skeptical of Rosenberg's conversation. According to William Barrett, a key figure at *Partisan Review*, Rosenberg "had the bewildering habit, even while he dazzled you, of leaving any subject more complicated and puzzling than when he took it up." But de Kooning relished exactly that ambivalent effect; he appreciated intellectual talk so long as it was open-ended and seemed to invent itself as it went along. "I don't think writers are necessarily more intelligent or better speakers than artists," he said, "but I find their conversation very stimulating. Sometimes I could say of myself that I painted with a good ear, because their talk, the words they used, made a picture in my mind."

Just as important, the cultural moment made the two men allies. Unlike Greenberg, Rosenberg believed that, in 1952, a major painter was still free to depict the figure. Indeed, he insisted upon that freedom. In contrast to Greenberg, who respected art more than artists and emphasized what the historical evolution of form demanded of original art at any particular moment, Rosenberg instead stressed the moral position of the artist in a debased society—especially the willingness of the alienated

artist to challenge that society by freely developing his individual vision. He was outraged by Greenberg's imperious *dictats*. As a social philosopher and literary critic who revered Dostoevsky, Rosenberg thought de Kooning was wrestling with his furies in ideal Dostoevskian fashion. It was not easy for Rosenberg to find an artist-hero who could wear the existential crown that, in the early fifties, the critic longed to bestow. Gorky was dead. Rothko, Rosenberg thought, had "a business-man's mannerism." And Pollock appeared increasingly lost—either desperately drunk or, when he was on the wagon, desperately wanting to be drunk. Why not de Kooning?

Rosenberg was growing increasingly disenchanted with Pollock. The artist's wife, Lee Krasner, disturbed by her husband's problems yet fiercely protective of his reputation as the most significant American painter of his generation, sensed that Rosenberg and others were beginning to turn away from him. At parties, she and Elaine would circle around each other, superficially friendly, but wary as cats, each fixated upon her husband's genius. And now, Castelli had invited the de Koonings to live at his big house in fashionable East Hampton and was giving parties to which Lee and Jackson were often not invited, largely because of Pollock's surly behavior. Lee's resentment was sharpened by her great respect for de Kooning as a painter—a lesser figure would not have similarly aroused her competitive ire—and a long-ago romantic slight. In the late thirties, Lee, a proud and highly sensitive woman, had become infatuated with de Kooning. Not only did she regard him as a brilliant artist, but she also found him handsome, charming, sociable, and funny. She "adored" him and sometimes followed him around the galleries. At a New Year's party in the late thirties, she sat on his lap, acting kittenish. Then, according to the Pollock biographers Naifeh and Smith, "at the climactic moment . . . just as she was about to kiss him he opened his knees and let her drop comically to the floor, humiliating her in front of friends and fellow artists. After drowning her shame in drink, she began to rail at him, calling him 'a phony' and 'a shit,' until Fritz Bultman dragged her away and forced her into the shower with all her clothes on."

Pollock would regularly show up unannounced at the Castelli house, sometimes stumbling with drink, to visit de Kooning. He would leave his Model A running in the driveway, shaking and rattling like an old teapot, as he roamed through the house shouting for Bill. The purpose of the visits, which Lee objected to, was never quite clear. Pollock may have sensed that the art world was beginning to take sides; the politicking may have disturbed him. De Kooning would always spend some time with Pollock,

but, like most of the art world, he did not know how to handle the distraught painter. In any case, neither Pollock nor de Kooning was the sort of man who could banish competition, end neurotic nonsense, and tell wives and others to stop meddling.

Pollock's boorish behavior was beginning to make him unwelcome in the Castelli house even during the day. A year or two later, when Pollock visited Rosenberg in the Springs and began "acting drunk and pissy," Rosenberg stood up and, according to one observer, "got a very tall glass, filled it to the top with straight booze and gave it to Jackson, ordering him to drink it. It was very cruel and humiliating. Jackson took a couple of small sips and then left."

In the fall, de Kooning moved to 88 East Tenth Street, across the hall from Vicente, who faced the street. The building, on the south side of the block, pushed out in back beyond the building east of it. De Kooning's space was long and narrow. His painting wall was in the rear, where the building jutted into an unkempt garden. To the left and right of this wall were windows, the west one opening onto an air shaft and the east one overlooking some scroungy city trees and a mass of tangled greenery that was home to dozens of alley cats. He blacked out the air shaft window, which faced a small factory where young women worked. Unlike his treatment of the Fourth Avenue space, de Kooning took pains with the new studio. In addition to bringing his kerosene stove and battered old cupboard with him, he carefully built a new table on which to set his paints, talking to friends as he worked. Milton Resnick sometimes stopped by to help him fix things up. (Resnick himself soon rented a studio in the building.) Harold Rosenberg, now a fast friend, dropped in several times a week to talk about art and to encourage de Kooning to pursue his elusive vision. Rosenberg often brought a bottle.

In the new studio, de Kooning took yet another look at the *Woman* series, and resumed making changes. Then, in December 1952, just before sending the pictures off to the Sidney Janis Gallery, he once more attacked the original image, *Woman I*. When first laying in the picture, he had intentionally used more canvas than the image required, to give himself some flexibility if he should wish to change the size of the painting or the positioning of the figure. He covered the unused edges in aluminum paint so they would not "make a plane." Now, he decided to include those eight added inches on the right, thereby putting the figure more off center and adding some aluminum-colored open space to the image.

Sidney Janis knew, of course, of de Kooning's struggle with *Woman I*, and hoped it was a phase he would ultimately abandon. The artist whom he had asked to join his gallery was the painter of *Excavation*, after all, not the painter of weirdly ferocious female idols; as a champion of abstract art, particularly that of Mondrian, Janis was well aware that many serious critics and painters believed that abstract art owned the future. He was only just beginning to show contemporary American art and wanted to present pictures that, to his eye and that of the collectors he knew, could live comfortably with the forward-looking masterpieces of European modernism. The abstract black-and-white paintings were perfect for this purpose. It made no sense to the art dealer that de Kooning would turn away from *Excavation*. Of course, de Kooning could add color and tinker

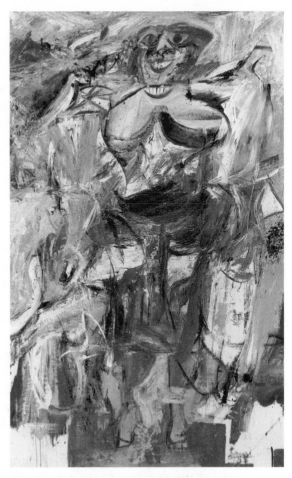

Woman and Bicycle, *1952–53, oil on canvas,* 76 ¹/₂″ × 49″

with scale, but why abandon altogether such a magnificent style? Hadn't Mondrian spent decades refining a particular look? Now, this American painter was asking him to exhibit some of the most difficult figurative paintings of the century. Even Castelli, who maintained closer relations than Janis did with artists downtown, preferred the black-and-whites to the *Women*. In any case, de Kooning was slow to want a show; Janis had to prod him. Once, when Robert Jonas happened to be visiting the studio, Janis came by to encourage his painter. De Kooning, Jonas said, "treated him very coolly and said he wasn't ready."

Despite Janis's misgivings, de Kooning took genuine satisfaction in

Woman I. His treatment of the theme gave him the sensation of a truth that was plural, never pure, and powerfully informed by the awkward and the paradoxical—elements somewhat concealed by the gorgeous fluency of his black-and-white paintings. When Janis, on another visit to de Kooning's studio, asked him to return to an abstract style now that he had gotten this "Woman" out of his system, the painter complained to friends that the art dealer did not know what he was talking about. But Janis agreed to show the outrageous pictures in March 1953.

Woman I

"I sound my barbaric yawp over the roofs of the world," announced Walt Whitman in *Song of Myself.* The barbaric yawp of American painting is *Woman I*, the most unsettling painting of the postwar period and one that sometimes seems as difficult to look at as it was to make. Fifty years after they were completed, the drip paintings of Jackson Pollock fit comfortably into the museums, as do the black-and-whites of de Kooning. And curators can present without a second thought the most extreme statements of sexual anger or outrage. But *Woman I* still appears eternally out of place—homeless among the masterpieces at the Museum of Modern Art. *Woman I* is personally, socially, culturally, and artistically fraught with uncertainty. Its anxiety is irreducible. It breaks all rules of safety, even those of the avant-garde.

Woman I was an eruption, opening a Pandora's box that not only liberated the demons of one man, but also released many essential issues that would bedevil art and culture during the last half of the twentieth century. At the heart of the anxiety in the painting was the fear that something shockingly unexpected might fly out. A woman, a picture, art itself, might explode into the unexpected or embarrassing. Alcopley once asked de Kooning why, when he was surrounded by so many attractive women, he chose to paint *Woman I* as he did. De Kooning said, "Al, go to Klein's [a department store on Union Square]. Go to the bargain center."

And I saw how these women were—how greedy and nasty they are. It was much worse than he had told me. Women were just tearing the bargains to pieces. I looked at their faces; he had painted from memory what he had seen. It was this woman. Otherwise you see them in this store and they are all elegant. And then they come to the bargain table and are like animals. I don't know why, but this attracted him. Perhaps

he had some memories of certain women who were otherwise angelic and lovely and became like this.

De Kooning's remark that he intended to paint a beautiful woman—but that she changed, willy-nilly, into a monster—described such an unanticipated transformation. When he was a child, de Kooning's mother often burst into unpredictable and violent rages. A mother who could not be depended upon, who would erupt into furious anger, could well become an idol who must be propitiated and a symbol that no security or trust can be found in this world. (The high heels in many of the *Women* look like potential weapons.) Even as an adult, de Kooning was unconsciously on guard against the unexpected attack: Conrad Fried once innocently raised his hand, and de Kooning flinched as if he were about to be struck.

But *Woman I* is far from being just the respectful propitiation of a great power. Critics have made a mistake when they overemphasized the female figure in the painting, isolating her for discussion, for *Woman I* is the depiction of a relationship. It suggests two figures locked in struggle. If the artist himself is not literally described, he is present nonetheless in the slashing and furious brushstroke. The perspective is that of a child looking up at an adult. The calligraphic line, as personal as any in art, dances in furious attendance upon the figure. Yet she remains almost immovable, her outsized eyes and toothy leer seemingly fixed in place while everything around her erupts in mayhem. There is no better suggestion in art of a tantrum, no truer rendering of the child who knows only that he *wants*—and is desolate—as he hurls himself back and forth against an unyielding strength. De Kooning's mother did not like to touch children, except for public show, which may help explain why he had such difficulty depicting hands. In the *Women*, hands are typically either hard to find or reddish claws. Yet the terror and hatred in *Woman I* are interesting because de Kooning succeeded in conveying, at the same time, so much physical longing. The sculptor Isamu Noguchi once said, rightly, "I wonder whether he really hates women. Perhaps he loves them too much."

The sexual anxiety in *Woman I* is palpable. It almost forces the eye away, as one would turn away from another's sudden and unexpected embarrassment. It seems visceral, frank, unabashed, humiliating—and far more immediate than that found in the European surrealism of the twenties and thirties, where the sexual tension often looks calculated or bookish, as if it came from a drawer. The teeth of *Woman I* are not the Latinate *vagina dentata*; they are smiling American choppers without a conscience. In *Woman and Bicycle*, the female figure even has two sets of

teeth, the lower one becoming a necklace above her breasts, as if she were ready to snap should any pathetic boy wish to suckle. And yet, as always, de Kooning's brush also caresses.

In *Woman I*, the eruptions and ambiguities are not just personal. The picture is temporally unstable as well, sliding uneasily between past and present, evoking both the ancient icons and the modern goddesses of mass culture, whom Hess called "the American female idols in cigarette advertisements . . . the girls whose photographs are paraded through the city on the sides of mail trucks, pinup girls with their extraordinary breasts." Part of the picture's instability comes from the way de Kooning collapsed the grandeur of ancient and primitive art into the present. A bedrock figure of human consciousness—the female idol—becomes the cause of intense contemporary anxiety. There is nothing left in *Woman I* of the fertile and reassuring earth mother, nothing of the still, Olympian presence of a goddess—although it is clear from the cubist underlay of the picture that the artist understands stability and structure. Instead, she is the mistress of the monstrous visual flux of the modern. Are the cutie on the billboard and the siren on the screen concealing their true nature? Will their feral spirit escape from behind the beautiful banality of Hollywood's mask?

For those concerned with the modernist proprieties, however, the greatest anxiety aroused by *Woman I* came from de Kooning's fierce assault on taste. It was sometimes believed by modernists—who admired above all things the revolt of nineteenth-century avant-garde art against bourgeois society—that only the stuffy bourgeoisie suffered from good taste. But "good taste" could form in all intellectual circles and social environments, on the left no less than the right, and in *Woman I* de Kooning managed to challenge almost every standard. It went without saying that in 1952, when the argument "my nine-year-old could do that" was still being seriously made against modernism, middle-class Americans would hate this picture. But *Woman I* also offended serious collectors and curators—people of discernment—in part because it seemed to bring together qualities that should still remain apart, or when brought together done so with irony and tact. A serious or trained eye in 1952 would have immediately seen that de Kooning was a brilliant draftsman and a painter who loved both Rubens and the cubists. Why would such an artist jangle those traditions into this grotesque scrawl of a woman? It was one thing to shout "Fuck you!" It was quite another to shout it in elegant French. In the *Women*, the elegant and the vulgar became indistinguishable, an impure mating that many found more disturbing than the mixture of hatred and love in the series.

In *Woman I*, de Kooning first expressed his class anger in a mature form, one directed as much at highbrow modernists like Greenberg as at bluebloods in the Metropolitan Museum of Art. De Kooning knew in his bones that taste often betrays truth—or at least his truth. Earlier in his life, de Kooning occasionally called upon the rude or goofy. He always relished cartoons (as a young man, he drew them). Some of his goggle-eyed women from the late thirties and early forties were bizarre. In *Woman I*, however, de Kooning emerged as the master of a Rabelaisian strain of grotesquerie that was traditionally very important in the Low Countries and was found in those scenes of drunkenness and debauchery that, whatever their overt moralizing, served to counter an often oppressively smug Dutch Calvinism or august Catholicism. It was an essentially petit bourgeois art that provided recognition, in short, for the earthy life lived beyond the pale of manners and taste. The figure in *Woman I* does not have breasts; she has boobs. No American critic of the period recognized de Kooning's transposition of this Dutch and Flemish perspective into American art. Neither the Puritan cast of American culture nor the new determination to show that American art could be as "high" as any other nation's permitted frank enjoyment of the sublime vulgarity of *Woman I*. Many in the art world could accept manly brawniness as a quality that might distinguish American truth from European taste, but not this rude catcall in the temple. A man like Leo Castelli could easily admire *Excavation*, for example, as he would one day admire the smart ironies in American pop. But *Woman I*? He recoiled. It was too vulgar, too petit bourgeois, for an educated European.

A kind of manic, hooting, and inelegant laughter attends *Woman I*. De Kooning himself, when asked about the painting, insisted upon "the hilariousness of it. I do think that if I don't look upon life that way, I won't know how to keep on being around." "Beauty," he said elsewhere, "becomes petulant to me. I like the grotesque. It's more joyous." The laughter recalled the roughhouse joy of de Kooning and his friends when they tried, in the thirties, to adopt the classical poses of Nijinsky. De Kooning even found the teeth of the American cuties that he scissored out of magazines desperately funny. They were impossibly straight, perfectly white, a symbol of purity that could hurt and humiliate. And these teeth were so unlike his own.

There is a final desperation in *Woman I*, one that has grown more poignant over time. In 1952, de Kooning sensed that the possibilities for painting in the last half of the twentieth century were narrowing. What were the great formal issues that might yet stimulate major work once

cubism and surrealism were brought together in *Excavation*—and transcended in the manner of Pollock, Rothko, and Newman? And what was to become of the individual self in modern society if art now sought to leave behind the personal brushstroke and flirt with infinite spaces? With *Woman I*, de Kooning began to place enormous pressure upon both the conventions of painting and upon the romantic cult of the individual, not to destroy them, as later artists and critics felt driven to do, but to preserve them. In *Woman I*, he celebrated, with "go to hell" conviction, his know-how, his love for the idiosyncratic brushstroke, and his devotion to traditional iconographies.

In *Woman I*, art seemed to have no settled home. There was no illusion that art was moving step by historical step toward some future destination or that the figure could be firmly situated in modern space. There was no reassuring settlement, finally, of any of the modern dilemmas—not from this immigrant painter. The picture was constructed of paradoxes, not the least of which was that it was at once radical and conservative. It conveyed de Kooning's quarrel with a tyrannical, devouring, and hilarious muse, and, more important, embodied his frustrating conviction that in contemporary culture a "resolved painting" might amount to a lie. What Schapiro inspired in de Kooning was, above all, the thought that perhaps, just perhaps, a picture should *not* appear fully resolved: perhaps the forms should not settle into a finished "composition"; perhaps there should be something fundamentally broken in the image if you were to convey the ambiguous meanings of modernity. If de Kooning played the good boy in *Excavation*, exquisitely balancing the twin inheritance of cubism and surrealism, in *Woman I* the two traditions banged and scraped against each other. His "personal mark" shredded the cubist grid; the grid, in turn, became a rattling and imperfect cage. There must be no final reconciliation. As de Kooning said:

> For many years I was not interested in making a good painting—as one might say, "Now this is a really good painting" or a "perfect work." I didn't want to pin it down at all. I was interested in that before, but I found out it was not my nature. I didn't work with the idea of perfection, but to see how far one could go.

This approach, of course, was highly dangerous. It could be used to justify failed or sloppy work. Many people believed—and have continued to believe—that de Kooning after *Excavation* fell into decline. Clement Greenberg would soon argue that the work de Kooning made after the black-and-white paintings reflected a failure of responsibility and, ulti-

mately, of character. The painter's sensibility went slack, Greenberg thought, when he refused to respect the evolving demands of history and the visual requirements of serious composition and, instead, merely indulged his genius as a draftsman. But when an artist of de Kooning's power, who knows very well what formal resolution is, chooses for expressive reasons *not* to fully resolve his pictures, the image develops a haunting power. *Woman I* contains the implication of a well-made painting, the ghostly air of the rejected resolution. That is perhaps its single most disturbing aspect: he can, but he won't.

24. Our Gang

There's no way of looking at a work of art by itself. It's not self-evident—it needs a history, it needs a lot of talking about; it's part of a whole man's life.

During de Kooning's long and public struggle with *Woman I*, Elaine would sometimes twist her face into a look of comic indignation—she had the quick features of an actress—and declare to friends that it was obviously not *she* who was the model for the fearsome figure in the painting. No, if anyone was responsible, it was Bill's mother, whom Elaine often likened to the imposing and busty figurehead on the prow of a ship. But anyway, she implied, it was absurdly corny and vulgar to argue that a great artist like Bill would ever deign to be so literal. Only earnest drudges and bush-league critics would take such a view. She herself *loved* the series of *Women*. They were yet another example of Bill's genius. And weren't some of them funny?

Both Elaine and her brighter friends understood, of course, that this approach to the *Women* was somewhat disingenuous. *Woman I* might indeed be both no woman and Everywoman, at once the mother from hell and the whore in the door; indeed, she might be whatever an imaginative intelligence found in her. But she could not also fail to be, in some part, a reflection of Elaine's marriage to Bill. A sensibility as alive to the emotional resonance of the female form as de Kooning's could not help but let inchoate feelings about the marriage find expression in this painted woman whom he had so much trouble "resolving." The air of revelatory shock could suggest, among other things, that here the real truth had emerged gloating and grinning from behind the mask of marriage.

Elaine's jokey dismissal of any comparison between herself and *Woman I* therefore served an important social purpose. It sent a signal to the world about the character of her marriage, implicitly ridiculing the gossip and the unspoken thoughts of friends who might suppose that something was essentially wrong in the relationship, or that, in de Kooning's mind, Elaine had turned into his mother. She even asked the photographer Hans Namuth to take a photograph of her beside the painting. "I said, 'Take one of me in front of the painting to demonstrate, once and for all, that it has nothing to do with me.' Hans snapped me standing in front of the painting and I was fascinated to discover that I became part of the

painting, as though I were the *Woman*'s daughter and she had her hand, protectively, on my shoulder."

In other words, she was more de Kooning's sister than mother. No one could conclude from her attitude of laughing dismissal that de Kooning hated women in general or Elaine in particular. In the meantime, she continued to talk about "Bill" constantly. He was so much a part of her conversation—what Bill said yesterday to Franz at the Cedar, what new brush Bill had just bought, what that bastard Clem was saying about Bill—that anyone listening to her could easily assume that she had just left de Kooning's studio a few minutes ago. She gave the impression that it did not matter to her that they did not live as the usual "man and wife." Indeed, she made it a point of pride. Among the artists and poets at the Cedar, little or no respect was paid to the conventions of marriage or family. The important life was lived in the studio and the bar, not in the home. The situation of wives—especially those raising a family on an uncertain income—was very difficult. The status of "wife" counted for little when compared to that of "artist," and many men doubted that a woman could be a serious artist. Those wives who were also artists were expected as a matter of course to sacrifice their art to husband and family. (Annalee Newman, the wife of Barnett Newman, was regarded as saintly for supporting her husband for decades by working as a stenography teacher.) And few male artists tolerated any conventional limits placed upon their sexual freedom. Staying out all night with the new girl met at the bar was one of the privileges of the profession.

The strongest female figures of the period, refusing to be pitied, became remarkably tough survivors. They often did so not by rejecting the macho of the period, but by embracing it, showing the world that they could out-boy the boys. Lee Krasner was manly-looking and had a blunt manner. Louise Nevelson seemed to live behind a wall of royal self-confidence. Joan Mitchell had a mouth that could shame a marine and could be especially cutting about other women. She called Helen Frankenthaler, who was known for staining her unprimed canvas with misty washes of paint, "that tampon painter." Elaine, in turn, drank as hard as any man, played the field like a male artist, and adamantly refused to accept the part of meek wife or mistress. She regularly repeated de Kooning's famous quip: "Vat we need is a wife."

Elaine's behavior implied that she and Bill were past all that, having transcended the conventional jealousies and claustrophobic arrangements of bourgeois society. It made a fine image to set against *Woman I*. The example of Simone de Beauvoir, who had published *The Second Sex* in 1949, probably reinforced Elaine's attitude. De Beauvoir was well known

for her apparently free and unconstrained relationship with the existentialist philosopher Jean-Paul Sartre—then a hero to many New York painters and intellectuals—and the couple had toured the United States together. Although Elaine was not an early feminist, she would naturally approve of this European arrangement, in which two people could be both free and committed to each other. Among admiring friends, many of them refugees from the traditional war between the sexes, Elaine's relationship with de Kooning began to seem a fashionable ideal and a model for modern artists.

In the late 1940s and '50s, Elaine even had affairs with de Kooning's two main critical champions, a brief fling with Rosenberg, and a longer, more substantive relationship with Hess that extended well into the decade. And yet, no one doubted that de Kooning remained the most important man in her life. Many, in fact, believed that she chose to sleep with the two critics in order to promote her husband's career. That act of devotion was, however, unnecessary; they were already committed to de Kooning. The truth was probably simpler. Elaine was an appealing and seductive woman who was separated from de Kooning and chose not to take sex very seriously; if she had done so, her life with de Kooning would have been too wounding.

At the Cedar, the new air of success around American art together with the loosening of restraints created by drinking brought a special swagger to evenings. It was hardly surprising that middle-aged male artists, making up for lost time, should play cock of the walk. De Kooning was no exception and casually saw different women. A few represented liaisons of a night, two nights, or a week. Occasionally, he would be seeing several women at once. In the early fifties, he set up a bell system at his studio to protect his privacy and sort out his girlfriends, giving each a different signal, such as one or two or three rings. That way he could be out, when necessary, while at home. Although he may have felt under some pressure to join in the cowboy swagger, de Kooning was still not generally regarded as sexually aggressive. He could even be courtly and old-fashioned; like many Dutchmen, he enjoyed giving flowers. The art world, moreover, was still a small and remote place. The women who look mainly for power, money, and celebrity had not yet arrived upon the scene. De Kooning's liaisons continued to be with old friends, artists and aspiring artists, and those who, as one woman put it, were looking for a great soul, not just great power or great sex.

What de Kooning loved most was the flare of the quick infatuation. That seemed to nourish his work; the intensity of the early days of a rela-

tionship could carry over into the paint. He could be almost feminine in his intuitions about a person he was interested in and extraordinarily receptive to the mood of the moment. (The next day he might be coolly aloof.) In his more sustained relationships, he also had a remarkable gift for finding a woman who could strengthen him in some fashion, providing just what he needed at that particular moment. During one of his bleakest periods, for example, when art hardly seemed worth the struggle, Mary Abbott brought a sensible, bright, and youthful good cheer into the dark Fourth Avenue studio.

The most important woman to enter de Kooning's life in the early fifties was Joan Ward. She and her twin, Nancy, began dropping into the Cedar in the winter and spring of 1951–52, when they were in their mid-twenties. De Kooning immediately liked Joan's down-to-earth manner. She had a good brassy laugh and was very bright, but not intellectual, with a pleasing suspicion of cant and mumbo-jumbo and a humorous twinkle in her eye. Perhaps she reminded him of women from Rotterdam who worked and played hard and were quick to mock Amsterdam airs. Ward disliked the relentless and airy theorizing of Harold Rosenberg—"that thin nasal voice"—whenever he dropped by the studio. She thought a John Cage concert was preposterous. She didn't like snobs of any kind. De Kooning found her refreshing, in part because some piece of him remained eternally suspicious of the big city and its pretensions. Like his barkeep mother, he did not want to be sold a bill of goods by a fast talker. And especially in 1952 and 1953, he was sensitive to the slights and snubs of high-minded intellectuals. He knew many artists and critics recoiled from the American vulgarity of his *Women*. Joan was not that way.

The Ward sisters were commercial artists who came to New York in 1945 from Clark's Green, a small town near Scranton, Pennsylvania. Their father, who was English, grew up performing in music halls. He met their mother, who was from a well-off Welsh family in Scranton, while both were taking classes at the Art Students League. (Before the marriage, their mother dated Alexander Calder.) During the Depression, the couple was unable to make ends meet, and they split up. The twins' father joined the U.S. Army, and they rarely saw him; their mother moved with the girls to rural Pennsylvania. The twins spent much of their childhood drawing. "We were raised on commercial art," said Ward. "We loved the great illustrators." In 1945, after their graduation from high school, they moved to New York and, like their mother before them, enrolled in the Art Students League. Their father decorated a studio apartment for them in the legendary Artists' Building on Tenth Street, built to provide studio

De Kooning with Joan Ward in the early 1960s

space for nineteenth-century American artists. Their apartment had no bathroom, no kitchen, and was often freezing cold—in short, it was, ideal for two adventurous and high-spirited girls just starting out in New York.

The Ward sisters soon found work as sketch artists. Joan was hired by the J. M. Mathes advertising agency, whose largest account was Canada Dry Ginger Ale. By 1952, they were both successful career women. At the Cedar, they were very popular. Young and pretty women were still fairly rare in that artist and workingman's bar. Some of the more sour spirits muttered that they weren't "proper" artists. Both de Kooning and Kline, however, had worked as commercial artists and respected the field. The genial Kline—who, like the Wards, was from Pennsylvania—took a special liking to them. According to one friend,

> The Ward sisters had a certain mystique. These two little artists who came down to New York, and they had voluptuous delicious little figures. Tiny wasp waist and voluptuous while also being dainty. Nancy said sweetly she had shoulders to make strong men weep. They could dance marvelously. They could make money at a time when everyone was hard up. And they had that lively Welsh talk.

Quick to laugh at a good story, Joan and Nancy could also enjoy a drink and party long into the night. There was something of the flapper in their youthful merriness and a devil-may-care charm that excited the middle-aged artists, who had not been able to enjoy the Roaring Twenties. Of the two, Joan was born first, and Kline said, describing the difference between them, that "Joan always knew where to put the furniture." Nancy—who had a five-year affair with Kline in the early to mid-fifties—

was considered the more outgoing and free-spirited. When Alcopley was leaving for Europe in 1952, the cry went up at a going-away party for presents for the departing artist. Nancy reached into her blouse, pulled out her brassiere, and tossed it to the artist.

In the spring of 1952, Joan occasionally visited de Kooning at his Fourth Avenue studio, and he visited her at her apartment on East Eighth Street. The painter George McNeil was also interested in her. After de Kooning returned from East Hampton in the fall, he was in good spirits. He moved into his new and larger studio on Tenth Street and rapidly began painting many of the *Women* in the series. It was at this moment, when life once more seemed to be opening up before him but many doubted his achievement, that his relationship with Ward began. Although Joan was considered slightly more "serious" than Nancy, she was no less fun-loving than her sister. She would drop by after work and watch him fix up his new studio. She admired how deft he was with his hands. He was not like many of the critics, poets, and painters at the Cedar who seemed made of nothing but talk.

Sometimes, when she stopped by after work, de Kooning would walk across the street to the liquor store and buy a pint of whiskey, although there was not yet any bingeing. They would share the pint and, perhaps later, drop by the Cedar. De Kooning was smitten for a time, but there was no question on his part of an enduring love affair. However, Ward fell deeply in love: "There was never," she said, "anyone else for me." In 1953, Ward told him she might be pregnant. She was "petrified" by the prospect. The morning she told him the news, as they walked down the street after leaving the Eighth Street Automat, de Kooning kept nervously wrapping and unwrapping a piece of string around his hand. But it was not her condition, she realized, that was making him anxious. It was that his painting was not going well. That was where his heart was, even at that moment.

Everyone assumed she would have an abortion: that is what single women in the art world were expected to do and had done for decades. They had little choice, if they intended eventually to marry or to continue working as artists. Married women in the art world often did the same, Elaine's abortions being a typical example. So Ward followed the conventional practice in her milieu. De Kooning found a doctor. But Ward did not recover as quickly as most did. She remained physically healthy afterwards, but found the process sordid and degrading and fell into a long-lasting depression, spending the next year, she said, as "a wreck." Nancy often came by her apartment to care for her. "If I could have afforded it," she said, "I would have had a nervous breakdown."

De Kooning remained on good terms with Joan, but was not especially

sympathetic to her plight. He had made no commitment to her, abortions were common, and few painters spent much time worrying about their girlfriends' pregnancies. Except on those occasions when he was head over heels in love, moreover, de Kooning was inclined to keep seeing other people. And yet this passing moment with Ward would have profound consequences. She would become, for reasons he never anticipated, a woman he could not leave.

In the fall of 1952, not only Sidney Janis but also de Kooning's close friends knew that the *Women* were immensely risky pictures. It seemed certain that the public would dislike them, though this did not necessarily matter: the public was expected to make errors in judgment about avant-garde art. Of much greater concern was the response of critics, painters, and other insiders. Clement Greenberg, a strong supporter of de Kooning's black-and-white paintings, continued to insist that de Kooning was making a major mistake by trying to reinstate the figure. Would it be left to Greenberg and his followers to shape the serious response to the new figurative turn in de Kooning's art?

That fall, de Kooning's two main critical admirers, Rosenberg and Hess, each wrote an extraordinary paean to the artist. There is no proof that the critics intentionally mounted a preemptive strike on the opposition, but it seems likely that they resolved that here, with de Kooning's *Women*, they would make their stand and battle Greenberg's domineering taste. In all likelihood, Elaine encouraged them. Taken together, the two articles seemed to make any quarrel with de Kooning's work appear cheap and low-minded. Both pieces appeared in *ArtNews*, where Hess was the editor. Both were hagiographic. The first, published three months before de Kooning's first show with Janis, deliberately mentioned no artist by name but announced the coming of what could be mistaken for a new messiah in painting. The second appeared the same month as the opening and treated the particular details of de Kooning's struggle over *Women I* with awestruck reverence.

Harold Rosenberg's "The American Action Painters"—his first influential essay as an art critic—came out in December 1952. For the small art world of the time, the essay was less a piece of criticism than a clash of cymbals, announcing the arrival of a great new American hero who would rise above the gray-flannel fifties. The "action painter" did not bear the burdens of the past and belonged to no "school" in the traditional sense: "What they [the action painters] think in common is represented only by

what they do separately." They were individualists who did not emerge from an aesthetic response to earlier art, as Greenberg might argue, or from a Marxist-inspired desire to change society. As Rosenberg put it, "The Great Works of the Past and the Good Life of the Future became equally nil."

> With a few important exceptions, most of the artists of this vanguard found their way to their present work by being cut in two. Their type is not a young painter but a reborn one. The man may be over forty, the painter around seven. The diagonal of a grand crisis separates him from his personal and artistic past.
>
> Many of the painters were "Marxists" (WPA unions, artists' congresses)—they had been trying to paint Society. Others had been trying to paint Art (Cubism, Post-Impressionism)—it amounts to the same thing.
>
> The big moment came when it was decided to paint . . . Just to *Paint*. The gesture on the canvas was a gesture of liberation, from Value—political, aesthetic, moral.

The new painting, far from being a conventional picture of the world, embodied an "event" or an "action" that transmitted "the same metaphysical substance as the artist's existence. The new painting has broken down every distinction between art and life." It was "inseparable from the biography of the artist. . . . What matters always is the revelation contained in the act. It is to be taken for granted that in the final effect, the image, whatever be or be not in it, will be a *tension*." The new painters, recoiling from the "intellectual and moral exhaustion" of the postwar period, did not aspire to better the world. Instead, they hoped to *create* a world. "Based on the phenomenon of conversion the new movement is, with the majority of painters, essentially a religious movement. In every case, however, the conversion has been experienced in secular terms. The result has been the creation of private myths."

The decision not to mention the names of individual artists in the essay only made Rosenberg's preferences more pointed and titillating to the knowledgeable. No one believed that Rosenberg, who relished intellectual combat, was reluctant to name names or that he was above playing the politics of reputation. The art world, reading between the lines, knew who "Harold" liked best of all, the artist whom he visited almost every day and admired without reservation: de Kooning. Insiders also knew whom Rosenberg disliked and immediately recognized his attack upon

de Kooning's rivals, including Jackson Pollock. The article brought to the surface what would become the ugliest and most vulgar quarrel of the 1950s—"de Kooning against Pollock."

The early part of Rosenberg's essay seemed to laud Pollock, which only made the eventual deflation more devastating. In the end, Rosenberg implied, Pollock succumbed to the corruption of middle-class society. To distinguish the true hero from spiritual quacks, Rosenberg fiercely attacked what he called "apocalyptic wallpaper," the sort of histrionic or novelty-based mysticism that lacked adequate tension and became just another way to score in a debased society. "When a tube of paint is squeezed by the Absolute," he said, "the result can only be success"; "the man who started to remake himself has made himself into a commodity with a trademark." It was these lines, among others, that were read as an attack on the first abstract expressionist to "make it" in American society and the artist whose drip paintings were indeed regarded by many as a "trademark" style. The phrase "apocalyptic wallpaper," which parodied Pollock and Greenberg's aspiration for an "all-over" composition, was especially cruel. However one measured his achievement, Pollock, an artist deeply interested in mystical experience, did not think like an interior decorator or play the poodle for the rich. At the moment, moreover, he was foundering in alcoholism and bravely struggling not to repeat himself.

The art world knew that de Kooning was not an ambitious mystic who made apocalyptic "wallpaper." Of course, he was also not an "action painter" in any physical sense: he spent hours studying an evolving composition and carefully worked and reworked his pictures. But de Kooning's slashing stroke certainly appeared to be the work of an "action painter," and much else in the essay seemed to elevate de Kooning's particular sensibility, especially as it was reflected in *Woman I*. De Kooning, like Rosenberg, rejected "purity" and good taste. He celebrated "tension." He welcomed the explosive mixture of sources in an artwork and, at the easel, embodied the biographical struggle of the artist with his personal and psychological demons. Rosenberg's aphorisms even had the *éclat* of de Kooning's gestural brushstroke, and some of the writing describes the tormented, back-and-forth creation of *Woman I*:

The canvas has "talked back" to the artist not to quiet him with Sibylline murmurs or to stun him with Dionysian outcries but to provoke him into a dramatic dialogue. Each stroke had to be a decision that was answered by a new question. By its very nature, action painting is painting in the medium of difficulties.

What the new painters required, Rosenberg argued—well before most of them had received any notable recognition or paycheck—was an understanding audience rather than publicity, a market, or "the taste bureaucracies of Modern Art." Rosenberg ended this way:

> In our form of society, audience and understanding for advanced painting have been produced, both here and abroad, first of all by the tiny circle of poets, musicians, theoreticians, men of letters, who have sensed in their own work the presence of the new creative principle.
>
> So far, the silence of American literature on the new painting amounts to a scandal.

The declamatory style of Rosenberg's essay was as significant as its gist. This was a masculine prose hammered out for American men of "action." It honored the man who did not succumb to the corrupt and petty seductions of his society, but instead found his way to the revelatory truth. Filled with capitalized words and italic emphases, it was martial in spirit—"A sketch can have the function of a skirmish"—and dismissed the "professional enlighteners" and effete appreciators of art: "You don't let taste decide the firing of a pistol or the building of a maze." With this essay, Rosenberg transmitted the ideological and moral fervor of the thirties and forties, when revolutionaries and intellectuals battled bourgeois society, into the art world of the fifties, but without the socialist agenda. Since politics had failed so many intellectuals of the Left, "the artist" was now called upon to assume and preserve the role of the disaffected, incorruptible hero. The spirit of Dostoevsky and of Trotsky, the most seductive of communist outsiders, would pass to artists like de Kooning. He would be "understood" only by a small circle of forward-looking people.

There were skeptics in the art world, even among admirers of Rosenberg, who regarded the article as thunderous bullshit. (It was not forgotten that Rosenberg worked for the Advertising Council for twenty years, inventing such icons as Smokey the Bear.) The article might celebrate a certain kind of individual, but it had little to do with the actual practice of making art and even less to do with judging the quality of a picture. Nonetheless, the rhetoric was powerfully seductive. What red-blooded artist would not want to be such an action hero?

Hess's article "De Kooning Paints a Picture" appeared only three months later, in the March 1953 issue of *ArtNews*, just before de Kooning's opening at the Sidney Janis Gallery. Like Rosenberg, Hess made an existential hero of de Kooning, portraying him as a man who, disdaining the easy success, pursues an ideal that can never be finally attained. If

Rosenberg outlined the general profile of the new hero, Hess now filled in the details. Because both Rudy Burckhardt and Frank Auerbach had photographed versions of *Woman I*, Hess was able to depict several stages in de Kooning's struggle with the painting, which he likened in his article to a "voyage; not a mission or an errand, but one of those Romantic ventures which so attracted poets, from Byron, Baudelaire, through Lewis Carroll's *Snark*, to Mallarmé and Rimbaud (Ingres' harem, Delacroix's *Barque*, Van Gogh's *Berceuse* who was to accompany lonely sailors are parallels in painting)."

These were not the only high-flown comparisons. De Kooning's improvisatory method of taking apart and reassembling the body, the critic said, resembled that of Procrustes, the giant of the Greek myth who fit visitors to his bed by trimming or stretching their legs. Hess compared the smile of *Woman I* to the "lips of the Greek Kouros and mediaeval Virgin." If the painting had a "resoundingly affirmative presence," it also had a "vacillating Hamlet-like quality." (There was no mood, Hess implies, of which de Kooning was not the master.) De Kooning required doubt "to keep off-balance" and "Ambiguity exactingly sought and exactingly left undefined has been the recurrent theme in Woman." Not only was de Kooning a voyager in the great romantic tradition, but—lest that seem too nostalgic—he was also entirely modern, unsentimental, and of his time. Hess anticipated all the criticisms that could be directed at *Woman I* in order to banish them from serious discussion. There were sophisticated eyes, for example, that still thought de Kooning was too devoted a child of Picasso, and unsophisticated eyes that still thought that their child could draw as well. Hess answered:

> Parenthetically, it should be added that de Kooning's dissatisfaction with conventional proportions—which have satisfied such older re-inventors of anatomy as Picasso—is based on long experience with them. Years of training at the Academy of his and a later period of what might be termed lyrical Ingrism, gave him the mastery of tradition essential to discarding or changing convention.

Hess also defended de Kooning, widely acknowledged as a draftsman of genius, against those who did not consider him a great colorist. He even refused to concede that de Kooning's radical approach to his subject matter—the sheer ferocity of his presentation—could disturb any serious viewer or critic. He wrote many paragraphs on the artist's formal practice, but addressed de Kooning's fraught relation to the theme of "Woman" only in a passing, lighthearted manner. "De Kooning's perceptions focus

on the New York he daily observes, populated by bird-like Puerto Ricans, fat mamas in bombazine or a lop-sided blond at a bar." Hess referred to *Woman I*'s "air of opulence, violence and laughter." Such a picture should be "fixed to the sides of trucks" or used on a billboard, he suggested, replacing those "more than beautiful girls" who usually served as models. He argued that there were no elements of sentimentality or caricature in the expressionist forms.

How successful *Woman I* was as a painting—judged by conventional criteria—finally seemed beside the point. It was the journey, not the final destination, that mattered. The stages of the painting "illustrate arbitrarily, even haphazardly, some of the stops on route—like cities that were visited, friends that were met." The image of the artist as romantic voyager should enthrall the mind's eye, not just the postcard left behind.

The figure in *Woman I* would often, over the years, be likened to an idol. Here, her creator was also idolized: the man became the masterpiece.

The inflated tone of both essays made abundantly clear that de Kooning was now first among equals in the New York art world. The city's radical intellectuals, represented by Rosenberg, stood aligned with the old money, taste, and power represented by Hess, the wealthy WASP who edited *ArtNews*. Only a fool would have actually called de Kooning "number one" or played with the meaning of his Dutch name, "the king," for that would have violated an unspoken understanding of an art world that, in recognition of the years of shared obscurity, could not easily tolerate such overt distinctions. But no one else was able to play the leading role: Gorky was dead; Pollock was succumbing to alcoholism; Rothko, Newman, and Still often seemed like apocalyptic cranks.

Apart from their genuine regard for the artist, Hess and Rosenberg each found in de Kooning a way to build a reputation: a critic often enters history on the back of a great artist. In their articles, each distinguished himself from Greenberg, who was closely associated with Pollock. When Rosenberg referred contemptuously to artists who tried "to paint Art" and to "the expanding caste of professional enlighteners," he was attacking Greenberg, whose arrogance only increased the determination of an intellectual streetfighter like Rosenberg. But Rosenberg and Hess also recognized and brought to the surface important elements emerging in art that Greenberg did not take seriously. The desire to use art to confront mainstream culture with existential gestures was becoming increasingly important. And the coming to America of a stylish "master" in the European sense, who, in addition to everything else, brought a joyful and

unabashed tastiness to art—that was also something new, which Hess could celebrate in his passionate and purple prose.

Still, it was the power play of the two critics, the way they publicly crowned their favorite, that impressed the art world. Even before the articles appeared, *ArtNews* was becoming, in the eyes of many, a house organ for de Kooning. From the early fifties onward it was rare to read an article in the magazine on a contemporary painter that did not contain at least a passing mention of de Kooning or a reminder of his prominence. Elaine's affairs with Rosenberg and Hess only increased the whispering about a conspiracy. In the end, the victory of *Woman I* seemed easily gained, for no real public opposition developed at the time to de Kooning. In intellectual circles, only Greenberg could have publicly challenged Rosenberg and Hess with any success. However, while Greenberg regarded Rosenberg's article as beneath contempt and disliked de Kooning's *Women,* he also had nothing good to say about Pollock's recent paintings. He saw no reason to get involved in an angry public quarrel with Rosenberg, who was obviously eager for a fight.

De Kooning's close friends sometimes wondered what his own position was about the politicking. Was he as innocent or otherworldly as he sometimes seemed? Or was he secretly pulling the strings? De Kooning was not naive about success in America. Had he wanted to, he could have stopped Elaine, Rosenberg, and Hess from promoting him so actively. But he let them go ahead. He was an easy hero to tolerate, in any case, for success did not seem to go to his head: he still cleaned up the dishes at the Club and was always just one of the gang at the Cedar. Even Clement Greenberg said it was hard to "write against him." And so, most artists acceded to the growing hero worship, and enjoyed the reflected glory.

On March 16, 1953, the art world thronged to the opening of the *Women* show at the Sidney Janis Gallery. Six large *Women* oils were hung in one room of the gallery; in another room there were sixteen small pastels and drawings on the same theme. De Kooning was still retouching some of the paintings, said Robert Jonas, when they were already hanging in the gallery. Many people were shocked by the paintings, giving the exhibition the added appeal of a *succès de scandale;* an article in *Time,* entitled "Big City Dames," reported that "even the initiates . . . came out reeling a little." The critics at *The New Yorker* and the *New York Times* wrote cautiously, expressing interest but also warning that the pictures perhaps went too far and were not quite resolved. Like Hess, Howard Devree of the *Times* refused even to acknowledge the explosive charge of the work, writing loftily: "May one go farther and feel that the figures are the outcome of highly cerebral concepts rather than emotional reactions

to the theme?" The guarded responses of the mainstream press did not harm de Kooning's reputation in the art world, which believed that vanguard art should provoke some controversy and not be welcomed with open arms by establishment critics at *Time*, *The New Yorker*, and the *New York Times*.

In the art world, it was those close to Pollock who approached the show with the greatest suspicion. And none more so than Lee Krasner, who was infuriated by Rosenberg's article and Greenberg's failure to come to her husband's defense. Tigerish in her protection of her tormented husband and dogged in her assertion of his position in the New York school, she regarded Rosenberg's article as a personal betrayal, the natural result of his turn toward de Kooning the previous summer. Shortly after the article appeared—still three months before the show—de Kooning and Philip Pavia innocently paid a visit to the Pollock house and found Lee railing against Rosenberg. De Kooning "announced his liking for the article," which further inflamed Lee and, probably, only confirmed her suspicions that a conspiracy was afoot to raise de Kooning above her husband in the eyes of the world. Pollock did not initially discern an attack upon himself in the article; indeed, he believed that he had given Rosenberg the phrase "action painting." But he was soon persuaded by Lee that the critic had attacked him.

But Pollock would never accept that de Kooning was part of any such conspiracy. The two painters might compete, as brothers would, but they would also continue to admire each other as relations worsened between their camps. Pollock would sometimes acknowledge that de Kooning was the better painter, in a way that suggested that he, Pollock, was the greater *artist*. "You know more," Pollock told de Kooning, "but I feel more." (De Kooning was very sensitive to such slights: Pollock's distinction was similar to Gorky's way of using "very interesting" to mean "too interesting.") The writer Lionel Abel put the relation between the two painters best: "They were competitive, but there was a lot of generosity lurking in that competitiveness." On one evening cherished by the art world, the two painters stumbled out of the Cedar, sat down on the curb, and began passing a bottle back and forth like two old bums, while parodying the conflict between them. "Jackson, *you're* the greatest painter in America," de Kooning would declare, taking a swig and handing the bottle to Pollock. "No, Bill," Pollock would answer, "*you're* the greatest painter in America."

But they could not always escape the struggle around them. At the party after the opening of the *Women* paintings, amid the backslapping and gossip and easy praise, Pollock, drinking heavily as usual, suddenly

yelled at de Kooning: "Bill, you betrayed it. You're doing the figure, you're still doing the same goddamn thing. You know you never got out of being a figure painter." The room grew quiet. De Kooning, remaining friendly, answered, "Well, what are *you* doing, Jackson?" De Kooning probably intended to suggest that Pollock, too, was now experimenting with the figure. But, as Steven Naifeh and Gregory White Smith suggested in their biography of Pollock, "Jackson took it another way": as a derisive reference to his current inability to paint much of anything. Pollock stormed out of the party in a drunken rage. The moment appeared symbolic. Power in the New York art world had tilted toward de Kooning.

The success that attended the exhibition seemed surreal, almost miraculous, to de Kooning. Less than a year before, he had still been mired in *Woman I*, working on a painting that he was confident few would like. The struggle had damaged his health, he believed, and friends told him that he was harming his career. Now, all around, friends, painters, and hangers-on congratulated him. The Museum of Modern Art was buying *Woman I*, and Blanchette Rockefeller, the wife of John D. Rockefeller III and a great patron of the Museum of Modern Art, was buying *Woman II*. Blanchette Rockefeller! A symbol of class, privilege, and inherited wealth. A graceful woman of impeccable manners. (About this time, de Kooning was introduced to Blanchette. Often nervous when in the presence of the lofty rich, de Kooning, wanting to make a good impression, was tongue-tied for a moment. Then he let out "You look like a million bucks!") Who could have predicted that *Blanchette Rockefeller* would one day bestow approval upon a de Kooning *Woman?* An unimaginable gulf lay between two such women. De Kooning had come a long way from North Rotterdam, and his triumph seemed complete. And then, like a ghostly Greek messenger come to warn the king of hubris, a slight figure appeared at de Kooning's door.

No one in New York admired de Kooning more than the young Robert Rauschenberg or better understood what de Kooning was bringing to contemporary art. Rauschenberg loved all the usual things that people appreciated in de Kooning's work—the vital, brushy touch, the spirited draftsmanship, and the unmistakable bravura. And, like so many young artists of the time, he respected the many years of struggle. But Rauschenberg also admired in *Woman I* precisely those things that made the art world uncomfortable. Rauschenberg believed in its clash of high and low and its messy embrace of the open-ended. Most of all, perhaps, he loved the rude parodic squawk in the temple of art. That was the American

sound of modernity. Later critics who would one day admire *Woman I* rarely acknowledged how important the picture was not just to Rauschenberg, but to the evolution of pop and later American art.

Nonetheless, Rauschenberg knew that the older artist would not appreciate this particular errand. "I was hoping to God," he said, "that he wouldn't be home." Rauschenberg brought along a bottle of liquor to bolster his courage. "I was completely prepared to share it with him." But de Kooning was home and greeted Rauschenberg affectionately. Accustomed to visits by young artists, de Kooning was friendly and willing to talk. He particularly enjoyed this playful young man. How could he not? Apart from Rauschenberg's winning manner and mischievous smile—he looked like a boy with his hand eternally caught in the cookie jar—much of the young artist's work was an homage to de Kooning. For a while, the two men engaged in small talk. And then Rauschenberg, hemming and hawing, asked the older man if he might have a drawing. That in itself was not unusual. Artist friends often exchanged work. But Rauschenberg wanted the drawing not to hang in his studio, but to *erase.*

There was a moment of silence. The younger man wanted de Kooning to hurry up and just give him a minor drawing so he could quickly leave. But de Kooning instead chose to take his time. He went to the door and leaned a painting against it, in order to ensure that the two artists would not be disturbed. He told Rauschenberg: "I know what you're doing."

De Kooning was referring, in part, to Rauschenberg's recent monochromatic paintings; erasing a drawing would create a ghostly monochromatic work without imagery. But de Kooning was doubtless aware of the many other implications of Rauschenberg's request. The young artist was engaged in a symbolic act of generational and Oedipal murder, at once comic and deadly serious. He was ridding himself of a burdensome father. He was doing so, moreover, in the joking language of Dada, a movement that did not respect the sanctity of the art object or celebrate the romantic passion of de Kooning's generation. He was declaring that, for ambitious art, de Kooning stood in the way. He must be erased. Rauschenberg's errand had little charm for a middle-aged painter who had spent decades struggling to escape from Picasso's shadow. Wasn't he, de Kooning, the emerging artist? To date, de Kooning had enjoyed only three or four years of modest recognition and was still trying to make ends meet. Now, his moment having just arrived, he found a young artist at his door anxious to announce the death of the old man—and lampoon collectors for their desire to own "a de Kooning."

De Kooning probably sensed, too, that Rauschenberg's visit was an omen. It would not be long before art would turn away from de Kooning,

for in the end it was young artists and not writers who performed the essential acts of criticism, clarifying what is fresh and challenging what is stale. (The greatest critic of Cézanne was Picasso during his cubist period. The most devastating critique of academic French art issued from the playful brush and mind of Manet.) Rauschenberg would retain much of de Kooning for the future—his rude American vitality, his open-endedness, and his devotion to a process of permutation and change—but Rauschenberg had to escape from the air of Old World connoisseurship and private touch that was inevitably a part of a de Kooning drawing. Rauschenberg could not make conventional "drawings" or "paintings," much as he loved them, because he did not believe they contained the contemporary truth. He had to erase that part of de Kooning.

De Kooning recognized that Rauschenberg's request was a deep if disturbing compliment: the son loves the father he must kill. And so, he returned the compliment, playing out his part in the Oedipal game with surpassing generosity. He did not let the affair become just an inside joke that could be easily dismissed. He made the younger artist squirm, for the death of a father must not come too easily to a son, especially if that son is an artist. "He really made me suffer," Rauschenberg said, referring to the elaborate process that de Kooning established for the execution. De Kooning brought over a portfolio of drawings and began leafing through them. At last, he seemed to settle on one. He looked at it. But then he slipped the drawing back into the portfolio. "No," he said, "I want to give you one that I'll miss."

De Kooning brought over a second portfolio. He leafed through it as slowly as he had the first, examining one drawing and then the next. "These I would miss," he said. "I like them." He seemed to settle on a particular image. "No," he said at last, "I want it to be very hard to erase." He brought over a third portfolio. Finally, he selected an important, fleshy drawing for sacrifice—a dense mixed-media image that contained, Rauschenberg said, "charcoal, lead, everything. It took me two months and even then it wasn't completely erased. I wore out a lot of erasers." Later, de Kooning became angry when the younger artist publicly exhibited *Erased de Kooning*. De Kooning believed the murder should have remained private, a personal affair between artists, rather than splashed before the public. He was from an older generation.

25. High Style

DE KOONING: I wouldn't say that Rubens is a greater painter than Rembrandt, but I would differ with your point of view by calling him just as great a one.

SELDEN RODMAN: On what grounds?

DE KOONING: For creating a great style and working in it with complete conviction and reckless abandon.

After a lecture or panel at the Club, de Kooning would usually walk to the Cedar with a group of friends, some of whom might carry the arguments of the evening onto the street. On a busy night familiar greetings would ring out from old friends when de Kooning entered the bar. "Hiya, fellas," de Kooning would say. "Hiya, fellas." People he knew and others whom he was just beginning to know—poets, younger painters, admirers—would glance up: in 1954, someone might say, "That's de Kooning." From the crowd, Elaine, smoking and chatting, would toss him a wave. Rauschenberg would smile. Frank O'Hara and Mercedes Matter would make room for him at the bar.

The Cedar smelled of spilled beer and tobacco smoke. The air was thick, the light a "bilious yellow-green," said one Cedar regular, "that made everyone look worse than they already looked." In the low light, you could not be sure, at first, who was sitting in the booths along the wall. The Cedar—reminiscent of the "brown bars" of Rotterdam that de Kooning grew up with—was a working-class bar entirely without distinction. And that, in the New York of the 1950s, was precisely its distinction. It appealed to the downtown painters because it was *not* French, *not* tasteful, *not* smooth, *not* witty, not, that is, a Parisian café where artists chatted and sipped. These were important "nots" to painters determined to declare their independence from Paris: the Americans were hard drinkers at a dive whose existential aura owed more to Brando on the docks than to Sartre at Deux Magots. The Cedar represented a perfect blend of high and low, of proletarian circumstance and intellectual aspiration. English hunting prints in elegant black frames hung, absurdly, on the dingy walls.

Often, de Kooning would belly up beside Franz Kline at the bar. Kline always seemed to be finishing one beer and calling to Sam or John, the owners, for another. Franz, people were beginning to say, lived on beer the way a

With the artist John Chamberlain at the Cedar in the 1950s

baby lived on mother's milk. De Kooning, like other regulars, would just lay a bill on the bar and begin to run a tab. While waiting for Sam to fix his drink, he might make a small crack about the conversation at the Club—"Yaaah, it was a lot of baloney"—as if to brush aside the fancy philosophizing of poseurs and get down to the more serious business of discussing paint. In the circle around de Kooning and Kline, there was a working-class suspicion of the newcomers, who talked big but did not know firsthand what it meant to be a day-to-day artist during the hard years. Although de Kooning usually changed into clean clothes when he went to a party or to an event at the Club, he sometimes wore his paint-stained overalls to the Cedar. The poets and younger artists beginning to show up at the bar after their graduation from college regarded the stains with reverence.

De Kooning, nowadays, would order Scotch, the new drink among painters. Scotch was stronger and cost more than beer; it was a symbol of the changing conditions of art in the mid-fifties. Unfailingly generous, de Kooning would buy everyone around him a drink if he had the money. He rarely said much at first, especially since Kline, in particular, was a marvelous conversationalist. By the mid-fifties, Kline, warmed by drink, had invented a kind of fantastic double-talk. His stories did not have a traditional beginning, middle, or end. They would wander and curl back in upon themselves, a kind of storytelling through free association. According to Conrad Marca-Relli:

> At the Club we had a meeting and people were asking questions . . . and
> all of a sudden Franz raised his hand and said, "I just was curious about

what you meant by the fact that cubism was more important than . . ." whatever it was. He asked a question that nobody could understand. Complete double-talk. When it was over people applauded. . . . He would never answer a question straight. "How old are you?" "When I was eighteen I was a young man." Very provocative, the way he did it.

After a drink or two, de Kooning found it easier to enter into the back and forth of conversation, and he would add teasing or wry asides and begin telling stories. He became increasingly aware of the way others looked at him. The people he did not know well, such as the poets and the younger artists, stared with unfamiliar intensity. The loose eyes in a room, which never before fastened upon the Dutchman in the dumpy clothes, often turned his way.

The middle years of the fifties, following the success of the *Women*, were a halcyon moment in the life of both de Kooning and the New York art world. Success, still fresh and unexpected, had not yet imposed its burdens, and the future remained rich in possibility. De Kooning was much too tense—and much too committed to the difficulties of art—to relax easily or pursue any version of the good life without ambivalence. But he seemed during this period to live in a happier light. Not only had he left behind the gloomy Fourth Avenue studio, where he painted his great cave paintings, the black-and-whites, and struggled endlessly over the darkly mythic *Woman I*, but he had risked revealing his demons to the world and earned praise rather than rebuke. Working in the brighter space of Tenth Street, he had swept through the remaining paintings of the series without suffering any major blocks, while making dozens and dozens of beautiful drawings on the same theme. Now, he was moving into a new series of large abstractions. His marriage to an American girl had collapsed, but without blighting his life; Elaine remained his friend and supporter in the art world. Around four or five p.m., before going to the Cedar, de Kooning would sometimes climb down his fire escape and rap on the back door of a neighbor, the painter Al Kotin. The two would have a drink, toasting the work of the day.

Many in the art world were in a mood to celebrate with him. The fifties would serve as a second Roaring Twenties for the group of American painters who were roughly the same generation as Ernest Hemingway and F. Scott Fitzgerald, but who, unlike those writers, had not enjoyed youthful success and now appeared determined to make up for lost time. The New York painters at the Cedar lived in a way that others wished to emulate, much as the names Hemingway and Fitzgerald, if mentioned in the same breath as "Paris," would immediately arouse an intense longing

in many people. It was during this time that de Kooning's way of thinking, talking, and behaving became the essential model for many younger New York artists and poets. That model depended above all upon the pleasures of subversion and the violated boundary. For the old-timers at the Cedar, it had a different import than for the young people pushing through the door. De Kooning's edgy existence, in which he instinctively upended conventional wisdom and settled authority, was not a style or affectation. It was rooted in both his private history and in the risky personal experience of the New York painters during the Depression and war years, when they made a very big bet with their lives, enduring poverty in order to take a shot at making important art in a provincial country. To find the courage to live poor and unknown required a compensatory bravado, a subversive and swaggering "We'll show 'em," attitude toward the presiding powers of European and American culture. It was an attitude developed less to convince others—since no one was watching or listening—than to embolden themselves.

But now that someone was listening, now that even a painting like *Woman I* found a respectful audience, the challenge to authority was no longer so risky. The bet was won. What began as a way to keep going—developed over endless late-night cups of nickel coffee—could now become a café manner adopted by the young. What was once desperate could become marvelous. The subversive could be smooth, polished, and playful. Alcohol helped power the change. It not only enabled a private man like de Kooning to assume a more public role; it also encouraged others around him to strike a pose and believe in an extraordinary "scene." The feelings of individual omnipotence that it fostered could help inspire an artist to take chances and cross boundaries. And wasn't that the essence of America in general and abstract expressionism in particular—that the individual refused to be contained by the conventional boundaries established by either European or middle-class taste?

With alcohol came a fashion for violence, usually not serious violence, but, instead, the kind of barroom swagger that Hemingway inspired in young writers. Pollock was celebrated for ripping the men's-room door off its hinges at the Cedar. He would glower into his drink, greet men with "Fuck you" and women with "Wanna fuck?" and often pick fights. But even Pollock, a man in serious psychological trouble, recognized that the tough-guy stuff was mostly a pose. Once, in the Cedar, Pollock began tormenting Kline from behind, knocking him off his barstool. He did it once, he did it twice, and then Kline suddenly turned on Pollock, slammed him against the wall, and slugged him in the gut with a left and then a right. "Jackson was much taller," said an observer, "and so surprised, and

happy—he laughed in his pain and bent over, as Franz told me, [and] whispered, 'Not so hard.' " Drinking also made de Kooning pugnacious. He was quick to lose his temper, and he would sometimes take a drunken sock at people who offended him, including, on occasion, Pollock. At the Cedar, de Kooning and another painter once took turns slapping each other as hard as they could across the cheek, the idea being to take the hit without flinching.

De Kooning did not paint while drinking, but the alcohol-enhanced exuberance of the period could not fail to affect him. He usually went to the Cedar two or three times a week. As more artists were given exhibitions, there were also more openings and celebrations with liquor. Elaine believed that it was these parties, together with Rosenberg's habit of stopping by the studio with a bottle, that tipped the crowd-shy de Kooning into alcoholism. Even so, he still drank less in 1954 and 1955 than many others, notably Rosenberg, who seemed to have a limitless capacity. (Friends always joked that the booze drained into the bum leg of the exceedingly tall critic.) Kline was already drinking very heavily, as was Elaine herself. After two drinks, a close friend said, de Kooning became a brilliant raconteur and conversationalist. Before that he was too reserved; later, too drunk. This kind of fine distinction was often voiced in the hard-drinking fifties. Businessmen took pride in three-martini lunches, and many painters believed that alcohol could stimulate art, conversation, and sexual desire. Who in the fifties would not take on Pollock's afflictions if they brought Pollock's genius?

In the middle fifties, the New York art world, like de Kooning, was still in the two-drink stage of its party. Pollock was regarded as the pioneer, the man who broke the limits of conventional European practice not only in his painting but also in his cowboy-on-a-spree drunks. De Kooning, the immigrant from Europe, forever caught betwixt and between cultures, engaged in a more subtle and poetic subversion than Pollock's. After two drinks, de Kooning began to talk in a way that seemed to undermine authority, confront unspoken rules and crack language itself into surprising new pieces. The poets who were now starting to come regularly to the Cedar—much younger, as a rule, than the first generation of abstract expressionist painters—delighted in de Kooning and Kline's slangy and unexpected way with language. Frank O'Hara, then the poet closest to the art world, worked as a guard at the Museum of Modern Art and also wrote criticism. Fey and funny, he sometimes enjoyed baiting the old bears at the bar, who liked him not only for his boyish charm but for his boundless admiration for abstract expressionism. O'Hara so loved de Kooning's Dutch accent, edgy wit, and earthiness that he would teasingly parody

them. Saul Steinberg, one of the great wits of the time, also relished de Kooning's accent and way with words, as when de Kooning called the rich "the ritz." He studied de Kooning's talk closely:

> The marvelous thing was his homemade eloquence. It was a real act of creation. . . . I would watch him starting to say something partly because of the fume of the drink, partly because he was bored. Then he would make a U-turn in midair. What it amounts to is to be able to catch up with your thinking while talking. Also to think while you're talking. . . . The secret of interesting talk is not to deliver lines but to invent. . . .
>
> He mostly spoke in malaprops, but they were beautiful. The fact that he used primitive English for refined purposes is the essence of poetry. There was a poetry of improvisation caused by puns both in ideas and in the language. . . . He used vulgarity—four-letter words—with great ability, and with courage. He used it when it was essential to accentuate something.

Part of the acrobatic pleasure of conversation was to court danger. De Kooning once gave a drunken speech about "the Jews" in front of Steinberg, who had fled the Nazis from his native Romania, and Rosenberg, the prototype of the Jewish intellectual in New York. What captivated Steinberg was that de Kooning did not temper the speech with irony or caricature. That would have been too easy. He chose instead to skirt dangerously close to true anti-Semitism. In his Dutch accent—which sounded vaguely German to Americans—he announced that he loved all the Jews dearly, yah he did, some of his best friends were Jews, except for Harold and Saul. "We knew what it meant," Steinberg said. "He had to say that because he was free to say it. He knew it was funny and he knew he was playing with danger." De Kooning would have known, too, that both Steinberg and Rosenberg shared his taste for subversive language and recognized its subtextual codes. Both enjoyed the high-wire act.

Like his painting, Kooning's two-drink style was pungent, unexpected, and utterly distinctive. There was something *sui generis* in his manner, or, as Steinberg put it, "homemade." The New York of the mid-fifties revered this kind of individuality, which stood out powerfully in an era that was otherwise conformist in outlook. Steinberg said the effect of Rosenberg's conversation, for example, was that, "At the end you don't know what he's talking about, but it is very precise. It's a poetic precision that inebriates you. Having talked nonsense gives you the courage to continue." Not surprisingly, de Kooning's distinctive manner began to

attract imitators. The butt of many jokes was the painter's old friend from the thirties, Milton Resnick, who some thought went so far as to imitate de Kooning's Dutch accent. In fact, this was unfair: Resnick had a slight speech impediment that explained the "accent." But like many artists of the time, he did pick up some of the speech patterns and affection for slang that de Kooning made his own—such as the use of the word "terrific" and "How do you like *that!*"—and he lived directly below de Kooning at 88 East Tenth Street. De Kooning himself, who was known for his prodigious sneezes, would sometimes complain that he couldn't sneeze without hearing an echoing sneeze from the studio downstairs.

The most common form of imitation was a self-conscious desire on the part of many younger artists and poets to present themselves as notable "individuals" who violated boundaries in the manner of Pollock and de Kooning. This crowding toward the individual had just begun in the early fifties; it was not long before Rosenberg would dryly refer to the "herd of independent minds." Although both Pollock and de Kooning served as models of such individuality, Pollock was more difficult to imitate as a painter. His drip paintings did not have a "handwriting" or brushstroke as personal as de Kooning's, and his paintings maintained a certain classical distance despite their *Sturm und Drang.* No young painter could use Pollock's technique without being accused of overt copying. But de Kooning's brushstroke celebrated a kind of personal handwriting, a living record of one's feelings and sensations. At a certain moment, to move a brush like de Kooning seemed to represent the epitome of grace under pressure. His brushstroke was manly, beautiful, despairing; and he attracted followers much as Hemingway did. "De Kooning really took a whole generation with him," said Clement Greenberg, "like the flute player of the fairy tale." Other painters of the period dreamed of developing a brushstroke as personal. According to the painter Al Held, "De Kooning provided a language you could write your own sentences with. Pollock didn't do that."

And yet, it was not merely the charm of his idiosyncratic style, or even the appeal of his art, that explains why de Kooning became for many in this period such an inspiring figure. Artists also loved his workingman's attitude and unpretentious manner. He worked hard. He suffered hard. He played hard. The photographer Robert Frank, who was not a hero worshipper or a sentimental man, could see into de Kooning's Tenth Street studio from where he lived and said that he would sometimes simply watch, filled with admiration, as de Kooning struggled with a painting.

> I'd see him with his hands behind his back, his head bent, pacing up and down the length of his studio. I could see the easel standing there and I'd wonder if he ever would get to paint and stop walking up and down. Quite often I think of that image now. That was the time when I was a photographer, doing jobs or going out on my own to photograph in the streets. Then it seemed to me I was making a big effort. Now thinking of de Kooning, I understand better what it is, to face a white sheet of canvas; to face something which does not respond to my movements, all will have to come from inside me. No help looking through the viewfinder and choosing the Decisive Moment . . .

Many painters especially admired the open-endedness of de Kooning's approach, which seemed to fill the world with possibility. His decision to return to the *Women* was inspiring to those who, searching for their own way, feared or disliked the *dictats* of a critic like Greenberg. "Bill had the attitude, 'I want to reverse it all the time. So give me something to reverse,' " said Marca-Relli. "He was not a guy who was going to find a dogmatic idea, invent one image and stay with that, like Rothko and Newman." There was also a certain poignancy in de Kooning's two-drink style. Many at the bar knew that his drinking was also a form of release, a way of spilling some of the tension that made his heart race. Alcohol gave him a moment's ease. It was a form of indulgence, even, sometimes, of protection. De Kooning, everyone instinctively knew, was not just a performer. He could not finally depend upon stylish games of irony or the fashions of the young. He was an acrobat working without the net. He had paid dues and come a long way, an immigrant with no choice but to invent himself. A New Yorker by necessity.

In 1954, de Kooning had a brief relationship with Marisol Escobar, a talented sculptor whom many likened to an idol or a beautiful sphinx. For years, he invariably referred to Marisol as "that lady" when he passed her building. Born in Paris of Venezuelan parents, Marisol, who had not yet shown her work, already intrigued the art world. She appeared splendidly remote—like the reincarnation of an ancient queen—though some said she was simply shy. She could remain preternaturally still. She was given to long silences, magnificent fits of temper, and occasional highly eccentric actions. She was ideally suited to a period that revered Jung and Freud and loved a good story. In his memoir of the period, *The Party's Over Now*, John Gruen described a time when Marisol remained so quiet and motionless during the course of an afternoon that a spider slowly spun a web

upon her body. Another time, she went to the Club wearing a mask and, when everyone demanded that she take it off, she did so—only to reveal yet another mask.

De Kooning and Marisol did not see each other every day during their affair. "He always seemed to have three women," she said. "It was embarrassing to visit him, because often the others were there." They soon drifted back into friendship. However, it seemed fated that de Kooning, a painter of iconic female figures, would be drawn to a woman who evoked so many archetypes. (She could also be the smoldering Latin lover or the seductive enchantress.) Marisol, in turn, considered de Kooning not only a great artist, but also in some way "a very pure person."

> There was something about him that was like a little boy. Something in his face, expression. Also the way he would walk. He also liked young people. There was an affinity there. . . . He had that socialist air. He dressed in overalls. He had been a commercial artist. They were a Depression generation. Poverty in those days wasn't sad. They had enough to eat and it didn't matter to have a beautiful loft. It represented a kind of honesty.

However, Marisol also sensed a terrible new pressure building within de Kooning. Something was constantly troubling him. She could not quite define the trouble, but it came from the changing art world. De Kooning might be politically adept in that new world, Marisol said, allowing Elaine and others to further his interests, but he also stayed somehow aloof and untouched. He remained a man of the thirties and forties even as the fifties put him on a pedestal. It was not easy, however, to live in this paradoxical situation. At the time of their affair in the spring of 1954, de Kooning was starting to drink more consistently and heavily. When he was drunk, Marisol said, his face would develop an expression of great suffering and also anger, "like a deep brooding." He would still sometimes become convinced that he was dying. Once, de Kooning and Marisol drank together all night; and then, about six in the morning, de Kooning thought the pebbles in the street were floating about. "He wanted to be taken to the doctor then and there. Bill thought he was dying."

More than he could ever have imagined, de Kooning was becoming a man in the spotlight. In May 1954, Huntington Hartford II, the heir to the A & P fortune and a collector of conservative salon painting, bought advertising space in newspapers across America and published "The Public Be Damned?," an angry polemic about modern art in general and abstract expressionism in particular. He was particularly contemptuous of

de Kooning and *Woman I.* In a way, de Kooning and his friends could not have asked for a more useful enemy. Like the earlier snub from the Metropolitan Museum of Art, the attack placed the abstract expressionists once again in the heroic role of the misunderstood impressionists. The polemic only focused more attention upon de Kooning and the artists at the Cedar, making them appear young and exciting and rebellious. Certainly, no one at the Cedar could have invented a better or more comic name than Huntington Hartford II, which sounded like the perfect definition of a stuffed shirt. Attacks from the right could, of course, become a serious matter during the McCarthy era. But the abstract expressionists were not an isolated or defenseless group without friends. They had the support, for example, of wealthy and established tastemakers at the Museum of Modern Art. During the mid-fifties, the U.S. State Department began to work closely with MoMA in an effort to promote abstract expressionism and American art throughout the world. Established American power wanted to ally itself with the downtown painters, hoping to counter Soviet propaganda and socialist realism with vivid examples of American individuality and cultural strength.

Not long after the Hartford polemic appeared, de Kooning, together with Elaine and some friends from the Club and the Cedar, decided to rent a house on Long Island for the summer. De Kooning could probably have joined Castelli once again in East Hampton, where he had spent the previous two summers, but he now had a little money of his own with which to rent a house. He and his friends heard about a dark red, gingerbread Victorian in Bridgehampton, a village between Southampton and East Hampton that was then mainly a farming community with a small summer colony. Some remember the cost of the rental as $200, others as $300. De Kooning asked around, seeing who wanted to chip in. In the end, de Kooning, Franz Kline, Ludwig Sander, Elaine, and Nancy Ward, who was seeing Kline, rented the house. It had very little furniture, and the artists disliked its wallpaper. (When Philip Pavia found reams of abandoned graph paper in a dumpster in the city, they papered the walls with it.) Elaine described it as "that crazy house, that most unusual house on the road, the famous red house on the road at the edge of Bridgehampton, ridiculously cheap . . . and each of us had a room with two doors, an entrance and an exit. The exits appealed to us most. There was a living room, a sort of communal room, and then to the right of that the kitchen . . . Bill painted out in the garage behind the house."

Even before the summer was over, the time at "the Red House" became idealized as part of the lore of American art. It was the party that followed the long winter of struggle. At the Red House, life was a drink, a

laugh, and a trip to the beach. All summer long, the screen door would creak open and slap shut as friends, and friends of friends, dropped in to see what was going on. Barefoot artists in shorts sat around drinking beer; a party always seemed to be in the offing. The sweet and fussy Victorian, which looked like a Gothic version of a Grandma Moses, became the country Cedar, an open bar without the noise and pressures of New York.

De Kooning did not have a particular girlfriend that summer. He and Elaine stayed, and slept, separately. Joan Ward, still distraught from her abortion, came to visit de Kooning and Nancy during her two weeks of vacation from the advertising agency where she worked. Nancy asked her, "Are you sure you want to come?" Joan and de Kooning did not resume their relationship, but they remained friendly. De Kooning gave her his bedroom and moved into a smaller room. The daily pattern at the Red House did not vary much. Money was chronically short. They had so little money, Elaine said, that they used paper plates and then washed them. For de Kooning, every morning began slowly, as always: he would sip his mug of coffee. The frequent late-night partying did not make waking up any easier. Even in the morning, however, the mood of the house was playful and flirtatious. Ludwig Sander, in particular, was a great gossip and tease. According to Joan Ward:

> Lutz had a lot of girlfriends. The ladies liked Lutzie. They were all still very poor, you know, but always some rich lady was coming to whisk Lutzie off. Buffie Johnson in her big car. Bill and Franz would be standing there, sort of unkempt. Lutz had a charm. Quite frankly, the way he talked, it was sort of salacious. He'd say, "Get a steak. Get one big as a toilet seat." Or he'd refer to "chicken-shit yellow."

De Kooning went to the beach less often than his friends. He disliked the glare at midday, and, since he was very fair and did not swim, he "would just get hot and sticky and sandy and sun-burned." Instead, he liked to go to the beach in the late afternoon and at dusk, when the breeze came up and the light glanced across the water. He would sometimes bicycle or get a ride to the Bridgehampton town beach late in the day or join in the evening clambakes and barbecues by the ocean. Not much work was done in the garage studio, since there were so many visitors and distractions, but he would make drawings and enjoy the beautiful, sea-rinsed light. Often, the artists in the house and any visitors and children would set up games in the afternoon that seemed, in retrospect, a light-hearted relief from the growing competitive spirit in the New York art world. Kline, who particularly loved games, was usually the chief impre-

sario and cheerleader. Croquet was a favorite, but the gang also sometimes played softball. Many artists not that long off the boat—such as the Dutchman de Kooning, the Romanian Steinberg, the Italian Pavia, and the Spaniard Vicente—cultivated a comic appreciation for the American sport. They would often play in the yard at the Zogbaums' in the Springs. Vicente recalled one particular game, which occurred either that summer or shortly afterward, in which Elaine came up to him with a plan.

> We got three balls—two grapefruits and a coconut—and painted them white. I was the pitcher. Nobody else knew but Elaine and me. Pavia was the champion hitter. I threw the first grapefruit to Pavia. He hit it—juice everywhere. But nobody knew anything. Then I threw the coconut—pieces everywhere. So then Kline rushes to me and says, "What the hell are you doing? Let's be serious" and pushes me out. I still had the second grapefruit.

Pollock brought an occasional dark and cloudy note to the bright summer days. During the previous summer, many artists chose to avoid him altogether. The social life of the Hamptons art world was intensifying, with increasing numbers of artists vacationing there, just as Pollock became more and more isolated. Although he was not particularly welcome at the parties thrown by the Castellis and others, the Red House was an artists' house—and Bill was there—so it became a particular magnet for Pollock when he wanted to hang around with the guys. He would often drive over in his Ford and drop in unannounced to see de Kooning or whoever else happened to be around, grabbing several beers from the icebox. Sometimes, he arrived in the evening when there was no party. Ward said he would join the artists huddled around the small TV set upstairs, watching the flickering black-and-white image. Television was still new, especially for the downtown artists, and de Kooning, in particular, found himself fascinated by the moving, static-filled pictures.

Early in the summer, Pollock drove over one afternoon when de Kooning, Kline, and Sander happened to be in East Hampton picking up furniture that friends, Carol and Don Braider, were loaning them. Pollock had been drinking. He was brooding. According to Nafieh and Smith:

> Sensing trouble, Elaine de Kooning called her husband in East Hampton. When de Kooning and Kline arrived, "they threw their arms around Jackson," Elaine later recalled, "and began to horse around." Locking each other in a rigid embrace, Jackson and de Kooning staggered blindly around the yard until they stepped into the path that led

from the back door to the garage and the outhouse. Worn down by years of use, the path had become a virtual "trench," recalls Philip Pavia, who was standing nearby, and it caught Jackson by surprise. He stumbled and fell heavily to the ground. De Kooning fell on top of him. Under their combined weight, Jackson's ankle snapped.

De Kooning and the others took Pollock to the clinic in East Hampton. Not surprisingly, Lee blamed de Kooning and his gang for the injury. Gossips had something new to talk about: increasingly "de Kooning vs. Pollock" sounded like a title fight. For much of the summer, Pollock was laid up and unable to drive his car to the Red House. On those occasions when he did get out, especially when he could drive again, de Kooning and the others treated him with increasing concern and, perhaps, condescension, as if, Marca-Relli said, he were an "orphan."

Elaine found something disturbing about the summer in the Red House. It was the beginning, she thought, of a manic stage in the art world's party. The Red House, she later told the writer Joseph Liss, "attracted people like a little pile of honey attracts flies."

> It was a kind of pleasant but nightmarish summer, parties every night, entertaining in the way a nightmare could be entertaining, if you know what I mean. . . . I mean a tremendous amount of social life. An artist needs his isolation even if you enjoy people's company: There is such a thing as too many friends, too much talk, too much booze, too much of a good thing. These are problems of the City, and the City was brought to the Red House in Bridgehampton.

At the end of the summer, a huge storm, Hurricane Carol, slammed into Long Island. Great trees lay uprooted in the villages, branches were scattered over the sandy roads, houses lost their roofs along the beach. The aftermath of such storms was always particularly beautiful, when the light was sharp and the air ocean-fresh. The artists at the Red House gave an end-of-the-summer party that no one who was there has ever forgotten. Joan Ward arrived right before the party was to begin and preparations were desperately late. De Kooning was painting the outhouse seats. Elaine and Nancy Ward, in old clothes, were making large paper flowers and wiring them to the house and trees and bushes and then—to add the illusion of nature to artifice—spraying them with perfume. Then they went upstairs to get dressed. According to Joan Ward, they were acting like such "*girls!* . . . Nancy had quite a figure at that stage, a lot of cleavage. And Elaine came down ready to go all in white ruffles. Nancy had her stole on

and a little black dress and took the stole off and teased Elaine. 'Elaine, I'll give you one chance!' "

Every artist, writer, and hanger-on in the Hamptons seemed to show up at the party, parking their cars in a long line down both edges of Montauk Highway. The garden in back was soon elbow to elbow with people drinking, many with a strange intensity. "That Saturday, it was very beautiful," said the painter Michael Goldberg, "and people were very drunk and crawling off into the corners." For many people, one particular image stood out. A woman "of considerable girth" began slowly spinning in circles, finally crashing into the table that held all the liquor and glasses. Her boyfriend staggered over and tried to haul her to her feet, the two of them seesawing back and forth. "The next morning there were people in the bushes," said Joan Ward. "Three days later they found a couple still in the attic. I don't know what they did. Maybe they went up and down the stairs and nobody noticed."

One unexpected guest that summer was de Kooning's mother, Cornelia. She and Marie still wrote regularly to de Kooning. He rarely replied, but occasionally sent them small gifts of money. His Dutch family sometimes heard news of his growing success from relatives who passed through New York. Cornelia had not visited the United States since 1935 and, almost a decade after the conclusion of World War II, was eager to see her son. What could de Kooning say? By all accounts he was now a successful artist in America with, occasionally, some spending money. If de Kooning would not stir up the past by visiting Holland, the seventy-seven-year-old Cornelia had every right to cross the ocean to see him, if she wanted to.

De Kooning was ambivalent, of course, about the prospect of seeing his mother. But there were aspects of the visit that he could look forward to. The sweetest and simplest part of success for a man like de Kooning was showing his family that he had made it in America. That counted for something in the old neighborhood. But there was one irksome problem: he didn't have the cash to buy Cornelia a ticket. Sidney Janis agreed to advance him $300, but then Janis and his wife, Harriet, left for Europe without authorizing the disbursal of the money. And so de Kooning sold several pictures to an ambitious young art dealer named Martha Jackson, who was visiting the studios on Long Island, spreading cash around by purchasing pictures directly from the artists. (One person estimated that de Kooning earned $4,000 and was then angered to hear, not long after the sale, that Jackson resold a single work to the Guggenheim for that same amount.)

It probably did not occur to de Kooning, who had no head for business, that Janis would disapprove of sales to other dealers; in any case, he would never tolerate the idea that someone could tell him what to do with his own work. The infusion of cash made him feel as well off as he had been at A. S. Beck, when he could buy the miraculous record player.

De Kooning's mother and sister, Marie, at home in Rotterdam in the 1950s. Portraits of Elaine and de Kooning are behind them.

With Elaine's sister, Marjorie, de Kooning and Elaine drove to Hoboken to meet Cornelia, who had come by ship, and take her directly to the Red House. De Kooning's friends were delighted to welcome Cornelia, about whose character they had all speculated. She was certainly a more exotic addition to their circle than just another artist or girlfriend. Most found her amusing and polite. Cornelia was now an elderly white-haired lady, small and birdlike except for a formidable bust, but as intense, domineering, and energetic as ever. She and her son would speak Dutch together, but his Dutch was now broken and halting and she complained that he "didn't understand." She, in turn, would speak Dutch at a rapid rate to everyone she saw—her son, his friends, shopkeepers—as if they *should* understand her even if they couldn't. Ludwig Sander, who spoke German, helped with crude translations.

The household found it slightly comic to see the fifty-year-old artist play the part of a dutiful son and, every evening, take his respectable *mutter* for a walk up and down the main street of Bridgehampton. During the day Elaine and de Kooning and various friends toured Cornelia around the villages of the eastern end of Long Island. The painter Robert Dash remembered her posing for a photograph beside the windmill in Watermill. De Kooning no doubt enjoyed this joke about her Dutch background, though he may also have wryly wondered if the image symbolized the impossibility of ever escaping from Holland to a New World. (Dash observed that

"New York was also New Amsterdam."] Joop Sanders, who saw Cornelia in the city, found her conversation both amusing and disturbing: "She entertained us one entire evening at dinner with how she cleaned the garbage can. And how this bitch of a neighbor of hers tried to imply that *she* was the one who had the unclean garbage can when as a matter of fact you could lick her garbage can." At the Red House, the elderly Cornelia would get up at six in the morning and scrub the stairs. Along with her Dutch obsession for cleanliness, she unintentionally revealed to Sanders just how cloying and smothering she must have been as a mother. Cornelia told him that "nothing's ever really changed between them, he's still her darling." She spoke "in terms almost of being a young girl, my heart goes bang, bang, bang waiting for him to arrive when he's a little late. They would go to the movies, she said, and hold hands."

Cornelia also baited her son, constantly, as if he were somehow disreputable. She might be proud of his growing eminence and financial success—as she was proud of his half brother's success as the maitre d' of the Rotterdam yacht club—but she dismissed out of hand his current work as an artist. She had strong views about what was appropriate and "nice." A painting such as *Excavation*, not to mention *Woman I*, offended her sense of what was proper, and she was not reluctant to let the world know how she felt. She managed to convey to everyone around her, despite her lack of English, that the pictures her son made as a student in Holland were much better than his current monstrosities. More important, she often expressed her deep disapproval of de Kooning's irregular way of life. Although Bill and Elaine kept up a pretense of being happily married, Cornelia probably saw through their performance. And she harped upon her son's drinking. She could recognize the signs of alcoholism and, like many bartenders, regarded heavy drinkers with contempt. Although de Kooning often appeared somewhat embarrassed by his mother, he could get along with her when he was sober. But when he made himself a drink—and she sharply told him to watch it, that he was drinking too much—they would begin fighting as if they had never been separated for a day. According to Joan Ward:

> Most of the time he knew what was going on—she kind of clawed at him—but he would get a couple of drinks in him and finally they'd start screaming at each other and there'd be this argument in Dutch. Both of them at the top of their voices. He would retire sadder and she would retire completely happy. She'd had his full attention. She loved a good screaming match.

De Kooning and his mother even had a rousing public argument during the legendary end-of-the-summer party at the Red House. A chic and well-put-together friend of Joan Ward's, who worked at the same advertising agency in New York, was so taken aback by the argument that she told her friend, "For God's sake, Joan, why don't you get yourself a decent boyfriend instead of that crazy screaming Dutchman in the dirty shirt?"

Rather than return to Holland after the summer ended, Cornelia stayed in America for several more months. She did not live with de Kooning and Elaine in New York, since Elaine was now on East Twenty-eighth Street and de Kooning on Tenth Street. Instead, she lived for a time with Elaine's sister and also with a Dutch artist named Martha Bourdrez, whose husband was head of the Netherlands Information Office in New York. Cornelia served as an occasional nanny and babysitter and spoke Dutch to the children. "She stayed with us," Bourdrez said, "because they didn't know where to put her up and she didn't talk a word of English. A difficult woman. She was so crazy about Bill but so opinionated. This wasn't good and that wasn't good. Constant criticism." She even complained, after a visit to the Cedar, that artists did not know how to have fun when drinking. They looked too "sinister" and unhappy. (She did not recognize, of course, the existential burden of being an artist.) De Kooning visited his mother regularly, taking her to the movies and out to dinner. He did not hide her from the art world. "She was very intelligent for a totally uneducated person," said Sanders. "Of course, life had educated her. And she fitted in beautifully, in one sense, everywhere. Bill took her to a party that Nelson Rockefeller was giving. She talked Dutch to everybody and everybody thought she was wonderful. Of course, the woman was accustomed to mixing because she had a bar." Still, she continued to fight with the son she adored. Once, while Cornelia was staying at the Luyckx apartment, Marjorie invited de Kooning and his mother to lunch with some relatives. The fight that ensued was an example of the physical violence that underlay the relationship between mother and son. According to Conrad Fried,

> Bill comes in and is very well dressed. He has a highball, a few drinks, gets a bit sloshed. Then he and his mother had heated words. Bill throws about half a highball into his mother's face—he was capable of doing that when drunk. His mother, by now an old lady who was *sober*, then takes a coffee cup filled with hot coffee and hurls the whole thing at his head. He ducks and it breaks and shatters into a million pieces on the shelf behind him.

After Cornelia returned home, de Kooning's sister, Marie, wrote him a scolding letter about his drinking. The letter infuriated de Kooning. He expected a more understanding response from the beloved big sister who had always been his ally and provided a sympathetic ear during the years spent with a tyrannical mother. But Marie, it seemed, had now joined with Cornelia in order to criticize him. De Kooning, after the 1954 visit, appeared to want to forget his family altogether. Once, when Elaine suggested wiring flowers to Cornelia on her birthday, his response was, "The son of a bitch is trying to outlive me."

During the partying summer of 1954, de Kooning, always intensely responsive to his surroundings, began making pictures in which the female figure and the countryside mingled so intimately that they became almost inseparable. In de Kooning's art, if not in his life, there could be no separation or escape from the female figure. She *was* the environment; she *was* the fleshy brushstroke. "The landscape is in the woman," he said during this period, "and there is Woman in the Landscapes." As usual, de Kooning did not himself think of such pictures becoming more or less "figurative" or "abstract"; that was a distinction for critics and historians. But the blending of figure and place now yielded pictures that were becoming more conventionally abstract. Then, back in New York in the fall of 1954, de Kooning once more brought the city strongly into his pictures, creating over the next year and a half what Hess called "abstract urban landscapes," with such names as *Gotham News, Saturday Night, Street Corner Incident, Police Gazette,* and *The Time of the Fire.*

Artists and critics immediately recognized, in these paintings, the mean streets of downtown New York. De Kooning slashed the gritty surfaces with various tools and whipped lines of charcoal through the paint. The visual rhythms were discordant; the planes clashed against one another; the light of the garish city was both shady and overbright. De Kooning himself referred to the overheated "circus" colors in the pictures. Even their titles could be tabloid headlines. De Kooning had a passion for crime stories, and not the genteel English kind. He preferred "BLONDE FOUND DEAD IN BACK ALLEY." The tough-guy air of film noir continued to appeal to him, and he loved the explosive light of the flashbulbs, the splayed limbs of the corpses, and the mythic feeling of night-menace found in the images of the great tabloid photographer Weegee. The paintings themselves had a "She was a tough dame" look and seem redolent of the dimestore detective novels and magazines that de Kooning sometimes read.

In this series of pictures, de Kooning created a third major "New York" style, one that followed upon his haunted, Depression-era men and his discordant symphony of postwar New York, *Excavation*. What was surprising was that, during this period of growing renown and high stylishness, de Kooning should be so powerfully drawn to the idea of crime and catastrophe. In part, the pictures continued the proud assault on "good taste" represented in *Woman I*—a crime against art intended to rattle the teacups of connoisseurs. Like the *Women*, the "Weegee" paintings celebrated a robust, petit bourgeois joy in the kitschy and lurid. And yet, it was probably not coincidental that de Kooning painted these pictures during and shortly after Cornelia's visit. He had discovered that nothing had really changed, that she still picked at him as she had when he was a child. What could be more grotesquely lurid than this relationship between an old woman and her son, who screamed at each other, hurled things at each other, declared that they loved each other? How could de Kooning not, like Raskolnikov, dream of murder? Of course, he never found it necessary to be literal; no one can find "the body" in these urban abstractions. And de Kooning made only a few pictures in this lurid vein. More important, the last of these urban abstractions was very different from its predecessors. It was a picture in the grand style, in which he dreamed of new life as well as death.

Easter Monday

Easter Monday could be the title of a poem by Frank O'Hara: the phrase perfectly captures the characteristic outlook of the painters and poets who frequented the Cedar, as they sought to turn the expected on its head or make a surprising or witty marriage of opposites. If Easter invariably occurred on a Sunday and was the holiest and most joyful day of the Christian year—a time of resurrection when man transcends his base nature—Monday was the day when people returned to work. Calling a picture *Easter Monday* clapped together, like a pair of cymbals, the transcendent and the vernacular, at a time when the New York school celebrated both the lofty dreams of Rothko and Newman and the gritty working-class spirit of the Cedar.

De Kooning, who respected earth more than heaven, was not one of the period's mystics. Religious themes occasionally entered his oeuvre and he admitted to a lifelong fascination with the Crucifixion. But the higher reaches of religion made him anxious. To this most tactile of

painters, religious reverie seemed too airy and intangible; literally out of touch. He would have been one of the boys in the congregation who wonders what people could possibly find to do in heaven. It irked him that contemporaries continued to puff up their art with the high-flown importance of "myth" or "transcendence" or "history." And so, the phrase may also have appealed to him as a way to participate in the mythic chorus of abstract expressionism while also teasing its more earnest apostles, reminding them that the day after the miracle must also be accounted for. The phrase had a way of twisting the tail of meaning—of turning back in doubt—that complemented de Kooning's hooking brushstroke.

De Kooning's titles were rarely intended as guides to the meaning of a picture. And this one may have little more than the inspiration of a moment, happened upon because de Kooning's second one-man show at the Sidney Janis Gallery was scheduled to open on April 3, 1956, the day after Easter—on, that is, "Easter Monday." He was struggling to make the deadline; he apparently finished the picture on the day of the opening. Even so, de Kooning probably did have Easter in mind during the final stages of work. Like the previous urban abstractions, *Easter Monday* evoked the mean streets. It was built upon a grid pushed and twisted by a slashing brush, conveying an impression of the kaleidoscopic jumpiness of the city. And, as was de Kooning's habit, the painting had sometimes been covered with newspaper to keep the paint wet, which left behind the ghostly shimmer of newsprint in the final image. If *Easter Monday* suggested a crime, however, it was one that far transcended the cheap murders in de Kooning's detective stories. It recalled instead the greatest crime in Christendom—the Crucifixion.

The verticality of the picture and some geometric, angular brushstrokes evoked the cross, even if they did not describe it. The flesh tones and the violent twisting of the brush suggested both the convulsive physical agony and the transcendent spirit of Christ; a gash of red even recalled the lance wound in Christ's left side. This crime, however, ended in joy—the resurrection. *Easter Monday* was far more elevated in feeling than de Kooning's other urban abstractions. It was larger and more vertical and seemed to reflect the light glancing off the sky, not just the lurid glow of the streets. The paint was less beaten and clotted, the palette softer and more springlike. The pinks, whites, and light blues are as dressy as an Easter outfit. Still, mainly secular resurrections were being celebrated in *Easter Monday*. There was, of course, de Kooning's personal sense of resurrection. In the forties, lost in despair, de Kooning painted a great black-and-white called *Black Friday* that evoked the Crucifixion. By the mid-fifties, however, de Kooning was no longer being figuratively cruci-

fied. He had certainly risen in the world, becoming a kind of secular deity among the artists of New York. In his review of the 1956 show that included *Easter Monday*, Hess wrote that de Kooning "had replaced Picasso and Miró as the most influential painter at work today." New York, too, was elevated. The brushstroke in *Easter Monday* rose above the streets, at once celebrating and transcending the artist's adopted city. And the downtown milieu of artists and poets in New York, which had suffered such neglect and ignominy in the thirties and forties, also found its paradoxical moment of resurrection. The artists and poets at the Cedar, in 1956, were no longer a struggling underground. Whatever the particular circumstances of individuals, the group as a whole was becoming successful and admired. Abstract expressionism was now a dominant style, entering a period of glorification rather than of discovery.

Easter Monday was de Kooning's first truly mainstream painting. He was no longer a tormented explorer in this picture, but an artist in control of his time, place, and style. Even the painting's ambiguities appeared stylishly confident: he was in full command of his contradictions. In the mid-fifties, de Kooning, the most individual of painters, was beginning to dream of a grand style that could transcend, as well as embody, the personal. He would have known T. S. Eliot's essay "Tradition and the Individual Talent," which was influential at the time among critics and which famously argued:

> Poetry is not a turning loose of emotion, but an escape from emotion; it is not the expression of personality, but an escape from personality. But, of course, only those who have personality and emotions know what it means to want to escape from these things.

De Kooning aspired to the art of Rubens, not Rembrandt, in the mid-fifties. Americans had always preferred the Protestant individuality of Rembrandt to the more Catholic, aristocratic stylishness of Rubens. But de Kooning, a working-class immigrant who still fit awkwardly into his new country, understood the glory of a grand style. He once called Rubens, admiringly, "that show-off." De Kooning in *Easter Monday* sought a heightened fluency in which he could work, like Rubens, "with complete conviction and reckless abandon." That was a resurrection, and release, worth the years of personal struggle and hardship.

26. Other Lives

There is no such thing as being anonymous.

The resurrections celebrated in *Easter Monday* came three months after de Kooning's own life underwent a profound transformation: on January 29, Joan Ward gave birth to his daughter, Johanna Lisbeth de Kooning.

The birth did not mark the resumption of a serious relationship between Ward and de Kooning. Although de Kooning was the love of Joan's life, he still did not reciprocate her feelings, regarding her as a "good friend" rather than as a serious lover or a potential wife. Nonetheless, they had continued to see each other occasionally. In later years, neither Ward nor de Kooning could recall the circumstances that led, in 1955, to her second pregnancy. It was apparently the result of a moment's fancy, a tumble into bed, perhaps, after a day or night of drinking. The art world talk, spread by Elaine, was that Joan showed up at lunchtime with "a pitcher of martinis." De Kooning assumed she would have another abortion, as did Elaine, who told her, "Well, you know, Bill and I always intend to have children." But Ward was too wounded by her first experience with abortion to have a second. "I couldn't," she said. "I couldn't, again." Gossips wondered if she had tried to become pregnant in order to "catch Bill," but Ward herself saw nothing reassuring in the future. She knew that she could not depend upon de Kooning for either emotional or financial support. She would have to give up the job she loved, moreover, to raise the baby. "I was at a crossroads," she said. "I was terrified." She considered the pregnancy "a nightmare."

When Ward told de Kooning that she planned to have the baby, his response, she said, was "oblique." "He never said yes," Ward said, "but he never said no, and he was somehow more for than against." De Kooning always had a soft spot for children, though he knew that he was not suited to be a father and, in the past, whenever the prospect of fatherhood arose, an abortion was the predictable result. If Joan herself insisted upon having the child, however, he seemed to think, well, why not?

During the pregnancy, de Kooning did not help Ward much. At five months, when she could no longer conceal her condition, she resigned from the job she had held for ten years. She began to collect unemploy-

ment insurance, which helped her pay the rent on a small apartment on Leroy Street. When labor began, she called her sister, and Nancy and Franz Kline took her to the hospital. The baby was born an hour or two after midnight. De Kooning arrived at the hospital in the morning, and, not having heard the news, crept into Ward's room looking, she said, "like the white rabbit." It was one of the few times, she said, "that I've seen Bill in total shock." He hurried to see the baby. An Italian-American couple, the sculptor James Rosati and his wife, Carmen, found de Kooning standing behind the glass gazing into the nursery at his newborn daughter. He was rocking back and forth, his hands behind his back, softly humming to himself, "Hmmmm . . . hmmmm." The Italians, who had four children, looked through the glass and said, "Isn't the de Kooning baby beautiful?" De Kooning beamed: Italian families, like the Randolfis in Rotterdam, knew children. He continued to rock back and forth, humming to himself, sometimes repeating, "She's beautiful . . . she's beautiful." According to Joan, "Once she was born he fell in love forever."

Joan was mainly responsible for naming the baby. She wanted a Dutch name. She checked various possibilities with de Kooning, who had no particular preference, except that he disliked "Nellie" because, he said, "it sounded too much like a maid." "Johanna" was a common name in the de Kooning family, and "Lisbeth" was Dutch for Elizabeth.

De Kooning took great pleasure in showing his friends the apple-cheeked baby, whom one and all said looked Dutch. He would often drop in to see her at Joan's apartment, and he tacked up her photograph on his studio wall, among the reproductions of paintings, magazine ads, drawings, and pinups. He would proudly point out the picture to visitors. There was no doubt that he loved the baby. But there was also no doubt that he would not fundamentally alter the pattern of his life. As before, he slept in his studio, worked on his paintings when he wanted to, and drank away the nights with his friends at the Cedar.

When his old friend the artist and scientist Alcopley returned to New York in the spring of 1956 after several years in Europe, de Kooning invited him to have dinner at Joan's and see the baby, nicknamed Lisa. Early in the evening, Alcopley dropped by de Kooning's studio to pick him up, and the two friends decided to walk to Ward's apartment. As they passed the Cedar, de Kooning said, "Let's just go in for one drink." "I don't think we should do this," Alcopley said, "because Joan expects us for dinner." But Bill said, "We'll only stay for one little drink." Inside the bar, there was a chorus of greetings: "Oh Bill, Bill, Bill!" According to Alcopley:

He had not one drink but several drinks. It seemed like he paid a few hundred dollars for everyone to have drinks. When we finally arrived at Leroy Street he was dead drunk and Joan was crying. She was afraid to let him hold the baby, but he insisted. So I put my arms under the baby as Bill held her so that she wouldn't fall.

Ward's tears represented not just her disappointment over the ruin of one evening, but, more tellingly, her recognition that the birth of Lisa would not transform de Kooning into a responsible father or renew his love for her. De Kooning, it was clear, was simply not going to inconvenience himself—or his art—to accommodate other lives. It would instead be Joan and Elaine, the women with the greatest claim upon him, whose lives would be upended. Joan naturally dreamed that de Kooning would marry the mother of his child; at the very least, she hoped he would help her create a stable home for Lisa. Now, her darker apprehensions seemed to be coming true. She might well be left a single mother, raising Lisa alone on an uncertain income and forced to nag de Kooning for help. The demands of raising a child would not allow her to resume her job or to laugh with the art world at the Cedar. De Kooning would continue to party without her, whether or not she put dinner on the table. The New York art world had little interest in a mother with a baby.

The situation was just as troubling to Elaine, though she did her best not to show it. Professing herself delighted that Bill was a father, she immediately went to the hospital to see the baby and congratulate Joan. There, she found a chilling portent: Joan was admitted under the name of "Mrs. de Kooning." The words forced Elaine to confront—perhaps for the first time—what Lisa's birth might mean for her. She could not fail to be hurt and angry. *She* was Mrs. de Kooning. It seemed outrageous to her that Joan Ward would assume her name and, possibly, supplant her position in de Kooning's life. To Elaine, Joan was just another fetching young thing, a girl in the bar, a passing fancy—whereas she, Elaine, had been with Bill for years, during the hard times. But Joan now had the one claim upon Bill that Elaine could never match, that of a shared child. During the pregnancy, Elaine did not let herself believe that an accident like a baby would ever threaten their widely admired artists' marriage. But she now recognized that the marriage might actually collapse. In order to make Lisa more "legitimate," de Kooning might divorce her.

Elaine knew that de Kooning could be old-fashioned about such things: he might decide that the parents of his "little angel" should be married. As a result, she might lose the man who remained the center of her life. And she was thirty-eight years old. It did not make her

feel any better that she and de
Kooning had discussed having a
child together; or that she had had
three abortions; or that she had just
had a hysterectomy, making chil-
dren an impossibility. She also knew
in her bones the terror and despera-
tion that aging and loss could bring
to a woman. Her mother's near mad-
ness—the painted face and dramatic
moods and desperate search for "the
artistic"—were probably never far
from her thoughts, even as she
maintained the witty air and public
sense of control that Marie always
demanded. Elaine later said that
she raised the issue of a divorce her-
self rather than waiting for de Koo-

Elaine de Kooning in 1957

ning to bring it up, a version of events contradicted by her brother. But
de Kooning would probably have responded to the prospect of a divorce
the way he usually did to issues about which he was ambivalent, by
doing nothing. He might have wanted to get divorced because of Lisa; but
he did not want to marry Joan. Besides, he was always made anxious by
anything official. A divorce would call attention to his legal status in
America.

Elaine, equally true to form, transformed her difficult emotional situ-
ation into an occasion for stylish wit and storytelling. It was a way of mas-
tering the problem and earning respect rather than pity. According to a
story that made the rounds of the art world, Elaine, when she went to the
hospital and saw Joan identified as "Mrs. de Kooning," immediately
quipped, "Oh . . . Bill and I always wanted a child." The line was worthy
of Dorothy Parker (although Joan did not recall Elaine saying it). Elaine
appeared breezily at ease during the painfully awkward visit to the hospi-
tal. She cluck-clucked over the newborn, whose face was temporarily
scrunched up by the passage through the birth canal. Joan, anxious at
Lisa's appearance, suddenly joked, "Well, the baby actually looks sort of
like Jackson Pollock!" Elaine seized upon the remark, telling everyone at
the Cedar, as if it were the funniest thing in the world, "The baby looks
like Jackson!" She loved the story because it playfully suggested the baby
was not really Bill's, and that Joan was the kind of girl who did not neces-
sarily know who the father was. The stories about the "pitcher of marti-

nis" and the baby "looking like Jackson Pollock" and Joan's presentation as "Mrs. de Kooning" not only served to put Joan in her place, but also assured the world that the baby would not change her relationship to de Kooning. Soon, Elaine developed a charming way of explaining away the business of "having a baby." She preferred to be a "fairy godmother." Children were marvelous, of course, but the onerous day-to-day responsibility of raising them was something no truly clever or magical person—and certainly no committed artist—could accept.

Elaine's friends noted that she was drinking more and more. She would often begin the morning with a shot in her coffee and was starting to drink throughout the day. Joan, too, was a drinker. For those around de Kooning, the party in the art world was beginning to change character by the mid-fifties. Alcohol was used less to celebrate good times than to escape from burdensome personal pressures. This was particularly true of de Kooning himself, whose drinking was developing a new intensity as time passed. He would increasingly fail to call it a night, staying out until he was sloshed; sometimes he drank until he passed out. He also left the studio more regularly in the evening, hitting the Cedar, or, occasionally, other bars when he and his friends found themselves at an opening or a party elsewhere in town. After two drinks, de Kooning might become a marvelous raconteur. But after five or six, his mood, like Pollock's, could instantly darken. Then he would grow surly, brooding above his glass. In his eyes, a shade seemed pulled down partway. Sometimes he lashed out unexpectedly.

De Kooning was becoming a binge drinker. There were times when he would pass out, awake hungover, kill the hangover with another drink, and then begin drinking heavily again. No one could control him during a binge. It could go on for a week or more, until exhaustion felled him. His behavior seemed different from the practice of ordinary alcoholics, who drank consistently every day. The binges seemed explosive, as if they were the only way to discharge unbearable internal stress. In addition to the daily pressure he felt to create strong new art, de Kooning now had the added responsibility of being a father, both to Lisa and to the New York school. He did not know how to sort out the politics of painters, wives, girlfriends, and mothers. Lisa's birth threatened to awaken memories from his own childhood of claustrophobic anxiety and an angry, broken family. His marriage to Elaine had not been a conventional success; now, his official wife was not the mother of his child, his daughter was "illegitimate," and the disappointed Joan—who loved him but with whom he did not wish to live—berated him over his obligations as a father. All his life, de Kooning without fail instinctively rebelled against the expectations of

others. He could love Lisa without reservation. He could want to be a good father. He could even maintain an old-fashioned belief in the proprieties, as in "a man must look after his family." But he could not, finally, submit to the demands of other lives.

As a teenager, de Kooning fled from his suffocating family at the first opportunity, adopting in its place the community of artists and outsiders struggling to scrape by in an alien world. This "family" sustained de Kooning both in Rotterdam and in New York. He made the floating group of "have-nots" his true home. But de Kooning's adopted family was now becoming unrecognizable. The competitive air of the new art world, exacerbated by critics, dealers, and hangers-on, disturbed him. De Kooning wanted to be successful; but he also wanted the artists' world to remain intact, characterized by an equality born of common struggle. The scale of the New York art world was growing, its air becoming more moneyed and rarefied. De Kooning could not help feeling somewhat out of place—an impostor king. It may be that, paradoxically, the binges helped restore some measure and balance to his life, for on those occasions he became, once again, another beat-up man of the streets.

In April 1956, de Kooning exhibited his mid-decade abstractions, including *Easter Monday*, at the Sidney Janis Gallery. The show was an enormous success. Not surprisingly, Janis was delighted that de Kooning had "returned" to abstraction. Collectors clamored for the new work. The press was laudatory. A certain unreality attended the hoopla around the show, at least for de Kooning. He was pleased, but the opening on Fifty-seventh Street was not anything like the gathering of friends that once constituted an artist's opening. There were many people whom he did not know or recognize. And while he could always count upon being surrounded by old friends and youthful admirers, he could not fail to notice that even some old-timers were beginning to look at him sharply. It had long been obvious that the "gentleman's" clique of uptown artists disapproved of the "bum's" clique at the Cedar. Now, however, there was an air of resentment surfacing among some artists, especially those less fortunate than the leading figures. They were becoming disgusted by the big parties, the big prices, and the ongoing adulation of de Kooning.

Even some admirers of de Kooning, such as Conrad Marca-Relli, began to voice reservations about him. If they once took de Kooning's friendliness for granted, they now wondered whether his willingness to praise young artists or to clean the cups at the Club represented the politicking of a man determined to get ahead. Artists talked often about this. The

playing out of de Kooning's life had, for many, a symbolic import. According to Marca-Relli:

> Bill kept two levels. He mentioned it once. One was friendship, the other was his ambition as a painter, the professional. I even asked him once when he was getting a lot of success. "How do you think? We had nothing and then all of a sudden . . ." He said, "It's another world. I'm still the same in one way with friends. That's another activity. I look at it as another kind of thing."

Marca-Relli considered de Kooning "shrewd" in his relations with the larger world.

> I guess that goes with it. If you want to be the top banana, you've got to have these qualities in you. Like Picasso. Picasso was a great painter. At the same time, he was the greatest operator. Between Tom Hess and Harold Rosenberg and Elaine who promoted him . . . I tell you, Bill was so involved. Unquestionably he had this dynamic of making sure of how it goes and how it works and what the system is here. Don't forget, this is a Dutch boy who came here on a boat. He's going to make it. He had more drive to make it than someone born here who was more relaxed. He knew that this was a tough place to break through. And he used all the power in him. . . . Once I remember Lee Eastman [de Kooning's lawyer] said to me on the beach, "Isn't it wonderful how a guy like Bill, so simple and so timid, could get all this success?" I looked at him and said, "Are you joking?" But it's very difficult to pin down Bill on that. Because if he were to walk in right now his presence would almost disqualify everything I'm saying because he would be so sweet and so generous.

One of de Kooning's oldest friends, Milton Resnick—who first questioned de Kooning's motives as early as 1950, after the insiders' session at Studio 35—now openly despised de Kooning as a sellout. The painter Ad Reinhardt, an artist who combined a powerful drive toward aesthetic purity with a bitterly satirical view of the evolution of the art world, also took a skeptical view of de Kooning's advance. While Reinhardt always maintained a measure of respect for de Kooning, he could not abide either the fancy rhetoric about "the meaning" of abstract expressionism or the way in which painters were beginning to flirt with dealers, collectors, and socialites. In an exhibition chronology of his life, which Reinhardt wrote himself, he described the mid-fifties in this way:

1952 Debates for several weeks on "The Hess Problem" at Artists' Club.
1952 *Farouk abdicates Egyptian throne.*
1953 Gives up principles of asymmetry and irregularity in painting.
1953 Visits Greece.
1953 Paints last paintings in bright colors.
1954 Daughter born.
1954 *Cambodia, Laos, Vietnam achieve independence.*
1954 *MacDonald Wright returns to Abstract Art.*
1955 Listed in Fortune Magazine as one of top twelve investments in art market.
1956 Borrows money from bank to travel.
1956 *Suez crisis.*
1956 Makes last cartoon, a mandala.
1957 Willem de Kooning says in the ChuckWagon, "The rich are all right."
1957 Buys Pearl Bailey's record "They're Good Enough for me."
1957 Forms SPOAF (Society for the Protection of Our Artist Friends) (from themselves), after reading "Nature in Abstraction" statements.

It was not just the curdling of gossip and the resentments over success that poisoned de Kooning's sense of family and increased the pressure on him. Serious resistance to his art was also developing in the mid-fifties, and de Kooning, despite the praise lavished upon him, was sensitive to such criticism. Clement Greenberg remained the best-known skeptic. The art world knew that he disliked the *Women;* the critic told de Kooning to his face what he thought. But most people reduced Greenberg's argument to gossip: he was engaged in the marquee fight "Jackson vs. Bill" or "Abstract vs. Figurative," or "Clem vs. Harold." The argument with de Kooning, many thought, was essentially personal, since the two men continually found new ways to insult each other. (Once when Greenberg was visiting de Kooning's studio, for example, the painter offered the critic a sketch he had admired, perhaps in an effort to patch things up. Greenberg turned it down.) In fact, Greenberg was engaged in something more threatening than gossip: he was developing a serious and influential challenge to de Kooning's art. Greenberg was too wily a critic to damn with faint praise. He damned, instead, with encomiums to de Kooning's genius—his *failed* genius. It was so disappointing, Greenberg would suggest, that de Kooning should ultimately fail to bring his great gift to fruition.

It would not be until the early sixties that Greenberg would directly and harshly attack de Kooning in print, but in conversation the outlines of his critique were already clear by the mid-fifties, and it was not difficult to

read between the lines of his prose. In 1953, Greenberg had written an admiring foreword for a small de Kooning retrospective at the Workshop Center for the Arts in Washington, D.C., in which he argued that de Kooning was trying to make "advanced" art that did not break from the past.

> De Kooning strives for synthesis, and in more ways than one. He wants to re-charge advanced painting, which has largely abandoned the illusion of depth and volume, with something of the old power of the sculptural contour. He wants also to make it accommodate bulging, twisting planes like those seen in Tintoretto and Rubens. And by these means he wants in the end to recover a distinct image of the human figure, yet without sacrificing anything of abstract painting's decorative and physical force. Obviously, this is highly ambitious art, and indeed de Kooning's ambition is perhaps the largest, or at least the most profoundly sophisticated, ever to be seen in a painter domiciled in this country.
>
> This is painting in the grand style, the grand style in the sense of tradition but not itself a traditional style, attempted by a man whose gifts amount to what I am not afraid to call genius (his ability as a colorist is larger than even his admirers ordinarily recognize). No wonder de Kooning has had such a tremendous impact on American painting in the last several years. He is one of the important reasons, moreover, why that painting has ceased to be a provincial one and become a factor in the mainstream of Western art today.

Despite its air of praise, however, this small essay seemed full of thoughts left portentously unsaid. Nowhere did Greenberg suggest that de Kooning succeeded in this synthesis or in his desire to recharge advanced painting. Instead, de Kooning "strives" for synthesis and "wants" to create "something of the old power of the sculptural contour." The critic's use of "something" was a rhetorical dagger, subtly applied. The famous struggle over the return to the figure and *Woman I* was not mentioned; the circumspection stuck out like a thumb. Whatever the painter's success or failure, however, de Kooning's "ambition" was "perhaps the largest" in American art—or, if not, then the "most profoundly sophisticated." The phrase "profoundly sophisticated" was also two-edged, almost an oxymoron. It suggested that de Kooning might be deeply schooled, yet lacked the depth and authenticity that were part of the "largest" ambition.

In the landmark essay of 1955 called " 'American-Type' Painting," in which Greenberg laid out his views on the work of the first generation of the New York school, he was somewhat more direct. But the words were

still those of a critic knocking an artist off a high perch. Once again, Greenberg emphasized de Kooning's ambition, saying that the painter had "both the advantages and the liabilities—which may be greater—of an aspiration larger and more sophisticated, up to a certain point, than that of any other living artists I know of except Picasso." As the dig about "liabilities" suggested, Greenberg seemed to think that de Kooning had merely proposed, but not realized, "a synthesis of modernism and tradition." By invoking the figurative contours of the past, the painter "risks" a "secondhand effect." And, like Picasso, de Kooning "hankers after terribilità"— another brilliantly cutting phrase, for no one who actually possesses terribilità would ever *hanker* after it. Also like Picasso, de Kooning had a "nostalgia for tradition"—which is not the same thing, of course, as maintaining a tradition. "And it would seem," Greenberg wrote, "that there was even more Luciferian pride behind de Kooning's ambition: were he to realize it, all other ambitious painting would have to stop for a while because he would have set its forward as well as its backward limits for a generation to come."

Luciferian pride may be large, but it is hardly admirable. And other ambitious painting had *not*, of course, stopped for a while, the implication being that de Kooning had therefore not realized his Luciferian ambition. "If de Kooning's art has found a readier acceptance than most other forms of abstract expressionism," Greenberg continued, "it is because his need to include the past as well as forestall the future reassures most of us." Another cutting sentence: no vanguard modernist wanted either to "forestall the future" or to "reassure." Greenberg would not even concede that the *Women* were disturbing, for "the methods by which these savage dissections were carried out were patently Cubist." In other words, they were safe and old-fashioned. Not surprisingly, Greenberg ended by once more concealing a rebuke behind what seemed a generous celebration of genius. The critic preferred some of the artist's later, smaller *Women*, he said, to the larger *Woman I* and her sisters. "In certain of his latest *Women*, which are smaller than the preceding ones, the brilliance of the success achieved demonstrates what resources that tradition has left when used by an artist of genius. But de Kooning has still to spread the full measure of that genius on canvas."

Greenberg's words were wounding because, more than any other critic of the time, he was constructing a modernist pantheon. He was attempting to establish who and what really mattered in modern American art. It was clear that de Kooning, for all his talents, would not be admitted to this pantheon as an authentic successor to the masters of the past. For a critic of Greenberg's sensibility, de Kooning, trapped between traditions,

in love with both the past and present, was finally too impure in outlook and too unclear about the historical responsibilities of genius. (Eventually, Greenberg would come to believe that de Kooning's failure was essentially one of character—that he went soft and showy.) It was probably less the critic's condescension that galled de Kooning than his refusal to understand and respect what impurity could mean: it was exactly the impurities of life and art that excited in de Kooning the sensation of truth.

There were other pantheons beginning to rise in the mid-fifties that also excluded de Kooning. Barnett Newman, Mark Rothko, Clyfford Still, Adolph Gottlieb, and William Baziotes were proposing a kind of temple. They were visionaries with little patience for an appetite like de Kooning's. To such artists de Kooning seemed not only trapped in the past but also unable to sound the sublime chords of myth that they believed should animate art. And some hinted that de Kooning should not occupy a central place in American art because he was not, finally, *American* enough. They believed he was essentially French in outlook, a chef-painter of the School of Paris who created an art of tasty effects lacking in the rough-hewn force and visionary convictions of true American art.

As for younger artists—there, too, a challenge was developing. Many "second-generation" painters aped de Kooning's style and passion, but there were also young painters with an ironic, laughing eye. Not only had Rauschenberg erased a de Kooning drawing, but he continued to satirize abstract expressionism. A fresh appreciation for irony and wit, together with an unabashed interest in American pop culture, was beginning to enter the studios of some young artists. Rauschenberg's close friend Jasper Johns painted his celebrated *Flag* in 1955 (although it was not exhibited until 1958), and John Cage was a ubiquitous questioner of all holy platitudes and grandiose pantheons. Among the younger painters and poets at the Cedar were a number of wits, notably Frank O'Hara, who, while revering de Kooning, also maintained an irreverent taste for camp that seemed very "knowing." De Kooning worried that "They have no innocence."

But above all, his contemporary Jackson Pollock reminded de Kooning that, in America, there was an inner circle that he could never quite penetrate. In the mid-fifties, Pollock was in a period of near collapse, wracked by alcoholism and floundering as a painter. Even Greenberg, his greatest champion, would not write in support of his most recent work. In " 'American-Type' Painting," Greenberg was almost as tough on Pollock as he was on de Kooning, refusing to grant Pollock a preeminent position in American art. And yet, even Pollock's self-destruction had a kind of grandeur that many in the art world respected. Pollock seemed a purely

American figure, an authentic visionary, cowboy, and maverick. Compared to Pollock, de Kooning could not help but feel both old-school and old-country. The "immigrant" might have been as important to American history as the "cowboy," but he did not possess the same seductive romance. If few doubted that de Kooning was the superior painter, many considered Pollock the greater artist and more authentic American.

De Kooning was not a man secure in the role of "insider." And the small circle of doubters in the art world, questioning his motives or wishing to exclude his art from high praise—arguing that his painting was *not* in the vanguard, *not* visionary, *not* American, *not* quite authentic—only seemed to grow larger the more famous and celebrated he became.

In the spring of 1956, Joan Ward decided to spend the summer on Martha's Vineyard rather than on Long Island. The social life of the Hamptons art world was too intense and distracting for a mother with a six-month-old baby. More important, Joan hoped in this quieter setting to convince de Kooning to settle down and become a family man. Perhaps here, on an island removed from the art world, she would bring Bill, herself, and Lisa together, and create a genuine household. She even began to wear a wedding ring.

De Kooning agreed to spend much of the summer on the Vineyard with Joan and Lisa. A close friend of Joan's offered to share a rented house with the family. On the island, de Kooning was not entirely cut off from the art world. A number of writers and artists traditionally summered there, and one of de Kooning's casual friends from the Cedar, the painter Herman Cherry, rented a house just down the road. There could be no doubt, however, that the pressures of New York were further away on the Vineyard than they were on Long Island. De Kooning spent the days working on the porch of the house, mostly making drawings, and he doted on the baby. On August 12, Cherry stopped by their house with some news. According to Joan:

> Bill was painting on the porch and I was inside. Herman, with his face down to his knees, says, "Bill here?" I said, "Yeah, he's out on the porch." He went out with heavy shoulders sagging. I heard voices going on. About ten minutes later they come in, Bill looking rather startled, rather like the White Rabbit, you know, "What am I supposed to be doing here." Then he said, "I guess we better tell Joanie. Jackson Pollock was killed last night in an automobile accident."

There was a long pause. Joan said "How terrible," and glanced at Bill for help, as if he could provide the right response. "Bill just looked at me kind of round-eyed. But Herman, I tell you, I thought he was going to say, 'And now he belongs to the ages.' The way Herman was acting, I thought we were supposed to cast ourselves into the sea." Cherry decided to charter a plane in order to attend the funeral. De Kooning agreed to go along, while Joan stayed behind with the baby. Cherry and de Kooning flew to East Hampton and found the art world gathering in the Springs for the funeral. Neither Pollock's death nor its cause came without warning. Pollock had been drinking himself to death, and his friends often worried about his drunken driving. Unfortunately, he had not only killed himself. He had decided to take his lover Ruth Kligman and her friend, Edith Metzger, to East Hampton. He did not feel well, however, and chose to return to the Springs. On the way back, he was driving too fast—terrifying the two women—and finally lost control, smashing into the trees. Metzger was crushed to death under the car. Kligman was thrown free and survived. Pollock hurtled into a tree and was killed instantly.

For the art world, Pollock's death immediately assumed a kind of mythical power. If he was the first to succeed, he was also the first of the major figures, with the exception of Gorky, to die. His end complemented his life and art. The violence and self-destruction were not, in his case, a pose or something for show. In death as in art, Pollock seemed to set the standard. He had gone all the way. He was first. Although many in the art world were prepared to make a dark romance of his death, some observers (notably Greenberg) insisted upon its sad and sordid aspect. Pollock was also a drunk who killed a young woman.

Not surprisingly, Pollock's death disoriented the living. How would the art world fit together with such a large and essential piece removed? Had an era passed? Was abstract expressionism coming to an end? At the gatherings and the funeral, de Kooning was extremely quiet. He seemed moody. Pollock, like Gorky, was family. Like every serious figure in the art world, de Kooning was forced by the death to think about first principles and the scale of artistic achievement. He talked for a while to Elaine, who had been with him during the hard years. He appeared in no hurry to fly back to Martha's Vineyard. After the death of this passionate, outsize figure, he could not easily return to his small domestic life on Martha's Vineyard, with its nagging expectations and responsibilities.

Elaine joined de Kooning and Cherry on the charter flight back to Martha's Vineyard. Her arrival came as a shock to Joan. De Kooning did not warn Joan that he was bringing Elaine with him or tell her what it

meant. He had not called Joan from Long Island the way a husband might have, even after a couple of days, and Joan had no idea what he was doing or when he would return. (At last, she had called Nancy to ask where de Kooning was, and Nancy, perhaps sensing what was happening, said only, "I don't know, but Elaine was here.") Once they arrived on Martha's Vineyard, de Kooning and Elaine moved into Cherry's house. After two days, the friend sharing the house with Joan said, "I know what we're going to do. We're going to give a party. Put on a good face."

Elaine came to the party, but de Kooning did not. Joan could not stand the situation for long. She went up to a friend and asked her to tell Elaine to leave. Elaine responded by walking up to Joan and saying with a smile, "I understand I'm being asked to leave," as if the idea were a big joke. The following day, Joan's friend, who had a car, saw Cherry and de Kooning at a gas station. De Kooning got out of Cherry's car and into the friend's, saying, "Let's go home now." Back at Joan's house, de Kooning and Ward immediately quarreled. The next day, Elaine came to the house. This time she was not in a joking mood. She told Joan, "You wear a phony wedding ring." Joan answered, "It's no phonier than yours." Elaine said, "You little girl from Scranton!" Joan answered, "I'm not from Scranton, for God's sake. Somebody from Brooklyn isn't going to tell me what to do." Finally, Joan picked up Lisa—a baby was even better than the last word in an argument with Elaine—and shut herself in her bedroom. Outside, Elaine tried to talk to de Kooning, but he refused to engage her in serious conversation. Elaine, furious, then left for the airport and flew back to New York.

It was not the first time that de Kooning had set up a conflict between two women who loved him. In this instance it sent an oblique but unmistakable signal to both Joan and Elaine: each must understand that neither could own him. But the death of his great rival and friend also left de Kooning more troubled by internal pressures than ever before. Now, in addition to everything else, he would become first among equals in the New York school. It was something he both wanted and did not want. During the next few years, the stress of great expectations occasionally led de Kooning to behave in an uncharacteristic way, especially when he was drinking. Conrad Marca-Relli, who lived near Pollock's house in the Springs, told a chilling story about the aftermath of Pollock's funeral.

> Jackson's dogs came into my house because they were looking for their master. It gave me the creeps. I said something and Bill said, "It's all right. That's enough. I saw Jackson in his grave. And he's dead. It's over. I'm number one." I said, "Bill, come on. This is something else."

de Kooning

De Kooning, who would boast only when drunk, went into the garden. Eleanor Ward followed him to see what was wrong and returned, saying, "He's crying. He's in a very bad mood." De Kooning was crying not over Pollock, Marca-Relli said, but over his own isolation. He felt abandoned, lost at the top. "What's wrong?" Marca-Relli asked him. "Why don't you back me up?" de Kooning answered. "I told him 'You've got everything, for God's sake. Why do I have to back you up?' But this was the way his mind was working. He felt everyone was supposed to back him up for being number one."

27. Imperial New York

It's not so much that I'm an American: I'm a New Yorker.

I n the mid- to late fifties, Picasso became the genius-king of Western culture, surrounded by a court of admirers and sycophants. His life on the Riviera, his succession of mistresses, his bull-like visage and smoldering stare, entranced writers and photographers. He did not appear bound by the ordinary rules of either art or life. He did not pay the bill at restaurants, it was said, but instead left behind a doodle. The superstar supplanted the modernist.

The New York that de Kooning returned to in the fall of 1956, following the death of Jackson Pollock, was similarly prepared to crown the man who, more than thirty years before, had stolen onto a ship in Rotterdam. Its critics and painters were now routinely proclaiming that New York had replaced Paris as the center of art. If New York could not have Picasso, it must nonetheless have its own superstar. De Kooning did not have the reputation of Picasso, of course—no living artist did—and he could not successfully compete with the sainted dead, such as Pollock. But the camera loved de Kooning, as it did Picasso, and de Kooning, too, led an intriguing private life sparked by a succession of mistresses. His drinking bouts were becoming legendary, and behind his fair countenance seemed to lie a brooding darkness that the sentimental could regard as romantic, for weren't geniuses supposed to suffer? He had a court of devoted acolytes and a scribe. Hess regularly wrote of the "second generation" and *l'école de Kooning*.

In 1957, the Museum of Modern Art presented a large Picasso retrospective on the occasion of that artist's seventy-fifth birthday. The exhibition, a kind of apotheosis of Picasso, traveled around the country. At the same time, MoMA was preparing a show of abstract expressionist art to send to cities across Europe that would not only attract crowds but send abroad the implicit message that the art of New York now dominated high culture. The New York art world was beginning to glitter. It was not impossible that, on some stray evening, a fashionable person like Gloria Vanderbilt would show up at the Cedar, although that was still not the rule. Sidney Janis began aggressively taking on additional contemporary

artists, such as Philip Guston, and successfully selling their work. Leo Castelli, recognizing the burgeoning market, planned to open a gallery.

The New York scene jelled on de Kooning's doorstep. Throughout the 1950s, young artists were pouring into the city, typically settling in the area becoming known generally as "Tenth Street," a low-rent section of the Village between Eighth and Twelfth Streets and First and Sixth Avenues. The center of the district was de Kooning's street; a number of the more established artists of the period lived on his block between Third and Fourth Avenue, including Esteban Vicente, Philip Guston, Michael Goldberg, and Milton Resnick. Not surprisingly, newcomers arriving in New York, many of whom went to art schools in the area, wanted to exhibit their work. Early in the fifties, the Hansa Gallery, the Stable Gallery, the Martha Jackson Gallery, and the Tibor de Nagy Gallery began showing the art of emerging artists. As the art scene grew, young artists also began to open cooperative galleries, managed and financed by the artists themselves, around Tenth Street. The first to open was the Tanager Gallery in 1952. By 1957, the Camino, Brata, March, and Area Galleries had joined the Tanager on de Kooning's block. Although some young artists in the Tenth Street galleries resisted de Kooning's influence, many adopted his gestural "language" and almost all revered him. De Kooning's main hangouts, the Cedar and the Club, were also in the neighborhood, further intensifying the air of cultural excitement and celebrity.

De Kooning not only accepted, but sought, the spotlight. At no other time in his life did he step forward in this fashion. Some admirers have refused to mark the interlude, continuing to regard him as untainted by any ambition beyond art. They have tried not to notice that sometimes he played to the grandstands; or they have blamed such behavior on drinking. Drinking did usually precipitate such behavior, but it went beyond barroom bravado. For a time, de Kooning's head was turned. Not every day, and not with everyone, but often enough to make the period seem a very strange and histrionic parenthesis in his life. It would have been remarkable, of course, if de Kooning had ignored the blandishments of celebrity. He was ambivalent about almost everything. Why not fame? His difficult youth, his anxiety as an immigrant, his years of struggle, and his desire to succeed in the New World made it unlikely that he would simply turn his back on attention. The money and renown must have seemed, in part, a kind of miraculous gift.

Marca-Relli remembered coming upon de Kooning one day at the Jewish Museum, which organized a number of important shows of contemporary art during the late fifties. Although de Kooning stood by himself, he looked like he was posing, playing the role of the isolated genius for those

De Kooning on his stoop on Tenth Street, the center of the art world in the late 1950s

regarding him with fascination. He remained obsessed with Jackson Pollock, who in some respects was a more formidable rival dead than alive. De Kooning's outburst after Pollock's funeral was not an aberration. During a panel at the Club called "An Evening with Jackson Pollock," held on November 30, 1956, he again refused to play the part of a mourning admirer and mythmaker. At openings, he was almost always a center of attention. The Tenth Street galleries often organized joint openings on Friday evenings, creating a kind of floating cocktail party along Tenth Street. De Kooning, as he came down the high stoop from his studio, was acknowledged as a modern master at work in New York. He was unfailingly encouraging to the new kids on the block and usually found something respectful to say about their work, whatever his private doubts, even if it was just his trademark, "Terrific, terrific." As he made the rounds,

people called out "Hi, Bill," and tried to take him aside. They listened too hard to what he said. Young artists watched him. Everywhere he turned on Tenth Street he came upon complimentary reflections of himself, as if he lived surrounded by admiring mirrors. He saw his importance not just in the eyes of artists and hangers-on but in the paintings of followers who worked in *l'école de Kooning,* which hung on the walls of the Tenth Street galleries. Frank O'Hara divided the American art kingdom between Pollock and de Kooning, calling Pollock the period's Ingres and de Kooning its Delacroix. In his poem "Radio," written on December 3, 1955, in which he longed "for a little reminder of immortal energy," instead of the "dreary music" from the radio, O'Hara ended with:

> Well, I have my beautiful de Kooning
> to aspire to. I think it has an orange
> bed in it, more than the ear can hold.

At the openings or at the Cedar, de Kooning could not fail to notice the stares of young women. They were coming into the Village, women painters and poets intoxicated by the idea of art, eager to sleep with an American Picasso. Kline and de Kooning were special targets. In one famous story from the period, told by Herman Cherry, a woman spent the night drinking and flirting with Cherry at the Cedar and then agreed to go home with him. When they woke up in the morning and he asked how she liked her eggs, she murmured, "Any way that you do, Franz." Some women mailed de Kooning naked pictures of themselves. Whether or not he was in a sustained relationship with one woman, de Kooning continuously slept with others. As the decade wore on, de Kooning picked up women more aggressively than he did before, but was rarely as crude or dismissive as some imagined. He would fall into conversation with a woman; he would be charming, take an interest in her work, and invite her to drop by for a studio visit—a difficult invitation to resist. If the woman did come by the studio, she was usually interested in him; and he might initiate an affair after coffee and talk. He might also go home with someone from the Cedar whom he had seen a few weeks or months before.

One woman with whom de Kooning had a casual liaison in the late fifties was Shirley Stoler, an actress with an unusually independent and balanced perspective, perhaps because she was not part of the art world or the Cedar crowd. Her moment with de Kooning was typical of his brief affairs. She first met him at a party where Larry Rivers was playing the clarinet. "It was not an aggressive pickup or anything from either side. It

just seemed to happen." Their affair lasted two weeks. Since she was not a young painter eager to visit his studio, he would visit her at her walkup on Avenue C, six flights up. The first time he went to her place he did not seem in a hurry. He immediately went over to a small still-life and admired it. "Yah," he told her, "I used to make pictures like that in the academy." According to Stoler, "He didn't seem to be painting much during that two-week period. We'd wake up midday and go to the Jumble Shop for brunch. Then he'd go to the Cedar, usually." She might join him there for a while, but, not being a heavy drinker, would leave early. He would join her again after midnight. "It was all very casual, in the way of that period. A period when the word 'relationship' didn't even exist." He bought her, spontaneously, a dark green jade bracelet and a string of fire-eater beads from a Greenwich Village shop. He often talked about his daughter, Lisa—"he was crazy about her"—and "seemed surprised by his success." At one point he tried to give her a drawing, but she would not accept it. "He kept saying, 'I want to give you a present,' and I would say, 'You're my present.' He'd say, 'No, no, I'm nobody's present.'" Stoler considered de Kooning "sweet, gentle, interested in me, quite virile and a good lover." Like many women, she was also taken by his appearance. "He looked like he was in a morality tale, playing the Good One. Not an Adonis, not ravishing, but a handsomeness that was inner." But she could not accept, finally, either his heavy drinking ("he became absent") or the way the world insisted upon treating her as his "adjunct, his girl of the moment." And so she left him. There was no confrontation, nothing official. She just stopped going to the places where they ran into each other, and their moment together drifted past.

With a woman like Stoler, de Kooning never acted important. She considered him unfailingly "modest." But de Kooning was not the same man to all women. The young women at the Cedar or the Tenth Street openings were not groupies, as is sometimes suggested, but more like idolaters—eager for the touch of genius. In her book *Elaine and Bill*, Lee Hall quotes one anonymous woman artist who was typical of the women who arrived in New York looking for something special and fell into a casual affair with de Kooning. "I came to New York to get away from unimportant things," she said. "I really chased [Bill]. He didn't run, though, not at all. I was young. I was sure as hell naive. I convinced myself that he was interested in me as a creative person, as an equal—as someone who understood him and who could share his life."

In retrospect, however, she came to believe that the older artists loved only themselves, "in the way soldiers or outlaws who've been through a lot together love each other. They were ambitious. They were against the

world. They saw themselves as romantic figures, like the French Foreign Legion or something." Like many of the women at the Cedar, she had an abortion; over time, the flashy public style of the late fifties came to disgust her. She felt screwed.

However, the women who developed a sustained relationship with de Kooning—whether that of a wife or a long-term lover—never regarded him with such bitterness. Once the relationship ended, they might speak about him ruefully, but none of them regretted the time spent.

In this extravagant period, the star of the scene took a theatrical lover. Hardly anyone at the Cedar who heard, in 1957, that de Kooning was seeing Ruth Kligman could believe it. Or perhaps it was poetic injustice. Kligman was the survivor of the car crash that killed Pollock and Kligman's friend, Edith Metzger. In the eyes of most artists, she was the hot young thing who had swooped into the drunken Pollock's deteriorating life, driving away his wife, Lee Krasner, and behaving with a va-va-voom flamboyance new to the art world. Elaine called her "pink mink." Franz Kline preferred "Miss Grand Concourse." What understandably excited and impressed the armchair psychiatrists at the Cedar was how psychologically strange and revealing the relationship appeared. Was Bill *still* competing with Pollock, even now, after Jackson's death? "Going with Ruth really put the stone on Jackson's grave," said Anne Schwertley, who was a friend of Joan Ward's, "and it was often regarded that way at the time." Ward herself, still hoping to establish some kind of family life with de Kooning, was appalled by the turn of events.

Ruth herself seemed made for the gossips. She had about her the air of the earthy, voluptuous movie stars of the era, such as Elizabeth Taylor or Sophia Loren. She wore clingy dresses and a sultry, "Kiss me, you fool" expression, and her voice was throaty and seductive, as if it were made for sharing secrets. To the older men at the bar, especially, certain slang words and expressions came up when describing her. "That dame's trouble." "Ruthie, she's been around the block." Kligman had few qualms about sleeping with married men. According to one friend, "She once told me that when wives or girlfriends heard she was coming to a party they would go out and buy a dress." De Kooning himself liked to say about her: "She really puts lead in my pencil." Kligman came to New York fully intending to capture a great artist, according to the painter Audrey Flack, and asked Flack whom she considered the three most important painters. Flack answered, Pollock, de Kooning, and Kline. Ruth asked, "Which one is *the* greatest?" And Flack said "Pollock." Once Pollock and Kligman

began their affair, many people in the art world, sympathizing with the predicament of Lee Krasner, regarded Kligman with anger. But some also acknowledged her strange and questing nature, her determination to break into an insular male environment and fling herself dramatically upon the altar of art. She was one of those people who could be despised, gossiped about, snubbed, and criticized but never quite, in the end, ignored. Frank O'Hara famously referred to Kligman as "death car girl." But he also later made it a point to befriend her. Not surprisingly, Kligman took a different view of herself than that held by most others—and would spend much of her life fighting the condescending treatment accorded her in accounts of the period.

Kligman had a troubled childhood. Her mother, hardly nineteen when Ruth and her twin sister were born, was abandoned by her father, a con man known as "Bootie." She raised the girls alone in Newark, in near poverty. There were many crying jags by the mother and daughters. On rare occasions, the handsome father would swoop briefly into the household, as if from another world, and then leave again. Escaping into an intense fantasy life, Kligman lost herself in the movies and, as she grew older, began to dream about art in a romantic fashion. Her dream of art was peopled by passionate souls, geniuses isolated from the ordinary crowd and torn by powerful impulses. Beethoven, Rodin, and van Gogh inspired her. From a very early age she had longed, she said, to be "an artist, a painter or a writer or a composer." Then, at sixteen, she read Irving Stone's fictional biography *Lust for Life*, a stirring and often sentimental portrayal of van Gogh published in 1937, that defined once and for all the figure of "the tormented artist" for popular culture.

After high school, Kligman took a job modeling on Seventh Avenue. She had a number of affairs with older, sometimes married, men because, she said, her childhood left her always looking for a father figure. "Men were such frightening people to me," she told the Pollock biographers Steven Naifeh and Gregory White Smith, "that I could only manipulate them." With one married sugar daddy, she said, "I took advantage. I had him wrapped around my adorable little waist. I cried, got drunk when I didn't get my way, he spoiled me." After the end of that affair, in the mid-fifties, she threw herself into art, taking a painting class at the New School and a job at the Collectors Gallery. She saw de Kooning's work before she saw de Kooning himself, at the show Martha Jackson mounted of the paintings she bought in the summer of 1954 at the Red House.

It was the romantic aura of older, fatherly genius that had first drawn Ruth to Pollock. What did it matter that he was old or self-destructive or nothing special in bed? Wasn't the suicidal van Gogh difficult to live

with? Ruth was interested in the higher forms of romance—in being the muse to genius, like Camille Claudel to Auguste Rodin. Ruth had, of course, met de Kooning while she was with Pollock. In the spring of 1956, de Kooning came up to Pollock at the Cedar and said, "Hiya Jackson, is that your girlfriend?"

> He said it in this heavy Dutch accent and Jackson said, "Keep away from her you old bastard" or something and he held his hands around me like a shield and Bill starts laughing and teasing him. "Oh, what are you afraid of Jackson, you afraid I'll see her" and Jackson kind of rushed me out of the Cedar Street Bar very fast and wouldn't let me look at Bill. And I said, "That's Bill de Kooning, isn't it, isn't he a good friend of yours? He's a great artist." He said, "Let's not talk about it."

Pollock's dramatic death did nothing to diminish Ruth's ardor for the artist's life, and, after recovering from her injuries, she returned to the art world. De Kooning, in turn, had not forgotten her. He had been quite taken with Pollock's girlfriend, even trailing Pollock and Ruth onto the street after teasing him at the Cedar. One night at the bar, probably in the fall of 1957, de Kooning noticed Ruth having dinner. "He looked at me in a certain way," she said, "and I didn't feel like talking to him because he'd been drinking so much. And he ran out of the bar and he came back with a bunch of violets and gave them to me. Which was very sweet." (Elaine would describe the beginning of the affair differently, saying that Ruth sent de Kooning a note in a restaurant.) Once the affair began, Ruth saw de Kooning regularly, though not every night. De Kooning still did not have a phone, so plans often remained vague. She would visit his studio a couple of times a week, and they would frequently meet at the Cedar or at her apartment down the street, on University Place. "We saw each other almost every other night, you know—like it would be weekends, Friday, Saturday, Sunday, then we wouldn't see each other until Wednesday." Since de Kooning remained remarkably handsome, the Cedar gossips had no difficulty this time explaining why a young woman was attracted to the most celebrated painter in New York: he brought her the razzmatazz of attention and glamour.

But that was not all Kligman sought from the relationship, and she deeply resented the art world's attribution of base motives to her. "I don't think it was that I was looking for boyfriends. I was looking for geniuses. I was looking for ideas." She was especially taken by the desire in de Kooning's milieu to upend platitude.

I would say even now he was the most interesting person I ever met, truly brilliant, and I mean brilliant in an unconventional way, in the sense of his mind. He never said anything to please anybody, he was extremely spontaneous, just turned things around, which is what I mean about how ... he would take a pack of cigarettes and turn it upside down and say, "You see?" or he'd say, "Well, you know a car could be on the street sitting on its four wheels, but put the car with the wheels up in the air and something strange happens, the same car, just change the position of it." So he taught me to see in that sense. You know, he'd always turn paintings around. Every painting should work on all four sides. He loved seeing how things looked upside down, which was part of his vision.

Kligman believed that sex alone was not what attracted either Pollock or de Kooning to her. They were no less interested, she believed, in her mind. According to Kligman, what she and de Kooning mostly did together was talk, passionately, often about art. If she was swept up in a romantic dream of their life together, de Kooning himself was probably somewhat more calculating: it's remarkable what intelligence a middle-aged man will find in a young woman he wants to bed. And yet, it was not just her "come-hither" look that interested de Kooning. He spent almost three years, off and on, with her. With Ruth, de Kooning's life played out on a grand stage. He was the presiding genius of his time, and she was his flamboyant mistress. Rosenberg and Hess might praise de Kooning without reservation, but, however adulatory their prose, they were also edgy intellectuals. Elaine might call him a genius, but she also knew him too well, and from too far back. His old friends might acknowledge his achievement, but they were not going to stand around genuflecting. In Ruth's passionate gaze, there were no such qualifications: he was Picasso, Rembrandt, and van Gogh. And she made him feel young. All his life de Kooning worried about advancing age and death, but Ruth made a point of living as if there were no tomorrow. Her desire to stay up all night talking between drinks and kisses was characteristic of the young. He liked that she came from poor beginnings and was making her way in the world. And he always had a certain admiration for theatrical figures. Once, when someone mentioned that Ruth was a gold digger, de Kooning said, "I sort of like that." After the lean years, Ruth was de Kooning's fleshy reward, the fruit of the strange, imperial interregnum in his life.

Ruth knew where the parties and luminaries were. Under her influence, de Kooning bought new, more stylish clothes. He began to attend

more social events, both uptown and downtown. With the success of abstract expressionism, and the ever-growing acceptance of modern art by New York society, artists were now welcome at the parties of writers and intellectuals and those who took an interest in "culture." In February or March 1958, de Kooning took Ruth to Cuba for a week. He did not tell Joan Ward that he was leaving the country. Joan just heard rumors. "He was going away and I couldn't understand it. I was furious." While in Cuba, de Kooning visited Hemingway's house. He had never expressed any particular interest in Hemingway, but the writer was often in the news in the 1950s and regularly hailed as the prototype of American literary genius. De Kooning—often celebrated in similar terms—would have naturally taken a collegial interest in Hemingway. De Kooning said Cuba "was like being in New Jersey, except for the palm trees," and the trip marked the first low point in his relationship with Ruth. According to Ward, he came back to New York complaining about Kligman, calling her "a pain." For a while that spring, the two drifted apart; Joan, as always, hoped that the relationship was over and that de Kooning would now settle down with her and Lisa. But then de Kooning and Ruth reconciled, and, after making a brief trip to Martha's Vineyard in the early summer of 1958, they spent some time at Marca-Relli's cottage in the Springs.

Ruth loved the Hamptons' mix of art, beach, and friends. She had rented a small house in Southampton after Pollock's death, and, according to Jane Freilicher, "She used to walk back and forth on the beach. She looked terrific with this sort of . . . remember the Rudy Gernreich swimsuits that were the first suits that were not molded, but like leotards almost? Very low cut and curvaceous." The Hamptons were not then accustomed to a sultry, swaggering sort of European beauty. Ruth seemed to be made of exotic promises, and, as long as de Kooning or some other important man was standing beside her, she could behave as she wished. De Kooning and Ruth visited the house in Water Mill of Freilicher and Joe Hazan, which Jane Wilson and John Gruen were sharing. Freilicher said Ruth and de Kooning "both came out for a few days to visit. . . . She was very anxious to come out for the weekend. He wasn't very happy about it because he didn't take weekends off. She arrived with a large hamper of clothes. She had these wonderful thirties beach pajamas with polka dots on them like a movie star. . . . She had this idea of being a kept woman with all the accouterments and perks. And he was hooked on her but at the same time he seemed ill at ease in public."

During their time in the Hamptons, they often went out in the evenings with de Kooning's old friends. Increasingly, they also saw new people who were attracted to the blend of money and art in the Hamptons.

Ruth particularly liked the idea of celebrated figures gathered together at one party. Whenever she and de Kooning heard that there would be a famous guest at a dinner party, Ruth said, they would talk "about what we would wear and what we would do, and we would always read the books before we were going to a dinner party that was in honor of a person." It was probably Ruth who did most of the talking and bought the books and wondered what to wear to the party. Outside the studio, de Kooning was far too disorganized and distracted to keep a complicated social calendar, let alone plan a wardrobe and read the books of those he was about to meet. Yet de Kooning was not averse to Ruth's excitements. He always remained, in part, the poor boy with his face pressed to the glass, staring at the celebrated. Ruth described one party this way:

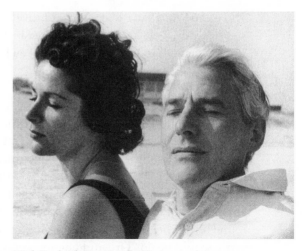

With Ruth Kligman in the Hamptons in 1959

> And then another time . . . [a couple] invited us to dinner and they were very close to Paul Tillich, the famous theologian. So we went to Bob Keene's bookstore in Southampton and bought these books, I remember one in particular, a book called "The New Being" by Dr. Paul Tillich, and there's a chapter called "The Holy Waste" which was very much how Bill and I used to live, which was not like a waste but we always thought that goofing off and the daydreaming, the hours of talking and tremendous working but—and Dr. Tillich talked about the idea of the holy waste, not being obsessive about time, as if the time people have together talking, getting drunk—and Bill and I did it all the time—was very precious. So we read a couple of books and went to the dinner party and Paul Tillich came and sat next to me, which was very fascinating because at the time I was in group therapy. He couldn't get over that, he spent the whole night asking me about my group therapy. So Bill . . . says, "Well, how'd you do that? What'd you monopolize him for?" I said "I didn't. He kept asking me questions about group therapy," which he did.

And then later that summer I gave a party, and Harold came and everybody, you know, a couple hundred people, and I invited Paul Tillich and Harold Rosenberg said, "You beat us all. You have the best guest of honor of the summer."

For de Kooning, Ruth's romantic intensity was exciting, but also exhausting. She could not just waste time as others did; the lost hours became nothing less than theologically certified "holy waste." She understood that de Kooning needed to spend much of the day alone in the studio, but she did not necessarily like it when he withdrew from her into his work and would seek him out at times when he did not wish to be found. Whether or not de Kooning would get a divorce continued to trouble those around him. The painter was becoming a source of unending gossip. What finally would he do? Or would he forever do nothing? He seemed built of questions, in his personal life no less than in his art. He was a man whom others wanted to possess and who would not be possessed. What was he supposed to do? he once asked Joan. Divorce Elaine, marry Joan to legitimize Lisa, divorce Joan, and marry Ruth?

As inevitably occurred when de Kooning felt trapped or pressed, he and Ruth would quarrel. Ruth threw herself into arguments with her characteristic gusto. She seemed to expect a great artist and his muse to have furious, moving, meaningful, titanic quarrels. De Kooning himself had more patience for this pattern of quarrel and making up than many men. His relations with women—above all with his mother—were often characterized by an ongoing cycle of stormy fights and emotional reconciliation. Ruth also pressed de Kooning to take her to Europe in order to see Paris, Venice, and Rome. He listened and expressed interest, but did nothing about it. De Kooning was restless enough as an artist and felt no compulsion to travel or "see the world." Moreover, he was still not an American citizen. He did not really know how to leave the country and did not want to ask. He also thought that he should not be so far from Joan and Lisa. Suppose he could not come back and he never saw Lisa again?

Eventually, Ruth lost patience and, in the late summer of 1958, went by herself to Paris and then to Venice. She may have decided, as some friends thought, that this would provoke de Kooning into following her. She wrote him regularly, trying to entice him to join her. Instead, somewhat surprisingly, de Kooning invited Elaine to join him at the Marca-Relli cottage in the Springs. Elaine remained his wife, after all, and she often needed money, which de Kooning continued to provide. In public, Elaine refused to regard Ruth as a serious threat to her relationship with de Kooning. (It was always de Kooning's devotion to Lisa that concerned

her, for that could lead to divorce.) Once, when Elaine heard that Frank O'Hara and his lover Joe LeSueur had invited de Kooning and Ruth to dinner, Elaine called to ask if she could drop by for a drink late in the day. She made certain to be there when de Kooning and Ruth arrived. Then she stayed another hour, cheerfully talking, until she announced, apologetically, "Oh! I've got to run; I have a dinner date—I'm already late." According to LeSueur:

> What did she hope to gain or prove? You'd think she would have been afraid of losing her dignity, not to mention her composure. Well, she didn't; and the *coup d'éclat* she miraculously pulled off must have been what she had in mind when she phoned that afternoon. For if anyone was to be pitied it was poor Ruth: shorn of her customary confidence, her voice faltering, she said in an aside to me as Elaine made her leading-lady exit, with Frank slipping out with her to see that she found a cab, "I feel sorry for her." It was all I could do not to laugh.

In the fall of 1958, de Kooning finally agreed to meet Ruth in Venice. Upon his arrival, Ruth, perhaps irked that he had not come earlier, appeared somewhat standoffish. De Kooning was staying at the Cipriani, and he visited Harry's Bar, the celebrated hangout of writers and artists. Then he heard that Ruth was seeing another man. Outraged and hurt, de Kooning took the train to Rome. Once there, he looked up the poet Gregory Corso, who spent several days showing de Kooning the sights. De Kooning took an immediate, visceral liking to the city. Everything about Rome suited his mood. As one attracted to crime stories, he responded strongly to the barbaric tales of ancient Rome. He thought the Sistine Chapel "for sure the most terrific thing ever done," but it also overwhelmed him and made him "cranky," probably because his own art appeared small by comparison. (And so he made jokes: the Chapel became an "upside-down" carpet when you stared at the ceiling; it was as big as Cecil B. DeMille's "Moses.") The city's crazy-quilt layering of different cultures, its sensual too-muchness, deeply moved de Kooning. He found a reflection there of his own romantic and ambiguous sensibility. For all its august beauties, Rome also embodied the coarser truths. It mixed high and low. It was a city that would understand what he meant when he said he found himself attracted to "the melodrama of vulgarity."

De Kooning only remained in Rome a few days before returning home, which became a source of amusement to his friends. According to Esteban Vicente, de Kooning had announced, " 'I'm leaving tomorrow. Going to Italy.' 'Why?' I asked. Want to see it. Maybe there a month.

About two days later he's back. He said he didn't like it." Recoiling from Ruth, de Kooning this time asked Joan to join him in the Marca-Relli cottage to set up a more conventional household. He worried about Lisa. He did not want to become the father to her that Leendert was to him. It was during this period, according to Joan, that de Kooning first began to consider the Springs as a place where Joan and Lisa might live year-round, and, possibly, a place where he too might live. However, he continued to spend most of his time in the city, in part because there was no place for him to work comfortably in the country.

The grand abstract paintings that de Kooning completed in the city in 1958 and 1959 looked eastward, reflecting the light, ocean, and color of Long Island. Their large and heavy brushstrokes were often compared to highways and aptly so, for de Kooning during this period was constantly traveling back and forth between his New York studio and the house in the Springs. (While he himself never learned to drive a car, he loved sitting in the passenger seat, studying the highway and glimpsing the passing landscapes.) But the paintings, while touched by the country, were in no sense retiring. They were instead bold and declamatory, even domineering. De Kooning did not seem to fuss overmuch with small subtleties. His beautiful highway strokes swept through the picture plane with the bravura of an emperor traveling through his dominions. The paintings had panache; they displayed the confident "grand style" of which de Kooning dreamed. He always enjoyed looking at the billboards along the highway, and his pictures of the time capture the eye with the instantaneous impact—the "gotcha"—of an unforgettable sign.

Janis was delighted with the continuing abstractions. He knew that he would have no trouble selling them for very high prices and believed that de Kooning, if he painted abstract pictures, would be the dominant painter of his time. He and his wife, Harriet, who occasionally wrote about art, now talked about publishing a book to help promote him. Such talk only made de Kooning anxious. When the Museum of Modern Art approached him in the winter of 1958 about organizing a one-man show—in those days, an extraordinary honor for a living American artist—he turned down the invitation, telling the museum he was "not ready." No doubt Janis was shocked.

De Kooning did not entirely trust Janis. Since 1954, when the dealer went abroad without advancing him the promised funds to bring his mother to America, de Kooning had felt uncertain about whether or not he could count upon him. Would Janis take advantage of his inexperience in the way his first dealer, Charlie Egan, had? De Kooning also disliked being bound to a dealer, or to anyone else, and would occasionally sell

works out of his studio to private art dealers, much as he had with Martha Jackson in 1954. A private dealer named Harold Diamond, for example, often hung around de Kooning and came away with a number of paintings and drawings. In 1959, Joseph Hirshhorn bought two de Koonings from Diamond, an abstract work painted that year and a figurative picture from 1951. As the money and attention flowing toward his work increased, de Kooning became more and more apprehensive about his financial affairs, and he began to look for outsiders to protect his interests. In May 1958, he hired an accountant, Bernard Reiss, to review his transactions with Janis. In the early summer of that year, during his trip to Martha's Vineyard with Ruth, he also renewed his friendship with Lee Eastman, a street-

In Water Mill in the summer of 1959

smart lawyer who de Kooning knew could not be hoodwinked. Eastman liked de Kooning and was eager to offer advice when called upon.

In late 1958 or early 1959, de Kooning began to look for a better studio. He could afford one, having completed several large canvasses that Janis could sell in the spring. Eventually, he found a loft on the top floor of 831 Broadway, not far from Tenth Street. By the standards of the time, the space was enormous, with a skylight and a parade of large windows facing the street. De Kooning planned an extensive renovation. He wanted to strip down the space into an open studio. But he moved ahead lackadaisically, in no hurry to leave his familiar surroundings on Tenth Street. Ruth continued to write de Kooning from Europe, hoping to effect a reconciliation. Joan and Nancy Ward noted the arrival of the letters. For Joan, the back-and-forth affair with Ruth was becoming an unending nightmare. She could never finally escape from Ruth's shadow, even

when the couple was quarreling and de Kooning stayed with Joan and Lisa. "His clothes started changing. He wore a black silk suit. And he had a camel-hair coat. Then he said things he never used to say, like 'Oh that Yul Brynner, women really like him. . . . They say 'You can put your shoes under my bed any time.' I looked at him and said, 'I think I know who you've been talking to lately.' " Ruth's letters had their intended effect: the affair resumed again when Ruth returned from Europe. It was a powerful blow to Joan, who was hoping that de Kooning was finally over his infatuation.

> How did we get through those two years? It was terrible. It was just impossible to keep going with this. Bill got all of us into such a locked-in situation that nobody could move. It was terrible. Day after day after day of this. I was down to about one hundred pounds and . . . Oh, that's where the ugliness comes in. That's why I finally had to get up. And then he'd show up. So finally I said, "Okay, let's set this up. Let's have you come and have a regular day when you take Lisa out." So then he'd go and get drunk with Ruth and Sunday afternoon would arrive and . . . It was just impossible. A very ugly, tawdry period. Then to have it come around again was just too much.

On May 4, 1959, Sidney Janis opened an exhibit of de Kooning's large new abstractions. The gallery was jammed by five p.m., the official opening time, but the line of admirers first formed at eight-fifteen that morning. At the opening, according to one reviewer, de Kooning was "doing his unsuccessful best to fade into the woodwork." Nineteen of the twenty-two oils were sold by noon, ranging in price from $2,200 for the smallest oil sketch to $14,000 for each of the five big canvases. By the end of the week every work had been sold. The notices in the press were adulatory. Sidney Janis's wife, Harriet, and Rudi Blesh, preparing the monograph on de Kooning, described the new work in this way:

> No pure abstract geometry ever elated people as did De Kooning's latest paintings at their preview in May, 1959. More abstract than any previous De Kooning paintings, they seem even more intensely real. The old violence now communicates a most remarkable triumph and exhilaration. Calligraphy and forms merge in brush strokes so huge and spattering that they seem created with an energy and speed beyond the human.

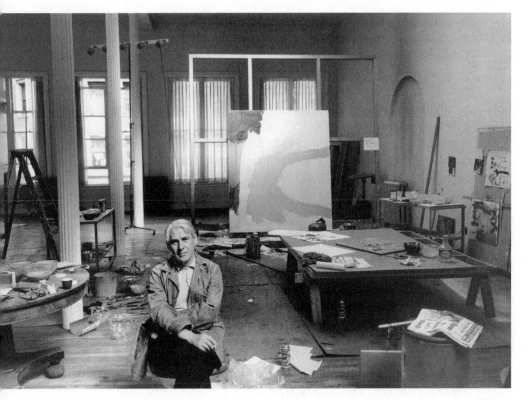

In his top-floor loft at 831 Broadway in 1962

De Kooning himself was beginning to smell the bull in this kind of extravagant praise. The review in *Time* magazine, entitled "Big Splash," contained a strangely defensive remark that suggested his growing weariness with the art scene. "There's no way of astonishing anyone any more," de Kooning told the reviewer. "I'm selling my own image now. It's being understood. That's the way it's supposed to be." De Kooning, always well aware of the criticisms mounted against him, liked to outflank his critics by insisting that he actually *sought* what they disliked. But it is doubtful that he really thought "that's the way it's supposed to be"—the remark sounded like it belonged to an ironic pop artist. The same review mentioned that de Kooning "shuts himself up in his Greenwich Village studio for weeks at a time, refusing to see visitors or acknowledge telegrams."

De Kooning and Ruth spent the early part of the summer of 1959 in a rented house in Southampton. However, Ruth still longed to go to Italy

with de Kooning, and pressed him on the subject. De Kooning disliked going anywhere he did not have a place to work. During the summers when he left the city, he would typically set up a temporary studio and work on smaller-scale projects—drawings and oils on paper—if there was not space for anything larger. After the show at Janis, however, de Kooning was cash happy. Was it such a bad thing to take his pretty young girlfriend on a European trip?

When Joan Ward heard that de Kooning might once again fly to Italy to be with Ruth, she finally began thinking seriously about building a life elsewhere, far from New York. "I told Bill, 'Are you going back to Europe?' He said, 'Yes.' I said, 'Don't count on us being a springboard to go from anymore.' " No ultimatum, of course, would stop de Kooning. On July 28, the couple left for Rome. Before he left, however, de Kooning, using money from the Janis sale, purchased 4.2 acres of land on Woodbine Road in the Springs, just off the main highway to East Hampton. On June 23, he paid Wilfred Zogbaum, an artist friend, $500 an acre for the parcel. He was beginning to dream of a studio of his own in the country.

M any American writers and artists in the fifties visited or lived in Rome for a time, among them Guston, Kiesler, Rauschenberg, and Twombly. According to the Italian artist Piero Dorazio, "Rome was like Paris, it had become the navel of art in Europe. Americans were no longer going to Paris—that had been in the twenties and thirties. In the fifties, Rome was full of artists. It was like the Parisian café scene. It wasn't fancied up. People were different then. Everyone was an artist."

De Kooning knew Conrad Marca-Relli very well—the American artist had close Italian connections—but many others were also quick to offer advice about where to live and whom to meet. Marca-Relli gave de Kooning introductions to well-known Italian contemporary artists, among them Alberto Burri, Toti Scialoja, and Afro Bassaldella (known universally as "Afro"). The writer and art critic Gabriella Drudi, a close friend of Hess and Gregory Corso (and Toti Scialoja's wife), also helped de Kooning get settled in Rome. Ruth, of course, had already spent much time in both Rome and Venice. Afro and the art dealer Plinio de Martiis picked de Kooning up at the airport. "We drove to the Piazza del Popolo and stopped the car," de Martiis said. "Afro asked him what he thought. Bill said, 'Old hat.' " De Kooning rented lodgings at the Pensione Pierina, 47 Via Due Macelli, a nondescript older Roman building with a shop on the ground floor. He did not intend to set up a household with Ruth—or with any woman, with the possible exception of Lisa's mother—and so Ruth stayed

at the legendary Excelsior Hotel. De Kooning's pensione occupied the fourth and fifth floors of the building; he lived on the fifth, with a pleasant balcony. He arranged to use Afro's nearby studio at 94 Via Margutta, a street near the Piazza del Popolo and the Spanish Steps where many of Rome's artists traditionally lived. Afro's studio was actually a small apartment with one large room and no skylight.

The Italians, of course, had heard of Willem de Kooning. Not only had his work been exhibited at the Biennale in Venice, but the Isola Tiberina Gallery in Rome had recently mounted an influential show that included work by both Italian artists and the celebrated abstract expressionists. The Museum of Modern Art's exhibition of American art was also touring Europe. "There was this myth of American painting," de Martiis said. "Action painting. And this small group. There was a romantic sense of a burned generation. And the drinking. A little like Fitzgerald." Most European painters in the fifties were unabashed in their admiration of New York, and many slavishly followed New York fashions. They were excited when the American master came to Rome. "The whole of Rome was notified that he was coming," said Barone Giorgio Franchetti, a well-known collector. "He was received in high society. In Italy there is a peculiar situation—high society is more aware of contemporary arts. One who entertained him was Dado Ruspoli, the son of the prince of Ruspoli. He was one of the highlights of the international jetset. He had cocaine and joints at his parties. Bill functioned extremely well in this world."

According to Drudi, "He was of course invited and asked to dinner and parties. But it was Ruth who wanted it." Left to himself, Drudi said, de Kooning would only go back and forth between the Via Due Macelli and the Via Margutta. "Friends of ours wanted to meet him. He would say, 'Sure, sure, sure.' He was so . . . nice."

> All the young artists, even the amateurs, asked him to come see their shows. And if it was a painter, he felt he had to go. He had this feeling that if somebody wanted to be an artist, you had to respect him. That was a disaster for him. When he walked from the Via due Macelli to the Via Marghutta, there were a lot of artists there then. "Ciao, de Kooning" and so on. There was the pressure of the artists, but that didn't disturb him. What *was* bad for him was the social life Ruth wanted.

De Kooning usually had lunch and sometimes dinner at the Café Rosati on the Piazza del Popolo, the main artist's hangout in Rome. Filmmakers, writers, and musicians were regulars there. He would sometimes

have three or four martinis before both lunch and dinner, then drink whiskey during and after the meal. ("I taught Bill how to drink wine," Dorazio said.) His favorite Italian dish was *fettucini con piselli.* "There was a regular gang," said Marisol, who was spending that year in Rome. "Afro, Marca-Relli, Twombly, Burri, Plinio, Salvatore Scarpita . . . The group would go out to dinner every night. Different restaurants. Always a big table. On weekends we would drive to small towns outside Rome." After dinner, the artists might go to a private party or a nightclub, including one called "il Pipistrello" ("The Bat"). At one point, a large group went to see Dizzy Gillespie at the Sistina Theater on the Via Sistina. "In Italy I have the feeling we went mainly to restaurants rather than museums and so on," said Marisol. "I'm sure he saw everything. But I think that generation was trying to break with the past, with Europe, so they didn't make too much of a point of other art."

Ruth relished the society and the heightened mood of *la dolce vita.* Among the Italians, she was likened to—and occasionally mistaken for— Elizabeth Taylor. Sometimes the paparazzi photographed her and de Kooning for the cheap papers and magazines. She bought as many clothes as de Kooning could afford, and persuaded him, too, to buy some fine Italian suits. But she and de Kooning often fought, especially when they had been drinking heavily, which shocked the Italians, who were unaccustomed to the late-night noise and brawling. Afro, a courtly man from Venice with gentlemanly airs, would sometimes smooth things out when they, or other drunken Americans, began to misbehave. Not surprisingly, the daily pattern of long lunches, late nights, and heavy drinking seriously compromised de Kooning's work habits. During his five months in Rome, he made a number of works on sheets of fine Fabiano paper, seventy by one hundred centimeters in size, and some collages. He used black enamel paint, mixed with ground pumic to dim the sheen, to create bold, brushy drawings that had, said Hess, an "almost Chinese, Zen-like" character. "He was starting with a shape and then destroying that shape and finding how it could be reproduced," said Drudi. "But it was just to have this relationship with himself, not to lose his connection with his work. He had his social life, he had Ruth . . ." According to de Martiis, few people visited de Kooning in the studio. "He was not really engaging himself." That fall, Janis stopped in Rome during a European trip to ensure that de Kooning was not giving his work to dealers there. "Sidney Janis arrived and left the next day," said de Martiis.

It seemed like something out of an American film. "I've got an exclusive on Bill. You can't do anything." He was tough. Sidney Janis also

In Rome, 1959, with Marisol and Ninni Pirandello

said that de Kooning's black-and-white drawings were too much like Kline. . . . When Janis was here, de Kooning was like a puppy. But as soon as Janis left, he said, "Don't worry. I'll give you stuff." Then he did.

De Kooning asked de Martiis to give the money from any drawings he sold to Afro, presumably in payment for the studio space.

Even within his imperial interlude of the late fifties, the months that de Kooning spent in Rome, the greatest imperial city of all, seemed anomalous. It was not just the indiscriminate socializing of his days and nights, the elegant clothes, or the heavy drinking. What was surprising was that de Kooning suddenly seemed unlike himself. In Rome, art no longer centered his life. He was too busy for the studio. His days became trivial. He seemed to be acting a part. De Martiis took a photograph of a group excursion to the gardens of Bomarzo, north of Rome, a Renaissance fantasia of sculptural conceits and grotesque statuary. Pictured in these heightened surroundings are Barone Franchetti, the finely dressed Afro, Marisol, and de Kooning. De Kooning, wearing a beautiful raincoat, is holding a gun. He has been shooting—as if he were an aristocrat.

On New Year's Eve of 1959, precisely ten years after the legendary New Year's celebration at the Club in New York when Philip Pavia welcomed in the new decade with the toast that "the next half century belongs to us," de Kooning went with Ruth and some friends to dinner at the Ristorante Passetto. It was billed as a "Grand Cotillion," a dinner with

party favors. Pavia had been proven correct so far: the abstract expressionists owned the fifties, with de Kooning preeminent among them. But the partying in Rome that ended the decade had little of the sublime pizzazz of that earlier celebration, when the world beckoned like a dream before de Kooning and his friends. It seemed ironic that de Kooning would conclude the 1950s in Rome rather than in New York, which, ten years earlier, had so proudly taken from Europe the mantle of modernism. Rome was a city that, more than any other, embodied the past. De Kooning himself appeared to be in decay, falling apart, past his prime. He was tired of partying; he did not seem excited by his art; he spent too much time in petty squabbles. After the dinner at the Ristorante Passetto, an acquaintance named Judy Gendel handed a menu to de Kooning and asked him to draw a cat. He did so. Then she asked him to sign it. Ruth interrupted the exchange, telling de Kooning not to sign the picture. Whereupon de Kooning signed it. The party then moved to the Excelsior Hotel, where paparazzi snapped a shot of Ruth, Bill, Toti Scialoja, and Gabriella Drudi. From there, the party went to a nightclub. Soon Ruth and de Kooning began to quarrel. "It was four or five in the morning," Drudi said, "and it was absolutely awful. They were screaming at each other. Finally Bill said, 'Why don't you go into the grave with your Jackson Pollock.' And Toti was absolutely upset. And Ruth said, 'I had two months with Jackson Pollock but he's jealous.' And then all of a sudden with the sun coming up de Kooning said, 'That's nothing. Let's go to sleep.' After this screaming that was like 'La Dolce Vita.' " But not long afterward, de Kooning returned to New York.

Ruth's Zowie

Coming into de Kooning's studio one day, not long after their relationship began, Ruth Kligman saw a large blue and yellow painting on the wall and immediately exclaimed, "Zowie!"—a piece of art criticism de Kooning relished. It might remain the ambition of de Kooning and his friends to create a "masterpiece," but in the late fifties it would seem corny and hifalutin—and too European—to use a word like that. "Zowie" was, instead, the sort of sinewy street slang that de Kooning and the other painters of the period relished. In Ruth's eyes, de Kooning had knocked one outta da park. Hit the jackpot. Scored big time. *Kaboom!*

Later, de Kooning called the painting *Ruth's Zowie*, which sounded like an open-ended and lubricious euphemism. It could be the title of a

jazz tune about a great time in the sack. Everyone on the street corner would know exactly what *zowie* meant without requiring a precise definition. The painting contained an explosive coming together of brushstrokes, a knotting of forms into a climactic burst. There was an angular velocity to the feminine V shapes, and the "wet on wet" application of the paint had a slip-and-slide quality that was sexual. Some areas of the painting appeared worked upon and lingered over. Others had the quick inspiration of a caress. Even so, *Ruth's Zowie* was not just about lovemaking. As usual, de Kooning's feeling for content was glimpsing and fragmentary. The palette of the picture actually contained few flesh tones: its blues and greens and yellows suggested a watery landscape splashed by sunlight more than they did a female figure. In any case, as in so many de Kooning paintings, figure and landscape became almost one in the painting.

What was new about *Ruth's Zowie*—and the work generally from this period—was the singular, declarative power of individual brushstrokes. Not only were they fewer and larger, but they dominated the foreground, which, in turn, governed the rest of the painting. Negative space and the complex interlacing of strokes became less important than before. *Ruth's Zowie* was an early example of de Kooning's muscular imperial style, completed before his trip to Rome. The commanding brushstrokes, like the new highways then overpowering the American landscape, proudly claimed great swaths of space. An air of performance and exaggeration was natural to an imperial style, which typically depends upon theatricality to wow the crowd. As Kligman's admiring exclamation suggested, the painting was not lost in details or byways but had a splashy simplicity and an impressive stylishness, too, with its long confident strokes and, in places, elegant turns of the wrist. An imperial style is vested in a celebrated man. In *Ruth's Zowie*, de Kooning seemed to throw his whole body (not just an arm or a wrist) into the rhythms of the painting; the picture has his physical impress. This was the work of a painter at once public and personal, a master of his milieu, whose autobiographical "mark" created wonder and applause. His eye was his "I."

28. Exhaustion

At the end they kept running after me in mobs.

De Kooning returned to New York in early 1960 with every reason to be confident about the future. He was a powerful and stylish figure in the dominant culture of the age—an artist at home in imperial cities—who had been celebrated for the last ten years for the extraordinary fecundity of his imagination. And yet, de Kooning himself appeared increasingly world-weary. Beginning with *Excavation*, de Kooning, during the past decade, had developed—excavated from within himself—four distinct moods or styles of painting. No other painter of the time had exhibited a comparable energy and variety. Despite his ongoing doubts, the world at large applauded each successive cycle of work. The immigrant from Holland had made America his own. After ten years of unflagging work and partying, however, what remained to be done? Now that America was his settled home, where was the space of escape, change, and discovery?

Nothing was more telling about de Kooning's frame of mind in 1960 than that, in Rome, for the first time in his life as an artist, his day did not center around the studio. The truth was that he had not worked especially hard. It mattered less that he produced little, for he had often before passed through dry periods, than that he appeared to be dabbling rather than struggling. He seemed to be losing his sense of urgency around art, his daily need for the touch of the brush. This did not change once he arrived back in New York. He continued to maintain his studio on Tenth Street, but put much of his energy into renovating his new, unfinished studio on the top floor of 831 Broadway. The new studio appeared to be made for large ambitious paintings. But de Kooning worked there mostly on a small scale, when he worked at all.

Only twice in 1960 did de Kooning make large-scale works. And *Door to the River* and *Spike's Folly*, each a large and luminous painting, actually marked an ending—the close of the artist's imperial or "highway" style of boldly stroked paintings. As its evocative title suggests, moreover, *Door to the River* was steeped in dreams of escape and renewal. De Kooning had always been especially interested in doors and windows. (A decade before, as he was finishing *Excavation*, he added the small door near the

bottom.) For a restless man returning wearily to New York, a door was naturally a powerful symbol, a rectangle suggesting both an opening and a closing of possibilities. A river, of course, was an ancient symbol of life and regeneration. Flowing water could represent change, movement, openness, freedom, fear, and bliss. In the painting, a dark rectangle-door lay within a pastoral burst of yellow and flesh colors. The de Kooning door was characteristically ambiguous. It could represent both joyful release and a stab of black in the heart of life.

Door to the River, *1960, oil on canvas, 80" × 70"*

During the early 1960s, de Kooning became a man possessed by two contrasting visions of the world: one full of life, the other of despair. He began to dream of leaving New York City and building a studio-home on the land he bought near the sea. At the same time, he flung himself onto the streets of the city, entering a spectral world of alcoholic bingeing and dissipation that often ended in the gutter. It was not clear which artist would emerge from these violently contrasting perspectives; and until he passed through this crucible de Kooning would not know what kind of art to make.

In the early sixties, Robert Frank made several portraits of de Kooning that did not romanticize the artist, as virtually every photographer before and after him did. In one night scene on the streets of New York, he depicted de Kooning as a haunted, grainy figure emerging from the abstract flicker of the city. In another picture, taken in the artist's studio, he showed the painter seated at a table with his arm cocked on his waist. Behind him was a collection of images, some cut out of magazines and newspapers. There was a shot of Lisa, a photo of the duke and duchess of Windsor, various jottings and postcards. On the table in front of him, near his hand, lay a pen and a brush. And yet, de Kooning held only a cigarette.

He did not look like an "action painter," but a man strangely still, lost in a melancholy reverie.

O f course, many in New York remained eager to lionize de Kooning, both in the press and in the art world. In 1959, Hess published a monograph on de Kooning, and, the next year, Harriet Janis and Rudi Blesh brought out their adulatory book on the artist. The English critic David Sylvester also conducted a lively interview with the painter, later edited into "Content Is a Glimpse," that became a classic of its kind; together with de Kooning's written statements of the late forties and fifties, it formed the essential record of his views as an artist. In the interview, de Kooning, while continuing to emphasize his earlier nervous, existential outlook, also spoke of a greater ease, which reflected the confidence of a widely acclaimed master. "I have . . . a bigger feeling of freedom. I am more convinced about picking up the paint and the brush and drumming it out." But this would turn out to be more hopeful than accurate, for de Kooning, after the conclusion of the highway paintings, would struggle for several years to find his way and "drum out" paintings as he had in the late fifties.

After his return from Rome, de Kooning never again settled back comfortably into New York. For much of 1960 he seesawed between his Tenth Street studio and his Broadway space. Once finished, his loft at 831 Broadway was, said Hess, one of the most handsome in the city, "with beautifully polished floors, painting walls on casters so that they could be moved to catch the best light, elegant modern chairs (the gift of a friend) . . ." But de Kooning was not entirely at home there, with a settled work regimen. The city was changing. His New York was hot and fervent; now a more ironic and cool city, which Andy Warhol would soon symbolize, was developing around him. The contemporary art world was becoming increasingly remote from his inner life as an artist. The constant parties, the bright young faces, and the air of fashion took him far from his own roots. There seemed to be no center any longer. "Where *is* everybody?" Hans Hofmann asked Elaine, after running into her in the early sixties. "Where do the artists go to meet nowadays?" "Nowhere, Hans," she sadly told him. In fact, artists did meet in certain places, but those places did not belong to de Kooning's generation. Nonetheless, de Kooning found himself often drawn into the new scene.

At the Cedar Tavern, suddenly it seemed that every art student in America was arriving at the bar to get drunk with Bill and Franz. Slumming uptown celebrities and Hollywood stars passing through dropped in

regularly. "One time, Elizabeth Taylor was at the next table with her first husband," said the artist Martin Pajeck, a good friend of Kline's. And was that Marlon Brando in a booth? Once, a European with a sombrero walked up to de Kooning and said, "I'm White Eagle. Who are you?" Then, said de Kooning, "I knew it was time to go." The old group retreated to a rundown bar nearby called Dillon's on Eleventh Street and University Place, but they were not as happy there as at the Cedar. And more than ever the conversation seemed, even among themselves, to be about the ups and downs of reputation rather than about painting. De Kooning was widely expected to produce major work, and strangers or acquaintances who were part of the rapidly expanding art world—students, critics, curators, dealers, painters—constantly made demands upon his time.

In the late fifties, before he went to Rome, de Kooning had met a younger artist from California named Dane Dixon whom he sometimes saw at the Cedar and then at Dillon's. De Kooning was comfortable around "Dane," and, when he arrived back in town, Dane eventually became an informal assistant. According to a friend of Dane's named Pepe del Negro, "Dane became a sort of guardian for Bill out of pure friendship. He took care of Bill when he was drinking, got him out of scrapes and helped him home." Dane answered the studio door—if de Kooning did not want to see Ruth, for example, or Janis—and passed along messages from the art swarm outside. He was handy and a carpenter and therefore able to help with the finishing touches on the new studio and stretch canvas for large pictures. He was someone to talk to when de Kooning wanted to talk and someone to drink with when he wanted to drink. He could also make himself scarce when necessary. He never criticized de Kooning or judged him in any way.

Sometimes, now, there were parties at the new Broadway studio. De Kooning himself did not put them together. He left it to Dane and to friends of Dane's, among them del Negro. These parties, many of them spontaneously created, were also something new in de Kooning's life; not since his days on Twenty-second Street had he invited a partying crowd into his studio. Dane was the bouncer. He also looked after de Kooning's first phone. De Kooning hated his phone and always remained, at heart, a man from "before the telephone." He considered it nothing but an ongoing interruption, and rarely answered incoming calls. Not long after the phone was installed de Kooning looked out the window and saw workers installing a telephone booth outside and became exasperated, telling friends he could have just used the phone downstairs. In an effort to ensure that he received important messages, an answering machine was attached to the phone. Every week Dane

would erase the messages. He called it "erasing the mice"—meaning the messages from women. De Kooning objected when the landlord offered to install an elevator because he thought the convenience would bring him more visitors.

De Kooning was remarkably generous to people who asked him for help, giving money to everyone from Gregory Corso to the Living Theatre. And he still often bought a round at the bar. But he disliked a world that constantly made demands upon him. He later told an interviewer,

> New York is a great city, but in the long run I got kind of dried out by everything happening there day and night. I was less and less able to work regularly. Besides, I didn't really feel like running to all these artists' parties. In the long run I didn't even pick up the telephone. It really became quite awful.

He could also be suddenly cruel and arrogant to those seeking "an audience" to ask him for a favor. The sculptor Sidney Geist, with some friends, once went to de Kooning's studio to ask him to support an artists' group lobbying for better housing. They were let into the studio and found de Kooning in a narrow bed with Ruth, the sheet drawn up and the couple side by side. "We felt like supplicants before the king and the whore of Babylon," said one of the visitors. "Bill listened to the spiel and said *No*. He hated all that kind of official stuff . . . he believed in the illegal loft situation. Geist was furious afterwards. It was humiliating."

In the early sixties, de Kooning's private life became a running sore of irresolution, aggravation and guilt. True to her word, Ward, two months after de Kooning went to Rome with Ruth, moved with Lisa to San Francisco, hoping to make a new life for herself as an illustrator. She did not know a single person there. She found a place to stay. She quickly made friends and began seeing an actor. Soon after he returned to the United States in early 1960, however, de Kooning flew to San Francisco to see Joan and Lisa. He demanded that she return to New York. He hated the idea of being separated from his daughter, even if he did not want to be burdened by family responsibilities. He did not stay long, returning to New York City without Joan and Lisa.

In the summer of 1960, de Kooning and Ruth rented a house on Main Street in Southampton. What many remember about that time was the couple's Labor Day party. It was to be a grand affair with many well-known people. The party went as planned, except, friends reported, that de Kooning at the last moment abandoned Ruth to host the party alone. In the following months, Ruth would sometimes join him at the new studio,

but there were also times when de Kooning would refuse to let her in and she would bang on the door or yell up at the windows from the street. De Kooning's girlfriends could be extraordinarily persistent. One morning the phone rang, and rang again and again and again. "And it rings and never stops ringing," said an artist who lived on the courtyard side of de Kooning's studio and could see into his windows. "Hundreds of times. It's driving me and my husband crazy. Suddenly, seemingly all at once, a window in Bill's studio flies open and a phone and its ripped-out cord fly out and the window slams shut and the phone smashes in the courtyard below, scattering the pigeons."

De Kooning continued to implore Ward to return to New York, promising her that he wanted a family life. There were letters and discussions, sometimes through lawyers, of marriage and support for Lisa. Late in 1960, de Kooning flew a second time to San Francisco, this time for a month. He made some lithographs in Berkeley with, among others, the Bay Area artist Nathan Oliveira, who had met de Kooning in New York in 1958, and the printmaker George Miyasaki. "They were these big, beautiful broad strokes," said Oliveira, who also took de Kooning to local galleries and parties. According to Joan, de Kooning went on a "tremendous bender" and demanded once again that she return home. Eventually, he gave Ward what amounted to an ultimatum, if one so given to ambiguity and indirection could ever be accused of issuing an ultimatum: she must return or de Kooning would cut off contact with her and Lisa for good. Ward was doing well in San Francisco. But in January 1961, she made the critical decision. She and Lisa returned to New York City. "I was doing great," she said. "And then he came along and simply took me over." The rest of her life would be defined, in large measure, by de Kooning. To make a better home for them, he began renovating an apartment around the corner from his studio on Third Avenue, installing them meanwhile at Tenth Street. De Kooning himself lived in the Broadway studio. Kligman told her friends, "Joan's back with the baby. And I don't know whether I'm in or out with Bill."

After Joan and Lisa returned, de Kooning also began to think seriously about buying a house for them in Springs. Then they would be close, but not too close. On April 14, 1961, he purchased a dogleg of land next to Peter Fried's house on Accabonac, which stood across from the Springs cemetery where Jackson Pollock was buried, with the understanding that he would eventually buy the house too. He paid Fried—Elaine's youngest brother—with a painting. That summer, Joan and Lisa stayed in the house; de Kooning moved back and forth between there and the city. While in Springs, he began to make inquiries locally about building a studio on the land he had purchased on Woodbine in 1959.

With Lisa, in 1962

De Kooning loved being with Lisa, and longed for her when she was in San Francisco. She was very fair, with a rosy Dutch complexion and a straightforward, sweet nature. He found her enchanting. So did much of the world. When he was drying out on the couch, she would mother him, tidying up and chattering and asking him if he wanted anything. Like most children, she used language in amusing ways, an attribute enhanced, in her case, by her father's Dutch accent and imperfect command of English. She would say, "Things is gooder" or "Let's go get a taxi-crab, Dad." He worried about her and even considered trying to overcome his fear of the water in order to protect her. "I want to learn how to swim," he told a friend, "because what if my daughter were drowning and I couldn't save her?" He loved to take Lisa to Washington Square and sit on a bench and watch her and the other children playing. He strongly empathized with children and seemed moved by their predicaments. In particular, he liked to see them break free or make a strong statement. Many years later, he told a studio assistant that he and Lisa once saw a little bug crawling on a stone in Washington Square. According to the friend, "Lisa took a step back and it kept coming toward her. She took another step back and it kept coming toward her. And finally she went WHAM! Bill thought that was very funny."

Still, de Kooning could not tolerate domestic life for long. He could hardly bear to see a child disciplined or told what to do. He said to a friend that the sound of a tired and sharp-tongued Joan saying "Lisa! Lisa! Lisa!"—as she tried to get their daughter to do something—almost made him sick. He imitated the sound, spitting out the words "Lisa! Lisa! Lisa!" as if the words were slaps to the face. Lisa herself never doubted her parents' love for her, but she also remembered her childhood as lonely. The 1950s and '60s were not a time, she thought, when the art world paid much attention to children. Her mother and father both seemed distracted by work, arguments, friends, and drinking. Her mother could be judgmen-

tal; her father was often absent. Sometimes he knocked furniture around, and Lisa began to fear such eruptions among grownups. At parties, when voices were raised, she would sometimes flinch. De Kooning and Joan once gave a birthday party for Lisa while they were staying on Tenth Street and invited many of their friends. The centerpiece was a magnificent ice cream cake. But then the drinking began and, a friend noted, the ice cream cake melted away.

De Kooning now began to see Ruth less often, telling Joan that he wondered what he ever saw in her, but he continued to meet new women at Dillon's, at parties, and at his loft. He drank consistently, buying his supplies at a liquor store on Tenth Street just off Broadway. Often, he would open a bottle of J&B Scotch at eight in the morning to kill his hangover and calm his nerves; then he would finish the bottle during the day. Young artists and women now took him to trendy new bars, clubs, and restaurants, not just to the places that he was already familiar with. Sometimes, he found himself at a party where he did not know the host. In the early sixties, the number of young people interested in joining bohemian circles was rapidly increasing and the sexual revolution was well under way, fostered in part by the advent of the birth control pill. De Kooning spent more and more time in this seductive world. In late 1961 or 1962, he began an affair with Marina Ospina, an aspiring young artist from Venezuela with a willowy figure and dark, beautiful eyes. Lively and charming, Ospina was separated from her husband, who often beat her. She was given to melancholy and depression and, like many in the milieu, flirted with self-destruction. De Kooning helped Ospina with money, including her hospital bills after she went into the hospital suffering from a beating. Ospina loved de Kooning, but she could not hold on to him, and in late 1962 she left New York to go to Florence, from where she sometimes wrote him loving letters over the next year. In early 1964, she begged him for money and said that she "nearly killed myself." "Frankly speaking Willem I'm very bad off and was wondering if you would help me. That's why I ask myself if you still remember me and the wonderful times we had together. I was happy then two years ago. Now I have nothing."

In March 1962, de Kooning was drinking with Kline in Dillon's when his friend waved over a young black woman who was sitting in a group with Larry Rivers. Mera McAlister was another pretty girl who was partying hard among artists, poets, and musicians. Wilder and tougher than Marina Ospina, Mera was a natural survivor. The daughter of a black father and a Native American mother, she was born in Alabama and came to New York with her mother, an occasional actress and gospel singer

named Alberta McAlister. In the fifties, Alberta would sometimes drink at the Cedar. She was talkative, funny, and outrageous; one of her good friends was Jack Kerouac. Alberta raised Mera alone in Bedford-Stuyvesant, a black section of Brooklyn. Mera was twenty-four years old when she met de Kooning. She had dropped out of school at sixteen, become pregnant, and given birth to a son. At that time, New York State could send an unmarried juvenile with a child to an institution if a parent of the juvenile reported her as living outside the home. McAlister's mother reported Mera, who then spent just over one year in an institution and called it "jail." When she was eighteen, she began hanging out with musicians around Birdland on Fifty-second Street and, she said, took up with "the guy who created the Singing Chipmunks. I was pretty wild. I had lots of boyfriends, *lots* of boyfriends." Soon she met the jazz-loving Rivers and Howard Kanowitz and then, three or four years later, de Kooning. "He was shorter than me, but it didn't matter. He was such a gorgeous guy. His hair and his eyes. He had these hazel green eyes. Matter of fact, he got better looking as he got older."

McAlister was living with her mother—now on good terms again—and brought de Kooning to meet her almost immediately after their relationship began. "Bill had on a dungaree suit and brougham shoes with paint all over them and my mother said 'And what do you do?' She had never heard of him." The couple went to visit Mera's mother quite often.

> He would go anywhere with me. You know, white guys in Bedford-Stuyvesant. . . . The kids used to follow him around. They loved him. He used to walk all over. He was interested in architecture—the forms of the buildings. He would say, "That's a nice old building." He was a crazy Dutchman. My mother adored him because he was so much fun. He'd tell stories and things to her. She could relate to him more than I could because they were closer to the same age. He'd tell her about when he was a young boy. They'd be drinking Scotch.

De Kooning and McAlister spent most of their time together drinking. Mera's crowd also urged other intoxications upon de Kooning. "I know one time we got him to try some reefer. That was funny. I'd never seen anyone smoke reefer who acted as if he had been drinking. But it was still just like he was drinking liquor. I think someone got him a track of cocaine once. Still the same." She also enjoyed their lovemaking, though that was not what held her. "I found that sometimes he was a little shy at first. Afterwards he was normal. He was a loud lover. He made a lot of

noise." Sometimes, alcohol provoked quarrels. "I remember one time he threw me and my girlfriend out of the house. He gave us each a hundred-dollar bill and said, 'Get the fuck out of here.' " But de Kooning mostly appeared delighted by his young girlfriend. She was not like any of his other lovers. At one point she was even arrested for parole violation and sent briefly to jail.

De Kooning told Mera, as he did most of his longer-term girlfriends, that he wanted to marry her but that Elaine would not give him a divorce. He frequently gave her money. He would spontaneously give her $100, for example, and tell her "to buy a dress for dinner." Mera asked for little in return, not even a drawing or two—because, she said, "she didn't like his art then." De Kooning doted upon her young son. He paid $500 to send him to camp in the summer. (Hearing that amount, then a large sum, Mera's mother said, "Uh-oh, Bill must be selling drugs.") The boy called de Kooning's paintings "ice cream colors," a phrase the artist loved and borrowed to describe his palette during an interview with *Harper's*.

In the winter of 1962, McAlister ended the relationship with de Kooning, one of very few women ever to leave him. She found him fascinating, but he was too old, melancholy, and inward-looking for her, and he was spending weeks at a time with Joan and Lisa in Springs, which left her feeling lonely. "We were winding down. I met this Jewish pilot. Wow-ee. He just flew away with my heart. I saw a face that didn't look unhappy and didn't look sad. I said good-bye to Bill."

A haze of alcohol now hung over de Kooning's days. He drank consistently, often from the moment he awoke. Except during the periodic binges, however, he did not usually appear drunk during the day. Many people did not realize he was drinking, yet he would regularly nip at a bottle. And during the long binges, he would seem particularly charming and talkative for the first three days or so—as one friend put it, "more energized." But he would then move into a stage when his behavior became unpredictable and he would seethe with rage. His close friends grew concerned that the drinking might kill him. A doctor at the hospital told him that he was destroying his liver; he regularly went to a doctor at Sixty-first and Park Avenue for vitamin B shots and spent days at a time attempting to dry out, usually shut away in his loft, or in Springs or, sometimes, in the apartments of friends. The image that he presented by the end of a drunk was spectral. Once, at the height of de Kooning's fame, Joop Sanders went to a secondhand furniture store on the Bowery.

> I was in the store and saw a drunk standing on the street and pointing in the window and mumbling to himself. And I thought, "God, I'd forgotten how horrible the Bowery is and how all these people are totally spaced out at nine in the morning." And then the guy opens the door and says, "Joop! Joop!" It was Bill at the very end of a drunk week, I would say.... He was having anxiety pains which he thought was angina.... He had literally slept in the gutter. Covered with dirt.

Sometimes, de Kooning would disappear for days, prowling the tough dives along the Bowery and the waterfront. His friends worried that he might die of exposure in a garbage-strewn doorway or be killed in a bar fight. The boyish horseplay of the early days at the Cedar was developing into something more serious: de Kooning was potentially violent. He knew with intimate intensity, from his childhood, the sudden rush of heat to the face and the smack of flesh against bone. Ordinarily, of course, his rage lay deeply buried, but alcohol could release his fists. Sometimes, he would even hit his lovers. They invariably seemed to forgive him, believing that the violence, at some deep level, was not really directed at them. Moreover, de Kooning would often provoke a woman to strike first. He knew how to use a glance or a word to madden someone close to him. According to McAlister, "He could really bring that out in you." Once, after a woman hit de Kooning with a bottle of liquor, he told McAlister, "Damn, I thought it would be like it is in the movies, that the bottle would break."

De Kooning would also occasionally lash out at men, and it was not always a forgiving friend on the other side of his temper. In December 1960, a drunken de Kooning allegedly punched out the teeth of an Air France engineer smoking a pipe in the Cedar, who then sued de Kooning for $100,000 in damages. De Kooning said he merely picked up a glass "and as I did so my elbow hit this guy's pipe. I suppose that he had his teeth clenched on the pipe. Anyway, they weren't his teeth. It was a bridge that got knocked out." Keeping a straight face, de Kooning's lawyer, Lee Eastman, repeatedly delayed the case by claiming that the artist was deeply involved in a new period of work and that genius must not be disturbed for an appearance in court. (The suit was eventually settled privately, and favorably for de Kooning.) The main concern of de Kooning's friends, however, was not that he would come to harm at an art hangout but that he would finally confront some truly tough guys. But de Kooning was a charmed drunk. According to Pepe del Negro, he and Dane once spent the night looking for de Kooning, who, it turned out, had drunkenly crashed a union meeting of dockworkers. No doubt he was reminded of

the political meetings of the thirties, for he decided to deliver a speech to the workers.

> We searched every one of his haunts and couldn't find him. Then in the very early hours of the morning, about seven or eight o'clock, Dane came down to my studio and said, "Bill's back." "Where the hell was he?" Well, the story I gather is that, drunken, he wandered down to where the stevedores work in the Hudson River area, where they were loading. Now, this was all Mafia. In those days it was completely corrupt. You know, like an *On the Waterfront* type of scene. And Bill got up on a soapbox and started to preach socialism to these stevedores. You know, Bill was very erudite and could speak on any subject quite fluently. At one point, a foreman was going to get that bum off there. What is he doing, keeping these guys from working. And a little guy in a Chesterfield coat said, "Let him talk, I want to hear this guy." It turned out to be Costello [an important gangster]. He took Bill out afterwards and they had breakfast together. Bill came back and said, "You know who I was with? I was with the big boss."

A doctor might have called de Kooning simply an alcoholic, a man addicted to alcohol and nothing more. But the journey from the top of the world into these fantastical regions of self-destructive bingeing appeared more complex than that. The years of failure did not turn de Kooning into an alcoholic; success did. The life he led as a celebrated artist violated, in some way, de Kooning's deeper sense of the world. The gutter of New York grounded him, exposing the lies of polished society. Rauschenberg once said that de Kooning's "aura eclipsed his shadow." De Kooning did not want to lose that shadow. All his life, he identified with bums, outsiders, and marginal people of every kind. On his binges, he lived with bums as an equal. Esteban Vicente said de Kooning was on a first-name basis with every bum in the neighborhood. "They became very good friends with Bill. One day Bill disappeared and one of them said, 'Where is Bill?'

" 'Oh, Bill moved. He's on Long Island now.'

" 'I hear,' said the bum, 'he's doing very well these days.' "

Drink provided de Kooning with a strange kind of redemption. No one could ever say he lived on Easy Street. There was a desperate joy to be found in drinking, an intensity and freedom not available to the trivial people of polite society. For de Kooning, who had significant links of feeling to the romantic tradition of the nineteenth century, health and sobriety were not ends in themselves: he would rather burn bright. He would have agreed with Baudelaire in *Paris Spleen:*

One should always be drunk. That's the great thing; the only question. Not to feel the horrible burden of Time weighing on your shoulders and bowing you to the earth, you should be drunk without respite.

Drunk with what? With wine, with poetry, or with virtue, as you please. But get drunk.

Of course, the boozing was extraordinarily destructive. Its gifts were momentary at best and illusory at worst, and it drained energy from the dreams of art. (Baudelaire suggested getting drunk on poetry or virtue, not just wine.) But drinking also created moments of strange beauty. Once, after a night in a bar, de Kooning and a group of friends spilled onto the street to get some coffee. A bum approached asking for spare change. Someone gave the bum a quarter, which he then dropped. The quarter rolled slowly onto the avenue and into the oncoming traffic with the bum staggering after it, dodging the cars as they zipped around him. De Kooning, watching, said, "That's my kind of space."

Even as he maintained relationships of a kind with Marina Ospina, Mera, Joan, Elaine and Ruth, de Kooning slept casually with other women. One time, when Nathan Oliveira was visiting New York in the early 1960s, "I went to the Cedar and there de Kooning was next to a young girl, rubbing her thighs," he said. "There was no way that I could connect with him. He was in the middle of a toot." Perhaps, for de Kooning, life in New York grew stale without the intensity of a stiff drink or a new woman. The need for novelty seemed to feed upon itself, sometimes lending a desperate and absurd quality to his days. At parties or on the street de Kooning would run unexpectedly into Ruth, Joan, Elaine, and other women he might be seeing. Elaine once quipped that "There were three Mrs. de Koonings at the bank today cashing their checks." Elaine was also becoming an alcoholic who slept around promiscuously. In the mid- to late fifties, her alcoholism appeared under control, and her friends and acquaintances tended to admire the way she played the field. But by the early sixties, she, too, was darkening, becoming a sloppy drunk. Increasingly, she seemed to need an audience of young people—often gay men—to admire and fawn over her. She was growing mannered, some thought, trying too hard to be marvelous.

Elaine was frequently broke, and so she took a string of teaching jobs, beginning with the University of New Mexico in Albuquerque, where she went in 1957. Although she lived near him on Broadway, de Kooning avoided her. The birth of Lisa did not lead to a divorce, but it prompted de

Kooning to reduce his ties to Elaine to a bare minimum. In Elaine's presence, de Kooning was usually distant and occasionally coldly furious. She evoked knotty subjects for him, such as the legitimacy of Lisa and the issue of divorce. She frequently wanted money, and he did not like the way she quoted him or, he thought, used their marriage and his name to advance her reputation. In public, he disliked acknowledging his marriage to her, even on ceremonial occasions. When Elaine's mother, Marie, died, Elaine began drinking heavily and then wanted de Kooning notified of the death, but was afraid to call him herself. Instead, she asked an assistant to call him with the news. After doing so, the assistant was about to hang up when Elaine

New York noir: de Kooning photographed by Robert Frank in the early 1960s

grabbed her, saying, "Ask him if he's coming to the funeral, tell him the location of church, when and where." The assistant nervously conveyed the invitation. After a long pause, de Kooning said very coldly, "I'll tink about it."

Elaine seemed a highly social animal to de Kooning, longing for money, power, and prestige. This view of her was underscored when, in 1962, the White House asked Elaine to paint a portrait of President Kennedy. She was smitten by Camelot. She adored the president and may have hoped to entice him into an affair. De Kooning thought she was more interested in gaining the world's admiration than in painting. She did not

have his soulful ambivalence about the world. In 1963, well after she had painted the Kennedy portrait, Elaine removed an ugly linoleum floor in her studio and replaced it with gray wall-to-wall carpeting. John Cage stopped by and burst out laughing, because there was essentially no change in the character of the floor. "Later, Bill came by," said an assistant of Elaine's. "They had some discussion. As he was leaving, Bill stood at the door and he looked intently over Elaine's shoulder, piercingly taking everything in, and he said in this guttural cold expressionless Dutch way, 'You could make Siberia out of anywhere.' "

Despite his heavy drinking, de Kooning nonetheless set to work on many mornings. Janis, eager to capitalize on the success of the 1959 exhibition of highway paintings, pressed him for another show. After finishing *Door to the River* and *Spike's Folly*, however, de Kooning completed only three or four full-scale oils during the next two years. They were forceful, big-brushed works, closely related to the highway paintings, but they did not take his art in a new and dramatic direction. None had the lyrical force of *Door to the River*. And yet, a vague new idea was beginning to excite de Kooning. He was thinking a great deal about Courbet, especially about how "concrete" that artist was—"how overcome with reality." De Kooning began to dream of being similarly overcome by the light and landscape of Long Island. Perhaps he could "grab a piece of nature and make it as real as it actually is." That would mean giving up the hard colors, and hard forms, of the highway paintings. He was also beginning to think about Lautrec and perhaps imagined doing a figure with that kind of caricatural panache. De Kooning was not getting much work done, but his imagination was active and, as always, ripening.

Relations between de Kooning and Janis began to sour. De Kooning, who always thought Janis nickel-and-dimed him, began to suspect worse: that the art dealer might also be hiding profits, snookering him as Charlie Egan had a decade before. Janis, in turn, was angered when de Kooning privately sold *Door to the River* shortly after its completion to the Whitney Museum of American Art. Although no formal contract governed their economic relationship, the dealer believed that they had an understanding that he, Janis, would sell and share in the proceeds of major works such as *Door to the River*. In addition, he thought a painting of such significance should be shown first in an exhibition.

Around this time, Janis began to wonder whether or not de Kooning was washed up. The stories of boozing were not encouraging to a sober businessman who watched the market, listened to advisors, and believed in cutting losses. Janis recognized that a new style, pop art, then called

"the new realism," was starting to create a stir. He also recognized that the histrionic "gestural painting" of de Kooning's followers, the "second-generation" abstract expressionists, was now suddenly being consigned to the past and creating widespread revulsion among serious tastemakers—including Alfred Barr at the Museum of Modern Art. In particular, Clement Greenberg and many critics and artists influenced by him were now relentlessly attacking de Kooning as a has-been who had done his best work before 1950. Around the time of de Kooning's great gallery success in 1959, the Museum of Modern Art mostly ignored de Kooning's gestural followers in its influential "Sixteen Americans" exhibition, instead emphasizing the cooler, harder-edged work of the young Frank Stella and Ellsworth Kelly. Then, in October 1961, a show titled "The American Abstract Expressionists and Imagists" opened at the new Frank Lloyd Wright building of the Solomon R. Guggenheim Museum. The curator, H. Harvard Arnason, emphasized the color-field abstraction of Morris Louis and Kenneth Noland, both admired by Greenberg, rather than the work of de Kooning's followers. As Florence Rubenfeld wrote in her biography of Greenberg, "Politically, Arnason's exhibition signaled the end of action painting's long reign and the ascendance of antigestural abstraction. It signaled the decline of the de Kooning/Kline influence, the Artists' Club, and the Tenth Street phenomenon."

At the time of the Guggenheim show, Greenberg gave a lecture at the museum called "After Abstract Expressionism" in which he spoke with condescension about de Kooning's recent work. About a month later, Greenberg and de Kooning met by chance at Dillon's, where each was having lunch. Their respective accounts differed about what happened. As reported by the writer Lionel Abel, who heard the story from de Kooning, Greenberg "came up to him as he sat at the bar and made the accusation, 'Why do you tell people that I got my ideas from you?' Bill said that he realized Clem intended to hit him, and so he thought it best to get in the first blow. He hit Greenberg on the jaw and then the two were separated." Greenberg, however, gave this account to Rubenfeld:

In actuality what happened was that I was with Jim Fitzsimmons and Kenneth Noland, and Bill came in with a couple—new people to me—and they went to sit in a booth. We were at a table. He left his companions and came over to me and said, "I heard you were talking at the Guggenheim and said that I'd had it, that I was finished." Well, yeah. I had said that. Sure. I meant it too. And I still think that he was finished. He hasn't done a good picture since 1950 or '49. Anyway, Bill sat down

with us. . . . He just left his companions sitting alone in the booth. That was Bill. He was a barbarian like his wife, Elaine . . . no manners. Supposedly manners went out in the sixties, but at the Cedar Street Tavern they went out long before that.

Well, I was misguided enough to trade words, to bandy words with Bill. Then some of the painters gathered round to watch this spectacle. . . . I don't want to go into what he said next—it was so awful—about Tom Hess. . . . De Kooning said Tom [Hess] was riding on his back. Then he said, "Well, Pollock said you were riding on his." I didn't believe him. Pollock never said that. As drunk as he could be, I don't think he said that.

Then I said, my voice going to falsetto, "So what did I get out of it? So what did I get out of it, you son of a bitch?" And he took his elbow and poked me. It didn't hurt. He got up and punched me lightly while he was standing. So I got up to go after him and then we were separated. There was a scuffle in the separation because the kids—the louts who had been watching—all took his side. He was the hero down there. It took Ken Noland to intervene, to pull somebody off me. Then the next thing—they'd rushed Bill to the back of the bar. And then he was allowed to come back and he said, "I'm not scared of you. I'm not scared of you."

It could not have pleased Janis that his hard-drinking and small-producing artist was literally fighting the most influential critic of the period. Nonetheless, he scheduled a de Kooning show for March 1962. The pressure on de Kooning to produce something special—as critics, younger artists, and fashion turned against him—was immense. "Every year you have to knock out your opponent," he bitterly told a friend. "That's what painting is." As the confrontation with Greenberg suggested, de Kooning felt keenly the shifting in contemporary taste. He was never an artist, however, who could create art merely to meet the demands or expectations of others. His studio in the winter of 1961–62 did not, would not, fill with dramatically new art. In the end, the show included three large oils, drawings, collages, and small paintings on paper. A series of eleven small paintings of women, rendered with elegant, geometrical twists of the wrist, masterfully skirted the edge de Kooning loved between landscape and a woman's body. To give the show more weight, Janis also included *Door to the River* and *Spike's Folly* in the catalog, and he told *Newsweek* that he expected the show to sell out in the first half hour, at prices ranging from $4,000 to $35,000. Hess could always be

counted upon to celebrate de Kooning's work, and, in his essay for the catalog, he was breathless, writing, "In the scarred flesh of his paint, in the numb idol-icon look of the new Women who have grown out of the moving flesh of pigment, is the pathos and irony of art as a criticism of our (his, its) life. These pictures are not substitutes for Morality, surrogates for Joy, they will not serve as space dividers, museum captions, or esthetic décor. They are not objects for contemplation, they are in themselves acts of passionate, intellectual, hypercritical real thought."

A crowd came to the opening—de Kooning was still a star—but the show otherwise fell flat. Hess, searching for a compliment that would fit, called it de Kooning's most "intimate" to date. Others simply called it small. Even favorably disposed critics such as Dore Ashton suggested that some pictures were less successful than others; she emphasized that de Kooning's "process" was on view. In fact, the 1962 exhibit had a slapdash air. It was a show just to have a show, and it disappointed many well-disposed viewers for that reason. "You see?" was the attitude of the anti–de Kooning group. "Washed up. A drunk." When Alcopley ran into the painter Helen Frankenthaler outside the show, he said she told him, "Oh, there's nothing to see, let's go for a walk."

Two months after de Kooning's show opened, Franz Kline died. His friends knew, of course, that his prodigious drinking was dangerous. He had also been seriously ill with rheumatic fever and suffered a series of heart attacks. But his death seemed sudden and unexpected nonetheless. The gossip columnist Leonard Lyons, on the day of Kline's death, had mentioned that the painter was off the critical list. But then the artist Earl Kerkam came into Dillon's, where de Kooning was sitting, and quietly told people that Franz had just died. Beloved by many, Kline, unlike most of his friends, had an appealing smile and a genuinely playful spirit. He was the one to sit next to, the barstool raconteur who never became a bore. His death was the death of the Cedar and, for the downtown artists, a powerful symbol of the changing of the guard.

For de Kooning, the personal loss was profound. On the simplest level, Kline's death reminded him of his own mortality; the doctors also warned him that he would not live long if he continued drinking heavily. More important, the death of his friend stripped de Kooning of emotional support, leaving him more exposed to the world. When de Kooning and Kline looked at each other, something private and family-like would pass between them, a glint of recognition that, together, they knew what was

what and saw through the false allure of the larger world. In *Kline: An Emotional Memoir*, Fielding Dawson captured their relationship—and the lush melancholy of the period—by describing a quiet afternoon at the Cedar:

> It was a bright afternoon. For some reason I wasn't sitting at the bar, but in one of the small center booths, quite near the telephone. Franz was sitting a couple of stools down towards the door from the beer taps, at the bar, drinking a beer and smoking a cigarette.
>
> He was clean-shaven. He had his black pin stripe suit on, and a clean white shirt open at the collar; his shoes were shined. He had his hat on, slightly to one side, front brim snapped down. He was dramatic and beautiful.
>
> Now, de Kooning, in his paint-splattered paint clothes, sat unnoticed by Franz, at the end of the bar near me, exactly in my line of vision, and of course I watched them both.
>
> Bill's left elbow was on the bar, and his right hand cupped his right knee—feet hooked over the run of the barstool—his head was forward, arrowhead, profile. His blue eyes held a certain silvery glitter, perceiving Franz. Franz, there, glowing, de Kooning was looking into the glow.
>
> But then he, Bill, began a change. I saw the start of a smile, and he looked so directly at Franz a personal beam of intense affection came out of his eyes and shone on Franz; almost religious, or a fullness which revealed torture. Bill stepped partly off the barstool and whispered,
>
> "Franz!"
>
> Franz turned. "Bill!"
>
> Bill picked up his drink and walked down, sat on a barstool beside Franz; after an instant of speaking I heard Bill say, softly, like someone telling a dear friend a piece of great news not everyone is allowed to hear, What about a little drink?
>
> Franz laughed, and Bill said to Louie, "Let's have a couple of little drinks here. And this one's on me."
>
> Quite a while later they were in the same place, but they were leaning on each other, heads together, like small stocky guys—no, tall buildings tilting across avenues against each other—skyscrapers, rather; having a little close conversation.

The funeral was at St. Bartholomew's. There were pansies on the coffin, which some in the large crowd did not like, considering them ill-suited to a man who made big, brawny paintings. Not surprisingly, de Kooning soon began drinking hard. He felt guilty because he had not vis-

ited Kline in the final days. He and Ruth had gone to the hospital, but
Ruth was so dressed up and alive—"She looked like a Christmas tree," de
Kooning told a friend—that he decided at the last minute not to see his
friend. After the service, de Kooning and others continued drinking at Dil-
lon's. In the evening many artists ended up at the apartment of the collec-
tor Robert Bolt on Washington Square. De Kooning left very late and,
according to one report, became so drunk he shouted at or disturbed
someone trying to clean up. He never went home, but disappeared for sev-
eral days on a drunk. His friends became so worried that they set up a
search on the Bowery and in the darker bars.

Eventually, Harold Rosenberg found de Kooning on the street, alone,
grizzled, and without a jacket. It was cold. Rosenberg urged him to go
home. De Kooning shook his head. Rosenberg offered him an overcoat. De
Kooning just walked off.

In the early sixties, de Kooning resembled a man trying to escape. There
can be little doubt that if he had continued drinking in New York the
way he did after his return from Rome, he would have soon died. But even
his dance with death had a purpose, for it finally forced him to make a dra-
matic decision, something he was ordinarily loath to do.

He was continuing to dream of a "loft in the woods," a studio in the
Springs with a feeling of air, light, and space. Something reminiscent, per-
haps, of a boat on the sea. He could wash it down every week, as you
might a factory floor or the deck of a ship. He imagined steel girders and
oblique angles. No right angles, no boxy rooms, no walls pressing inward.
In 1961, he sought out a local builder on Long Island with whom to dis-
cuss his thoughts. "He had asked at the local lumber company if they
knew a builder who could do modern buildings," Ed Mobley said. "I had
just completed my house at the time. They referred him to me. Mine was
a California design." According to Mobley, de Kooning "wanted to build a
building like he made a painting—up and out. You have a point that your
eye intercepts, like in a painting. That's what he wanted—a viewpoint
that was up and out. You're aware in the studio of it being lower in the
middle and higher on the sides."

De Kooning got along well with Mobley. In addition to discussing the
loft in the woods, de Kooning invited the builder into New York to help
with the interminable renovation of the Broadway studio. Then, in the
spring of 1962, Mobley oversaw the renovation of the Accabonac house
prior to Joan and Lisa's move there. Only the Springs studio, however,
really fired up de Kooning. In the evenings he spent with Joan and Lisa in

Springs, sometimes during periods when he was drying out, he would make rough sketches of the studio and show them to Mobley. "I put them on paper for working drawings. . . . We'd see if they were feasible or not from a construction point of view." De Kooning was beginning to worry, however, where he would find the money to build his dream studio. The money he earned from his 1959 show was rapidly disappearing, drained by his high life in Rome and his New York renovations. At Ibram and Ernestine Lassaw's house in Springs one evening early in 1962, an engineer "came with blueprints and all sorts of things and laid it out on our table," said Lassaw. "And Bill kept saying, 'We've got to cut down on expenses.' He thought he could save money by having a structural house instead of the usual way of wood and masonry." According to Mobley, the design evolved through such ongoing discussions. "He was very excited. . . . I suggested the prefab building system. It was the Prudent Barn Framing System. With industrial metal trusses. We turned them backwards. Put the columns back to back to make a butterfly roof. It's a proprietary system. There's many of them around. We turned this around so it went like so to get a butterfly roof. . . . It had a butterfly roof because he liked the aesthetics. He wanted that soaring quality. . . . Only way is with steel trusses."

De Kooning also dreamed of other qualities. The working studio would be the heart of the building, but he would also have a great cellar with a wonderful heating system. He imagined a spacious kitchen with a magnificent stove and an open room where large parties could take place. He would install only the best modern appliances. He gave much less thought to the private quarters upstairs. In his studio, there would be nothing cramped or penurious, no residue of his years of poverty. According to Mobley, he was always asking for thicker, double sized, or extra large—to create a feeling of the massive together with the light airiness. "He was playing with the idea of casting furniture in concrete, like a concrete sofa." The furniture in boats was often built-in, of course, to create stability amid the roll of the sea. De Kooning's studio dream reflected the paradoxes that governed his life and enlivened his art—it would be at once fixed and flowing.

In September 1962, de Kooning asked to take out a loan of $50,000 from Chase Manhattan Bank to build his studio. After the transaction was finished, the secretary said, "Mr. Rockefeller wants to meet Mr. de Kooning." Rockefeller, of course, knew who the painter was. He lowered the interest rate from 12 to 4.5 percent, "then said, 'I admire your work, but you're very expensive,' " recalled Lee Eastman, who accompanied de Kooning to the bank that day. "So Bill said, 'Mr. Rockefeller, when I paint a nice little picture, I'll call you.' " Later that fall, de Kooning paid $3,100

for more land around the studio site (a subsequent purchase brought the total amount to eleven acres) and advanced $5,000 to Mobley. Soon after, work began at the studio.

That November, the Sidney Janis Gallery opened an exhibit called "The New Realists" that celebrated the work of the leading figures of pop, among them Andy Warhol, Roy Lichtenstein, and James Rosenquist. The art world thronged to the opening, staged in an ample ground-floor space on Fifty-seventh Street that Janis rented especially for the occasion. The show was a sensation and the talk of the town. De Kooning went to Fifty-seventh Street, but, observing the scene within, would not enter the gallery. Instead, he stared in from outside, then walked away unnoticed. That same month de Kooning broke ground for his new studio. He was ready to leave New York. He was prepared to emigrate, again.

Pastorale

On December 19, 1962, not long after the "New Realists" show opened at Janis, a retrospective of Arshile Gorky's painting opened at the Museum of Modern Art. The show came at a critical moment for de Kooning. Gorky remained one of de Kooning's presiding inspirations. In the thirties, Gorky had provided the young de Kooning with an example of what it meant to be an artist, a model of vocation and commitment in an often hostile world. Although Gorky had now been dead for almost fifteen years, the sight of his paintings—and the memories they must have aroused—once more helped the troubled de Kooning find his way.

Toward the end of his life, Gorky, despite his success in New York, left the city to settle in the country. The move was partly responsible for the late flowering in his art. Outside the city, Gorky abandoned himself to his private Garden, to a transcendent sensual joy in the natural world. The pictures seemed painted for no one but himself—not for the art dealers, not for the collectors and patrons, not for the fashionable European surrealists. They were a personal lyric. Gorky's example could only strengthen de Kooning's own resolve to leave the city and seek out a private renewal in the countryside. He could abandon History with a capital H, letting others chase after Warhol's pop or Greenberg's color-field abstraction. Instead, de Kooning would live with Arshile in the country.

The retrospective contained a Gorky oil from 1947 called *Pastorale*, a loosely painted work enlivened by a brilliant chromatic chord of yellow

and peach hues. In the winter of 1963—the show continued into February—de Kooning painted two oils in the same high key of yellow and peach. Always generous in his acknowledgment of artists he respected, de Kooning called one *Pastorale* in homage to Gorky and the other *Rosy-Fingered Dawn at Louse Point*. (Louse Point was a spit of land in the Springs where earth and sea seemed to mingle and come together; the Homeric phrase *rosy-fingered dawn* also evoked the odyssey of an artist-wanderer who moved between land and water.) The canvases were the same size, but *Pastorale* was seventy by eighty—that is, more horizontal—and *Rosy-Fingered Dawn at Louse Point* was eighty by seventy. The first major paintings he had made since 1960, they marked an essential turn away from the grand style of the late fifties. The imperial king of Tenth Street had abdicated. He was a private artist, again.

No powerful public "highway" brushstrokes dominated the landscape of *Pastorale*. Instead, de Kooning seemed to have traveled to the end of the highway and into roadless country. The brushstrokes dissolved into light and watery reflections, into what the artist Scott Burton called "form-obliterating radiance." De Kooning appeared to have yielded to his senses, to have become more feminine and lyrical. The palette of yellows, peaches, and whites—what Mera McAlister's son called "ice cream colors"—looked back to the playful pastels of the rococo rather than to more masculine, assertive styles. Though no one noted this quality at the time, they were also brave works. It would be hard to imagine anything that would irritate a smart young critic in 1963 more than a loosely focused, brushy painting full of personal touch.

In fact, as the critic and curator Lynne Cooke has suggested, de Kooning's retreat to the country was much richer and more radical than any of his contemporaries recognized. His private reverie was also an eccentric advance in a great Western tradition—that of the pastoral—at a time when American society was itself showing a fresh, idealistic concern for the landscape. The pastoral tradition was always an essentially urban preoccupation, of course, reflecting a longing for a simpler life outside the city. The pastoral evoked the Garden of Eden; and yet it also, inevitably, suggested the Fall and worldly corruption, as viewers gazed longingly upon paradise from their vantage point in the actual world. De Kooning was ideally suited to explore this fraught space between joy and corruption. Certainly, he had no intention of creating Edenic landscapes ("I'm not a pastoral character. I'm not a—how do you say that?—'country dumpling' ") or visions of prelapsarian happiness like those found in Giorgione or, in a modern form, Matisse. In particular, he would never show the figure entirely from *outside*, the way earlier artists might display a nude by a

river. In his work, the body would almost fuse with the landscape—and therein lay the dream of a transcendent pastoral unity. But this being de Kooning, there must still be movement and tension. Doubt must snake through the paint.

De Kooning was not an intellectual painter who changed only to make a point or advance a theme. If *Pastorale* and *Rosy-Fingered Dawn at Louse Point* represented his early efforts to renew the tradition of the pastoral, they also emerged from something profoundly personal. In the early sixties, after the forward-moving decade of the fifties, the aging de Kooning began to steep himself in the backward-remembering sensations or "springs" of youth. De Kooning would find on Long Island many visual echoes of his youth in Holland. He would also begin to reach into the inchoate passions of childhood. The uneven fusing of the body and the landscape, the heart of de Kooning's version of the pastoral, also embodied the dilemma of the young child struggling to distinguish himself from the world. No artist could more convincingly convey the contrary, burdened passions of the boy who careers wildly back and forth between the glorious body of the mother and a joyful, liberating freedom.

It would take de Kooning more than a decade, a troubled time that one friend called "the hangover years," to develop these springs. *Pastorale* and *Rosy-Fingered Dawn at Louse Point*, painted in his Broadway studio, were the last significant works that he would complete in New York City. And in many respects, even as he painted them, he had already left town. Already his brush was working in another light.

Springs

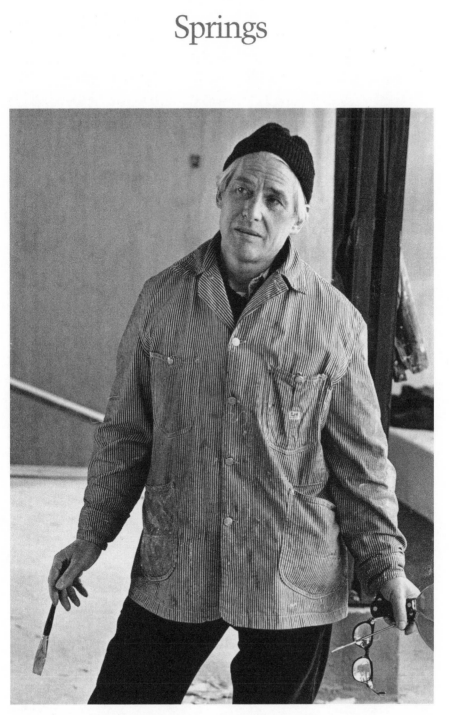

De Kooning at work in his unfinished studio in Springs, 1964

29. Home Again

I don't want to be new anymore.

De Kooning's dramatic decision in 1926 to leave the Old World and come to America made him an immigrant in the classical sense, but there were also many other, more symbolic emigrations in his profoundly restless existence. There was no forever in his sensibility, no eternal in his heart, no permanence in his painting. In March 1963, when he moved to the small shingled house on a quiet country road in rural Springs, joining Joan and Lisa, he was just one year away from being sixty years old. It was a disturbing and almost unimaginable benchmark for an artist too committed to the quickening of blood associated with youth to accept graciously the diminishments of age. Must he finally settle down at the age of sixty? Many in the art world were hurrying him into the pantheon—or was it putting him out to pasture?—by declaring that his time had passed. Even friends seemed to want to treat him as "retired" to the country.

In all likelihood de Kooning *was* feeling considerably older after Kline's death. His body remained strong, but a decade of hard work, late nights, and spectacular binges could not have failed to sap his strength. It was not clear, moreover, how he could make a life in the country for himself. He was a man of the city. What would he do without the urban grit? Without the friends at the Cedar? Would he settle, uncharacteristically, into rural domestic life with Joan and Lisa? When would his new studio, still far from completion, be finished, and how could he complete any serious work without one? And how would he pay for everything?

Even so, in his early months outside New York, de Kooning appeared to friends unusually sanguine. He did not talk about losing center stage, but instead stressed how much he loved the prospect of his new studio. He felt comfortable, he declared, in this almost Dutch landscape near the sea, with its low horizon and flat and marshy ground. Moving to the Springs was a kind of Dutch homecoming. "Actually I've fallen in love with nature," he said, "I don't know the names of trees but I see things in nature very well. I've got a good eye for them, and they look back at me." After the heated social scene of the city, he seemed to relish the idea of living among fishermen and working people. That, too, represented a kind of

homecoming, evoking the working-class milieu of his youth. He soon charmed and befriended his new neighbors, among them Clarence Barnes, the owner of a small country store on Springs Fireplace Road not far from where de Kooning's new studio would be. "He liked very poor working people," said Barnes. "Water working people. He always talked about them, about how hard they had to work. And he talked about being poor in New York City when he was a housepainter and how he jumped ship. About how he hardly had any food or anything."

The scruffy look of Springs suited de Kooning. "Snob Hill [his name for the old-money Lily Pond Lane area of East Hampton] is really nice, too," de Kooning said, "but the trees have already grown up there and it looks like a park—it makes me think of people in costume and Watteau." In the scrub land of the Springs, he told Harold Rosenberg, he was "fascinated with the underbrush, the entanglement of it." Life there was "kind of biblical, the clearing out to make a place." The scale of the trees, which were not much bigger than a human being, also appealed to him. "For a painter like myself it is so much better to be surrounded by a *small* nature," he wrote in a letter. "Places like the Grand Canyon would frighten me to death." A side of de Kooning also enjoyed being kingpin in the poorer part of town, for he understood the working-class expectations of his mother and siblings and their desire to "make it in the eyes of their peers." According to one friend, "He said he wanted to be the richest one in the Bonacker [the name of the local fishermen] community, rather than be on Snob Hill." If there was no Cedar in the Springs, de Kooning still found many old friends from the city. By the early sixties some "old-timers"—as de Kooning called them—and many Ninth and Tenth Street artists lived in the neighborhood, either as full-time residents or as week-enders and summer residents, among them John Ferren, James and Charlotte Brooks, Saul Steinberg and Hedda Sterne, Nick Carone, Conrad Marca-Relli, and Ludwig Sander. Philip Pavia was often there, and Rosenberg had a summer house just off Accabonac Road.

The move to Springs prompted de Kooning to try to establish a home life apart from his studio, something he had not seriously attempted since the mid-forties. In the renovated house on Accabonac Road, living with Joan and Lisa, he could perhaps keep together what the seductive city separated. While not in love with Joan, he respected her as a steady companion and the mother of his child. And he had a Dutch workingman's appreciation for the comforts of home. He could enjoy a clean and tidy house, which Joan provided, in which he was the undoubted master. He liked poached eggs and hard toast and coffee for breakfast; and he was not

disturbed if he wanted to spend breakfast reading Wittgenstein, a philosopher he now loved to puzzle over. At night, he liked to eat a Dutch dinner of what Ward called "ugly food"—stews and boiled meats—and then relax in front of the snowy black-and-white television while making drawings. Of course, living in close quarters with a mother and child could also awaken unhappy memories of his home life in Rotterdam, and he resented the close little rooms of respectable domesticity. But de Kooning was a bohemian with qualms: his daughter must have a father. And so, like a good husband and father, he left for work each day, walking across the yard to the garage.

The one-car garage behind the house, where he had worked off and on since Joan and Lisa moved to the Springs in the summer of 1962, served as his makeshift studio. The space was cramped, the interior rough. De Kooning could not easily spread out his full array of paints and brushes, nor could he step back to study larger compositions. Still, the studio alone did not explain the small scale of the pictures he began to make in the garage, for he had worked in cramped studios before and made large, ambitious works there, such as *Excavation* and *Woman I.* Instead, de Kooning, in the early months in Springs, was experimenting—casting about for a fresh feeling in his art. When compared with *Pastorale* and *Rosy-Fingered Dawn at Louse Point,* the most important work to emerge that spring and summer, *Clam Diggers,* was tiny. Just twenty by fourteen inches and painted on paper mounted on composition board, *Clam Diggers* was nothing less than a rococo idyll, a dream of Eden encapsulated in the watery figures of two women in the sunshine.

The painting depicted two naked women standing full-length and gesturing at the viewer. Unlike the women of the fifties, they were coy and inviting: pink, shimmery, and voluptuous. There could be no doubt these nymphs relished sex; they were moist with allure. In de Kooning's handling, the brush probed for the sexual quick, much as clam diggers felt for the clam, and seemed to caress and tickle the women into life. De Kooning's spun sugar palette—glowing pastels set against a background so white as to be almost blinding—glinted with light. The hues seemed to be further softened in watery reflections. The figures could even represent a reflection in the water; hardly a straight line existed in the image. It was this sensation of watery dissolve that particularly excited de Kooning. That was the direction announced by *Pastorale:* no bold and singular brushstrokes typical of the imperial or highway paintings, but a yielding of the wet brush to the blooming profusion of nature. Water, always essential to a Dutchman, could be controlled but not dominated. All now

seemed a watery illusion, but one that still had a physical power, as did the sea. De Kooning later said of *Clam Diggers* and the paintings that followed, "I try to free myself from the notion of top and bottom, left and right, from realism! Everything should float. When I go down to the water's edge on my daily bicycle ride I see the clam diggers bending over, up to their ankles in the surf, their shadows quite unreal, as if floating. This is what gave me the idea." He would not, he said, "let that go for anything."

Clam Diggers was a joyful painting, perhaps the most radiantly happy in de Kooning's oeuvre. It may have reflected the pleasure he took in his move to Long Island and the excitement he felt in the dreams of renewal and the birth of a new, watery style. But the Edenic image did not reflect a comparably blissful domestic life. The two naked blondes were not wives or mothers. If the sixty-year-old artist sought renewal in the landscape, the sixty-year-old man must find it with a young woman. It would be only several months—by the summer of 1963—until the old patterns muddied his new life in Springs and de Kooning was once more on the move.

Ever since Lisa's birth in 1956, de Kooning's connection to Joan Ward had been a dizzying on-again, off-again—and sometimes angry and drunken—relationship. It was for Lisa's sake that he listened to her continuing requests that he divorce Elaine and make Lisa "legitimate." In the early sixties, this was still an important concern. And it was primarily for Lisa's sake that he bought the house on Accabonac Road. But de Kooning could not maintain a consistent relationship with either Joan or his daughter. His attention would wander when he was with Lisa, even as he idealized her. "She's the apple of my eye," he always said, "an angel." (Joop Sanders observed that fathers who consider their daughters angels are rarely interested in who their children really are.) Lisa herself said that "He didn't know what to do with me, looking back. He wasn't a good father. He loved me very much, but it took me years to understand that the painting came first and would always come first. If you were the child it's just not admissible. But he loved me and that was good."

De Kooning's relationship with Joan became, if anything, more troubled in 1963 than it had been during their earlier attempts at a rapprochement. He continued to value her as a companion and mother, but de Kooning always sought more than that from a woman—perhaps, in the end, anything *but* that. He found Joan constricting and judgmental. "You're always putting things in boxes, Joanie," he told her. He resented

the emotional hold she had upon him as the mother of his child. Any feelings of personal entrapment were only exacerbated by his working conditions. His last loft at 831 Broadway had been an artist's dream. Now, he had a cramped work space and a pinched psychological space, cooped up in a small dark house with a mother and a child. It would be months before he could work or live in the new studio. Perhaps, as the months passed, the settled quiet of the country also began to weigh upon a man accustomed to the sirens and bright lights of New York. Perhaps, too, the silence from the art world gnawed at him. After the disappointment of his 1962 show, de Kooning began to drift away from Janis. He let another art dealer, Allan Stone, sell some smaller works in the fall of 1962. Like many of his contemporaries, he believed Janis was abandoning him in favor of the younger pop artists.

Neighbors recalled hearing, that summer, the sound of loud arguments coming from the house on Accabonac. Some noticed bruises on Joan's arms. Toward the end of summer, de Kooning slipped into a bender that never seemed to stop. At one point, two young women who had rented the house next door threw a party for friends who were visiting from the city. In neighborly fashion, they invited Joan and de Kooning, whom they knew slightly from New York. De Kooning was drinking heavily, in the wound-up talkative phase of a bender, but nothing unusual happened. Then, a night or so later as the two friends sat up talking, they heard a noise in the bedroom. The light was on, and they went to investigate. They found de Kooning, drunk. Instead of entering through the front door, he had squirreled through a bedroom window. And then, he wouldn't leave. Over the next few days, his friends wondered where he had gone. To New York? Italy, perhaps? In a Chaplinesque echo of his earlier emigration and concealment in the freighter, de Kooning had indeed fled home, only to conceal himself in the neighboring house. And when he finally emerged again, he was no longer living with Joan, but looking for places to rent with his new twenty-six-year-old girlfriend, Susan Brockman.

Brockman was an elegant dancer with a string-bean figure and a fetchingly artistic air. She belonged to a world that liked Beat novels, European films, and advanced jazz. She knew her way around the arts generally and was attracted to art and photography as well as to dance. She had rented the cottage in the Springs for the summer with a friend, Clare Hooten, but had been visiting the Hamptons for years. Her family, which was well-to-do, owned a house near the ocean in the wealthy area of East Hampton. But Brockman had no desire to be a socialite or rich man's wife. She was sensitive and soulful, and she seemed to understand, and accept, people

with moody temperaments. She was certainly no stranger to the difficulties of life: her mother committed suicide when Susan was sixteen. In the city, Brockman would sometimes go to the Cedar, but she was not a woman who played on the wilder shores of bohemia. On the contrary, she was fairly quiet and self-contained, and certainly not a star-chaser on the make. To an artist recoiling from the New York scene and longing to feel young again, she appeared fresh and guileless. She was not tempestuous like Ruth, or demanding like Joan. According to de Kooning's old friend Mary Abbott, who met Susan while both were studying with the same dance teacher in a town near the Springs, "She had everything. She had sensitivity, brightness, originality, and looks."

Brockman had met de Kooning the previous February during one of his periods in New York. At the time, she was celebrating Clare's birthday at the Cedar. "Bill was there," she said, "and I had been an art student in college and of course knew who he was." At some point, de Kooning joined them and, later, accompanied the two young women to Clare's nearby apartment for a nightcap. According to Brockman, there was no special personal chemistry. But two events from the evening stood out in her mind. One was de Kooning's treatment of Clare's young son, who was then three or four years old. Awakened from a deep sleep and upset at seeing a stranger, he exploded into a tantrum and began to hurl sizable play blocks made of wood at de Kooning. De Kooning responded in a way the embarrassed women did not anticipate. He became very serious, and, rather than stopping the attack, let the child pound at him until the anger was completely spent. "Empathize, don't criticize," de Kooning then told Clare, perhaps remembering his own childhood furies, when his mother did the opposite. "After that Hootie [the son] was serene and so happy to be able to let out this rage and that Bill took it," said Brockman. De Kooning followed this by sending the women flowers, "a big bouquet," she said. "Of course we were both kind of thrilled." But that was as far as it went. Three months later, however, Susan and Clare turned up in the house next door to Joan and Bill.

On the first night, Brockman said, "We were up for a long stretch talking. And then he never left." Their night together began a two-year odyssey, in which the couple moved constantly around Springs, inhabiting eight houses along the way. Their affair began so suddenly that only later did Brockman seriously consider what was happening. "I can't remember if I thought, 'Wow, what is going on here?' or whether it was just that it was the times," says Brockman. "At that moment in life, things sort of fell into one's lap. Literally. I don't think I thought that he was staying for the next few years. My mind was not at that place." Given

de Kooning's own state at the time, no one could have guessed his intentions. The first few weeks passed in a blur, for de Kooning did not give up the bender once he moved in with Susan. "I was thinking it would be over," says Brockman. "But it didn't change. It didn't stop. And I had no experience whatsoever with anyone who drank."

In retrospect, Brockman believed, it was de Kooning's guilt over Joan and Lisa that pushed him into the bender, and that then kept him drinking during the following weeks. "[The drinking] was an excuse for him to do something daring," she said, "which was to leave Joan and Lisa." Alcohol loosened the emotional knots; he could then escape, emigrating to a freer place. De Kooning would get drunk, she said, "when he wanted to change something and couldn't resolve something, or when something upset him emotionally and he didn't know how to deal with it." After moving in with Susan, de Kooning never walked across the yard to face Joan. She learned of his whereabouts only through friends, the same way that she learned in the summer of 1956 after Pollock's funeral that he had moved back in with Elaine. Months later, de Kooning would still not collect his personal things and art supplies.

After Susan and Clare's rental ended, de Kooning and Brockman briefly occupied a tiny summer cottage on Barnes Landing, a short distance from the original rental on Accabonac Road. Then, as cool weather approached, they moved into a nearby house owned by Berenice D'Vorzon, a painter and friend of Joan's. But this was only temporary. In the end, D'Vorzon "very politely asked us to relocate," says Brockman, because of her feelings for Joan. So they moved on "in a bit of a caravan," said Susan, this time to the house of de Kooning's old friend Frederick Kiesler. By then, it was clear that their relationship was more than a fling. "At that point we were alone, just Bill and me, and I guess I knew that we were pretty solid," said Brockman. The couple began to look for a more lasting place to live. Around early November, they rented the house of Rae and John Ferren on Springs-Fireplace Road. From their house it was just a quick walk through the woods to de Kooning's unfinished studio. Each day, de Kooning could easily check what the workmen were doing. It was in the Ferren house on Springs-Fireplace Road that his life resumed some normalcy after the months of wandering. The house itself was a brown-shingled cottage typical of the area. Especially in the winter months, it seemed closed-in and dark, but it had an adjacent studio, and, for the first time since leaving the garage at Joan's, de Kooning began to work again. Susan moved a cot into the studio and began making small, mixed-medium constructions. De Kooning struggled with a picture called *Two Standing Women*, which he obsessively redrew and repainted throughout

the rest of 1963 and into 1964. Like *Clam Diggers* but slightly larger, it also depicted two watery nudes with wavily outlined bodies and an air of sexual suggestiveness.

For Ward, of course, de Kooning's behavior was almost unbearable. His affair with Ruth Kligman had been difficult enough. It was finally finished. And now? This kid next door? Ward was particularly upset by the affair's effect on Lisa, who was now seven. Lisa would sometimes look for her father at the neighboring house and did not understand why he was not at home. Tormented by what she called de Kooning's "oblique soul," Ward was also exhausted by the constant tension and ambiguity.

> I wouldn't say he was madly in love with me but I think he did trust me beyond any of the others. He once said, "You're so honest." Then again another time he said, "You're so devious." I said, "Hey, the master is calling me devious? That's quite an accolade." The trouble with Bill was that it was ingrained. It was like playing with a cat. You're faster but in the long run the cat will always get you because of its nature. It was second nature for Bill. In the end he was always a little more devious. Just when you didn't expect it. Finally your guard would have to go down and then wham!

Ward's position was difficult. The art world often slighted her, taking no particular interest in the mother of de Kooning's child. And de Kooning often spoke dismissively of her to friends. Ward believed she should probably have stayed in San Francisco. But she could never, finally, turn away. And so, over the years, she became the woman forever waiting at the door. She bitterly resented every new girlfriend; she reminded him of his duties as a father; she monitored his coming and going; she nursed him when he was ill; and she hoped against hope that he would finally settle down with her. She played the part until the end. Around New Year's Day of 1964, Joan and Lisa moved back to the apartment on Third Avenue in New York City. Except for occasional visits to the country, they remained there for the next several years, maintaining only distant contact with de Kooning, which, in turn, filled him with remorse.

Brockman soon became aware that, in the art world, de Kooning's reputation was declining and that he felt increasingly isolated. "When we first got together, in a sense Bill was not painting," said Brockman. "And Bill was not in the public eye. Pop art was just coming in. He was sort of being forgotten. And he was a little bit bitter. He would say, 'I don't know

why they have to knock one thing for the other.' Nobody was coming around and he was quite in disfavor." He felt, said Brockman, that he had been symbolically raped by Rauschenberg when the younger artist erased his drawing. "He didn't take pop art very seriously. He said pop art had no innocence. He used to call Andy Warhol 'Andy Asshole.' He later came to respect him, but he was not a fan of his at that moment." Just how deep de Kooning's feelings ran emerged in a taped roundtable discussion between de Kooning, Tom Hess, and Rosenberg in the early sixties. At first, the two critics and the artist discussed his early years in America. Soon, however, de Kooning, clearly fueled by alcohol, began a virulent tirade against the vagaries of the art world and its constant search for the new and the novel. In Europe, he said, masters were allowed to rest on their laurels. Here in America, they were forced to prove themselves again and again and again.

Brockman also became aware that de Kooning was "financially in debt." There would be no going back to the high life of New York. That winter, he and Brockman cleaned out the rest of de Kooning's possessions from 831 Broadway, since he could not afford to keep the studio in New York and build a new one on Long Island. For long stretches of time during his first winter with Susan, de Kooning was drinking. But he was not as badly off as he had been in the city. On Long Island, he never woke up in the gutter, and the pattern of his drinking began to change. Now, he no longer drank every day from morning to night, with brief periods of drying out. Instead, he sometimes went for several months between binges. Once a binge began, however, it could continue for as long as a month or more, with an endless round of drinking and talking that exhausted everyone but de Kooning himself. He could be quite funny and affectionate while on a binge. "He was very lucid up to a point," she said. "Just when every-one else was kind of worn down he would be coming up with these asso-ciations. He would come out with things like about Harpo Marx and Chico Marx and then Karl Marx. You'd be exhausted from his kind of bril-liance and luminosity and trying to follow his brilliance or get out of the room."

Under the manic talk, of course, lay melancholy and despair. "He had big, big swings in those alcoholic binges," said Brockman. "It would go between elation and depression. He was really a miserable man. He was not feeling good. He was complaining." Sometimes he would sleep around the clock. At other times, he would start drinking at dawn and go for the whole day, downing huge amounts of Scotch and vodka and Gallo wine. If Brockman took away the liquor, he would simply find more. "He'd be sneaky," says Brockman. "He'd take a whiskey flask and put it in his pocket and go out on his bicycle. He'd go to some unknown Bonacker

house and drink with them and be out on the road. That was terrifying. Or he'd get a ride into town and come back worse." Eventually, Brockman would simply have to end it one way or another. A honey cure she found in an old Vermont home remedy book sometimes worked. A mixture of apple cider, vinegar, and honey, it made someone drinking alcohol nauseous. "While it didn't thoroughly eliminate it," she said, "it was certainly a moderator." Often, stronger intervention was required. Brockman would call Dr. Kenneth Wright at Southampton Hospital, who specialized in alcoholism. "He was quite involved with Bill psychically," said Brockman. Then she would drive de Kooning to the hospital. By that point, de Kooning seemed to sense how dangerously near he was to serious injury or death and would offer no resistance.

Once released from the hospital, de Kooning typically stopped drinking for a period. He could even drink socially without precipitating a binge. "We'd go to people's houses and there would be wine and there was no problem," said Brockman. "He'd have a glass or two or not." But then something would happen to create stress—a visit from someone whom he did not want to see or "something pending that he didn't know how to say no to"—and he would be off again. Drinking then became a relief, a way to release hostility, especially against those who did not understand what it meant to be a serious artist. Once, de Kooning, Brockman, and the Lassaws went together to a birthday party. Another guest, a woman, said that she did not especially like the work of Jacques Lipchitz. "Who the fuck are you?" erupted de Kooning, with an anger that stunned the room. "And what the fuck do you know about the work of Lipchitz?" Then he took his hand and chopped it down on the birthday cake. Icing flew everywhere— on the walls, on the guests, and on the horrified woman. Hangers-on who did not know what it meant to struggle day after day with art particularly enraged de Kooning. During this period, according to Saul Steinberg, "Bill was angry. No question. He was angry against society, the anger of the artist or poet. He would go through extreme violence, hurting people. He was a real avenger. Art lovers would offend him. He knew that they didn't understand a damn thing. It was like shooting fish in a barrel. That was real glory for him after so many years of neglect."

At home, de Kooning also sometimes erupted into anger. He never struck the gentle Brockman, but he would throw around furniture, magazines, crockery. "It was very upsetting," said Rae Ferren. "Because our then caretaker told us that he [de Kooning] wouldn't let him into the house to do things that were necessary to do. And we got very worried that he was going to wreck the place." Eventually, said Brockman, John

Ferren "very politely asked us to leave." The couple then moved to a tiny cottage next door that was owned by an elderly couple. That arrangement ended after only a month or so. "He ruined the place," said Rae Ferren. "Throwing up all over things. It was a real disaster." Not surprisingly, de Kooning did little painting that winter. Brockman said he just worked and reworked *Two Standing Women.* "Not that much was cooking for him at that point," she said. "No one quite knew what to make of it [his new nudes] or where he was at. Because he was in a major transition, as was the art scene. They were absolutely ignoring Bill. My deepest thoughts—I never said this to Bill—were that this could have been the end of his painting." Her fears were to the point. Why would a rational observer believe that this sixty-year-old drunk would rally?

Adding to de Kooning's anxiety was his unfinished studio. The studio had always been his touchstone. Without one, he was essentially homeless. By the fall of 1963, it was evident that the building, which was slowly rising on a patch of land covered with scrub oaks and small pines, would cost more, and take longer to complete, than de Kooning anticipated. According to Susan Brockman, he was chronically broke because every dollar went into the building. The chief carpenters, who had been hired by the contractor, Ed Mobley, were a pair of brothers from Sag Harbor named Al and James Weatherall. They required regular paychecks. The Weatheralls, in turn, were assisted by a number of others, including Hans Hokanson, a young artist and immigrant who had known de Kooning distantly in New York, and various local welders and handymen, all of whom expected to be paid. And there were always new materials to buy. After initially trying to keep costs down, de Kooning reversed himself and, according to Al Weatherall, wanted "the best of everything." Even though de Kooning did not cook, for example, he fitted out the kitchen with a professional Garland stove and a gleaming restaurant sink, purchased on the Bowery. Big stainless steel hooks were attached to the ceiling to hold rows of large pots and pans. He designed the space, de Kooning said, for "marvelous dinner parties," although he almost never threw a party once the studio was complete. The baseboard had a beautifully curved, made-to-order top installed by a special woodworker. The cabinetry was impeccable.

The essential scheme was never in doubt. "I designed it like a loft," de Kooning said. "I guess I was one of the first painters in New York to have a loft, back in 1930. Now I [wanted] this feeling of great, open space. The whole thing [was] really a workman's dream." The painting area was to be a soaring, two-story space that tilted up to the left off a rectangular floor plan, turning the building into something like a rhomboid; the two side

walls would be glass, letting in the dazzling light of Long Island. The studio would be separated from the two-story living quarters by a supporting wall. The first floor of the living area would contain a large kitchen that flowed into a sitting room; on the floor above this would be five bedrooms. Generous in scale, the light-filled studio would have rising romantic lines, yet be as businesslike as a factory.

During the work on the studio, de Kooning constantly dickered with the details. "The original plan showed the shape of the building," said Al Weatherall. "But as we proceeded everything more or less got changed. When we got it up he didn't like it, so you'd tear it down and put it up again in a different shape or size, which he might or might not like." In the five years that it took to finish the studio, de Kooning's quixotic approach became a running joke. De Kooning, everybody observed, treated his studio like a painting. One day a painting might look fine. But the next day he would want to move something over an inch or two. That, in turn, would change the composition of the whole painting, requiring further changes. Now, that process was played out on the much larger canvas of his studio. De Kooning could not finally design a building in the abstract. He had to see, in person, its evolving space, color, and light. Only then could he judge whether or not the building felt right to him—and had, as he once described his expectation for a completed painting, "a countenance." Any house de Kooning built for himself would obviously require a complicated countenance, moreover, one that reflected the many and often contradictory moods of a tense sensibility. It would have to be uplifting but not corny, practical but not pedestrian. It must be sturdy and free, the home of an imagination that did not want to be compressed, ordered about, or constrained. Walls would matter little in this studio-home.

In the fall of 1963 and the winter months of 1964, de Kooning routinely visited the studio on most mornings to discuss the day's work. "If he was in East Hampton, he'd come and give us any of his ideas that he wanted to change at that particular time," said Al Weatherall who, with his brother James, took over the running of the project after de Kooning and Ed Mobley had a falling-out and Mobley departed for another job in Bogota, Columbia. "And we knew, with Bill, that when he told us what he wanted that that wasn't necessarily what we'd wind up with." The workmen did not mind, however, because de Kooning was so easygoing. "At first, we thought he was one of those *characters* from New York," said Weatherall. "But he was just a likable guy, that's all. Very down to earth. Very charitable." Among the many examples of changes midstream, said Al Weatherall, was a double staircase, a central feature of the building. De

Kooning first wanted one set of metal stairs to sweep down into the studio from the upstairs living quarters, while a second would descend into the living area at the other end of the house. Accordingly, the Weatherall brothers laid out the stairs to scale in brown paper in the studio. Then de Kooning began to fiddle with their direction and angle. By the end, he had changed the stairs dramatically. Another time, said Hokanson, de Kooning objected to the wall separating his studio from the living area. "It didn't give the right idea of space," said Hokanson "and he wanted space." At great expense the workers replaced it with one that had larger glass panels across the top where the wall met the second floor of bedrooms above, an updated version of transom windows. De Kooning gave the discarded windows to the husband of the art dealer Grace Borgenicht for his studio.

In his work space, toward the far wall, de Kooning ordered an elaborate trapdoor built so that, as he worked on a painting, he could raise it up or down. "Bill was obsessed with the trapdoor that Rubens had in his studio," said Gus Falk, who had studied with de Kooning at Black Mountain. "And he put something like that into his own studio when he came to build it. He loved that studio craft stuff." For those occasions when he wanted to paint at night or when it was cloudy, de Kooning mounted big, adjustable klieg-like lights on movable platforms next to his windows. He also devised a thin metal arm, lined with lightbulbs, that he could attach to the canvas for painting at night. According to de Kooning,

> The floor was a problem. I wanted it all in white, but it couldn't be so sharp that all the light would be reflected from it. I thought it over at length and finally got hold of a photo of a chapel in the south of France [being] painted by Matisse. What struck me most was that the floor was covered with old newspapers. Later on I heard from some people who live in the south of France and knew Matisse personally that he always put newspapers on the floor while he was painting—not to keep the floor clean but to regulate the reflection of the light.

Accordingly, de Kooning found a terrazzo tile that was almost the same shade of newspaper white. He also put much effort into the basement. He deeply respected the engine rooms of the world—they were part of the belly of life—and designed a large workshop below his studio where he could store materials and where his paintings could be stretched and framed. The basement also contained his particular pride and joy, two enormous boilers. (As a stowaway, he had spent much of his time in the engine room of the ship.) The poor boy from Holland never forgot what it

was to be cold, and he loved the rumbling sound of heat being made. Later, he would also install a sauna in the basement.

One particularly difficult problem was the fireplace in the first-floor living quarters. A local mason built a careful, symmetrical one. Then de Kooning spotted a crooked, half-falling-down fireplace in the Sag Harbor house of John McMahon, a young artist who had floated on the edge of de Kooning's world in the late 1950s, along with a number of other young painters, and whom de Kooning would soon hire as a full-time assistant. De Kooning insisted that was what he wanted too, a fireplace with personality. The proud mason answered that he would never build such a monstrosity. In the end, said Al Weatherall, "the mason finally smeared it all over rough smooth, like stucco. . . . It looked like the rear end of a pig. The fire box was in between the two legs, as it were." De Kooning's desire for a fireplace with "personality" suggested that he recognized something odd about his studio. It had no domestic center, no traditional feeling of home. Its heart was not the hearth, but the working space. The bedrooms upstairs appeared pleasantly impersonal, like the cabins on an ocean liner. (Eventually, de Kooning would design walk-in closets, blocky headboards, and sturdy mirrors, all of which could survive the onset of heavy seas.) The two front bedrooms were particularly exposed and seemed almost public, each having an all-glass wall that overlooked the studio, so that even sleep remained open, transparently so, to the working dreams of art. De Kooning's friends regularly visited the strange and ever-changing building. They recognized that what de Kooning was erecting in the woods of Springs was sui generis. According to Jane Freilicher and her husband, Joe Hazan, "He said, 'You know, I don't have a cozy room in this place.' . . . He made this kind of industrial space that was so big that there was no place that seemed warm or comfortable. Everything was on a scale for an army." But de Kooning, while he sometimes pined for a cozy room or fireplace, was also delighted to be free of the domestic. Once, when his friend Saul Steinberg visited the construction site, Steinberg immediately and instinctively began a series of imaginative improvisations about what this place must actually be. No, he said, this was not a home, no, this was not an industrial space, no, this was not a studio. This was actually a very large airport in an undeveloped country where no planes had yet landed. Everyone was standing around waiting for a plane to arrive. Steinberg did not say so, but it was understood that he meant de Kooning himself was waiting for his next plane to arrive.

By the fall of 1963, the framing was essentially done and the building enclosed. De Kooning decided to throw a party for the crew to mark the occasion. He took the Weatherall brothers and the other workers to Chez

Labbat, the fanciest restaurant on the Springs side of the railroad tracks in East Hampton. It was a place de Kooning often went. The workers arrived in their funeral suits. According to Al Weatherall:

> We had the front room all to ourselves. There must have been twenty or thirty of us. It was lunch time. We had a few drinks at the bar and then we went into this room to order lunch. So the waiter brought the lunch menu. Bill took one look at it and said, "This is the lunch menu. Bring the dinner one." With that, he threw the menu back at the waiter.

Jean Labbat, the owner of the restaurant, returned with the dinner menu. According to Al Weatherall, "Bill says, 'Now, you order anything you want. And if it comes and you don't like it, throw it on the floor and order something else.' Of course we didn't. But how can you not like this man?" The crew ate a gargantuan lunch, then drank and talked away the afternoon.

> And then it came time for supper. And we all had supper again. A second time. The same dinner menu. It must have cost the man a real fortune. And then, it must have been about seven o'clock that we finally left Chez Labbat and went up to Jungle Pete's [a local bar on Three Mile Harbor Road]. And we hung around there until around 10 o'clock. By that time we were all getting ready to go home. So finally we said to Bill, "It's time to knock this off. We've been partying since twelve o'clock." And he got mad as hell because we were going home. Oh, he was having a ball.

As the studio came together, friends admired its radiant light and expansive scale. "One time this six-foot, four-inch Swedish architect visited me out here and liked the house," de Kooning would tell people who visited the studio. "Later someone asked him what he thought about the place and he said, 'Everything was big except de Kooning.' " Measuring roughly fifty-two feet by fifty-four feet, the studio space seemed even larger because of its thirty-foot-high ceilings.

It was Athos Zacharias, a sometime assistant, who had had the inspired idea of painting the Y-shaped steel struts that held up the ceiling a bright white in order to make them appear weightless. Although the dazzling stretches of glass, the white walls, and the upswept beams reminded Steinberg of an airport or hangar, de Kooning himself always saw a ship come to rest, incongruously, among the scrubby pines of the Springs.

"This house reminds me of a ship," said the artist who loved the water, "its decks, the stairways, the basement—the big, open space below the main level." Along the perimeter, he designed built-in benches for stowing paint boxes and brushes: he loved a shipshape studio. He also constructed a walkway that projected into the studio at a rakish angle from the top of the troublesome stairs, like the flying bridge of a boat. From this vantage point, Captain de Kooning could watch over his command. (In the end, however, he rarely used it.) Sometimes, the studio put him in mind of the ship that brought him to America in 1926. "This is to keep alive my memory of my trip to this country," he told one Dutch interviewer, gesturing to the open stairs with metal railings that also resembled those found on ships. He told still others that the studio reminded him of the Staten Island Ferry, likening it when the mood struck him not to one of the aristocratic clipper ships of high modernism but to a broad-bellied working vessel.

30. Helping Hands

Somebody must bring home the bacon. Right?

I n March 1964, de Kooning, wearing a heavy jacket and a wool watch cap
to ward off the spring chill, moved a few boxes into the studio, and, with
the builders still working around him, began setting up his new work
space. "Goethe said that when you're sixty you start all over again," he
told an interviewer at the time, "and that's what I'm doing." He posi-
tioned his easel next to the trapdoor in the floor; he began laying out his
paints and brushes. Three years after he first began planning the building,
and a year and a half after he first broke ground, he could finally work in
the studio. There was still no possibility, however, of living in the unfin-
ished space. So de Kooning and Susan moved again, this time renting the
house owned by Nicholas Carone and his wife, Adele, for a year. It was on
Three Mile Harbor Road not far from the studio on Woodbine Drive. Like
most of the old houses in the area, it was originally a farmhouse with low
ceilings and small windows. It was dark inside, especially in the winter.
"There was a heavy atmosphere," said Brockman. But it had the great
advantage of being quite close to the studio.

The soaring spaces and beautiful light of the studio probably helped
create in de Kooning a feeling of new beginnings, yet also presented a chal-
lenge. This was not a place for minor ambitions. Its scale seemed to invite,
even demand, the creation of major work. De Kooning himself had antici-
pated the possibility of creating vast paintings. When the Weatherall
brothers built the far wall of the studio out of vertical wood siding, they
left one section unfinished and joined to the other walls with removable
battens "so that this board could be taken off at any time," according to Al
Weatherall, "and if he did a thirty-foot mural, he could pass it out to the
outside." Not surprisingly, de Kooning accomplished little at first. During
his life, he had found beginnings almost as difficult as endings, often start-
ing with an idea from an earlier drawing or picture. But there was not yet
much work around. And so many questions still hung upon his brush.
How was he to begin? What could he accomplish at his age? Where would
money come from? Perhaps because he disliked being alone with such
thoughts, de Kooning welcomed the bustle of the workmen in the studio.
"I am of course looking forward to it to be eventually by myself," he wrote

in a letter, "but it was in a way inspiring with all the noice and continuous shatter [*sic*] of the men."

Then a door opened in his art—almost literally. Early that spring, six hollow-core doors were delivered to the studio for installation. De Kooning, the perfectionist, insisted on solid-core. When told that he could not return the hollow ones, he asked the delivery men just to lean them against a wall of the studio. There, they gradually became part of the studio environment. At a certain point, de Kooning recalled, "I kept looking at the shape so I put some paper on them and painted that size. . . . I liked the shape." From there, it was only a step further to paint the doors themselves, especially since the restless, claustrophobic de Kooning had always been attracted to doors and windows. It seemed appropriate, as he opened his working life in the studio, to paint an actual door. He even imagined joining three together in a large triptych.

Surprisingly, what emerged on the first door differed markedly from the playful pastoral depicted in *Clam Diggers*. Although this new figure was painted with a similarly loose and fluid stroke—she could also be a reflection—the water around her appeared to churn furiously, tugging apart her body. Only her carnivorous teeth appeared fixed in place. In contrast to the earlier painting, moreover, *Woman, Sag Harbor* was large—door size, at eighty inches high—and painted in bold shades of red and bright pink. The figure aggressively flaunted her sexuality. Her legs splayed open. Her vaginal gash, outlined in slashing strokes of bloodied brown, resembled a wound. Her flaming red hair flowed down her shoulders, and her big blocky teeth glinted. De Kooning gave her what appeared to be empty sockets for eyes and a kind of animal snout for a nose. Beneath her feet, which resembled cloven hooves, was a mass of earthy colors. She was a watery Colossus, her genitals at the viewer's eye level.

The sharp turn in feeling in de Kooning's art was unexpected, and it signaled that his move to the country would not necessarily tame the furies and lead to calmer, more gentle pictures. *Woman, Sag Harbor* marked a resurgence of the scabrous grotesquerie and manic laughter of *Woman I* of 1950–52, which also offended taste, upended expectations, and announced to the world that de Kooning would not become a painter of tasteful, irreproachable abstractions. It would be a mistake to connect the disturbing *Woman, Sag Harbor* too closely to Brockman, for de Kooning rarely transcribed his experience in such a literal way. The lean figure in much of his figurative imagery of the time echoed Brockman's physical likeness, but the turbulence in *Woman, Sag Harbor* did not describe their peaceful relationship. De Kooning, in making a painting, rarely ended where he began. He might start with a visual cue from the outside world,

but would then draw upon numerous impulses, feelings, and memories as he struggled with the forms. The unexpected move from idyll to idol probably reflected his refusal, as in *Woman I*, to propitiate the world and its expectations. The country did not transform his life; his alcoholism continued; his family and the larger world exasperated him, demanding what he could not give. During the same period that de Kooning painted *Woman, Sag Harbor*, he also depicted the male figure in a pose of melancholy and suffering. It was in 1964 that he first began, occasionally, to make powerful drawings of a crucified man. He also completed a small oil, *Reclining Man*, which recalled the wan men of the thirties. The face was fully realized but the body seemed to be coming apart. The man lay passively on the ground, as if he were slowly decomposing into the earth.

A series of gentler images, also painted on doors, followed the shocking *Woman, Sag Harbor*. Two came from "oil transfers." With newspaper, de Kooning "lifted" the image off the working surface of the original painting. Then he placed the newspaper against another surface and gently rubbed it, leaving the outlines of the oil smeared into interesting new

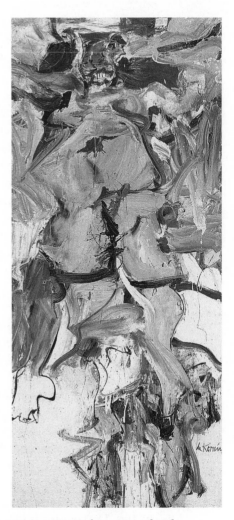

Woman, Sag Harbor, *1964, oil and charcoal on wood, 80″ × 36″*

patterns. The result was work that differed significantly from the original but still retained a family resemblance. *Two Women*, lifted from an early version of *Woman, Sag Harbor*, shared the same dark, red-splattered palette and the blurred, faceless features. But the body language was different. The two women stood one behind the other, with the woman in the rear looking over the other's shoulder. Both had perceptible smiles on their faces. As de Kooning said at the time about his paintings of paired women, they were "very cozy together, not very avant-garde for me."

Increasingly, the *Women* in the series melted into the landscape. De Kooning could not long confine himself to the figure when such extraordi-

nary things were happening to the land, water, and light around him. He did not have a painting table yet in the new studio, but he set up bowls on the floor to mix up his paints. He tried to make a palette of the elements.

> When I came [to the Springs] I made the color of sand. . . . As if I picked up sand and mixed it. And the grey-green grass, and the beach grass. . . . When the light hits the ocean there is kind of a grey light on the water. . . . I had three pots of different lights. . . . Indescribable tones, almost. I started working with them and insisted that they would give me the kind of light I wanted. One was lighting up the grass. That became that kind of green. One was lighting up the water. That became that grey. Then I got a few more colors, because someone might be there, or a rowboat, or something happening. I did very well with that. I got into painting the atmosphere I wanted to be in. It was like the reflection of light. I reflected upon the reflections on the water, like the fishermen do.

De Kooning also began to develop a new medium to increase the visceral sensation of touch in his paintings. Beginning with the work of the mid-sixties, he created thick, succulent swirls of paint that sometimes appeared almost geologically encrusted upon the canvas. Increasingly, over the years, the paint would take on a vitality of its own, as if it were the essential clay of life. This new, more physical quality was the result of de Kooning's novel use of safflower oil, water, and benzine with the pigment. At the time he began using the medium, de Kooning was seeking a richer, more lush look, which he referred to as a "blubbery" quality. Before leaving the city, he had gone for advice to his old friend Leonard Bocour, of Bocour Paints, who had been making his own oil paint since the thirties. De Kooning told him he wanted a paint that was rich and very slow to dry, so he could run wet color into wet color and build up the physicality of his surfaces. Bocour suggested that de Kooning try slow-drying safflower oil, instead of the usual linseed oil, and sent him to the local grocery store to buy some. Not only did de Kooning switch to safflower oil, he also made up the mixture using benzine. When Mary Abbott told him the fumes were unhealthy, however, he substituted kerosene. Since the mixture separated, he had to emulsify it by whipping it up like salad dressing each time he wanted to use a particular color. De Kooning sometimes resembled a busy chef in his kitchen. "He'd use teacups and mix the colors himself," said a studio assistant of the time. "You emulsify it and shake it up. He would maybe have thirty or forty different things on his central palette table." In many of his later pictures, the juicy brush-

strokes would trail off into bubbly, foamy ridges. Here, the oil and water had separated in the drying process, leaving behind small bubbles. It was a further, textural effect that de Kooning welcomed—"a funny texture," said Mary Abbott, "kind of like the top of a pudding."

At work in a studio he could now call his own, de Kooning's life began to settle down. Brockman was not a fighter, but a soothing, stabilizing presence. They rarely quarreled. Throughout the spring and summer and well into the fall of 1964, their life appeared unusually serene, particularly when compared to the haphazard wanderings of the previous nine months. Brockman helped de Kooning develop a routine between home and studio. "It was essentially a low-key atmosphere," she said, "with lovely drives, lovely walks. We had a lot of very peaceful times together. Which was not that typical for Bill. I remember once with Conrad [Marca-Relli] I was baking a ham and Conrad said, 'Well, Bill's finally got a home.' I mean, I think it was a major transition for Bill to be a more peaceful person in a way, even though he had his bouts of drinking." As de Kooning himself described the relationship in a letter of the time, "I love my little 'doll' and am 'contended'—something I didn't know much about before." Each morning after breakfast, he would get on his bicycle at the Carone house and pedal to the studio. He would work there until midday, when Susan would pick him up and the two would eat lunch at a diner on Montauk Highway in East Hampton. "Bill never took days off," said Brockman. "I asked him once why he didn't take days off and he said, 'What would I do? Go over and talk with Ernestine [Lassaw]?' He just sort of worked around the clock, although on a very orderly, organized schedule. Like a businessman's day." The only break de Kooning allowed himself—especially when work was going poorly—was a long bicycle ride. De Kooning loved his Raleigh bike. Much of his experience of the Springs, and a great part of the joy he experienced in his later years, came from bicycling through the countryside. Nothing dramatic happened on these excursions, but they were probably as important to him as any lover and, certainly, more important than the binges. The bicycling became almost a form of meditation for de Kooning, a way to refocus himself upon what was important. Three miles from his studio was Louse Point, the spit of land jutting into Gardiner's Bay that he particularly loved for its flat and watery Dutchness and ever-shifting atmosphere.

Nights were usually quiet. Often the couple stayed at home. Sometimes de Kooning would draw free-form figures with charcoal. He also loved watching television, especially Les Crane, one of the early television talk-show hosts. According to Brockman, "It was sort of a big thing to have a talk show on TV at night in the wintertime, January and February,

when it was dark at 4:20, 4:30. You'd finish dinner by six and a country gloom would set in slightly. And there were no movies like now." Several nights a week, de Kooning and Brockman would go out to dinner. Usually they saw old friends of de Kooning's who were also in the Springs, among them the sculptor Wilfrid Zogbaum and his wife, Marta. It was "Zog," as he was known, who drove de Kooning back and forth to the Springs in the early sixties before his move to the country. Ernestine and Ibram Lassaw were frequent companions, as were Conrad and Anita Marca-Relli, who spent long periods on Long Island when not in Rome. "Many of Bill's friends visited us in this period and I know reported back to Joan that we were okay," said Brockman.

As peaceful as de Kooning's daily life was, worries over money and being forgotten continued to nag at him. But three separate events in 1964 helped ease his mind about his new life in the Springs. The first sign that he was not forgotten came from a phone call in August, while his cousin Henk Hofman's wife was staying with the couple for a week on a visit from Holland. The phone often did not ring for days; even then, de Kooning usually did not pick it up. Knowing this, Mrs. Hofman answered. On the other end was an operator at the White House. "I said, 'Willem de Kooning never comes to the phone,'" said Mrs. Hofman. "'Maybe in this case he will,' replied the operator, 'because he is getting the Medal of Freedom. . . . This is the *White House* calling.'" At the best of times, being singled out for recognition unsettled de Kooning. "I have no need to be celebrated, to shake hands with a lot of people," he said. "In the end, it's just your friends and your work that count." In fact, de Kooning still sometimes felt like an impostor attempting to "pass" in American society. He had not even become a citizen until March 1962, when he traveled to Canada and reentered the country "legally," thus making it possible to apply for citizenship. "You know, Bill was very proper and never took any chances with bureaucracy," said Brockman. "He was really on his best behavior around telephone operators and bureaucrats." According to Saul Steinberg—a fellow immigrant and brilliant taxonomist of American society—de Kooning, apart from his genius, was otherwise a classic American type: the little-schooled, slightly guarded European immigrant from the turn of the century. De Kooning once complained to Brockman that he could never be just another American guy, sauntering down Second Avenue with an easy gait and saying, "Hey, Mac, what's the time?"

De Kooning eventually returned the call. He was tense and tentative, Brockman said, and painfully polite on the phone, almost like a schoolboy with cap in hand. On September 14, he went to the White House, in a formal blue suit bought especially for the occasion, to accept the Medal of

Freedom. Ernestine Lassaw, who, with Ibram and Susan Brockman, flew down to Washington with de Kooning from Islip, Long Island, said that the two couples stayed in the Shoreham Hotel directly across the park from the White House. In the late morning, when it was time to leave for the ceremony, they simply walked across the park and presented themselves at the White House gate. This seemed natural to de Kooning, but it startled the White House guard. "We were the only ones walking," said Ernestine Lassaw. "All the others had limousines, and we had to walk up the driveway with all these limos going by. The guard was very amused." Once inside, they were led into the ornate, gilt-edged East Room for the ceremony. President Johnson read the citation of each honoree, who was then presented with a medal. Afterward, the group lined up in a small reception room to shake the president's hand. "You go ahead," said John L. Lewis, the retired president of the United Mine Workers, stepping back to let de Kooning precede him. "No," responded de Kooning with a flash of humor born of the thirties. "We look to you for that."

As proud as de Kooning was of his Medal of Freedom—he kept it close at hand to show visitors to the studio—it also delivered a sting. Usually, the medal was given to those past their prime, and it seemed to consign a recipient to history. De Kooning's last successful show had been five years ago. But then that fall, he was further singled out for attention; and this time it was for his ongoing work in the Springs. The recognition came in the form of a profile in *Vogue* that September by Rosenberg. The piece was not aimed at the serious art world, but it showed de Kooning to great advantage in his new studio, looking healthy and very masculine in a heavy wool watch cap and thick workshirt. The article lent both interest and glamour to de Kooning's recent series of women, which Rosenberg dubbed "today's cuties." For the first time, in short, a respected critic looked at de Kooning's new Long Island paintings and provided a context in which they could be considered. These new *Women*, the article implied, were nothing if not contemporary: they were the sexually liberated "girls" of the sixties. According to Brockman, the article helped de Kooning feel less like an old master and more like a vibrant young artist. It "kind of turned things around for Bill. All of a sudden people remembered. It got Bill back in the press from what seemed like obscurity and debt."

A third form of recognition would ultimately make the most difference to de Kooning, whose financial situation was growing dire. It was provided by the collector, and immigrant, Joseph Hirshhorn. Among the modern Medicis, Hirshhorn was arguably the most vulgar, crass, and

cocksure. However, during four decades of acquiring more than seven thousand "items," as he preferred to call his works of art, Hirshhorn also proved to be a rare and admirable collector in one critical respect: he was his own man. What Hirshhorn liked, he liked. What he did not like didn't get a second glance. And he didn't care who thought otherwise. Born in Latvia, the twelfth of thirteen children of a poor Jewish merchant, Hirshhorn emigrated to the United States when he was six. His father had died when he was an infant. His mother, facing poverty and anti-Semitism at home, then emigrated to America and worked in a sweatshop in Brooklyn making ladies' purses while slowly putting aside money to send for her children. Hirshhorn grew up in the Jewish slums of Williamsburg, retaining for the rest of his life the Brooklyn accent he acquired there and the memories of a poverty so abject that once, when his mother was hospitalized after a fire in their tenement, her children had nothing to eat. "I've known what it is to survive on garbage—*real* garbage—watermelon rinds out of trashcans," Hirshhorn said. He told an interviewer, "I never had one toy. No kiddin'."

In a Horatio Alger story of success, Hirshhorn—five feet, four inches of relentless energy—made it by the age of seventeen to New York's Curb Market, the predecessor of the American Stock Exchange. By 1929, he had amassed a fortune of four million dollars, selling out with his usual combination of smarts, instinct, and exceptional luck several weeks before the Crash. Success followed success in his subsequent Canadian mining adventures, culminating in the early fifties with his biggest gamble and greatest success, the mining of uranium in the Algoma Basin on 56,000 acres that his employees covertly tested and secretly staked claims to under the noses of other prospectors. Eventually, he sold his mining interests for $48.5 million, an enormous fortune in the seventies.

Unlike those who bought art to polish their money, Hirshhorn was a true believer who began to collect early in his life. From the beginning, he also equated the buying of art with the art of the deal. He liked to buy in bulk, pay on the spot, and get hugely discounted prices as part of the package. From 1939 to 1946, he ran a collectors club of six or seven businessmen who would have lunch on Saturdays and then visit artists in their downtown studios. At the time, few New York artists showed in galleries, and the deals that Hirshhorn wangled seem astounding in retrospect. In 1940, for example, he bought forty paintings from Milton Avery for $300 each. He went to Gorky's studio at Union Square and bought twenty-two paintings for $200 each. He was also the first to collect the sculptor David Smith. The deals were good because few others were willing to take a chance on American artists. "Those artists were in bad shape," Hirshhorn

said. "They were all starving. You know, times were very bad. As a matter of fact, about fifteen years ago I tore up, I think, either $88,000 or $92,000 in notes that they owed me. I knew I wouldn't be able to collect anyway so I wrote the whole works off." At the time, Gorky, with his usual secrecy, did not introduce Hirshhorn to de Kooning. Hirshhorn himself recalled meeting de Kooning only in 1947 and was not then especially taken with his work. By 1964, however, Hirshhorn did not just like de Kooning's art, he revered it. And when Hirshhorn admired something, he went after it with gusto.

Sometime in 1962, Hirshhorn invited de Kooning to dinner at his mansion in Greenwich, Connecticut, a baronial pile set on twenty-four acres that was studded with his trophies. The two men immediately liked each other. Both came from poor and unsettled backgrounds, both were earthy and self-made, and both were grateful to America for giving them a chance. Throughout his life, the working-class de Kooning respected the enormously rich, but always preferred money that was a little brassy. (He especially enjoyed the pop image of gangsters who waved around big bills.) After their dinner in Greenwich, Hirshhorn told an interviewer, "I think de Kooning is the greatest painter alive today in America." He routinely paired de Kooning with Picasso, whom he had also befriended late in life.

By 1964, Hirshhorn was well aware that de Kooning was falling out of favor in the art world. He also knew that, as with the other abstract expressionists, de Kooning's relations with Janis were deteriorating. He sensed a golden business opportunity, the chance to deal out the middle man and buy directly from a famous artist who needed money in a down cycle. And so Hirshhorn drove to Long Island in the spring of 1964 to visit de Kooning in his new studio. With him was the private art dealer Harold Diamond, who, while ostensibly representing de Kooning during any possible sales, was also closely associated with Hirshhorn. He had helped bring the two men closer together and had been at the Hirshhorns' dinner party for de Kooning in 1962. What happened next is disputed. According to the lawyer Lee Eastman, who began to represent de Kooning formally at mid-decade and whose business acumen was well known, Diamond and Hirshhorn "showed up with $10,000 in cash and booze and a $50 jacket and started to get de Kooning loaded. They cleaned him out. They got art worth $100,000 or more." Abram Lerner, the curator of Hirshhorn's collection, recalled a more benign version of patron and artist. Whatever the precise details, two things were clear. Hirshhorn did indeed buy about a dozen de Kooning paintings and drawings from the financially desperate artist, including important early works such as *Queen of Hearts* and various black-and-white paintings from the forties. And he made it clear that

he wanted an ongoing financial arrangement with de Kooning, in which Hirshhorn would get first pick of new paintings.

By September 1964, when Hirshhorn and his wife, Olga, visited de Kooning's studio again, they came as patrons. This time, Hirshhorn departed with thirteen works by de Kooning, including *Woman, Sag Harbor.* Buying on this scale was certain to attract attention, and word of the relationship—if not the particulars—soon leaked out. That October, *Time* called Hirshhorn to ask about an alleged purchase of $250,000 worth of de Koonings. Although testy when asked to confirm the amount, Hirshhorn conceded that he had bought many de Koonings: eight paintings, seven of them of women, and five drawings. They were, he said, an addition to the dozen or so works by the artist that he already owned. And more were coming. "He's been working on a painting for six months that's already been purchased by me," said Hirshhorn. "I own it." Then he added, "If I ever have a museum, I'm going to have a de Kooning room." For his part, de Kooning was obviously relieved to have a steady buyer. A month or so later, he sent Hirshhorn a list of people to whom he owed money, probably because Hirshhorn had agreed to pay these debts as part of their arrangement. "I feel so much better, and it is so much better for me doing it this way," de Kooning wrote, in a graceful allusion to Hirshhorn's patronage.

Diamond even found a novel way to increase de Kooning's slim output. He urged de Kooning to sell the newspapers and large sheets of vellum that were applied to the canvases to keep them fresh or preserve an image. Often, the floor in front of the easel was littered with dozens of such transfers. De Kooning never thought of them as works of art and would throw away the transferred images once a painting was complete. (An assistant recalled carting hundreds of transfers and drawings to the town dump in the Springs.) Initially, de Kooning did not agree with Diamond's proposal to name the transfers "monoprints" and sell them. However, he began to look at the transfers in a different light, and sometimes reworked them. Or he might move the newspaper slightly on the surface when he applied it, intentionally making a rippling effect in the paint, thereby creating a sort of monoprint. In the end, Diamond had a number mounted on canvas; they were shown in an exhibition in 1965 at the Paul Kantor Gallery in Los Angeles.

Hirshhorn's help may well have saved de Kooning from bankruptcy and the loss of his new studio, for the estimates of what the studio would finally cost kept rising. "The cost of it is enormous," he wrote Hirshhorn, "completely out of proportion. But I thought, if someone would start a restaurant for instance, he would have to lay out a very large sum of money before he ever hoped to make a living. So from that point of view I

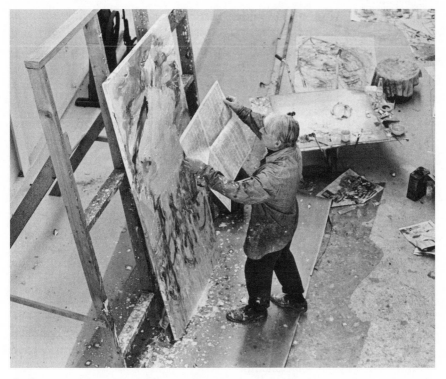

Applying newspaper to a painting, 1964

have build [*sic*] such a [*sic*] expensive studio." Then he added, "I think art is good enough to be made in a especially build place for it. Instead of doing it in some leftover hole in the wall nobody ells' wants any more." Over the coming months, Hirshhorn avidly collected whatever de Kooning produced, with what Abram Lerner once called "inspired greed." According to Lerner, "When [Hirshhorn] visited his studio, he was a happy, excited man, going from painting to painting, thrilled at the prospect of owning some." He would spend a great deal of time looking at each picture individually; then the negotiating process would begin. Diamond would represent de Kooning as the painter chatted with Lerner or his wife or whoever else had come along. According to Lerner, "Business at an end, Hirshhorn would take everyone to lunch and, afterwards, might even visit an artist in the area, usually someone suggested by Bill."

Only very rarely did problems emerge between de Kooning and Hirshhorn, invariably because the horse trader in Hirshhorn pushed too hard for a deal. However, even then, something in de Kooning admired the instinct that made Hirshhorn angle for the last nickel. Again and again, de Koo-

ning would tell with great fondness a story about Hirshhorn going crab-bing in Florida near one of his many homes. After a while, Hirshhorn had caught a bucketful of crabs, and the others in his party were ready to leave. "No, no," protested Joe. "There's more down there where they came from." De Kooning gave Hirshhorn and his wife a number of paintings outright, as gifts. One present to Hirshhorn in 1967 was particularly telling. De Kooning inscribed on the oil and charcoal painting, "Anything you want / anything I can / to Joe / love Bill." It was a truncated figure of a woman, somewhat reminiscent of the dance hall girls of Toulouse-Lautrec. One of her legs was kicked up in sensual abandon. Her hair cas-caded down her back; her heavily outlined eyes shifted seductively to one side. She seemed to offer herself to the viewer, but the viewer must obvi-ously be careful—for she could never quite be possessed. As the inscrip-tion suggests, it was probably a private joke on de Kooning's part about the flirtation between artist and buyer. There could finally be no question about who controlled either de Kooning or his art. Once, after the conclu-sion of business, Hirshhorn asked de Kooning to throw in another draw-ing. De Kooning turned suddenly cold. "Go ahead, Joe, take it," he said. "Just take it." But Hirshhorn knew better. If he had taken the drawing, that would have been okay, de Kooning said, but that would also have been the end of their relationship.

31. Old Demons

I can't get away from the Woman. Wherever I look, I find her.

In 1965, Lee Eastman—another powerful man—began to emerge as a central figure in de Kooning's life. He had first represented de Kooning in 1961, when the Air France engineer sued the painter for knocking out his teeth. He had also drawn up a few contracts when de Kooning began to build his studio. Eastman was eager to help de Kooning and his fellow artists with their financial affairs. At the time, many made their own deals. "They were innocents when it came to money," said John Eastman, Lee's son. The art dealer Sam Kootz, whom Eastman also represented, first introduced him to the art world. "Through Kootz I met Hans Hofmann and through Hofmann Kline and through Kline Bill," said Eastman. "I genuinely loved these artists, and I decided that I would be the guardian of their affairs." In early 1965, observing the disarray in de Kooning's private life, Eastman decided to press him into action.

The murky situation with Joan, Lisa, Elaine, and Susan made little sense to the hands-on lawyer. All the parties, he believed, should behave like adults and come to a clear understanding about money, rights, and expectations. In January 1965, Eastman initiated discussions with Joan Ward, telling her of de Kooning's desire to help her and Lisa financially. He also began to talk to de Kooning about clarifying his relationships with Elaine and Susan. There was no immediate need, however, to resolve these personal situations. The same was not true of de Kooning's unsettled relationship with Sidney Janis. Eastman believed that neither Janis nor Bernard Reis—the accountant for many Tenth Street artists, including de Kooning—was properly advancing the artist's interests. More important, de Kooning owed Janis money, and the art dealer was angry that the painter sold work privately. The Hirshhorn situation, Eastman recognized, could provoke Janis to sue de Kooning to recover his property.

Eastman decided to defend de Kooning with a preemptive attack. In February 1965, at his lawyer's bidding, de Kooning formally sundered his relationship with Janis, ending plans for an exhibit scheduled for later that year. Then, on March 30, de Kooning sued Janis in New York State Supreme Court for $150,000 on the grounds that the art dealer had not paid him all the money due him because of selling to insiders at favorable

prices. The suit also demanded the return of all sixty or so unsold works held at the gallery. Janis immediately filed a countersuit for $203,000, claiming through his lawyer that de Kooning "breached an exclusive contract with Mr. Janis by selling $450,000 of his works himself, on which Mr. Janis is entitled to $150,000 in commissions." The lawsuit included a claim of a lien against the paintings at the gallery to secure the damages that Janis alleged de Kooning owed him.

For a tough lawyer like Lee Eastman, suing Janis was just part of a good day's work. For de Kooning, it was a more complex and personal matter. De Kooning shied away from direct confrontations. It was difficult to make a break, even if he wanted to. Just as he had been grateful to Charlie Egan for taking him on in the late forties, so he remembered how thankful he had been to join the Sidney Janis Gallery. Similarly, he considered Bernard Reis, an art-world insider whom he hired as an accountant in 1958, as a friend. In later years, de Kooning would often say he "made an honest man of Sidney," but it was clear that he felt guilty at the time. De Kooning was the only one of Janis's original group of abstract expressionists—which included Rothko, Kline, Guston, Motherwell, and Gottlieb—to remain with the gallery. The others abandoned Janis en masse after the dealer's pioneering show of pop artists in 1962. "Before he left, Bill even wrote a long, rambling letter apologizing for leaving," Eastman said, marveling at de Kooning's sentiment and unworldliness, since the lawsuit was pending at the time of the letter.

As the lawsuit against Janis began, Eastman got an important reminder of what, finally, could and could not be expected of de Kooning. Eastman had earlier established an annual series of lectures at Smith College in memory of his first wife. It mattered a great deal to him personally, and he asked de Kooning, whom he revered, to deliver the third annual lecture. Simultaneously, the college planned to mount a small retrospective of thirty-five significant de Kooning paintings. Conscious of the personal debt he owed to Eastman, de Kooning agreed. "I'm not a lecturer," he told the *New York Times*, "so I'll just hold impromptu talks. I've done it before. Sometimes they come out fine and sometimes they fall flat. Whatever the girls want to discuss we'll talk about—except me." On the day of the lecture in April, Eastman's son John, a young lawyer who had recently joined his father's firm, arrived with his wife, Jodie, to drive de Kooning to Smith. Susan Brockman came out to meet them with the news that de Kooning was on a drunken binge, sodden and uncommunicative. He never made the trip. According to Brockman, de Kooning felt trapped by the personal obligation and escaped in his customary way. Later, he

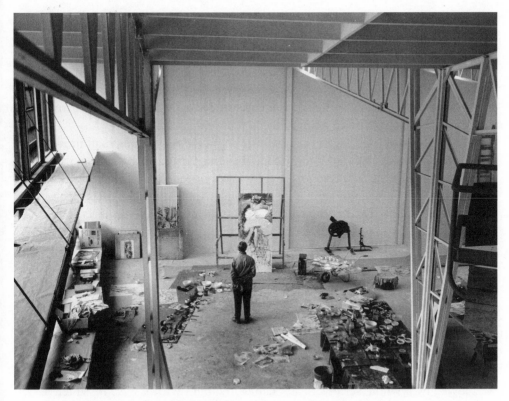

Studying Woman, *a door painting, 1966*

sent John Eastman a remorseful letter on long yellow legal pages. He also wrote an apology to the president of Smith. But he had made his point. He was beholden to no one. If he made a murky wilderness of his life in the Springs, that was his business. As Lee Eastman put it philosophically, "He was a Dutchman. You could only push him so far."

In the new studio, de Kooning's art was going poorly. Throughout the fall of 1964 and into the early winter months of 1965, no large paintings emerged to follow *Woman, Sag Harbor* and its immediate successors. More than once, de Kooning complained to Hirshhorn that he had yet to make any big new paintings. Instead, he restlessly made drawings. Although he had always drawn prolifically, in the middle years of the sixties he produced free-form charcoal drawings by the hundreds, mostly of women. He liked to make the drawings while watching television in the

evening; he would draw with his eyes closed or hold the pad horizontally or turn the figure upside down or use his left hand. The idea was to try to subvert his own facility as a draftsman—and see if he could transcend his knowing hand. "In this way," said de Kooning once, "the drawing comes from something deeper." The approach derived from the old surrealist idea of "automatic writing," and it suggested that de Kooning was searching for new sources of inspiration.

A satirical edge began to surface in his work. As a young man in Rotterdam and Brussels de Kooning had, of course, flirted with being an illustrator, and he had always passionately loved cartoons and caricature. The new works were playful and wry: the women seemed made of hats, boobs, and silly grins. De Kooning loved to smear red—like a smudge of lipstick—across a picture of a cutie. When, finally, the next large painting in his "door" series appeared, she seemed the flip side of her savage sister. *Woman* of 1965 faced the viewer directly, a redhead who could be the slightly blowsy dame met the night before. The scorching red lines of *Woman, Sag Harbor* were teased into the outlines of a fashionable little dress, and the sharp teeth of her predecessor became a toothy smile surrounded by bold red lipstick. Most noticeable of all was her friendly pose—one high-heeled leg crossed nonchalantly over the other, with an outthrust toe seeming to tap the ground invitingly. She would soon be followed by a whole series of zany dames: *Woman with a Hat*, in which a miniskirted figure wore an absurdly wide-brimmed hat, *Singing Woman*, and the comical *Woman—Red Hair, Large Mouth, Large Foot*.

Although de Kooning was working again, his private life still concerned Eastman. In the spring of 1965, as the lawyer pressed him to make decisions about his future, de Kooning became increasingly worried about Susan. What had begun as a bit of unpremeditated, sixties-style adventuring had now evolved into something more permanent; they had now been together for almost two years. De Kooning appeared genuinely troubled about her future, much as a father might be. "He felt that he was interfering with her life," said Mary Abbott. "She was so young, and he was really concerned about her."

In the spring of 1965, their lease on the Carone house ended, forcing them to rent a cottage "that we both hated," said Brockman. They considered living in the still rough and unfinished studio, but Brockman disliked the prospect of being installed there as his official "mistress." Predictably, de Kooning started to drink heavily. By the middle of the summer, Brockman began to think that their relationship could not continue. Just as de Kooning had gone on a bender in order to leave Joan, so, she believed, he was repeating the pattern because he was fretting about his relationship

with her. "We met on a bender," she thought, "and we are ending on a bender."

A visit to the studio by Lisa brought the situation to a head. In the previous few months, de Kooning had been seeing his daughter somewhat more regularly. Joan and Lisa would occasionally spend weekends in the Springs, where Lisa had her pony, and de Kooning sometimes visited Lisa in New York. This time, Lisa spent a day at the studio. After she left, de Kooning came upon one of her dresses lying abandoned on the doorsill. De Kooning, always sentimental about his daughter, was "heartbroken": the empty dress symbolized the absence of the little girl from her father's life and his failure to make a home for her. De Kooning went to Joan's house to return the dress; shortly afterward, he disappeared on a bender. The days went by and still de Kooning did not clarify his relationship with Brockman. She decided she must get on with her life. Much as she might love de Kooning, she could not wait forever for a more serious commitment. In late summer, with a minimum of fuss—she was not a scene maker—she moved back to New York. De Kooning wrote her a check for $500 to cover moving expenses. The relationship, for all intents and purposes, was over. Brockman visited de Kooning in the Springs that winter, and the following year he sent her a Christmas present—a "terrific" coat from Abercrombie and Fitch with a fur lining and enormous pockets—and a wonderfully affectionate letter. "I really felt love coming from him," said Brockman. "And for years after." As difficult as the transition was for her, it was harder for de Kooning. He still adored Susan; now she was gone. "He really did love Susan," said Mary Abbott. "He told me that he cut it off because he didn't want to upset her life. I do believe that. He was being very decent; he wasn't being dramatic."

The prospect of a Long Island winter without Susan was not appealing. Only a tiny group of full-time artists remained in the Springs year-round, and there was not much companionship—or love—to be found. As in the past, de Kooning's first thought when feeling adrift was to reestablish his relationship with Joan and Lisa. After the incident with the dress, Joan allowed him to live in the Accabonac house (she and Lisa were still in the city), but she would have no part of a quick reconciliation. She and Lisa lived in the old apartment on Third Avenue. That autumn and throughout 1966, Joan discussed her situation with a New York estate lawyer named Shad Polier. Her conditions for getting back together with de Kooning included financial and legal commitments from him, which he began to meet. He drafted a will that left most of his money to Lisa. Then he gave paintings to Joan and Lisa. Joan also pressed for a clarification of de Kooning's relationship with Elaine. In the autumn of 1965,

Polier began talking to Elaine's lawyer about a formal separation and property settlement. On five separate occasions, according to Joan, de Kooning began efforts to divorce Elaine.

> He was afraid of divorce—he had a peasant's fear of the law—but that didn't mean that he didn't get the lawyers. But each time Elaine would disappear or he would lose interest. At one point he was so furious. He came back and slammed things around. He said, "She said that her analyst said it would be 'catastrophic' at this time to get a divorce." At that point Bill had given Elaine a whole collection of drawings as a first installment to pay for the divorce. As part of her settlement. Then she was going to get a picture. Things were being worked out. At that point she called a halt.

Over time, Ward believed, it was de Kooning's growing anger toward Elaine more than his devotion to his daughter that underlay the discussions about divorce. He began to feel, Joan said, that Elaine was "holding him up . . . and really wanted to go through with it." The fact remains, however, that de Kooning never did get a divorce. Had he finally wanted one, a lawyer as deft as Eastman could certainly have arranged it. Nor could Joan get de Kooning to make regular child-support payments. Polier discussed it with de Kooning, as he wrote Joan, "but I am not sure I made any impression."

Distracted by the legal sparring, de Kooning spent the nights by himself in the house on Accabonac Road. He would live that way, uncharacteristically alone, for a little more than two years. After a solitary Christmas he went on a long binge early in the new year; it ended in Southampton Hospital, where he saw a psychiatrist named Dr. Wayne Barker in addition to his usual doctor, Dr. Wright, in an effort to wean himself from alcohol. In late January, he traveled to New York for Lisa's tenth birthday party. Then he returned to Long Island. The Springs was no longer new. Susan was gone, as were Joan and Lisa. He was beset by legal and financial problems. New York ignored him. He was having trouble in the new studio. He was getting older. It was winter. At night in the small dark house, he had little company apart from the rumbling of the furnace, turning off and on, and one small black and white TV. The situation was not like New York, where de Kooning could walk down the block any evening of the year and find welcoming friends at the Cedar.

. . .

For company, de Kooning turned increasingly to studio assistants. In the Springs, an important early assistant had been the painter Athos Zacharias, who helped de Kooning establish his initial studio in the garage on Accabonac. "Zack," as he was known, also organized a big party for Joan and de Kooning in the summer of 1962, and he continued to help de Kooning during the years of building. But Zacharias would not work full-time, so de Kooning hired John McMahon. The infusion of money from Hirshhorn enabled de Kooning to formalize the relationship. For the next twelve years, McMahon devoted much of his life to de Kooning. Born in Kentucky and raised in Atlanta, he was part of the generation of artists who followed and often idolized the abstract expressionists during the late fifties. He came north in 1957 to participate in the New York school, and soon afterward met Franz Kline and began going to the Cedar. By the early sixties, he had moved to Sag Harbor, supporting himself by building houses. It was this expertise as a builder that first led de Kooning to him. According to McMahon, de Kooning said, "You know, we seem to get along together." McMahon gave de Kooning a constant feeling of support in the studio.

It was both difficult and exhilarating being de Kooning's assistant. He was friendly, famous, and good company. But he was also disturbingly intense, absorbed, haunted by his work, and almost uncontrollable when drunk. Over time, some close friends and helpers felt it necessary to withdraw from him somewhat. After several years as de Kooning's full-time assistant, McMahon, consumed by the demands of the job, began looking for another artist to help out. According to Michael Wright, the artist whom McMahon found to work alternate days with him, "It was a pretty intense thing to work for somebody like that after awhile. It gets very personal, and also your own identity starts to go. At that time of his life, John was very influenced by Bill, and it was one thing that I didn't want to happen to me. I used to kid John, 'John, stop talking like Bill.' He'd get drunk and he would *be* Bill." Wright, too, came to New York in the fifties. He dated Ruth Kligman casually before her affairs with Jackson Pollock and de Kooning. He also knew Joan Ward. Like John McMahon, he began supporting himself as a carpenter and builder on Long Island and did some work on McMahon's house. It was at that point that McMahon asked him if he wanted to work for de Kooning. "John and him set it up," said Wright. "This was '65. Bill came over one day while I was doing carpentry on John's house and he said, 'I heard all about you. That you're an artist and have three kids and been in the army. That's impressive. Want to work for me? You work for me three days a week and get four days off to do your own work.' "

By the mid-sixties, de Kooning no longer drank daily. According to Wright, he was either sober or bingeing—and the periods of sobriety were often lengthy. "He led a very Spartan life while he was painting," Wright said. "After breakfast, he'd start to work. He'd go for a month or so without drinking. He'd work and suddenly you'd see him start to get a little testy, a little nervous. He knew that it [going on a binge] was probably going to happen again. Accumulated feelings would come up." Once de Kooning began to drink, he could not be stopped. He would go for two to three weeks straight drinking Johnnie Walker Red around the clock. "Everybody drank too much then," said Wright. "East Hampton was that way in the wintertime. It was hard to avoid it."

> He did phenomenal drinking. I was amazed that he could stay alive. He would hardly eat anything. He'd be up all night, wandering around, and you'd try to get some sleep. You do that for three or four days and you need a rest yourself. Bill usually would drink until he was retaining so much water that he was all bloated and could hardly move. His fingers would get so fat from the water. His belly would be out to here. His eyes were little slits. By then John and I would say, "Time to get him to the hospital." Then we'd call an ambulance or we'd take him and he'd dry out for two or three weeks.

De Kooning developed a new band of drinking buddies. It included workmen on the job, young artists whom de Kooning hired for chores, and local residents of the Bonacker community. According to a neighbor, the artist Cile Lord Downs, "Bill had a clear-cut gang. Somebody said he was like a big tree and nothing very much would grow under it. I had the impression of a lot of small-scale people around him. All these guys who were constantly over there. Some of them worked for him. Not just artists, although I guess most of them were in some sense artists." De Kooning's friends became fearful that the workers at the studio were getting de Kooning drunk deliberately so that their jobs would never end. Often, said Zacharias, he, McMahon, and Wright functioned as de Kooning's "twenty-four-hour watch" when a binge began. At Dr. Wright's orders, the three would give de Kooning a tablespoon of paraldehyde every few hours. "It's a very old drug they used in hospitals to keep patients calm," said Wright. "But it seems terrible. You start drinking it and you reek of it." They would also do their best to get de Kooning to eat something. He would talk constantly, often about Wittgenstein. And, of course, he would grow angry. "When Bill was drunk he could be terribly abusive," said Wright. "Booze would release a lot of feeling. . . . He didn't like his

mother very much. He would rant and rave and scream about how much he hated her: 'She's ninety years old. How long is she going to live?' And then he would rant and rave and scream about Elaine, how much he hated her." After hours of that, de Kooning, exhausted, would put Beethoven's Ninth Symphony on the stereo and, said Wright, "cry and moan. I used to go through hours of this with him."

De Kooning developed a reputation as an easy mark. He was known in the community for lending money. He also supported people in New York. "He had all of these I call 'em leeches," said Weatherall. "He called 'em friends. They milked him every time." He continued to see many different women. One consistent lover during this period was Molly Barnes, a woman from California whose father and first husband had been in the movie business. She spent summers on Long Island. After Brockman left, Barnes—slim, blond, and classy-looking—went to the East Hampton post office for ten or so days in a row, invariably at the time when de Kooning and John McMahon would come for mail. Finally, McMahon came up to her and said, "Mr. de Kooning would like to meet you." There followed lunch, fueled by lots of alcohol; then de Kooning took her back to his house, and the two went to bed. "I was obsessed with him," said Barnes. "I would come back here every summer." Occasionally, Barnes would also visit in the winter, fall, or spring. De Kooning loved talking to her about her Hollywood connections. "He always wanted to know about John Wayne and Doris Day. And then if I came up with somebody I'd just met, some movie person, then he'd want to know all about them and then it would trail off into his own interpretations of what they were like as public figures." As happy as de Kooning was to see her, however, he always kept a distance. "I would have loved to get closer to him," said Barnes. "He was my idol. But he was very elusive. . . . I'm sure any woman who got involved with him had the same difficulty because he wasn't there for you all the time."

Suddenly, in July 1966, de Kooning was stunned by the death of the poet Frank O'Hara, his good friend from the Cedar days. O'Hara and a group of travelers, while riding in a communal beach taxi on Fire Island, were stranded at about two o'clock in the morning when one of the oversize tires on their vehicle spun off. Standing somewhat apart from the others, O'Hara was then struck by an oncoming jeep, leaving him battered and with an irreparably damaged liver. Elaine, who was on Long Island and heard the news of O'Hara's accident at a party in East Hampton, hurried to tell de Kooning. It was one of those rare moments during the period when the two communicated, for the accident powerfully evoked their earlier life together. They drove to see O'Hara, who had been taken to

Bayview General Hospital in Mastic Beach. De Kooning arrived with a "business-size" checkbook in hand, offering, according to O'Hara's close friend, Joe LeSueur, "a blank check to the hospital. 'I vant the best for our friend.' " He was one of the few allowed to see O'Hara. "When I spoke his name, he opened his eyes and he said, in that way of his, 'Oh Bill, how nice!' " said de Kooning. "He had so much grace, that man, even through all the delirium and agony." O'Hara died two days after the accident.

De Kooning was not entirely comfortable with the overt homosexuality of O'Hara's crowd—he called effeminate gay men "gigglers"—but he deeply respected O'Hara. "I liked him immediately, he was so bright," de Kooning said. "Right away he was at the center of things, and he did not bulldoze. It was his manner and his way. There was a good-omen feeling about him." O'Hara, for his part, idolized de Kooning and made it clear that he considered him one of the three or four greatest painters of the twentieth century. Recently, the two men had been in touch because O'Hara wanted to organize a retrospective of de Kooning's work at the Museum of Modern Art. At first, de Kooning demurred; he had already turned down one offer of an exhibit from MoMA. But O'Hara had gently persisted, and de Kooning finally relented. O'Hara's funeral on July 28—he was buried in Green River Cemetery, across the street from de Kooning's Accabonac house, where Pollock was also buried—crushed de Kooning's spirits. He had lost both a friend and a champion of his art. "We were very good friends," de Kooning later told a Dutch writer. "He was killed on the beach not long ago. It was terrible. I wasn't able to work for weeks. Everything you do is without meaning. A total void. And of course after a few weeks you start over again. You want to live and keep on seeking for something. And at the end you die. And that's a kind of fiasco."

In much of his art of the period, de Kooning seemed to focus upon the youth-oriented culture around him. He occasionally drew peace signs on the backs of his paintings. He felt an affinity, he said, with "the young kids with their long hair and strong fists"; they reminded him of his own youth. Although he emphasized that he was "not a member of any political party," he also said he was "very involved with American problems" and even signed an antiwar protest, an uncharacteristically political act that ended the invitations extended to him by the White House. (According to Joan Ward, de Kooning later regretted signing the petition, having always retained a fundamental respect for the U.S. government.) On trips into New York, de Kooning frequented Max's Kansas City, the new downtown hot spot and center of the counterculture. At one point, de Kooning

grew his hair longer in a version of a Beatle haircut, and he sometimes talked about the atom bomb and modern technology. "The future lies with chemistry and electronics," he said. "ICI and IBM have a finger in the pie everywhere. Also in my studio." However, he did not seem to think that the future would fundamentally change human nature. When men landed on the moon, he quipped, "We haven't landed on earth yet."

His eye responded to the new ways of dress and behavior. It was in the sixties that women began to wear miniskirts. *Penthouse* and *Playboy* went from depicting women in lacy lingerie to full frontal nudity, while the hard-core *Hustler* began to display wide-open vaginas. On television, "go-go" girls, suspended in cages, gyrated madly to the beat of the music on *American Bandstand*. Many female singers dressed in the latest mod clothes, their long hair streaming down their backs. De Kooning often caricatured the young women of the time and, beginning in 1966, drew and painted a series of these new American girl-icons. In *Women Singing I*, two members of a singing group—one with blond hair that cascades down to her hips—stood before the microphone, crooning with closed eyes. They appeared to wear the tiniest hot pants, and they had, on their faces, a vacant stare. The same sort of figures permeated de Kooning's drawings. In one, *Screaming Girls or Untitled*, two female groupies, like those who mobbed concerts by the Beatles, stood screaming at their idols. The more fully realized figure, wearing over-the-knee boots, wore her hair teased above her head in a towering beehive. The rest of her wore nothing: de Kooning exposed the lips of her vagina.

While sensitive to social change in American society, de Kooning had never before addressed a period in such a literal way. It was possible that his response to the sexual revolution of the sixties was, in part, an uncharacteristic effort to be relevant—or, in the language of the time, "with it"—by a painter dubbed irrelevant by a younger generation of pop artists. The suggestive clothing and come-on behavior of young women were also, perhaps, sexually frustrating to an older man of another generation who worried about aging. De Kooning himself seemed to recognize that these caricatural works were not as energetic or as densely layered with meaning as his earlier, fiercer depictions of women. That may also explain why he had difficulty making bigger images of the cuties—he could not summon the requisite intensity for a larger-scale work.

During this period, de Kooning's loose and watery brushstroke, which seemed joyful in *Clam Diggers* and threatening in *Woman, Sag Harbor*, often became merely slapdash and casual—without concentrated focus. He would occasionally touch upon his great pastoral theme, the merging of the nude into the landscape, but he typically emphasized the difficulty

of that union. In *Running Figure* of 1966, the "figure" was a curving mass of flesh tints set against a background of colorful brushstrokes; only the two legs, awkwardly appended to the figure, suggested "running." Other landscapes looked like comic metaphors for sex. In *Figure in Watermill Landscape*, a pair of bountiful breasts undulated across the canvas, much as rolling hills ripple across the landscape just north of Watermill, a small town not far from the Springs.

As the months passed, however, his art began to intensify. Calling again upon the powerful Flemish strain of flesh and *grotesquerie* in his sensibility—and perhaps frustrated by the smallness of his recent art—he started to push the sexual character of the cutie pictures into more disturbing areas. The comic breasts and vaginal peeks became less satirical; instead, the images grew increasingly vulgar, gloating, wild, manic. They were certainly intensely embarrassing to cultivated taste. Many viewers cringed at the cartoonish women squatting with their vaginas splayed open. (The pictures have remained among de Kooning's least popular.) Unprotected by cool irony or the traditional filters of high art, the imagery represented yet another cathartic eruption. Did the world want a masterpiece from de Kooning? Well, he would give it a master piece of ass. He would make use of sleazy calendars and pornographic images. And yet, it was not just the subject matter or even the vulgarity of the pictures that created unease among viewers. The same person who recoiled from de Kooning's work could easily, for example, enjoy the erotic prints of the aging Picasso or the lewd comedy of certain works of pornography. The unsettling power of the pictures—and their originality—lay in their way of mimicking the sexual act itself. It almost seemed as if the artist were *screwing* the women rather than painting them. The visceral touch of de Kooning's brush could almost be the sexual stroke of a man's hand; the slippery wetness of the paint evoked sweaty arousal; the messy convulsion in the forms and splattering of drops suggested the abandonment of orgasm. No detachment from the object of desire existed in these pictures, no sense of the flesh being offered to the eye from a distance. The more extreme pictures, disturbingly crude and slapdash, brought *cunt* into the living room of art. Once, when the country-store owner Clarence Barnes was looking through a collection of paintings with de Kooning—the artist had promised to give him one—Barnes asked what was happening in a particular picture. De Kooning replied, "Can't you see? Here's a *cunt*. And there's a *penis*. Didn't you know that I'm *cunt* crazy?"

Like all of de Kooning's most difficult work, these pictures were not like anything else found in art, and they conveyed, finally, a kind of poignant pathos. Their physical closeness to the sexual act almost made

them seem a substitute for the real thing, as if the artist were passionately holding on to something being lost. What really seemed naked, and a fit subject for embarrassment, was not the women but the revealed artist— the gloating old man who cops an eager feel and rails at the sexual injustice of aging. At the time, de Kooning was beginning to talk sadly about growing older. "I'm 63 now and I don't have the Don Quixote energy like I used to have in my painting," he said in 1967. "I can't work as much. A certain sadness comes over me when I walk around here; it's so beautiful and I worry about getting on in years—getting on to the other side."

The melancholy shadow behind the outrageous images emerged in a portfolio of twenty-four charcoal drawings from 1966 that Walker and Company published in 1967. All were figurative and made under handicapped conditions—an instance of de Kooning drawing the figures upside down or with his eyes closed—to help him find the rougher, more unexpected truth. Some showed women sitting with crossed legs or leaning back, their thighs spread to reveal the sexual gash. Others were of men, some apparently crucified, with outstretched arms and hanging bodies. De Kooning responded to the Crucifixion in physical, not spiritual, terms. "*Oh*, on that cross," he once said, referring to the nailing. The Walker catalog was remarkable for bringing into the same pages two images not usually likened or compared—the sexually splayed and the crucified.

The Visit

Like many paintings of the period, *The Visit* depicted a woman spread open on her back, like a frog prepared for dissection, except that there was nothing dead, cold, violent, or unhappy in her pose. On the contrary, she appears delighted and ready to receive her lover. She is all bawdy face and waiting body. The title of the picture, there is little doubt, describes a visit that led to sex. The woman's face appears tumid and darkly flushed with desire; her body, by contrast, is surprisingly white, conveying an astonishing sensation of nakedness even though few details of the body are sketched in. The open field of white, in turn, serves as a foil for the focal point of the painting, a hooking finger of paint that both describes and penetrates her vagina.

The dark color of this fingerpaint is the same one used to depict the woman's facial features and expression, creating a powerful sensation of intimacy, as if what happens between her legs also lights up her face. The finger of paint is aggressively lewd; it suggests, with more joy than anger,

the rude gesture of "giving the finger" and the language of "up yours." Although some critics find such pictures misogynistic or humiliating to women, as if the male were having his way with a passive female, that does not convey the full sensation in the image. Finger and vagina are the same wet stroke, one and indistinguishable. There is no alienation or separation: no mere doing *to*, but doing *with*. While often described as paintings of women, de Kooning's images always have a strong male presence, expressed through the character of the brushstroke. In *The Visit*, the man is felt not just in the vaginal finger, but also in the press of swollen red paint against the woman's body. The writhing forms, in turn, convey the movements of a man and woman copulating.

Writers are understandably timid in their descriptions of a picture like *The Visit*, unable to use the words that describe what the forms are doing. Part of the reason is that the actual act of sex is usually the subject of pornography, not of serious painting. De Kooning himself appeared somewhat embarrassed by the pictures, as if he had once more misbehaved. In fact, embarrassment is an essential part of the picture's power, an acknowledgment of the silly-looking, embarrassing physicality of sex. And yet, sex also turns the figure in *The Visit* into a kind of absurd frog-monster who has an almost childlike charm.

De Kooning longed to recover the intensity of the child: the sex here was also a form of fingerpainting. And he seemed to push the physicality of sex as far as it could go, as if to finally displace feeling to some other, larger place. The title of the painting, with its promise of birth and rebirth, evoked the Annunciation. It may have seemed profane to link divine birth with bawdy sex, but the desire to transfigure the intensely physical into a sense of transcendent oneness also lay close to the heart of most religions. It was not surprising that de Kooning was simultaneously absorbed, as the Walker catalog showed, with images of the Crucifixion and pictures of a radically sexual character. (The shapes and powerful reds of *The Visit* even contained a distant echo of the Crucifixion.) And yet, there was an air of frustration in *The Visit*, as if even this fearless vulgarity could not quite capture the pastoral oneness de Kooning sought. Entering a body should open the door to paradise, but it doesn't quite. In *The Visit*, the swirl of the vaginal finger could almost be a question mark. Where does the opening of the body lead?

32. Established Ties

I only want to be happy in an old-fashioned way.

Early in 1967, surprising news circulated through the art world. After three years without a dealer, de Kooning had a new gallery, and one that no one would have predicted. He would join M. Knoedler and Company, the oldest and one of the most prestigious old-master galleries in New York. Xavier Fourcade would be his representative. Fourcade, who had been hired by the gallery to establish their contemporary art department, was a friend of the artist Joan Mitchell, who lived just outside of Paris and was represented by Knoedler. She had known both Bill and Elaine well since the late forties. When Fourcade asked her advice in the mid-sixties about what artists he might attract to Knoedler's New York gallery, she immediately thought of de Kooning. "[Fourcade] was trying to get artists," said Mitchell, "and was talking to me about Newman or Motherwell. Bill was not doing that well at the time, and I said, 'Hell, why not de Kooning?' "

Fourcade loved the idea. And so Mitchell asked Tom Hess—who was no doubt worried about de Kooning's precarious situation—whether or not the painter could be persuaded to join the gallery. A Francophile, Hess liked the prospective match. But it was Lee Eastman who engineered the deal. All along, Eastman had chafed at the way Hirshhorn and Diamond bought art from de Kooning. Eastman, never one to mince words, called Hirshhorn's bulk-buying "a debacle" and said, "Bill had to have a buffer." Accordingly, Eastman arranged to have lunch with Roland Balaÿ, who was president of Knoedler. Eastman proposed giving Knoedler the right of first refusal for the next three years—an opportunity to see and buy de Kooning's work before anyone else. In exchange, according to Eastman, "I said I wanted a guarantee of $2,500 a week for Bill—over a hundred thousand dollars a year." When Balaÿ asked why, Eastman replied, "I want Bill to feel like a movie star, with a movie star's salary." Eastman conceded that "It was a phenomenal amount of money for the time." All Balaÿ said in response was, "How droll." Eventually, however, the tenacious Eastman succeeded in wrangling an annual guarantee for de Kooning of $100,000 a year. "I told Bill about it, and it reminded him of Caruso, such a large sum of money for a concert," said Eastman. "He said, 'I'd better paint some good pictures.' "

Even so, the match between de Kooning and M. Knoedler and Company appeared incongruous. Housed in elegant quarters at 14 East Fifty-seventh Street, Knoedler was the sort of Old World establishment that still showed art on dark velvet-covered walls and had an air of exclusivity. As the *New York Times* noted in January 1967, while speculating on rumors that de Kooning might join Knoedler, it was not only New York's oldest gallery but also "one with a reputation for being rather staid." When de Kooning joined the gallery, its other artists included Andrew and Jamie Wyeth, Henry Moore, and Salvador Dalí, rather than other New York school painters. The antithesis of Charlie Egan's fly-by-night gallery or Sidney Janis's avant-garde American group, it was the sort of conservative place, as the critic Paul Richard described it, "where salesmen dressed like bank presidents hold price lists closely to their vests."

But there was also a certain genius to the connection. Despite his difficult subject matter, de Kooning, in the era of pop and minimal art, was regularly criticized for being too European and too old-fashioned—too much, that is, like an old master. (As de Kooning joked, "My art is just like an old hat now.") Why, then, not take advantage of the situation and join Knoedler? The gallery could provide him with security. After several shaky years, he told Joseph and Olga Hirshhorn, in a letter of late 1966 thanking them for a Christmas gift of a shirt and three ties, he was more than ready for an art dealer. De Kooning told them that he was very happy with "an excellent contract" that Lee Eastman drew up for him with Knoedler. "It is encouraging to think that I am well taken care of," he continued. "And thus I am looking forward to a peaceful working period." In an allusion to Hirshhorn's patronage, he added, "And Joe, I am thanking you for also encouraging me to go thru with the deal." For Hirshhorn, of course, de Kooning's new relationship with a gallery was bad news. He and Harold Diamond could no longer visit de Kooning in his studio and take their pick of his paintings. But even Hirshhorn acknowledged that a gallery arrangement was better for de Kooning over the long term.

Hardworking and ambitious, Fourcade, who was born in Paris, had joined Knoedler only in 1966. But he had spent his first eleven professional years in America. "One of those princely Frenchmen," as one art world insider described him, Fourcade was cool, brisk, and sometimes waspish, a European homosexual with an upper-class air. He was not the sort of man whom de Kooning ordinarily liked, but their relationship worked well from the beginning. Fourcade treated de Kooning with European formality and a respectful, businesslike reserve. In one of his first letters to de Kooning, on January 19, 1967, he wrote, "I am extremely happy that we are now at the end of our formal problems [Lee Eastman's legal

negotiations], and I am looking forward to working with you." He enclosed a list of the initial seventeen paintings that de Kooning consigned to Knoedler on January 25, not long after the deal was completed. All was precise and orderly, as were Fourcade's subsequent letters that spring. They were usually signed "Sincerely yours / for M. Knoedler and Co. / Xavier Fourcade."

The formality suited de Kooning, himself a reserved man from Europe. He did not need an art dealer who also wanted to be a close friend or hanger-on. If Fourcade was not one to drink with the guys at the Cedar, he was also not one to presume upon a relationship. Despite his strong views about how to market de Kooning, he never made demands or offered criticisms, and he provided unfailing support and encouragement. He also had an instinctive understanding of how to handle de Kooning's outbursts and binges. He seemed to follow the advice that de Kooning had offered the mother of the boy who threw a tantrum: "Empathize, don't criticize." Early on in their relationship, as de Kooning recovered from a binge in March 1967, Fourcade wrote him a letter at once kind, encouraging, and diplomatic: "To be the greatest painter only makes your problems greater and your road more solitary. If I could be of any use to you, or if you ever feel the need of talking to me, I hope that you will never hesitate to call me." When Fourcade left Knoedler in 1972 to open the Fourcade, Droll Gallery, de Kooning loyally followed him; in 1976, he became de Kooning's exclusive dealer. In the 1960s and '70s, Fourcade often served as de Kooning's chaperone and protector when he appeared in public. He also made certain that de Kooning never felt forgotten. Almost every Sunday, he would drive from his weekend house in Bellport, Long Island, to the Springs—about one hundred miles round-trip. He did not always know what he would find. If de Kooning was drinking, he could be curt and suspicious, demanding, "Who are you to tell me what I should be showing?" Once, he even threw a pot of paint at Fourcade, who, while shaken, did not lose his unflappable air.

Taste in the American art world was nothing if not fickle. Fourcade hoped to turn de Kooning from a has-been into a revered contemporary master, and he methodically set about accomplishing this goal. He immediately scheduled a show for the fall of 1967. But that was just the beginning. An artist of de Kooning's stature, Fourcade believed, should have his achievement validated by a major retrospective at the Museum of Modern Art. Aware that curators at the museum were growing less enthusiastic about de Kooning—in common with much of the art world—Fourcade quickly firmed up plans for the intended retrospective. The death of Frank O'Hara, who had intended to organize the show for MoMA, created a

De Kooning, Susan Brockman, and Brian O'Doherty in the sixties

potential problem that was solved by bringing Tom Hess into the project. Hess of course shared O'Hara's enthusiasm for the artist, and the book that he was coincidentally writing on de Kooning could serve as the catalog for the MoMA show. Fourcade also developed plans to send the retrospective to Holland. He saw the great publicity value that such a show would have in Europe, where de Kooning was not well known among collectors, and he anticipated that the American press would swoon before the story of an immigrant painter returning home in glory after so many years in the New World.

Not least, Fourcade began to prepare the art world—and de Kooning himself—for the painter's inaugural exhibition at M. Knoedler in the fall of 1967, treating it with the importance usually reserved for a museum exhibition; the show would travel to Knoedler's Parisian branch after New York. To attract collectors, Fourcade began seeding de Kooning's work into the major museums in order to strengthen the artist's reputation and increase the prices his work fetched. Later that year, the Whitney Museum of American Art announced that it had purchased *Woman Accabonic,* one of de Kooning's door paintings, for $38,700. (What was not announced was that de Kooning donated $20,000 of the price, with another donor providing the remaining $18,700.) The art dealer also tried to enhance de Kooning's image. Together with Lee Eastman, he shut down a book that Eric Protter, a writer little known in the art world, was preparing on de Kooning. Protter, in Fourcade's view, was not distinguished enough to write about the master. So de Kooning refused further cooperation with him. At the same time, Fourcade did not intend to let the increasingly reclusive painter retire to his studio. Sometimes, de Kooning must perform—but in the right venues.

The prospect of his first New York show since 1962 seemed to galvanize de Kooning. Early in 1967, he created a flurry of new paintings to add to the seventeen he sent to Knoedler in January. At the time, said Michael

Wright, he was just switching from Bocour paint to the more expensive, and more heavily pigmented, Winsor & Newton paints. For years, he had been too poor to buy the best-quality materials. Now that he had a guaranteed income, he could afford better supplies, but he still had trouble spending the money for them. "He'd take me upstairs and open a box and say, 'Look at all this money!' " said Wright. "He wanted to have money around. He felt poor." Once he realized he would never be hungry again, however, de Kooning began to buy with abandon and squirreled away paint for future use. Abram Lerner once opened one of the built-in benches by the windows of de Kooning's studio and discovered fifty tubes of the same pigment waiting neatly, in orderly rows of boxes. De Kooning also began to buy more varied brushes. He asked Lou Rosenthal of New York Central Art Supply, whom he had known for years, to make a special brush for him "so he could do the swirling strokes," said Rosenthal. The result was the aptly named "de Kooning" brush, a round brush with stiff three-inch-long bristles and a long handle that enabled de Kooning to stand back from the canvas to see the effect he produced. "But he also liked some of the ordinary brushes that you buy in hardware stores," said Wright. "He liked brushes with long bristles that had a lot of snap. He liked to soak them in water until they were really soft and pliable. They gave him a line that he liked. . . . He wanted them kind of floppy—a little resistance, but not too much. He'd buy three or four dozen of those. He'd order stuff for about a year, and it would sit around in these benches waiting to be used."

Throughout the early months of 1967, with his gallery deal in place, de Kooning redoubled his efforts to improve his relationship with Lisa and Joan. In addition to the painter's earlier commitments, Eastman now urged de Kooning to give annual gifts of $3,000 each to Lisa and Joan. From Joan's point of view, much remained undone. Still, de Kooning was obviously trying. After Susan Brockman's departure, he had begun to miss Lisa more than ever, but he could only see her sporadically, mostly on trips into New York, when he would stay at the Hotel Chelsea. Joan hadn't really given up on him, however; she never would. De Kooning had already succeeded once in restoring the family, bringing Joan and Lisa back from San Francisco. Why not again? During this new effort at reconciliation, Lisa was in fifth grade. She had left Grace Church School in the Village to enter Dalton, one of New York's most prestigious private schools. Located on the Upper East Side, it was favored by many wealthy, progressive parents in New York. But Lisa was unhappy at Dalton, and

would often leave her classes to wander around the city. Her mother, in turn, found the school snobbish and unstructured and listened sympathetically to her daughter's complaints.

That spring, Joan and Lisa began to spend increasing amounts of time in the country. Eventually, Joan withdrew Lisa from Dalton and enrolled her at the Hampton Day School, located, somewhat incongruously, in the potato fields just north of Main Street in Bridgehampton. The family was back together once more, however precariously. For Lisa herself, in a life marked by many moves, childhood was best remembered by grade. "Nursery school was in San Francisco, kindergarten in New York, first grade and part of second grade in Springs, third, fourth, and fifth grades in two different schools in New York." Her father was a hazy presence. At times he would appear, only to vanish again for months. "I remember him coming one day—it's all so vague—like in second or third grade he'd come visit in New York and we'd buy things," said Lisa. "Or with my pony. He used to come a lot when I was about seven years old. He'd come by and see me horseback riding." Lisa made a family from animals, caring not only for her pony but for wild birds, rabbits, and any creature that needed help.

With the return of Joan and Lisa to the Springs in 1967, however, de Kooning came more clearly into focus as her father. She now knew how famous he was. She saw that people singled her out as the great man's daughter. Once, when she was in fourth grade, someone introduced her at a birthday party as Lisa *de Kooning*, and the other adult whistled knowingly, which upset her. "What's wrong with that?" asked Joan, who enjoyed her daughter's connection to a famous painter. "Oh, *Mom*," she answered. Her life was already different enough from that of other children, without her having to represent her father. An eleven-year-old could not understand the relationship between such parents. They were not married the way other parents were; their relationship had become an arrangement based mainly on their mutual love for her. There was no sharing of parental roles. They sometimes fought. Her father's bingeing—which she sometimes witnessed—intermittently darkened her world. And the shadow of someone named Elaine fell over the household. It was only by chance that Lisa discovered, when she was twelve years old, that her parents were not married. Her mother wore a wedding ring, yet her father was actually the husband of someone named Elaine. Over time, she learned that Elaine was a distant but powerful figure in her father's life; no one was supposed to mention her name unless he mentioned it first. Rather than explain Lisa's background, official chronologies of de Kooning's life often found it simpler to leave her out altogether. Even at the age of eleven Lisa sensed that she was an awkward fact. "From a daughter's point of view

it was hard," said Lisa. "A lot of times I was cut out of situations because it raised questions about [her father and Elaine]. Which really bugged me."

In his own way, de Kooning tried to be a responsible father. At one point, according to the painter Ellen Adler, de Kooning even performed the part of local "godfather" to the area's children, solving a difficult problem at the local elementary school where a flasher was exposing himself to girls near the school.

> The mothers couldn't go to the police—I guess they had no hard evidence—so they went to Bill as the leading citizen of the Springs, the one who was the most rich and famous and also the father of a daughter. Bill found out who it supposedly was—a middle-class, decent member of society in the Springs. So Bill said, "I invited him to my studio and made sure that I was still painting when he arrived. The whole time I'm painting and he's sitting there. And then I said, 'I understand the little girls have been bothering you.' And he never flashed again."

It was a good example of de Kooning's sly wit. "It was so perceptive—de Kooning scared the life out of the guy," said Adler. "He went right to the heart of the matter. I once asked him, 'What do you think people are thinking about when they're meditating?' And he said, 'I think they're really scheming.' " But a child does not want only wit from a father, and de Kooning could offer his daughter little useful or practical help. "Guidance was nonexistent," said Lisa. "My mother was extremely critical of me and my father wasn't at all. There was no balance in this childhood. And then he's an artist, and an abstract one, and the best. I guess it was overwhelming for me. I never knew where I stood."

As much as de Kooning could ever be said to settle in, however, he did so during that summer of 1967. The days took on a regular pattern. "In the mornings he always drank a *big* cup of tea with lots of sugar in it," said Lisa. "And he'd sit there and slurp it down and go 'Ahhhhh.' Then he'd get on his bike around nine or ten and go off to the studio." Whenever he didn't feel like biking to his studio, de Kooning would be picked up by Mike Wright or John McMahon. "I'd take him to the studio and make him tea or coffee and some toast," said Wright. "He'd be into his work right away and he'd be busy until lunch. We'd have lunch at this little restaurant near the corner of Main Street [in East Hampton]. A little luncheonette with booths. We talked about very mundane things. People. Or he asked me what I thought of something. Then, in the late afternoon, he'd take a break and I'd make tea. In summer he'd work until dark, because he liked natural light. And then I took him home at night. He really was a

hard worker. Probably of all the painters of that time he was the most workmanlike."

De Kooning and Joan established a social life, much as there had been during de Kooning's days with Susan. At the time, Hans Namuth and Saul Steinberg did quite a bit of entertaining. The Rosenbergs gave dinner parties, as did Ernestine and Ibram Lassaw. During the winter, said the artist Charlotte Brooks, a little band of artists and assorted friends, most of whom came out from the city for weekends, met regularly for potluck suppers. The group included the Rosenbergs and the Lassaws, as well as Charlotte Brooks and her husband, the artist James Brooks, and the painter John Little and his wife, Josephine. De Kooning also came, first with Susan and later with Joan. De Kooning went regularly to Water Mill, a village on Montauk Highway between Bridgehampton and Southampton where many artists and poets of the younger generation—that of Larry Rivers, Jane Freilicher, John Ashbery, and Kenneth Koch—clustered. It was a tightly knit world with many connections to the days at the Cedar. Other regular hosts in Water Mill were the artist Jane Wilson and her husband, the writer John Gruen, as well as two gifted pianists who had become society regulars, Robert Fizdale and Arthur Gold. "At that point Bill was quite sociable and going out," said the art dealer Elaine Benson, who founded a gallery in Bridgehampton in 1965. She recalled one particularly memorable dinner at the Lassaws' in the mid-sixties that she and her husband attended. Along with de Kooning, the guests included Harold Rosenberg, Saul Steinberg, and Saul Bellow. In 1966, Rosenberg had become a professor of social thought in the art department at the University of Chicago, where Bellow was on the faculty. "I remember it vividly because Bellow and Rosenberg got into one of those polemical, Trotskyite discussions and they were screaming at each other," said Benson. "And Saul Steinberg was throwing in an occasional remark. Bill never opened his mouth and neither did my then husband. When I got into the car I said, 'Emanuel, you never said anything.' And he said, 'Well, those two guys have been at this for so many years. And if you noticed, Bill de Kooning was smart enough not to say anything either.'"

However much de Kooning enjoyed the cloud-making of philosophical talk, he never left the studio for long, and he would regularly retreat from social life, going for days without talking on the phone or seeing anyone at the studio. Sometimes, he appeared lonely; but it was a loneliness that Mike Wright believed was of his own choosing. "He liked his privacy," said Wright. "I think if he was lonely, he made himself that way. He did isolate himself. Work was his primary life." At home, de Kooning

relaxed with the mindless conviviality of television, retaining an immigrant's fascination with the pop heart of American society. He especially liked crooners—the cornier the better—and TV comedies. "He was crazy about Jackie Gleason, Tony Bennett, Frank Sinatra, Red Buttons, *Perry Mason, The Twilight Zone, The Honeymooners,*" said Lisa. Television also simplified his home life. It papered over the silences. "There was no conversation in my family," said Lisa. "Dinner was served in front of the TV." Almost always, de Kooning would work at home as he relaxed, making drawings at dinnertime with his eyes on the television and the paper on his knee, sketching blindly with a piece of charcoal. When he glanced down, he would find something that never quite looked the way he thought it would. "All through my childhood," said Lisa, "it was our routine, while dinner was getting ready, we'd watch TV and he was drawing, always drawing. He would draw a great deal with his eyes closed. Lots on legal pads or an eight-by-ten typewriter sheet pad. Sometimes he'd make a drawing for me to color in. He'd sit there with his eyes closed and his legs crossed as if he were looking at the TV. And he'd squint a lot. Then when he opened his eyes he'd turn his head to the left mostly or to the right and think about [the drawing]. Then he'd put it away. He'd do this like a lady does knitting."

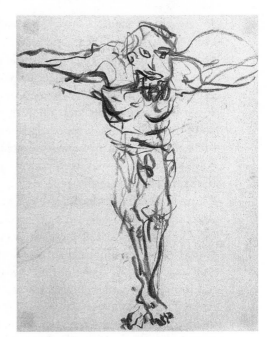

With the approach of the fall art season, Fourcade began to promote the upcoming show, inviting critics and journalists to interview the revered old master. On August 4, twenty-two more paintings arrived at the gallery, many of them continuations of de Kooning's figure and landscape series. They included several *Woman on a Sign* paintings, which reflected de Kooning's emphasis at mid-decade on sexually difficult work. (He did not trim his sensibility to suit his staid new gallery.) De Kooning had often described his fascination with the way that signs and billboards could convey a message in a split second.

Untitled, *a charcoal-on-paper crucifixion drawing made with closed eyes in 1966, 9 3/4" x 8"*

He wanted viewers to connect viscerally, and with a similar immediacy, to these works. The new *Woman on a Sign* paintings were less representational than some of the cutie images, with the figures more meshed into the background, but their sexual impact was unmistakable. Each woman was shown spread-eagled, her body flattened onto the surface plane. In *Woman on a Sign IV*, the figure leaned back with her legs raised awkwardly in the air. The viewer looked down into her body as though he—from this perspective every viewer became a "he"—were about to enter her.

When questioned at the time about the suggestiveness of his latest paintings, de Kooning agreed that they were "sexy" but said

> that's not the main issue for me. I'm working on a pose with which I can explore foreshortening and perspective. Sometimes I lay the figure out flat and then roll it all over the place. . . . You get interested in a pose and you just work with it. Like I have a standing one and a jumping one, that's about it for the poses I'm now interested in. I realized it looked kinda sexy, but I don't think it's pornographic, do you?

As the Knoedler show approached, de Kooning's working studio seemed to come together, and he was more optimistic than he had been in years. Shortly before the opening, de Kooning created a powerful new version of the pastoral—though it would be some time before he fully explored its implications. At seventy by eighty inches, *Figures in Landscape* was both larger and much more ambitious than anything that he had painted in years. It represented a new, more seamless synthesis of figure and field. The body was so abstract that only two masses of flesh color—with what may be a pair of splayed legs on one of them—alerted the viewer to the presence of a figure. The flesh colors gave the abstraction a human overtone, yet the palette was also a gorgeous profusion of country colors.

Only one essential element was missing to complete de Kooning's studio. At a secondhand furniture store in East Hampton, not far from the train tracks, de Kooning noticed two large wooden rocking chairs placed out front. They came, he was told by the woman at the store, from an old resort hotel in the Adirondacks. De Kooning asked her how much one chair cost. She said $25. "How much for both?" he asked, probing like Hirshhorn for a deal. She said $50. De Kooning loved her deadpan response and bought both. At the studio he positioned the rockers side by side and facing the easel, which was about fifty feet down an alley created by painting tables. As he rocked, the rocking itself evoked many things:

nervous energy, old age, the cadence of the sea. Over the years, friends would join de Kooning in the chairs, and they would rock as they talked, all the while facing the picture down the alley. Their talk about art mattered to him. But not as much as the solitary stare. Day after day, until the end of his life, de Kooning would sit in his rocker, staring down the alley at the painting developing on his easel.

33. Second Acts

You have to change to stay the same.

On the evening of Friday, November 10, 1967, several hundred invited guests pressed into the elegant interior of M. Knoedler and Company on East Fifty-seventh Street. Forty-five paintings, twenty-five large drawings, and numerous smaller works hung on the velvet-flocked walls. On one wall were the dramatic collection of door paintings: *Woman, Sag Harbor*; *Woman, Accabonac*; *Woman, Springs*; and *Woman, Montauk*. The least expensive paintings cost $12,000; *Figures in Landscape* was $55,000. According to *Time*, this was the most eagerly awaited show of the season. Not surprisingly, de Kooning himself was not on hand for the event or for the gala preview on the thirteenth for the benefit of New York's public television station, Channel 13, even though it was hosted by someone very important to him, Olga Hirshhorn. "I don't go to openings much anymore," he explained just before the show, adding that he rarely came into New York City at all. "It's quite a change," he said. "I used to go to parties and sit in cafeterias—Riker's—and talk for hours. Now I see just a few old friends." More than likely, de Kooning was drinking too much to come into New York for the party. Two weeks before the opening, he had purchased what one assistant called "an arsenal" of liquor.

It was his first show in five years and the first time that many people, including the critics in New York, would see the paintings made on Long Island. The lurid sexual imagery and wet, slapdash style of many works were nothing if not risky, and de Kooning knew people might find some offensive. But he could also hope that, as happened in 1953 with *Woman I*, the exhibit would find more support than condemnation. In the end, the critical reception was worse than anything de Kooning could possibly have anticipated. The most damning review appeared in the *New York Times*, where Hilton Kramer called the show a "debacle." Kramer's response was similar to Greenberg's earlier criticism of de Kooning, but his tone was harsher and he presented the viewpoint in more detail. His review began with the paintings of the 1950s, which he regarded, as Greenberg did, as a comedown from the masterpieces of the forties. As the fifties wore on, Kramer argued, "the cult of personality seemed to increase

in exact ratio to the decline of the artist's work," even as "the fabrication of synthetic de Koonings had become a 10th Street industry."

For Kramer, the crux of the matter was what he perceived as de Kooning's growing expressionism, which unbalanced his compositions. "This Expressionist tendency has been evident as one term in the dialectic of Mr. de Kooning's style at least since the 1940s," he wrote, "but in his best work it was never the dominant term. A stripped and battered Cubism, shorn of its rigidities and pressed to an extreme margin of flexibility and release, provided the basic pictorial syntax." De Kooning's success in this tense style depended, in Kramer's view, on his virtuosity as a draftsman. "Out of a flattened Cubism, raised to unexpected eloquence by the inspired improvisation of his draftsmanship, he had distilled a new classicism"—one in which, wrote Kramer, "the Expressionist component contributed a necessary spontaneity and immediacy." Beginning with the *Women* of the fifties, however, Kramer saw the balance move ever more strongly toward an unbridled expressionism. "Thereafter," continued Kramer, "the Expressionist element swamped the artist's style, bringing him by a long and tortuous route to his current impasse." The latest paintings carried "this Expressionist debacle still further." The critic would not grant de Kooning credit for a serious, if failed, struggle to maintain the great traditions of Western painting in contemporary terms. "His new paintings do not so much embody the crisis that has shattered the tradition in which he works—that would indeed be an accomplishment one could respect—as look back on an earlier crisis with nostalgia."

Even the gentler critics expressed doubt. Irving Sandler, who had been chronicling the achievement of the abstract expressionists for years, later wrote that he found de Kooning's spread-eagled women so sexually revealing he was embarrassed to look at them. Dore Ashton, also a strong supporter of abstract expressionism, thought the pictures were unsettling visions of women as helpless erotic objects. Paul Richard, the critic at the *Washington Post,* wrote: "De Kooning's work still shocks. Standing there amid all that frenzy, surrounded by those cruelly dislocated and expertly painted canvases, one understands immediately why de Kooning has earned himself a permanent place in the history of art." But on closer inspection, Richard continued, the viewer becomes disillusioned. "It takes long moments for the eye to adjust to the visual impact that they [the paintings] generate. But as it does, as the viewer begins to recover his bearings, as his shock begins to dissipate, he finds—quite suddenly—that his initial awe is dissolving as well." At heart, Richard felt, the paintings were empty rhetoric when compared with those of the past, the women "but pale parodies of their hideous ancestor."

A certain ideological anxiety also underlay the response of many critics. The pictures appeared so naive, so unschooled in the concerns of the day. In the late sixties, the dominant styles of art in New York—pop, minimal, and conceptual—appeared equally cool and self-conscious. A new magazine, *ArtForum*, had replaced *ArtNews* as the journal of the young and the ambitious, and it was developing a mandarin style of criticism that emphasized a kind of hip historical knowingness. An artist must *not* do certain things if he hoped to be original and take the measure of his time. De Kooning obviously failed to recognize that Pollock and Newman had opened a new territory, liberating art from the old-fashioned brushstroke and all reference to the actual world. He did not seem to know that major art had banished storytelling and "the literary." He had not concluded that compositions must now be, in Greenberg's phrase, "all-over." If anything, de Kooning's brushstroke appeared more shamelessly personal than ever before; some of his pictures could almost be illustrations in magazines. He certainly lacked the ironic filters and deadpan cool that Warhol and others brought to sex.

During the sixties, many American intellectuals were also worrying about the destruction of high culture by low- or middlebrow taste; the best-known essay on the subject was Dwight MacDonald's "Masscult and Midcult," which was published in 1960. Although the young critics at *ArtForum* had little in common with Hilton Kramer, who disliked the magazine and most of the art it championed, they shared with him a high-minded view of art and history. The Knoedler show offended both the left and the right wings of the art world, seeming neither to advance the great tradition admired by Kramer nor to reflect the new character of the contemporary world. De Kooning seemed painfully *low*, a lip-smacker in a venerable gallery, a half-cartoonist with a salacious eye. The critics were right in one respect: de Kooning was no longer keeping a close eye on their history of art. The paintings of the late fifties were the last de Koonings that seemed consciously made for the big stage. Now, if he chose, he might dabble with the surface of the time, caricaturing the sexy girls of the sixties, but he was otherwise indifferent to broader cultural concerns.

Of course, even the most light-handed of his pictures still retained a familial relationship with the powerful *Woman 1*. The art historian Robert Rosenblum later wrote that "the seemingly infinite energies de Kooning expended on [*Woman 1*] also gave birth to a huge population of lesser siblings, a seductive but threatening sorority that, like the chorus of fluttering cupids in a Baroque veneration of Venus, ceaselessly confirms the magical aura of an extraterrestrial being presiding over the erotic life of men on earth." But the harpies and cupids of the sixties were not them-

selves de Kooning's deepest preoccupation. Increasingly, de Kooning was turning inward, searching for a private pastoral: the play of his brush on a body; the shimmer of the light on the water at Louse Point; the messy eruptions of sex; the mating of landscape and body, figure and ground. And yet, he still wanted something broken or glimpsed rather than whole or perfected. Kramer's description of the imbalance in de Kooning's sensibility was astute, but that unstable quality was also one sought by de Kooning. "It all fits real good, don't you think?" de Kooning once asked his assistant Tom Ferrara, who was with him from 1980 to 1987, as they stood before a painting. "Fantastic," said Ferrara. "That's the whole problem," de Kooning answered. "There's no contradictions."

At his easel, de Kooning was too strong-minded to be swayed by the critical perspectives of the time. He would do what he would do; success and failure were not to be measured by others. That did not mean, however, that he was indifferent to the response of the outside world. The Knoedler disappointment was distressing because de Kooning had not had a gallery success since 1959. His show in 1962 had been, at best, coolly received. But the critics in 1962 seemed to view that show as merely premature, assuming the painter was between periods. This time, de Kooning had indeed entered a new period, but it was one widely regarded as disastrous. Most critics implied in one way or another that he'd "lost it": everything done since moving to the Springs was a failure. Collectors agreed with the critics. By the end of the year, only seven paintings had been sold, including the one Fourcade fobbed off on the Whitney.

The forthcoming retrospective, now only months away, probably increased de Kooning's anxiety. Under Fourcade's ministrations, the exhibition had grown into something much larger than O'Hara had originally planned. It would now be a traveling retrospective that would begin with much fanfare in Amsterdam, continue to London, and conclude in New York. De Kooning agreed to the plan largely because the Stedelijk Museum in Amsterdam assumed the job of organizing the show in place of O'Hara and the Museum of Modern Art. For years, de Kooning had been embittered by his lack of recognition in Holland. In the early fifties, Alcopley had once brought Willem Sandberg, the head of the Stedelijk, to de Kooning's studio, telling him that de Kooning was among the best American artists. Sandberg disagreed. Both Elaine and de Kooning had been "furious" about his dismissive attitude. However, Sandberg's successor, Eduard de Wilde, took a different view of de Kooning and, in the mid-fifties, began occasionally writing to the artist. De Kooning never answered. Finally, de Wilde came to America in 1964 and visited de Kooning in his studio on Long Island to ask him for a show. De Kooning

agreed, said de Wilde, but stipulated that he did not want a retrospective in New York. (Frank O'Hara eventually changed the artist's mind.) If New York was turning away from him, perhaps Holland, at last, was welcoming him back.

De Kooning would never admit to being bothered by the response to the Knoedler show; many hero-worshippers believed he was above noting criticism. But afterward he went on a binge that put him in Southampton Hospital for several weeks. (The bill for the psychiatric sessions alone, with Dr. Wayne Barker, was $1,510.) For de Kooning, the last years of the sixties were a time of constant distraction and painful eruption. When he was drinking, his feelings of disappointment would sometimes escape from his reserved character, and he would rage and rage at New York, a Lear on his private heath, furious that the world should turn its back on him after all he had done. Once, after listening to people discuss the stars of pop art at a party on Long Island, a drunken de Kooning suddenly rose up and told a friend, with a ferocity that was surprisingly sad: "*I'm* the hot potato."

The inexorable pressure created by public exhibitions seemed to trigger a deadly reaction in de Kooning's private life. The reuniting of the family did not stop the drinking, and the level of tension at home once more began to escalate. De Kooning could be cold, yet also erupt in anger. Joan could strike back. "They used to have some awful fights," said his assistant Michael Wright. "I'd come in [to pick up de Kooning on Accabonac Road in the morning and take him to the studio] and she'd say, 'He's started.' Every chair in the kitchen would be smashed." Neither de Kooning nor Joan, however, was willing to call it quits. For de Kooning, the obvious reason was Lisa. The drunken brawling might be hideous, but at least Lisa was part of his life again. As for why Joan tolerated the situation, some observers pointed to the benefits that the relationship brought her. "She loved him," said Wright. "But I think both she and her sister Nancy were very attracted to the famous art scene." Life with a famous artist brought perks, said Wright, including a fur coat that was the talk of the artists in the Springs. But that cannot adequately explain why Ward did not leave or why she nursed him again and again after his drunks. "I'd go over and pick up the stews and the food for Bill," said Wright, who would try to comfort Joan. "She had a sad life. I used to hear her cry at night. I'd leave her place at four a.m. and I'd hear her crying. She was alone, and so lonely. We would talk for hours."

In New York, Lee Eastman grew increasingly alarmed. Who could

bring order to the situation? Eastman himself visited East Hampton only occasionally, except in the summer. One of the few local people in a position to help de Kooning was the accountant Irving Markowitz, whom Eastman originally asked to monitor payments on de Kooning's studio. Gradually, Markowitz had assumed a greater role in de Kooning's financial affairs, doing his taxes for him, paying his bills, and helping with financial planning. When necessary, Markowitz could get tough with de Kooning about the drinking. "I picked him up at Jungle Pete's, or he'd end up at Chez Labbat and other restaurants," said Markowitz. "I'd get calls at two, or three in the morning and I had to go get him. And he listened. If I said, 'Come on, we're leaving . . . [he'd come].' Unfortunately you'd try to get liquor stores not to sell him anything, but he'd sweet-talk them. . . . I think he was very much at home living out here and being with the so-called Bonackers," he said. "In a sense it was security for him."

By December 1967, Markowitz, Eastman, and Fourcade were at a loss how to staunch the flow of drinking and domestic fights. In desperation, Fourcade asked Tom Hess for advice. The two men thought a change of scene might help de Kooning. They invited him to join them in Paris and London early in 1968 for a week and a half. A large exhibition of Ingres, one of de Kooning's favorite painters, was opening in Paris; Harold Rosenberg would also be there to participate in a panel on Baudelaire. Surprisingly, de Kooning agreed. On December 12, de Kooning received his new passport. He bought tickets to Europe shortly afterward and prepared to return to Europe for the first time in almost a decade. He did not ask Joan and Lisa to join him, and he went on a binge before he left, drying out in Southampton Hospital just before Christmas.

Together with Hess and Fourcade, de Kooning visited Fountainebleau and the Louvre. No doubt Fourcade took de Kooning to see the original M. Knoedler et Cie gallery in Paris, where his show of Long Island paintings was scheduled to open in June. De Kooning also visited his old friend Joan Mitchell, one of the few women accepted at the Club as an equal. In the fifties, when Mitchell lived on St. Mark's Place in the Village, de Kooning would drop by occasionally to listen to her recording of the Mozart *Requiem* and to eat ice cream—Mitchell's theory being that, if he ate ice cream, he would not drink. Not long afterward, Mitchell had moved to France with the French-Canadian artist Jean-Paul Riopelle. According to Mitchell, de Kooning's favorite painting at the Louvre was of a cow by Pater. As he described it wonderingly to Mitchell—who loved the same painting—it had "eyes in the back of its head." De Kooning was also impressed by the way Delacroix and Rubens handled the vast scale of their large paintings. From Paris, de Kooning went with Fourcade to Lon-

don. There he met the painter Francis Bacon, another artist who owed much to Soutine. De Kooning admired Bacon, who was five years younger than he was, and found his tormented imagery richly suggestive. "And so Xavier and I had dinner with him and [the art critic] David Sylvester and a few of Bacon's friends," reported de Kooning. "I knew he was a terrific guy . . . and he was." Sylvester's own view of the dinner was wry. "It was like a dinner in Berlin between American and Russian generals. Lots of toasts and bearhugs but not much communication."

The trip seemed to improve de Kooning's mood. Once back in Springs, he began edging toward more abstract works, creating "women in landscape" pictures that were less sexually aggressive and confrontational than his recent images. "My pictures have been getting bigger and require more time," he said, and "getting more and more baroque." The effect was of a growing softness, of the body flowing into the landscape. By the time de Kooning painted *Woman in Landscape VII* that year, all that was recognizable was a jumble of legs—or was it arms?—within a cloud of yellows, browns, and greens. One particular source of pleasure for him was the final touching up of his studio. The construction crews had departed, leaving Johann Luhmer, a master carpenter, to complete the built-in headboards that de Kooning designed for the beds. To add a homey note, de Kooning hung pink ceiling-to-floor drapes, having seen them in his neighbors' houses. "I'm keeping up with the Joneses," he explained. The appearance of the cheap curtains in the vast space was comical, said Lisa, who thought to herself affectionately, "Nice try, Dad." With the planting of trees that July in front of the studio—de Kooning did not want the light from his windows to bother his neighbors at night—the studio was complete.

But his upcoming retrospective in September 1968 still weighed upon him, as his dwindling output during that year attests. "I've never had a retrospective, and I don't like the idea of retrospectives," he told David Shirey of *Newsweek* not long before the opening in Holland. "It's as if the art world has rolled you up in a shroud and prepared you for quick burial." He believed, "These shows can sometimes mean the end of the artist. People will see that I have been painting for over thirty years and imagine me much older than I actually am. I'm not a senile artist. I still feel young in spirit, I still feel experimental. But the art world will look at thirty years of work and consider it enough for the lifetime of any man." Even more difficult, perhaps, was the prospect of returning to Holland. De Kooning was already feeling too old. Returning to the places of his youth, which he had left a half century ago, did nothing to assuage such feelings.

De Kooning recoiled from any direct confrontation with his past. When interviewers asked him why he had never visited Holland he usu-

ally became apologetic. "I was kind of scared of it," he said. "I believe I sometimes wanted to do it, but I was always a little frightened and so it never came off." About his Dutch years, he would say very little, even when pressed. "I lived with a sort of curtain which protected me from thinking too much about it." In part, the curtain was lowered to shut away his painful feelings about leaving his mother and sister, an abandonment that his mother never let him forget. Forty-two years after he had left Holland, and fourteen years after his mother's last visit to the United States, de Kooning would now face Cornelia again on her native ground. Cornelia, who was ninety-one years old, lived in a nursing home, her legs having finally failed after all those years behind the bar. Mentally, however, she remained as acute as ever.

The prospect of seeing Marie was, if anything, more difficult for de Kooning. He loved the older sister who had shared his childhood, often providing him with care and sympathy; she knew his childhood from the inside, as only a sibling could. For years, de Kooning had lived with the guilt created by his sudden departure, which left Marie alone with their angry mother. More than four decades later, the degree of de Kooning's guilt revealed itself in a remarkable act of indecision: he made no effort, as the trip to Holland drew closer, to organize meetings with his family. Neither Fourcade nor the Stedelijk dared to raise the subject with him. When his mother and sister finally asked the museum about his plans, de Wilde and Fourcade would tell them only that de Kooning planned to arrive the day of his opening—their way of suggesting that the master might, perhaps, be too busy for family visits.

As the show approached, de Kooning sometimes expressed a more general grudge against the Dutch. In 1968, only three de Kooning paintings could be seen in Holland. Two were at the Stedelijk, both purchased by de Wilde, and a third was in a private collection—a remarkably small representation. With their frugal nature and bourgeois values, the Dutch, de Kooning believed, had never nurtured artistic sensibilities, as witness the tradition of Dutch artists leaving the country. As one Dutch writer said in an article about de Kooning's return, Holland is a country "that would rather see artists go than come." But de Kooning still made good press. Months before the opening, the requests for interviews and photographs and visits to de Kooning's studio began to flood in. The Dutch newspaper *De Telegraaf* was the first to send a delegation. Many more followed. Several months before de Kooning's return home, teams of Dutch reporters and photographers assigned to cover "the immigrant who made good in America" were arriving fairly regularly on the Long Island Rail Road. De Kooning, unfailingly polite despite the intrusion upon his time,

typically greeted them at the East Hampton station, took them to lunch, and gave them a tour of his studio. But he did not enjoy the attention. "I don't understand why they're making such a fuss about things," he complained. "I just want to paint and sell my paintings. I don't want to change the world."

Not long before the show, Michael Wright resigned as de Kooning's assistant, exhausted by the life around him. "It got so confused that I didn't know how many hours I'd worked—what to charge him," said Wright. "It was a 24-hour thing. I used to have to help him take a shower, clean him up, dress him. All that made me feel that I didn't want to be part of him, although I liked him." Wright hated dealing with the ever-increasing stream of people who wanted to see de Kooning or get something from him. He regularly watched as visitors took drawings from the floor or coaxed them from de Kooning when he was drunk; now there was the added attention from the retrospective. "People would come up to you and ask for an appointment to see Bill," said Wright. "You were in the middle of everything. After a while you realized that you were working for this . . . national treasure. It turned me off." In the end, Wright treated a difficult situation much as de Kooning might have. He simply left without a word, telling Joan but not de Kooning that he was quitting. "Then I didn't see him for three months. I didn't want anything to do with him." When Wright finally did return for a visit, de Kooning was sympathetic. "He said, 'You know, I kind of understand why you wanted to quit. You're a good painter; you've got to have your own life.' And he was helpful to me in the art world."

At midsummer 1968, de Kooning was drinking steadily, and heavily. It became clear that his trip to Holland in September was in jeopardy. Because he feared flying, he had originally planned to go by ship and meet Fourcade in Amsterdam. But his alcoholism made taking a trip alone impossible. Knowing that he should not cancel, de Kooning fell back upon Joan for support. He had not invited her at first—a hurtful slight—but he did so now. And why not take Lisa as well, suggested de Kooning, and her friend next door, the daughter of Lila Moss, as a playmate? De Kooning also asked his old Dutch friend Leo Cohan to return with him. Although the two had moved in different directions since Leo engineered their trip to America together, de Kooning remained devoted to Cohan, who had settled in New Jersey and owned a vast jumble shop filled with old furniture, knickknacks, and gewgaws. Occasionally, Cohan would visit de Kooning. "He was very dear and my father was always very happy to see him," said Lisa. "He was very jolly. And he always brought these beautiful hand-carved clocks and antique scales that we still have."

Cohan agreed to accompany de Kooning. At one point, when de Kooning became so anxious that he threatened to cancel the trip, Cohan countered with a brilliant piece of wile. If you do not return, he told de Kooning, "The whole world will think you're eccentric." The prospect of being presented as an eccentric artist, one of the oldest clichés of modernism, so appalled de Kooning that he immediately took a brighter view of the trip. When the Stedelijk balked at the addition of Cohan to the party, de Kooning took offense. "There was some question from the museum that, well, he couldn't bring friends," said Lisa. "So he said, 'Well, then, I'm not going, either.' " Given an ultimatum by a heavy-drinking artist who hated traveling, the museum capitulated and agreed to reimburse him for the combined fare of almost $4,000 for the entire party.

The year before the retrospective, as de Kooning's dread built, he wrote a confession to Marie. He told her he could still find no love in himself for either of his parents. There had been no softening, over the decades, in his heart. About his mother, he said, "I am paranoid about her. With my self-centeredness and my unforgiving heart—I never forgave her." The letter suggests how close, in de Kooning, the child remained to the man.

Of course,—to think such things,—I admit—it isn't very grown-up.

I can't help it.
I stayed in this world of childish wonder

I think that a lot of creative people never grow up.

I am certain that a real man wouldn't paint any pictures!

Or wonder about the universe
Or believe in dreams.
Or think that trees sometimes look at him.

The first sighting of Holland was anticipated as impatiently as, once upon a time, de Kooning awaited his first glimpse of America. At three-thirty a.m. on September 15 he awoke in his stateroom aboard the liner the *Rotterdam* and looked out the porthole. "It was still very early in the morning and pitch dark," he said. There were no lights in sight, only the endless, black expanse of the sea. He knew, however, that land was approaching, that the *Rotterdam* would soon be passing the Hook of Hol-

land, the little promontory of land that juts out from the Netherlands into the sea, and he was too excited to sleep. He dressed and went up to the deck to await his first look at Holland in forty-two years. When it came, the sight brought an unexpected rush of feeling. "I was on deck when we were at the Nieuwe Waterweg [the great seaway leading from the ocean to the port of Rotterdam] and I marveled at all the lights on the shore," he later said. "I knew that Rotterdam had changed, that it is the world's busiest seaport today, but still I did not realize how and how much. I saw lights, lots of factories and I felt proud suddenly, very proud," he said. "After half an hour, daylight came, and I looked again. All the industry, all so clean, neat." He confessed, "I felt Dutch again."

In 1926, de Kooning had shipped out from the same port of Rotterdam, a stowaway hidden deep in the engine room of a freighter. Now he was returning a rich man, to a hero's welcome, the honored guest of the most influential museum of modern art in the flourishing country of his birth. Still, the artist who had worked so hard to reinvent himself as an American was not about to *become* Dutch again. Packed in his luggage de Kooning carried the Medal of Freedom awarded to him at the White House. It was a strange, childlike, and almost superstitious decision on the part of a sophisticated man to bring the medal with him, as if he must have a talisman to ensure that he would keep his American identity. The voyage was not easy. De Kooning was almost as fearful of boats as he was of planes. And he weathered the trip by drinking himself into a daze.

By the time the ship docked, however, he had pulled himself together. When he walked off the *Rotterdam*, followed by Joan and Lisa and his entourage, he was white and drawn but sober. Waiting for them was the photographer Claude Picasso, Pablo's son, assigned by the European edition of *Life* to cover de Kooning's visit. Also waiting was Leendert de Kooning, his half brother from his father's second marriage, as well as Leendert's wife and daughter. De Kooning had maintained little contact with his father's family since leaving for America. After the war, he had written at least two letters to their father, but when the elder Leendert died, communication had almost ceased. And so it might have remained had not Leo Cohan taken it upon himself to put the two sides of the family back in touch. The year before the show, he visited Leendert at the bottling plant in Rotterdam Noord that the younger Leendert inherited from his father. Cohan told him about the show and asked him if he wanted to see Bill when he returned to Holland. Surprisingly, given Leendert's extremely reserved nature, he had said yes. Cohan then told de Kooning of the meeting with his half brother, making it sound more serendipitous

than it had been. De Kooning was genuinely delighted. It was emotionally easier for him to meet Leendert than to see his mother or Marie. He wrote his half-brother, "Today Leo Cohan came to visit me here in East Hampton. I was so very surprised to hear that you and he walked into one another, and it was the nicest event for me in a long time. Your daughter and mine look so much alike, they could be sisters." He signed it, "Love, your brother Willem."

Now, here was Leendert and his family, along with a limousine sent by the museum to collect de Kooning and drive him the hour or so from Rotterdam to Amsterdam.

With old friend Leo Cohan in Amsterdam in 1968, at the opening of de Kooning's retrospective. Cohan smuggled de Kooning onto the freighter in 1926 that took him to America.

After greeting his relatives, de Kooning proposed a different scheme to the driver. He was touched that the Stedelijk would send a limousine for him, and he knew that there would be various officials and representatives of the museum awaiting him in Amsterdam, but he did not want to be whisked so hastily from Rotterdam. "I asked the driver of the car which was waiting for us to drive us around a bit." De Kooning's reaction was one of favorable surprise, just as it had been while he was still aboard ship. "I was astonished at the order and neatness," said de Kooning later. "I did not see much of the old Rotterdam I had left, but I was impressed." They drove along the Coolsingel, the old boulevard where the academy had once stood and where de Kooning had spent so much of his boyhood. With the exception of the town hall and the post office, however, both deliberately spared by the Germans during their saturation bombing of Rotterdam in 1940, little remained of the city center de Kooning knew.

"I was sorry to see a small park I used to know had gone [the park at the end of the Coolsingel where de Kooning passed the time with the Randolfis and other friends who lived on the margins of Rotterdam society]," said de Kooning. "But almost immediately I saw the town hall and the post office. I had seen them when they were brand new. They were not out of place now, and I admired them." De Kooning also liked the new and modern version of the Coolsingel, with its string of stark modern buildings. It was, said de Kooning, "an impressive boulevard now. I used to know it when it still was a canal." The subsequent drive to Amsterdam, shared with his Dutch family, was probably awkward given his half brother's reserve and the decades apart. Still, there was catching up to do and exclamations to be made about the striking similarity between Lisa and her first cousin. ("She looked just like me," said Lisa. "It was very strange.") Although de Kooning's arrival in Rotterdam went largely unnoticed, according to the *New York Times*, "by the time he reached the Amstel Hotel here [on one of the main canals of Amsterdam] he had to be wedged through a dense throng of reporters, art devotees and critics who crowded the lobby to get a first glimpse of the painter." The reception astonished both de Kooning and de Wilde. A country that treated artists poorly greeted its prodigal son as if he were a movie star. "When a biographical film of Mr. de Kooning was shown on television last night," reported the *New York Times*, "the staff of the hotel watched with such awe that one Dutchman remarked, 'It's almost like the coronation.' "

Interviewed at the time of de Kooning's opening, de Wilde chose to stress how American de Kooning's art was—intending, perhaps, an elegant comment on the nationalistic fervor. Tom Hess, who spoke at the opening, also emphasized de Kooning's American qualities. What mattered to the Dutch, however, was de Kooning's Dutchness. They loved having an international star to claim for their own. His show opened on September 18 to overflow crowds and enthusiastic reviews. A country that still accepted abstract art only gingerly now seemed intent on embracing the new. "I have never seen this in my life," marveled de Wilde, as the crowd built and built until prospective viewers crowded the street outside the museum. "Look at those people," he continued. "The name de Kooning has only been known in Holland for a few weeks." De Kooning was buoyed by the tremendous turnout. It was a welcome antidote to his sense of being left behind in America. Even in Holland, however, he could not forget the marked change of sensibility in New York. As he told one reporter, explaining somewhat cryptically why he had moved to the Springs, in the city "you're compelled to swing along with everything. You have to be careful what you say. Otherwise you can be easily out of

the loop. There's a progressive acceleration going in which you can only keep up if you communicate with a secret language." When asked who were the reigning artists in America, the possessors of the secret language, he answered, "Oldenberg, Newman, Rauschenberg and, nuttiest of all, Warhol."

Although flattered by the attention, de Kooning also hated crowds and the spotlight. Fourcade, in turn, worried that the strain would lead to an embarrassing drunk. A picture of de Kooning and Fourcade, taken the morning of the opening, showed a surprisingly relaxed-looking de Kooning dressed casually in slacks, checked shirt, and blazer. He was smiling broadly, like an American tourist out for a leisurely stroll. Fourcade was formally dressed in dark suit and tie, and his face registered nothing but worry and concern, as if he might have to thrust himself between the inquiring camera and his fragile artist. As the opening ceremonies approached, de Kooning's composure began to crack. By evening, as his party entered the museum through the crowded lobby, he appeared dazed. When the U.S. ambassador to the Netherlands, William Tyler, opened the show with an elaborate tribute in Dutch, de Kooning seemed to freeze with fear. He had expected the address to be in English, and his own Dutch, which he had hardly spoken in years, deserted him. He was unable to say anything in return and appeared, according to press accounts, flustered or "unmoved." Worse, the ceremony opening the retrospective became interminable, for it also included an award to de Kooning of the first international Talens Prize, which brought with it a $2,750 stipend and a lengthy citation. By the end, faced with the prospect of small talk and handshaking, de Kooning looked desperate to leave. According to one reviewer, Charlotte Willard, "He ran through the galleries without a glance at his pictures, and would have run right out onto the street if brick walls hadn't stopped him."

Deliverance came, appropriately enough, from the sister who had taken care of him in his youth. Suddenly spotting Marie in the crowd, de Kooning startled into focus. He seemed to forget that forty-two years had elapsed since their last meeting, or that he had failed to set up an engagement with her before his arrival. He excused himself from the eyes around him and made his way to her side. The next thing anyone knew, the guest of honor had left the opening with Marie and one of Koos Lassooy's daughters, having not braved the crowds long enough to see the show. Brother and sister retired to a coffee bar at the Amstel Hotel: Wim and Marie seemed to have no difficulty reconnecting. Whatever pain Marie had experienced at their separation, she was a woman who let bygones be bygones. She was emotional, but also understanding. "Marie had kind of a husky

With his mother in 1968 in Rotterdam, shortly before her death

voice and was very hearty," said Joan Ward. "If she lived [in the United States] you would probably have seen her in a cocktail lounge having a nice old-fashioned. She was very decisive. A version of her mother in her way. Both were very decisive, and very friendly."

Arranging a meeting with his mother was a different matter altogether. The intervening time since her visit in 1954 had done nothing to ease the memory of the feuds and screaming matches that summer. Still, de Kooning continued to be a dutiful son. For years, he had helped to support her and now was helping to pay for her upkeep in the PNIEL nursing home. It was one thing to support his mother, however, and another to show her respect or affection. Presumably he felt that if, at the age of sixty-four, he did not want to visit her, then he did not have to do so. However, the day after the opening, Marie and Koos came for de Kooning at the Amstel Hotel and drove him, Joan, and Lisa to Rotterdam, all the while telling him that he must visit their mother. As Koos said later, "He didn't want to go, but we persuaded him, and I think he was surprised by her fragility. And relieved. You see, she was a masterful woman who dominated the whole family."

De Kooning found his mother, still so powerful in his imagination, as fragile as "a trembling little old bird." With a kind of head-shaking wonder, he said afterward, "That's the person I feared most in the whole world." The same day, he, Marie, and Koos visited their father's beer-bottling factory in Rotterdam Noord, where de Kooning again saw the younger Leendert and perhaps laid the ghost of his father to rest. For the rest of the nine-day visit, de Kooning stayed in Amsterdam. Two days after the opening, he and Antonie Breedveld, Marie's son, returned to the Stedelijk to see the retrospective. But the crowds were still so thick that he left again without seeing his paintings, instead visiting the museum's great collection of van Goghs, which were housed nearby. He also went to the Rijksmuseum and marveled at the Rembrandts. After a few days, he

began to delight in simply being a tourist. "I feel happy to be in Amsterdam," he said. "The downtown area managed to keep some of the old atmosphere." On one day, de Kooning was taken to nearby Haarlem, the home of Franz Hals and an old town that retained, to an astonishing degree, its seventeenth-century appearance. There, de Kooning, Fourcade, and their party had lunch at an imposing "castle-like" building, as de Kooning described it. The ornate interior reminded him of the art nouveau style in which the Giddings had specialized some half century earlier. "It was like old times," said de Kooning, "seeing its decoration in the style of the Gidding brothers."

Eager to locate landmarks from his past, de Kooning searched for the street in Amsterdam where he had once lived with Marie. "There was a small bridge over a canal," he said, "but I could not find it any more. I felt so lost. It was near the Westertoren [West Tower], but I did not remember the number." Any twinges of nostalgia were more than offset, however, by de Kooning's impressions of the vibrant present. Again and again, he remarked on the prosperity that he found, no doubt contrasting it, in his mind, with the bitter poverty of his youth. "All those highways all over Holland," he said. "Like America, but cleaner and so neat." And the people themselves matched their new environment, he thought. "They wear better shoes," he said of the Dutch. He told one reporter, "I really was afraid to come. I thought it would be like coming back to an old family hotel where you had lived for years, sharing meals with the same people, listening to the same boring stories over and over again. I was quite wrong. Slowly everything is coming back, but not as an old story. There is a new vitality in everything that makes me feel really at home."

By the end of his visit, de Kooning had become so comfortable that he even lapsed, now and then, into Dutch. For years, he had resisted speaking his native language, using it only when his mother returned for a visit— and then grudgingly—or when Dutch visitors such as his cousin Henk Hofman's wife came to see him. Now he began to speak it again, if in a "slow, difficult" way, as one reporter described it. "How do you like my Dutch?" de Kooning asked one writer, obviously delighted with his progress. He was equally pleased when two old friends accosted him in the Holbein café-terrace of the Amstel Hotel. Pieter van der Ouderalder, a cartoonist for a Rotterdam newspaper, and Jan Smit, a contractor, had both known de Kooning as a boy. Van der Ouderalder had been at the academy, while Smit had been a neighbor. De Kooning insisted that they join him for coffee and a good reminisce about the past.

After his nine days in Holland, de Kooning planned to travel to Spain with Joan and Lisa. He wanted to see the Goya and Velázquez paintings in

the Prado. As the time drew nearer, however, he changed his mind; the time spent away from his easel was beginning to make him restive. "I can't leave my painting for too long," he said. "I feel a need to get back to it." The next show at Knoedler also weighed on his mind. "When the New York show opens in the spring [after traveling to London, the retrospective was slated to go to the Museum of Modern Art] I'll have a concurrent show at Knoedler of my latest works," said de Kooning. "I'll have to get them finished." And so, when the day came to leave Holland, de Kooning, Joan, and Lisa—loaded down with "tons of bags," as Ward recalled—boarded a plane bound for New York. There to say good-bye were Leendert and his family, who picked up the party at the Amstel Hotel and drove them to Schiepol Airport. Throughout de Kooning's visit, Leendert had been attentive, while keeping a dignified distance. In addition to the initial meeting between the two families, they had had one dinner and now, at the end, a farewell. It was just the right approach for de Kooning—low-key and unassuming—given his dislike of the "stickiness of family." When they parted at the gate, recalled Leendert, Bill turned and kissed him. Leendert was surprised and touched. It made a lasting impression on him, he said, because it was not "the Dutch way."

De Kooning was hardly back in the Springs when word arrived of his mother's death. It was easy to suppose that Cornelia, who died on October 8, had willed herself to stay alive in order to say good-bye to her son. De Kooning showed no emotion at the news. Initially, he did not even tell Joan about his mother's death. She heard about it from Hess. "I said, 'Bill, did your mother die?" 'Yeah.' 'When?' 'About two weeks ago.' I opened my mouth to say, 'Why didn't you tell me?' and then I closed it."

That autumn, failing to find renewed direction in the studio, de Kooning agreed to attend the opening of his retrospective at the Tate Gallery in London on December 8. The week before he was to leave, he and Joan went to Thanksgiving dinner at the home of Cile Lord Downs. (At the time, Downs was married to Sheridan Lord, a painter later admired for his Long Island landscapes.) The couple had made large Thanksgiving get-togethers a tradition for several years. "We would set up an enormously long banquet table made out of everybody's card tables," she said. By the time the dinner began to wind down, said Downs, the guests were drinking heavily. On the drive home, Joan and de Kooning had an accident. Soon afterward, de Kooning wrote Hirshhorn: "We could have been killed. Twas a miracle. We're going very slow, very slow. That saved us. Right into a telephone pole." De Kooning's forehead smashed into the wind-

shield, shattering the glass, and Ward broke three teeth and injured her right hand. "It's a very funny thing," de Kooning continued. "This one awfull [sic] lousy moment—that fat—black creosoted pole . . . and then . . . like Jacky Gleason says— . . . away we go!"

De Kooning canceled the trip to London. It was just as well, for the reaction to his work was reserved. The English critics expressed particular doubts about de Kooning's paintings of the sixties. Writing in the *Times*, Edward Lucie-Smith described them as having been painted, seemingly, in lipstick. "In these, the artist 'thinks pink' till finally we are no longer looking at countryside but candyfloss. The nudes, meanwhile, edge closer and closer to the banal hues of a Vogue colour-spread, but the colours are employed, alas, without a trace of irony." The call for irony was characteristic of a certain element of cultivated English taste, which blanched before de Kooning—partly for class reasons. Irony, often a weapon of class, was not a quality that he emphasized, preferring gusto and a "reckless abandon" that was foreign to a country like England. (England would never have produced a Rubens.) Critics also did not respect the constant change in his work. Lucie-Smith wrote, "De Kooning seems to have run through as many periods as Picasso, and the indications are that these changes are the product, not of originality but of uncertainty."

De Kooning and Ward spent December recuperating from the car crash. Christmas was not very cheerful. "He never really thought about those things," said Lisa of her father's lack of Christmas spirit. "He talked about Christmas when he was a child. The name was different and Santa Claus had brown boots and wore a leather outfit." (However, de Kooning did make Lisa a small Santa Claus painting that the family would take out every Christmas.) In January, Hirshhorn asked de Kooning to join him at the groundbreaking ceremonies for the Hirshhorn Museum and Sculpture Garden in Washington. De Kooning did not feel up to the trip. In a letter to Hirshhorn full of his idiosyncratic English, he explained, "I am writing you all this because I really wanted to come to Washington . . . but I yust could'nt." The reason, he said, was that he was "to worried to lose the rythm of working." He added that he had been at work "for weeks and weeks on end on a large picture . . . and have to keep the paint wet . . . so that I can change it over and over,—I mean, do the same thing over . . . and over, and that it will look fluid than . . . and fresh.—as if it was really a small picture."

De Kooning was not just making excuses: he was still worried about creating enough work for the next show at Knoedler, which was timed to coincide with the opening of his retrospective in March at the Museum of Modern Art. The trip to Holland had interrupted his concentration, mak-

ing 1968 almost a lost year. His last major painting had been the masterly *Figures in Landscape* of 1967, in which he had melded figure and ground seamlessly. Although he had subsequently completed a series of "women in landscape" paintings, he had put most of his energy into hundreds of drawings, both because he was in a searching mood and because he was able to draw in between interruptions. Given the response to his first Knoedler show, de Kooning anticipated more hostility, but, unexpectedly, his work was now beginning to sell somewhat better. Fourcade responded to the failure of the 1967 show by *raising* prices and constantly pressed de Kooning's case with collectors and museums. Fourcade was correct in his assessment that sentiment would eventually turn de Kooning into a revered survivor and founding father. By 1969, a de Kooning oil might sell for as much as $75,000—then a huge sum.

As the retrospective at MoMA approached, the first glimmerings of this new form of social adulation began to appear. De Kooning might be a painter in decline, but he was still *de Kooning*, the very one who had palled around with Jackson Pollock. The artist's relative seclusion on Long Island only increased the air of mystery surrounding this fascinating dinosaur. By February, critics and journalists were requesting visits to the studio. It seemed that every magazine that had not covered de Kooning's triumphant return to Holland now wanted to profile "the Dutch-born U.S. master," as *Look* hailed him in a feature that interspersed reproductions of his paintings with photographs, including a huge photo of the studio. Dan Budnik, a longtime photographer of the artist, portrayed de Kooning walking alone on the beach bathed in the golden light of late afternoon, his longish hair swept back by the wind. It was a story that the public never tired of reading: the romantic genius, storm-tossed by doubts, but still handsome and prolific as he weathered into a wise old age.

Even larger than the version at the Stedelijk and the Tate, the MoMA retrospective contained 147 paintings, drawings, pastels, and collages, presented in eleven rooms of the museum. As usual with a high-visibility exhibit, the museum organized a gala dinner and viewing for the opening night. The show at Knoedler covered only a brief period, works completed between January 1968 and March 1969. Not surprisingly, de Kooning began looking for reasons not to attend the New York openings. According to Ward, he rarely worried before a show; but this was an exception. Not long before the opening in early March, he told Irving Markowitz that he intended not to go. Markowitz told him that he must. If I go, de Kooning countered, then you must also. "I didn't want to go," Markowitz said. "I had left behind black tie and all of that jazz." But he acquiesced. On the

afternoon of March 3, the two men left for the city. The opening-night gala seemed to be a great success. The several hundred invited guests ranged from Lee Eastman and his wife, Monique, to a sprinkling of Rockefellers and art world lions like Larry Rivers, who was ostentatiously dressed for the black-tie event in a bomber jacket and T-shirt. Joan and Lisa stayed near de Kooning, Joan in a stylish Geoffrey Beene dress and Lisa, now thirteen years old, in brown velvet and pumps. Markowitz stood guard should de Kooning begin to drink too much. De Kooning saw to it that old friends like Mary Abbott were invited and given seats of prominence. "I got dressed up and had my hair done and thought, 'I'll get to the door and they'll say, "Mary Abbott? Who's that?" ' " said Abbott. "But it turned out that I was sitting on his left on the dais."

In the end, the critical reaction was more dutiful than passionate. By 1968, the issues raised by de Kooning's art seemed well rehearsed to the art world. Those who despised the cuties of the sixties had already expressed their views on the occasion of the 1967 show at Knoedler. Since even de Kooning's fiercest critics admired his earlier work, their treatment of his retrospective had a regretful "on the one hand and on the other" tone. Some acknowledged that de Kooning was forced to pay for the sins of his followers and that the fashion for pop now made it difficult to judge his work. When Warhol's soup cans were being celebrated, in short, de Kooning's old-master stylishness was bound to disappoint. One intelligent, if withering, review came in *ArtForum* from Walter Darby Bannard, who compared de Kooning's all-over style unfavorably to Pollock's. It was Bannard's view that de Kooning had long worked against his own best talents as a draftsman. Calculating that a sort of expressionistic cubism would prevail, Bannard argued, de Kooning had blown up his draftsmanship and used color in order to be an all-over painter like Pollock. But it had never worked, concluded Bannard, after the "very fine" black-and-white paintings of the late forties, which he thought de Kooning might not have considered ambitious enough. With the large *Excavation*, de Kooning was already out of his depth, Bannard believed, and the subsequent return to the figure had been a "symbol of defeat" and "desperate retrenchment." In *ArtNews*, Andrew Forge raised similar issues— but cast them in a strongly positive light. He agreed that de Kooning's expressionist side seemed over the top at times and that the tension between figure and ground was never fully resolved. But like Hess and Rosenberg, he viewed such contradictions as part of de Kooning's power: "his pictures, restless and contradictory as they are on so many levels, are always calmly and definitively *there*." Something in the painting with-

stood the mayhem of the surface. Forge also praised what he regarded as de Kooning's rare place in contemporary art, as one of the last to confront experience directly.

ArtNews, where Hess was still editor, also praised the Knoedler show. John Perreault hailed the "joyously squashed, smashed, flung up against the wall" women and stressed de Kooning's humor and energy. "There is something youthful about de Kooning's new work. If he were 25 instead of 65, unknown instead of celebrated, he could easily be heralded as a new boy wonder, moving in some personal way beyond the anti-form obsession of other young artists. How interesting to see real paint on canvas again!" Perreault also attacked the attackers, an implicit recognition of de Kooning's emblematic position in the culture wars. "His new works are shocking because they are of high quality, but do not cater to current fashions and clichés." De Kooning's debt to cubism, moreover, looked "more and more like an art-criticism fiction, a dodge or an irrelevancy." He even suggested that the "paintings are just as interesting for what they dare as for what they actually accomplish," adding, "Formal criticism cannot approach his works because his paintings are closer to life than to art."

With the distractions of exhibiting over, de Kooning began to increase the pressure upon himself in the studio, searching, as always, for something fresh. He continued experimenting with an off-center axis for the figure. And he began to change his palette. In the past, the conclusion of a period in his art was often foreshadowed by a change of palette. In the previous two decades, he moved from the black-and-whites to primary colors and then to what he dubbed "circus colors"; in the early sixties he adopted the pale peaches and pinks and turquoises of his "Howard Johnson" phase, named after the blurry pastel swirls in which one flavor of ice cream melts into another. Now, as if deliberately flouting those who dismissed his sixties women as vulgar and his colors as candyfloss, de Kooning deliberately keyed up his palette to the shrieking point. In *Montauk I,* the start of a small series that showed little evidence of the figure, he used some brilliant reds and yellows. The most dramatic effect, however, came from the pale turquoises and darker greens that permeated the canvas, making it seem watery. Although de Kooning's work of the mid-fifties was sometimes highly keyed, it also contained lines drawn in dark charcoal or painted in black enamel, which anchored the image and brought order to the color. Now, the anchoring lines were gone: all that was left was great, flowing strokes of paint.

Montauk I and the subsequent paintings did not move quickly off the easel, a sign, perhaps, that de Kooning had not found a new approach that satisfied him. He continued to draw, often with his eyes closed, shutting

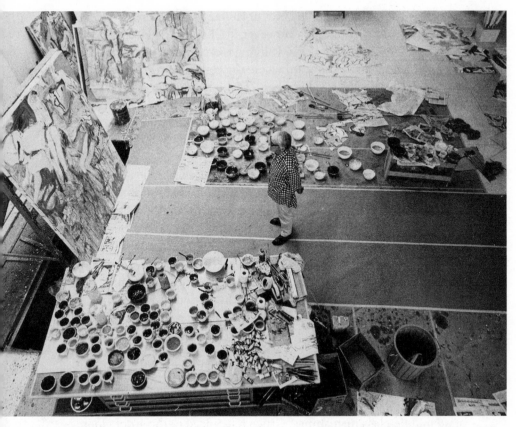

In his Springs studio, 1968

out the world in order to feel his way to something fresh. Restless as always, he considered moving into the studio, away from the cramped house on Accabonac. But he was not sure whether or not he should leave Lisa. Sometimes, he thought of moving the whole family into the studio. "I always say, maybe one day we'll all move in here and I'll get rid of the little house," he told John Gruen. That spring, he and Joan decided to enlarge the Accabonac cottage. Originally a summer place, it seemed smaller than ever with Lisa a teenager. They planned to add a large living-room wing to the front of the house, adjacent to the small existing one, and extend the kitchen. Next to the garage that de Kooning used as a studio in 1963, they intended to construct a swimming pool. "Bill loved building," said Joan. "He stood over me at the drawing board and said, 'This is going to be fun, Joanie.'" They "argued for two weeks about where the swimming pool was going to go. He wanted it straight; I wanted it at an angle." (De Kooning also preferred to leave the fill around the pool,

creating a bank that reminded him of Holland.) In the end, Ward did most of the planning and design. However, de Kooning added an interesting grace note. At one end of the new living room, which had a cathedral ceiling, he placed a small cupboard where the ceiling came to a V. "If you look way up there, there's this door that leads to nowhere," said Lisa. The cupboard could not be reached and had no purpose but looked enigmatic and somehow right—enlivening, mysteriously, the big room.

Of course, pools and living rooms were only an incidental interest. De Kooning, always his own toughest critic, recognized that he still hadn't created a major style in the Springs. The images of splayed women were lively, intense works of art, but lacked the largeness of sensibility—or soul—found in his earlier art. Like much of his work in the sixties, they also seemed diminished by a kind of gnawing, sexual irritability. Just how gray de Kooning's life could be was memorably captured by John Gruen, who interviewed the artist during this period. Before driving to the Accabonac house, Gruen telephoned ahead, rousing de Kooning only after a long while. Joan and Lisa were not there. "Bring me a small shot of whiskey," de Kooning told him. When Gruen appeared, he found de Kooning looking like a wreck in a house that was empty except for the blaring sounds of a large television. "You know, it gets pretty lonely out here," de Kooning told him, eyeing the liquor bottle. "That's why I keep the television running. What I do, see, is, I turn the TV on, then I go upstairs and lie down, and then it sounds as though there were people downstairs." The staid middle-class furnishings, Gruen felt, added to the air of gloom.

In contrast, the echoing emptiness of the silent studio to which de Kooning then took Gruen struck the writer as full of promise. Everything in the huge kitchen gleamed. The bedrooms upstairs, two years after the carpenters and painters had finished their work, appeared stark, empty, and fresh. Inside the closets were heavy wooden clothes hangers. "I always promised myself that one day I would own the most expensive clothes hangers available," he told Gruen. "I never wanted to see a wire hanger again in my life." Each one had cost him $12.50, he announced proudly. The effect, Gruen thought, was that of a "dream house, never to be inhabited."

34. Mud in Your Eye

The figure is nothing unless you can twist it around like a strange miracle.

What would you think, asked Priscilla Morgan, a publicity agent and a casual but old friend of de Kooning's, of coming to Italy this summer? Morgan was promoting Gian Carlo Menotti's Festival of Two Worlds in Spoleto, an Umbrian town about an hour from Rome, where a small show of de Kooning's work was planned. De Kooning was tempted by the offer: trips were becoming a way for him to escape from the pressures, both domestic and artistic, of life in the Springs. When a reporter in Amsterdam asked him if he would ever return to Holland, he said no, but that he did think of going to Italy: "I feel an affinity there." He also understood that Morgan, whom he had known since the 1950s, would take good care of him. Attracted to celebrities and fame, she had sometimes helped him dry out in the old days in New York and he was fascinated by the theater world she inhabited and admired her command of details and scheduling. She respected him enormously and hoped, she admitted, that de Kooning would one day become romantically interested in her.

Italy's foremost contemporary composer, Menotti had established his festival in 1958. It encompassed not only opera, Menotti's particular passion, but all forms of music. It also included an annual show of art. The art exhibition, Morgan told de Kooning, would run from June 28 through July 13. De Kooning could attend the festival as a sort of informal artist-in-residence during that period; he would be honored along with the poet Ezra Pound. Once de Kooning agreed—"I have a little vacation coming to me," he wrote the Hirshhorns—he made a surprising decision: he invited Susan Brockman to accompany him rather than Joan and Lisa. Since the end of their affair, de Kooning and Brockman had remained good but distant friends. He sometimes visited her when he came to New York for one of his frequent dental appointments. Susan, after some initial surprise and hesitation, agreed to join him. Not surprisingly, Ward was furious. De Kooning's decision also hurt Lisa's feelings. Both she and her mother had hoped there would be more family trips like the one to Holland. Late that June, de Kooning arrived at Morgan's duplex on Sixty-fourth Street carrying several wallets, each stuffed with a wad of hundred-dollar bills. Sev-

eral days later, he flew with her to Rome, where Brockman intended to meet him later.

The Rome to which de Kooning returned had changed little since he and Ruth partied away the waning months of 1959. But de Kooning himself certainly had a different perspective. Perhaps, by going to Italy with Susan, he could reawaken a sensation of youth and promise. De Kooning and Brockman had never formally concluded their relationship, and he never tired of her. Perhaps they could still make a life together. Once in Rome, de Kooning immediately made it clear to Morgan that he was not in a mood to socialize. He had brought sketch pads with him, and wanted to work. Morgan booked him a suite at the Albergo Nazionale in Rome, her favorite hotel and just a short walk from the Piazza Navona. She also got him a room in Spoleto at Menotti's house, a Renaissance palace. De Kooning could spend the week in Rome and weekends in Spoleto.

After he arrived, de Kooning began brooding about the lack of studio space in Rome. And in Spoleto, where he was expected on weekends, he found the demands upon his time burdensome. Then, one afternoon, he was touched by serendipity. He was sitting with Priscilla Morgan at a small café off the Piazza di Santa Maria in Trastevere, across the Tiber from downtown Rome. A working-class neighborhood of artisans and craftsmen, where a slangy subculture flourished, Trastevere was a part of Rome where de Kooning felt particularly at home. Around four-thirty each afternoon, when the furniture-making and cabinetry shops in the neighborhood closed, the central square would rapidly fill with workers having an *aperitivo* and also with members of the Italian film community, who had moved into some factory spaces in Trastevere. De Kooning was sitting behind some waist-high flower boxes filled with green hedge when, suddenly, a man poked his head over the hedge and exclaimed, "My God, it's Bill de Kooning."

It was the sculptor Herzl Emanuel, who had lived in Rome since 1962. "I was driving through in my minibus," said Emanuel. "And there he was. I hadn't seen Bill since the middle fifties. I pulled the car over and said, 'Bill.' And he said, 'Ah, Herzl. I knew you were in Europe.' " Although de Kooning and Emanuel had drifted apart, their acquaintance was a long one, dating back to the Depression and the WPA era—a fact that always mattered to de Kooning. In the thirties and forties, Emanuel was actively involved in the Communist Party. In the early fifties, when de Kooning proposed Emanuel for membership in the Club, the sculptor was uncomfortable with the group's revisionist political bent. "I didn't like the way they were going," he said. "They were shedding any vestiges of left-wing orientation. McCarthyism was going, and everybody tried to clean their

skirts." As a result of the red scare in the fifties, Emanuel was dismissed from his high school teaching job in New York and eventually moved to Rome, where, through a lucky break, he took over a large former factory space in Trastevere that included a crude foundry. "I wasn't interested in the foundry, but I was in the space, which was like a big New York loft," said Emanuel. By the late sixties, he was a well-established sculptor in Rome with a family—and a foundry. "We had a very warm greeting," said Emanuel of his meeting with de Kooning, "and then they piled into my bus and we went to my foundry." It was located on the Via dei Riari, a small street not far from Trastevere's main square. The buildings lining the street generally dated back two centuries. In the foundry's wall was a heavy old door, behind which a walkway led to a long and low second building set back from the street. Up the hill from this building were Rome's botanical gardens. The architectural effect was startling, as if one were wandering from modern Rome into another century. According to Emanuel,

> When Bill came in, he fell in love with it. The walls, the floor, the pit. He said, "My God, it looks like the days of the Renaissance. The Etruscans." Then he saw my pieces. I had stuff being prepared for casting. He said, "Where's your studio?" I said, "You want a studio here? I have a lovely little studio." It had a big skylight, and it looked out on a little garden. There were a lot of cats in it, but it had charm. He was so carried away by the ambience.

Emanuel soon established de Kooning in the studio. Inspired by his strange and ancient-seeming surroundings, de Kooning became excited by the possibility of doing some sculpture. "Bill said, 'Do you suppose I can get my hands on some clay?'" said Emanuel. "He was hanging around Spoleto with not much to do"—creating a series of blind drawings, one of the few things he could do with no space of his own—"and he saw the opportunity to make his stay far more productive. And have a brand-new experience."

For the next week or so in Rome, de Kooning settled into a studio routine. By then, Susan Brockman had joined him. Each morning, he and Susan would meet Emanuel, and they would walk to the Via dei Riari, where de Kooning would work until late afternoon. "He'd be asking me little questions," said Emanuel. "He was doing very nice, impassioned little figures. They looked like a group of figures on a beach. I left him alone, but I did comment on his work. I thought he was having a marvelous time. To me the figures were in the spirit of his blind drawings." De Koo-

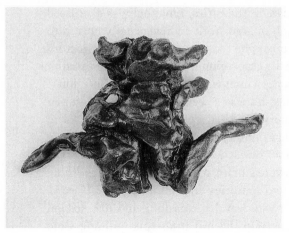

Untitled #2, *1969, bronze, 6 ³/₄" × 10³/₄" × 3"*

ning became so involved with his new project, in fact, that Susan asked Emanuel not to tell anyone of his presence, for fear of interruptions. "I agreed to keep it an absolute secret," said Emanuel. "Some Americans said to me, 'Isn't that Bill?' And I said, 'No, no, no.'"

From this short burst of work came thirteen small sculptures. While making them de Kooning imagined, as Emanuel said, a beach tableau. The smallest figure was seven inches high but only three and three-quarters inches across; the largest was a little over fifteen inches high. Each was stretched and pulled and pummeled, much as the figures were in his recent paintings. The first two leaned back with their legs splayed out awkwardly in the squat, pinioned pose of the figures in his *Women on a Sign* series. Others appeared to be something between figures and inanimate objects. *Untitled No. 5*, a figure thirteen and three-quarters inches high, stood more or less conventionally upright. Like de Kooning's drawings of the time, the sculptures were done with his eyes closed and, while not abstract, evoked the feel rather than the appearance of the body. Heavy limbed and earthbound, with something of the primordial ooze about them, each seemed in the process of being born. In contrast to the smooth and anonymous surfaces of much modern sculpture, the figures, each remarkably personal, were full of thumb- and fingerprints: de Kooning's hand was always close at hand.

The painter relished the touch of this new medium, in which he could translate his instinctual feel for the human body directly into the clay itself without the interruption of the brush. He would work from mid-morning until early evening. Then he and Susan, sometimes accompanied by friends, would go out for dinner, followed by late-night strolls around the city to unwind. Much as he loved working, de Kooning also loved Rome at night. "We would walk all night," said Morgan, who regularly joined de Kooning on her free days. "He was a night person." Always conscious of poor working people, de Kooning liked to buy flowers from the old women who hawked them nightly in the fashionable cafés of Rome.

One time, said Morgan, they saw the same woman twice. It was very late the second time, and de Kooning gave her money. In a show of gratitude, she piled all of her unsold bouquets onto Priscilla.

The Spoleto festival came to life on weekends, when de Kooning was expected to be in attendance. His quarters in Menotti's palace were luxurious. An elegant butler looked after the house and took care of the guests. Each morning, the butler offered to make de Kooning's bed, which de Kooning could not tolerate. According to Morgan, "Bill said, 'He's too handsome. He looks like a nobleman. He shouldn't make my bed.'" In the sixties, Spoleto had not yet become crowded with tourists. "The concerts were on the very highest levels," said Emanuel. "The emphasis was on youth, and there were also marvelous dancers. We got tickets to everything and anything. . . . The whole place is theatrical-looking. It has wonderful baroque palaces, and a big piazza. There are also a number of small theaters from Renaissance days. It was made for performance arts." Although de Kooning loved the theater, he rarely went in America, so he particularly enjoyed the performances. There was also a continual round of partying among the celebrated guests whom Menotti attracted. At one party, the guests included Ezra Pound and two old friends of de Kooning's: Buckminster Fuller, who had been at Black Mountain with Bill and Elaine; and the sculptor Isamu Noguchi. De Kooning was also given an airy backstage room in a theater as a workplace, where he made some pen-and-ink drawings.

De Kooning and Brockman got along well, but it soon became clear that they were destined to remain friends rather than to renew their romantic relationship. Both keenly felt their difference in age, and Brockman was not feeling well during the Italian trip. De Kooning's passion was for the clay, and she delighted to see his absorption in the new medium. "Towards the end he was obviously very pleased," said Emanuel. "He said, 'Geez, you know, this is wonderful,' and he was very grateful. He had a very good working period in Rome. He had said, 'You know, these trips, they can be very disruptive.'" De Kooning was so pleased that, after much hesitation, he asked Emanuel if the little figures could actually be cast. Emanuel assured him that they could be. The process involved firing the pieces, made of water clay, in a kiln. From the hardened clay a mold would be made, which would then be used for casting the sculptures in bronze. "Mind you, I'll pay you," de Kooning told Emanuel.

De Kooning flew back to New York at the end of July. At first, he stayed with Brockman and then, characteristically, gradually went to see Joan and Lisa. Ward was still upset by de Kooning's seemingly inexplicable overture to Susan. In time, however, de Kooning returned to his house in

the Springs. The memory of the foundry lingered. Perhaps working "blind" with charcoal, and now, unexpectedly, clay, was cleansing his eyes and making possible a new beginning; perhaps a blind man's touch would reopen his eyes. Not long after his return, he wrote Emanuel a typically rambling, chatty letter. "The last couple of days, that strange, hot odour of your foundry came back into my nose . . . and those strange mysterious quiet brick mound's coming out of the ground came into my head again . . . the men working . . . the dog . . . and the junk in the Italien backyard. And it certainly was nice of you when you told me to come over. And I am glad and grateful that I did!" The purpose of his letter was to see how serious Emanuel was about casting the little sculptures into bronze. The two had tentatively agreed upon making six editions of each work. Since de Kooning would be back home at the time of the casting, Emanuel had told him that he could not sign them, but that they could nonetheless be dated and numbered, and "de Kooning" written upon them. "I know how things are . . . but I hope that you still are willing to go ahead and do what we agreed upon," wrote de Kooning. "To go ahead and cast what ever you think can be done which ever way."

Despite his experience in Rome—and the fact, as he wrote to Emanuel, that he was "really taking it [sculpture] serious enough"—de Kooning did not resume making sculpture upon his return to Springs. He may have felt too daunted to continue without Emanuel's know-how and encouragement. Perhaps the experience also seemed foreign, something that had occurred almost magically while on vacation and could not be repeated once he returned home. However, he did insist upon enlarging one piece, the tiny *Seated Woman*. At the recommendation of Sculpture House in New York City, which helped sculptors with everything but the actual casting of their pieces, he hired David Christian, who had worked there, to make a larger trial version, twenty-five and one-half inches tall. Christian was not a specialist in the highly technical process of enlarging, in which an artist's maquette is blown up by stages using a pantograph or gridding machine, and *Seated Woman* would have proved a challenge, in any case, for even a highly trained enlarger; there was not a uniform contour anywhere on the work. The surface appeared ravaged, since de Kooning had compressed the clay into countless ridges and craters. The figure's arms resembled wings; the legs were stumpy; the bottom part of the work was detached and rested beside the figure. In the end, the painstaking process took months, with Christian doing much of the enlarging by eye alone, adjusting and calibrating along the way. When Christian finally finished enlarging *Seated Woman*, the Modern Art

Foundry in Astoria, Queens—which was located in the former stables of the mansion of the piano-making Steinway family and adhered to the same tradition of European craftsmanship—was selected to cast it.

As winter approached in late 1969, de Kooning, still struggling at the easel, began to sink into the well-known routine of drinking and fighting. Although the Italian trip gave his assistants a brief respite, John McMahon and Irving Markowitz, who (along with Ward) mainly took care of him during the binges of the previous five years, were tiring of the work. Increasingly concerned by what he regarded as de Kooning's depression, Fourcade once again decided to provide a diversion, this time a January trip to Japan. The World's Fair would open in Osaka in March 1970 and would include an exhibition of works by contemporary artists from many countries, including de Kooning, whose work had never before been exhibited in Japan. Isamu Noguchi would also be there working on a pavilion for the fair. In the past, de Kooning had never paid much attention to Chinese and Japanese painting; its air of immateriality did not particularly attract an artist devoted to the fleshiness of paint. In his "Renaissance and Order" talk of 1950, he said: "I admit I know little of Oriental art. But that is because I cannot find in it what I am looking for, or what I am talking about. To me the Oriental idea of beauty is that 'it isn't here.' It is in a state of not being here. It is absent. That is why it is so good. It is the same thing I don't like in Suprematism, Purism and non-objectivity."

De Kooning agreed to make the trip. For assistance in planning it, Fourcade called upon Kermit Lansner, the editor of *Newsweek* and the husband of the painter Fay Lansner, a member of the second generation of abstract expressionists. A keen observer of the art world and an admirer of de Kooning, the editor then asked the magazine's Tokyo bureau chief, Bernard Krisher, to help plan the itinerary. A noted figure in Japan, Krisher, whose many responsibilities included entertaining dignitaries and editors on their trips to Japan, was eager to meet de Kooning. He provided Fourcade and de Kooning with hotel accommodations, introductions, the services of a translator, and suggestions for various excursions. Their first stop was Tokyo, where de Kooning's introduction to traditional Japanese style was the Fukudaya, a charming Japanese inn or *ryokan*—one of the few left in the country—that elevated simplicity into an art. The floors were covered with *tatami*; the walls were the sliding paper partitions of traditional Japanese architecture. In such inns, individual rooms often contained only a small table and one decorative scroll, supplemented each night by futon mats placed on the floor for sleeping. Slippers were worn inside—never shoes—and baths were taken in shared pools.

The effect was spare, elegant, and serene. Fourcade hoped the serenity would influence de Kooning's behavior. Before leaving for Japan, the art dealer impressed upon him the need to remain sober. De Kooning promised to behave, but Fourcade still watched him carefully.

In Tokyo, the days were filled with entertaining. There were parties for eight or ten people at Japanese restaurants; de Kooning met his Japanese contemporaries, the artists Shiko Munakata and Jiro Takamatsu, and several leading dealers and art critics. Not surprisingly, Japanese art interested de Kooning more than the Japanese art world did. Accompanied by Fourcade and the translator Wakako Ogawa, he paid a prolonged visit to the Tokyo National Museum. Of all the works on display, he was most moved by Sumi painting, a style closely associated with Zen Buddhism, in which the artist draws with an ink-soaked brush. Monochromatic and calligraphic, Sumi painting resembled, to some extent, de Kooning's black-and-white pictures and Franz Kline's abstractions. It may have also reminded him of his recent sculpture. Sumi painting emphasized touch, freedom, and an escape from past practice. A Sumi painter would probably have understood the desire to work "blind."

After Tokyo, de Kooning and Fourcade traveled to Osaka, the site of the upcoming exhibition of contemporary painting. Fourcade intended to make arrangements for the loan of paintings. He was also eager to find new collectors. "I think the real purpose of the [Japanese] trip, for him, was to meet potential clients," said Krisher. "I was trying to suggest a de Kooning show to the Seibu people, who own the Sezon Group department stores. It's the department stores that have the major exhibitions here. What they wanted was a retrospective, since de Kooning was not such a big figure in Japan in terms of collecting. But Xavier brought up the fact that any show would have to be a Xavier show"—one limited to recent work that Fourcade himself handled and which was for sale at the gallery. While Fourcade engaged in business, de Kooning saw Japan's second-largest city. Osaka, more industrial than Tokyo and just as overbuilt, was not a common destination for tourists. But any lack of charm was offset by the presence of Noguchi, who was creating his waterworks project for the upcoming World's Fair. Aware of de Kooning's interest in the sexier side of popular culture, Noguchi took him—without Fourcade—on a long nocturnal outing through the city. The evening began with dinner: Osaka was known for distinctive fish dishes, including raw and boiled globefish and blowfish. Then they went to a Japanese-style massage house. From there, Noguchi and de Kooning moved deeper into the glittering Dotonbori, the entertainment quarter of Osaka. At one point, de Kooning, no doubt emboldened by alcohol, began to make passionate advances to a

Japanese stripper. Noguchi was highly amused. Years later, whenever he visited de Kooning on Long Island, he would always refer with a twinkle to the club in Osaka.

De Kooning's main taste of ancient Japanese culture came when he traveled to Kyoto and saw the Grand Shrine of Ise. Perhaps the high point of his trip was his last and quintessentially Japanese experience: a visit to Mount Fuji. De Kooning stayed nearby, at the Mount Fuji Hotel, but spent most of his time at a two-story wooden house owned by the Krishers at Lake Yamanako, at the foot of Mt. Fuji. The ground floor was filled with Japanese artifacts that interested de Kooning, including signature seals. The second floor contained a spacious living room, with one window that framed a spectacular view of the mountain. "January is the clearest month," said Krisher. "You could see Mount Fuji on the left and the lake before you."

As a rule, de Kooning was not especially affected by trips abroad. He enjoyed his larger-than-life stay in Rome in 1959 with Ruth Kligman and talked about it for years afterward; but usually it was all one could do, said Lee Eastman, to get him to talk about subsequent visits. It was different this time. "He was very impressed with Japan," said Markowitz. "There was a quietness in Japan, to the people. He appreciated that." The art also remained with him. "He liked the calligraphy," said Markowitz, "and he loved the rice paper." Even so, the trip did nothing to assuage de Kooning's restlessness. In April, the English sculptor Henry Moore came to New York for a show at the Knoedler Gallery and visited de Kooning in the Springs. After examining many large works in silence, Moore expressed an outsized admiration for a small drawing—a response that did not please de Kooning. However, Moore also saw de Kooning's Italian sculptures in New York and told Fourcade that he liked them. They would be stronger if enlarged, he said, perhaps to the monumental proportions of Moore's own work. Until then indifferent to the sculpture, Fourcade, perhaps sensing a potential market, changed his mind about their quality and looked forward to seeing the enlarged *Seated Woman* being made by Modern Art Foundry.

Although de Kooning remained moody throughout early 1970, a new helper, Carlos Anduze, brought an air of brightness to the studio and helped shore up the spirits of the flagging John McMahon and Irving Markowitz. An unflappable man from Venezuela, Anduze first met de Kooning during the painter's final years in New York. "He was big—a fantastic physical specimen—and black," said Michael Wright. "He was a

handsome guy and a great womanizer. But he never worked in his life. He lived off of men and women. He made people happy. I used to say, 'How can you do it? You're so bright—and yet you live off of people.' And Carlos would say, '*Ehhhhh . . .*' " When a vacuum developed around de Kooning in the late sixties, Anduze appeared, seemingly out of nowhere, to offer his assistance. "He used to come and go," said Markowitz. "It seems like somebody would send up a rocket when there was a problem, and Carlos would show up."

Eventually, he went on the payroll. But Anduze was not a typical assistant. He had studied economics and was a certified public accountant. "He'd never touch a hammer," said Wright. "What he did for Bill was . . . he'd talk with him. He could talk for hours, telling jokes and, you know, Bill liked him. He was like a bodyguard. He liked having somebody bigger than he was to protect him." Few people could handle a drunken de Kooning, either physically or emotionally. Carlos was an exception. He was never judgmental. He accepted de Kooning as he was. "We used to lock Bill in the house with him," said Markowitz. "He had a great ability to control Bill and to listen." Anduze quickly became a friend and protector of Lisa as well. According to Markowitz, "He moved into the family."

Up to a point, Carlos also defused domestic tensions. Ward remained hurt that de Kooning had chosen to take Susan Brockman to Italy. While she knew that de Kooning would not be faithful to her, she sometimes felt that he had no regard whatsoever for her feelings. Often, when she stopped by his studio, she would find another woman there. According to Molly Barnes, de Kooning's friend from Los Angeles, Ward would never acknowledge her presence. Once, at a birthday party de Kooning gave for Barnes at the studio, she appeared around eleven p.m. and begged him to come home. When he refused, she left in tears. De Kooning, who hadn't been drinking, asked for a brandy. "Why does she always do that?" he demanded of no one in particular. "She knows I'm out. She has plans herself. But she always has to make a scene. Why does she do it?" The artist Herman Cherry answered, "Because she needs drama." Barnes added, "Because she's a bitch." At that, de Kooning wheeled furiously upon Barnes and told her, "Go to hell." He could criticize Ward, but others could not. Joan's house still represented a home life to him, and she was the mother of his daughter. "He pretended to have no interest in her at all," Barnes said. "And then you'd say, 'Well, why does he go home, why does he keep this thing going?' And he always said it was because of the daughter."

In the summer and fall of 1970, de Kooning began to spend more nights at the studio. It was Lisa's departure from the house on Accabonac

that, in part, made this possible. In September, she left the Springs for boarding school, freeing de Kooning from the obligation he felt to live with Ward in order to provide Lisa with a sense of family. Now fourteen years old, Lisa had not adapted well to the local schools. At the Hampton Day School, where Ward enrolled her after their return to Long Island from New York, there were only about a dozen students in the entire high school, many of them disaffected children of wealthy people in the area. Lisa had attended Hampton Day from the sixth through the eighth grade, liking it well enough, but its permissive character concerned her parents. "We were a terrible bunch of kids," said Heidi Raebeck, who attended the school after Lisa left with the same group of people. "As I look back, I pity the teachers who tried to deal with us."

During the sixties, a rebellious youth culture was developing in the United States. The new mood was not lost upon teenagers on Long Island. During the summers, hip and well-to-do kids from New York would stream into East Hampton. "We'd hang out with these very groovy kids that were all hippies already," said Raebeck. The behavior of the imports inevitably rubbed off on the local kids, Lisa among them. She had a much larger allowance than most children her age. Rumors began to circulate that she was smoking pot. According to the local art dealer Elaine Benson, whose daughter went to school with Lisa, "She was obstreperous and adventurous and worrisome." Like many adolescents, Lisa was becoming more emotionally volatile. But she also had genuine passions. She became an accomplished rider and continued to be fascinated with animals, taking an increasingly sophisticated interest in them.

For ninth grade, Lisa's worried parents decided to send her to Buxton, a small, unconventional, and prestigious school in Williamstown, Massachusetts. On paper, Buxton seemed ideal for Lisa. It had only ninety or so students; the school's involvement with each was extraordinary. Founded by Quakers, Buxton adhered to goals of modesty and hard work and retained a work program in which students helped take care of the school. "It was supposed to be this utopian community that was separate from the rest of the world," said Joan Levy, an artist who roomed with Lisa and became friends with her during Lisa's first year there. However, many students found the school's emphasis on community claustrophobic. "You couldn't go into town except on Tuesdays from four-thirty to six-thirty and on Saturdays from eleven-thirty a.m. to eleven-thirty p.m.," said Levy. "And you weren't allowed to go on the Williams campus. And you couldn't talk to townspeople. You had to be with Buxton people. You had an allowance of four dollars that you could pick up on Saturday. And that was it." Moving from the freedom and disorder of the Hampton Day

School into this strict environment proved difficult for Lisa. "This business of who you can talk to, who you can socialize with, and being stuck on the campus was against her grain," said Levy. "It was limited in a way that was too confining and unrealistic for her." The school also had an air of supreme unreality. Despite its plain beginnings, it had turned into a place of wealth and privilege, filled with a disproportionate number of children of the rich and celebrated. According to Levy, "Most people's parents were famous musicians, writers, actors, painters, physicians." The result was a wild skew between the principles of modesty espoused by Buxton and the lavish way the children actually lived at home. For Lisa, the best aspect of the school was its strength in the arts. She also adopted a large menagerie of pets, including premature gerbil babies that she handfed until they could eat normally. Once, with delight, she gave Levy's pet duck swimming lessons in a school bathtub.

In September, de Kooning and Joan together brought Lisa to the school. Both also visited on parents' weekends, said Sidney Simon, a painter and sculptor who knew de Kooning and whose daughters attended the school. (Lisa herself remembered very few visits from her father.) "The school was famous because about 80 percent of the kids had divorced parents," said Simon. At the end of the open days, the mothers would go one way and the fathers another. De Kooning, in a fatherly way, befriended Lisa's friends, particularly Joan Levy, who was already very serious about her own painting. "I was in my Breughel and Vermeer period," said Levy. "Being several centuries behind the times, I had never heard of Lisa's father and knew even less about his work." De Kooning admired one of Levy's pictures. "He'd say, 'Go look up so and so,' " said Levy. "He told me to call him when I wanted to talk about art, and to reverse the charges. I'd call and he'd say, 'Hello, darling, vat are you vorking on?' I would talk to him for hours. We talked about the whole gamut of art history over the pay phone. He told me what to look for in particular artists. He'd say, for example, look at the way Hopper painted the people to look like the furniture and the furniture to look like the people."

D e Kooning turned unexpectedly to lithography in 1970. It absorbed his attention for much of the year. When the Museum of Modern Art had asked de Kooning and other artists in 1966 to contribute lithographs to a book in memory of Frank O'Hara, de Kooning enjoyed the process of illustrating the poems, so much so that he did twenty drawings on Mylar to be made into prints. He had also made seven other original prints that year with Irwin Hollander, a master printer who had recently moved from Cal-

ifornia to New York. Although Hollander encouraged de Kooning to make more, "It was not until [de Kooning] returned from his trip to Japan that he responded to do a body of lithographs. Perhaps the seeing and feeling of calligraphy, Sumi brush painting, and Zen inspired him to do prints. Whatever, the results were beautiful," recalled Hollander. The printmaking, in black and white, offered de Kooning an escape from the highly keyed colors of his most recent paintings. And the tools were different. And he worked within a different rectangle. If the liberating spirit of Zen encouraged him to make art without worrying too much—Zen sought to free the hand from the paralysis of thought—the regular trips to New York also allowed him to leave the studio and the claustrophobic house.

The first lithographs produced that summer at Hollander's workshop referred to his Japanese trip. Among them was a picture called *Love to Wakako*, in which two groups of calligraphic brushstrokes floated across a largely empty space, and *Weekend at Mr. and Mrs. Krisher*, in which the vertically soaring landscape of a scroll painting, or of Mt. Fuji itself, was evoked in a few circular strokes. By the latter part of the summer, the female figure began to appear in the prints. *Woman at Clearwater Beach*, for example, depicted a woman in the familiar splayed position seen in many of his paintings from the sixties. By the fall, de Kooning was working with increasingly dense patterns. *The Marshes* was an all-over image of spiky linear lines, reminiscent of reeds and marsh grass, and bubbly, waving ones that suggested water. At the time, both the Japanese lithographs and the small Italian sculptures appeared to be nothing more than momentary enthusiasms, taken up casually under the influence of a trip. But the sensations de Kooning experienced while in Japan and in Emanuel's studio in Rome remained with him, even though his interest in sculpture and lithography would not last long. He was getting a fresh feeling in his fingers. He was getting to know the earthy physicality of the wet clay, and, equally, the light and airy freedom of the Zen line. His desire for the essentials—water, air, light, earth—was strengthening.

35. Human Clay

You made me over.

De Kooning did not drive a car or keep an appointment book. Friends took him out when he was staying at the studio. In the middle of August 1970, Harold and May Rosenberg brought de Kooning to a dinner party in Bridgehampton given by the Iranian expatriate painter Manouche Yektai and his wife, Nicki. (Among the guests were Saul Steinberg and Robert Fizdale and Arthur Gold.) During the introductions, de Kooning met a woman in her thirties named Emilie Kilgore, called Mimi by her friends, who was married to a Houston businessman. Kilgore was dark and almond-eyed—like, friends said, an Egyptian princess. She appeared very proper, yet had a mischievous glint in her eye and broke easily into a warm smile or an open-hearted laugh. There was a yearning intensity about her as well, a desire to be more than a wealthy socialite who dabbles in the arts. At the Guild Hall museum in East Hampton, Kilgore had recently seen an exhibit of photographs of artists from the area and was taken by de Kooning's "wonderful" face. In the flesh, he was shorter than she would have thought—but there was that same face.

The dinner was a buffet at which the guests milled about. After dinner, Kilgore found herself sitting on a sofa with de Kooning, Rosenberg, and Christophe de Menil (whose parents, Dominique and John de Menil, would later donate their celebrated collection to the Menil Collection, a museum in Houston, Texas). The talk naturally concerned art—and, inevitably, the low melodrama of reputation. Like many women in her circumstances, Kilgore, who went to Smith College and came from a socially prominent family in St. Louis and Houston, knew how to simultaneously tease and flatter distinguished older men at a dinner party. (*"You're* the greatest painter," she told him.) Very soon, however, the conversation between de Kooning and Mimi developed into something more than light banter. She remembered:

> I was sort of transfixed. . . . I think I was unaware of anything else going on. And we just talked, looking straight at each other for a long, long time. And then he was leaving, because he was going home with Harold and May, and he said, "Am I ever going to see you again? You know, I

don't drive a car. Do you ride a bicycle? . . . We could take a bike ride maybe."

They made a date to meet the following Tuesday on bicycles at a tree in front of Guild Hall. Kilgore, who lived only a few minutes from Guild Hall, only half-believed that de Kooning would pedal all the way from the Springs to East Hampton to see her, a distance of several miles. De Kooning, similarly, doubted that the pretty young woman from the party would remember their date. Mimi arrived first, then de Kooning. They sat talking for awhile under the tree. De Kooning proposed that they have lunch together, perhaps at Montauk. So they bicycled to Kilgore's house, put de Kooning's bike in the back of her car, and drove to the eastern end of Long Island, where they had lobsters at Gosman's Dock—a favorite restaurant of de Kooning's—and walked around the famous lighthouse.

After lunch, Kilgore drove de Kooning home. He asked if she would like to see the studio, but she declined the invitation; she had a tennis lesson. Instead, she said she'd come the next day. He showed her around, and then they sat in the two rocking chairs and de Kooning brought her books of his work, telling her, "They call everything *Woman* now." About a week later, she invited de Kooning to accompany her on the Guild Hall annual house tour, in which people visited notable houses in the area. Only an infatuation well beyond the ordinary would have led de Kooning to participate in such an activity. On the driveway at one house, Kilgore noticed a frog that had been flattened by a car's tire. Its limbs were splayed out, much like a figure in one of de Kooning's pictures. She picked it up. And then she handed it to him. He kept it for the rest of his life.

It was during the house tour, de Kooning later told her, that he fell in love. Kilgore herself was less certain of her feelings. "I was fascinated. I was attracted," she said. "But whether or not I had fallen in love at that point is hard for me to say." Kilgore believed herself to be in love with her second husband, John Kilgore, a lawyer and partner at the venture capital firm J. H. Whitney, whom she had married five years before. Kilgore was an unusual man, a Southerner with courtly manners who wrote poetry and had translated a novel from Spanish into English. He had four children, and she one, from previous marriages; they also had a child together. The Kilgores were well known in East Hampton. They belonged to the Maidstone Club, an old-money preserve of mainly WASP families who summered in the area. A woman in Emilie Kilgore's position did not lightly get involved with an artist from the Springs.

Kilgore had always been attracted to creative, soulful men (among them the short-story writer and critic Walter Clemons). She loved Europe

Emilie Kilgore and de Kooning in de Kooning's rocking chairs, early 1970s

and spent her junior year at college in Paris. Her major at Smith was art history, and, like Susan Brockman, she had studied dance seriously. After college, she taught French at a private school in Houston before moving to New York, where she worked briefly at the Frick Collection. She regarded herself as a New Yorker, having been in Manhattan for eleven years, and she and her husband had lived in the city until 1969. Then, suddenly and unexpectedly, her husband proposed moving to Houston for business reasons. She had little say in the matter, although she wanted "to back up what he was doing." In late 1969, he made the decision to move the family. "I said I can't bear the thought of not having any place in New York, staying in a hotel." So she found a pied-à-terre across from the Metropolitan Museum.

De Kooning and Mimi saw each other several more times in the late summer of 1970. Their get-togethers were noticed. Gossips at the Maidstone reported that Mimi was visiting the famous artist in his studio. Joan Ward also noticed that de Kooning appeared smitten by a new woman. Of course, Ward acknowledged that, apart from Lisa, she had little hold over de Kooning. Like most women in her position, however, she found the idea of a passing affair less threatening than the possibility of a serious ongoing relationship. This new love recalled de Kooning's flight to Susan

Brockman in 1963 and, before that, his affair with Ruth Kligman. "By that time I was a little tired, too," said Ward. "I wanted to take a vacation from all this. The Emilie bit was just a little too much. It was getting a little too cutesy. We were getting older, and the same old game was being played out again." One night, Ward telephoned Kilgore's husband in New York to complain about the situation. "He said, 'Can't you control your husband?' I said, 'Can't you control your wife?' He was mad. The next day Bill looked at me with a sort of horrified admiration. 'That was a terrible thing to do, Joanie. That man was very upset.' I imagine he was."

John Kilgore was indeed upset by the news that his wife was visiting an artist in the Springs, although she had not begun an affair. He called her right away in East Hampton, saying, "I just had a phone call from Mrs. de Kooning." When Mimi asked what she said, he answered, "I'm not interested in what she said. I'm only interested in what you have to say. I don't expect you to respond this moment. Think about it and call me back when you're ready to talk." Then he hung up. Mimi immediately called him back and explained that she'd seen de Kooning four or five times in the last two weeks. They had not begun an affair, she said, but she found him a remarkable man and hoped that he would become a good friend of theirs. Kilgore told her, "I don't ever want to see him."

De Kooning was also upset, describing Ward's call as "a dirty trick." He told Mimi that he would call her husband to reassure him. De Kooning then did call John Kilgore in New York, who refused to take his call. At that point, Mimi realized that she would have to make the difficult decision about whether or not "to scratch Bill out of her life." She decided that she could not circumscribe her world in that way. But she always believed it possible that, if her husband had welcomed de Kooning as a friend, she would not have begun an affair with him. Not long before the Kilgores left East Hampton, Mimi made a last visit to the studio. He asked her for a photograph. She gave him two—one of her with her son, one with her sister. He also asked if he could keep an earring that she left by the phone. She gave him the other earring as well.

In Houston, the Kilgore family missed East Hampton. As a result, the Kilgores spent almost every holiday there. In the fall of 1970, they flew to East Hampton for Halloween, Thanksgiving, and Christmas. Mimi also occasionally visited New York. In October, de Kooning came into the city to see her. They spent the day roaming around with, among others, the artist Herman Cherry, who had moved to Long Island not far from de Kooning, and the art dealer Heiner Friedrich. It was a madcap day of youthful high spirits. (At one point Cherry admired the mink coat of a friend of Mimi's, who said she'd trade it to him for a David Smith drawing.

He put it on and, since she was much taller than Cherry, the coat dragged along the ground. Cherry then strode into a shop and emerged smoking a cigar.) The group went to a Picabia show at the Guggenheim, ate lunch at Fanelli's in Soho, and had dinner at a French restaurant on West Forty-sixth Street. During the holidays on Long Island, Mimi saw de Kooning whenever there was a free moment, usually at the studio or at a restaurant. When de Kooning received the proofs of his lithographs, he canceled one called *Valentine* by scrawling her name across it. He also gave her a lithograph of *Valentine* that he had printed on silk. On another cancellation proof—an image inspired by her—he wrote "With love" in the figure's hair. At the end of December, Kilgore, for the first time, saw de Kooning have a drink. During their years together, he almost never drank when she was present, and, in the beginning, she assumed he was a teetotaler. (He would ask for a Coke whenever she ordered a drink.) On this particular day in December, however, Mimi wanted de Kooning to meet her father, who was visiting for Christmas. He was almost exactly the same age as de Kooning. Her father was not judgmental, but the upcoming meeting probably made de Kooning anxious. When she arrived at the studio with her father, de Kooning was not there, and his assistants looked worried. She found him walking along the road and picked him up. According to Kilgore, the first thing he said after introductions was, 'I'm crazy about your daughter.' Then he said, 'Let's go to town and have a drink.' "

By now, there was no question how Mimi and de Kooning felt about each other. Their long separations were very difficult. They filled the hours apart with letters. Between 1970 and 1979, when he began to have difficulty writing, de Kooning sent Mimi seventy-five long and impassioned love letters—an extraordinary outpouring of feeling. He would pace the studio struggling with the sentences, and then (as he described it) "draw" the words in his rolling, calligraphic hand. In these drawn letters, the words were often spaced out on the page for visual effect, and the thoughts were episodic, the words conversational, as if he were right there with Mimi rather than alone. Sometimes, the letter kept him company for several days. He would add to it whenever the mood for writing came upon him.

He could not stop telling her how much he loved her. He would scrawl "I love you" again and again across the page. He waited impatiently for her replies. "You made me so happy with your beautiful letter this morning," he wrote. "I have been thinking that I will smear you with my gorgeous Howard Johnson colors. I mean my painting I am working on and I am kissing you now all over. I am crazy about you. Yes, I love you so

much." He often told her, "You're here wherever I am." In one letter, de Kooning wrote that he has become "some kind of closet and closed the door, you're inside and I will not let you come out. I love you and nobody knows you're here." Later in that same letter, he wrote:

> The Egyptians named the painter the maker of outlines. Day after day I have you in front of me. Even if I closeted you away I see your beautiful face. I see you in all other women. Your outlines are in my heart. The more I see beautiful women, other women on television and advertisements, I mean they are just photographed then. I see you in all of them. And when one of them is slow motion swaying her dark hair, in my heart I know it's you and I see a big green tree where the water's running free.

Most letters were filled with humor, art, memories, declarations of love, and an almost surreal free association—very much like de Kooning's way of talking. In one, he drew an old-fashioned movie house on which he put her name in lights. He would often compare her to water, perhaps the highest compliment he could pay anyone. One letter actually seemed to turn into water, the written lines becoming waves. It was not just the lovers' separation that provoked these letters, however, but an aging man's growing sense of urgency. De Kooning, desperate to renew himself as an artist, told Mimi in many different ways that he was being reborn in her love. She was the "angel" who "made me over." The letters suggested that, as with water, there should be no boundaries in consciousness—and that de Kooning could be young as well as old. In the first half of an early letter, for example, he wrote:

> Darling Mimi,
>
> But more—and more I love you. I told you that I found a way to write you. It has to do with having strange and longing feelings. I had—many—years ago. I remember walking in quiet streets. In a part of the Hague in Holland which was close to the sea then. It is natural to have those longing feelings when so young. [But?] I am walking there again now. For you. Naturally it has changed—but remembering it. . . . I can insist to have it the same as it was. As in a dream I found you there . . . and so I can write to you about it. Some time a longing cannot find a way to express with. But with you I can walk again in those empty streets. It is romantic and I can go and look for you there. Remembering the streets so well . . . they help me to be in the same neighborhood with you. It is a little like having lunch with you in Sag

Harbor. It is near all that water there. I told you that I came to America in the summer of 1926. Looking for work . . . I found myself in the Seventees and Madison Ave. And those rather classy houses there (particularly 5th Ave). I could then . . . not help feeling . . . that they made me in a strange way think about that quiet summer naborhood in Holland. In Holland the streets there go rather up and down . . . very much like the streets which emptied themselves on uptown Riverside Dr. I can also be with you in Brussels—there are streets there too which gave me the same unfulfilled feeling . . . but with you I am alright walking there. You see . . . I love you. With you a ceremony could be cleaning the house. You can be completely self-absorbed! If you want! With you I find places of the past to take the hardness out of me. . . . With you . . . the most romantic period of my life is available to me! But I cannot help thinking that Chopin had only to stick his neck out and he could look into George Sand's window. We must be in love . . . hopelessly.

At the end of the letter, de Kooning appended a charcoal drawing of Mimi's head and wrote "and love you" underneath. Then he added a coda on still another page: "After reading the letter over . . . meaby it's not so really very good. And thinking it over . . . I remember when I was wayting for you at the Guggenheim Museum. What a gorgeous day!!!

"And love you."

By January 1971, the essential pattern of their love affair was established. They would see each other on Long Island during the summers and on holidays, and in New York City on occasional days throughout the rest of the year. In East Hampton, they would go on drives and eat out, often in Sag Harbor or at the Spring Close restaurant in Amagansett. "Most of the time we talked. Or listened to music. Or danced. Or drove around. Or ate," said Mimi. Sometimes they played billiards at her house. "I can see every inch of his hands. His thumbs hung quite close to the rest of his hand. . . . The very first night I met him he put his hand next to me and I looked at it and made some joke about now I'm going to tell your fortune and he said, 'You see, I have the simian line.' He had very few lines on his hands. Like three. . . . He kept his hands beautifully groomed. . . . Never covered in paint." She loved to watch him paint.

How much time there was concentrating and looking, sitting in that chair! Maybe having a cigarette. But still just looking with such intensity. And then getting up and walking over . . . still with his eye on the painting and then *Kershewwwww!* [painting so rapidly]. Everything

leading up to it was so long and then he got there and it was always pretty quick.

In the summer of 1971, concerned that they would rarely find time alone—especially with Lisa on vacation and often at the studio—de Kooning rented a small house in Noyac, a working-class community near Sag Harbor. They "spent some rather blissful, somehow sweet and domestic afternoons" at the house. It had a little yard of uncut grass and a swing. "There were neighbors nearby and he would swing me in the yard and they loved it. They didn't have a clue who he was." When they met in New York, they would usually go to galleries, museums, the ballet, and the theater. De Kooning loved *A Little Night Music* and often asked her to sing "Send In the Clowns." They would also meet at the apartment de Kooning owned on Third Avenue and Tenth Street or at Kilgore's pied-à-terre, once its renovation was completed in the summer of 1971. More than once, de Kooning stood on the top of the steps outside the Metropolitan Museum of Art and waved at Mimi in her window.

In the fall of 1970, not long after de Kooning met Emilie Kilgore, Fourcade notified him that the casting of *Seated Woman* was complete. At the artist's request, it was colored black in a three-step process in which copper nitrate, then iron nitrate, and lastly ammonia sulfite were applied to the surface. ("You use a torch to get the color," said Bob Spring, the president of Modern Art Foundry. "The color is in the surface of the metal. You heat the bronze, and at different temperatures the nitrates and ammonia sulfite are applied to create the patina. The first time it's done with an artist, you establish their color. Bill liked black.") The piece was waxed to preserve it and then taken to Knoedler. When de Kooning came in to the city to see it, he was both startled and delighted by the large, powerful presence of the figure; he was pleased, too, that so much of his touch remained visible, the bronze fingerprints echoing the distinctive stroke of his brush on a canvas. The English critic David Sylvester would later liken *Seated Woman* to a goddess. "She arouses visions of a Bernini fountain in which the figures and the water have become interchangeable. . . ." She "seems to be made, not of flesh and blood, but of the sea. She is an incarnation of the pitiless movement of the waves." De Kooning himself liked to quote Brancusi: "All sculpture is water."

So excited was de Kooning by *Seated Woman* that he decided to forgo further enlargements of the Roman pieces and instead begin an entirely new sculptural series. Perhaps the sense of renewal stimulated by his rela-

tionship with Mimi also contributed to this bold decision. It would be necessary, in any case, to find a knowledgeable assistant to help him. Would the young man who had enlarged *Seated Woman* be interested? Yes—David Christian agreed to help. So in June 1971, almost two years after making the little clay pieces at Emanuel's foundry in Rome, de Kooning returned to sculpture in earnest. He approached the project with an open-ended feeling of freedom, extending the sense of liberation he found in the Zen-inflected art of Japan and in his recent printmaking. He did not feel, while working as a sculptor, oppressed by history or know-how or fashion. "I wasn't obliged even to myself," de Kooning said. "I mean, I never studied modeling or anything. I took it serious, and less serious. You know—the way it came out." Toward larger considerations about the direction of modernist sculpture, which since the fifties had been mostly abstract and made of materials more impersonal than clay, he remained completely indifferent. "De Kooning's audacity, in the face of what now passes for the 'issues' of modern sculpture," said the critic Peter Schjeldahl, "has been precisely to ignore them."

Initially, de Kooning had to overcome a visceral dislike of the water-based clay, recoiling from its slick and gooey feel as he made large pieces. In Rome, his sheer delight in making the little figures tempered this feeling. Now he decided to use a variety of gloves that enabled him to maintain the mark of his hand without directly touching the clay—workmen's gloves from the hardware store, gloves in every size so he could put one pair over another. A second problem he confronted was scale: he wanted to make larger pieces than he had in Rome. Christian proved both imaginative and adept at figuring out ways to solve the technical issues of scale. Although he was not "one of the boys" in the way Athos Zacharias, Michael Wright, or John McMahon were, Christian created an air of possibility in the studio. If de Kooning wanted to alter a clay figure again and again, Christian gave him hope that they could technically find a way.

De Kooning chose to begin with a large male figure. For Christian, the challenge was to devise flexible armatures for the figure that would enable de Kooning to make as many changes as necessary in clay. Some were plywood profiles, mimicking in wood the recent drawings that were often an inspiration for his sculpture. These profiles could be used as a starting point for applying the clay. If de Kooning wanted an arm, Christian would make one out of plywood with aluminum crossing around it to give it strength. These constructions could be cut with a saw, even through the clay, if de Kooning decided to lengthen, shorten, or otherwise modify the shape. Christian also devised a variation on the standard aluminum wire armature, in which thin wire is twisted around thicker wire and mounted

on a block of wood to provide a frame for the clay. Since de Kooning wanted something more pliant, Christian created sturdy structures made of pipe with twisted aluminum appendages that could turn as much as 180 degrees. "David was very clever," said Bob Spring. "He made armatures that could move, and yet were still strong enough to work on"—an important requirement given the heavy masses of water clay that de Kooning would pile upon his sculptures.

De Kooning named the evolving figure *Clamdigger.* Like the women depicted in his earlier painting *Clam Diggers,* the sculpture was inspired by figures de Kooning observed searching for clams in the mud. Whereas the women in the painting were pinkly voluptuous, however, this new clam digger was heavy, dark, and very masculine. De Kooning worked on *Clamdigger* for many months, putting the piece through the same crucible of creation and re-creation as a painting. According to Christian, "A figure that began seven or eight feet tall was cut down to five feet; an arm was cut off, another bolted on; it went through countless versions of heads, two of which were cast from the figure in progress in order not to lose them." Every day, Christian would pre-knead blocks of clay; de Kooning liked to keep the clay as wet and malleable as possible, just as he tried to keep the paint wet in his paintings. ("Bill must work wetter than any sculptor has," said Christian.) If he initially disliked the feel of clay, de Kooning rapidly came to appreciate its mutability as he punched, beat, and shaped it. "In some ways, clay is even better than oil," he told *Craft Horizons* magazine in 1972. "You can work and work on a painting but you can't start over again with the canvas like it was before you put that first stroke down. And sometimes, in the end, it's no good, no matter what you do. But with clay, I cover it with a wet cloth and come back to it the next morning and if I don't like what I did, or I changed my mind, I can break it down and start over. It's always fresh."

In August 1971, de Kooning left the Accabonac house and moved into the studio. His work was momentarily interrupted by Lisa, who decided to drop out of Buxton several months after beginning her second year there. She disliked the headmaster, who enjoyed analyzing the Buxton students to their faces, and she could not stomach the rules. She returned briefly to the Hampton Day School, but said that was "like going backwards." Her final stop was the local high school in East Hampton. "I got in there and did half of tenth grade and then I dropped out completely," she said. "It wasn't working out." Upon her return to the Springs, she moved into the studio with her father; she was then fifteen. If she sought as little guidance as possible, she found what she wanted with her father. "I think children do contemplate dropping out of high school, and their parents

say, 'That's very nice. Now get on the bus,' " said Lisa. "But my father said, 'Nowadays you go up to the cash register and it has that machine. It counts the food. It's fantastic.' I told him I wanted to drop out and those were his remarks. The way I interpreted it, if such incredible things can be done nowadays, who needs the education? I didn't have anybody saying that I should keep going. My mother didn't either. What could she say? I was living at the studio with my father."

Father and daughter relished each other's company, but did not find living together easy. "I didn't stay there long," she said. "I was his daughter and he loved me and of course I could stay there. But I was a teenager and he was so much older, almost in his seventies. One time when I came home from school and went to put the music on—you know, Jimi Hendrix, The Mothers of Invention, something like that—there was a written note in charcoal on one of these pads that my father used that said 'A day without music.' It was written in this elegant script, since he was a trained sign-painter." De Kooning often had a funny, disarming way of communicating with his teenager. She came home another time to find her drawers and closet emptied and clothes strewn around her room. When she confronted her father, he said, " 'Well, gee, you know, you seem to like it like that. So I thought I'd help you along a little bit.' So I got the point that even though it's your room, you have to keep it clean because it's my house. I thought it was an ingenious way of handling the situation." Lisa often went into Manhattan and, by the end of 1972, moved into the old rental apartment on Third Avenue and Tenth Street where she and Joan had lived years before. "Lisa was running around the world when she was fifteen," said Heidi Raebeck, Lisa's friend from East Hampton, who lived for a while around 1973 in the New York apartment. "There was a bunch of people who were very independent."

At the time, the East Village was filled with teenage runaways caught up in the counterculture of the period. "I lived with Lisa and walked down St. Mark's Place, and there were hundreds and hundreds of young lost little hippie souls," said Raebeck. "There was a lot of mescaline and acid and psychedelic drugs." The East Village was also home to a chapter of Hells Angels—perhaps the most active in the country outside California—whose headquarters were in a dilapidated, six-story building on East Third Street. Lisa hung out with the Angels as well as with the college students at nearby New York University. The Angels, for a time, became a surrogate family for her. "I felt safe with them," she said. But she also chose to work, teaching, for example, at a local Head Start program and eventually becoming adoption coordinator for the ASPCA.

Not surprisingly, de Kooning worried about his daughter. He asked Lou Rosenthal of New York Central Art Supply to look after her, since his store was close by de Kooning's apartment on Third Avenue. He also used Carlos Anduze as a troubleshooter in New York. Often, when Lisa went to bars around the Village, Carlos would linger nearby, to help if she got into trouble. Even John McMahon was sent to New York on occasion to check on Lisa. Stories circulated about wild parties at her place and, according to Raebeck, "The one time I took acid was in de Kooning's apartment." But thousands of young people were behaving similarly in 1972, and Lisa's father, himself a rebellious young man who escaped from home at a similar age, refused to rebuke his daughter. Besides, he was distracted, as always, by his work—and by his passion for Emilie Kilgore.

By March 1972, de Kooning was essentially finished with *Clamdigger*, which he dated on the underside of the penis. Next came several figures related to the paintings that immediately preceded his move into clay. Notable among them was *Cross-legged Figure*, which was suspended slightly above the ground rather than rooted in the earth like *Clamdigger*. Twisted brutally around a central axis, the figure has arms that are flung backward, in a dramatic counterpose to the legs; its huge hands were splayed out like those of a tap-dancing minstrel singer mugging for a crowd. *Cross-legged Figure* displayed less control, however, than a minstrel singer would. It seemed to be the puppet of forces larger than itself, juiced by unexpected jolts of electricity and spasmodically contorted into new positions. De Kooning told Joop Sanders, "I always twist the torso so the back is the front and the front is the back. Because if it doesn't look good, it always looks rather interesting, you know. It makes it mysterious."

In the late fall of 1972, de Kooning had accumulated a small but significant series of sculpture. Besides the four larger pieces—*Clamdigger*, *Cross-legged Figure*, *Floating Figure*, and *Seated Woman*—he had the original thirteen small figures from Rome as well as two small, flayed-looking heads. The question was where to exhibit the new sculpture and painting. In 1971, Xavier Fourcade decided to start his own gallery. De Kooning wanted to remain with him, but the dealer had not yet opened his new space.

And so it seemed propitious that in 1971, after five years of litigation with Sidney Janis, Lee Eastman and his son John negotiated an out-of-court-settlement that led to one last de Kooning show at Janis. The legal skirmishing had gone back and forth. On the first round Janis had won the right to sell the sixty or so works still at the gallery against the actual

amount of less than $2,000 which the gallery was out of pocket (as opposed to the $150,000 originally claimed by Janis). Since the decision was anomalous at best, the Eastmans then appealed and won the appeal, first in appellate court and then in the Court of Appeals. The courts ruled that de Kooning owed Janis only $2,366. De Kooning was ordered to pay that amount, and Janis was ordered to release the paintings. "I went with Bill to a warehouse on West Forty-second Street where the pictures were," said John Eastman. "He was so happy to get them back. It was hot weather. Afterward, we were walking along the street and some kids on the street sprayed us [from a hydrant] and Bill was smiling."

Once the Eastmans got the paintings back, "we decided that there was no reason to have the suit," said John Eastman. So Lee Eastman arranged to have lunch with Janis's lawyer. "I said, 'I tell you what I'll do. We'll settle the case by giving you one show,' " recalled Lee Eastman. According to the curator Manuel Gonzalez, then a key employee of Janis's gallery, "Nobody really wins. It was more of a lovers' quarrel than anything else. But Sidney thought that he had won. All he wanted was a last show. He wanted to prove that he was right. He gave his lawyer an Arp to pay him." The shrewd Eastman insisted that de Kooning set the prices as part of the agreement. Eastman then priced the paintings so high—at around $80,000 a painting, an enormous sum in 1972—that Janis could sell almost nothing. De Kooning's paintings of the last four years filled three rooms of the gallery. In addition, there was a long case that contained de Kooning's small sculptures from Rome, as well as the larger pieces that he had made over the past two years. Afterward, to compound the irony surrounding the event even further, Leo Castelli, the man who even more than Janis turned the pop artists into stars, gave a party.

By 1972, the rancorous opposition to de Kooning that developed in the sixties was moderating. He remained an irrelevance to many in the art world, but not one who had to be fought. The critic Robert Hughes began his review of de Kooning's new show in *Time* by quoting Harold Rosenberg's witty observation: "Like Western civilization, like humanity itself, de Kooning is constantly declared by critics to be in a state of decline." The *Time* critic then wrote a favorable, if hedged, review. While acknowledging the doubters—"There is no doubt that since the middle 1960s Willem de Kooning has suffered in reputation. As one of the father figures of Abstract Expressionism, he has offended critics who believe in the iron laws of stylistic turnover by outliving his 'period' "—Hughes admired de Kooning's irrepressible energy and willingness to change. Nine months earlier, moreover, the Museum of Modern Art had followed its de Kooning retrospective of 1969 with a second, small show titled "Seven by de Koo-

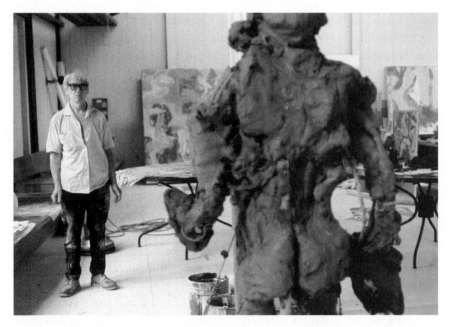

At work on Clamdigger, *the first in a series of large sculptures he began in 1971*

ning" that ran from December 30, 1971, until the end of February 1972—
a signal that, whatever the ebb and flow of reputation, the aging de Koo-
ning was now an essential figure in the modern canon.

Clamdigger

"Sculpture," said Picasso, "is the best comment that a painter can make
on painting." De Kooning would no doubt have agreed. He worked in clay
partly because it helped isolate and clarify a crucial element in his paint-
ing: *touch.* And not just touch as it's often defined in the art books, as
something especially fine that only a connoisseur can appreciate, but
touch as the visceral act of pushing and squeezing and shaping. In the mud
puddle, perhaps, a master of painting could recover the joy a child takes in
the world of sensation. His hands could momentarily replace the brush as
he shaped the human clay.

De Kooning loved the idea of clam diggers, occasionally returning to
the theme after completing the painting with that name. Digging for
clams was yet another form of excavation. Clam diggers searched by

touch for life buried in the mud. Like the clams they sought, they were essentially blind. They had to rely upon instinct, feeling, and touch, much as de Kooning did when making drawings with his eyes shut. The hidden clam was also, of course, a symbol of female sexuality.

De Kooning seldom depicted the male figure. When he did, the image often had autobiographical overtones, and typically, as in his Crucifixion drawings, reflected feelings of persecution and suffering. In *Clamdigger*, the figure was ungainly and misshapen. His feet were massive clumps at the end of spindly legs; his hands resembled clubs; his genitals were grotesque. In part, *Clamdigger* represented another eruption of the goofiness in de Kooning's art, that current of manic existential "hilarity" that some observers found low or embarrassing. (*Clamdigger* was the husband of *Woman I*.) But the figure in *Clamdigger* also appeared indomitable. He seemed to be awakening, half formed, from the primordial bog, a man of inchoate sexuality who still searched for the clam—or the quick—of existence. He was wet and blind with birth, at once old and young, ancient and contemporary, a Giacometti who has not yet found his spine. Like a clam digger, de Kooning himself, exhausted from the fifties, was still struggling to recast himself. In 1972, his relationship with Mimi brought him more happiness than he had known in years. With *Clamdigger*, he seemed to be reaching way back, perhaps to the child for whom touch was the first truth.

36. Santa Emilia

It seems that a lot of artists, when they get older, they get simpler: they feel their own miracle in nature; a feeling of being on the other side of nature.

De Kooning's passion for Emilie Kilgore continued to deepen. He lived mostly alone, but his life now had a bearing, a star upon which he fixed with a kind of rapturous, childlike innocence. His letters seemed to overflow with feeling. "I love you wherever you are forever. . . . You made me over. . . . You're with me all the time even when you're not with me." He would wait anxiously for her letters, and he spent hours composing his own. "I have never had a woman like you in my life. You have made me a romantic man. You have given me something no one has ever given me." He showered her with extravagant statements, such as "I dedicate all my paintings to you." In the spring of 1971, he sent her a painting in Houston.

Those around de Kooning had little idea of the impact of the relationship. While obviously infatuated, de Kooning was also a man in his late sixties whose main focus had always been the studio, and Mimi spent most of the year in Houston. Friends naturally regarded her as simply his latest diversion, though the more astute among them recognized that she was also the kind of woman to whom he was especially drawn. She was what de Kooning liked to call "a classy dame." And "classy dames," de Kooning's old friend Mary Abbott always believed, were what he found most consistently intriguing. Marisol, Susan Brockman, Abbott herself, and now Mimi, had what Abbott called "an aura," creating an air of mystery and remove. But Mimi was obviously much more than a "classy dame" to de Kooning.

Music, all kinds of music, was an important part of our relationship. . . . He whistled beautifully. He whistled Bach all the time and was terrific at doing it. I knew that he liked Rachmaninoff, so I gave him all the best recordings. . . . One time he burst into tears while listening to a tenor. . . . He loved show-tunes. We would sing songs together. I loved dancing, so I would dance. And do cartwheels outside the studio near a gazebo. We would dance together outside. I taught him the tango. He didn't pick it up easily. His feet were too big. He

always said he was supposed to be much taller than he was, but they didn't have enough vitamins during the war, and he'd say, "Look at my feet!" You know, the feet of *Clamdigger* are also very big in relation to the body.

The joy she brought de Kooning was unencumbered. She did not ask for money or pictures or marriage. She did not even ask for more time with him. She did not treat him as "older." De Kooning instead became younger with her, awakening once more to youthful dreams and passion. Together, they would often look at the sky, sometimes sitting on the grass outside the studio when it was dark. "He would look up in awe," she said. "He really responded to a night sky full of stars, but not with the kind of spirituality of Rothko, but just looking up in awe. He would say things like *billions,* and then *billions* more behind that, and *billions* more behind that. He said that it's overwhelming because it makes you feel both very small but very big at the same time."

In New York City, Kilgore wanted to see the shows in galleries and museums, and she enjoyed dining out with friends and going to the theater. Her enthusiasms swept the retiring de Kooning along. Whenever she came to New York, he would take the Long Island Rail Road into the city, sometimes staying at his old haunt from the sixties, the Hotel Chelsea. Kilgore delighted in his way of seeing the world. Sometimes, she jotted down his asides. About Vermeer: "You never know what the milkmaid's thinking." About critics: "There was mutual aid in reverse. I can do without them and they can do without me." About photography: "Photography does a good job. It takes all the misery out." He would often tell her, when they saw examples of contemporary art that were self-consciously ironic or witty: "I don't have a sense of humor about art."

Kilgore was naturally flattered by the attention of a man she considered a genius, and she could hardly fail to respond to his ardor. "It's lovely to love someone," she said, "but it's also lovely to love the way in which you are loved. He said to me once, 'There is absolutely nothing that you could do that would make me not love you.' That's quite something! Almost like the unconditional love of a mother. I always felt I had to make people love me." She was also moved by his inner intensity. He was usually fighting his demons, in a state of desperation about his work, and he would often cite Groucho Marx's response to the person who asked him whether he was a man or a mouse: "Throw a piece of cheese on the floor and you'll find out!" (De Kooning would say "*Trow* a piece . . .") She found something gallant in de Kooning's struggle with his demons, including those of age and decline. Their difference in age rarely came up,

but when it did he would sometime tease her by confiding, "I'm giving you the best years of my life!" The prospect of drying up, of losing the juice of life, tormented him. He wrote her that once, many years before, when he was a young artist in Chelsea, he saw an old man sitting alone in the corner of an almost empty cafeteria on Twenty-third Street. And he remembered wishing that some romantic song would start playing so the old man could "cry his eyes out, he could wallow, be tragic almost, *instead of old.*"

In 1971, de Kooning began to dream of spending some time with Mimi in Venice. The Venice Biennale would be held in June 1972, and Mimi was planning to go there with her sister. It was hardly surprising that he wanted to be with Mimi in Italy, which was always de Kooning's version of paradise. Italy elevated the senses into a kind of religion; Italian artists (especially of the baroque) were not embarrassed Puritans but, on the contrary, relished joyful visual extravagance. In Italy, the past lived in the present; and similarly, age might unite with youth. In 1971, de Kooning saw Visconti's film of Thomas Mann's *Death in Venice.* No doubt he responded to the theme of an older man's lush and melancholy infatuation. He wrote to Mimi that their upcoming trip "could very well be THE most romantic event of my life, and that is only because I am so crazy about you that I tell you."

De Kooning and Mimi met in Venice in June 1972. They stayed with a cousin of hers who lived in a palazzo in the city, the artist Timothy Hennessy, and they participated to some extent in the social swirl of the Biennale and an Italian summer. Many people associated with the Cobra group, some of whom de Kooning knew, were in Venice. (The well-known painter Pierre Alechinsky was the subject of a Biennale show.) At one point they attended a lavish party outside Venice given, de Kooning recalled, by a "Texas lady with a hair-do." The pianists Gold and Fizdale, friends from the Hamptons, had rented a villa nearby. De Kooning and Mimi also went briefly to Rome and to the Spoleto Festival, where they spent several days with Roland Penrose and Lee Miller, making excursions to Assisi and Perugia. Only once did de Kooning threaten to begin drinking. He became "nervous as a cat," Mimi said, but she was able to talk him out of it. He told her, "You saved me from myself."

Mostly, they wandered the Italian streets. Mimi was indefatigable. De Kooning loved the youthful hurrying about, though he also gently chided her. One angel on a church, he wrote in a letter, told him "that you were getting fed up taking us to all the places that you wanted to see." They visited the island of Torcello, where the Byzantine Virgin in the apse of the church reminded Mimi of her mother, and they ate in small restaurants.

De Kooning delighted, as lovers will, in Mimi's little habits and expressed his pleasure with a charm that she found irresistible: "Anything you did not feel like eating yourself too much of you most of the time decided I should have a little more of." On the way back to the United States, the couple stopped in London, where Mimi visited her sister. De Kooning continued home. Both understood implicitly that their time in Venice would become the defining moment of their relationship, the symbol of what they meant together. "I think," Mimi said of their relationship, "that he was trying to hold on to something." At the baroque church of Santa Maria del Giglio, de Kooning later wrote, they looked upward "at that gorgeous church, that one most beautiful angel." The angel on top of the church, de Kooning told her, was looking at *him*. No, Mimi smiled, the angel was looking at *her*. It didn't matter: they felt singled out, together, by the angels. Later, de Kooning would often refer to "the angel on top of the roof of Venice." And his pet name for Mimi became "Santa Emilia."

In the studio, de Kooning lived in an increasingly circumscribed world of work and occasional visits from friends, with Mimi never far from his thoughts. He kept her Phi Beta Kappa key, of which he was inordinately proud, next to his Medal of Freedom. With their relationship more widely known, they tried to behave more discreetly than before, attending parties together in East Hampton only rarely. De Kooning did not want to embarrass Mimi or her husband (they did not separate until 1980). Instead, he would take her to get-togethers with close friends from the art world, such as Saul Steinberg, Constantino Nivola, or Hans Namuth. During the presidential campaign in the fall of 1972, the *New York Times* highlighted de Kooning in an article about artists who supported McGovern, but it was mostly friends, not de Kooning himself, who took an interest in politics.

It was only in the summer that de Kooning regularly saw Mimi. At night, during much of the year, he sat alone in front of the television, a small figure in the large expanse of the studio and living area. He rarely saw Lisa during this period; she was in New York, living a life, he was told, edged with drugs and danger. As always, Ward remained on the periphery of his life. De Kooning would ordinarily go to the Accabonac house for help when he got into trouble drinking. He seldom made trips into Manhattan except to see Mimi or, on rare occasions, to attend the opening of a friend's show. Old friends mattered more than ever, but many had died or came to Long Island only in the summer. They would stop at his studio in the late afternoon; or, he might drop into a friend's house while biking around the neighborhood. He especially liked to visit Nivola,

who lived with his wife, Ruth, just a short bike ride away down Old Stone Highway. An immigrant from Italy, Nivola, like de Kooning, had had to scrap his way through the world; the two men felt comfortable together in the way of two Europeans who never quite forgot their good fortune in coming to America. Often, they would sit in the kitchen—rarely in the more formal living room—or chat in the garden together "about art and ideas and the world situation," recalled Ruth Nivola. Herman Cherry would also drop by de Kooning's studio, sometimes with a bottle. A regular at the Cedar in the fifties, Cherry was a garrulous if somewhat pugnacious painter originally from California. "Dad kind of liked Herman Cherry," Lisa said, "because he was such a grump." Tom Hess always stopped by when he visited the Hamptons. Sometimes Marisol appeared. She would sit silently by the hour in the studio, watching de Kooning and gazing at the paintings and drawings strewn about.

More than anyone else, however, de Kooning looked to Harold Rosenberg. During the summer, when he and his wife, May, lived in the Springs, the critic regularly visited the studio, his arrival announced by the sound of his bum leg dragging across the driveway. Rosenberg could still discourse for hours on almost any topic. Although de Kooning sometimes wearied of his grand conversation, he still relished the intellectual stimulation and the feeling of a shared past. Throughout his life, de Kooning retained a special affection for his friends from the difficult thirties and forties. Rosenberg, moreover, had remained a staunch supporter of de Kooning through both good times and bad. According to Lisa, "They always looked settled together. Both of them in the rockers and very settled. They talked about things that were important, but in such a casual way." They also knew how to smile together. De Kooning loved to tell friends a Mutt-and-Jeff story about the time that he and Harold were driving by the tiny local airport in East Hampton. De Kooning pointed to a sign that said "Low-flying aircraft." Rosenberg—a towering figure beside de Kooning—replied, "What are you worried about? I'm taller than you."

A late and unexpected friend was Salvador Dalí, who, like de Kooning, was represented by Fourcade and began visiting de Kooning. The reputation of the flamboyant surrealist was much diminished in the seventies, but de Kooning always enjoyed him. "I like Dalí very much," he told John Russell of the *New York Times*. "He's very quiet now—not like he used to be—and when I said to him 'Why did you paint those Salvation Army pictures?' he said, 'Maybe I'm not really a good painter, after all.' " Fourcade himself continued, with churchlike regularity, to pay a weekly Sunday-morning visit to de Kooning, who would sometimes unload his resentments upon the diplomatic dealer. De Kooning could never quite

understand why, if he was such a successful artist, Fourcade did not bring him cash after the sale of his pictures. What use was being rich if you couldn't, like Joe Hirshhorn, peel off a few hundreds? Lee Eastman regularly visited de Kooning—partly to judge his condition but also because they had become very friendly over the years. In the 1970s, Eastman, who had represented de Kooning for more than a decade, would take children and privileged visitors to the studio so that, it seemed, they could breathe the air of genius. Eastman seemed to regard de Kooning as the Einstein of art. Occasionally, he invited the painter to dinner at the family's house on Lily Pond Lane in East Hampton. Typically, de Kooning arrived in comically mismatched jackets and shirts, the plaid of one clashing with the stripes of the other. "Bill talked in a stream of consciousness that turned out to be precise," said Eastman. "It would have an unforgettable point." By 1976, the get-togethers sometimes included Paul McCartney, who had married Eastman's daughter, Linda, and was interested in de Kooning's work.

At times, de Kooning, always ambivalent about the party world, flew into a rage at the social trivia around him. He told friends that he hated "the chit-chat" of parties (in his Dutch accent the phrase was "shit-shat") and complained that every Tom, Dick, and Harry felt free to drop by his studio. He sometimes cursed strangers off his land and hung a chain across his driveway. Once, when the young critic Peter Schjeldahl was at the studio—de Kooning considered Schjeldahl one of the few critics who understood him—an obsequious South American artist dropped by. De Kooning was drinking and offered the artist some Johnnie Walker Red. Some time passed. "Later," Schjeldahl wrote,

> de Kooning appeared to take his first notice of Enrique, who was gazing at him worshipfully. "Enrique! My friend!" exclaimed the master, embracing him. With one arm around the handsome, slightly chubby Latin, he addressed me [Schjeldahl] as if I were the world. "This man is my friend. Enrique here is so important to me. I love this man!" Enrique wept with happiness. "But Enrique," de Kooning cooed in a stage whisper tremulous with hurt feelings, "I want you to tell me one thing. Tell me, why are you so goddamned second-rate?"

Apart from Mimi, Lisa, and friends from the old days, de Kooning had little patience for visitors. During the long winter months, he liked to invite the owners of the local general store, Clarence and Dorothy Barnes, to dinner. Sometimes, he would not want them to go home. "I thought he

was lonely and sad," said Clarence. "We'd take him over meals on holidays. He'd eat like he was starving. Not like ordinary people. He'd just shovel it in." Ruth Nivola saw de Kooning as "a man who liked his solitude," who even at parties was "always sort of removed, thinking about his art." De Kooning relished being an honorary fireman. Every year the Barneses would take him to the Fishermen's Fair in Springs, a charity for local fishermen, with whom de Kooning empathized. De Kooning also invited artists who were Lisa's friends to stay at the studio. They provided company, reminded him of his own peripatetic youth, and gave him the chance to talk informally about art.

One example was Lisa's friend Heidi Raebeck, who had been living with Lisa on Third Avenue in New York. When the two began to get on each other's nerves, Lisa proposed a generous and novel solution. Why not live with her dad for a while, since Heidi was an aspiring artist? "I think Lisa just called up and said, 'Is it okay if my friend Heidi stays with you for a while?' So I moved in and Bill and I lived together. And no one was ever there." (By the time Raebeck arrived, in 1973 or 1974, de Kooning's longtime assistant, John McMahon, was spending less time at the studio.) Another recipient of de Kooning's generosity was the young painter Joan Levy, Lisa's former Buxton roommate. Levy would periodically stay with de Kooning in the Springs for a week or so. Her relationship with de Kooning, like Raebeck's, revolved almost exclusively around art. When she would arrive in the late afternoon—so as not to disturb his day's work—he would make two huge cups of coffee and they would sit in the rockers. "We'd talk about what he was working on in the studio," said Levy. "Or he'd say, 'Did you bring any pictures with you?' And he'd critique them, some-

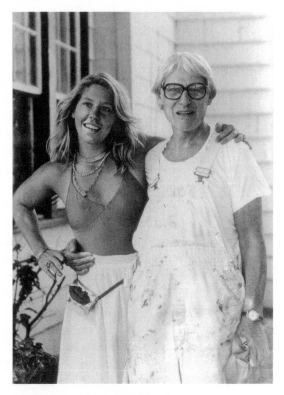

De Kooning and daughter Lisa, late 1970s

times hard. Or we'd look at what he was working on." De Kooning was interested in her responses. He believed, he told her, in a pure vision unspoiled by too much "art education." He was also moved by her youth—by the image of an artist whose working life still lay ahead.

Over many hours of studio visits, Levy came away with a vivid sense of how de Kooning still struggled over each painting. He continued to work out of doubt. "One little shift of color or line could change the form so another image appeared," she said. "But then as soon as it starts to appear you have to make a new choice about which avenue to take. That's what Bill used to call 'the anxiety of possibilities.' " She would ask him, "How the hell can you paint something if you're trying to not paint it? Can you imagine being a kid trying how to understand how to paint and here's this guy unpainting himself? This used to stymie me. The thing was, it stymied him just as much. So in his presence I would feel this almost contagious anxiety." The youthful Levy looked at the aging painter and saw that, for a man like de Kooning, the challenge never diminished. In the winter of 1974 and 1975, she sensed that the internal struggle was particularly intense.

De Kooning's binges, in the early seventies, were infrequent but devastating. He wrote to Mimi about "a strange feeling hovering about me . . . at times, I feel as if I were walking on the other side of myself, that some existential panic was taking me over." He told her of sitting "in this big white [studio] here in all my colossalness as an upright worm." In February 1973, he seriously damaged his liver and pancreas during a binge that ended, once again, in Southampton Hospital. In October and November 1973, he was admitted to a treatment center in Freeport, Long Island. Kilgore visited him as much as possible in New York and the Springs, but family responsibilities often kept her away. She scheduled brief trips with him, to Boston on an art tour and to Washington to the Hirshhorn Museum. In 1976, de Kooning's half brother Koos paid another visit to the United States; de Kooning, at a loss how to entertain his relative, flew with him to Houston to see Mimi. At one point when she was busy teaching, Mimi asked the young painter John Alexander to take de Kooning to the Rothko Chapel so that he could see the somber abstractions Rothko painted shortly before his suicide. De Kooning sat on a bench in the chapel, perhaps remembering when he first met Rothko on the bench near Washington Square, and wept.

As always, de Kooning's anxiety stemmed largely from the extraordinary demands he placed upon himself. "Santa Emilia," he wrote, "I was writing you this long letter yesterday I have in front of me but I really didn't like it. It wasn't good enough. I have also at night been walking

around the grounds growling like a dog. I feel like biting somebody. I'm exhausted working-wise. Didn't do bad but each idea gives me a new one." Writing letters to her, usually late at night, became a way to temper his loneliness and exhaustion. Often, the letters would become very playful; the writing of them improved his mood. He would mock his despair by drawing little pictures on the letters of arrow-pierced hearts or weeping Santa Emilias. In one letter, he comically enumerated a night of TV:

> 1) It is twenty minutes after ten and 2) Lisa and I are watching television 3) A picture about the Civil War 4) Good looking men on horses are continuously crossing shallow rivers 5) And at times are praying for the dead 6) And often one sees tombstones with names like "James" on it 7) And then, too, people are singing in small churches with prayer books in their hands 8) The woodwork is light in color there 9) It is difficult to end the picture. Lisa and I are waiting. We want to go to bed. More and more people are getting killed. And it seems the whole business is done because Jimmy Stewart is the father.

Although de Kooning appeared to be working mainly on sculpture in the early seventies, he continued to devote most of his energy to painting. "Bill's primary artistic expression was not sculpture but painting," said Bob Spring, who saw de Kooning at most three or four times. "We did not have a normal sculptor-foundryman's association." He worked sporadically in clay, completing four new pieces in 1973. The following year, de Kooning turned to sculpture for the last time. *Large Torso*, like *Clamdigger* and *Seated Woman on a Bench*, conveyed a primordial sense of life as something fragmentary and rooted in the earth. The arms of the torso were long and massive, weighing down the trunk and evoking the origins of mankind in the muddy ooze. Nothing could have been further in spirit from the classical ideal of beauty in Western culture, which is often represented by fragments of ancient Greek sculpture. *Large Torso*, like most of de Kooning's sculpture, implicitly celebrated change, mutation, and the possibilities of the shaping hand.

Again and again, de Kooning told Mimi he wanted to see her more often. Then, in 1975, he asked her to marry him. "He was in one of those chairs in front of the television set," she said, "and I was sitting below him on the floor leaning on his chair, and I had turned around and was looking at him, and he asked me to marry him. I didn't know how to respond." There was a long pause. Then de Kooning said with a kind of glum humor, "You don't supposed to be silent." In fact, he had already discussed the possibility with Lee Eastman, who told him that he could

indeed get a divorce without Elaine's agreement after so many years of separation. De Kooning told Mimi he would build her a separate house, if she wanted—he even promised to be "the greatest influence" on her children—but Kilgore demurred. "It was tempting," she said, "but it would have been too big a change. So many lives would have been affected." And she had "compartmentalized," as she put it, her relationship with de Kooning. But Mimi also recognized that their periods apart actually strengthened the relationship. De Kooning had never lived happily with a woman for any sustained time; Mimi did not consider herself the exception. She understood that he wanted to be alone when he wanted to be alone, free from emotional pressure, to concentrate upon his work. She, too, wanted time alone. Since de Kooning never felt crowded by Kilgore, he could continue to love her. "The relationship lasted," she said, "because of what it was. He could have me the way he wanted me, in his head."

Kilgore sensed that, to de Kooning, she was also a symbol. She embodied a dream about existence that he refused to yield to age. "In his head," the aging painter—who turned seventy in 1974—was veering between powerful moods: on the one hand, a heightened joy; on the other, isolation and a yearning melancholy. Almost every afternoon, as he bicycled through the countryside, he instinctively identified her with the watery landscape around him. "I was on my bike to the bay," he wrote her, "and had a look at the back of your neck there." The back of her neck was the beach. Where her hair fell across her neck was the shoreline. The soft beginnings of her hair was "the grass where the pebbles of the bay are." He longed to drink "the water of her mouth." In one letter, he wrote, "Give me water Emilie and love." He would often explain that they were not separated: "You are myself even more than I. How you like that one! You're inside of me." In the seventies, de Kooning, who often mentioned Zen, believed that he was beginning (in Kilgore's words) to "live his whole life in the present." He knew age, of course, but Mimi brought back the young de Kooning. Bicycling along the water was also touching the back of her neck. Everything he was—and had been—could flow together in a moment.

In the spring of 1975, de Kooning's long dry spell ended—boldly, grandly, dramatically. In six months, he completed twenty sumptuous abstractions. He himself appeared surprised at this sudden upwelling of images, especially that so many should survive his scrutiny. "I couldn't miss," he said. "It's strange. It's like a man at a gambling table [who] feels that he

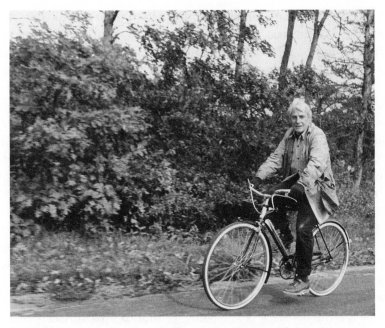

De Kooning's favorite pastime, biking to Louse Point, mid-seventies

can't lose. But when he walks away with all the dough, he knows he can't do that again. Because then it gets self-conscious. I wasn't self-conscious. I just did it." The lush paintings, each eighty by seventy inches or eighty-eight by seventy-seven, contained none of the anger or bitterness that sometimes animated his earlier work.

De Kooning's immediate inspiration was the watery landscape of the Springs, especially at Louse Point. His loose curving brushstrokes captured the free play of the water, light, and sky. "He said that he was really intrigued with the way all of those colors would reflect off the surface of the water, and how the forms would emerge and dissolve," said Levy. "It provided a huge supply of possibilities for paintings." Paradoxically, the pictures were also the most earthy—the most physically like wet clay—that de Kooning had ever made. They were full of puckers, bubbles, ridges, and spatters. The paintings embodied the sort of epiphany that de Kooning and Mimi were discussing, when the evanescent sensations of a long life seemed to come together. Their watery character conveyed the savor of such moments. Water had no boundaries; water reflected the earth, sky, figure, and landscape; water was ever-moving desire; and water brought to mind, as well, a kind of lovely "life is passing" melancholy.

De Kooning had always been a tactile painter, of course, and in the sixties his whipped-up mixtures of safflower oil, water, and turpentine

had given extraordinary emphasis to the actual paint. He liked to say, "I am the world's greatest mixer of paint." In 1975, using the same basic methods as before, he would first prepare a canvas by sizing and resizing it, painting it with lead white paint and then sanding with sanding plaster until the surface became almost translucent. "He went down layer by layer until it was fine like paper," said Mary Abbott. "The white glows." He would also roughen up the surface somewhat so that he could draw on it more easily with charcoal, which was his traditional way of beginning a painting. And he would use newspapers to slow the drying process of his emulsion, often struggling to keep the picture wet.

In the mid-seventies, however, the paint gained even more texture. It seemed to rise tumescent from the surface of the canvas, color laid into and over color. "I get the paint right on the surface," de Kooning told Mimi proudly. "Nobody else can do that." According to Tom Ferrara, the assistant who joined de Kooning in 1980, "He wanted the paint really juicy and thick." During this period, de Kooning looked yet again to Soutine. "I've always been crazy about Soutine—all of his paintings," he said. "Maybe it's the lushness of the paint. He builds up a surface that looks like a material, like a substance. There's a kind of transfiguration." When describing his first glimpse of the Soutine paintings years before at the Barnes Collection in Philadelphia, he said that "the Matisses had a light of their own, but the Soutines had a glow that came from within the paintings—it was another kind of light." De Kooning compared his handling of the paint to the way Miles Davis made music. "Miles Davis *bends* the notes. He doesn't play them, he bends them. I *bend* the paint."

Despite their sealike freedom, the best paintings were carefully composed. They depended to some extent upon an informal grid, but not one that constrained the flowing brushstrokes. "The way I do it, it's not like Cubism, it's like Cézannism, almost," said de Kooning of the way he patterned his brushstrokes, which he termed "fitting in." A supple layering of the space was also a way in which he brought a feeling of controlled form to the watery image. A loaded brush skittering across the surface like a splash of water might be rhythmically related to a deeper and ghostly level of watery space below, where the paint had been partially wiped away. (Often, de Kooning would scrape down a canvas but leave traces of paint behind, creating, for example, an astonishing sensation of the sky's reflection upon momentarily quiet water.) The most original compositional device, however, was de Kooning's masterful way of varying the visual "speed" of his brush. His stroke would lead the eye at one speed and then another. A loaded brush of crimson would move at a certain tempo, then fishhook, dropping into a slow-seeming patch of yellow. Rhythm,

speed, and tempo—not just strokes—came into visual balance.

By autumn, de Kooning had more than enough new paintings for an exhibit that October at his dealer's new gallery, Fourcade, Droll, Inc. "He said, 'They just poured out of me like water,'" according to Joan Levy. The show itself hardly made an impression upon de Kooning, though he helped select the works to hang: he was too busy working. The number of paintings continued to increase. Most were called "Untitled" and distinguished by number. There was a strong family resemblance among them. Although de Kooning's

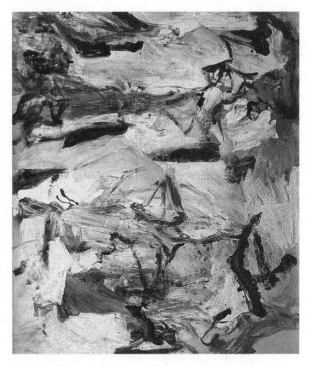

North Atlantic Light, *1977, oil on canvas, 80″ × 70″*

palette differed from painting to painting, as did the degree to which the "fitting in" of the brushstrokes was loose or compressed, they all contained ideas borrowed from other works. Throughout this period, de Kooning surrounded himself with recent canvases. Often he would make a drawing from a recently completed picture, which then served as the starting point for another.

Of course, the figure was reflected in the "water"; or, more accurately, she became part of the flowing water. "I could sustain [the figure] all the time because it could change all the time," he said. "She could almost get upside down, or not be there, or come back again, she could be any size." In his new paintings, the figure, finally, seemed to find a home at sea. There was none of the goofiness, awkwardness, or difficulty that was part of de Kooning's insistent earlier truth about the relation of the figure to its environment. The pictures themselves were at once passionate and familial in feeling. "I like a big painting to look small," he said. "I like a big painting to get so involved that it becomes intimate; that it really starts to lose its measurements; so that it looks smaller. To make a small painting look big is very difficult, but to make a big painting look small is also very

difficult." The paradoxes that powered de Kooning's art came together seamlessly. Water and earth, man and woman, figure and ground—who could separate them in these works?

I t seemed astonishing to those around him that de Kooning could summon this burst of painterly energy. Had he died when he was seventy-five years old, he would have been remembered for creating a passionate late style—for leaving the world with a kind of glorious painterly burst.

What became clear at the time, however, was that he was burning himself out. In his letters to Mimi, he wrote of his exhaustion and his "terrible state of depression," the worst he had ever known. He could not stop working, even to take a brief trip to Mexico. "I cannot lay down the brush." During the years from 1975 to 1978, when he created this cycle, de Kooning very nearly drank himself to death. As always, it was partly the burden of expectations—imposed by both others and himself—that led him to discharge the tension through bingeing drunks. The crowd of lionizers was growing larger and larger outside the studio door as de Kooning changed from a has-been to a "grand old man" of painting. In September 1974, the Australian National Gallery in Canberra purchased *Woman V*, one of de Kooning's famous cycle of fifties *Women*, for $850,000. It was a record amount for a work by a living American artist. Soon everyone knew the value of the throwaway drawings on de Kooning's studio floor. Even when he was drinking in local bars, people would "cozy up" to him in an effort to get invited to the studio, where, they hoped, they could collect their own "de Kooning."

In the sixties, there had been only one major show of his work, the 1968 retrospective that originated in Amsterdam. By the mid-seventies, however, the number of shows seemed to grow exponentially. In 1974, the Walker Art Center in Minneapolis mounted an important exhibit of de Kooning's drawings and sculpture, which focused as none had before upon his draftsmanship. The same year, Fourcade, Droll organized a comprehensive show of de Kooning's lithographs that continued to travel around the United States until early 1977. In 1975, the Japanese finally staged the exhibition that Fourcade lobbied for on his trip to Japan with de Kooning; and there was a show in Paris as well. Then, in 1976, no fewer than eight significant de Kooning exhibits opened, including two in Amsterdam. Plans were under way for an ambitious exhibit, sponsored jointly by the Hirshhorn Museum and the U.S. Information Agency, that would tour eleven cities throughout Europe and Eastern Europe, introducing de Kooning's work to Poland, Yugoslavia, Hungary, and East Berlin, with stops as

well in Spain, Norway, and Dordrecht. In New York, Fourcade also mounted another show of new paintings. Smaller than the one from the previous year—there were twelve new works—it drew favorable notices when it opened in October. Writing in the *New York Times*, John Russell praised the new landscapes with their occasional references to the "same buttery female body" of de Kooning's past. He concluded: "Mr. de Kooning in his 70's is still inventing new ways of mixing the paint, new ways of getting it to do his will, new ways to accommodate the thrusts of the psyche." Most important of all was Diane Waldman's proposal to mount a retrospective at the Guggenheim of de Kooning's years on Long Island. Scheduled for 1978, it would provide the first opportunity for many people to see de Kooning's work since his move to the Springs. The critical consensus remained that the Long Island period represented a decline, but Fourcade believed that continually exhibiting de Kooning's late painting would change that perception.

De Kooning could not entirely ignore such outside distractions, and they probably contributed to the pressures that, his friends feared, would soon kill him. The periods between binges seemed to shorten. Halfway through the seventies, de Kooning had already dried out several times at Southampton Hospital and other institutions that took care of alcoholics. Sometimes, he tried to make light of the stays. He liked to tell people about the time he was admitted to the hospital and got undressed. Then, the nurse left him alone for a minute, so he got dressed again, hailed a cab, and went to a local bar. But the truth is that the hospital interludes were extremely depressing. According to Elaine Benson, who volunteered at the hospital, few people visited de Kooning in Southampton. And no one was there to pick him up. "I saw him sobering up maybe six times," she said. "He looked so small and Chaplinesque, with these hairless white legs hanging out of these hospital gowns. . . . You felt that nobody was taking care of him. He had this orphan quality." One time, Benson asked de Kooning when he was going to be released, and he said, "I think today, but I don't know if anybody is coming to get me."

Part of the problem was that John McMahon had left the studio for good late in 1974, after nearly twelve years as de Kooning's assistant. What prompted the break was McMahon's marriage and subsequent move to Atlanta. The wedding reception was held at de Kooning's studio. (Before the wedding, de Kooning took McMahon upstairs to his room and gave him one of the suits that he had bought, with Ruth Kligman, in Italy. "Look," Bill told John. "Roma. Feel the material. They don't make suits like that here.") According to de Kooning's housekeeper, Gertrude Cullem, "John stayed in the studio a couple of weeks before he left

because Bill missed him. He just wanted to see him and be with him. John used to take him around. Like his son, really." Before he left, McMahon recruited Dane Dixon, who had looked after de Kooning for a time in New York in the early 1960s, to replace him. It was not an ideal arrangement, however, despite the warm friendship between the two men. Dixon was physically up to the job of handling de Kooning. He was burly—"like a bear," said McMahon—with a yeoman's beard and an intimidating manner, and he could head off trouble with a threatening "Fuck off" or "Get lost." But Dixon was also an alcoholic and, while he never urged de Kooning to drink, he was often drunk himself. He was a good old boy who liked carousing at local bars and inviting pals back to the studio.

Joan Ward was always there to help de Kooning, but she could not control him as his condition worsened. One Saturday morning in the early seventies, the artist David Porter found Joan and de Kooning in bad shape at the Accabonac house. In 1970 de Kooning had helped Porter recover from near-fatal burns over 70 percent of his body by calling up nine successful painters and asking each to contribute $500 to Porter and his wife "because David and Marian need money." Later, when he went to thank de Kooning, de Kooning offered him more money. "With that, he pulled out a roll of bills," said Porter. "I never saw so much money in life—and [he] pushed it on me. He said it was $100,000. I said, 'Bill, I don't need it now.' "

Porter asked de Kooning if he would like to go to a clinic for treatment. "They were both at the kitchen table and Bill's ankles were like this [so swollen]," said Porter. "He had no shoes on. And each was drinking solid dark brown alcohol, probably Scotch. He was so drunk. She wasn't so bad. I talked to them both. She said to Bill, 'Do you want to try to stop drinking?' He said yes. So I said, 'I'll take you to a place that will help you stop drinking.' " A member of Alcoholics Anonymous, Porter was familiar with the treatment centers on Long Island. He asked an AA buddy to help him drive de Kooning to South Oaks, a center in Amityville with an excellent reputation. "I drove [de Kooning] to Amityville, a long drive, and he was right behind me," said Porter. "The whole time, he had his hands around me and I almost choked. It was terrible—I'll never get over that. Talking away." After they arrived, de Kooning had to walk barefoot into the institution because his feet were so swollen that he couldn't put on his shoes. "And when Joan and I got him inside he couldn't sign his name," said Porter, because his hand was trembling so badly. Instead, he simply made an X on the signature line. De Kooning probably remained at South Oaks for the prescribed twenty-eight days of treatment. "At Amityville, you go to AA meetings while you're there," said Porter. "They give you

personal attention and load you up with vitamins, and they get rid of the edema."

After he was released, de Kooning continued to go to AA meetings. However, he was never a good bet for any long-term commitment—except to art—and he soon sloughed off the organization's requirements. "I'm all right in the meetings," he told Mimi. "I just can't take it home with me. When I feel broken down I take a drink and that works for a while." By 1977, de Kooning's drinking became life-threatening. Often, now, when friends were scheduled to visit de Kooning, they would get a call from an intermediary who would tell them not to come. No sooner would de Kooning return to his studio after a stay in the hospital, newly sober and with a fresh supply of sedatives to calm him down, than he would fly off again, increasingly strung out from the combined effect of drugs and alcohol. The sound of an ambulance wailing down Woodbine Drive to collect him became almost routine.

At this juncture, de Kooning was persuaded to try AA once again, this time through the indirect auspices of Elaine de Kooning. In 1976, Elaine had become the Lamar Dodd Visiting Professor of Art, a newly created position at the University of Georgia. She was commuting between Athens, Georgia, New York City, and Long Island. After years of being only distantly in touch with de Kooning, she was edging back into his life, having bought a summer house nearby in the Springs in 1969. Newly through AA herself, Elaine often went to the local meetings. Like all faithful followers, she tried to recruit her alcoholic friends to the organization. At one AA meeting in Bridgehampton, she heard a Montauk man named Eugene Tiritter speak. Afterward, Elaine introduced herself and told Tiritter that de Kooning had mentioned hearing him speak in Montauk. Something that Tiritter had said there—about the cave paintings of Lascaux and the people who created them—had impressed de Kooning. It was not the sort of thing that ordinarily came up at an AA meeting. Even though de Kooning had left AA, Elaine asked Tiritter if he would be willing to help him. Tiritter was the sort of person, as Elaine knew, whose company de Kooning enjoyed. Like Clarence Barnes, he was a down-to-earth man. His family was Romanian. He himself was a mason. Born in Brooklyn and raised in Queens, just outside Manhattan, he moved to Montauk in 1965, following the new wave of building on the eastern end of Long Island. Like Wimpy de Ruyter and other old Dutch friends of de Kooning's, he had served in the merchant marine and could talk to de Kooning about ships and the sea. And like de Kooning, he loved philosophy—and was self-taught. If de Kooning would listen to anyone about booze, in short, it would be to a salt-of-the-earth philosopher like Tiritter.

At the outset, Tiritter did not know who de Kooning was. By the time he learned that he was a celebrated artist, he had accepted him as a regular guy. "I genuinely enjoyed him even after I knew he was famous," he said. "He was so funny. He'd say things like, 'You know, I'm really a pretty famous guy.' But it wouldn't make you mad. If you got to know him, it wasn't ego." Once a week or so, Tiritter would pick up de Kooning and take him to a local AA meeting. Usually, they would drive to Montauk, where the meetings were held in the dingy basement of the local Catholic church. "Sometimes he'd come in his overalls that were all full of paint," said Tiritter. "He enjoyed that, because he had been a housepainter. He'd go to meetings and sit through them. I don't ever remember him talking a lot at AA." Tiritter would also visit de Kooning in his studio, where they would sit in the rocking chairs and talk about philosophy. According to Tiritter, "He was with Wittgenstein, I with Sartre."

De Kooning nonetheless began another binge. It was worse than ever. Not only was he admitted to Southampton Hospital, but he also lost his memory and became so disoriented that he did not know who he was. Frantic about de Kooning's latest lapse and about the alcoholics and hangers-on increasingly swarming around him at the studio, Joan Ward asked Tiritter what to do. "I didn't think Bill was really the kind of alcoholic who would kill himself [through drinking]," said Tiritter. "That's what I told Joan." Then Dr. Wright, de Kooning's physician in Southampton, asked the psychiatrist Dr. Ralph Junker, who had become a friend of de Kooning's after seeing him off and on for several years, to evaluate him. As Tiritter shrewdly noted, de Kooning's habit of making friends with his doctors was not especially helpful. "I think Bill liked to become very friendly with people and think that he had some kind of control," said Tiritter. "If he got friendly with his psychiatrist, for example, then he could be in control." If de Kooning were in control, then he could manipulate his doctors, rather than follow their lead. De Kooning, too guarded to open up to a psychiatrist, similarly could never meet the demands of AA, which involved confessing with brutal candor the personal problems and degradations created by alcoholism. The relentlessly confessional tone of AA certainly did not suit his reserved Dutch nature. "There were the funniest stories of Bill in AA," said Joan. "He went to Montauk, where the people weren't all that rigid. He finally said, 'You people sure can beat a dead horse.' They thought that was very funny."

Drugs were also becoming a problem. At the time, doctors routinely gave alcoholics sedatives to calm them as they were weaned from liquor. "Pills keep up the sedative effect," said Tiritter. "And then you crash when you're back home [without drugs] and you drink again because you

feel terrible." There was the further danger of mixing alcohol and drugs. De Kooning never intentionally mixed them, but he became hooked on the calming effects of sedatives, which created the danger that he would begin drinking and not remember that he had already taken pills. Sometimes, de Kooning would forget and take another round, and lapse into a stupor. With neither AA nor psychological help having an effect, the bingeing de Kooning began to end up at the hospitals-of-last-resort for alcoholics. He had already been to South Oaks Hospital and to the rehabilitation facility in Freeport. Subsequently, Porter and Tiritter took him to the Brunswick Hospital Center in Amityville. De Kooning looked pleased, said Tiritter, when a large young attendant came to take him away. De Kooning always felt most comfortable, it seemed, when strong helpers were nearby to take care of him.

By 1977, de Kooning's short-term memory was beginning to falter. The people around him naturally concluded that any forgetfulness on his part was caused by his excessive drinking. He was always worst, in this regard, when exhausted from a binge; he would improve markedly when on the wagon. De Kooning himself was aware of some mental slippage; he even discussed his absentmindedness with a friend, the painter Dan Rice. But the dangerous bingeing, not the absentmindedness of a man in his seventies, was what worried those around him. Too much time now was spent lying listlessly on the couch recuperating in Joan's house. Ward said, "He did not even feel much like seeing Mimi, because he didn't feel well." Strung out on either alcohol or sedatives, de Kooning became so desperate that he sought out a practitioner of alternative medicine, Dr. Lee Hammer, who believed in using acupuncture, herbs, and teas to straighten out chemical imbalances in the body. "He didn't believe in too many pills," said Ward. "He liked folic acid and things like that. The natural way. And acupuncture. One time he left a needle in Bill's head. He had it banged all the way into the [lower back of his head]. Every time we went over there he would give me some new herbs. This one taken here, three of these taken there." Under Hammer's care, de Kooning began a nine-day, all-liquid diet intended to clean his system. "Look at the iris," Hammer told Joan. "You'll see how [his eyes] clear up." De Kooning drank only teas made out of roots that Joan fixed in a blender. At the end, his body did indeed seem purified. "I think it probably would have cleared up anyway with a decent diet and not drinking," said Ward. "But it didn't hurt Bill, and it gave him something to concentrate on."

Whatever the reason, de Kooning felt strong enough after the regimen to move back into the studio. Somehow, he returned to work; the great cycle of landscapes would continue into 1978. And then the endlessly

dreary bingeing started again. De Kooning certainly had no conscious desire to kill himself. He feared death, as he told Mimi, and "drinking yourself to death" would have struck him as "corny." Still, he may well have believed that he would die after concluding this last great cycle of paintings. What more was left for a man of his age? It was somehow fitting, at the end, to hold nothing back.

In the summer of 1977, Lee Eastman decided to intervene. He had come upon de Kooning one too many times with his head on the table, mumbling and defeated and dirty. Only radical measures, he believed, would end the downward spiral. Joan could not stop him. And Mimi spent most of the year in Houston. The situation, Eastman told de Kooning, must change. What exactly Eastman said is not known. But the lawyer had years of experience with de Kooning's indirection, and he was probably able to convey to the painter that nurses and possibly institutionalization—in effect, the loss of his studio—lay in the not too distant future. And so, at Eastman's urging, de Kooning turned to the one person in the world whom Eastman thought might be able to bring order to chaos. His wife, Elaine.

. . . Whose Name Was Writ in Water

When the poet Gregory Corso showed de Kooning around Rome in the late fifties, he took him to the house where Keats lived at the end of his life. Moved by the poet's early death, de Kooning never forgot the epitaph that Keats wrote for himself, for it perfectly captured the painter's own sense of a momentary and ever-changing world.

When he painted . . . *Whose Name Was Writ in Water*, de Kooning was seventy-one. He was a man nearing death, blissfully in love with a younger woman. Like all truthful invocations of paradise, the painting was suffused by melancholy: the garden of desire was a fleeting image written in a stormy pool of reflections. But . . . *Whose Name Was Writ in Water* was equally a masterpiece of lyrical joy. It contained no recognizable figure, but the flesh tones glinted among the bending forms of the painting, and the long stroking touch of the hand was everywhere. Desire here did not appear only erotic; it did not seek only to possess. Desire seemed something larger and more encompassing—a delight in the quick of existence. The digger felt the clam.

In the best works of the series, of which . . . *Whose Name Was Writ in Water* was an early example, de Kooning redefined the pastoral tradition

in an original way. He found a means, at last, to unite the figure and the landscape into an ideal image that he could believe in. His originality lay in the perspective he adopted. He presented the pastoral from within— from the perspective of the figures in the landscape—rather than from without. He was not the outsider who surveys the ideal scene from afar. He had passed through the looking glass; he created, as he put it, "a feeling of being on the other side of nature." The physical touch that de Kooning carried from wet clay into paint enabled him to embody more vividly than ever before the tactile pleasure of those within the landscape. The lush brushstrokes, while living together harmoniously, appeared free and spontaneous. Nothing appeared imposed.

De Kooning always insisted upon movement, both palpable and metaphysical. . . . *Whose Name Was Writ in Water* coiled with an energy without beginning or end. Its left side contained an extraordinary concatenation of speeds, for example, resembling what happens when water backs up against a pier. In art, the pastoral was traditionally presented as an image of preternatural stillness; it usually appeared delicate, aristocratic, and easily broken, like porcelain. De Kooning instead animated the pastoral, his dream made of verbs, not nouns. Nothing could long trap or hold the eye in . . . *Whose Name Was Writ in Water.* The aging de Kooning in the Springs, like the young man who crossed the ocean to America, did not believe in a static image of existence. He relished the sea of consciousness, stirred ceaselessly by different moods, desires, memories, and sensations. To know the miracle of nature, from the inside, it was necessary to remain off-balance rather than centered. "Y'know the real world," de Kooning said, "this so-called real world, is just something you put up with, like everybody else."

> I'm in my element when I am a little bit out of this world: then I'm in the real world—I'm on the beam. Because when I'm falling, I'm doing all right; when I'm slipping, I say, hey, this is interesting! It's when I'm standing upright that bothers me: I'm not doing so good; I'm stiff. As a matter of fact, I'm really slipping, most of the time, into that glimpse. I'm like a slipping glimpser.

Twilight

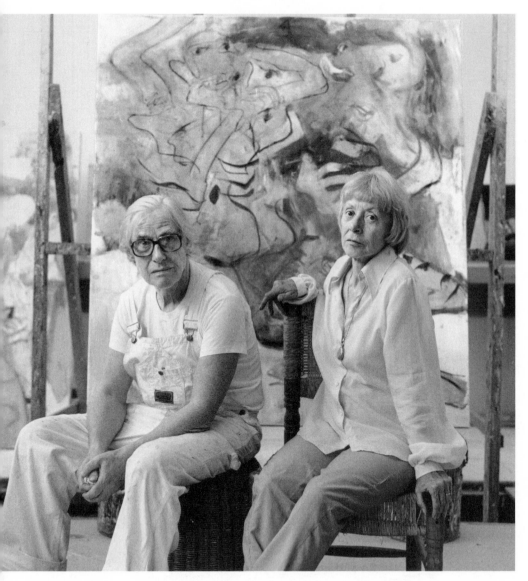

Together once more. Elaine came back into de Kooning's life in 1977.

37. Elaine, Again

That Elaine, she's always the emergency girl.

It seemed miraculous, at once wonderful and improbable, that de Kooning would turn to Elaine for help. Not only had he been estranged from her for two decades, but Elaine herself, a newly reformed alcoholic who constantly struggled to make ends meet, had many serious problems. But, as everyone also knew, Elaine turned everything she did into a larger-than-life story. Her move back into de Kooning's life was no exception: wasn't it marvelous that they were back together? As time passed and she became more confident, she presented their reunion as at once romantic, generous, and soul-stirring. Not only did she stop the great artist's drinking, saving his life, but she moved into the studio, restoring the closeness they shared thirty years before in their loft on Twenty-second Street.

There was considerable truth to Elaine's story line. But the reunion, on both sides, also owed much to a pragmatic assessment of the facts. Only the certain prospect of failing health and imminent death led de Kooning, who had always resisted ceding authority to anyone, to give Elaine control over his affairs. There was no question, on his part, of any romantic rekindling of feeling; he remained passionately devoted to Emilie Kilgore. He regarded Elaine, when things were going well, as a cozy domestic friend. But Elaine was still deeply attached to him. Now as always, he was the center of her life. She was also weary of the years of scraping by, and returning to de Kooning provided her with what she had long craved but never found: financial and emotional security. Being with him solidified her position in the world. Not surprisingly, she did not emphasize the practical aspects of their reunion. "Part of Elaine was about being very open and honest," said Elaine Benson. "And part of her apparently had this 'True Romances' concept of their relationship, because she came back and was mother hen to him and kept him alive. She refused to admit that she lived in her house and he lived in his house and that she rarely even stayed overnight."

After Lisa's birth in 1956, de Kooning made little effort to see Elaine. She struggled through the following years with a kind of desperate gallantry. As an artist, she specialized in portraits painted with the slashing brushstrokes of fifties action painting. The high point of her career had

come with the commission in 1962 and 1963 to paint President Kennedy. Otherwise, she sold paintings irregularly, and, when financially pinched, turned to de Kooning for help. In addition to paying her bills occasionally and sending her a check for $250 or $300, he would give her pictures to sell, sometimes shaking his head in admiration at her wonderful talent for self-dramatization. (Once, when asking for a painting, she told him, "I don't want to wind up on a street corner selling pencils.") But Elaine also tried not to depend upon de Kooning for money. To support herself, she became a kind of itinerant art professor and lecturer, teaching over the years at the Pratt Institute and Parsons School of Design, both in New York; as well as at universities in New Mexico and California; at Carnegie Mellon in Pennsylvania; and, most recently, at the University of Georgia at Athens. Her students adored her. She treated them as if they were already serious artists, emboldening them. "The first thing she told us was that we weren't painting large enough," said one of her students and later assistants, Eddie Johnson, who was at the University of New Mexico in Albuquerque during Elaine's first teaching job in the fifties. "At that time, an eighteen-by-twenty-four-inch painting was considered large for a student. It took most of us a semester or two to work up to [that size]. All of a sudden, here we were working on four-by-six-foot paintings. It was a very liberating experience." She never referred to her separation from de Kooning and spoke intimately of Kline, Pollock, and other celebrated artists. "Her friends were our gods," said Johnson. "She was like Prometheus."

Outside the classroom, Elaine partied hard with both students and faculty. Of the men who mattered most to her in the late fifties and sixties, all were married: Tom Hess, Harold Rosenberg, and the sculptor Robert Mallary, whom Elaine met in New Mexico. One of Elaine's neighbors in the early sixties would joke about her sex life by counting out the days: Tom would be Wednesday, Harold Thursday . . . unless Elaine was not seeing a more casual lover. Between teaching jobs, she lived in downtown lofts, first at 791 and then 827 Broadway. In the sixties, Elaine's behavior became increasingly self-destructive. She was a heavy smoker as well as a drinker. She liked to gesture with a cigarette in hand, the swirling motion underscoring the dance of the conversation. She had always been sexually free, but now she was sometimes careless with men. One story she regarded as "amusing" concerned a mugger hiding in the shadows who accosted her, pulled a knife, and demanded her money. Rather than scream, Elaine feigned laryngitis, so he would not hurt her. Then, she invited him up to her loft for coffee, and the two became friends. People laughed—oh, that Elaine, they would say.

Elaine loved the idea of artists gathered together. "She always reminded me of what I read about Gertrude Stein," said Johnson. "She didn't have a formal salon. But every time I was over there, there'd be a knock on the door and some other artist was popping over for a visit." However, New York was changing. Most of the surviving abstract expressionists, including de Kooning, had left the city; the buzz in New York was now about pop and later styles of art. More and more, hangers-on filled her studio. Many were greedy and calculating. Betsy Egan Duhrssen recalled a party at Elaine's loft when "all of these young men kept bringing her checkbook to her and saying they needed more booze." By the end of the evening, "she had signed away about $900." Duhrssen tried to make Elaine see what she had done, "but she didn't want to hear it." To strangers, Elaine sometimes looked like a boorish drunk who spilled drinks and scattered cigarette ashes. She borrowed regularly from friends— often more than $1,000 at a time.

And yet, she usually had a marvelous sparkle around her. She seemed to enlarge life. In order to join her friends on Long Island, she scratched up enough cash for a charmless shotgun house on Shelter Island, which was linked to the rest of Long Island by a ferry. It was only a boat ride away from the East Hampton artists, she announced, and besides she adored the people on Shelter Island because they were "so straight." One time, the painter Robert Dash took the ferry over to visit her. "It was about eleven in the morning, and it was like a Booth cartoon," he said. "The ceiling was about three feet above this oilcloth-covered table. There was a sick geranium in the window and a broken lightbulb, and Elaine with a bottle of Scotch saying, 'Oh, I *love* this place.'" Few recognized Elaine's sometimes frantic way of living for what it was: a dancing in the dark that kept her private demons at bay. (Her behavior may have stemmed, in part, from the doubt and worry created by her mother's institutionalization during Elaine's childhood.) She recounted her troubled inner life, which she concealed from others, only to a diary that she kept religiously. One person who sensed despair in Elaine was the poet John Ashbery, who said, "Despite the immediacy and vivacity, I felt that Elaine was always holding something back, that there was some secret that she couldn't impart."

Her sister Marjorie, who knew all the secrets, finally decided that she must intervene in Elaine's life, and sometime around 1974 she taped one of Elaine's drunken discourses without her knowledge. Far from being amusing and witty, as Elaine fancied herself when she drank, she was rambling, incoherent, and tiresome. Horrified, she vowed to quit drinking. It was her fear of losing control of the image she presented to the world

that finally inspired her to seek treatment. She joined Alcoholics Anonymous, and with the help of three people—Marjorie, her therapist, and an Episcopalian priest—succeeded in breaking the addiction.

At the same time, Elaine found a new financial advisor in Aladar Marberger, whom she met during a teaching interlude at Carnegie Mellon and encouraged to come to New York. Flamboyantly gay, with a taste for gossip and intrigue that rivaled Elaine's, Marberger became director of the Fischbach Gallery. Soon Elaine, whom Marberger affectionately called "Mother," began to exhibit there. Aladar also urged Elaine to seek a regular allowance from de Kooning and promised to help her get one. Half of de Kooning's worldly goods, he reasoned, legally belonged to Elaine. Why not go after them? Nothing formal came of his plans. But in 1969 Elaine did trade her Shelter Island house for a small summer cottage on Sandra Drive in Springs, just down the road from de Kooning's studio. Eventually, Elaine sold that house and bought a more comfortable year-round one on Alewive Brook Road. It was about ten minutes from de Kooning's studio, in a leafy area of East Hampton called Northwest Woods. She added a studio; when her landlord in New York decided to raise her rent exorbitantly, she moved to the country full-time. "She wasn't willing to be gouged," said the artist Jim Bohary, a close friend of Elaine's.

Before the early seventies, Elaine paid de Kooning occasional visits in the Springs. But now, with a house of her own in the neighborhood, she saw him more often. "I know that she and Harold Rosenberg used to come over to visit Bill," said Bohary. Sometimes, de Kooning also visited Elaine. It was natural, since she lived nearby, that Elaine would become interested in de Kooning's alcoholism after she herself joined Alcoholics Anonymous. "The thing about AA is that you're supposed to go back through your life and see the people whom you've wronged," said Betsy Duhrssen. "So when Elaine went into AA, she tried to make amends to people." It was during this time that Elaine asked Eugene Tiritter if he would work with de Kooning. Along the way, she also persuaded de Kooning to see a doctor in Manhattan for professional advice about treating his alcoholism.

It made some medical sense, therefore, for Elaine to step in and monitor de Kooning's day-to-day health at the studio. She had always denied, in any case, what de Kooning's intimates assumed—that the rift between her and de Kooning was permanent. Friends often observed that Elaine always spoke about de Kooning as if she had seen him the day before, even when years elapsed between visits. "I always used to think it was rude to her boyfriends to talk about Bill constantly," said her friend Jane Freilicher. "But she was oblivious to it." Even so, Elaine was initially very tentative

at the studio and often stayed at her own house. "Believe me," said Joan Ward, "she came in and she was on tiptoe. She didn't know how much she could put over, or how much Bill would take. Or how much power Lisa and I had. In those first years, if I ever stopped over to see Bill, within ten minutes Elaine would appear. I don't know what she thought we were going to do with Bill. After all these years, I wasn't going to shanghai him and bring him back here. But that shows you how unsure she was."

Elaine also proceeded cautiously because she feared de Kooning's temper. She was well aware, from the early years of her marriage, that their rhythms of living were different. He was a solitary, preferring to be alone or to talk to a few "old-timers," whereas Elaine lived like a social whirlwind. ("I have a thousand close friends," she liked to say.) Dealing with the other women in de Kooning's life presented an immediate challenge. In 1977, Lisa was a rebellious twenty-one-year-old forced for years to struggle with an awkward family situation. She was not going to treat Elaine as a fairy godmother. Nor would Joan warmly welcome Elaine. Even though Ward and de Kooning had lived more or less apart since 1971, they had remained in close touch, and de Kooning almost invariably turned to her when he was ill. On some level, de Kooning, Joan, and Lisa continued to function as a family. At Lisa's twenty-first birthday, said Elaine Benson, "Bill was very much there and being the father and they were a little nuclear family. I think having the child was very important to him."

There was also, of course, Emilie Kilgore. In the late seventies, her relationship with de Kooning remained strong. While she continued to live in Texas, she maintained her apartment in New York and visited East Hampton as often as she could. Elaine initially treated Kilgore much as she treated Ruth Kligman, assuming a clucking air of affection, as if she found it charming that Bill should have girlfriends. When Kilgore would arrive at the studio to take de Kooning somewhere, she would solicitously send the two off together like a mother seeing her son off on a date. Early on, Elaine and Mimi had one misunderstanding created, characteristically, by de Kooning himself. Elaine had accepted a dinner invitation. But de Kooning, without telling Elaine, instead went out with Mimi. He did not tell Mimi he had had prior plans. Elaine, stood up, furiously upbraided Mimi and de Kooning when they returned. And yet the two women soon developed a friendship, implicitly acknowledging that each had her essential part in de Kooning's life.

Given the uncertainty of exactly who stood where in de Kooning's life, Elaine did not immediately quit her job teaching at the University of Georgia in Athens. The position, while untenured, was for three years and

paid extremely well—$40,000 a year. Since it was only a two-day-a-week obligation, she was able to commute to and from Georgia. But the job still kept her away from the Springs for significant amounts of time. In the fall of 1977, not long after agreeing to help de Kooning, she asked two of her nephews—Christopher (Jempy), her sister Marjorie's son, and Clay, her brother Peter's son—if they would spend some time with de Kooning. Their real job was to control his drinking, as Dane Dixon seemed unable to do so. The arrangement worked fairly well that fall and winter. Elaine's nephews made sure he regularly attended AA meetings at St. Luke's Church in East Hampton. De Kooning was still working hard on his late pastoral landscapes, twelve new examples of which were shown by Fourcade in October, which helped to keep the studio calm.

De Kooning seemed to be in a settled state of mind in 1978 as the opening approached of the Guggenheim's "Willem de Kooning in East Hampton." It was his first big museum exhibition in New York in nine years. Fourcade set up a number of interviews to publicize the show. Writing in the *New York Times*, John Russell described de Kooning as "small and delicate, with an altar-boy's fringe of fair hair, an almost weightless walk and a quickness of response and perception which most people lose in first youth." De Kooning spoke to Russell at length about Matisse, who was supplanting Picasso as a key inspiration. Organized by the curator and scholar Diane Waldman, the show, which opened on February 10, was a courageous one—it was still common for intelligent critics to treat de Kooning's Long Island years with either condescension or contempt—and selected with unusual discernment. Of the fifty-six paintings on view, half were from the series that began in 1975, among them . . . *Whose Name Was Writ in Water.* As a result, viewers were left with a stronger impression of the pastorals of the seventies than they were of the candied, sexually lurid paintings of the sixties. The show also included some of his best drawings and a selection of sculpture.

The reviews, however, were subdued. No critic recognized the originality of what de Kooning was doing with touch, the figure, or the pastoral tradition; critical taste in America had never displayed much patience, in any case, for the heightened color and swirling "too-muchness" of Rubens and the baroque, which de Kooning was carrying forward into modern painting. ("I'm crazy about Rubens," de Kooning said, "all those voluptuous women. He was the ultimate of the Baroque period—all hallelujah.") It had also become a point of honor for serious critics in the seventies to resist the hype of the commercial art world. Fourcade's unrelenting effort to advertise de Kooning's contemporary work as a great late flowering backfired among the strong-minded. Both Hilton Kramer and

Robert Hughes emphasized, as if to protect art's honor, that de Kooning's recent paintings were decidedly *not* comparable to the late work of Cézanne, Monet, and Matisse. Kramer praised de Kooning's "extraordinary energy and confidence," but also found the exhibit "dispiriting," referring to the "delectable painterly surfaces, which begin by seducing the eye and end—for this observer, at least—in a suffocating surfeit of sweetness and charm. There is a certain invertebrate quality to Mr. De Kooning's late work that turns soft and mushy under examination, as if it were an organism consisting of flesh without bones." Hughes acknowledged de Kooning's "seriousness as an artist and his historical achievement," but thought that the latest work "was not remotely of the same order as the late works of other old men of the modernist mountain—Matisse at 80 with his colored cutouts, the last paintings of Cézanne, Monet's lily ponds."

What critics gave to de Kooning with one hand, in short, they still took away with the other. In any case, by 1978 de Kooning seemed to accept his role as an artist more honored than understood. The transition to wise old irrelevance that began with the Presidential Medal of Freedom in 1964 was, in fact, becoming almost burdensome: the Edward MacDowell Medal from the MacDowell Colony for "outstanding contribution to the arts"; the gold medal for painting from the American Academy of Arts and Letters; a medal from the Albert Einstein College of Medicine; and, later in 1978, membership in the American Academy of Arts and Letters. The attention was part of a revival of interest in the entire New York school. In October 1978, the Whitney Museum of American Art exhibited a retrospective of abstract expressionism—the first ever—that included 120 paintings by 15 artists. Even more dramatic was "American Art at Mid-Century: The Subjects of the Artist," the show that in May 1978 opened the new East Building, designed by I. M. Pei, of the National Gallery in Washington. It focused on de Kooning and six of his contemporaries: Gorky, Pollock, Newman, Rothko, Motherwell, and David Smith. The festivities that marked the opening began on May 30 with a lavish black-tie dinner presided over by Paul and Rachel "Bunny" Mellon for two hundred guests. The building's atrium was filled with hurricane lamps and topiary trees. Both Elaine and de Kooning were there.

In May 1978, Elaine decided to resign from her teaching job in Georgia rather than return for a third year. The prospect of taking care of de Kooning seemed preferable to the tiring commute. She was also irked that the University of Georgia had offered Philip Guston $2,000 for one lecture. Although her $40,000 annual salary for her two-day-a-week job was more money than she had seen in years—"about a thousand dollars a day," said

Conrad Fried—she felt undervalued next to Guston. Before giving up the lucrative job in Georgia, however, she wanted a more formal agreement with de Kooning to protect her financial position. She first discussed the idea with de Kooning himself, who agreed in principle to a new arrangement. So did Lee Eastman, who always believed that de Kooning should not divorce Elaine, anticipating that she might again play a role in his life. But Eastman was also not a man blinded by sentimentality or emotion; and he knew who he worked for. He drew up papers specifying that Elaine would get a handsome financial reward—but only if she gave up the right to control de Kooning's estate. Elaine was insulted. But reluctantly, after angry discussions with family and friends, she agreed to his terms. When she told the University of Georgia that she was resigning, they offered her a $5,000 raise and tenure. But tenure, Elaine said, was a "trap." She quit her final teaching job with few regrets.

On July 11, 1978, Harold Rosenberg died of a stroke, complicated by pneumonia, at his house in the Springs. De Kooning immediately fell to pieces. Not only was Rosenberg an intimate from the early days in New York, but he was the most consistent champion of de Kooning's art, never doubting his friend even as others hedged their bets. He was the old-timer who put in the most talk time with de Kooning, joining him in the studio rockers to reminisce or to tilt at the absurdities of the present. Rosenberg was a large-minded man, a battler in the philosophical skies, whose death diminished the world around him. And then, two days after Harold's death, Tom Hess died suddenly of a heart attack. In the space of two days, de Kooning lost two dear friends and his earliest, most steadfast critics.

De Kooning was not a realist about death. It unfailingly shocked him. He could not bear the thought, he told Mimi, of its finality. The loss of his two friends left him more isolated than ever, and the grief drove him into the most destructive drunk of his life. Years later, one of his closest neighbors, the artist Rae Ferren, still vividly recalled being awakened early in the morning by the sound of Lisa's two huskies baying and howling at the studio. "That was their reaction to the ambulance having taken Bill away," said Ferren. "He was desperately ill." Southampton Hospital could do little for him: he just began drinking again once he was released. The binge stretched first into weeks and then months, with occasional brief periods of drying out.

What did he think about during his sober times? About the sober facts, perhaps. His painter-friends Gorky, Pollock, Kline, Rothko, Newman, all dead. Now Tom and Harold. Increasing mental difficulties of his

own, including short-term memory loss, a harbinger of old age and death. And control of his studio slipping away. Soon, Elaine's nephews could not stop his drinking. He would swat them away, becoming bearish and violent if anyone tried to stop him. Even in his mid-seventies, he was stocky and strong. He punched and lashed out if crossed. Elaine's nephews told her they wanted to leave. Elaine was at a loss about what to do. So was Joan Ward, who feared that this one might really kill him. Ward again sought the help of Eugene Tiritter, who had become de Kooning's most important AA connection. She proposed that he take de Kooning to his own house for a weekend, and see if he could break through to him. On a Friday, Tiritter drove the half hour west to the Springs, picked up de Kooning, and brought him to Montauk. The first evening in Tiritter's small and neat house passed fairly well. In the morning, however, de Kooning was surly. He wanted to go home and begin drinking again. "It was very uncomfortable," said Tiritter. "Bill was getting sober and he wanted to be in his own bailiwick." As Tiritter stalled, de Kooning became a cajoling, duplicitous, negotiating drunk. Would Tiritter like a painting?

Elaine grew increasingly desperate. Her job was to control de Kooning's drinking, but by the late fall of 1978, he showed no sign of emerging from the serial binges. How could she keep liquor away when de Kooning could bike down to the Barnes Country Store for a couple of six-packs and many visitors seemed all too happy to share a bottle? The local doctors stepped forward with dire warnings: if de Kooning did not stop drinking, he would soon be dead. Elaine tried intimidation. When she would find him with his head on the kitchen table, a down-and-dirty drunk, she would tell him, "If you keep this up, you're so strong that you'll wind up sweeping the floor in your own studio and that will be the only thing you'll be able to do." The fear of losing his mind sometimes sobered de Kooning up, but his resolve would soon weaken. It was not hard to get a bottle from Dane Dixon. Dixon did not want de Kooning to drink, but he could not, after their years together, deny his friend and employer.

Elaine then turned to her brother Conrad, the one person whom she thought could handle the situation. She drove up to see him in Livingston Manor, where he lived in a house in the heart of the Catskills on land that the Fried family had originally settled in the 1840s. Although Conrad had continued painting since his days as de Kooning's assistant and informal student on Twenty-second Street, he had also pursued a career as an inventor. He was known as a problem-solver. "I was separated from Elaine and Bill for a good number of years because of the boozing," Conrad said. "It was stupid and crazy. So I wasn't close to Elaine. I would see her every couple of years." After Elaine stopped drinking, however, they reconciled.

Conrad had never forgotten how kind de Kooning had been to him. "I owed Bill a lot," he said, "because he helped me not in a physical way, but a psychological way. He became a mentor. He helped me to know what I was doing."

So Conrad reluctantly agreed to live in the studio. "I went out there and moved right in on Bill. I'd take him out bicycle riding and walking. I made sure that he had vitamins and good food. And I kept the booze out of him. People would feed him booze because he was helpless. Anyone could take a drawing." Together, Conrad and Elaine systematically went through the community, asking local bars and stores to stop selling him beer and liquor. Some, like Clarence Barnes, complied. "What a hard thing that was to do, with the kind of money that household was spending," said Barnes. "But I had to tell him no." De Kooning then began to pedal to stores farther away, putting the beer in the basket of his bicycle. After Elaine removed the basket, he was spotted riding along with a six-pack tucked under one arm. It did not take long for tension to rise between Conrad and de Kooning. Like Elaine's nephews, Conrad had a difficult time controlling de Kooning when he exploded into a bull-rage. Instead of ignoring the outbursts, Conrad took them personally. And de Kooning could be remarkably abusive. He would sometimes fight for a drink like an enraged animal; once, he smashed his fist into Conrad's stomach.

Elaine decided to try antabuse, a foul-tasting drug that sickens a person who drinks alcohol. It was a Pavlovian cure with which de Kooning was already familiar. Elaine did not tell de Kooning that she was giving him the drug. She simply began to add antabuse to his eggs in the morning or to the health drinks from his earlier regimen that he still consumed. And he did become dreadfully ill. Elaine would say, "That's what drinking does to you." The problem was that de Kooning—once he started to drink—drank quickly and kept on drinking regardless of the consequences. By the time the antabuse began to take effect, he had often consumed as much as half a quart of Scotch. The results were terrifying; instead of merely becoming sick to his stomach, he would lose consciousness. If Conrad, Elaine, or Dane were not around—and de Kooning was still often left on his own—his life was in danger. One time, when the writer Arnold Weinstein and his wife dropped by the studio to take de Kooning to a party, they found him lying on the floor in an apparent coma. "This was really terrible," said Weinstein. "My wife got really scared; she thought he was dead. We called up and got him to the hospital. He was drunk, and this was the response to the antabuse."

Several months after he moved into de Kooning's studio, Conrad, too, wanted to leave. But abandoning de Kooning was tantamount to killing

him. So Conrad devised another solution. At one point, while he had been working in Maryland, Conrad befriended a group of talented young painters, including Tom Ferrara and his friend, Robert Chapman, who were studying at nearby schools. "I was like a guru to these young fellows," said Conrad. At the time, they were an active part of the rebellious sixties generation, but by the late seventies, said Conrad, they had "straightened out and become serious. I said, well, Elaine needs help. And I brought up Tom." Ferrara arrived early in January 1979, eager to meet de Kooning and full of the excitement of a twenty-five-year-old artist in thrall to a legendary figure. The initial meeting between the two that Elaine had planned never took place, however, for de Kooning began drinking. At first, Ferrara lived with Elaine in her house on Alewive Brook Road. Gradually, Elaine began stopping by de Kooning's studio with him, either for dinner or after they had been grocery shopping, to see how the two got along. "He was pleased that I had an Italian name," said Ferrara. "In a way I guess he thought I was a foreigner too." As the months went by, Ferrara began to help de Kooning stretch canvases and carry out some of the odd jobs usually performed by Dane Dixon, who was himself in poor shape and was rarely around. Toward the end of 1979, Elaine began easing Dixon out of his job. Loyal to his drinking buddy and susceptible to Dane's pleas, de Kooning resisted her efforts for a while, but even he probably realized that Dixon drank too heavily to be an effective assistant. "At that point, Bill really did need someone at least to fix dinner and stay there," said Ferrara. "There were all these people who tried to hustle him and get things out of him. It was like being a 24-hour watchdog."

The gradual departure of Dane Dixon in early 1980 marked the true beginning of Elaine's control over the studio. By then, Tom Ferrara was living there almost full-time, with a bedroom down the hall from de Kooning's. His friend Robert Chapman would join him as a studio assistant in October 1982. The new arrangement suited Elaine: she could sometimes stay at her own house, make trips abroad, and generally come and go as she pleased. By the end of 1979, de Kooning had stopped drinking. But he had also stopped painting.

The deaths of Rosenberg and Hess, and the destructive bingeing that followed, effectively ended de Kooning's cycle of pastoral paintings. By late 1978, several months after their deaths, the flow of paintings had already been reduced to a trickle. Then, at a certain point in 1979, de Kooning simply walked away from the easel. By the time Ferrara moved into the studio, de Kooning was hardly working at all. "He said he got to a

point where he felt like he could make the paintings with his eyes closed," said Ferrara. "His way of describing it was 10-20-30. It had become predictable." De Kooning told Joan Levy that he "had a dream that the water was turned off," and that he could not then paint another picture in the cycle.

The year 1979 was extraordinarily difficult for de Kooning, not only because he was drinking but because he was deeply depressed. Sometimes, he hardly seemed to move, rendered helpless by a melancholy darkness closing over him. "He used to talk about angst," said Ferrara, "about how there was not really a word in English to describe it." He referred to his condition as a "state of shock." A "gloom" had settled over his body. It might take several hours before he could be cajoled out of the dread that gripped him. When the depression grew so severe that he could not bear it, he would demand a slug of whiskey. Occasionally, a combination of alcohol and sedatives left him disoriented and foggy. The blank canvases in the studio added to his unease. On a visit in 1980, Joan Levy recalled seeing a painting on de Kooning's easel that had long since dried—which she knew meant it had been abandoned, since he kept his "living" canvases wet. There was an anchor form, she said, "stuck right smack in the middle of the canvas."

De Kooning's failing memory further deepened his depression and signaled a more general deterioration of his mental faculties. He was aware of the problem, painfully so, but spoke to no one about it. As early as 1974, before leaving for Georgia, de Kooning's longtime assistant John McMahon began noticing how vague de Kooning could be. Molly Barnes, his sometime girlfriend from California, noticed a similar vagueness by 1977. It might now take him a while to recognize a neighbor or someone he saw infrequently. When telling a story, particularly about the past, he would remain completely focused and recall every detail. But then, a few minutes later, he might retell the same story. Almost everyone explained such symptoms as the result of drinking. How could anyone drink as de Kooning did without such consequences? As far back as the late fifties, he had suffered from blackouts. During one particularly bad episode in Rome in 1959, an Italian doctor warned him that such abusive drinking could adversely affect his nervous system.

In 1979, de Kooning wrote his last letter to Mimi. He could begin but not end it. He repeated the opening passage again and again. It was, said Mimi, "the same letter seven times," and he handed it to her rather than mailing it. Nevertheless, she remained one of the few people around whom he brightened, and he continued to take a great interest in her life.

When her sister died at the age of forty-two Kilgore established, in 1978, the Susan Smith Blackburn prize in her memory. (The prize, awarded each year to a woman playwright in the English-speaking world, soon became very influential.) De Kooning created and signed a limited edition of prints to be given to the winner and others associated with the award. He was growing increasingly anxious about Mimi's future. In 1980, the Kilgores told family and close friends that they were separating. "He would get very worried about me," she said. "He knew I wasn't poor, but he had this view of me as a waif or as an orphan."

De Kooning feared that family tensions close to home were erupting in ways he could neither understand nor resolve. He was now surrounded by women, each with a different but strong claim upon him: wife, lover, mother, daughter. He was particularly concerned about Lisa. He liked to wrap his arms around her and sing a version of a song from *Guys and Dolls*—"Sue me, sue me, what can you do but sue me, I love you." But he knew Lisa was unhappy about Elaine's presence in the studio. Elaine had moved into Lisa's room, and her larger-than-life personality and efforts to bring order to the studio did not leave much breathing room for a quixotic daughter. Lisa began to feel uncomfortable taking her father for a drive. She wondered what had happened to all the photographs of her in the studio. De Kooning did not know what to do about her uneasiness. And so, Lisa began spending more time on the West Coast, working at a variety of jobs in which she trained and cared for animals. She helped make the Mercury "Cougar" commercial; she once rode Orca the Killer Whale. But she kept an eye on home, too, and continued to try to find a place for herself there. In 1979, she helped develop a charity benefit for the ASPCA, and she asked both her parents to attend. Elaine did not like de Kooning to appear in public without her. The situation quickly became so emotionally fraught that, in the end, neither parent attended the event; after the benefit, Emilie Kilgore took Lisa and some of her friends to dinner. Lisa said the experience "scarred" her. Not surprisingly, she began to look to people outside her immediate family for guidance in how to respond to a world increasingly interested in "de Kooning's daughter." De Kooning's old friend Priscilla Morgan became a "sort of surrogate mother," according to Ferrara, which set up still another awkward situation, since Priscilla and Elaine were not friends. Lisa spent less and less time in the Springs.

As de Kooning weakened, Elaine assumed complete control of the studio. Through his bookkeeper, Frances Shilowich, she monitored his cash flow. She oversaw who was hired and fired, who visited him at his studio,

and what publicity he engaged in. According to Joan Ward, he finally awoke to what having Elaine back in his life meant:

> Bill was playing the game out to the end. He thought between the three of us [Joan, Elaine, and Emilie] there would be a real push and pull. OK, everybody is up for grabs now. Come in and fight over me and let the best man win. He loved push and pull around him, playing one person against another. But he didn't realize that as he was getting older and a little shaky, Elaine as the wife could come back and legally take over. And, I must admit, I retreated. It wasn't until he realized that he was trapped—that nobody was going to do battle—that he tried to rebel. But it was too late. He was trapped in his own trap.

It was Ward's theory that de Kooning stopped painting in 1979 as a way of resisting Elaine. "It drove her frantic," said Ward. "Think about it: I've captured the lion, and now the lion is no longer doing what makes him the lion. I've saved him from himself and he isn't painting? How's it going to look to the outside world?" It was a theory that Tom Ferrara disputed. De Kooning just needed a new way of working, in his view, a fresh source of inspiration. In fact, de Kooning did sometimes resent Elaine's authority and would belligerently demand of Ferrara, "Who's in charge here?" as if, said Ferrara, he was genuinely worried that he might not be. And a new cycle of work would obviously help. But de Kooning's own explanation for the block—"angst"—was probably the most accurate. De Kooning was too red-blooded to yield graciously to the indignities of age. The reader of Kierkegaard, who believed there wasn't a word in English to convey what "angst" truly meant, was suffering from the soul-sickness that northern Europeans knew so well. He was facing age, death, and diminishment. White winter light and early darkness.

In 1980, de Kooning was seventy-six years old. Sometimes, Elaine thought he must be finished, much as Susan Brockman had two decades before. But one day in the spring of 1981, after months of staring at the dried-out canvas on his easel, de Kooning, without ceremony, laid out his paints, picked up a fistful of brushes in his left hand, and began the final series of his life.

38. The Long Good-bye

Then there is a time in life when you just take a walk:
And you walk in your own landscape.

De Kooning was not an artist who worked by plan. The notion form-
ing in his mind about his next cycle of paintings probably resem-
bled an intuition or an inkling, something that could be fully
apprehended only through exploration at the easel. But its outlines could
already be sensed in his talk. During the spring of 1981, Gorky, never far
from his thoughts, became a particularly powerful presence. "In a way,"
de Kooning said in the early eighties, "I have him on my mind all the
time." In April, the Guggenheim mounted a retrospective of Gorky's art;
Elaine and Tom Ferrara took de Kooning into New York to see the show.
His old friend's way of drawing with the brush—especially the wandering
whimsy of his line—must have stirred de Kooning, given the work that
would shortly emerge in his studio. Matisse, too, was often in his
thoughts. He admired the graphic simplicity of *La Danse*, which he had
often seen in the Museum of Modern Art, and he loved the spirit of the
cutouts. "Lately I've been thinking," he said in 1980, "that it would be
nice to be influenced by Matisse. I mean, he's so lighthearted. I have a
book about how he was old and he cut out colored patterns and he made it
so joyous. I would like to do that, too—not *like* him, but joyous, more or
less."

If asked to describe what he admired about the French painter, de
Kooning said it was the "floating" quality of his pictures: "It was the ethe-
real thing about Matisse," said Ferrara, "that appealed to him as an old
man." (De Kooning loved the airy Tiepolos he saw in Italy.) The paint-
laden works of the late seventies also seemed to float, but with the liquid
viscosity of water near the shore. The "float" that now interested him
seemed airborne. During this period, a conservator warned de Kooning
that his unconventional mediums of the sixties and seventies, mixtures
based mainly on safflower oil and water, might actually destroy his paint-
ings over time. "This conservator came to the studio and said, 'Because
you're using this safflower oil and spackle and water as medium, your
paintings are not going to last," said Joan Levy. "He said, 'The guy told me
to use traditional medium.' " The warning increased de Kooning's impa-

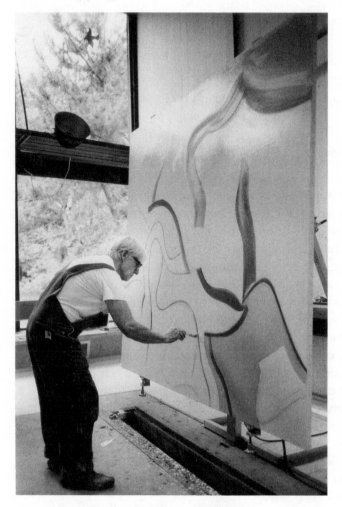

At work on a "ribbon" painting, 1983

tience with the dense surfaces of his late-seventies work and reinforced his growing desire for lighter, more evanescent art.

De Kooning had made a kind of peace with age. The furies abated; he recoiled less from the injustices of time. He was no longer the man who made the passionate pastorals. But perhaps something might yet be done. Age, too, had its light. In the spring of 1981, de Kooning essentially began to empty out the landscapes of the late seventies. At first, he sometimes dipped into his old bowls of color, but, gradually, the paint in the bowls near his easel began to dry up. Now, instead of whipping up the paint beforehand, he often squeezed it from a tube onto his palette—a huge, glass-topped worktable on wheels—and then pushed his brush into his new Bocour medium, a classic mix of varnish, oil, and rectified turpentine. Once the brush was loaded with medium, he would pick up a blob of paint and apply it directly to the canvas, often creating ribbonlike forms against a white ground. He used a spackling knife to remove excess pigment with sweeping strokes, leaving behind scraped patches and ghostly residues on the white ground. "I scoop off what I don't like," he said. In *Untitled I* of 1981, the thick impasto and interwoven brushstrokes of the late landscapes disappeared, replaced by a surface more like his smooth, thin-skinned paintings of the thirties and forties. If the paint once lay heavy on the canvas, now the

white background shone through and flicking strokes—made with a liner brush whipped around with the wrist—danced across the surface. The new images looked spare and open, less layered than before. The dazzling intensity of the underlying white gave each an inner radiance. Before beginning, he painted each primed canvas white so that he could work wet-in-wet, the colors blending in interesting ways. "When he started doing those paintings of the eighties, the light was pouring out," said Joan Levy. "He said, 'What do you think?' I said, 'They're so ethereal. It looks like you died and went to heaven.' " De Kooning agreed. "Yes, that is what I was going for."

De Kooning was not just scraping off the weight of the past. He was also beginning to empty out the turmoil in his art, having already abandoned in the seventies the edgy anger that fired much of his art. He still sought visual tension; the art historian Richard Shiff described the work of the early eighties as being wound as tight "as a coiled spring." But he now also hoped to create a thoughtful sensation of tranquillity. According to Ferrara, de Kooning once said of his paintings from the eighties, "I like them because they don't go for the throat." It was important to him that they seemed to come effortlessly, as if "breathed" onto the canvas. He often spoke of wanting to connect simply and directly. "Bill talked a lot about sign painting," said Ferrara. "He said, 'I want [the paintings] to be just like a sign.' He wanted that really explicit statement." According to Conrad Fried, "Bill wanted 'ease' in his paintings. He said that if you work painstakingly, what happens is that some of that pain comes across to the viewer. But if you work freely, then that comes across and makes the viewer feel free. He'd say, 'For no reason at all' about what he was doing. He'd say, 'I might work on a painting for a month, but it has to look like I painted it in a minute.' " It was difficult to attain that ease. De Kooning, in the early eighties, continued to work and rework his paintings. An assistant photographed no fewer than fourteen different stages of *Untitled XXIII* of 1982.

Once embarked on the new series, de Kooning worked steadily throughout 1981 and 1982, producing fifteen paintings the first year and twenty-eight the second. He began to draw less than he had in the past. Now, he would make an initial drawing on the canvas itself, and then use recently completed paintings to stimulate his eye. He would lift passages from paintings with charcoal and tracing paper (as he had often done in the past), which he would then transfer to other pictures. "It was like the process of making collages," said Ferrara, who watched de Kooning move the tracing around until it worked with the picture. With canvases propped around the studio for reference, the evolving paintings, like the

seventies cycle, bore a family resemblance to one another—increasingly so as the decade wore on and de Kooning began one painting by looking directly at its predecessor. Still, they varied greatly. Some from the early part of the decade were covered with thick, muscular tongues and ribbons of paint. Others had the delicacy of *Untitled XXIII* of 1982, in which a few blue ribbons—and one patch of red—floated above a white-and-pink-tinted background. All had the same luminous, floating atmosphere. "When he started using straight paint with the traditional medium he thinned the surface of the canvas, but he also compressed the visual illusion of space," said Joan Levy. "It was compressed onto the surface."

Concerned about de Kooning's change of direction, Fourcade approached the first show of de Kooning's works from the eighties gingerly. "New Paintings: 1981–1982" was carefully selected and scheduled for the end of the spring season; Fourcade chose only ten examples. The response by the *New York Times* was enthusiastic. Noting the quiet strength of the new works, John Russell praised their "many points of repose" and went on to write, "These are 'late' paintings, inasmuch as [de Kooning] may no longer have energy to burn in the way that he had twenty years ago. But in place of that almost ostentatious energy there is a new spareness of statement. Even five years ago, he would not have shored up the composition as he does today, with big battens of paint that bring the kind of balance we expect in a shipyard."

Tension in the studio subsided once de Kooning stopped drinking. Then, as he began to work again, Elaine and the assistants did everything possible to make painting easy for him. When he complained that his back hurt from the strain of moving around canvases on the easel, for example, the technically gifted Fried designed a new metal-framed and hinged easel—with clamps on top and bottom to hold the canvas in place—that de Kooning could rotate whenever he wanted to experiment with the orientation of a painting. Those close to de Kooning now had time to think about a future. In 1981, Lisa began to build her own house on the studio grounds; she could be near her father but out of Elaine's way. And Elaine herself—free of teaching responsibilities and with access for the first time to significant amounts of money—began to transform the public life of the studio. It developed an extraordinary aura. As the aging de Kooning increasingly withdrew into his private world, Elaine created a seductive persona for him. He became the grand old man with a mop of white hair, a Matisse for the late twentieth century, walking about in his painting overalls, lost in profound reveries and yet smiling and full of charm. Celebri-

ties, friends, artists, CEOs, and the worshipful young came to pay court. The studio became her dream of the way life should be, a place to gather in the informal atmosphere of genius and talk away the night at a long rough kitchen table. On a less exalted level, Elaine—and especially the new assistants she brought into de Kooning's life—established a welcome sense of order and a comforting rhythm to his daily studio life.

But Elaine also knew—and chose, initially, to ignore—that de Kooning was beginning to suffer from mental problems in the late seventies that could not be blamed entirely on alcohol. Tiritter, the painter's AA sponsor from Montauk, suspected a problem related to age. He knew alcoholics with severe brain damage—so-called "wet brains"—who could barely feed themselves. But he did not think a binge drinker like de Kooning consumed enough daily to harm his brain seriously. At Tiritter's recommendation, Joan had taken de Kooning to a neurologist in Riverhead, who thought he might be suffering from multi-infarct dementia, essentially a series of small strokes that disrupt circulation in the brain. More ominous still was the prognosis of a doctor in New York whom Elaine consulted in the seventies before she took control of the studio. He agreed that heavy drinking and bingeing could cause some short-term memory loss in a man de Kooning's age, but he also detected what he thought could be the early symptoms of dementia or an Alzheimer's-like disease.

After de Kooning emerged from his last great bout of drinking, however, his mental health actually improved dramatically. His symptoms almost disappeared. It may be that his problems in the late seventies did stem mainly from drinking, or that the drinking worsened the early symptoms of the disease. Alzheimer's-like dementia was not well understood then; a diagnosis could not be confirmed until after death. (While magnetic resonance imaging—MRI—can now show deterioration in the brain, it still cannot confirm a diagnosis of Alzheimer's in a living person.) De Kooning's symptoms were similar to those found in other ailments, moreover, including those of long-term alcoholism—most notably Korsakov's syndrome, in which chronic alcoholism leads to memory loss, organic brain damage, and finally dementia. Elaine could therefore convincingly argue that once de Kooning stopped drinking he recovered, and his problems were merely those of age and habit. His eyesight was worsening, and he constantly fumbled between eyeglasses designed for viewing his paintings at sixteen feet and close-up glasses for reading. He smoked too much, with the butts piling up in a sand-filled bucket that he kept between the rocking chairs. He sometimes had trouble getting going in the morning, which had been true all his life. Why wouldn't he have such problems? He was seventy-six years old.

It is a serious mistake to view the 1980s as a single or uniform period in de Kooning's life and work. In the first years of the decade, de Kooning was an elderly but still robust man, focused upon his art and in full control of his easel. There were many very good days. Sometimes, Ferrara said, "he was up and dressed by seven a.m." He would still occasionally bicycle alone to Louse Point. He could carry around canvases and studio furniture. He tolerated no interference whatsoever with his studio practice. Once under way in the morning, he would maintain a steady momentum until lunch. Often he liked to work to music, although he usually let others decide what to put on. He still loved Stravinsky and jazz but also welcomed the music of his young assistants and became a particular fan of the Talking Heads. The sound of Bob Dylan and the Beatles filled the studio, especially after Ferrara replaced the decrepit stereo system. "You'd put in a tape and he would stand in front of the speaker," said Ferrara. "I don't know whether it was something rhythmic or melodic [that intrigued him]." One time, said Ferrara, he put on a record of old classical favorites. A particularly romantic song by Rossini deeply affected de Kooning. "He stumbled out with both hands full of palette knives and brushes and said, with tears in his eyes, 'Who put that on? God bless you!' It must have been something nostalgic for him."

De Kooning would continue to work hard until the late afternoon or early evening. He still watched television regularly at night, and he would leaf through the Sunday edition of the *New York Times:* he liked to read the book review section, and he would study the advertisements in the magazine. "He always liked advertising," said Ferrara. "A lot of times on TV he would comment on the commercials. I think he enjoyed the fact that [American] advertising was so straightforward. . . ." On most nights, he would be in bed by ten p.m. But an early bedtime never ensured a good night's sleep. "He was up and down all night," said Ferrara. "He would pace through your room hoping you'd wake up." It was during the nights that de Kooning would sometimes be overwhelmed by angst and gloom. A friend of Conrad's was staying in the studio once when, in the middle of the night, she was startled awake and saw de Kooning standing in the doorway, his fist in his mouth and tears running down his cheeks. There were times when he just went back downstairs, turned on the studio lights, and began working on a painting.

Tom Ferrara and Robert Chapman helped wean de Kooning from Valium and began to give him B vitamins and niacin, which opens the blood vessels and gives some people a "niacin flush." Although this regimen helped him get going on many mornings, he would still sometimes remain in bed until ten or eleven a.m. But even those days could turn out

well. The assistants discovered that there was always one thing that could animate him and restore his spirits—talking about his paintings. Ferrara would sit in one of the Eames chairs in the living room and, as de Kooning ate a breakfast of cereal or eggs, the assistant would mention something about a painting. In time, de Kooning would become interested enough to move toward the easel. On the better days, he would eat sitting in one of the rockers staring at the painting on the easel. "Just being able to sit there was important to him," said Ferrara. "If he discussed the painting, it would be something like, 'There's too much blue there,' or 'There's too much going on in the center,' or 'If you could just move that over a little to the right.' " When nothing else worked the assistants would take him to Louse Point. In the winter he would sit in the car, silently looking out, and in the summer spend hours quietly on the sand. Louse Point never failed to soothe de Kooning. Once, when Ferrara tried unsuccessfully to get de Kooning out of bed by promising him a ride to Louse Point, de Kooning finally reared up and said, "Trying to seduce me out of bed, are you?"

Left to himself, de Kooning would have maintained little contact with the world beyond his studio and Louse Point. Often, it seemed to his assistants, he did not even want to see his old friends. Only Lisa and Mimi delighted him. Other visitors whom he greeted with pleasure were the very young—whether painters like Joan Levy, fresh-faced admirers, or children. "They seemed to get him going," said Jim Bohary about de Kooning's interactions with his young son. He would even admit a reporter from a local paper, sent to get a story, if the reporter was young enough. He particularly enjoyed the company of young women, including the assistants who came to work for him as the decade wore on. Otherwise, de Kooning seemed increasingly to need no company but his own. In 1982, he told the writer and critic Avis Berman, "I enjoy my life so much now because I can stay here [at his studio]. I can paint all the time. I don't have to do anything else."

Elaine, of course, had no interest in a reclusive life. Her life was blossoming outward. Her husband was much sought after in the early eighties, on the short list of creative figures considered for every public award. Elaine was delighted when Courtney Sale, the future wife of Steve Ross—then the head of Warner Communications—decided to produce a documentary on de Kooning. Elaine worked hard to get de Kooning to cooperate. It was not easy. The second visit of the film crew was a near disaster; de Kooning became enraged that they returned again to intrude upon his time. He only calmed down when Elaine's assistant, Edvard Lieber, coaxed him into painting. The movie made no mention of Joan or

Lisa or Mimi, but Elaine played a prominent part. She became good friends with both Sale and Ross, visiting them in Positano, Italy. For his part, Ross, a man who adopted people in the arts, enjoyed befriending de Kooning. He invited Elaine regularly to dinner and gave tapes of newly released movies to de Kooning to watch at night. After he and Sale were married and purchased a Hollywood-size house in East Hampton, they displayed de Koonings prominently on their walls. There was even a framed photograph of de Kooning on their piano.

Elaine was also happy about the Eastmans' connection to Paul McCartney (who married Lee's daughter Linda). De Kooning liked McCartney, but what pleased him most, the Eastmans thought, was Lisa's excitement at knowing a Beatle. "Paul and Bill are very chummy," Elaine told Avis Berman, adding that "Paul and Linda always come to visit us when they're in East Hampton." De Kooning told Ferrara that he was once in the hospital on his birthday and everyone seemed to have forgotten him "until Paul and Linda called to sing him Happy Birthday." In the early spring of 1982, with Elaine prominently by his side, de Kooning embarked on a series of public events. The first was the premiere, in March, of the hour-long documentary produced by Courtney Sale (and directed by Charlotte Zwerin) about de Kooning's life, history, and art. The actor Charlton Heston introduced the film at the Kennedy Center in an elaborate ceremony. On that same trip to Washington, de Kooning received a second Presidential Medal of Freedom; he had misplaced his first one. At the White House dinner, he was seated next to an Indian chief who kept helping himself to more food. After a while, de Kooning said, "Hey chief, don't you think you're taking a little bit too much?" To which the chief replied, to de Kooning's unending delight, "A little bit too much is just enough for me."

The next month, de Kooning returned to Washington with Elaine, this time for festivities hosted by the Dutch government. Over the years, the Dutch had grown eager to celebrate their famous expatriate. In 1979, to commemorate his seventy-fifth birthday, de Kooning was named an Officer of the Order of Orange in Nassau. Now, Queen Beatrix of the Netherlands was making an official, five-day state visit to the United States, and the de Koonings were invited to the White House for a dinner in her honor. They had also been invited to a dinner cruise in New York on the *Rotterdam*. Elaine loved going to the White House and to harbor cruises with a queen. Aboard the *Rotterdam* were Governor Hugh Cary of New York, Henry Kissinger, Arthur Schlesinger, and Brooke Astor. De Kooning was the only male guest who did not wear a tuxedo. "I'm not difficult," he said. "There are just certain things I don't ever do." Most gratifying to

de Kooning was his private meeting with the queen in New York—the only private audience she granted during her visit. He never imagined, the stowaway said, that he would one day meet the Dutch monarch. "She's pretty cute for a queen," he told Levy. But such occasions also made him anxious. Five of his paintings were hung in the ballroom of the Vista International Hotel in New York's World Trade Center so that the queen, an amateur sculptor, could chat with de Kooning about them. Unfortunately, throughout the meeting, as reported by the *New York Times*, de Kooning was even more diffident than usual.

Elaine treated money with the careless panache of an aristocrat: it was there to be enjoyed rather than hoarded. "Never scrimp on the luxuries," she liked to say, "the necessities will take care of themselves." Even when broke, she was always an extravagant shopper. Now, in the basement of her new house in Northwest, she collected so many shoes and outfits that she began cataloguing what went with what in the manner of socialites and first ladies. ("Before there was Imelda and shoes, there was Elaine," said Denise Lassaw, the daughter of Ibram and Ernestine.) One room was devoted exclusively to jewelry, much of it bought from the local art dealer Elaine Benson, who said Elaine de Kooning became her best customer. She also began to treat herself and friends to trips—to France in 1983, where the caves at Lascaux would inspire her last series of paintings; to Spain in 1984; to Kenya, Egypt, China, and Japan. She remained as generous as ever, continuing to buy the work of other artists, particularly young artists who needed support, and she prodded de Kooning into thoughtful acts. On the trip into New York to meet Queen Beatrix, Elaine arranged for de Kooning to see the ailing painter Aristodimos Kaldis, whom they remembered fondly from the Waldorf Cafeteria days. At Elaine's urging, de Kooning asked Kaldis to exchange paintings with him. "Kaldis died about a week later," said the painter Irma Cavat, "but not until he had called everybody in New York saying, 'De Kooning dropped by begging me to exchange paintings with him.' I think he died a happy man."

When Elaine wasn't traveling, she often put together serendipitous parties at the studio. The assistants became adept at planning meals that could serve any number of people. She liked to bring together different kinds of guests, from rich celebrities to impoverished artists, as if to create a charmed circle of the truly interesting from every age and realm. "Some people said that the party was over, but that was not a consideration for Elaine," said the artist Paul Russotto. Her friends sat at the long kitchen table, helped themselves at the restaurant stove, and talked to de Kooning in the studio. Elaine's own house was usually filled with people; assistants helped to make food for de Kooning's studio and people dropped by just to

chat. Elaine's longtime friend Connie Fox, whom she had met in New Mexico, lived nearby and was Elaine's "sweet but very efficient first lieutenant, whom Elaine trusted completely," as Russotto described her. There was much laughter, talk, and exchange of ideas. "We're all in this together," Elaine once told Russotto. The only unspoken rule for members of the circle, said Russotto, was that "there was to be only one King, and that of course was Bill de Kooning. Elaine was the Queen . . . and she wore that robe well. In some ways, she was almost like a Hollywood star."

Although Elaine spent less time at the studio than many thought, her authority was unquestioned. Through Frances Shilowich, the bookkeeper, Elaine kept abreast of every move of Lisa's as well as of the assistants in the studio. She was usually there to greet visitors, often dominating the conversation when they tried to talk to de Kooning. Even when he went to the doctor, she did most of the talking. One time, after she answered most of the questions that Dr. Oxenhorn, de Kooning's new psychiatrist, directed at him, Oxenhorn simply sat back and looked at him, as if to say "Hmmm . . ." De Kooning would sometimes stare at his vivacious wife with a searching look, his expression conveying wonder that a person could talk so much. Once, he told a friend, Elaine rushed over to tell him, "Bill! Bill! Guess what? I dreamed about Watteau last night!" De Kooning immediately came into focus. "Well, what did he say?" de Kooning asked. "I don't know," Elaine answered, "I did all the talking." She was adept at controlling publicity. Journalists invariably loved her, and she burnished the image of de Kooning as vigorous, spirited, and painting as well as ever. Avis Berman's lengthy feature in the February 1982 *ArtNews* was entitled "I Am Only Halfway Through." Berman described de Kooning as "a person of immense warmth, charm and tolerance." An accompanying photograph presented him standing in front of a recent canvas, looking alertly at the photographer while Elaine, barefoot and relaxed, sat in a chair opposite him. Another article from the same period, in *Architectural Digest*, extravagantly praised de Kooning's studio. In both, the underlying point was the same—"Bill and Elaine" were very much together, and de Kooning himself had lost none of his energy.

During Elaine's parties at the studio, de Kooning was usually lost in thought—"in the moment," as Ferrara put it, either thinking about his paintings or observing things around him, such as the changing light or a shadow on the wall. Often, he would simply get up and wander back to the studio to stare at his paintings, bored by the gossip and the art world intrigue. But there was also something increasingly odd about his behav-

ior. For Elaine, whose experience with her mother had left her particularly frightened of mental illness, such behavior was both personally disturbing and socially awkward. How could she explain his prolonged silences or his repetitive stories? Moreover, if questions arose about de Kooning's mental competence, wouldn't people begin to question the value of his art? Most of his earlier paintings had been sold, leaving the current work to generate income, and Elaine stood to gain enormously from sales of the recent art. Not surprisingly, she made light of his symptoms. She presented him as a genius too busy with the problems of existence to bother with mundane reality. If he could not always follow what others said, the fault lay with the natural absentmindedness of genius, or, she began to say, with some loss of hearing.

Elaine turned examples of his forgetfulness into marvelous stories. One favorite was about the time in 1983 that they were flying to Amsterdam for a show at the Stedejlik Museum called "North Atlantic Light." In the middle of the in-flight feature, de Kooning got up and said, "This is a lousy movie. Let's get out of here." On another occasion, de Kooning supposedly turned to her and said, "Elaine, we're getting along so nice. Let's get married." And after a White House dinner where de Kooning was seated with the president, Elaine told friends, she rushed up to him afterward and said, "Oh, God, I wish I could have sat at your table. It must have been thrilling. What did he say?" To which Bill allegedly replied, "What did who say?" When told that it was President Ronald Reagan, he said, "Geez. I *knew* he looked familiar!"

It was understood, within Elaine's circle, that no one would act as if anything were wrong. Elaine told Emilie Kilgore that if Bill did or said anything strange, "Let's just laugh uproariously, as if it's an inside joke only we get." The bad times were not mentioned. On the trip to the Stedelijk, for example, de Kooning became increasingly agitated. He forgot that he was a citizen and feared that he would be deported when he tried to return to the United States. A year or two later, said the painter Jane Freilicher, she was at a dinner party with her husband, Joe Hazan, at the home of Paul and Lisette Georges. Before going into dinner, de Kooning continually asked her, "So how's your work?" Every time she answered, "Well, I'm painting," and about five minutes later he asked again, "So how's your work?" After the guests sat down to dinner, he repeated several times that he'd had a late lunch in Montauk and was not hungry. However, he not only finished his own food but reached over and started eating the chicken off Hazan's plate. "I also remember him putting lots of sugar into his cup," said Freilicher. "He just kept putting spoonfuls into it, over and over." The acceleration of de Kooning's decline was probably

related to his former drinking. According to the neurologist Dr. Donald Douglas of Lenox Hill Hospital in New York, "Alcoholism fosters cell loss. It depletes someone's resources. If a dementia then develops, the process goes very quickly."

Over time, said Ferrara, de Kooning slowly became more confused. He would speak often and charmingly about the past, but sometimes seemed disoriented or forgot the present so completely that he thought he was a young man in the thirties or forties. During a *New York Times Magazine* interview in 1983 with the writer Curtis Bill Pepper, de Kooning's mind suddenly flipped back to 1935, when he was living on Twenty-second Street and doing window displays for the A. S. Beck shoe company. "What does it matter anyway?" he said, cocking his head critically at one of his recent paintings. "They'll just put shoes in front of it." His increasing vagueness posed new problems for his assistants. "It got to the point where you would rotate staying at his house," said Robert Chapman. "Tom had a life, I had a life, and you had to maintain your sanity. Around 1983 we were having to stay there quite a bit. Around the time of the *Times* piece." In the early eighties, de Kooning still did not allow his assistants to clean his brushes for him. "It's good for me," he would say, dunking the brushes in a big bathtub in the basement. But sometime around 1983, Ferrara noticed, the brushes were left to grow stiff with paint.

Still, de Kooning's work was the one area where he continued to function almost normally. In 1982, the painter Chuck Close visited de Kooning and found him withdrawn until they went into the studio. Then de Kooning became engaged, talking animatedly about the progress of his current paintings. The same thing happened the following year during the interview with the *New York Times*. De Kooning was detached and silent until Pepper pulled out a book of his old paintings. And then everything about de Kooning seemed to awaken. He came alive, even discussing in detail how he had painted *Excavation* and *Easter Monday*.

At the easel, the emptying out continued. Beginning in late 1982 and continuing through 1983 and 1984, a discernible if uneven progression toward a stark new simplicity came into de Kooning's paintings—a stripping down to the basics of line, form, and color. He had already abandoned great skeins of paint, heavy impasto, and cloudbursts of color. But a number of works from 1983 onward displayed a reduction that was dramatic even by his new, pared-down standards. *Untitled XXIII* of late 1982, which led the way in this direction, was more striking for what was left out than what was put in. There were no more heavy ribbons, but, instead, a few blue and red lines that flickered and floated across the surface, enhancing the translucent and ethereal air of the canvas. In succeed-

ing works, he began to use thin, whiplash lines evocative of his paintings from the late forties. But the pinball-wizard velocity of the earlier paintings was gone; the wrist was now slower, gentler. If the paintings of the forties burst with biomorphic forms muscling into the space, the lines of the eighties floated serenely through space. By *Untitled XV* of 1983, de Kooning had refined his colors down to two primaries—red and blue—and hints of yellow, all set against the luminous white of the background. In several places, he used a palette knife to scrape blue and

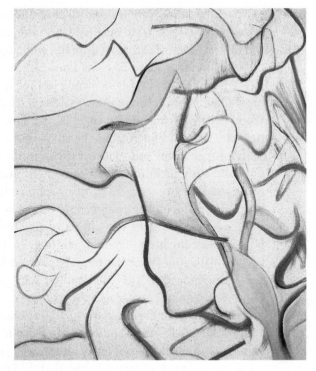

Untitled IV, *1984, oil on canvas, 88″ × 77″*

red across the background, creating shards and streamers of an icy, bluish white. The effect was spare but festive—like bright confetti blowing in some imaginary breeze.

In 1983, and continuing through 1984, de Kooning produced the simplest and most shimmering paintings of his career. In some, he used intense yellows as well as reds and blues. In others, the palette was mainly blue and red. In all of them, however, the emptied-out white of the background predominated, as did the exhilarating sense of forms caught in mid-dance. "I am becoming freer," said de Kooning. "I think you can do miracles with what you have if you accept it." In both their spareness and their pared-down palette, these works brought to mind yet another influence—that of his fellow countryman, Mondrian. De Kooning had once referred to Mondrian as that "merciless" artist, "the only one who had nothing left over." De Kooning loosened the grid of his great predecessor. Some of his late paintings look like a Mondrian reflected in rippling water.

De Kooning appeared fascinated with sharp, clearly defined lines. "It would be like removing the flesh and all the complications and going down to the skeleton," said Robert Chapman. "He saw beauty in that bare

essence and some sort of vitality that did something for him." He had never been, as Joan Ward once said, a "hard-edge man." But particularly in the mid-eighties, he stopped dripping and building up layers of paint, and his lines became more like the hard-edged lettering on signs. It was an effect, said Ferrara, that de Kooning labored hard to achieve. "Those lines on the late paintings look easy," said Ferrara. "But a lot of time he would spend days working on one edge. He used brushes, paper towels, and his fingers. He would hit it from the color side and then from the space side with a paper towel and then with his thumb." Although de Kooning had not used such techniques for years, there was a precedent, said Conrad Fried, in his Depression-era paintings of men in the thirties, when he used his thumb to blend paint seamlessly on the portraits.

Always known for his difficulty finishing work, de Kooning completed an astonishing fifty-four paintings in 1983 and fifty-one paintings in 1984—roughly twice his rate of 1982. As his mental troubles became more pronounced in 1985, he painted sixty-three pictures. According to Elaine's assistant, Larry Castagna, people said, "What is going on here? Is he becoming a factory?" (As Robert Storr pointed out in the catalog for a show of late de Kooning paintings mounted in 1996, de Kooning averaged "almost a painting a week" for four straight years, from 1983 to 1986.) At the same time, speculation began that de Kooning was in decline. If he were slipping, the reasoning went, his critical faculties would be affected first. He might still draw with authority or create a serious composition at the easel. But he would no longer be capable of judging the result. The increasing production suggested, in any case, that he was no longer quite himself. Did the emptying out of his work parallel an emptying out of his mind?

In the usual progression of Alzheimer's-like dementia, most patients function fairly normally in the early period. Behavior established for years can continue in an undiminished way, particularly, as in the case of de Kooning, when there is a familiar routine to daily life. "Because he repeated himself, people figured that he was out of his mind," said Ferrara, an unsentimental observer who watched de Kooning very closely. "But for the most part his mind stayed largely intact for a very large time, even after he started to repeat himself and do things that made him outwardly seem off his rocker. He was capable of putting together very complex ideas." De Kooning seemed to have lost nothing "in the present moment," when talking to a friend or telling a nuanced story. Similarly, he appeared to have lost nothing while absorbed at the easel.

It was on either side of the moment at hand that deterioration occurred. He was losing his short-term memory and his sense of the

future. Around 1983, having concluded he had little time left, de Kooning decided to forgo second-guessing and let each canvas stand or fall on its own merits. "There's no end, really," he said of his early-eighties paintings. "I just stop it. Abandon it." According to Ferrara:

> He knew that he was at the end of the line. He was conscious of it and would sometimes joke about it. He really did want to do some work. He felt good, and there was always a stack of fresh canvases there. In a way he treated them like big drawings. Some he would work on only a day or two. He was breezing them out. Some he worked on for weeks.

Photographs taken by Ferrara throughout the mid-eighties show that many paintings continued to evolve slowly in stages. Still, de Kooning would no longer agonize over a painting. He would often work on variations on a theme rather than struggle over one canvas until a "definitive" version existed. The result was a series of closely related works from 1984 that could almost be part of one giant mosaic. At one point in 1984, he made a couple dozen paintings inspired by one work from the seventies. "We used to say that he was treating the canvases like a pad of paper," said Chapman. He was trying "to concentrate on something he was best at," said Ferrara, "which is drawing."

Two years after de Kooning first began his eighties paintings, it became clear that he must paint—not only to create salable work, but also to keep him mentally and physically alert. The few times that he stopped painting in the mid-eighties (when, for example, he once hurt his back), his mind deteriorated. Elaine's solution was to provide de Kooning with multiple helpers and every possible stimulation. He had an inexhaustible supply of new canvases and thousands of dollars' worth of paint at his fingertips. His canvases—some two hundred in all—were stretched for him. Meals were always ready. Assistants catalogued each completed work, carefully asking de Kooning which end was up, and then stored the paintings. The establishment became quite large. In addition to Tom Ferrara and Robert Chapman, the core group included the conservator Susan Brooks. Larry Castagna, Elaine's assistant, was often there, and Gertrude Cullem did the housekeeping. Frances Shilowich continued to do the accounting. In the background were the lawyers Lee Eastman and his son, John.

De Kooning controlled all artistic decisions throughout the early years of the decade. Not even Elaine or Xavier Fourcade could convince him to change direction once his mind was made up, although they sometimes tried. In 1983 and 1984, for example, Elaine began to worry that

de Kooning's palette was too limited. She asked Ferrara to open tubes of new colors and put them on the large worktable that de Kooning used as a palette. De Kooning would have none of it, an indication that he was still fully in command of his faculties as an artist. According to Ferrara, "He stuck with what he was doing." Although Fourcade would discuss with de Kooning which works to exhibit, the final decision still remained de Kooning's. He alone determined when a painting was finished. In some cases, de Kooning refused to exhibit his best paintings simply because he wanted to keep them nearby to give him fresh ideas. "Certain paintings I don't want to sell because they give me a good pictorial feeling," he said, "and I want to stay with it."

In May 1983, *Two Women*, the only painting from the famous fifties series of *Women* that remained in private hands, was sold to the art dealer Allan Stone for $1.2 million—$400,000 above its auction house estimate. The sale was trumpeted in the press as the highest price ever paid at auction for a painting by a living artist. The next year, Stone resold the painting at auction for $1.98 million. Three years later, a de Kooning brought even more at auction when a major work from the forties, *Pink Lady*, sold for $3.63 million. If de Kooning's earlier work commanded the most interest, the market for his work of the sixties and seventies was also strengthening. Even de Kooning's recent pictures were priced between $300,000 and $350,000 as the contemporary art market heated up. In 1967, when he had first begun to show with Fourcade at the Knoedler Gallery, the highest asking price for his paintings was $40,000, with smaller works going for as little as $12,000.

Collectors also seemed eager for his sculpture. Sensing an opportunity, Fourcade returned in 1980 to the Modern Art Foundry, which had cast de Kooning's work in the early seventies, and asked them if they would cast additional pieces. But by then, said Bob Spring, the director, the rubber molds had been destroyed. Undeterred, Fourcade blew up photographs of de Kooning's sculpture using an overhead projector and persuaded de Kooning to authorize a series of enlargements of the original Rome sculptures, to be done by the Tallix Foundry in Peekskill, New York. "Fourcade and Eastman decided to make some money," said Spring. "They were selling the little ones for a high price, and I don't think de Kooning cared." In May 1983, Fourcade celebrated this putatively new sculpture in a gallery show entitled "The Complete Sculpture: 1969–1981." (The dating implied that de Kooning was still involved in sculpture, whereas the recent pieces were simply enlarged versions of old

ones.) With the sculpture selling briskly, Elaine authorized a new edition of a de Kooning piece from Rome known as *Untitled #2*. The Gemini foundry in California cast the sculpture in a sterling silver edition of six.

Interest in de Kooning was further increased by the "neo-expressionist" artists, who first appeared in Europe in the seventies and then became fashionable in New York. They embraced him as a great predecessor and emphasized qualities of unfiltered violence and raw emotion that de Kooning, a classicist in many respects, probably would not have admired. Largely as a result, the Whitney collaborated with museums in Berlin and Paris to mount a large de Kooning exhibition that stressed his expressionist tendencies. As the curator, Jorn Merkert of the Akademie der Kunst in Berlin, wrote in his catalog essay, "Now that a new violence in painting has been catapulted into the vanguard, de Kooning's achievement seems more brilliantly contemporary than ever." The Whitney show was top heavy with works from the sixties through the eighties because, art world cynics observed, auction houses and art dealers wished to promote their sale.

The Whitney blockbuster opened to great fanfare on December 15, 1983. The day before, de Kooning, Elaine, and Tom Ferrara flew to New York in Steve Ross's private helicopter. (Ross and Elaine were such good friends by now that Warner Communications underwrote the drawings show that accompanied the main exhibition.) They landed at the helipad on the East River and drove through a resplendent sunset to Lisa's new apartment on Wooster Street in Soho. De Kooning, forever unaccustomed to the hullabaloo of wealth, appeared impressed with the goings-on. That night, they attended an exclusive pre-opening party. The next night, close to two thousand people gathered at the museum for the official opening. Many of them—all donors of $250 or more to the Whitney—came simply to see de Kooning himself. "A living artist is a big draw," said Flora Miller Biddle, president of the Whitney, to the *New York Times*. "People hope to see him." De Kooning could not face the crowd, however, so Lisa and Elaine represented him. Those disappointed by not seeing de Kooning may also have felt underwhelmed by the show, which was poorly selected and presented in a museum that was, under the best of circumstances, a difficult place to show paintings. The 250 paintings, drawings, and sculptures, packed tightly into claustrophobic rooms, were given little room to breathe. Viewers could hardly take in at once so many dense surfaces, highly keyed colors, and swirling brushstrokes. The inclusion of forty-four paintings from the past two decades left the impression that de Kooning's sensibility had dissolved into a voluptuous sprawl.

The reviews of the show were uniformly negative. Both Grace Glueck

of the *New York Times* and Robert Hughes of *Time* argued that Merkert had mistakenly weighted the show toward de Kooning's expressionist side, which they considered the weaker part of his sensibility. Although the "old cunning of the hand" remained in the late paintings, wrote Hughes, there was also "a lot of banality and self-parody, conscious or not." (It would be eleven years before a rigorous retrospective organized by the National Gallery of Art in Washington would present a balanced view of de Kooning's oeuvre.) De Kooning, who hadn't seen the exhibit, drove to the Whitney with Tom Ferrara on its last day. He was then a struggling man and artist, but flashes of his old self still regularly broke through his withdrawn demeanor. On that day, said Ferrara, he was "on top of the world." Rather than ask for preferential treatment, the pair stood in a long line of people waiting to buy tickets. When they finally reached the counter, de Kooning said with a hint of puckish humor, "They're charging to get in here? Shouldn't I get a cut?"

Morning: The Springs

Some critics have regarded the "emptying out" of de Kooning's art as a loss of vitality. There was always another way, however, to think about his late, undulating rhythms. In many cultures, nothing is more admirable than the aging man who, instead of clinging to wealth and fame, begins to give himself away with a kind of fearless abandon. With age, such a person does not pretend to be what he is not, but instead accepts the natural waning of his energies, seeming to grow less and less heavy as he approaches death. He exchanges substance for light; he leaves the world almost as naked as he entered it. In his best work of the eighties, de Kooning's desire to shed the glorious baggage of his younger years has that sublimely generous quality of letting go. Some pictures were better than others. What did it matter? He was content to enjoy the morning light in the Springs.

Morning: The Springs, filled with the tranquil spirit of the country-side, has the distinction of being one of the rare pictures after 1960 with a title. As in his work of the mid- to late seventies, de Kooning remained in this painting very concerned with "touch." But his touch created air and light rather than the more visceral sensations of earth and sea. De Kooning's wandering hand seemed to draw away the weight from the world. The way he scraped off pigment gave a breezy freedom to the ribbons and, just as important, highlighted the radiant whites that suffuse the image.

The painter whose art was always so full of fight finally yielded, on his rocker, to the gentler rhythms of existence. Robert Storr observed that de Kooning seemed, in such works, to be "painting for the first time without any material or psychic resistance."

Morning: The Springs told the truth about the evening of life. It had an old man's bursts of intensity, as in a testy swipe of darkness; and it seemed, sometimes, to slip away into absent dreaminess. It took an artist with that gift for tuning out to convey the slow intensification of yellow in the lower corner of *Morning: The Springs*. In the composition, too, there was something wandering and episodic, a scattering of the whole into sharply remembered pieces; an aging mind, similarly, sometimes skips or misses a step. Was that a weakness in the art? Or a truth yet unacknowledged by those who do not know what it means to be old? De Kooning's late work has the misfortune of being judged by those who have never been to the country where it was made.

Like many people his age, de Kooning lived increasingly in the past. His painting of the eighties depended upon drawing—his first and earliest talent—and he consistently reworked ideas from the forties. If such "remembering" lacked the drama of original invention, it was also not the same as copying. It had the savor of age. As de Kooning's mind rambled, he made use of its wanderings, recalling earlier moments in his art and gathering around him, like an extended family, ideas to which he was devoted. Even so, the best paintings of the eighties did not lose themselves in the past. In *Morning: The Springs*, De Kooning also seemed to relish each present and passing moment. The fluttering ribbons have the joyful insouciance of a boy trailing his hand behind him. De Kooning's art, said the painter Robert Dash, "always seems to be saying good-bye." And there is that, too, the wave of the hand in the famous twist of the brush.

39. Dementia

De Kooning suffered a serious mental downturn in late 1984, followed by another the next year. He failed to recognize familiar faces and spoke less often, sometimes resorting to a private sign language of nods, claps, and gestures. He had difficulty signing his name. When upset, he would bite his fingers and cry. His housekeeper of twenty years, Gertrude Cullem, sadly observed the decline on an almost weekly basis. There were times, even until 1985, when she thought him capable of a normal conversation. "When I talked to him, and he felt like talking, he sounded like a very intelligent man," she said. But there were other times when he did not respond or make sense or did strange things and "you knew it wasn't Bill." One day in 1985, she arrived at the studio to find all of de Kooning's clothes—"all of these beautiful suits"—strewn over the floor of de Kooning's bedroom. "I went downstairs," said Cullem, "and I said, 'Bill, do you want me to take these clothes to the cleaners?' He said, 'To the cleaners?' I said, 'Well, they're all over the floor.' He came upstairs and said, 'Did you do that?' I said, 'No. Why would I do that to your clothes?' He said, 'Well, Gertrude. I think we'd better pick them up before they get wrinkled.' Really he was . . . you know, quite a ways then."

Such odd behavior—like pulling clothing out of drawers—is a well-known symptom of middle-stage Alzheimer's. In her attempt to keep de Kooning's lapses private, however, Elaine did not want this eccentric behavior discussed in the community. And so, when Cullem told her what had happened, Elaine essentially fired her. She gave Cullem a check "and told me that Bill was going to get a male nurse." It would actually be several more years before Elaine would hire professional nurses to care for de Kooning, but she was eager that people not begin talking. And so began the "compact of protective secrecy," as Robert Storr termed it, that from the mid-eighties onward shrouded de Kooning and his behavior at the studio.

Now, even old friends were discouraged from dropping by, which aroused their ire. They were instructed to call Elaine, who scheduled their visits and made sure that she was present when they arrived. Often, she did the talking for de Kooning. She also represented him in public. When de Kooning was given still more awards—the Kaiserring in Germany in 1983, the New York State Governor's Art Award in 1985—Elaine appeared

in his stead, invariably making a gracious impression. It was becoming hard to take him anywhere, even privately. His sense of dislocation became acute. If taken for a drive, he would still recognize his own street. But he now often thought that he was living on Tenth or Twenty-second Street. If he went out, it might take him several hours to reorient himself in the studio. On those rare occasions when he did accompany Elaine somewhere, "it was a major, major operation," said Tom Ferrara. "Part of it was being around his work. Part of it was also just a matter of tempera-ment. He had his paints, his refrigerator, his bedroom, his bathroom, where everything was laid out very nicely and he knew exactly where it was. He had his television there. He didn't need anything else."

De Kooning had long since stopped bicycling down to the Barnes Country Store or dropping by to say hello to old friends. For a while, Elaine made an effort to invite people over to see de Kooning, hoping that would raise his spirits. "But after he quit drinking, he became grouchy," said Clarence Barnes. "He didn't want to see too many people." Old age made it dangerous for him to walk or bike on the road. He had several near misses with cars that terrified him, and his increasing disorientation made him reluctant to venture far from the studio. Instead, his assistants supervised him as he pedaled around the parking lot. In 1985 or 1986, he got a stationary bike, making him even less likely to leave the studio. Fer-rara and Chapman landscaped the grounds; Emilie Kilgore's son Alexander cleared a walking path for him through the woods. It was becoming clear, however, that he would soon require around-the-clock care. One morning, the assistants found that he had fallen headfirst down the stairs. Another time, said Chapman, "we found him sitting right where we had left him the night before."

Elaine did not move in full-time with de Kooning. That left the job of caring for him to his assistants, who had lives of their own and were not always there at night. Tom Ferrara, who lived at the studio in his early years with de Kooning, now had his own house, though he would stay overnight when needed. So would Robert Chapman. Night duty could be hair-raising. One time in the mid-eighties, said Chapman, he woke up after falling asleep in front of the television and saw de Kooning sidling up the stairs. He had a coffee cup in one hand and a bottle in the other, no doubt recalling the days when he poured alcohol into his coffee cup. But what was in the bottle was Ortho Brush-Be-Gone, a poison used to kill shrubs. "So after that we had to start putting things more out of reach." A new assistant, Kathleen Fisher, was hired in 1985. She spent most nights at the studio in order to keep an eye on de Kooning and assumed the role of companion and all-around helper. She worked on holidays or did the

unpopular four-to-eleven p.m. shift or prepared the food when Elaine invited a party of people over to dinner at the studio. Fisher's tenure coincided with the period in which de Kooning's mental state began to decline precipitously. He appeared, she said, to have no short-term memory. Often, he seemed unable to follow conversations. He was noticeably silent around Elaine. If Elaine arrived he stopped whatever he was saying, though no one knew whether it was because he was irritated with her or had just grown accustomed to her talking for him. He started to age noticeably. His body appeared to shrink in his big work overalls, and he began to walk with a shuffle.

Even so, he had flashes of complete lucidity. About a month into her job, Fisher said, she and de Kooning were alone at the studio when Emilie Kilgore telephoned. "And all of a sudden here's this man who at that point I really thought was somewhat out of it—I didn't really think there was anything very much there," said Fisher. "Until they had this conversation that was 100 percent on the dot. There was a topic, and it was a thoroughgoing conversation. That was my first clue that there was something really there." According to Chapman, "He really, truly loved women. He related to them much better than to men." If one of the assistants brought a girlfriend to the studio, de Kooning would go upstairs to comb his hair. Often he gave them a tour of his studio, and he always remained animated around Mimi. "Bill would pick up when Emilie came around," said Chapman. "Elaine was vibrant, but Emilie was vibrant in a more feminine way. She would flirt with him—the sparks would start up." One time, Mimi even persuaded de Kooning to dance with her at a party on Three Mile Harbor Road.

On a day-to-day basis, however, the only way to rouse de Kooning was to engage him about art. At night, when Fisher fixed de Kooning's dinner, "99 percent of the time it was just Bill and me alone," said Fisher. "We would have our little salmon dinner. We had long conversations literally about palette knives. We could sustain half an hour just on palette knives." Most of the time, de Kooning rose at dawn. He was no longer sluggish in the mornings, thanks to the B vitamin supplements that he began taking earlier in the decade. When the first of his regular assistants arrived at eight a.m., he was often already at his easel. He would work from around eight a.m. until four p.m., stopping occasionally for cups of the extra-thick coffee that he favored. There were also many nights when de Kooning, whose biological clock seemed scrambled, also wanted to work. He continued his pattern of going to bed by ten p.m., but woke up two or three hours later. "It got to the point," said Ferrara, "where he could survive on two to three hours of sleep." Fisher began sleeping in the

one bedroom without an overhead light so that de Kooning could not turn on the light and startle her. Once awakened, an assistant would usually turn on the lights downstairs and let de Kooning go back to work. The broken nights took their toll on him. "He would only sleep for an hour or two at a stretch, and it wasn't enough to get into a deep REM state," said Chapman. As a result, he began to hallucinate both at night and during the day. As the eighties wore on, the hallucinations worsened.

Often, the best way to get de Kooning to relax was to let him watch television in the evening. Soothing routines also helped. He would often wander over to the big, stainless-steel sink in the kitchen area, which Gertrude Cullem had kept polished to a high sheen. De Kooning, who took great pride in his industrial sink and professional stove, had liked watching Cullem polish the sink with Cameo cleaner. Now he undertook the job himself. "He would polish and polish and polish," said Fisher. "He wouldn't paint until that big stainless-steel sink was polished." According to Irma Cavat, who stayed in the studio in the mid-eighties while visiting Elaine, "He wasn't the same Bill. What happened is that he got sweeter and sweeter. The sweetness that he always had became a kind of passivity on his part." One night, de Kooning, who could still reminisce about the old days, began discussing his first show with Charlie Egan in 1948. "Bill said, 'He cheated me. He didn't pay me,' " said Cavat. "He was very bitter, but in a sweet way. Everything was very sweet."

While Alzheimer's cannot finally be diagnosed without an autopsy of the brain, de Kooning's symptoms fit the classical profile of an Alzheimer's-like dementia. Based on new research into Alzheimer's and an examination of records in Holland, it seems highly likely that a genetic predisposition to develop dementia runs in the de Kooning family. Despite his problems, however, his assistants firmly believed that until late 1984 he remained in full control of his art. The paintings were uneven, but the best among them were works of authority and ethereal beauty. For the aging painter, the early eighties opened a brief window of grace. Against huge odds, he rallied from the alcoholism that nearly killed him and from the devastating depression that nearly extinguished his spirit, to create a significant coda to his oeuvre.

By 1985, however, it was clear that the dementia would soon destroy him. It was in that year that Emilie Kilgore noted what she considered a fundamental change. Not only was de Kooning suffering from hallucinations, but he told her that he wanted to stop painting. She wrote down what he said: "They didn't like my work. They don't want me anymore. I

didn't say anything, but I was going to quit anyhow. I don't need them. I can get all kinds of work—decorate apartments." Almost certainly, de Kooning was recalling rejections of his art in the twenties and early thirties, when he worked at Eastman Brothers and A.S. Beck and also sometimes decorated apartments. "Well," he told her, when she pointed to all the current paintings around him, "the man didn't like them, they just didn't click for him. It's a style. He wants to get them the way he wants them." What impressed Kilgore, however, was that de Kooning—*de Kooning*—would ever mention giving up painting.

De Kooning himself, realizing that he was near the end, now painted to live. Painting was therapy as well as art. In terms of sheer numbers, 1985 was his most productive year ever. He created sixty-three paintings, an average of one every five and a half days. In this last concerted push, he also changed direction yet again. He abandoned the evanescent simplicity of his paintings from 1984 in favor of bolder lines, more complicated surfaces, and larger areas of filled-in color; and he began using brushes instead of the palette knives that he had favored for their directness. His assistants began to help him much more than previously: the paintings that emerged now were de Koonings with an asterisk. In 1985, Elaine made her second attempt to amplify his palette. The first time, he had rejected her efforts and refused to use paint premixed by his assistants in other colors. This time, Elaine succeeded. "We all started getting anxious that he was only interested in red, yellow, and blue," said Chapman. "For some reason his palette was becoming more and more limited." The assistants then began gradually to premix paint with medium for him, augmenting the primary reds and blues that de Kooning preferred with a wide range of other colors. "Since he steered toward red, yellow, and blue still, we'd start setting up mixes of red, yellow, and blue so that they weren't the same red or cerulean blue that he had been using," said Chapman. "It would be a little bit of deviation from one painting to the next. And then gradually we started introducing more and he seemed willing to try some." Both *Untitled XIII* and *Untitled XX* of 1985 still made use of de Kooning's characteristic red and yellow. But in *Untitled XXIII* there was a striking new shade of turquoise green, dramatically present in two large shapes and one bold line. In *Untitled XX* a strange violet-purple appeared.

De Kooning's most ambitious project of the period was a triptych for St. Peter's Church in New York City that he worked on in late 1984 and into 1985. The Reverend Kenneth Reichley, then a young assistant pastor at St. Peter's, had read the profile of de Kooning that appeared in the *New York Times Magazine* on November 20, 1983, and was struck by de Kooning's discussion of the Matisse chapel at Vence, in which he said, "I'd

like to do something like that if somebody would commission me to do it." Why not commission de Kooning, Reichley thought, to create a large-scale painting for his church? St. Peter's was part of the soaring new Citicorp Center at Fifty-third Street and Lexington Avenue. "We live in the 20th century," Reichley said, "so why not use 20th-century art forms to express our spiritual nature?" Reichley and his associates made a proposal: if de Kooning would undertake a triptych, the church would display the painting on a tryout basis for possible purchase. If the congregation approved, the church would look for a donor—at three times the going rate of a single de Kooning, or $900,000, because of the three different panels. Reichley then contacted Fourcade, who approached de Kooning with the idea. De Kooning was enthusiastic. Late in 1984, his assistants assembled three canvas panels. No doubt de Kooning had in mind Matisse's chapel, and the idea of side-by-side panels seemed to suit his style of working, in which one canvas emerged from the one just completed.

However, the execution proved difficult. De Kooning could not figure out how to get across the recessed joint that attached the center canvas to the two smaller side panels. The unfamiliar dimensions of the two, narrower side panels also bothered him. Once he had painted his way from the center canvas to the side panels, no further ideas came to him. "He was basically almost done with the painting in the middle," said Chapman, "but there was nothing on the side panels. We had just about given up on him." But one day, as Chapman watched from the yard, de Kooning "kept getting closer to [the strip of wood joining the center and side panels] and closer, but there was still this barrier. Like an invisible wall. And all of a sudden, he went across. And once he was there, it was okay." The final effect of the triptych was serene and meditative. The stripped-down palette was the same red, white, and blue that de Kooning had recently been using. Thin ribbons of red and blue floated across a vast and luminous expanse of white, broken here and there by a few areas of red. In the center panel, much of the lower half was simply white. De Kooning left it empty and dramatically still.

Still, de Kooning was not happy with it. Fourcade then suggested simply joining three paintings together. Many different combinations were tried; de Kooning chose the final arrangement. The series of three new paintings, among the first executed by de Kooning in 1985 in his bigger and bolder style, were joined into one huge twenty-one-by-seven-foot triptych. In contrast to the earlier image, many more areas—mostly painted a vibrant yellow—were filled in, which left little of the luminous white background shining through. The air of boldness and motion was heightened by the jostling of the colors at arbitrary joints of the panels, where,

for example, a narrow red line suddenly segued into a broad blue banner of paint across the divide. "Xavier was desperate to make the deal," Chapman believed. "That was why he put the three individual paintings together."

Entitled *Hallelujah*—de Kooning loved to speak of the "hallelujah skies" of Long Island—the triptych looked dramatic when installed behind the altar in the fall of 1985. "One Sunday," said Reverend Reichley, "when the painting was up, the choir was singing an anthem by a 20th-century composer, in a space designed with 20th-century sensibility and materials, and I was looking at a painting by a 20th-century artist. At that moment I said, 'I am worshipping God in the 20th-century.' " From the moment that *Hallelujah* was installed, however, members of the congregation objected. Some disliked its high-keyed colors. Others found the forms distracting. Overall, the subjective nature of de Kooning's art proved a lightning rod, with a sizable proportion of the congregation wondering whether such "a personal form of art can be used to further the goals of group worship and prayer." Seven weeks after it was installed, the triptych was removed.

When earlier paintings stopped inspiring him to begin a fresh canvas, the assistants began to project drawings onto the canvas for him to use as a starting point. De Kooning and an assistant would go down to the basement where the projector was kept and lean a canvas against the wall. De Kooning would then trace in the lines of the projected drawing with charcoal, and the assistant would bring the canvas upstairs for him to begin. As de Kooning found it more difficult to draw bent over, he would ask for help in tracing the bottom of the image near the floor. Sometimes, he became bothered by the shadow of his hand and asked for help. Using a projector was not necessarily out of keeping with his customary practice. As early as the forties, de Kooning had sometimes used a projector when making his black-and-white paintings. Once a drawing was complete, the assistants would take the canvas and "block [the drawing] in with white pigment." That way, said Chapman, there would be no "holidays," as de Kooning called them, or missed spots where the primed canvas showed through. Prepainting the entire canvas white also locked in the charcoal from the drawing so it would not smear.

De Kooning occasionally became "so involved with the upper half [of a painting] that he would forget about the bottom," said Chapman of de Kooning's final painting years. "We'd have to be the ones who turned it over so at least the rest of the painting would get done." When trying to judge whether or not de Kooning was through with a canvas, and it was time to remove it from the easel, they would take into account how long

it had sat untouched as well as such cues as "his body language and move-ment and claps." If he looked at a painting sideways enough times, that, for example, might be a signal to pivot the painting. Occasionally, de Kooning could still produce a strong canvas. The state of mind of a person with dementia can vary enormously from hour to hour: a person com-pletely lost in the morning may become lucid in the afternoon. The char-acter of the disease also varies greatly from person to person. "What you're likely to have is a slow deterioration that's spotty, meaning that the patient can be good at times," said Dr. Donald Douglas. "Some show almost mental intactness at times."

As hard as it may be to chart the effects of dementia on ordinary human beings, it is even more difficult to do so when dealing with cre-ative intelligence. In a painter, for example, what's called "procedural memory"—which Dr. Jeffrey Cummings, the director of the Alzheimer's Disease Research Center at the University of California at Los Angeles, defines as the unconscious memory that governs complex motor acts—is critical. Although researchers agree that short-term memory and reason-ing ability decline relatively quickly in the victims of Alzheimer's and other dementias, they disagree over how long procedural memory can survive. Procedural memory governs the movement of the hand while painting or playing a musical instrument. "Part of the mind can work at a depth that is not verbal, or memory," said Dr. Douglas. "It doesn't even use the same brain mechanisms." As a result, painting could be one of the activities spared until the onset of the later stages of the disease. Were Shakespeare suffering from Alzheimer's, posits Douglas, he could not have written his plays, because of their verbal and psychological complex-ity. But Picasso might have continued to paint because the complex lan-guage of painting was almost instinctual with him. "It is considered one effect of some manifestations of dementia that once somebody learns a language, he doesn't forget the whole thing so easily," says Douglas. "What happened yesterday, however, is a different matter."

In 1984, Conrad Fried and the artist S Again made a movie of de Koo-ning working. De Kooning, who did not know the film was being made, was entirely assured at the easel. Still spry at eighty years old, he focused with complete concentration on his work. In his right hand he held a scraper, which he used to make the surface of the painting glassy and smooth. In one shot, he could be seen studying a previous painting, set up to the right of his easel, while simultaneously drawing on the fresh can-vas. Most telling of all, the camera caught him as he applied one of his whiplash lines to the canvas. The brush was steady, the movement confi-dent. Two years later, however, when Fried and S Again returned to film

him, de Kooning appeared shrunken and much more feeble. He still approached the canvas confidently, with his characteristic gestures in place, down to the clutch of brushes and palette knives held in his left hand. But his concentration was obviously slipping. At one point, he looked at a nearby painting, as he often did to get ideas, but when he turned back he appeared lost. Unpublished videotapes taken of de Kooning at work during the same period showed him getting stuck in one portion of a painting, or in one particular motion, according to Robert Chapman. Still, even amid the perilous decline into dementia, the human imagination may yet find a way to express itself seriously, especially in art. According to the neurologist and writer Dr. Oliver Sacks, whose books have probed the responses of certain people to shattering illness, each brain is wired differently. The almost indefinable aspect of "style"—what makes one person, or one person's identity, different from the next—can be retained very far into dementia. As Sacks wrote of cases similar to de Kooning's:

> I have myself seen all sort of skills (including artistic ones) preserved or largely preserved, even in advanced stages of dementing diseases such as Alzheimer's. Indeed, I think this preservation, if not of artistic skill, at least of aesthetic and artistic feeling, is fundamental. . . . A colleague of mine specializes in this and has some remarkable paintings done by people with Alzheimer's so advanced that they have become incapable of verbal expressions. Such paintings are not mere mechanical facsimiles of previous works but can show real feeling and freshness of thought.

All people attempt, according to Sacks, "to replace, to compensate for and to preserve identity" in the face of dementia. However, the ability of some people to do so is vastly superior to that of others. "A person like de Kooning has capacities that the original disease description does not apply to," said Dr. Douglas. "He has resources that the average man doesn't have. I would hesitate greatly to apply the general rules to him." What seemed to have happened with de Kooning, then, was that his ability to transcend short-term memory loss by drawing upon something deeper and more instinctual carried him until the mid-eighties. It helped that, in his final paintings, he moved toward drawing, his most instinctive gift.

As the year 1986 progressed, de Kooning no longer seemed to resolve compositions through varying the velocity of the brushstrokes that led the eye in and around a space. Now, that dance was over: the brushstroke lost its partners. His canvases no longer seemed to breathe in the same

way. He was filling in the space between lines, rather than animating the entire surface. By late 1987, it was not clear when he had finished a picture. Fourcade himself never expressed any reservations. He would appear at the studio, said Ferrara, and discuss with Elaine and the assistants which paintings he should take to hang. In October 1985, Fourcade mounted a show of de Kooning's most recent pictures, those from 1984 and 1985, and worked with the Anthony d'Offay Gallery in London the following year when it exhibited his paintings of 1983–86. From a financial standpoint, Fourcade and Elaine had an obvious incentive to establish a strong market for work priced at from $300,000 to $350,000 a picture. Given de Kooning's prolific output, the late paintings were potentially worth—even with some judicious editing of less successful ones—tens of millions of dollars.

But suddenly, the people positioned to make such decisions themselves fell ill. In 1987, Fourcade was diagnosed with AIDS; the 1985 show was de Kooning's last at his gallery. Lee Eastman was suffering from Parkinson's disease. And Elaine, who thought she had beaten cancer, suffered a recurrence of the disease.

40. Epilogue

Y'know, the moment you really do something, it's gone.

De Kooning outlived himself. His final years, when he was hardly there, became a Balzacian story of melancholy, gossip, money, and decline.

On April 28, 1987, Xavier Fourcade died. His death brought to an end the most successful artist-dealer relationship of de Kooning's career and left him without gallery representation at a difficult moment. Since 1982, he had been making paintings dramatically different from those produced in previous decades. Although his earlier works brought high prices, a market would have to be developed and maintained for this late work. Who would now do that for de Kooning? The painter himself was in no condition to choose a successor. He was not told that Fourcade had died; Elaine and Tom Ferrara feared he would become too upset.

Elaine would once have enjoyed finding a successor to Fourcade. But her own failing health now preoccupied her. During the eighties, her friends became alarmed by Elaine's chronic, wracking cough, which punctuated her conversation as surely as the cigarette that she continued to wave stylishly in her right hand. It appeared obvious that she was beginning to suffer from pulmonary illness. Few knew that she had already lost a lung to cancer earlier in the eighties. At that time, Steve Ross, with great secrecy, had flown Elaine to the Thomas Jefferson Hospital in Philadelphia, where Guy Fried, her nephew, was a doctor. There she underwent surgery to remove the diseased lung. The operation helped for a while, but Elaine's health began to worsen again in 1987. She developed severe emphysema, made worse by the lost lung, and had to use an inhaler. Her carotid arteries were blocked. Worst of all, a tumor was pushing against the back of her spine. Her healthy diet and the beneficial effects of exercising, which she had done religiously since the 1950s, could not offset decades of smoking. With Fourcade dead and Elaine and Lee Eastman failing—and de Kooning himself entering late-stage dementia—the affairs of the artist fell into a state of near collapse.

By 1987, de Kooning's illness left all those around him feeling hopeless. "It was heartbreaking, particularly for those who had known Bill in

his prime," said Ferrara. "He was so stubborn. He [went down] so slowly, so gradually." It was now difficult to take de Kooning as far as Louse Point. Each time he returned home, even after the shortest excursion, his disorientation was painful to watch. If prompted, de Kooning, almost miraculously, could still lucidly discuss the past. But his short-term memory was entirely gone, and, according to Ferrara, he was very depressed. Kathleen Fisher, the assistant who usually stayed overnight at the studio, lived in dread of de Kooning disappearing. One time, she awakened at five in the morning, sensing that something was wrong. Sure enough, de Kooning was gone. She finally found him on Springs-Fireplace Road near Clarence and Dorothy Barnes's store. A customer had come into the store looking concerned. "There's an old man out there who acts lost," he said. When Clarence went to check, he found de Kooning outside with silverware stuffed in his pockets.

Such events exposed the real problem: with Elaine distracted, no one assumed final responsibility for de Kooning. Several days might go by without Elaine visiting the studio, which placed great pressure on the assistants. "Elaine played a lot of the 'I'm Mrs. de Kooning' thing, but I was definitely her cover," said Fisher. "She was completely absentee. One strong fear was that if he died, they would project the whole thing onto me. I was really nervous about that a lot." In the late spring of 1987, Elaine and the Eastmans considered asking Ferrara to take even more responsibility. But Ferrara had health concerns of his own. That June, he resigned.

There remained an ample number of assistants. But there was no central person to oversee the running of a studio that was also, increasingly, a nursing home. The assistants did not regard de Kooning's physical upkeep as their responsibility. They had not been hired as nurses. Elaine occasionally tried, said Fisher, to get him into clothes. But as the summer wore on, de Kooning became increasingly disheveled. He was afraid to bathe, a typical symptom of later dementia. "De Kooning was in dreadful shape," said John Eastman. "He was incontinent, and practically naked, and nobody was taking care of him." Lisa de Kooning, who had recently married and was spending a good deal of time in Europe, was shocked by what she saw when she made a trip home—and immediately called Frances Shilowich, her father's longtime accountant, and demanded that something be done. Elaine then brought in a nurse's aide at night to watch over him.

The biggest problem of all was that de Kooning, who seemed only half alive when not working, began to slow down artistically. After painting sixty-three pictures in 1985, de Kooning produced forty-three in 1986,

twenty-six in 1987, twenty-seven in 1988, and many fewer in 1989. So a second campaign began to keep de Kooning working. He could still respond when a drawing was sketched onto a blank canvas for him. His assistants therefore selected drawings to project, and then drew them onto the canvas for him, in order to start him painting. Often, they would combine parts of different drawings to add variety. "I tried to keep some sort of sense about them that would relate to what Bill was working on at the time," said Robert Chapman. "Not deviate drastically." Still, the projections obviously lacked the coherence and energy of de Kooning's own mind and wrist. (Perhaps the complexity that resulted from combining drawings contributed to the clotted quality of many late paintings.) An overwrought palette was also a problem. On the days that she worked, a new assistant, Antoinette Gay, who was not trained as an artist, sometimes laid out colors if de Kooning needed fresh paint. Sometimes, she chose awkward colors—"Thalo colors and things that became a problem," said Chapman, "if you try to change them too much." Turquoises, roses, and purples appeared on late canvases. A series of photographs taken in de Kooning's studio in 1988 showed some filled with brilliantly colored lines, shapes, and shaded-in areas. One in particular contains a profusion of biomorphic forms reminiscent of Gorky. Most appeared lifeless. According to Chapman, de Kooning still had rare moments of lucidity. Once, he saw the artist looking around. "He had all his paint on his palette, but something was bothering him. Eventually he reached over and grabbed a tube of black or dark blue and took the cap off and squirted some on the palette. That was the only time I'd seen him do that in years. Where there was something going on where he felt he needed a certain color and made a selection from the pile of tubes." De Kooning also seemed to respond to his first grandchild (Lisa would eventually have three children). Lisa believed he knew who the baby was and liked to push her in a stroller.

De Kooning's eyesight began to fail. Often he'd miss corners of a picture. Earlier, said Chapman, the assistants would bring those unpainted "holidays" to de Kooning's attention: "We'd give him a brush with some white and say, 'Fill in that area.' " Now, in late 1987 and 1988, they would do more. "A lot of it depended on our understanding of art and what Bill in particular might be after," Chapman said. "So if it looked like from the surrounding paint that it was deliberately left, we'd either leave it or try to match the difference in tonality so that it didn't look like the same white all the way across." Such intervention was not discussed publicly; if anything, the secrecy surrounding de Kooning intensified with Fourcade's

death and Elaine's illness. The "help" was done with good intentions, since everyone believed that painting was the only thing that kept de Kooning alive. "The impulse was tremendous to help Bill in any way you could," said Ferrara. "The temptation was to be overzealous." The problem was not that such interventions took place, but that the paintings continued to be treated as if they were completely de Kooning's.

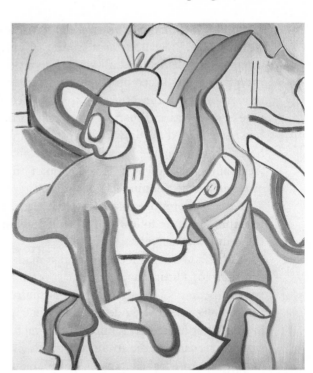

The Cat's Meow, *1987, oil on canvas, 88″ × 77″*

Elaine was aware that de Kooning would have stopped painting without the help of the assistants. She also knew that working kept him alive. At the same time, casting doubt upon his art was not in her best interest. Her understandable supposition was that de Kooning would predecease her, leaving part of his valuable estate to her. In his 1981 will, executed after Elaine reentered his life, de Kooning stipulated that his estate be left on a fifty-fifty basis to Elaine and Lisa. Should Elaine die first, however, everything would go to Lisa; Elaine's heirs—her sister, Marjorie, her brothers, Conrad and Peter, and their children—would not be legally entitled to anything from the painter's estate. Elaine adored her family and, since her return to the studio, had quietly worked to increase her own and her family's wealth, showering gifts and favors upon her relatives. She had borrowed about half a million dollars from de Kooning while he was suffering from dementia and, in her own house, she had many de Koonings whose ownership remained uncertain.

Since Elaine controlled artistic decisions, acting as de Kooning's agent, she could approve new ventures devised to make money. In 1987 or 1988, she decided to print a series of twenty drawings that de Kooning

made in 1966 for the book *In Memory of My Feelings*, published by the Museum of Modern Art as a tribute to Frank O'Hara. Only three were originally published, but all were drawn on Mylar so that they could be run off as prints. Accordingly, Elaine masterminded the publishing of the remaining seventeen prints by the Limited Editions Club of New York. One edition was an illustrated book, the other a portfolio. But de Kooning had never signed the drawings, which diminished the value of the project. Somewhere along the way de Kooning's signature appeared on the prints. At that point, however, Lee Eastman intervened, the press run was stopped, and de Kooning's signature was removed. The final edition represented a compromise. On a separate page, there was a reproduction de Kooning signature followed by the prints. But there were no signatures on the prints themselves.

An unconventional deal was also made with de Kooning's old friend, the sculptor Philip Pavia, to cast several contemporary pieces of sculpture—a *Leda and the Swan* series purportedly created by de Kooning in the mid-eighties. When de Kooning first wanted to try sculpture in the Springs after his trip to Rome in 1969, he turned to Pavia for advice. This time, Pavia came to the studio and was handed three small clay maquettes and a plaque and asked to cast two enlargements and thirty-six bronzes of each piece. The sculptures raised all sorts of questions. Why, after so many years, would de Kooning have returned to sculpture—and would he have been capable mentally of familiarizing himself once more with a strange medium? Lisa de Kooning worked occasionally in the studio doing sculpture and ceramics; she had installed a state-of-the art kiln in the basement early in 1985. Perhaps de Kooning saw some clay and a desire to work with it resurfaced. Or perhaps someone put clay into his hands, and de Kooning simply shaped it into something resembling the little figures that he had executed in Rome in 1969. The plaque, it was later determined, was indeed by de Kooning, but the origin of the other two pieces remained in doubt. Whatever the case, no written contract was drawn up between de Kooning and Pavia. In the process, Elaine set in motion future legal troubles and questions concerning the authenticity of the works that would continue after the painter's death.

During this period, Elaine tried to change de Kooning's will. As her secret illness progressed, she complained to friends about her financial concerns. Wasn't she entitled by law to half of his money, Elaine would ask, even while both were living? After all, she was his wife. But she knew the answer—if she died first, the 1981 will stipulated that her family was guaranteed her own money, but would not get de Kooning's. And so Elaine

devised a plan to free herself of the Eastmans, whom she regarded as unsympathetic to the interests of her and her family. (The Eastmans had also objected to Elaine's gifts of de Kooning paintings to members of her family.) Courtney Ross, whose advice Elaine sought, sent her to Arthur Liman, a head of the New York firm of Paul, Weiss, Rifkind, Wharton, and Garrison. The firm prepared a codicil to de Kooning's 1981 will that removed John Eastman—Lee's son and his successor in the law firm—as an executor of de Kooning's estate in the event that Elaine predeceased him. Instead, the new executors would be Lisa and Lisa's personal attorney, John Silberman, also at Paul, Weiss.

When Elaine first attempted to get de Kooning's signature on the codicil in July 1988, he refused to sign, responding angrily, "You want to take my home from me," and throwing the papers on the floor. As his mind floated in and out, he worried about whether or not the studio was actually his. But he finally capitulated. Elaine, Lisa, and Robert Chapman acted as witnesses to his signature. If Elaine thought that that was the end of her dealings with the Eastmans, however, she was mistaken. According to John Eastman, he refused to acknowledge the validity of the codicil. De Kooning's signature was just a scrawl, Eastman argued, and the painter was clearly not able mentally to decide if someone should be removed as his executor. The validity of the codicil would have to be decided in court, Eastman informed Arthur Liman.

Elaine's own health was deteriorating dramatically, even as she maintained a busy schedule. To all but her family and closest friends, she insisted that she was basically fine—she was just suffering from a bad case of Lyme disease. She kept up appearances until the end. The crisis came on the evening of November 5, at the opening of her latest show of paintings at the Fischbach Gallery on West Fifty-seventh Street in New York. (The paintings were inspired by her visit to the caves at Lascaux. She loved the idea of artists at work in a flickering firelight, which would flare up suddenly to reveal a bison or antelope on the walls.) The gallery was crowded, and the work drew praise from her friends. Aladar Marberger, one of Elaine's closest friends as well as her art dealer, was not there; he had recently died of AIDS. Elaine herself was clearly in pain and wracked by constant coughing. Conrad Fried, among others, became very concerned. He tried to take Elaine from the opening, without success. The next day, Elaine, still following the advice of Steve Ross, entered Memorial Sloan-Kettering Hospital in New York, where Ross admired a particular doctor. It was the beginning of a tremendous ordeal. Elaine was willing to endure anything, including a hugely expensive series of blood transfu-

sions. It was to no avail. She grew weaker by the day and, at last, was taken by car to Long Island. On February 1, she died at Southampton Hospital, one month and a half from her seventy-first birthday. De Kooning never knew that he outlived her.

Six weeks after Elaine's death, several hundred people came to the great hall at Cooper Union College, close to the old Tenth Street neighborhood, to honor her. It was a fitting gathering for a person like Elaine de Kooning; it included the Old Guard and the Young Turks, the celebrated and the obscure, poets and dealers and artists and family. There was even some sense of festivity about the proceedings, in keeping with her indomitable spirit. Edvard Lieber, Elaine's longtime assistant, established the tone of the evening when he recalled that he and Elaine had once been watching television when the death of a congressman was announced. His family, the reporter said, requested that there be no eulogies, whereupon Elaine turned indignantly to Lieber and told him, "When I die, I want *tons* of eulogies."

Elaine got her wish. First there had been the funeral in East Hampton, followed by a gathering at Joan Ward's house on Accabonac Road—which Elaine herself would no doubt have found amusing. In the complicated personal life that de Kooning maintained over the years, it seemed perfectly appropriate that the gathering for his wife be held at the house of the mother of his child. Still to come was a memorial service at the Guild Hall Museum in East Hampton, in which Elaine's many friends on Long Island would extol her. But the biggest event was the gathering at Cooper Union, one of the fifteen universities and art schools at which Elaine had taught during the 1970s. Twenty-six speakers participated, in a marathon memorial lasting several hours. Despite its length, it seemed hard to let Elaine go; she played a significant part in many lives. The speakers ranged from friends of Elaine's from the early days in New York to student friends she had made at Carnegie Mellon and later, all contributing one humorous or endearing anecdote after another.

On February 11, 1989, ten days after Elaine died, Lisa and John Eastman, represented together by John Silberman, filed a petition in state supreme court asking that de Kooning be declared mentally incapable of looking after his affairs. The reason, stated the petition, was that de Kooning's physical and mental condition prevented him from managing his finances, property, and business affairs; an affidavit from a neurologist, Dr. Frederick Mortati, was attached, stating that "de Kooning appeared to be suffering from Alzheimer's Disease." The petition also asked that Lisa and

Eastman be officially named co-conservators of de Kooning's assets. (John Silberman and Lisa had decided in the end not to take the disputed codicil to de Kooning's will to probate, which left John Eastman as co-conservator and eventually coexecutor of the estate.) While he continued to paint "daily and masterfully," they told the court, de Kooning could no longer manage his financial affairs or the daily details of life.

The first public acknowledgment that de Kooning was suffering from an Alzheimer's-like dementia came as little surprise to those who had watched his downward progression first hand. De Kooning no longer knew where he lived, and his recognition of his own family came and went. With no dealer named to replace Fourcade, no one actively promoted the sales of de Kooning's recent paintings. As a result, sales plummeted from the high point of 1987, when Fourcade—himself sick and selling off many of his old de Koonings—sold $9.3 million dollars' worth of paintings, to $1.7 million the following year. The conservation of de Kooning's work also presented problems. No one had assumed responsibility for the condition of earlier work that he owned. The storage building next to de Kooning's studio was overflowing with recent paintings. While adequate for short-term storage, it did not have the proper climate control or archival conditions for long-term maintenance of paintings and works on paper.

Clearly something needed to be done, as Lisa de Kooning and John Eastman stated in their petition—but what? Pierre Lundberg, the court-appointed guardian who was assigned to the case, drove out to interview de Kooning in March. He found a man who could shake hands, read words off a paper, and brush his teeth. But he did not talk. "I could elicit no direct or meaningful response to any question I asked," said Lundberg. Upon investigation, Lundberg objected to the rate at which de Kooning's money had been spent throughout the eighties. His assets were valued at about $7.6 million in real estate, cash, and securities. He had realized between $500,000 and $550,000 annually off those investments. At the same time, expenses for studio assistants and round-the-clock nursing care amounted to roughly $450,000 a year—not to mention the $375,000 annually that de Kooning was paying his daughter to represent him. There were additionally hundreds of works in his possession, valued at anywhere from $50 million to $150 million. Even so, in Lundberg's view, the demands made upon the artist's money were excessive. "Mr. de Kooning's present expenses . . . appear to exceed his investment income," wrote Lundberg. He suggested that Lisa's monthly allowance be reduced from $25,000 to $13,000 and that she no longer receive the additional $75,000 given to her annually to cover taxes. He also recommended that Lisa not

serve as sole conservator for her father. Although not part of the proceedings, stories of Lisa's freewheeling past appeared in the press and were called to Lundberg's attention. Her past behavior, he was quoted as saying, might "have an impact on whether she is appointed a conservator." John Silberman was at pains to explain that that period of her life lay behind her. Lisa's primary residence, he pointed out, was next to her father's on Woodbine Drive in Springs. She had become, said Silberman, "a devoted mother, wife, daughter and artist."

The closest the court proceedings came to the issue of de Kooning's neglect was a letter sent to Lundberg and to the judge in the case, New York State Supreme Court Justice Robert Meade, by six of de Kooning's friends, including Ibram and Ernestine Lassaw. In it, they raised doubts about de Kooning's medication—they had heard that he was taking tranquilizers again after being weaned from them years earlier. They expressed concern that he had not been seen by an eminent neurologist or gerontologist. And they protested what they perceived as his enforced isolation, in which de Kooning's oldest friends were denied access to him. "We, whom he has known for most of his life, are turned away at the door," stated the letter. At the hearing, Lundberg questioned Lisa about the use of tranquilizers, and about the allegations that old friends were not being given access to her father. She denied that he was sequestered or that plans were being made—as rumor had it—to put him in a nursing home. His occasional use of sleeping pills, she said, had no effect on his work. She agreed to reduce her allowance to the stipulated $13,000 a month, with no money provided for taxes, and also agreed not to make important decisions about the estate without the agreement of a co-conservator. After Lisa and John Eastman pledged to pursue all avenues of medical and psychological care for de Kooning, the court duly appointed them co-conservators, in August 1989.

While the legal proceedings played out in the press, art dealers maneuvered for the right to represent de Kooning. At the time of Elaine's death, the field had shrunk from four or so to two apparent front-runners, Arnold Glimcher of the Pace Gallery and Larry Gagosian. The next year, Gagosian would buy one of de Kooning's eighties paintings, *Untitled XII* of 1982, for $3.74 million at Christie's, thereby helping to establish a high price for recent paintings. Glimcher outlined an ambitious marketing campaign for de Kooning's recent art when interviewed by Pierre Lundberg. Still, a successor to Fourcade had not been named at the time of the hearing, and just who would win the valuable prize of representing de Kooning continued to be a hot source of gossip in the art world.

One weekend, Lisa asked de Kooning's assistants to put a fresh canvas

up on her father's easel—without making a drawing on it first. She wanted to see what would happen if her father had no visual stimulus to inspire him to start a new work. Puzzled, de Kooning stared at the easel for some time; it had been years since he faced a blank canvas. Finally, he picked up a brush and painted a dot near the middle. "He spent the next week going around and around it," said Chapman, until he created a bull's-eye of concentric circles. Then, he painted another set of concentric circles in the upper-right-hand corner. The result was a dramatic example of the repetitive fixation on whirling vortexes and arcs and circles that would mark de Kooning's final paintings—testament to a mind locked into a continuous loop. As Chapman said, "It was almost as though Bill was more fascinated by the movement of his hand than with what he was doing." Even so, said Chapman, a few more paintings followed. What fascinated the assistant, who watched de Kooning paint until the end, was that he did not just use the same mechanical gestures over and over again as his mind failed. "I'm sure that if you look at those last half-dozen paintings, you'll see a wide variety," said Chapman. "All of those paintings originated from the same handful of drawings. He still managed to have them all look different. I think there was still something going on."

During 1989 de Kooning's physical health deteriorated. The first downturn came after a hernia operation on May 21 at Southampton Hospital. Two months later, he was hospitalized again for prostate surgery. It was this second surgery, said his assistants, that marked the true beginning of the end. "Bill had a terrible reaction to the anesthesia," said Chapman. "He was drooling when he came back. Gradually he got a little better. But I don't think he ever got everything back." He now required around-the-clock help, composed of both nurses and nurses' aides. Frances Shilowich organized the intricate schedule of care so that de Kooning was never alone. With the nurses came a new rhythm to de Kooning's days. Instead of the quiet of the studio, there was the cheerful hum of meals being made and daily maintenance being carried out. The television was on much of the time, as in the hospital, breaking up the tedium of the day. At Lisa's insistence, the tubes of paint remained at the ready on de Kooning's palette and the canvases that he had last worked on remained propped around the studio. But early in 1990, de Kooning drifted away from his easel for good. With no real job left to do, both Robert Chapman and Antoinette Gay left in 1990. Only Jennifer McLaughlin, the last assistant hired, remained. She would leave in 1993.

In the world outside the studio, the jockeying over de Kooning's legacy continued. Two big gallery shows in New York, both in 1990, made the case that de Kooning was not the wild man of expressionism who had

been on view at the Whitney retrospective. Writing of the mini-retrospective at the Salander O'Reilly Galleries, Michael Brenson of the *New York Times* argued that "the show is so different from the disappointing de Kooning painting retrospective at the Whitney Museum of American Art in 1983 that it seems to be a clear reaction against it." The second show, a comparative view of de Kooning's and Dubuffet's women at the Pace Gallery, also displayed de Kooning's women paintings to advantage, wrote Brenson, even though, as he made clear to readers, it was a clever bit of campaigning by Pace to win the de Kooning estate. In the larger museum universe, the great de Kooning send-off came three years later, with ninetieth-birthday observances that stretched from Washington to New York to East Hampton to London. The Hirshhorn Museum, the possessor of Joseph Hirshhorn's numerous de Koonings, was the first in line, with an exhibition that opened on October 21, 1993. While the Hirshhorn show included some de Koonings from each decade, it concentrated on the sixties, the period when Hirshhorn underwrote de Kooning. Far grander in scale was the retrospective of seventy-six paintings that opened at the National Gallery in Washington seven months later and then traveled to the Metropolitan Museum in New York and the Tate Gallery in London.

Curated by Marla Prather, Nicolas Serota, and David Sylvester, the retrospective was a powerful gathering of paintings made during the course of fifty years. Only the most admired works, period by period, were selected for display. Near the end of the exhibit a large room was devoted to the sumptuous paintings of the 1970s. If the last and final decade was somewhat scantily represented, the more serious problem—overemphasizing the 1980s in a way that distorted a career of more than half a century—was avoided. It was an exhibit worthy of de Kooning's "oceanic art," as the critic Paul Richard wrote in the *Washington Post*. "This exhibit . . . scans his long career, or at least its high points, and locks them into order with such crispness and finality you can almost hear the click." The show was poignant not only because de Kooning himself was no longer painting but also because something seemed to be dying with him. In the eyes of many, de Kooning was the last great painter in a tradition that began in the Renaissance. In 1996, de Kooning's old academy in Rotterdam officially changed its name to The Willem de Kooning Academy.

After Elaine's death, Lisa assumed the de Kooning mantle in Washington and wherever else he needed to be represented. She also made certain her father received the care he required. Since his condition had deteriorated dramatically, no one was allowed to visit him anymore. The last of

his old friends stopped seeing him around 1989. Molly Barnes noted that he no longer raised his head to look at her. (But she was amazed to hear him mutter, "Nice legs.") Around 1992 and into 1993, he became more withdrawn and no longer recognized Mimi Kilgore. Unable to use the staircase, he lived downstairs and, increasingly, was given liquids. According to Joan Ward, he was "warm and fed. That's about it." In the end, de Kooning's heart, which had consistently worried him over the years, sometimes sending him to the hospital with palpitations, never faltered. And his legs retained their muscle tone after years of biking. But he barely survived an inflamed hernia during the winter of 1994–95, which sent his temperature spiking upward. "When Bill came back from the hospital, he was curled up with his head on one side," said Ward. Somehow, the will to live continued. His color improved, and he was taken off intravenous antibiotics. But for the next two years, as de Kooning sank farther into the final breakdown of dementia, the antibiotics failed to clear up pneumonia in his lungs, which eventually presaged a body-wide failure. De Kooning's temperature would sporadically soar; he would begin to thrash around; his nurses would rush him to the hospital. "The last time was like lightning," said Ward. "It's like a series of chain strokes." On March 19, 1997, at the studio, his breathing stopped, and did not start again.

The Saturday after his death, a funeral was held for de Kooning at St. Luke's Episcopal Church in East Hampton. The day was cool and blustery. Joan Ward planned the service with the help of Lisa, Priscilla Morgan, and the Reverend Thomas Pike. She wanted it to be dignified and brief. About three hundred people attended, including Ruth Kligman, Susan Brockman, Molly Barnes, and Emilie Kilgore. Although a few old-timers were present, everyone remarked that de Kooning had outlived almost all his friends, including those who warned him that he would die if he did not stop drinking.

Large banks of yellow tulips stood at the altar and on either side of the casket. The eulogy was short. Reverend Pike, who knew de Kooning only little and late, read the Collects and passages from the Old and New Testaments, including Psalm 121, which was selected by Joan Ward. Edward Caroll, a celebrated trumpeter, played "Morning Has Broken," a Welsh ballad popularized in the seventies by the folk singer Cat Stevens and, later, a solo by the religious composer Hovhaness. Apart from Reverend Pike, Joan Ward was the only person to speak. Sometimes slighted by the art world during de Kooning's life, she was the one woman to stand pub-

licly, at the end, and deliver a formal good-bye. Speaking in a small but firm voice, she used a military metaphor to convey her feelings.

> I would like to speak of Bill and his last painting years. He knew he had lost a battle, give the man credit for that magnificent perception, self-control, and plain old-fashioned courage. As he himself said, "A lot of trembling but no fear."
>
> Like an old soldier with a mortal wound, he was retreating step by stubborn step, no breaking of ranks, no wild scattering of troops, but a measured withdrawal. Marked by the iron control and discipline of a lifetime, he surrounded his beloved paintings and slowly moved them back, and back, and back.
>
> His flags are still flying, his ranks standing firm, his status though challenged unconquered to the end.

Then Ward came down the steps, grazing the coffin with her hand, and took her seat. The service closed with the trumpeter playing "The Triumphal March" from Verdi's opera *Aida*. A reception followed in de Kooning's studio, where everything remained much as it had always been, except that the two Adirondack rockers seemed very still. Some mourners confessed to a certain uneasiness. It was unfair that de Kooning, a painter of such vitality, underwent this slow wasting death; the car wreck that ended Pollock's life, or Rothko's suicide, at least complemented their lives. It seemed strange, too, that the funeral of an unorthodox man who never went to church was conducted by Episcopalians on "Snob Hill." And strange that he would not be buried in Green River Cemetery, where Pollock and many friends lay.

But the sensation that all the pieces did not quite fit—and that maybe the ending should be changed—also suited this restless immigrant and "slipping glimpser." De Kooning did not believe in purity or perfection, except, perhaps, at Louse Point, when he stared out across the water. They stilled desire. He preferred to keep moving, searching for that saving glimpse. "The last few years I have had this daydream," he wrote toward the end of his life. "I would like to have Frank Sinatra's record *Saturday Night (Is the Loneliest Night of the Week)* played at my funeral and imagine that all my friends' eyes should be drowned in tears."

Notes

The endnotes cite sources for all quotations and other significant material. Much information in the book comes from interviews conducted by one or both of the authors; these are termed "interview with the authors." In each chapter, after the first citation of an interview, further quotations from the same source are either identified in abbreviated form or, if not identified, understood to come from the same interview with the authors. Five sources were granted anonymity, a practice the authors generally eschewed. Of these five, only one offered some occasionally negative recollections, which were not used without considerable checking and the support or confirmation from a source or sources who are not anonymous. Extensive use is made of interviews compiled by the Archives of American Art, Smithsonian Institution. They are identified as "AAA" and, when available, a specific reel number is given. In each chapter, the first reference to a source contains full bibliographical details. All citations from de Kooning's letters are © The Willem de Kooning Foundation/Artists Rights Society, New York.

Introduction

On July 18, 1926: Newport News, Va., public library system and The Mariner's Museum Research Library, Newport News. De Kooning's arrival was later recorded as August 15; see *Willem de Kooning: Paintings*, essays by David Sylvester and Richard Shiff and catalog by Marla Prather, exhibition catalog (Washington: National Gallery of Art, 1994). August 15 was no doubt his arrival in New York City; his arrival in Newport News was on July 30. All subsequent references to the National Gallery catalog will be in abbreviated form.

xi "I knew one word": De Kooning, quoted in Ken Wilkie, "Willem de Kooning: Portrait of a Modern Master," *Holland Herald* 17 (March 1982), 22–34.

"What I saw": De Kooning, interview with Bert Schierbeek, in *Willem de Kooning* exhibition catalog (Amsterdam: Stedelijk Museum, 1968).

"He just poured fast": Curtis Bill Pepper, "The Indomitable de Kooning," *New York Times Magazine*, Nov. 20, 1983, 86.

xii After Jackson Pollock's death: Lionel Abel, interview with the authors, May 11, 1992.

"In da beginning was": De Kooning, "A Desperate View," a talk delivered at The Subjects of the Artist: A New School, 1949. Published in Thomas B. Hess, *Willem de Kooning* (New York: Museum of Modern Art, 1968).

xiv ("You have to change"): De Kooning to Tom Ferrara, his assistant from 1980–87, multiple interviews with the authors, July 8, 1991, to Feb. 16, 1996.

He was, as a friend said: Joop Sanders, multiple interviews with the authors, Oct. 31, 1990, to Mar. 13, 1993.

xv He liked to stare: Bert Schierbeek, interview with de Kooning in *Willem de Kooning*.

The aging painter: Lisa de Kooning, interview with the authors, July 18, 1991, with occasional subsequent conversations, 1991–2004.

Chapter 1

3 "My mother was a tyrant": Marie van Meurs–de Kooning in *Signalement*, VARA, Dutch television network. Televised Sept. 15, 1968. Translated for the authors by Rene Dessing.

"There is something": De Kooning, interview with Harold Rosenberg, in Harold Rosenberg, *De Kooning* (New York: Abrams, 1974), 50.

When he was only four: Marie van Meurs–de Kooning in *Signalement*.

4 He was born: De Kooning birth certificate, municipal archives, Rotterdam.

Until 1850: Many details of Rotterdam history were provided by Mr. R. van Bergen and Ms. Nora Schadee of the Historical Museum of Rotterdam (Het Schielandshuis). Interview with the authors, Dec. 1992. Dr. Hanneke Peters, who helped the authors research de Kooning's early years, also drew from P. J. Boumard and W. H. Bouman, *De groei van de grote Werkstad: Een studie over de bevolking van Rotterdam* (Assen: Van Gorcum & Co., 1952).

Notes

4 At midcentury: Records, municipal archives, Rotterdam, obtained and translated by Dr. Hanneke Peters.

5 De Kooning's ancestors: The authors are indebted to Mr. van Wingerden of the municipal archives, Rotterdam, for the information on de Kooning's paternal ancestors. Interview with the authors, Jan. 30, 1991.

His face was shuttered: Interview with Leendert de Kooning, half brother of de Kooning, Feb. 6, 1991; interview with Antonie Breedveld, de Kooning's nephew, Nov. 29, 1991.

He began his working life: Judith Wolfe, interview with Gerrit Jan Tamboer, husband of de Kooning's half sister, July 24, 1985, in *The Young Willem de Kooning: Early Life, Training and Work, 1904–1926*, diss., City University of New York, 1996, 24. The authors are indebted to the invaluable work of Judith Wolfe, who was hired by Elaine de Kooning from June 1985 to July 1988 to research the early years of de Kooning's life. This work was incorporated into Wolfe's dissertation.

Eventually he went off on his own: Interview with Leendert de Kooning. The address of Leendert's business is sometimes given as Vledhoekstraat, sometimes as Vletstraat. The street was renamed at some point, according to Leendert de Kooning; it was originally Vledhoekstraat.

6 Cornelia's family had lived: All of the information on Cornelia's family history comes from Mr. de Voogt, municipal archives, Schiedam. Her great-grandfathers had been, respectively, a fireman and a dyer. Her paternal grandfather, Christiian Nobel (born in 1814), had the distinction of being the only person in the family to have a white-collar job. He was a clerk. Her maternal grandfather, Laurens Oers (b. 1820, no date of death), was a gardener. Cornelia's mother, also named Cornelia, was born in 1849. She was one of seven children of Laurens Oers and his wife, Petronella van der Heide, three of whom died young.

(The lone son): Henk Hofman, de Kooning's cousin, interview with the authors, Dec. 1990. Hofman recalled visiting the Nobel family in Brooklyn.

She possessed . . . a "temperament": Interview with the children of Jacobus Lassooy, de Kooning's half brother, Apr. 1995; Mr. and Mrs. Henk Hofman, interview with the authors; Breedveld, interview with the authors.

Acquaintances consistently thought: Jacobus "Koos" Lassooy, in Ken Wilkie, "Willem de Kooning: Portrait of a Modern Master," *Holland Herald* 17 (March 1982), 24.

Her relatives credited her: She encouraged her son's interest in art partly because she found it romantic. She was also adventurous—she flew in one of the first planes in Holland—and emotionally seductive. According to her grandchildren, even as an elderly woman she wore a great deal of makeup and décolleté dresses.

As an adolescent: *Algemeen adresboek der gemeente Rotterdam* (address book for the city of Rotterdam). Until the 1940s, each family in Rotterdam had an individual address card, upon which all addresses and changes of address were listed. Details of all family moves are taken from these address cards, which were updated yearly in a new address book.

7 Such an occurrence: Mr. R. van Bergen and Ms. Nora Schadee of the Historical Museum of Rotterdam, Dec. 1992.

The couple was married: Marriage certificate, Schiedam municipal archives, Schiedam.

What is certain: The births and dates of their children come from their family card.

8 At the time of Willem's birth: Family address card.

Housing for workers: Interview with Mr. R. van Bergen and Ms. Nora Schadee; interview with Monique and Jan Gidding, Jan. 31, 1991; interview with Mr. van Wingerden.

The two families: Many Rotterdam houses still had outhouses as well. Monique and Jan Gidding, interview with authors.

9 In the early 1900s: Statistic contained in historical records, municipal archives, Rotterdam. There was still a fair degree of opprobrium attached to divorce even among the working class.

But on February 20: All information on the dates and proceedings of the divorce come from the Rotterdam courthouse records (Arrondissementsrechtbank Rotterdam) in the Central State Archives in The Hague. The authors are indebted to Dr. Hanneke Peters for copying the documents for us and obtaining an explanation of divorce law in early-twentieth-century Holland.

Years later: Leendert de Kooning, undated letter to Willem de Kooning, unpublished. Courtesy of the de Kooning family, Rotterdam.

Adding to the tension: Breedveld, interview with the authors.

10 On April 21: Rotterdam courthouse records. In the early 1900s, such extreme language was

necessary to file for divorce and may explain Cornelia's charges. Mr. R. van Bergen and Ms. Nora Schadee, interview with authors.

10 After filing the papers: Family address card.

According to the legend: De Kooning repeated the story of being kidnapped by his mother again and again. Among other places, it was referred to by Joop Sanders, multiple interviews with the authors, Oct. 31, 1990 to Mar. 13, 1993; and Marjorie Luyckx, sister of Elaine de Kooning, interview with the authors, June 14, 1994.

According to the Dutch records: Family address card.

11 De Kooning remembered those occasions: Lisa de Kooning, interview with the authors, July 18, 1991, with occasional subsequent conversations, 1991–2004; and Peter and Florence Grippé, interview with the authors, July 20, 1992.

On November 25, 1908: Records in the municipal archives, Rotterdam, courtesy of Mr. van Wingerden.

(Her own son): Leendert de Kooning, interview with the authors. "In the afternoon she liked to go out for teas and birthday parties in the neighborhood," recalled Leendert. "She always went alone. My father and mother lived for each other. They got along very well together. At night they often went to the cinema. Sundays they would go to the park. We children never went along. We were taken care of by an attendant." The authors are deeply grateful to Hendrik van Leeuwen for his follow-up conversations with the family of Leendert de Kooning, and for his translations of letters provided by the family.

Both de Kooning and his sister: Breedveld, interview with the authors. "What I heard from my mother is they couldn't get along with their stepmother," said Breedveld. "In my mother's words, she was a 'bitch.' And she probably resented the children of the other marriage."

He would say: De Kooning, in Paul Hellman, "De Verloren Zoon Zit Goed," *Algemeen Dagblad*, Dec. 24, 1976. The authors are deeply grateful to Mark Lynton for translating all the Dutch newspaper clippings.

De Kooning remembered his childhood: Ibid.

12 Cornelia regularly beat: The children of Koos Lassooy recalled their father talking about how he was beaten (interview with the authors, Apr. 1995). De Kooning described the beatings to many close friends over the years, including Elaine's brother, Conrad Fried (interviews with the authors, May 31 and June 1, 1995), Marjorie Luyckx and Emilie Kilgore (interviews with the authors, July 24–26, 2003). Dutch society at the turn of the century was more tolerant of the physical disciplining of children than it is today, but Cornelia's behavior was almost certainly excessive even by the standards of the time.

He was playing with marbles: De Kooning told this story often. See, for example, Amei Wallach, "My Dinners with de Kooning," *Newsday*, Apr. 24, 1984, 24. His daughter, Lisa de Kooning, also mentioned it (interview with the authors).

Marie observed, admiringly: Wilkie, "Willem de Kooning."

A grandchild of Cornelia's: Cornelia (Cory) Hendrika Maria Lassooy, interview with the authors, Apr. 1995.

13 As a small child: Anne Wedgwood Schwertley, interview with the authors, Feb. 15, 1995.

Leendert treated his second family: Leendert de Kooning, interview with the authors.

So tenuous did their connection become: Marie then had a photograph of herself made and sent it to him, as if that were the only way she might have a place in her father's life. Breedveld, interview with the authors.

Decades later, in a letter: De Kooning, letter to his sister, Marie van Meurs–de Kooning, Dec. 2, 1967. Courtesy Antonie Breedveld. © The Willem de Kooning Foundation/Artists Rights Society, New York.

He would never forget: Lisa de Kooning, interview with the authors. She recalled her father talking about the stamping of the horses. Ruth Kligman remembered de Kooning describing his father's high starched collars. Kligman, *Newsweek*, unpublished interview with Ann Ray Martin, background file, Sept. 17, 1968.

(Years later, de Kooning wrote Marie): De Kooning, letter to his sister.

He remembered his mother: Longtime friend of the Fried family, anonymous, June 18, 1993.

14 "He was good-looking": Mrs. Hofman, interview with the authors.

In the six years following his marriage: Family address cards, which also listed occupations.

He was part of a group of boys: Tom Ferrara, de Kooning's assistant from 1980 to 1987, interviews with the authors, July 8, 1991, to Feb. 16, 1996.

Hofman remembered that he would perform: Henk Hofman, interview with the authors.

His half brother Koos: Judith Wolfe, *The Young Willem de Kooning*, 46.

14 De Kooning remembered one particular moment: Kilgore, interviews with the authors.
Many teachers in Rotterdam's schools: Mr. R. van Bergen and Ms. Nora Schadee, interview
with the authors.

15 In later years, he would sometimes point to students: Luyckx, interview with the authors.

16 "At twelve, I was a very good pupil": De Kooning in Gaby Rodgers, "Willem de Kooning:
The Artist at 74," LI: Newsday's Magazine for Long Island, May 21, 1978.
"This made a terrific impression": Conrad Fried, interviews with the authors.

17 "De Kooning had the social ability": Sanders, interviews with the authors.
"He wasn't a jolly fellow": Breedveld, interview with the authors.
In Rotterdam the pubs ranged from: Information on pub life at the turn of the century
comes primarily from Mr. van Wingerden of the municipal archives, Rotterdam.

18 Only on April 26, 1916: The Lassooy family card.
Perhaps the most significant fact: As required by law, Leendert gave his written consent for
the marriage, but he could not—or, more likely, would not—attend. One reason, according
to his second family, was that he thought his daughter by his first marriage was too young
to marry. They also recalled that he was very angry—at her pregnancy, no doubt.
During the war years: Mr. R. van Bergen and Ms. Nora Schadee, interview with the
authors. See also E. H. Kossmann, "The Low Countries, 1780–1940," in Oxford History of
Modern Europe (Oxford: Oxford University Press, 1978).
During the left-leaning days: De Kooning's references to early socialism come from three
unpublished interviews with Robert Jonas, one of de Kooning's early friends in America,
conducted by Judith Wolfe as part of her research into de Kooning's early life. Wolfe is the
author of The Young Willem de Kooning: Early Life, Training and Work, 1904–1926, diss.,
City University of New York, 1996. Interviews with Jonas provided courtesy of his wife,
Liesl Jonas.
In May 1917: Records of his bankruptcy are in the Central State Archives, The Hague. The
proceedings listed a Mr. Kapteyn as the chief creditor, along with a number of others. Las-
sooy's assets included two houses that he owned jointly with his eight brothers and sisters,
plus his spirits license.

19 Like many people in Holland: Ruth Kligman recollected de Kooning's poor early diet in the
Newsweek background file.
His teachers had noticed his gift: Elaine de Kooning, in a "Personal History of Willem de
Kooning recorded by his wife, Elaine," which she compiled but that remains unpublished,
cited by Judith Wolfe in The Young Willem de Kooning. Estate of Elaine de Kooning.
Once de Kooning finished primary school: Rodgers, "Willem de Kooning."

Chapter 2

20 "You have to start, over and over again": De Kooning, interview with Bert Schierbeek, in
Willem de Kooning, exhibition catalog (Amsterdam: Stedelijk Museum, 1968).
The Gidding headquarters: Jan and Monique Gidding, son and daughter of Jaap Gidding,
interview with the authors, Feb. 6, 1991. The Giddings provided many of the details on the
family firm cited in this chapter.
Gidding specialized in: Ibid.
The firm not only served wealthy Rotterdammers: Information translated by Dr. Hanneke
Peters from Ro van Oven, "Japp Gidding," Elsevier's Geillustreerd Maandschrift (Elsevier's
Illustrated Monthly) vol. 31, no. 62 (1921), 296–301.
Part of the influential arts and crafts movement: Jan and Monique Gidding, interview with
the authors.

21 Of the two brothers: Background on Jaap's career comes from the Giddings. Other sources
include Jaap Gidding, obituary, Rotterdams Nieuwsblad, Apr. 26, 1955; J. M. Luthmann,
"Inleiding De Bijenkorf in Den Haag," Wendingen, vol. 7, no. 11½ (1925); Elsevier's Geil-
lustreerd Maandschrift; and Carine Hoogveld, Glas-in-lood in Nederland, 1817–1968 (The
Hague: SDU, 1989). The authors are grateful to Dr. Peters for her translations.

22 The modern elevation of good craftsmanship: Among the sources on art nouveau and the
arts and crafts movement in Holland are Gillian Naylor, "The Netherlands," Encyclopedia
of Decorative Arts, 1890–1940, ed. Philippe Garner (London: Quarto Publishing, 1978);
Peter Selz and Mildred Constantine, eds., Art Nouveau: Art and Design at the Turn of the
Century, exhibition catalog (New York: Museum of Modern Art, 1960); and Mario Amaya,
Art Nouveau (New York: Dutton, 1966). A good introduction in English to Hendrik Petrus

Berlage can be found in the *Macmillan Encyclopedia of Architects* (London: Collier Macmillan, 1982).

22 Like the Victorians: Berlage designed furniture, lighting fixtures, and posters in addition to buildings. He was also a disciple of Frank Lloyd Wright (he visited the United States in 1911) and became an important disseminator of Wright's ideas.

23 A late enthusiast: He and his brother were still young and could adjust to changes in fashion. Later, as the De Stijl movement and the Wiener Werkstatte gained popularity, Jaap incorporated aspects of those styles into his work as well. In 1925, he won a silver medal for his decorative artwork at the famed Art Deco exposition in Paris.

A frieze that he created: *Elsevier's Geillustreerd Maandschrift.*

In Rotterdam, during the early years: Jaap became particularly well known for designing richly colored glass windows, then popular in Holland.

For the first year or two: Jan and Monique Gidding, interview with the authors.

De Kooning later recalled working in hotel lobbies: De Kooning, in Ken Wilkie, "Willem de Kooning: Portrait of a Modern Master," *Holland Herald* 17 (Mar. 1982), 22–34.

24 As de Kooning said of his Gidding years: De Kooning, interview with Judith Wolfe, Aug. 23, 1985, in *The Young Willem de Kooning: Early Life, Training and Work, 1904–1926*, diss., City University of New York, 1996, 68.

About eight months after he joined: Hansmaarten Tromp, "Willem de Kooning: 'Elke Stijl is fraude,'" *De Tijd*, Oct. 21, 1977.

In 1916, his pay was one guilder: Paul Hellman, "De Verloren Zoon Zit Goed," *Algemeen Dagblad*, Dec. 24, 1976.

The head decorator: De Kooning, in Ben Dull, "Willem de Kooning is terug," *Het Parool*, Sept. 18, 1968.

Even Jan and Jaap: De Kooning, in Amei Wallach, "My Dinners with de Kooning," *Newsday*, Apr. 24, 1984, 24.

(As early as 1916): This early still life is in the collection of the artist.

25 When he was only thirteen: Gus Falk, interview with the authors, July 28, 1992.

Only one year: In modern Dutch spelling, the name of the academy is Academie voor Beeldende Kunst en Technische Wetenschappen. In de Kooning's day, however, the name was Academie van Beeldende Kunsten en Technische Wetenschappen.

(In the academy's yearbook): Each year the academy published annual reports. Through the 1922–23 academic year, students promoted from one year to the next were also listed.

By the fall of 1917: De Kooning's name first appears in the annual reports of 1917–18, as being promoted from Class I to Class II.

26 The long corridors: Photographs in a pictorial history of the academy, *Het Gebouw van de Academie van Beeldende Kunsten en Technische Wetenschappen, van 1 mei 1873 tot 1 September 1935*, contained in the academy's archives. Few records survived the Nazi blitz of World War II.

In later years, de Kooning: One notable instance of this was in de Kooning's interview with Anne Parsons, AAA, 1967.

As he told the *New York Times*: De Kooning, in Susan Heller Anderson, "De Kooning Has Meeting with Queen," *New York Times*, Apr. 25, 1982.

27 The academy's origins: Interview with A. G. M. Vreeburg, art history teacher at the academy, Dec. 1, 1992. Mr. Vreeburg is the source of much of our material on the turn-of-the-century academy and its origins. Other material came from a book about the history of the academy, *Het onderwijs aan de Academie van Beeldende Kunsten en Technische Wetenschappen te Rotterdam in 1913* (Rotterdam: W. L. and J. Brusse, 1914), and a speech on the occasion of the academy's seventy-fifth anniversary, J. Verheul, "De Academie van Beeldende Kunsten en Technische Wetenschappen 1851–1926." The authors are grateful to Dr. Peters for her copies and translations.

"The boys who went to the day classes": The artist Jan van Heel, in *Signalement*, VARA, Dutch television network. Televised Sept. 15, 1968. Van Heel, who lived in The Hague, was a well-known artist in Holland.

In 1916–17, the year before de Kooning enrolled: Annual reports.

28 As de Kooning later told the art critic: De Kooning, in Thomas B. Hess, *Willem de Kooning* (New York: Museum of Modern Art, 1968), 13, 14.

The first-year studies: Hess, *Willem de Kooning*, 1968, 13. Dr. Peters also found in the academy archives course books that outlined the curriculum in detail, including photographs of typical student projects.

Notes

28 Hess described the process: Hess, *Willem de Kooning: Drawings* (Greenwich, Conn.: New York Graphic Society, 1972), 18, 19.

29 Years later: Pat Passlof, interview with the authors, July 18, 1990.
"We had to work very minutely": Jan van Heel, *Signalement.*
The supreme arbiter: A. G. M. Vreeburg, interview with the authors.
"My professor was": De Kooning, in Hansmaarten Tromp, "Willem de Kooning."
To Hess, de Kooning conjured: Hess, *Willem de Kooning,* 1972, 18.

30 Despite the institution's: Mr. Vreeburg said that in 1918 the night classes were shortened from four hours to three. So de Kooning would have had only one year of the four-hour classes. At the same time, Saturday evening classes were abandoned. Jan van Heel, *Signalement.*
"Heyberg was a big man": Ibid.
De Kooning himself recalled: Tromp, "Willem de Kooning."
Of the seventeen who began: Annual reports.
The deadly epidemic: Many details of Rotterdam history were provided by Mr. R. van Bergen and Ms. Nora Schadee of the Historical Museum of Rotterdam, interview with the authors, Dec. 1992.
"Bill's mother had a very rough life": Antonie Breedveld, interview with the authors, Nov. 29, 1991.

31 Her children certainly understood: Joop Sanders, multiple interviews with the authors, Oct. 31, 1990, to Mar. 13, 1993.
"I worked hard and long": De Kooning, in Hellman, "De Verloren."

32 "Sometimes he performed for me": Ibid.
Years later de Kooning told his brother-in-law: Conrad Fried, interviews with the authors, May 31 and June 1, 1995.
At night, de Kooning walked: Emilie Kilgore, interviews with the authors, July 24–26, 2003.

33 One day, he had a terrible argument: Marjorie Luyckx, interview with the authors, June 14, 1994.
"At sixteen": De Kooning, *Time,* unpublished interview with Welch, background file entitled "An Analysis of Abstract Expressionism, its meaning, the major figures," July 20, 1958.

Chapter 3

34 "I read somewhere": De Kooning, interview with David Sylvester, in David Sylvester, *Interviews with American Artists* (New Haven and London: Yale University Press, 2001). The Yale volume contains the most complete version of this famous interview from 1960, which has been published in many different forms over the years. The interview is most often cited as "Content Is a Glimpse," *Location* 1 (Spring 1963), 45–53. Subsequent references will refer to it as "Content Is a Glimpse."
She often told her son Antonie: Antonie Breedveld, interview with the authors, Nov. 29, 1991.
Even when he was not: Ibid. Breedveld recalled that de Kooning came around when he needed something, especially money.
In late fall of 1919: Family address card, municipal archives, Rotterdam.
Marie established herself as a seamstress: Family recollections of Antonie Breedveld, Nov. 29, 1991, and the children of Koos Lassooy, de Kooning and Marie's half brother, Apr. 1995.

35 He also babysat: Breedveld, interview with the authors.
Cornelia was still aghast: Mrs. Henk Hofman, the wife of de Kooning's cousin Henk Hofman, said that "a son couldn't live with a mother like that. For her the most important thing was that he became a famous painter." Interview with the authors, Dec. 1990.
(She relished connections to the upper classes): Ibid.
While most academy records were destroyed: Such an award would most likely have financial implications. Of the 973 students enrolled in all of the academy's various departments in 1917–18, de Kooning's first year, only fifty-eight were awarded full scholarships. Annual reports of the academy.

36 Another early work: This drawing, held by de Kooning's sister, can be seen in a photograph of Marie in Ken Wilkie, "Willem de Kooning: Portrait of a Modern Master," *Holland Herald* 17 (March 1982), 22–43.

36 According to his friend: Joop Sanders, multiple interviews with the authors from Oct. 31, 1990, to Mar. 13, 1993.
Antonie Breedveld also recalled: interview with the authors.

37 Bernard Romein: Born in Hillergersberg, a small town near Rotterdam, Romein, like de Kooning, had great facility as an artist. The two shared much in common, from their training at the academy to their background and upbringing, which probably increased de Kooning's respect and admiration for his mentor. Like de Kooning, Romein came from a poor family. He was the eleventh and youngest child of a carpenter who, when Bernard was four, moved his family to the same working-class neighborhood in North Rotterdam where de Kooning was born. Romein's mother encouraged her son to pursue his gift for drawing. But she died when he was only thirteen, and after his father remarried, Bernard—again, like de Kooning—looked for emotional support to his eldest sister rather than to his own father. Romein first enrolled in the decorative and applied arts section of the academy from 1906 to 1908, supporting himself with housepainting. Then came four years (1908–12) in Heyberg's *handteekenen* division. In 1918, Romein was promoted to the seventh class; that same year, de Kooning completed his first year at the academy. While only ten years separated Romein and de Kooning, the gap in knowledge and sophistication was great. Among the many sources on Romein are the academy's annual reports; the Rotterdam city archives; Judith Wolfe, *The Young Willem de Kooning: Early Life, Training and Work, 1904–1926*, diss., City University of New York, 1996; a Sotheby's auction catalog of 1987 featuring the sale of Bernard Romein posters and art; "De winkelweek, Weste Wagenstraat," *Nieuwe Rotterdam Courant*, Nov. 13, 1925; "Ein Kalender," *Nieuwe Rotterdam Courant*, May 11, 1930; and "Kunst en Letteren," *Dordrechtsche Courant*, Apr. 19, 1927. The authors are grateful to Dr. Hanneke Peters for her translations. Dr. Peters also had a conversation with Romein's niece, Mrs. van Wijngaarden-de Vos, about her uncle.

38 One of several applicants: De Kooning, interview with Judith Wolfe, Apr. 25, 1985, in Wolfe, *The Young Willem de Kooning*, 265.
According to de Kooning's nephew: Breedveld, interview with the authors. Also Marie van Meurs–de Kooning in *Signalement*, VARA, Dutch television network. Televised Sept. 15, 1968.
In the early 1920s: Romein's work is in the collection of the Municipal Museum in Helmond. Three of his posters are also in the collection of the Stedelijk Museum in Amsterdam.
As de Kooning described him: De Kooning, interview with Judith Wolfe, Apr. 25, 1985, in *The Young Willem de Kooning*, 268–69.
Until he met him: De Kooning, in Jan Bart Klaster, "De Kooning gaat door ik schilder mijn binnenste," *Het Parool*, May 11, 1983.

39 Romein, de Kooning said: De Kooning in Ben Dull, "Willem de Kooning is terug," *Het Parool*, Sept. 18, 1968.
De Kooning told Judith Wolfe: De Kooning, interview with Judith Wolfe, Oct. 28, 1984, in *The Young Willem de Kooning*, 267.

40 Typically, the speakers were prominent: Interview with A. G. M. Vreeburg, art history teacher at the academy, Dec. 1, 1992. Mr. Vreeburg is the source of much of the material on the turn-of-the-century academy and its origins. Summaries of the academy's main offerings can also be found in a speech on the occasion of the academy's seventy-fifth anniversary, J. Verheul, "De Academie van Beeldende Kunsten en Technische Wetenschappen 1851–1926."

41 "I thought Mondrian was phenomenal": De Kooning, in Klaster, "De Kooning gaat door."
But de Kooning once observed: Ibid.
Originally from a small town: Vreeburg, interview with the authors.
He was struck by the imaginative use: Wolfe, *The Young Willem de Kooning*, 164–211.

42 He articulated his position: Ibid.
He and his students contributed work: Vreeburg, interview with the authors. Their work won a gold medal at the Fair.
Jongert also tried to appoint: When the academy balked at his Bauhaus appointment, Jongert resigned.
"At the academy in Rotterdam": Hansmaarten Tromp, "Willem de Kooning: 'Elke stijl is fraude,' " *De Tijd*, Oct. 21, 1977.

43 "We used to call that": Sylvester, "Content Is a Glimpse."
"He wouldn't mind it": De Kooning, interview with Sally Yard, Oct. 14, 1976, in Yard, *De Kooning: The First 26 Years in New York*, diss., Princeton University, 1980, 202 (fn). Subse-

Notes

quently published in book form by Garland Publishing (New York and London, 1986). Unpublished interview on file at The Willem de Kooning Foundation, New York.

43 One of his closest friends: Breedveld, interview with the authors. Benno was a year ahead of de Kooning at the academy, according to the annual reports.

As their name suggests: Wolfe, *The Young Willem de Kooning*. The authors are indebted to Wolfe's research for many details on the Randolfi family.

"When they played ordinary songs": De Kooning, in Paul Hellman, "De Verloren Zoon Zit Goed," *Algemeen Dagblad*, Dec. 24, 1976.

44 Later, de Kooning would tell: Wolfe, *The Young Willem de Kooning*.

45 Much of de Kooning's free time: Vreeburg, interview with the authors. Vreeburg recalled the main haunts of older students at the academy.

Chapter 4

46 "There were cowboys": De Kooning, interview with David Sylvester, "Content Is a Glimpse," *Location* 1 (Spring 1963), 45–53.

As a boy: Ibid.

"I had an uncle": De Kooning, in Ken Wilkie, "Willem de Kooning: Portrait of a Modern Master," *Holland Herald* 17 (March 1982), 24.

He would joke: Ruth Kligman, *Newsweek*, unpublished interview with Ann Ray Martin, background file, Sept. 17, 1968.

47 De Kooning was collaborating: Judith Wolfe, *The Young Willem de Kooning: Early Life, Training and Work, 1904–1926*, diss., City University of New York, 1996. The authors are indebted to Wolfe's research for many details on the Randolfi family.

His contributions to a Stedelijk Museum show: Details of Mondrian's final years before leaving Holland can be found in *Mondrian: From Figure to Abstraction*, exhibition catalog (Tokyo: Erik Wierda Art Books, 1997). Also valuable was Joop Sanders, multiple interviews with the authors, Oct. 31, 1990, to Mar. 13, 1993.

He himself would leave: Rotterdam address cards; Sotheby's catalog for a 1987 sale of Romein's work.

After Romein urged him to read: De Kooning told Joop Sanders he identified with Raskolnikov. Joop Sanders, multiple interviews with the authors.

48 In April 1921: Rotterdam address cards.

According to his half brother: Interview with Leendert de Kooning, Feb. 6, 1991.

Several years later: Tom Ferrara, multiple interviews with the authors, July 8, 1991, to Feb. 16, 1996.

49 Although such trips: Elaine de Kooning, in "Personal History of Willem de Kooning recorded by his wife, Elaine," unpublished, cited by Judith Wolfe in *The Young Willem de Kooning*. Estate of Elaine de Kooning.

It had been particularly important: Mario Amaya, *Art Nouveau* (New York: Dutton, 1966).

"I can't remember": De Kooning, in Hansmaarten Tromp, "Willem de Kooning: 'Elke stijl is fraude,' " *De Tijd*, October 21, 1977.

At first the trio: Wolfe, *The Young Willem de Kooning*, 429.

Later, he described: De Kooning, interview with Bert Schierbeek, published in *Willem de Kooning*, exhibition catalog (Amsterdam: Stedelijk Museum, 1968).

At some point: Wolfe, *The Young Willem de Kooning*, 430.

50 In particular, he was already thinking: Tom Ferrara, interviews with the authors.

In an interview with: Charlotte Willard, "De Kooning: The Dutch-born U.S. Master Gathers in the International Honors," *Look*, May 27, 1969.

"I admire cartoonists": De Kooning, *Newsweek*, unpublished interview with Ann Ray Martin, background file, November 20, 1967.

51 As de Kooning told Judith Wolfe: *The Young Willem de Kooning*, 381.

Both traditions: A number of these drawings are reproduced in Judith Wolfe, "Van Wim tot Bill de Kooning: Zeven decennia thematiek en vorm," *Jong Holland*, vol. 1, no. 1, 1994, 6–28.

As he told Judith Wolfe: Wolfe, *The Young Willem de Kooning*, 492–93.

52 In later years: Biography of de Kooning prepared for the 1939 World's Fair, in the archives of the Museum of Modern Art.

But there is no record: Research of both Judith Wolfe, *The Young Willem de Kooning*, 464–69, and Dr. Hanneke Peters, who helped the authors with research on de Kooning's life in Holland.

53 "I wasn't at all sure": De Kooning, in Jan Bart Klaster, "De Kooning gaat door ik schilder mijn binnenste," *Het Parool*, May 11, 1983.

As his later art made clear: De Kooning, always uneasy with labels, reluctantly called himself an expressionist to Klaster, ibid.

For a time, he rented with Benno and Wimpy: Rotterdam address card.

He also briefly lived . . . near the train station: Wolfe, *The Young Willem de Kooning*, 420.

(Or, as the dancer-choreographer): Merce Cunningham, interview with the authors, Apr. 30, 1998.

54 A photograph taken in 1922: This photograph was reproduced in Ken Wilkie's article in *Holland Herald*.

In tacit acknowledgment: Rotterdam address card.

Subsequently, Breedveld took a job: Antonie Breedveld, interview with the authors, Nov. 29, 1991.

Most important of all: Dr. Hanneke Peters, research in the municipal archives, Rotterdam.

Feeling sorry for her brother: Marie van Meurs–de Kooning, quoted in *Signalement*, VARA, Dutch television network. Televised Sept. 15, 1968.

(De Kooning told the art historian): Sam Hunter, " 'Je dessine les yeux fermes,' un entretien exclusif avec Willem de Kooning," *Galerie Jardin des Arts*, Paris, no. 152 (November 1975), 68–70. Antonie Breedveld said that he recalled his grandmother talking about de Kooning's drawings of the nude (Breedveld, interview with the authors). And in the *Holland Herald* interview of 1982, de Kooning joked, "Our models were muscular men then. For the anatomy. In American schools it's always naked girls. Nice to look at, but there are so many other things to draw in the world."

55 The city of Rotterdam: Rotterdam address card. According to Mr. van Wingerden of the municipal archives, de Kooning could have left the city up to one year before the recorded date.

What is certain: Although the academy stopped listing the names of its students by the year 1923–24, the Dutch versions of *Who's Who* published after de Kooning became a celebrated painter stated that he never finished at the academy. (Jan and Monique Gidding, interview with the authors, Feb. 6, 1991.) And while de Kooning obfuscated the dates of attendance in his early years in America, in later years he mentioned going to the academy for only four or five years.

"My only interest": De Kooning, "Willem de Kooning: Geduldig genie," *Volkskrant*, Sept. 28, 1968.

56 According to his future brother-in-law: Conrad Fried, interviews with the authors, May 31 to June 1, 1995.

The hiring clerk: Thomas B. Hess, *Willem de Kooning* (New York: Museum of Modern Art, 1968), 16.

There would be a farewell party: Fried, interviews with the authors.

"I had a lot of trouble getting [to America]": De Kooning in Curtis Bill Pepper, "The Indomitable de Kooning," *New York Times Magazine*, Nov. 20, 1983, 86.

The scheme struck de Kooning as far-fetched: De Kooning recalled that his father only gave him "a measly twenty guilders." Joop Sanders, multiple interviews with the authors, Oct. 31, 1990, to Mar. 13, 1993. Breedveld recalled it as twenty-five guilders. Breedveld, interview with the authors.

57 Leased for this trip: Shipping records, Harbor Master, Rotterdam.

There was no time to lose: De Kooning told this to Tom Ferrara. Ferrara, interviews with the authors.

In 1968 he could not even bring himself to telephone: De Kooning's sister and mother were not told of his arrival until the day of the show itself. *Newsweek*, unpublished background file by Stringer Willem Vuur, undated, fall, 1968.

On the morning of July 16: In Thomas B. Hess, *Willem de Kooning*, 1968, 16. Hess wrote that de Kooning almost stole aboard a boat bound for Buenos Aires; Leo Cohan then told de Kooning that South America was not a suitable destination. But that account varies from one given by de Kooning to Wilkie, *Holland Herald*. De Kooning told Wilkie that Leo Cohan "came round one day and said, 'Are you ready?' I said, 'Ready for what?' He replied, 'We're going to New York!' He'd already arranged to have me stowed away." De Kooning said the SS *Shelley* was ultimately bound for Buenos Aires and that he toyed with the idea of staying on, but Cohan pulled him off.

Notes

61 "I didn't think there were any artists": De Kooning, in Hansmaarten Tromp, "Willem de Kooning: 'Elke stijl is fraude,' " *De Tijd,* Oct. 21, 1977.

He saw "a sort of Holland": De Kooning, interview with Bert Schierbeek, in *Willem de Kooning,* exhibition catalog (Amsterdam: Stedelijk Museum, 1968).

"Look what needs doing": Lisa de Kooning, interview with the authors, July 18, 1991 and occasional subsequent conversations, 1991–2004.

Worse than the heat: Virginia (Nini) Diaz Halusic, de Kooning's first girlfriend in America, interview with the authors, Feb. 3, 1994.

"When we were disembarking": De Kooning, quoted in Ken Willkie, "Willem de Kooning: Portrait of a Modern Master," *Holland Herald* 17 (March 1982), 22–34.

When Leo Cohan and some sailors: Conrad Fried, interviews with the authors, May 31 to June 1, 1995.

Cohan, as cheerful and optimistic as ever: Typically, a transatlantic passenger ship would first anchor in the outer harbor of New York, south of Liberty Island, before continuing to its pier in the city. At that point, all passengers who had made the trip in steerage would be ferried by tenders to Ellis Island to undergo physical exams and a battery of tests and questions, such as who had paid for their tickets (almost always a relative who preceded them to America) and how much money they carried. Failure to pass the physical exam or to answer questions to the satisfaction of the immigration officers meant denial of entry into the country.

The passage of the Immigration Act: Page Smith, *Redeeming the Time: A People's History of the 1920s and the New Deal,* vol. 8 (New York: McGraw-Hill, 1991), 466–67.

Calling upon his network: Schierbeek, interview with de Kooning in *Willem de Kooning.*

62 Although South Street had been the center: "*New York Panorama: A Comprehensive View of the Metropolis,*" *Presented in a Series of Articles Prepared by the Federal Writers' Project of the Works Progress Administration in New York City* (New York: Random House, 1938), 3.

"We had enough money": De Kooning, quoted in Curtis Bill Pepper, "The Indomitable de Kooning," *New York Times Magazine,* Nov. 20, 1983, 86.

"This I remember": Schierbeek, interview with de Kooning in *Willem de Kooning.*

Their few possessions: In the 1920s and '30s, more than 110 piers and 24 ferry slips lined the western side of Manhattan.

Once a sleepy river town: Details about Hoboken, New Jersey, and the location of the Holland Seaman's House, etc., come from the Hoboken City Directory 1925–26; *Three Centuries of Progress: A Brief History of Hoboken, N.J., and Teaneck, N.J., from 1609 to 1940,* published to commemorate the seventy-fifth anniversary of the A. J. Volk Co.; William H. Miller, "Hoboken's Famous Pier B," in *Ocean Cruise News;* Brigid A. Cahalan, "Hoboken: A City in Transition," master's thesis, Queens College, City of New York; and John J. Heaney, *The Bicentennial Comes to Hoboken* (Hoboken, N.J.: Hoboken American Revolution Bicentennial Committee, 1976).

"My sailor friends": Schierbeek, interview with de Kooning in *Willem de Kooning.*

63 "Three days later": De Kooning, interview with David Sylvester, "Content Is a Glimpse," *Location* 1 (Spring 1963), 45–53.

After only one week of work: Schierbeek, interview with de Kooning in *Willem de Kooning.*

In the beginning: Robert Jonas, unpublished interviews with Judith Wolfe, author of *The Young Willem de Kooning: Early Life, Training and Work, 1904–1926,* diss., City University of New York, 1996. Interviews courtesy of Liesl Jonas. De Kooning also recalled his lack of English to Ann Ray Martin, *Newsweek,* unpublished background file, November 20, 1967.

"I was impressed by": De Kooning, in Martha Bourdrez, "Originality and Greatness in Painting," *The Knickerbocker,* May 1950.

64 "Sign painting was difficult": Wilkie, "Willem de Kooning. Portrait of a Modern Master," *Holland Herald* 17 (March 1982), 22–34.

Leo Cohan, who worked as a cook: Ben Dull, "Willem de Kooning."

De Kooning's keenest friendship: Max Margulis, interview with Sally Yard, June 17, 1977, in Sally Yard, *Willem de Kooning: The First 26 Years in New York,* diss., Princeton University, 1980, 27. Later published by Garland Publishing (New York and London, 1986).

65 "All through the 1920s": *New York Panorama.*

66 "Every Saturday and Sunday": Cecil Beaton, *Cecil Beaton's New York* (London: B. T. Bats-ford, 1938), 32.
"I liked the sentimental side": Bourdrez, "Originality and Greatness in Painting."
Crowded tenements: Edward Halsey Foster and Geoffrey W. Clark, eds., *Hoboken: A Col-lection of Essays* (New York: Irvington Publishers, 1976).
"We would stand": De Kooning, interview with Anne Parsons, AAA, 1967.
67 "I said to him": Leo Cohan, in Dull, "Willem de Kooning."
"There were just lots of Italians": De Kooning, AAA.
"Here in Greenwich Village": Sylvester, "Content Is a Glimpse."
He made some drawings: Tom Ferrara, multiple interviews with the authors from July 8, 1991, to Feb. 16, 1996.
"I didn't even ask": Sylvester, "Content Is a Glimpse."
"It turned out to be quite different": De Kooning, in Tromp, "Willem de Kooning."

Chapter 6

69 "Of course, New York is really like a Byzantine city": De Kooning, interview with David Sylvester, "Content Is a Glimpse," *Location* 1 (Spring 1963), 45–53.
"When I was hired": Anton Refregier, interview with Joseph Travato, AAA, Nov. 5, 1964, reel 3419.
Eastman Brothers: The description of Eastman Brothers comes from: 1922–23 New York City Directory; interview with Lewis (Lew) Jacobs, a casual friend of de Kooning's from the Eastman Brothers era, summer, 1991; interviews with Tully Filmus, who worked at East-man Brothers with de Kooning and spent a summer in Woodstock with him, Sept. 17 and Oct. 18, 1991; the AAA interview with Anton Refregier; and a WPA publicity handout on Refregier, November 7, 1941.
"Instead of making": Tully Filmus, interviews with the authors. Additional quotations from Tully Filmus in this chapter are from these interviews.
70 Refregier later said: Refregier, AAA.
"It used to be terrific": de Kooning in Martha Bourdrez, "Originality and Greatness in Painting," *The Knickerbocker*, May 1950.
The projects were often adventurous: One time, said Refregier, a flashy gangster named Larry Fay—whom James Cagney played in *The Roaring Twenties*—was killed in his speakeasy on Fifty-sixth Street in front of a mural that he, Refregier, had painted. Refregier, AAA.
71 "Looking back": Ibid.
"It was nice to be foreigners": Sylvester, "Content Is a Glimpse."
"He was more sociable": Lewis Jacobs, interview with the authors. Additional quotations in this chapter from Jacobs come from this interview.
For example, Refregier: WPA publicity handout.
72 One was Tully Filmus: Filmus, interviews with the authors.
Flamboyant, effusive, and intoxicated: Dore Ashton on David Burliuk in *The New York School: A Cultural Reckoning* (New York: Viking, 1972), 24.
73 Burliuk's circle included: Ibid. Also see Isamu Noguchi, interview with Paul Cummings, AAA, November 7 and December 26, 1973.
She was a tightrope or wire walker: Virginia (Nini) Diaz Halusic, interview with the authors, Feb. 3, 1994. Additional quotations in this chapter from Diaz come from this interview. All subsequent references for her are to Diaz, her maiden name.
75 A decade later: Conrad Marca-Relli, interview with the authors, May 1, 1991.
76 In 1927, he saw a show of Matisse's work: De Kooning, interview with Sally Yard, Aug. 14, 1976, for *Willem De Kooning: The First 26 Years in New York*, diss., Princeton University, 1980, 14,15. Later published by Garland Publishing (New York and London, 1986).
77 So limited was the New York art scene: Ilya Bolotowsky, interview with Ruth Gurin, AAA, 1963.
78 "The Armory Show was a complete disaster": Fairfield Porter, interview with Paul Cum-mings, AAA, June 6, 1968, reel 4211.
"The egg": Thomas B. Hess, *Willem de Kooning* (New York: George Braziller, 1959), 16.
79 In 1929, de Kooning had an unexpected vision: De Kooning, interview with Anne Parsons, AAA, 1967. See also Sally Yard, *Willem De Kooning*.
Not only did Hague: Raoul Hague, interview with the authors, December 7, 1992.

Notes

81 "I can't see myself as an academic": De Kooning, in "De Kooning's Year," *Newsweek*, Mar. 10, 1969.

"He always managed": Virginia (Nini) Diaz Halusic, interview with the authors, Feb. 3, 1994. Information in this chapter about their various apartments comes from Diaz.

His friends took advantage: Rudy Burckhardt, interviews with the authors, Mar. 29, 1990, and Oct. 9, 1991; Joseph Vogel, phone interview with the authors, Oct. 28, 1991.

81 As his Eastman work tapered off: De Kooning mentioned both of his design commissions in his official biography for the 1939 World's Fair. Library, Museum of Modern Art, New York.

According to Lew Jacobs: Lewis Jacobs, interview with the authors, summer 1991.

82 Tully Filmus, whom de Kooning showed around: Filmus, interviews with the authors, Sept. 17 and Oct. 18, 1991.

Sometime around the end of 1929: The A. S. Beck headquarters was at 139 Duane Street in lower Manhattan, a manufacturing area south of Houston Street celebrated for its cast-iron industrial buildings. Forty years later, it would become part of Tribeca, a highly fashionable artist's quarter. There were sixteen A. S. Beck stores spread out through the five boroughs of New York.

83 Jonas had grown up in Newark: All biographical information in this chapter concerning Robert Jonas, and much of the information about A. S. Beck, comes from three unpublished interviews with Jonas conducted by Judith Wolfe, the author of *The Young Willem de Kooning: Early Life, Training and Work, 1904–1926*, diss., City University of New York, 1996, and from interviews with Liesl Jonas, his wife, May 21 and Oct. 23, 1991. Interviews courtesy of Liesl Jonas.

"He came with a furious thrust": Jonas, interview with Judith Wolfe.

84 In the shop on Duane Street: Tom Ferrara, multiple interviews with the authors, July 8, 1991, to Feb. 16, 1996.

De Kooning's designs: Jonas, interviews with Judith Wolfe.

85 "Folks would put a sign": Leonard Bocour, interview with Paul Cummings, AAA, June 8, 1978.

De Kooning had gone: Ludwig Sander, interviews with Paul Cummings, AAA, Feb. 4 and 12, 1969.

86 (He would become a leading figure): In the forties, the work of Refregier became a political cause celebre after he won a nationwide competition to paint murals in a post office in Rincon, California, and then had his art attacked as subversive by local politicians and conservatives.

88 She had few regrets: Diaz believed it was worse to have children if you could not provide for them than to have an abortion. She herself had had a difficult childhood; her father, while charming, was irresponsible in providing for his four children. "I went through a life where I saw the torment of living without dollars," said Diaz. "They even had to give my brother away to a tumbling act." Diaz, interview with the authors.

The new apartment: Marie Marchowsky, interview with the authors, May 21, 1991.

89 One friend called it: Anonymous friend of de Kooning's girlfriend, Juliet Browner, interview with the authors, Jan. 7, 1992.

According to the artist Milton Resnick: Milton Resnick and Pat Passlof, interview with the authors, June 5, 1991.

But he was also obviously affected: Most information about the Depression comes from Page Smith, *Redeeming the Time: A People's History of the 1920s and the New Deal*, vol. 8 (New York: McGraw-Hill, 1991), 282–436.

90 De Kooning later told the art historian: De Kooning, interview with Sally Yard, Aug. 5, 1979, for *Willem de Kooning: The First 26 Years in New York*, diss., Princeton University, 1980, 19. Later published by Garland Publishing (New York and London, 1986).

The dancer Marie Marchowsky: Marchowsky, interview with the authors.

(An aspiring actress): Bea Reiner, interview with the authors, Nov. 1, 1991.

Marie was commuting: It was the beginning of a long friendship. In later years Marchowsky gave de Kooning a commission for the stage, a dance backdrop for Marie's own company. Her future husband, a businessman named Milton Robinson, would become one of de Kooning's first major collectors.

91 ("They had a wonderful subject"): Marchowsky, interview with the authors.

92 With this purchase: To buy the machine, said Tom Ferrara (interviews with the authors), de Kooning had to borrow against his future paychecks. He went to Jack Daniels, the president of A. S. Beck, for authorization to do so. Not only did he get the advance, which was an indication of how much he was valued as an employee, but Daniels also told de Kooning that he knew somebody who worked at the company that made the music systems and that he would be happy to approach him on de Kooning's behalf. De Kooning bought his Capehart at a special rate.

In a life in which it was: As Elaine de Kooning, his future wife, often said, "Never scrimp on the luxuries. The necessities will take care of themselves."

Chapter 8

93 "The atmosphere was so beautiful": De Kooning, "Letter to the Editor" [on Arshile Gorky], *ArtNews* 47 (January 1949), 6.

"I was lucky": De Kooning, interview with Harold Rosenberg, in Harold Rosenberg, *De Kooning* (New York: Abrams, 1974), 38.

De Kooning affectionately: De Kooning, in James T. Valliere, "De Kooning on Pollock," *Partisan Review* (Autumn 1967), 603–05.

94 De Kooning cherished: Tom Ferrara, multiple interviews with the authors, July 8, 1991, to Feb. 16, 1996.

In April 1929: De Kooning, interview with Sally Yard, Aug. 5, 1976, for *Willem de Kooning: The First 26 Years in New York*, diss., Princeton University, 1980, 5. Later published by Garland Publishing (New York and London, 1986).

Born in Kiev: Most of the biographical information on John Graham comes from Hayden Herrera, "John Graham's *System and Dialectics of Art*," unpublished course paper, Ph.D. program, City University of New York, May 1973; also interviews conducted by the authors with Graham friends Hedda Sterne, June 18, 1991, and Dorothy Dehner, Jan. 8, 1992. See also Dore Ashton, *The New York School: A Cultural Reckoning* (New York: Viking, 1973). An alternate version of some facts is set forth in Steven Naifeh and Gregory White Smith, *Jackson Pollock: An American Saga* (New York: Clarkson N. Potter) 1989.

95 During the revolution: Dehner, interview with the authors.

According to Ludwig Sander: Sander, interview with Herrera for "John Graham's *System*," 11.

Tall, with piercing eyes: Herrera, ibid.,8.

He enjoyed suggesting: John Graham, "Autoportrait," *Mulch*, Spring 1972, 1–3.

As he himself said: Graham, ibid.

96 David Smith later said: David Smith, in Marcia Epstein Allentuck, ed., *System and Dialectics of Art* (Baltimore: The Johns Hopkins Press, 1971), 15. Quoted in Herrera, "John Graham's *System*."

Graham was such a mesmerizing speaker: Eleanor Ward, interview with Hayden Herrera in "John Graham's *System*," 6.

"If the bookkeepers think": De Kooning, "Letter to the Editor."

97 According to de Kooning: De Kooning, *Time*, unpublished interview with Welch, background file entitled "An Analysis of Abstract Expressionism, its meaning, the major figures," July 20, 1958.

"[Gorky] always had the last word": De Kooning, interview with Karlen Mooradian, *Ararat: A Special Issue on Arshile Gorky* (Fall 1971), 49.

There are two versions: In an interview with Sally Yard on Aug. 5, 1979, included in Yard, *Willem de Kooning*, 5, de Kooning said he met Gorky in either 1930 or 1931. In the unpublished background interview for *Time*, he said 1929.

When de Kooning walked into the studio: De Kooning, "Letter to the Editor."

"He had this extraordinary": De Kooning, *Ararat*, 51.

98 Stuart Davis said: Davis, in Diane Waldman, *Arshile Gorky, A Retrospective*, exhibition catalog (New York: Harry Abrams, 1981), 23.

Ethel Schwabacher, a student and friend: Ibid, 37.

99 De Kooning said that when he "came to": De Kooning, "Letter to the Editor."

"He went out of his mind": De Kooning, *Ararat*, 50.

Max Schnitzler: Max Schnitzler, interview with Karlen Mooradian, *Ararat*, 53–54.

"He worked day and night": De Kooning, *Ararat*, 51.

Notes

100 Gorky was not much older: Most biographical information about Gorky comes from two recent biographies, Hayden Herrera, *Arshile Gorky: His Life and Work* (New York: Farrar, Straus & Giroux, 2003), and Matthew Spender, *From a High Place: A Life of Arshile Gorky* (New York: Knopf, 1999), or from *Ararat: A Special Issue on Arshile Gorky*. Gorky's actual birthdate was probably closer to 1900, not 1904 as he claimed.

The persecution was so fierce: Henry Morgenthau, quoted in Yuri Babayan, "Armenian History," www.armenianhistory.info.

101 "You find a fellow": De Kooning, *Ararat*, 49.

"There was no doubt": Ibid, 50.

"I kind of gave in": De Kooning, *Time*, unpublished interview.

"I had some training in Holland": De Kooning, interview with David Sylvester, "Content Is a Glimpse," *Location* 1 (Spring 1963).

102 Isamu Noguchi said: Isamu Noguchi, interview with Paul Cummings, AAA, Nov. 7, 1973.

"If he looked at something": Reuben Nakian, *Ararat*, 52.

On one occasion: Joseph Solman, interviews with the authors, May 8, 1991, and June 2, 1991.

"We both worked": George McNeil, interview with Irving Sandler, AAA, Jan. 9, 1968.

103 "Aha, so you have ideas": De Kooning, interview with Harold Rosenberg, in Rosenberg, *Arshile Gorky: The Man, the Time, the Idea* (New York: Horizon, 1962), 54–56.

According to Harold Rosenberg: Ibid., 66–67.

104 (De Kooning later said): De Kooning, interview with Sally Yard, in Yard, *Willem De Kooning*, 14.

The artist Ludwig Sander: Ludwig Sander, interview with Herrera, in "John Graham's System," 121.

"Being with Gorky": Reuben Nakian, *Ararat*, 52.

The sculptor Herzl Emanuel: Herzl Emanuel, interviews with the authors, Feb. 25 and Oct. 22, 1992.

105 However, according to both Hess and Rosenberg: Rosenberg, *Arshile Gorky*, 68.

One time, the two were walking together: Karel Appel, interview with the authors, Mar. 6, 1990.

So did de Kooning: Edwin Denby, *Willem de Kooning* (Madras and New York: Hanuman Books, 1988), 25, 46.

106 Peter Agostini, one of the original: Peter Agostini, interview with Colette Roberts, AAA, 1968.

In addition to Graham: Noguchi, AAA.

That, de Kooning later said: De Kooning, *Time*, unpublished background interview.

According to David Smith: David Smith, quoted in Patricia Passlof, ed., *The 30s: Painting in New York*, exhibition catalog (New York: Poindexter Gallery, 1957), 17.

"It was a real Villagey place": Milton Resnick and Pat Passlof, interview with the authors, June 5, 1991.

"Romany Marie was": Dorothy Dehner, interview with the authors.

107 According to Noguchi: Noguchi, AAA.

When they were in: Sterne, interview with the authors.

For de Kooning as for his "brother": Rosenberg, *Arshile Gorky*, 65.

108 De Chirico's paintings: Much information on these early discussions comes from Herrera, "John Graham's *System*," and also Solman, interviews with the authors.

According to Conrad Marca-Relli: Conrad Marca-Relli, interview with Dorothy Seckler, AAA, June 10, 1965.

De Kooning told friends: Rudy Burckhardt, "Long Ago with Willem de Kooning," in "Willem de Kooning, on His Eighty-Fifth Birthday," *Art Journal* (Fall 1989), 223.

Graham took the unknowable: Marcia Epstein Allentuck, *System and Dialectics*, p. 71.

As Robert Jonas said: Jonas, unpublished interviews with Judith Wolfe, the author of *The Young Willem de Kooning: Early Life, Training and Work, 1904–1926*, diss., City University of New York, 1996. Interviews courtesy of Liesl Jonas.

109 "They weren't dead": Sylvester, "Content Is a Glimpse."

Chapter 9

110 "Art is the thing you cannot make": De Kooning, "Prisoner of the Seraglio," *Time*, Feb. 26, 1965.

110 The parade began at the tip: Page Smith, *Redeeming the Time: A People's History of the 1920s and the New Deal*, vol. 8 (New York: McGraw-Hill, 1991), 602.

By 1933: Jack Tworkov, interview with Dorothy Seckler, AAA, Aug. 17, 1962.

Malcolm Cowley described the ethos: Malcolm Cowley, *Exile's Return* (New York: Viking, 1934), 60.

111 "All the artists were communists": Dorothy Dehner, interview with the authors, Jan. 8, 1992.

According to Isamu Noguchi: Noguchi, interview with Paul Cummings, AAA, Nov. 7, 1973.

"Like they say": Peter Agostini, interview with Colette Roberts, AAA, 1968.

The writer Alfred Kazin: Alfred Kazin, *Starting Out in the Thirties* (Boston: Little, Brown, 1962), 32–33.

112 By the mid-thirties: Much information on the WPA and the organizing of artists comes from Audrey McMahon, "A General View of the Federal Art Project of the Works Progress Administration," in *New York City WPA Art*, exhibition catalog (New York: Parsons School of Design, 1977). See also Page Smith, *Redeeming the Time*, and Dore Ashton, *The New York School: A Cultural Reckoning* (New York: Viking, 1973).

"This was the real beginning": Burgoyne Diller, interview with Harlan Phillips, AAA, Oct. 2, 1964.

The headquarters was on Sixth Avenue: Joseph Solman, interviews with the authors, May 8 and June 2, 1991.

According to the sculptor: Herzl Emanuel, interviews with the authors, Feb. 5 and Oct. 22, 1992.

"A lot of us wanted a base": Solman, interview with the authors.

For a while, Stuart Davis: Dore Ashton, *The New York School*, 63.

113 "It was Gorky's idea": Robert Jonas, unpublished interviews with Judith Wolfe, author of *The Young Willem de Kooning: Early Life, Training and Work, 1904–1926*, diss., City University of New York, 1996. Interviews courtesy of Liesl Jonas.

De Kooning loved to tell: Ashton, *The New York School*, 68.

"The place was a madhouse": Anonymous friend of Juliet Browner, de Kooning's second girlfriend, interview with the authors, Jan. 7, 1992.

114 The oldest of seven children: Much of the biographical material on Juliet Browner is taken from Judith Young Mallin, "Remembering the Faces of Juliet," *Quest* (Summer 1991), 46–51.

"She was so pretty": Anonymous interview with the authors.

115 "I was so moved": Juliet Man Ray, *Quest*.

"Bill was rather delicate then": Anonymous interview with the authors.

"When you saw Bill": Solman, interview with the authors.

116 According to Bea Reiner: Reiner, interview with authors, Nov. 1, 1991.

"I do know that Bill": Rudy Burckhardt, interviews with the authors, Mar. 29, 1990, and Oct. 9, 1991.

"Oh, the things that went on": Tully Filmus, interviews with the authors, Sept. 17 and Oct. 18, 1991.

117 Nini returned to New York: Virginia (Nini) Diaz Halusic, interview with the authors, Feb. 3, 1994. All the details of the breakup of de Kooning's relationship with Diaz were supplied by her.

Before their departure: Joan Ward, multiple interviews with the authors, Aug. 12, 1991, to April 17, 2004.

118 He moved into temporary quarters: De Kooning's temporary address was written on a letter that Juliet Man Ray sent to him that summer from Woodstock. Courtesy of Roger Anthony, The Willem de Kooning Foundation, New York.

Very different from: The description of Chelsea comes in large part from Robert Boral, *Turn West on 23rd: A Toast to New York's Old Chelsea* (New York: Fleet, 1965).

119 He could not stand: Burckhardt, interviews with the authors. Many of the personal details of de Kooning's life first on Twenty-first Street and then Twenty-second come from Burckhardt.

121 "He doesn't commit himself": Robert Jonas to Judith Wolfe, unpublished interview.

"They were shouting": May Rosenberg, cited in Steven Naifeh and Gregory White Smith, *Jackson Pollock: An American Saga* (New York: Clarkson N. Potter, 1989), 268.

122 "The decision to take was": de Kooning in David Sylvester, "Content Is a Glimpse," *Location* 1 (Spring 1963), 45–53.

Notes

122 "Then," de Kooning realized: Incident recollected on several occasions by Elaine de Kooning and Rudy Burckhardt.

Chapter 10

123 "I was reading Kierkegaard": De Kooning, in Thomas B. Hess, "De Kooning: Recent Paintings," M. Knoedler & Co., Inc., 1967, 9.
"For the overwhelming majority": Page Smith, *Redeeming the Time: A People's History of the 1920s and the New Deal*, vol. 8 (New York: McGraw-Hill, 1991), 789–813.
Given this degree of enmity: Ibid.

124 "I think these things": Ibid.
In New York, it was headed: Audrey McMahon, "A General View of the Federal Arts Project of the Works Progress Administration," in *New York City WPA Art*, exhibition catalog (New York: Parsons School of Design, 1977). *See also* Dore Ashton, *The New York School: A Cultural Reckoning* (New York: Viking, 1973) for details of the Arts Project in New York.
"I can't begin": Leonard Bocour, interviews with the authors, Nov. 30 and Dec. 11, 1992.
If, along the way: Joseph Solman, interviews with the authors, May 8 and June 2, 1991.
"The modern artists were suffered": George McNeil, interview with Irving Sandler, AAA, Jan. 9, 1968.

125 The first thing Diller did: Burgoyne Diller, interview with Harlan Phillips, AAA, Oct. 2, 1964. Diller's recollections of the WPA mural program, including the Léger project, are taken from this interview.
Diller's division: Gorky was also in the mural division, although not on the Williamsburg project. He designed a series of murals entitled *Aviation: Evolution of Forms Under Aerodynamic Limitations* that were eventually installed at Newark airport.
Although de Kooning began: De Kooning, interview with Anne Parsons, AAA, 1967.
"They were rather special": Ilya Bolotowsky, interviews with Paul Cummings, Mar. 24 and April 7, 1968, AAA.

127 ("I didn't realize at first"): De Kooning, AAA.
According to de Kooning: De Kooning, interview with Irving Sandler, "Conversations with de Kooning," in "Willem de Kooning, on His Eighty-Fifth Birthday," *Art Journal* (Fall 1989), 216–17.
"He looked like a longshoreman": Ibid.
"Léger became a human being": De Kooning, AAA.
Next, he dispatched his helpers: Sandler, "Conversations with de Kooning," 216.

128 "He worked like a sign painter": Ibid.
He also possessed: Ibid.
For several months: De Kooning, AAA.

129 According to de Kooning, "He would look": Sandler, "Conversations with de Kooning," 216.
According to de Kooning, "The project was so good": De Kooning, AAA.

130 "You know, everybody was really aware": Fritz Bultman, interview with Irving Sandler, AAA, Jan. 6, 1968.
He was never happier: Hofmann's school occupied four different locations in New York—the last on Eighth Street.
The first was a respect: Ashton, *The New York School*, 79–84.

131 According to the painter Larry Rivers: Larry Rivers, in Ashton, *The New York School*, 80.

Chapter 11

132 "If the picture has a countenance": De Kooning, in Robert Goodnough, ed., "Artists' Sessions at Studio 35" [1950]. In *Modern Artists in America*, ed. Robert Motherwell and Ad Reinhardt (New York, 1951), 9–69.
In 1937, Congress, led by Texas conservative: Page Smith, *Redeeming the Time: A People's History of the 1920s and the New Deal*, vol. 8 (New York: McGraw-Hill, 1991), 692–93, 812.
De Kooning never forgot: De Kooning, interview with Anne Parsons, AAA, 1967.
"That was a turning point": Rudy Burckhardt, interviews with the authors, Mar. 29, 1990, and Oct. 9, 1991.
"He did have sympathy": Robert Jonas, unpublished interviews with Judith Wolfe, author of *The Young Willem de Kooning: Early Life, Training and Work, 1904–1926*, diss., City University of New York, 1996. Interviews courtesy of Liesl Jonas.

133 "We divorced politics": De Kooning, interview with David Sylvester, "Content Is a Glimpse," *Location* 1 (Spring 1963), 45–53.

The artist Barnett Newman: Barnett Newman, quoted in Dore Ashton, *The New York School: A Cultural Reckoning* (New York: Viking, 1973), 73. Originally published in *Foreword to Igor Kropotkin: Memoirs of a Revolutionist* (New York: Horizon, 1968).

"They were always greeting": De Kooning, AAA.

"I remember him once saying": Burckhardt, interviews with the authors.

Denby remembered de Kooning struggling hard: Edwin Denby, *Willem de Kooning* (Madras and New York: Hanuman, 1988), 23.

On one occasion, when giving a talk: de Kooning assistant Tom Ferrara recalled de Kooning discussing this talk. Tom Ferrara, multiple interviews with the authors, July 8, 1991, to Feb. 16, 1996.

"Gorky told us that the whole idea was silly": Ilya Bolotowsky, interviews with Paul Cummings, AAA, March 24 and Apr. 7, 1968.

"De Kooning always wore someone else's overcoat": Joseph Solman, interviews with the authors, May 8 and June 2, 1991.

135 Gorky said of the years after the WPA: Gorky, quoted in Patricia Passlof, ed., *The 30s: Painting in New York*, exhibition catalog (New York: Poindexter Gallery, 1957).

"I took my trousers": De Kooning, in Sally Yard, "Willem de Kooning's Men," *Arts Magazine* (December 1981), 137.

136 He described the drawing: Ken Wilkie, "Willem de Kooning: Portrait of a Modern Master," *Holland Herald* 17 (March 1982), 22–34.

"He cut the Gordian knot": De Kooning, *Time*, unpublished interview with Welch, "An analysis of Abstract Expressionism, its meaning, the major figures," background file, July 20, 1958.

137 "Those shapes": Solman, interviews with the authors.

138 And, not surprisingly, de Kooning singled out: Elaine de Kooning, interview with Sally Yard on Aug. 5, 1979, for *Willem De Kooning: The First 26 Years in New York*, diss., Princeton University, 1980, 14.

139 "Everything is already in art": De Kooning, *Sketchbook No. 1: Three Americans, Willem de Kooning, Buckminster Fuller, Igor Stravinsky*, a film produced and directed by Robert Snyder (1960).

If de Kooning wanted: Interview with Harold Rosenberg, in Harold Rosenberg, *Willem de Kooning* (New York: Abrams, 1974), 47–49.

In the late thirties: Elaine de Kooning to Sally Yard, *Willem de Kooning*, 208.

The essential paradox: Denby, *Willem de Kooning*, 50.

140 According to Rudy Burckhardt: Burckhardt, interviews with the authors.

He tried to keep: Ferrara, interviews with the authors.

"No doctrine or style": Denby, *Willem de Kooning*, 49–50.

141 Or, as Denby observed: Ibid., 22.

"I destroyed almost all those paintings": De Kooning, interview with Selden Rodman, *Conversations with Artists* (New York: Capricorn, 1957), 103.

"No, no, no": Burckhardt, interview with the authors.

Denby said: "I can hear his light, tense voice": Denby, *Willem de Kooning*, 18.

142 An arm looks ridiculous: Jonas, interviews with Wolfe.

The artist Milton Resnick: Milton Resnick and Pat Passlof, interview with the authors, June 5, 1991.

"He said vehemently that it made him sick": Denby, *Willem de Kooning*, 25.

Chapter 12

144 "Work as though": De Kooning, in Elaine de Kooning, *The Spirit of Abstract Expressionism: Selected Writings* (New York: George Braziller, 1994), 226.

De Kooning first met them: Many recollections of Chelsea, in addition to specific references to de Kooning, can be found in Edwin Denby, *Willem de Kooning* (Madras and New York: Hanuman, 1988). Another source is Rudy Burckhardt's "Long Ago with Willem de Kooning," in "Willem de Kooning, on His Eighty-Fifth Birthday," *Art Journal* (Fall 1989), 222–25. Also, Rudy Burckhardt, interviews with the authors, Mar. 29, 1990, and Oct. 9, 1991.

145 "I think maybe this fellow": Max Margulis, interviews with the authors, Mar. 8 and Apr. 30, 1991.

Notes

146 "It was very spare": Joseph Solman, interviews with the authors, May 8 and June 2, 1991.
147 His life followed a fairly predictable: Burckhardt and Solman, interviews with the authors; Marjorie Luyckx, interview with the authors, June 14, 1994; Conrad Fried, interviews with the authors, May 31 and June 1, 1995.
 "And so, one night": De Kooning, in Joseph Liss, "Willem de Kooning Remembers Mark Rothko," *ArtNews* (January 1979), 41–44.
148 According to Herzl Emanuel: Emanuel, interviews with the authors, Feb. 25 and oct. 22, 1992.
149 "There's a dimension that we don't understand": Milton Resnick and Pat Passlof, interview with the authors, June 5, 1991.
 "There wasn't this terrible eagerness": Ibram Lassaw, interviews with the authors, May 23, 1990, July 2, 1991, and July 9, 1991.
 Earlier in the thirties: All of the material on Michael Loew comes from Mildred Loew, interview with the authors, July 17, 1991.
150 "He accepted my work": De Kooning, interview with Anne Parsons, AAA, 1967.
151 Altogether, more than three hundred buildings: Publicity handout from the World's Fair, Library, Museum of Modern Art.
 The general subject was "Production": Ibid.
 Years later, Juliet described how he worked: Juliet Browner, unpublished interview for *Willem de Kooning*, essays by Robert Rosenblum, Yves Michaud, Louis Marin, Thomas B. Hess, and Claire Stoullig, exhibition catalog (Paris: Centre Georges Pompidou, Musée national d'art moderne, 1984). All subsequent reference to the Centre Georges Pompidou catalog will be in abbreviated form.
152 Nini Diaz, for one: Virginia (Nini) Diaz Halusic, interview with the authors, Feb. 3, 1994. Also Burckhardt, interviews with the authors.
153 "He resented any hold": Joan Ward, multiple interviews with the authors, Aug. 12, 1991 to April 17, 2004.
 Around the summer of 1938: Anonymous friend of Juliet's, interview with the authors, Jan. 7, 1992.
 In 1940: Judith Young Mallin, "Remembering the Faces of Juliet," *Quest* (Summer 1991), 46–51.
 Elaine de Kooning once commented: Elaine de Kooning, in Lee Hall, *Elaine and Bill: Portrait of a Marriage* (New York: HarperCollins, 1993), 20.
 "These women": Burckhardt, interviews with the authors.

Chapter 13

154 "She had such beautiful hair": De Kooning, quoted by Joop Sanders, multiple interviews with the authors, Oct. 31, 1990, to Mar. 13, 1993.
 In the late fall of 1938: Interview with Bert Schierbeek, in *Willem de Kooning*, exhibition catalog (Amsterdam: Stedelijk Museum, 1968).
 Two years before: Marjorie Luyckx, interview with the authors, June 14, 1994.
 "Even before Elaine": Ernestine Lassaw, interview with the authors, Aug. 8, 1991.
155 "Bill is going to be": Luyckx, interview with the authors.
 "She once told me": Hedda Sterne, interview with the authors, June 18, 1991.
 According to the artist Janice Biala: Janice Biala, interview with the authors, July 27, 1992.
 The German photographer: Ellen Auerbach, interview with the authors, Apr. 15, 1998.
156 Elaine Marie Fried: Most information on Elaine's childhood and the Fried family comes from her sister, Marjorie Luyckx, interview with the authors, and her brother, Conrad Fried, interviews with the authors, May 31 and June 1, 1995.
 The artist Joop Sanders, who met de Kooning: Sanders, multiple interviews with the authors.
 According to the painter Jane Freilicher: Jane Freilicher and Joe Hazan, interview with the authors, June 19, 1991.
 "Behind every artist": Elaine de Kooning, in Lee Hall, *Elaine and Bill: Portrait of a Marriage* (New York: HarperCollins, 1993), 22.
158 "When I was five": Ibid., 23.
159 In 1932, Elaine entered the local Erasmus Hall: Notes from the Erasmus High yearbook and history of the school.

159 (The founders, a family called the Piccirilli): Peter Agostini, interview with Colette Roberts, AAA, 1968.

160 One of Elaine's teachers: Conrad Marca-Relli, interview with the authors, May 1, 1991.

According to Jonas: Robert Jonas, unpublished interviews with Judith Wolfe, author of *The Young Willem de Kooning: Early Life, Training and Work, 1904–1926*, diss., City University of New York, 1996. Interviews courtesy of Liesl Jonas.

It was at one such meeting: Geoffrey Dorfman, ed., *Out of the Picture: Milton Resnick and the New York School* (New York: Midmarch Arts Press, 2002) ,14–15.

161 "There were times I thought": Milton Resnick and Pat Passlof, interview with the authors, June 5, 1991.

162 "Bill was incredibly in love": Rudy Burckhardt, interviews with the authors, Mar. 29, 1990, and Oct. 8, 1991.

163 As Elaine herself put it: Elaine de Kooning, in Hall, *Elaine and Bill*, 26.

Soon after: According to Pat Passlof, however, Elaine also continued seeing Resnick for quite some time. Passlof, interview with the authors, July 18, 1990.

164 On a typical afternoon: Raoul Hauge, interview with the authors, Dec. 7, 1992.

She later told the art writer Lee Hall: Elaine de Kooning, in Hall, *Elaine and Bill*, 63.

At first called: Dore Ashton, *The New York School: A Cultural Reckoning* (New York: Viking, 1973), 109–13.

165 Gorky, however, was more deeply affected: Ibid., 113.

During one trip: De Kooning, interview with Sally Yard, Oct. 14, 1976, in *Willem de Kooning: The First 26 Years in New York*, diss., Princeton University, 1980. Later published by Garland Publishing (New York and London, 1986). Unpublished interview on file at The Willem de Kooning Foundation, New York.

166 He had been painting: Information on the opening of the World's Fair is from *Chronicle of the Twentieth Century* (Mount Kisco, New York: Chronicle, 1987), 492.

Chapter 14

168 "The group instinct": De Kooning, "What Abstract Art Means to Me," *Museum of Modern Art Bulletin* 18 (Spring 1951), 4–8.

Suddenly, as the art critic: Harold Rosenberg, in Dore Ashton, *The New York School: A Cultural Reckoning* (New York: Viking, 1973), 113.

Now, according to the painter: George McNeil, interview with Irving Sandler, AAA, Jan. 9, 1968.

On May 14 they firebombed Rotterdam: Information on Rotterdam and World War II comes primarily from C. L. Sulzberger, *New History of World War II*, updated by Stephen Ambrose (New York: Viking, 1997).

Rotterdammers said the scorched ground was still warm: Monique and Jan Gidding, interview with the authors, Feb. 6, 1991.

By 1940, the WPA: The Works Progress Administration officially ended in January 1943.

169 Years later, the artist Adolph Gottlieb: Adolph Gottlieb, in "Pollock Symposium," *Art-News* (April 1967), cited in Ashton, *New York School*, 118.

It was not the art itself: Information on Peggy Guggenheim and Art of This Century comes primarily from Karole P. B. Vail, *Peggy Guggenheim: A Celebration*, published in conjunction with an exhibition of the same name (New York: Solomon R. Guggenheim Museum, 1999), and Steven Naifeh and Gregory White Smith, *Jackson Pollock: An American Saga* (New York: Clarkson N. Potter, 1989).

170 When not at this "headquarters of surrealism": Naifeh and Smith, *Jackson Pollock*, 438.

171 As Levy, whose own shows: Ibid, 439.

The other Americans included: Ibid. p. 424–25.

A young intellectual: Much of the information on Motherwell comes from Stephanie Terenzio, ed., *The Collected Writings of Robert Motherwell* (Oxford: Oxford University Press, 1992).

172 (De Kooning once noticed): A favorite, frequently told story of de Kooning's. See Edwin Denby, *Willem de Kooning* (Madras and New York: Hanuman, 1988), 54.

At one party: De Kooning, interview with Anne Parsons, AAA, 1967.

"Matta burst on the New York scene": Julien Levy, *Memoir of an Art Gallery* (New York: Putnam's, 1977), 247.

Notes

172 "Gorky had surrealism": Robert Jonas, interview with Karlen Mooradian, *Ararat: A Special Issue on Arshile Gorky* (Fall 1971), 48.

173 When Matta arrived in 1939: Hayden Herrera, *Arshile Gorky: His Life and Work* (New York: Farrar, Straus & Giroux, 2003), 383–86.

174 "Their being here was overpowering": Ethel Baziotes, in Naifeh and Smith, *Jackson Pollock*, 418.

175 As George McNeil put it: George McNeil, AAA.

176 On one occasion: De Kooning to Lionel Abel, in Naifeh and Smith, *Jackson Pollock*, 420.
"With rationing and food stamps": Elaine de Kooning, in John Gruen, *The Party's Over Now* (New York: Viking, 1967), 213.
Elaine, however, said de Kooning was deferred: Ibid.
"We were jumping": Conrad Fried, interview with the authors, May 31 and June 1, 1995.

177 Like many ambitious American writers: Information on Biala comes from Stephanie Cash and David Ebony, Janice Biala obituary, *Art in America*, Dec. 2000. Also Joop Sanders, multiple interviews with the authors, Oct. 31, 1990, to Mar. 13, 1993.
De Kooning didn't seem to be painting much: Jack Tworkov, interview with Dorothy Seckler, AAA, Aug. 17, 1962.
"The people who bought paintings": Elaine de Kooning, in *The Party's Over Now*, 215.
"We had very little": Ellen Auerbach, interview with the authors, Apr. 15, 1998.

178 "Edwin and I would help him out": Rudy Burckhart, "Long Ago with Willem de Kooning," in "Willem de Kooning, on His Eighty-Fifth Birthday," *Art Journal* (Fall 1989), 222–25.
One time, when money was especially tight: Fried, interviews with the authors.
"If you never liked it": Peter and Florence Grippe, interview with the authors, July 20, 1992.
De Kooning asked him to pose: Rudy Burckhardt, background interview for *Willem de Kooning*, exhibition catalog (Paris: Centre Georges Pompidou, Musée national d'art moderne, 1984).
"In those early years": Elaine de Kooning in Gruen, *The Party's Over Now*, 209.

179 "I remember once going in": Auerbach, interview with the authors.
"Commercial success": Joop Sanders, multiple interviews with the authors, Oct. 31, 1990, to Mar. 13, 1993.

180 "Offers of commercial art": Conrad Marca-Relli, interview with the authors, June 1, 1991.
Each girl had a distinctive hairstyle: The illustrations are reproduced in *Willem de Kooning*, exhibition catalog, Centre Georges Pompidou.
"He said that if he kept this up": Burckhardt, "Long Ago with Willem de Kooning," 223.
While many contemporaries admired the drawing: Sanders, interviews with the authors.
(Largely on the basis): Milton Resnick and Pat Passlof, interview with the authors, June 5, 1991.

181 Elaine also decided to try fashion modeling: Elaine de Kooning, in *The Party's Over Now*, 209.
In the early forties: Fried, interviews with the authors.

184 When Edwin Denby dropped by: Ibid.
In 1944, Container announced an open competition: Dore Ashton, *The New York School*, 146.

185 They were later employed by de Kooning: Fried, interviews with the authors.

Chapter 15

187 "Even abstract shapes": De Kooning, in Thomas B. Hess, *Willem de Kooning* (New York: Museum of Modern Art, 1968), 47.
"The space between the figures": Edwin Denby, "Notes on Nijinsky Photographs," *Dance Index* (March 1943). Revised and included in *Dance Writings*, ed. Robert Crawford and Willam MacKay (New York: Knopf, 1986).
"It is interesting": Ibid.

189 "She moved in with Bill": Ernestine Lassaw, interview with the authors, Aug. 8, 1991.
According to Rudy: Rudy Burckhardt, interviews with the authors, Mar. 29, 1990, and Oct. 9, 1991.
"I just thought he was great": Elaine de Kooning, in John Gruen, *The Party's Over Now* (New York: Viking, 1967), 209.

189 "Bill and Elaine were very sharp": Joop Sanders, multiple interviews with the authors, Oct. 31, 1990, to Mar. 13, 1993.
"It was well-known": Dore Ashton, *The New York School: A Cultural Reckoning* (New York: Viking, 1973), 166.
"In painting, Bill was one of the few": Conrad Marca-Relli, interview with the authors, May 1, 1991.
"Gorky would come with his dogs": Philip Pavia, in Gruen, *The Party's Over Now*, 266.

190 "I mean, if I told you the remarks": Fairfield Porter, interview with Paul Cummings, AAA, June 6, 1968.

191 "He had this absolute genius": Hedda Sterne, interview with the authors, June 18, 1991.
American artists began to congregate: Information on the Waldorf Cafeteria comes from a number of AAA interviews, including de Kooning, interview with Anne Parsons, AAA, 1967, and Philip Pavia, interview with Bruce Hooten, AAA, Jan. 19, 1965. Also Philip Pavia, interview with the authors, Apr. 9, 1990, and interview with Gruen, *The Party's Over Now*.

192 "You could drop in any time": Elaine de Kooning, in Gruen, *The Party's Over Now*, 213.
"We'd all sit around": Philip Pavia, in Gruen, *The Party's Over Now*, 267.
Parties were frequent: Marjorie Luyckx, interview with the authors, June 14, 1994.

193 According to Elaine, artists served: Elaine de Kooning, in Gruen, *The Party's Over Now*, 214, 215.
(It was at one such gathering): Sanders, interviews with the authors.
"I remember him saying": Merce Cunningham, interview with the authors, Apr. 30, 1998.
The next six months: Edwin Denby, *Willem de Kooning* (Madras and New York: Hanuman, 1988), 11.
Before, recalled Conrad Fried: Fried, interviews with the authors, May 31 and June 1, 1995.
Although it had taken them: Elaine de Kooning, in Gruen, *The Party's Over Now*, 298.

194 Whatever his reservations: Fried, interviews with the authors.

195 According to the previous tenant: Alexia Johnson, phone interview with the authors, Sept. 14, 1991.

196 In contrast to the preparations: Elaine de Kooning, in Gruen, *The Party's Over Now*, 209.

197 "Actually, the wedding was kind of bleak": Ibid.
Typically, the couple rose late: Luyckx, interview with the authors. Much information on the daily routine of Elaine and de Kooning comes from Marjorie Luyckx and Conrad Fried.

Chapter 16

203 "I'm not poor. I'm broke": Conrad Fried, interviews with the authors, May 31 and June 1, 1995.
While he was readying the loft: Much of the information in this chapter on Peggy Guggenheim comes from Steven Naifeh and Gregory White Smith, *Jackson Pollock: An American Saga* (New York: Clarkson N. Potter, 1989), and Karole P. B. Vail, *Peggy Guggenheim: A Celebration*, published in conjunction with an exhibition of that name (New York: Solomon R. Guggenheim Museum, 1998).

204 Putzel actually did everything he could: Sally Yard, *Willem de Kooning: The First 26 Years in New York*, diss., Princeton University, 1980, 84. Later published by Garland Publishing (New York and London, 1986).
"I'm so hung over": Peggy Guggenheim, in Rudy Burckhardt, "Long Ago with Willem de Kooning," in "Willem de Kooning, on His Eighty-Fifth Birthday," *Art Journal* (Fall 1989), 224.
"That show was the first big melting pot": Philip Pavia, in John Gruen, *The Party's Over Now* (New York: Viking, 1967), 267.
The show was important: Naifeh and Smith, *Jackson Pollock*, 445–46.

205 Graham considered Pollock "a kind of bumpkin": Ibid., 347.
"Graham was very important": De Kooning, interview with James Valliere, "De Kooning on Pollock," *Partisan Review* (Autumn 1967), 603–05.
Pollock's second break: Reuben Kadish had known Putzel in Los Angeles, where he was also a friend (and briefly painted with) Pollock's older brother, Sande.

206 Among the artists on display: Robert Coates, review, *The New Yorker*, May 29, 1943.
As he later wrote: Naifeh and Smith, *Jackson Pollock*, 446.

Notes

206 In the announcement of the show: Ibid., 462.

In the brief introduction: Ibid., 462–63.

207 Robert Coates reaffirmed: Robert Coates, review, *The New Yorker*, Nov. 20, 1943.

A talented mosaicist: Joop Sanders, interviews with the authors, Oct. 31, 1990, to Mar. 13, 1993.

"Jackson Pollock's one-man show": Clement Greenberg, "Marc Chagall, Lyonel Feininger, Jackson Pollock," *The Nation*, Nov. 27, 1943.

208 The *ArtNews* reviewer: Naifeh and Smith, *Jackson Pollock*, 466.

Milton Resnick put it: Milton Resnick and Pat Passlof, interview with the authors, June 6, 1991.

Of the latter: David Porter, interviews with the authors, July 15 and Aug. 1, 1991.

209 Rubenstein bought *Elegy:* De Kooning recalled getting only $200 for the painting. (De Kooning, interview with George Dickerson, Thomas B. Hess papers, AAA).

"Pollock was the leader": De Kooning, in Jan Bart Klaster, "De Kooning gaat door ik schilder mijn binnenste," *Het Parool*, May 11, 1983.

Noguchi said, "That was for him arriving": Isamu Noguchi, interview with Paul Cummings, AAA, Nov. 7, 1973.

210 "He was going up the ladder": Conrad Fried, interviews with the authors.

In one brilliantly two-edged compliment: Robert Jonas, unpublished interviews with Judith Wolfe, author of *The Young Willem de Kooning: Early Life, Training and Work, 1904–1926*, diss., City University of New York, 1996. Interviews courtesy of Liesl Jonas.

Agnes had been introduced: Much information on Agnes Magruder comes from Hayden Herrera, *Arshile Gorky: His Life and Work* (New York: Farrar, Straus & Giroux, 2003).

211 "I can remember Agnes": V. V. Rankine, interview with the authors, Aug. 13, 1991.

She had begun to paint: Marjorie Luyckx, interview with the authors, June 14, 1994.

"In the mid-forties": Edwin Denby, *Willem de Kooning* (Madras and New York: Hanuman, 1988), 13–14.

"That devastating poverty": Elaine de Kooning, quoted in *Willem de Kooning: Paintings*, exhibition catalog (Washington: National Gallery of Art, 1994), 77.

De Kooning couldn't afford to pay for electricity: De Kooning, in Ken Wilkie, "Willem de Kooning: Portrait of a Modern Master," *Holland Herald* 17 (March 1982), 22–34.

212 According to Lutz Sander: Sander, interviews with Paul Cummings, AAA, Feb. 4 and 12, 1969.

He loved to announce: Fried, interviews with the authors.

De Kooning always publicly acknowledged: The same did not hold true for Gorky, although de Kooning helped him technically. See *Willem de Kooning: Paintings*, National Gallery of Art, 102.

213 "I hate to say this": Elaine de Kooning, in Gruen, *The Party's Over Now*, 209.

"Bill said my pace": Ibid.

Not long before the wedding: Janice Biala, interview with the authors, July 27, 1992.

A friend of Edwin Denby's: The information on Elaine's trip with Bill Hardy comes primarily from author interviews with Ernestine Lassaw, Aug. 8, 1991; Ibram Lassaw, interviews of May 23, 1990, and July 2 and 9, 1991; Sanders; and Luyckx.

214 Although Elaine always insisted: Ibram Lassaw, interviews with the authors.

No sooner did Elaine return: In her interview with John Gruen in *The Party's Over Now*, Elaine de Kooning erroneously recalled the date of the move from Twenty-second Street to Carmine Street as the summer of 1948, after they had returned from Black Mountain, where de Kooning taught in the summer session. At that point, according to Elaine, she went up to Provincetown; when she returned to New York, they were forced to leave their loft on Twenty-second Street. In fact, she and de Kooning did not go up to Provincetown in 1948, but in 1949. And they had lost the Twenty-second Street loft years before, in the winter of 1944–1945, when she also went to Provincetown and he visited her there. She had confused the two different Provincetown trips in her mind. Her brother, Conrad Fried, recalled the actual move as close to December 1944 or early in 1945. A series of photographs taken of de Kooning in 1946 by the photographer Harry Bowden show him already established in his Fourth Avenue studio.

"We could have fought it": Elaine de Kooning, in Gruen, *The Party's Over Now*, 211.

According to Resnick: Resnick and Passlof, interview with the authors.

In every other respect: Much information on the Carmine Street apartment and Elaine and de Kooning's life there comes from Fried, interviews with the authors.

216 One of the last to solicit one: Diana Kurz, interview with the authors, Sept. 23, 1997.
Another time, when de Kooning and his friends were partying: Anonymous friend of the
Fried family, interview with the authors, June 18, 1993.

Chapter 17

217 "Of all movements": De Kooning, "What Abstract Art Means to Me," *Museum of Modern Art Bulletin* 18 (Spring 1951), 4–8.
"It's hard to describe": Philip Pavia, first three sentences, interview with Bruce Hooten, AAA, Jan. 19, 1965; following sentences, Pavia in John Gruen, *The Party's Over Now* (New York: Viking Press, 1967), 268.
218 His rush to the Waldorf: Ludwig Sander, interviews with Paul Cummings, AAA, Feb. 4 and 12, 1969.
Even Jackson Pollock would drop by: Peter and Florence Grippe, interview with the authors, July 20, 1992.
During the day: Ibid.
The result: George McNeil, interview with Irving Sandler, AAA, Jan. 9, 1968.
219 He called Duchamp: De Kooning, "What Abstract Art Means to Me."
"Cézanne was very important": Joop Sanders, multiple interviews with the authors, Oct. 31, 1990, to Mar. 13, 1993. Sanders also said that de Kooning "talked about Soutine a great deal. His handling and pulling of the paint, his use of distortion, that sort of thing. Also the way the colors looked—scraped."
The revisionist view: John Ferren, *Time,* unpublished interview with Welch, background file entitled "An analysis of Abstract Expressionism, its meaning, the major figures," July 20, 1959.
In the famous words: Harold Rosenberg, "The American Action Painters," *ArtNews* (December 1952), 22–23, 48–50.
Jack Tworkov put it: Jack Tworkov, interview with Dorothy Seckler, AAA, Aug. 17, 1962.
220 The expected procedure: Lionel Abel, *The Intellectual Follies* (New York: Norton, 1984).
221 Greenberg had seemed destined: For biographical and other information on Clement Greenberg the authors have drawn upon Florence Rubenfeld, *Clement Greenberg: A Life* (New York: Scribner, 1997).
"All artists," he liked to say, "are bores": Clement Greenberg, in Steven Naifeh and Gregory White Smith, *Jackson Pollock: An American Saga* (New York: Clarkson N. Potter, 1989), 632.
"That one's a mistake!": Ibid., 633. The painter Mary Abbott recalled Clement Greenberg telling her, "If you don't paint the way I tell you to, you won't get anywhere." Abbott, interviews with the authors, Feb. 5 and April 7, 1992.
A natural "agent provocateur": Dore Ashton, *The New York School: A Cultural Reckoning* (New York: Viking, 1973), 160.
"The future of American painting": Clement Greenberg, "Art," *The Nation,* Nov. 11, 1944, 599.
The *New York Times* critic Hilton Kramer later characterized him: Hilton Kramer, "Art View," *New York Times,* July 23, 1978.
222 His friend Mary McCarthy: Mary McCarthy, "Ideas Were the Generative Force of His Life," *New York Times,* May 6, 1979.
Around 1936, Rosenberg also began to write: Rosenberg's commitment to art and art criticism deepened in 1947, with the publication of *Possibilities I,* a journal of the arts that lasted for only one issue, and for which Rosenberg and Robert Motherwell were the guiding inspirations.
According to Ibram Lassaw: Ibram Lassaw, interviews with the authors, May 23, 1990, and July 2 and 9, 1991.
(According to one story): Lee Hall, *Elaine and Bill: Portrait of a Marriage* (New York: HarperCollins, 1993), 73.
224 Since Guggenheim was closing: Naifeh and Smith, *Jackson Pollock,* 545.
He was "charming": Margo Stewart, interview with the authors, Oct. 29, 1997.
"He told us he couldn't stand working there": Milton Resnick and Pat Passlof, interview with the authors, June 6, 1991.

Notes

225 "He was crazy for de Kooning's work": Janice Biala, interview with the authors, July 27, 1992.

De Kooning himself described the main forms: Thomas B. Hess, in Sally Yard, *Willem De Kooning: The First 26 Years in New York*, diss., Princeton University, 1980, 146. Later published by Garland Publishing (New York and London, 1986).

226 Like so many: Marie Marchowsky, interview with the authors, May 21, 1991. Marchowsky is the primary source for information on the backdrop painted by de Kooning.

"We were talking": Ibid.

227 According to Resnick: Elaine later claimed that Resnick's role was much more limited. See *Willem de Kooning: Paintings*, exhibition catalog (Washington: National Gallery of Art, 1994), 102.

"Bill looked like": Joseph Solman, interviews with the authors, May 8 and June 2, 1991.

According to Conrad Fried: Fried, interviews with the authors, May 31 and June 1, 1995. Conrad Fried provided invaluable information on de Kooning's Fourth Avenue loft and life there.

228 That, plus a small bureau: Tully and Gladys Filmus, interviews with the authors, Sept. 17 and Oct. 18, 1991. Details of the studio can also be seen clearly in a series of photographs taken by Harry Bowden in the late forties. See *Willem de Kooning*, exhibition catalog (Paris: Centre Georges Pompidou, Musée national d'art moderne, 1984).

229 "[Hofmann's] school was on Eighth Street": Rae Ferren, interview with the authors, Sept. 19, 1990.

It was during this period: Kline was such a central figure of the period that almost all interviews mention him. See also Harry Gaugh, *The Vital Gesture of Franz Kline* (New York: Abbeville, 1985), *Franz Kline, Black & White, 1950–1961*, essay by David Anfam, exhibition catalog (Houston: Fine Arts Press, 1994), and *Kline: The Color Abstractions*, exhibition catalog (Washington: Phillips Collection, 1979).

230 "Franz and I worked": John Sheehan, interviews with the authors, Feb. 26 and Mar. 5, 1990.

231 He even wrote to the austere German: Letter to Albers, no date, unpublished, collection of the artist. © The Willem de Kooning Foundation/Artists Rights Society, New York.

Chapter 18

232 "If you are an artist": De Kooning, Robert Goodnough, ed., "Artists' Sessions at Studio 35" [1950]. In *Modern Artists in America*, ed. Robert Motherwell and Ad Reinhardt (New York: Wittenborn, 1951), 9–69.

On many evenings: Conrad Fried, interviews with the authors, May 31 and June 1, 1995.

A young artist named Mike Goldberg: Michael Goldberg, interviews with the authors, Apr. 18 and May 8, 1990.

De Kooning was so poor: Edwin Denby, *Willem de Kooning* (Madras and New York: Hanuman, 1988), 13.

233 In Chelsea one morning: Rudy Burckhardt, interviews with the authors, Mar. 29, 1990, and Oct. 9, 1991.

"After the war": De Kooning, in Paul Hellman, "De Verloren Zoon Zit Goed," *Algemeen Dagblad*, Dec. 24, 1976.

"They were absolutely ecstatic": Joop Sanders, multiple interviews with the authors, Oct. 31, 1990, to Mar. 13, 1993.

In November 1946: Letter of de Kooning to his father, Nov. 1946, provided to the authors by de Kooning's family in Rotterdam. This and other letters © The Willem de Kooning Foundation/Artists Rights Society, New York. The authors are indebted to Hendrik van Leeuwen for translating the letters.

Either Elaine or de Kooning: In at least one instance—*Woman—Lipstick 1952*—Elaine "kissed" a de Kooning painting. See Richard Shiff, "Water and Lipstick: De Kooning in Transition," in *Willem de Kooning: Paintings*, exhibition catalog (Washington: National Gallery of Art, 1994), 38–39, 66.

235 "Today is the tenth": Letter of de Kooning to his father, Feb. 1948, provided to the authors by the de Kooning family in Rotterdam. © The Willem de Kooning Foundation/Artists Rights Society, New York.

His letter, which contains: Letter of Leendert de Kooning to Willem de Kooning, 1948. Courtesy the de Kooning family.

236 After twenty years: Leendert's reserve, however, concealed a great deal of emotion and possibly regret. De Kooning's half brother, the younger Leendert, recalled that their father wept upon hearing a news report from Paris about the opening of one of his son's shows. Even so, the younger Leendert speculated that his father might have wept as much out of frustration that he would now be labeled the estranged father of a famous son as out of pride in his son's achievement or regret that they had drifted so far apart. Leendert de Kooning, interview with authors, Feb. 6, 1991.

The couple gave parties together: Sanders, interviews with the authors. Also, Conrad Fried and Marjorie Luyckx, joint interview with the authors, Aug. 2, 1997.

"Bill asked us": Janice Biala, interview with the authors, July 27, 1992.

237 Ernestine Lassaw later saw: Ernestine Lassaw, interview with the authors, Aug. 8, 1991.

De Kooning later told: Joan Ward, multiple interviews with the authors, Aug. 12, 1991, to April 17, 2004.

"Bill wanted an old-fashioned": Fried, interviews with the authors.

238 Nini Diaz, visiting once: Virginia (Nini) Diaz Halusic, interview with the authors, Feb. 3, 1994.

Once, during an outing: Marjorie Luyckx, interview with the authors, June 14, 1994.

"Michael went to feed the baby": Mildred Loew, interview with the authors, July 17, 1991.

239 By many accounts: While Conrad Fried believed Elaine was not interested in having children, her sister maintained that she did. Luyckx never referred publicly to Elaine's abortions. See also Lee Hall, *Elaine and Bill: Portrait of a Marriage* (New York: HarperCollins, 1993).

The artist Pat Passlof: Passlof, interview with the authors, July 18, 1990.

240 ("I live from the neck up"): Sanders, interviews with the authors.

At some point: Anonymous friend of the Fried family, interview with the authors, June 18, 1993.

241 Of all the stories that Elaine would tell: Conrad Fried, interview with the authors. Elaine told and retold this story throughout her life.

Chapter 19

243 "In Genesis, it is said": De Kooning, "A Desperate View," a talk delivered at the Subjects of the Artist School, New York, Feb. 18, 1949. Published in *The Collected Writings of Willem de Kooning* (Madras and New York: Hanuman Books, 1988) and Thomas B. Hess, *Willem de Kooning* (New York: Museum of Modern Art, 1968).

"A couple of times": De Kooning, interview with James Valliere, "De Kooning on Pollock," *Partisan Review* (Autumn 1967), 603–05.

244 "He freed us": De Kooning to Tully Filmus, interviews with the authors, Sept. 17 and Oct. 18, 1991.

Instead, the two artists: Conrad Fried, interviews with the authors, May 31 and June 1, 1995.

245 "On 4th Avenue": De Kooning, interview with Harold Rosenberg, in Harold Rosenberg, *De Kooning* (New York: Abrams, 1974), 49.

According to Joop Sanders: Joop Sanders, multiple interviews with the authors, Oct. 31, 1990, to Mar. 13, 1993.

(In one famously funny): The anecdote is so well-known that it was recounted by many artists. Philip Pavia, interview with the authors, Apr. 9, 1990.

An artist moves into black: Barnett Newman, quoted in Thomas B. Hess, *Willem de Kooning*, 1968, 50.

De Kooning used black and white: Ibid., 51.

But he kept the two original cans: Fried, interviews with the authors.

246 (The picture has usually been given): In his review of de Kooning's show, Clement Greenberg said that all the paintings had been completed within the past year—not as early as 1946.

247 According to the critic Harry Gaugh: Harry Gaugh, *Willem de Kooning* (New York: Abbeville, 1983).

"I am always in the picture": De Kooning, in Robert Goodnough, ed., "Artists' Sessions at Studio 35" [1950]. In *Modern Artists in America*, ed. Robert Motherwell and Ad Reinhardt (New York: Wittenborn, 1951), 9–69.

249 The critic Tom Hess: Hess, *Willem de Kooning*, 47.

Notes

250 "Despite his intent interest": Sally Yard, "The Angel and the Demoiselle—Willem de Kooning's Black Friday," *Record of the Art Museum*, Princeton University, vol. 50, no. 2 (1991), 12.

"I'm not interested in 'abstracting' ": De Kooning, in Aline Louchheim, "Six Abstractionists Defend Their Art," *New York Times Magazine*, Jan. 21, 1951.

Those were the seminal years: Clement Greenberg, "'American-Type' Painting," *Art and Culture* (Boston: Beacon, 1961), 219.

According to Egan's then wife: Betsy Egan Duhrssen, interview with the authors, Sept. 19, 1991. See also, *Willem de Kooning: Paintings*, exhibition catalog (Washington: National Gallery of Art, 1994), 103.

251 In general, de Kooning shied away: De Kooning, "Artists' Sessions at Studio 35."

Orestes referred to: In a discussion in the footnotes of "The Angel and the Demoiselle," Sally Yard recounts how the editors of the small magazine *Tiger's Eye* named the picture *Orestes* when they ran a reproduction of it that winter in an issue devoted to Greek mythology. But other sources deny the report; and the editors said that they would not have named the painting without de Kooning's consent.

"Charlie Egan, in desperation": Elaine de Kooning, in "De Kooning Memories," *Vogue* December 1953), 352–53, 393–94.

There was no opening-night party: Ibid.

According to Elaine, "Nobody thought of going": Gruen, *The Party's Over Now*, 334.

"Bill was acclaimed": Jane Freilicher and Joe Hazan, interview with the authors, June 19, 1991.

252 "Curiously enough": Sam Hunter, "By Groups and Singly," *New York Times*, April 25, 1948.

"Here," wrote Arb: Renee Arb, "Spotlight on de Kooning," *ArtNews* (April 1948), 33.

"Now, as if suddenly": Clement Greenberg, "Art," *The Nation*, Apr. 24, 1948.

253 With the exception of Greenberg: Steven Naifeh and Gregory White Smith, *Jackson Pollock: An American Saga* (New York: Clarkson N. Potter, 1989), 555.

"We were looking forward": Elaine de Kooning, "De Kooning Memories."

254 According to Peter Grippe: Peter and Florence Grippe, interview with the authors, July 20, 1992.

"He said he'd like someone": John Cage, interview with Paul Cummings, AAA, May 2, 1974, reel 3196.

255 "Black Mountain College combined": Mary Emma Harris, *The Arts at Black Mountain* (Cambridge: MIT Press, 1987), 47. Harris's book is the primary source for the account of the history and physical appearance of Black Mountain. See also, Ilya Bolotowsky, interviews with Paul Cummings, AAA, March 24 and April 7, 1968.

Amédée Ozenfant, a French purist painter: Amédée Ozenfant, *Memoire*, quoted in *The Arts at Black Mountain*, 96.

To the rural: Ilya Bolotowsky, AAA interviews.

256 Sometime during the night: V. V. Rankine, interview with the authors, Aug. 13, 1991. Rankine rode down on the train with Elaine and de Kooning.

"I feel like turning around": Elaine de Kooning, "De Kooning Memories."

257 One student, Pat Passlof: Pat Passlof, interview with the authors, July 18, 1990.

"Finally this little Dutchman comes in": Gus Falk, interview with the authors, July 28, 1992.

258 "One day [Fuller] held up": Elaine de Kooning, "De Kooning Memories."

259 "Albers didn't mingle with us": Peter and Florence Grippe, interview with the authors.

260 Elaine, for her part: Ibid.

261 News of Gorky's death: Much of this information comes from Hayden Herrera, *Arshile Gorky: His Life and Work* (New York: Farrar, Straus & Giroux, 2003), 504–613.

262 "Sir: In a piece on Arshile": De Kooning, "Letter to the Editor" [on Arshile Gorky], *ArtNews* (January 1949), 6. Pat Passlof recalled, however, that de Kooning also said after Gorky's death, "Now I have a chance" (Passlof, interview with the authors).

One was a performance: *The Arts at Black Mountain*, 154.

263 "I'm getting sick": Elaine de Kooning, "De Kooning Memories."

Chapter 20

265 "I always felt that the Greeks": De Kooning, "A Desperate View,' " talk delivered at the Subjects of the Artist School, New York, Feb. 18, 1949. Published in *The Collected Writ-*

ings of Willem de Kooning (Madras and New York: Hanuman Books, 1988) and Thomas B. Hess, *Willem de Kooning* (New York: Museum of Modern Art, 1968).

265 "Between the two world wars": De Kooning, in L. van Duinhoven, "Willem de Kooning's Levenswerk in Stedelijk Museum: Mijn Kunst is een ouwe hoed," *Algemeen Dagblad*, Sept. 18, 1968.

The autumn after the Egan show: Information on the Museum of Modern Art's purchase of *Painting* can be found in Alfred H. Barr Jr., *Defining Modern Art: Selected Writings of Alfred H. Barr, Jr.* (New York: Abrams, 1986).

"Fifteen distinguished critics": "A *Life* Round Table on Modern Art," *Life*, Oct. 11, 1948.

266 "When the moderator inquired": Clement Greenberg, in *Life*'s roundtable discussion.

The Museum of Modern Art: *The Museum of Modern Art, New York: The History and the Collection*, introduction by Sam Hunter (New York: Harry Abrams, in association with The Museum of Modern Art, 1984).

"By the time I knew his name": Louis Finkelstein, interview with the authors, Mar. 14, 1990. All subsequent quotations from Finkelstein come from this interview.

267 According to Betsy Egan Duhrssen: Duhrssen, interview with the authors, Sept. 19, 1991.

The heroes were no longer Marx, Lenin, and Trotsky: See Lionel Abel, *The Intellectual Follies* (New York: Norton, 1984), and William Barrett, *The Truants: Adventures Among the Intellectuals* (Garden City, NY: Anchor, 1982).

(The magnetic Sartre): Abel, *The Intellectual Follies*, 116.

As Rosenberg wrote: Harold Rosenberg, "The American Action Painters," *ArtNews* (December 1952), 22–23, 48–50.

According to *ArtNews*'s Tom Hess: Thomas B. Hess, "De Kooning Paints a Picture," *ArtNews* (March 1953), 30–33, 64–67.

268 "I think the outstanding thing": Joop Sanders, multiple interviews with the authors, Oct. 31, 1990, to Mar. 13, 1993.

"There were no facilities": Pat Passlof, interview with the authors, July 18, 1990.

If there was any money: John Sheehan, interviews with the authors, Feb. 26 and March 5, 1990.

A common technique for filling the stomach: Jim Bohary, interviews with the authors, Mar. 14 and Oct. 9, 1991.

269 "Some of us had gas heaters": Ibram Lassaw, interviews with the authors, May 23, 1990, and July 2 and 9, 1991.

Once, Bill was in his studio: Ibid. Mostly de Kooning used kerosene stoves, first on Twenty-second Street when the regular heat went off, and then on Fourth Avenue. According to Conrad Fried (interviews with the authors, May 31 and June 1, 1995), he would buy kerosene in five-gallon containers whenever he had enough money.

If de Kooning sold a painting: Marjorie Luyckx, interview with the authors, June 14, 1994.

"Bill was one": Alfred L. Copley, known as L. Alcopley, interviews with the authors, Apr. 28 and June 6, 1990. All subsequent references in the footnotes are to "Alcopley."

270 On a cold winter evening: Lee Hall, *Elaine and Bill: Portrait of a Marriage* (New York: HarperCollins, 1993), 65.

"Every time I paint a picture": De Kooning, *Time*, unpublished interview with Welch, background file, May 8, 1959.

In a memoir of de Kooning: Pat Passlof, "1948," in "Willem de Kooning, on His Eighty-Fifth Birthday," *Art Journal* (Fall 1989), 220.

271 He once said that when taking the subway: Thomas B. Hess, *Willem de Kooning*, 16.

Broke and unwilling to cook: Duhrssen, interview with the authors.

"Charlie was there": Ibid. Unless otherwise noted, the personal recollections that follow come from the interview with Duhrssen.

"There's one person I adore": Charles Egan, quoted by Durhssen, ibid.

272 De Kooning no longer felt: Alcopley, interviews with the authors.

273 Not long after his return from Black Mountain: De Kooning to Joop Sanders, interviews with the authors.

274 Just how deep his anger went: Tom Ferrara, multiple interviews with the authors from July 8, 1991, to Feb. 16, 1996.

275 As de Kooning once admitted: Alcopley, interviews with the authors.

According to Hedda Sterne: Sterne, interview with the authors, June 18, 1991.

Even though he had lived: De Kooning would not become a citizen until March 1962.

Notes

276 As she told John Gruen: Elaine de Kooning, in John Gruen, *The Party's Over Now* (New York: Viking, 1967), 217.
Born in Rye, New York: Biographical details can be found in Thomas B. Hess papers, Archives of American Art, Smithsonian Institution, and Hess's obituary, by John Russell, *New York Times*, July 14, 1978.
In December 1948: Thomas B. Hess, "The Whitney: Exhibit Abstract," *ArtNews* 47, Dec. 1948.
277 The friendship between the two men: Rudy Burckhardt, interviews with the authors, Mar. 29, 1990, and Oct. 9, 1991.
De Kooning himself said: De Kooning, interview with Irving Sandler, "Conversations with de Kooning," in "Willem de Kooning on His Eighty-Fifth Birthday," *Art Journal* (Fall 1989), 216–17.
The painter Mary Abbott: Mary Abbott, interviews with the authors, Feb. 5 and Apr. 7, 1992.
279 De Kooning began in a personal: De Kooning, "A Desperate View." Subjects of the Artist soon came to be known as Studio 35, and the school was eventually taken over by professors from New York University. For a more detailed account, see Dore Ashton, *The New York School: A Cultural Reckoning* (New York: Viking, 1973).

Chapter 21

283 "The Club was always misunderstood": De Kooning, interview with James T. Valliere, in "De Kooning on Pollock," *Partisan Review* (Fall 1967), 603–605
Its dramatic headline: "Jackson Pollock: Is He the Greatest Living Painter in the United States?" *Life*, Aug. 8, 1949, 42–45.
A summer haven: For a visual sense of Provincetown, see also Fred W. McDarrah and Gloria S. McDarrah, *The Artist's World in Pictures: The New York School*, introduction by Thomas B. Hess (New York: Shapolsky, 1988).
284 "I caught up": Joop Sanders, multiple interviews with the authors, Oct. 31, 1990, to Mar. 13, 1993.
285 "Look at him": Milton Resnick, in Steven Naifeh and Gregory White Smith, *Jackson Pollock: An American Saga* (New York: Clarkson N. Potter, 1989), 595.
"They used to hound us": Ludwig Sander, interview with Paul Cummings, AAA, Feb. 1969.
286 "These gorillas started making trouble": De Kooning, interview with Anne Parsons, AAA, 1967.
"We began to talk of our own place": Ibid.
With barfly affability: Much information on the formation of the Club comes from L. Alcopley, "The Club: Its First Three Years," *Issue: A Journal for Artists* (Reflex Horizons, Ltd., 1985), and from interviews with such founding members as Philip Pavia, interview with the authors, Apr. 9, 1990, and with Bruce Hooten, AAA, 1965; Conrad Marca-Relli, interview with the authors, May 1, 1991; and with Dorothy Seckler, AAA, June 10, 1965.
("Bill," Ibram Lassaw told de Kooning): Ibram Lassaw, interviews with the authors, May 23, 1990, and July 2 and 9, 1991.
"Some thought we might find": Alcopley, "The Club: Its First Three Years."
287 Finally, after Philip Pavia: Philip Pavia, AAA interview.
There were, in fact, only two "rules": Esteban Vicente, interviews with the authors, May 24, 1990, and Aug. 16, 1991.
288 "The Club started out": Conrad Marca-Relli, AAA interview.
"I mean, they used to just kill me": Harold Rosenberg, in John Gruen, *The Party's Over Now* (New York: Viking, 1967), 177.
De Kooning would say: Ibid.
289 As Marca-Relli put it: Marca-Relli, interview with the authors.
Around 1948 or '49: Conrad Fried, interviews with the authors, May 31 and June 1, 1995.
290 Speakers during the next couple of years: Details about speakers, membership, and the like come from Club notes kept by Philip Pavia, now at AAA.
"When we got the Club together": Marca-Relli, AAA.
291 "The Club came along": De Kooning, AAA.
"A friend of a friend": William Barrett, *The Truants: Adventures Among the Intellectuals* (Garden City, N.Y.: Anchor, 1982), 412.

291 "I think [Pollock's influence] was just phenomenal": George McNeil, interview with Irving Sandler, AAA, Jan. 1, 1968.

The twenty-seven paintings: Robert Coates, "The Art Galleries," *The New Yorker*, Dec. 3, 1949.

292 "Suddenly, there were people": Pat Passlof, interview with the authors, July 18, 1990.

According to Passlof: De Kooning's remark about Pollock "breaking the ice" has sometimes been misinterpreted to indicate that de Kooning was acknowledging an artistic debt. According to Passlof, Milton Resnick, and other close friends of de Kooning's, he was referring only to the way in which money, collectors, and the art world establishment were beginning to gravitate to Pollock. An alternate version, set forth by Irving Sandler, describes de Kooning calling Pollock an "ice breaker" at a meeting of the Club in 1956. Sandler, *The New York School* (New York: Harper & Row, 1978), 44–45.

"This is 1950": Gus Falk, interview with the authors, July 28, 1992.

293 The shapes, which often evoked sexual body parts: Thomas B. Hess, *Willem de Kooning* (New York: George Braziller, 1959), 29.

According to Gus Falk: Falk, interview with the authors.

294 However, the first inkling for *Excavation*: De Kooning, in Katharine Kuh, "The Story of a Picture," *Saturday Review*, Mar. 29, 1969. Later published in *The Open Eye . . . In Pursuit of Art* (New York: Harper & Row, 1971).

297 He described it as a "door": Joan Levy, interviews with the authors, Feb. 6 and June 13, 1995.

Chapter 22

301 "It is a certain burden": De Kooning, interview with David Sylvester, "Content Is a Glimpse," *Location* 1 (Spring 1963), 45–53.

"Gorky was before": De Kooning, interview with Karlen Mooradian, July 19, 1966, in *Ararat: A Special Issue on Arshile Gorky* (Fall 1971), 48–52.

If "the next half century belongs to us": Philip Pavia, quoted by Pat Passlof, interview with the authors, July 15, 1990.

302 "De Kooning asked me to join": Fairfield Porter, interview with Paul Cummings, AAA, June 6, 1968.

303 In April 1950: See Irving Sandler, *The New York School* (New York: Harper & Row, 1978), 30–31.

Motherwell, for example, would ask: All quotations from the symposium are in Robert Goodnough, ed., "Artists' Sessions at Studio 35" [1950]. In *Modern Artists in America*, ed. Robert Motherwell and Ad Reinhardt (New York: Wittenborn, 1951), 9–69.

304 "Ad Reinhardt and Motherwell": Interview with Milton Resnick, June 6, 1991.

305 During the three-day gathering: There are many accounts of the artists' challenge to the Metropolitan Museum. See Steven Naifeh and Gregory White Smith, *Jackson Pollock: An American Saga* (New York: Clarkson N. Potter, 1989), 602.

306 "The spirit of painting after World War II": Alfred H. Barr Jr., "Gorky, De Kooning, Pollock," *ArtNews* (Summer 1950).

Jackson Pollock, "Is he the greatest living painter?": *Life*, Aug. 8, 1949, 42–45.

The most astute response: Nick Carone, interviews with the authors, Mar. 15 and 21, 1991.

307 "Abstract Painting and Sculpture in America": Museum of Modern Art, New York, 1951.

Life sensed the shift in established taste: "The Metropolitan and Modern Art," *Life*, Jan. 15, 1951.

Jackson Pollock and James Brooks: Naifeh and Smith, *Jackson Pollock*.

Albers replied that the main reason was: Unpublished letter from de Kooning to Joseph Albers, date unknown, collection of Joan Ward. © The Willem de Kooning Foundation/ Artists Rights Society, New York. The actual letter that was sent to Albers is in the collection of the Josef and Anni Albers Foundation. Shown to the authors courtesy of the Albers Foundation.

De Kooning accepted the job: De Kooning tax records, AAA.

"I can't see myself as an academic": De Kooning, in "De Kooning's Year," *Newsweek*, Mar. 10, 1969.

At the first meeting of de Kooning's class: Anonymous interview, student of de Kooning's at Black Mountain, with the authors, Nov. 21, 1991.

308 "You think because your father is rich": Unpublished interviews with Robert Jonas, conducted by Judith Wolfe, author of *The Young Willem de Kooning: Early Life, Training and*

Notes

Work, 1904–1926, diss., City University of New York, 1996. Interviews courtesy of Liesl Jonas.

308 "These guys are so lousy": Joan Levy, interviews with the authors, Feb. 6 and June 13, 1995.

(His friends took particular delight): John Cage, interview with Paul Cummings, AAA, May 2, 1974.

"Well, from that point of view": Unpublished letter to Albers.

De Kooning continued to live in New York: "Willem the Walloper," *Time*, Apr. 30, 1951.

309 "genius shop": Thomas B. Hess, *Willem de Kooning* (New York: Museum of Modern Art, 1968), 73.

A number of Yale men: Anonymous interview with the authors, Nov. 21, 1991.

In June 1950: There are numerous accounts of de Kooning's struggle with *Woman I* and the technical processes he employed to make the picture. Most rely upon Thomas B. Hess, "De Kooning Paints a Picture," *ArtNews* (March 1953), 30–33, 64–67. See also E. A. Carmean, *American Art at Mid-Century: The Subjects of the Artist*, exhibition catalog (Washington: National Gallery of Art, 1978).

At the time, Clement Greenberg was arguing: Much of Greenberg's writing on this theme would come later in the decade. But he was already making this argument very strongly in person to artists.

"I had seen a picture of a Mexican goddess": De Kooning, in Jan Bart Klaster, "De Kooning gaat door ik schilder mijn binnenste," *Het Parool*, May 11, 1983. On the theme of ancient idols, see also Sylvester, "Content Is a Glimpse."

310 "seamless" work without the "hot spots": De Kooning, interview with Selden Rodman, in *Conversations with Artists* (New York: Capricorn, 1957), 105.

Now, as he began this new picture: Thomas B. Hess, unpublished papers, AAA. "The important point is that he thought of the women architecturally. Always said that *Woman* was not just a figure but a structure into which he could fit any content. For him it was a layout almost as strict as a grid. Said it freed him from the struggles of abstract artists, who had to invent their own emotion-laden frameworks."

311 "I always started out with the idea of a young person": De Kooning, *Newsweek*, unpublished interview with Ann Ray Martin, background file, Nov. 1, 1967.

312 People were beginning to talk: Alcopley, interviews with the authors, Apr. 28 and June 6, 1990.

Perhaps his greatest support: According to de Kooning's friends, he talked often and passionately about Soutine, recently the subject of a retrospective, "Soutine," Museum of Modern Art, New York, 1950.

313 Almost every day he would use a sharpened spatula: Joop Sanders, multiple interviews with the authors, Oct. 31, 1990, to Mar. 13, 1993. Balzac's fable *The Unknown Masterpiece* greatly interested de Kooning and most of the other abstract expressionists.

Clement Greenberg paid a visit to de Kooning's studio: The details of this visit are not clear and vary in different accounts, but de Kooning often told his friends about it, and it developed an emblematic power among painters who resented or disagreed with Greenberg. See Fairfield Porter, interview with Paul Cummings, AAA, June 6, 1968.

"The *Woman* became compulsive": Sylvester, "Content Is a Glimpse."

The Fourth Avenue studio became as dirty: Alcopley, interviews with the authors.

314 "He woke me up about two in the morning": Conrad Marca-Relli, interview with the authors, May 1, 1991.

A doctor de Kooning once consulted: Many friends recalled the painter telling them of his visits to doctors to discuss his heart palpitations. He loved to tell the story of the time he went to St. Vincent's Hospital and told two doctors, "Gee, my heart is beating so hard." They replied, "What do you want it to do? Stop?" Joan Ward, multiple interviews with the authors, Aug. 12, 1991, to April 17, 2004.

Now, de Kooning brought a bottle of whiskey: Alcopley, interviews with the authors.

It helped him: Emilie Kilgore, interviews with the authors, July 24–26, 2003.

"How do you know?": Marjorie Luyckx, interview with the authors, June 14, 1994.

Chapter 23

315 "An artist is forced by others": De Kooning, "A Desperate View," a talk delivered at the Subjects of the Artist School, New York, Feb. 18, 1949. Published in *The Collected Writ-*

ings of Willem de Kooning (Madras and New York: Hanuman Books, 1988) and in Thomas B. Hess, *Willem de Kooning* (New York: Museum of Modern Art, 1968).

315 By that June, only three drawings: De Kooning tax records, AAA.

De Kooning also believed: Information on Egan's business practices, personal life, and treatment of de Kooning come from Betsy Egan Duhrssen, interview with the authors, Sept. 19, 1991.

316 In the spring of 1951: Biographical material on Sidney Janis comes from John Gruen, *The Party's Over Now* (New York: Viking, 1967), 243–53, and an interview with Sidney Janis in Laura de Coppet and Alan Jones, *The Art Dealers* (New York: Clarkson N. Potter, 1984), 180–85.

317 In the autumn of 1950: "Young Painters in the U.S. and France," Sidney Janis Gallery, New York, 1950.

In the spring of 1951: For a sustained analysis of the Ninth Street show, see Bruce Altshuler, *The Avant-Garde Exhibition: New Art in the 20th Century* (New York: Abrams, 1994), 156–74.

"The charter members of the Club met": Ludwig Sander, interview with Paul Cummings, AAA, Feb. 1969.

318 Alfred Barr, for one, was stunned: Unpublished interview with Leo Castelli for *Willem de Kooning,* exhibition catalog (Paris: Centre Georges Pompidou, Musée national d'art moderne, 1984).

319 So de Kooning put on a jacket and tie: De Kooning almost always dressed formally when he went uptown for business reasons. Joan Ward, multiple interviews with the authors, Aug. 12, 1991, to Apr. 17, 2004.

But the two men almost certainly worked out an informal understanding: Ibid.

That spring and summer, the Art Institute: Conrad Fried, interviews with the authors, May 31 and June 1, 1995.

320 Katherine Kuh, a curator: Katherine Kuh, "The Story of a Picture," *Saturday Review,* Mar. 29, 1969.

When the check for the prize money arrived: Fried, interviews with the authors.

Those cataloguing de Kooning's estate: Records of The Willem de Kooning Foundation, New York; conversation with Roger Anthony at the foundation.

321 She brought a kind of youthful optimism: All quotations about de Kooning's relationship with Abbott come from Mary Abbott, interviews with the authors, Feb. 5 and Apr. 7, 1992.

323 He told Hess: Thomas B. Hess, *Willem de Kooning* (New York: George Braziller, 1959), 22.

324 "I cut out a lot of mouths": De Kooning, interview with David Sylvester, "Content Is a Glimpse," *Location* 1 (Spring 1963), 45–53.

"I like a nice, juicy, greasy surface": De Kooning, in Thomas B. Hess, "De Kooning Paints a Picture," *ArtNews* (March 1953), 65.

325 The statement of 1949: De Kooning, "A Desperate View."

The next two were an implicit defense: "The Renaissance and Order," a talk delivered at Studio 35 in 1950, reprinted in *trans/formation* 1 (1951), 85–87, and "What Abstract Art Means to Me," a talk given to a symposium at the Museum of Modern Art on Feb. 5, 1951, reprinted in *Museum of Modern Art Bulletin* (Spring 1951), 4–8.

329 "There followed a few hours of violent disaffection": Hess, "De Kooning Paints a Picture," 30.

In the end, de Kooning angrily ripped: Fried, interviews with the authors.

Later that year, the art historian Meyer Schapiro: Hess gave the original account of this visit in "De Kooning Paints a Picture." Subsequently, the dating for both the visit and the completion of the work have been questioned. See E. A. Carmean, *American Art at Mid-Century: The Subjects of the Artist,* exhibition catalog (Washington: National Gallery of Art, 1978). Conrad Fried has a clear memory that the visit by Schapiro occurred in the spring at de Kooning's Fourth Avenue studio. Fried, interviews with the authors.

330 One of Schapiro's passions: The essay "On a Painting of Van Gogh," written in 1952 about the time Schapiro visited de Kooning, is reprinted in Meyer Schapiro, *Modern Art: 19th and 20th Centuries* (New York: George Braziller, 1978), 87–99.

"Let's talk about this": Fried, interviews with the authors.

331 He began work on the three other *Women:* Hess, "De Kooning Paints a Picture."

He often visited the painter Esteban Vicente: Esteban Vicente, interviews with Elizabeth Frank, AAA, Nov. 1982, and Irving Sandler, AAA, Aug. 1968.

De Kooning liked the neighborhood: Description of the environment comes from Philip

Notes

Pavia, interview with the authors, Apr. 9, 1990, and Bruce Hooten, AAA, Jan. 19, 1965. Also Michael Goldberg, interviews with the authors, Apr. 18 and May 8, 1990, and Pat Passloff, interview with the authors, July 18, 1990.

332 De Kooning set up a studio on a screened porch: Unpublished interview with Leo Castelli for *Willem de Kooning*, exhibition catalog, Centre Georges Pompidou.

He mostly spent his time drawing: Thomas B. Hess, unpublished notes, AAA.

"*Woman I*, for instance, reminded me very much of my childhood": De Kooning, interview with Harold Rosenberg, in Harold Rosenberg, *De Kooning* (New York: Abrams, 1974), 49.

Once, when he was riding his bicycle: Joan Ward, multiple interviews with the authors, Aug. 12, 1991, to Apr. 17, 2004.

334 At the Castelli dinner parties: Leo Castelli, interview with the authors, Apr. 10, 1990.

According to William Barrett: William Barrett, *The Truants: Adventures Among the Intellectuals* (New York: Doubleday, 1982), 143–44.

"I don't think writers are necessarily more intelligent": De Kooning, in Storm de Hirsch, "A Talk with De Kooning," *Intro Bulletin* (October 1955).

335 Rothko, Rosenberg thought: Joseph Liss, "Abstraction at Louse Point," *East Hampton Star*, Feb. 25, 1982.

She "adored" him: Steven Naifeh and Gregory White Smith, *Jackson Pollock: An American Saga* (New York: Clarkson N. Potter, 1989), 708.

Pollock would regularly show up: Ludwig Sander, interview with Paul Cummings, AAA, Feb. 1969. Also Naifeh and Smith, *Jackson Pollock*, and Castelli, unpublished interviews for *Willem de Kooning*, exhibition catalog, Centre Georges Pompidou.

336 A year or two later: Ward, interviews with the authors.

De Kooning's space was long and narrow: Description of studio from Ward, interviews with the authors, and Paul Russotto, interview with the authors, Dec. 9, 1991.

Then, in December 1952: Hess, "De Kooning Paints a Picture."

337 Sidney Janis knew, of course: Janis denied that he disliked the *Women* or ever discouraged de Kooning from painting them, unpublished interview with Sidney Janis, for *Willem de Kooning*, exhibition catalog, Centre Georges Pompidou. But de Kooning told Hess, Rosenberg, and other friends that Janis did try to discourage him from painting the figure. There can be little doubt that, whatever Janis actually said to de Kooning, he personally preferred the abstractions to the *Women*.

De Kooning, Jonas said, "treated him very coolly": Robert Jonas, unpublished interviews with Judith Wolfe, author of *The Young Willem de Kooning: Early Life, Training and Work, 1904–1926*, diss., City University of New York, 1966. Interviews courtesy of Liesl Jonas.

338 "I sound my barbaric yawp": Walt Whitman, "Song of Myself," sect. 52, *Leaves of Grass*, 1855.

De Kooning said, "Al, go to Klein's": Alcopley, interviews with the authors, Apr. 28 and June 6, 1990.

339 Conrad Fried once innocently: Fried, interviews with the authors.

De Kooning's mother did not like to touch children: Cornelia Hendrika Maria Lassooy, the granddaughter of de Kooning's mother, interview with the authors, Apr. 1995.

The sculptor Isamu Noguchi once said: Dorothy Norman, *Encounters: A Memoir* (New York: Harcourt, 1987), 287.

340 "the American female idols in cigarette advertisements": Thomas B. Hess, *Willem de Kooning* (New York: Museum of Modern Art, 1968), 77.

341 A man like Leo Castelli: Castelli, interview with the authors.

De Kooning himself, when asked: Sylvester, "Content Is a Glimpse."

"Beauty," he said elsewhere: De Kooning, *Time*, unpublished interview with Welch, background file, July 20, 1958.

342 "For many years I was not interested": Ibid.

Clement Greenberg would soon argue: Greenberg, interview with the authors, spring 1993.

Chapter 24

344 "There's no way of looking at a work of art by itself": De Kooning, interviewed in *Sketchbook No. 1: Three Americans*, a film by Robert Snyder, 1960.

She even asked the photographer: John Gruen, *The Party's Over Now* (New York: Viking, 1967), 218.

345 In the meantime, she continued to talk about "Bill": Many of Elaine's friends remarked upon this habit. Jane Freilicher and Joe Hazan, interview with the authors, June 19, 1991. She called Helen Frankenthaler: Joan Mitchell, interview with the authors, spring, 1991. "Vat ve need is a wife": Perhaps the most famous quip about the de Kooning marriage. Conrad Fried, interviews with the authors, May 31 and June 1, 1995.

346 In the early fifties: Marisol, interview with the authors, May 15, 1992; and Mary Abbott, interviews with the authors, Feb. 5 and Apr. 7, 1992.

347 The most important woman: The information about Joan Ward comes from multiple interviews with Joan Ward, Aug. 12, 1991, to Apr. 17, 2004.

348 "The Ward sisters had a certain mystique": Anne Wedgwood Schwertley, interview with the authors, Feb. 15, 1995.
"Joan always knew where to put the furniture": Franz Kline, quoted in Schwertley, ibid.

349 Nancy reached into her blouse: Alcopley, interviews with the authors, Apr. 28 and June 6, 1990.

350 Harold Rosenberg's: Harold Rosenberg, "The American Action Painters," *ArtNews* (December 1952), 22–23, 48–50.

352 The article brought to the surface: Steven Naifeh and Gregory White Smith, *Jackson Pollock: An American Saga* (New York: Clarkson N. Potter, 1989), 704–21.
It was these lines, among others: Rosenberg was almost certainly directing his attack upon a simplified trademark style at Mark Rothko as well. Joseph Liss, "Abstraction at Louse Point," *East Hampton Star*, Feb. 25, 1982.

353 It was not forgotten that: Rosenberg had a part-time job at the Advertising Council, where he came up with the idea for a public service campaign to prevent forest fires based upon the character Smokey the Bear.
Hess's article: Thomas B. Hess, "De Kooning Paints a Picture," *ArtNews* (March 1953), 30–33, 64–67.

356 Even before the articles appeared: This was a view widely held by artists in New York and is mentioned by numerous figures of the period in interviews.
He was an easy hero to tolerate: Naifeh and Smith, *Jackson Pollock*, 713.
Even Clement Greenberg said: Clement Greenberg, in John Gruen, *The Party's Over Now* (New York: Viking, 1967, 1972), 181.
Six large *Women:* There are varied reports on the number of works in the show. This is the number cited by Marla Prather in *Willem de Kooning: Paintings*, exhibition catalog (Washington: National Gallery of Art, 1994).
Many people were shocked: "Big City Dames," *Time*, Apr. 6, 1953, 80.
Like Hess, Howard Devree of the *Times:* Howard Devree, "Masters' Drawings: Five Centuries of French Artists' Work at Metropolitan—de Kooning," *New York Times*, Mar. 22, 1953.

357 Tigerish in her protection: Naifeh and Smith, *Jackson Pollock*, 704–21.
De Kooning "announced his liking for the article": Ibid., 708.
"You know more": De Kooning, interview with James T. Valliere, "De Kooning on Pollock," *Partisan Review* (Autumn 1967), 603–05.
"They were competitive, but there was": Naifeh and Smith, *Jackson Pollock*, 709.
"Jackson, *you're* the greatest painter in America": Perhaps the most popular story of the period, mentioned by numerous people. See Deborah Solomon's interview with Sidney Geist, Mar. 1984, in *Jackson Pollock: A Biography* (New York: Simon & Schuster, 1987), 241.

358 "Bill, you betrayed it": Naifeh and Smith, *Jackson Pollock*, 715.
Now, all around, friends, painters: De Kooning was also selected to appear for the second time at the Venice Biennale, scheduled for 1954.
Then he let out "You look like a million bucks!": Another very popular story about de Kooning. Lee Eastman, interviews with the authors, Mar. 7 and Sept. 12, 1990.
No one in New York admired de Kooning more than: Rauschenberg's visit to de Kooning soon attained legendary status. The account given here is based on Robert Rauschenberg, unpublished interview for *Willem de Kooning*, exhibition catalog (Paris: Centre Georges Pompidou, Musée national d'art moderne, 1984); Leo Steinberg, *Encounters with Rauschenberg* (*A Lavishly Illustrated Lecture*) (Chicago: University of Chicago Press, 2000); and a conversation with Rauschenberg in Sept. 1997.

360 Later, de Kooning became angry: De Kooning's irritation, once he learned of Rauschenberg's public exhibition of the work, is rarely mentioned. Emilie Kilgore, interviews with

the authors, July 24–26, 2003, and Susan Brockman, interviews with the authors, Apr. 24, 1992, and Jan. 14, 1998.

Chapter 25

361 "I wouldn't say that Rubens is a greater painter": De Kooning, in Selden Rodman, *Conversations with Artists* (New York: Capricorn, 1957), 104.
The air was thick: Anonymous, interview with the authors, Oct. 28, 1991.
"At the Club we had a meeting": Conrad Marca-Relli, interview with the authors, May 1, 1991.

362 De Kooning, like other regulars: Numerous people have recorded their memories of the Cedar. Information with particular reference to de Kooning is from John Sheehan, interviews with the authors, Feb. 26 and Mar. 5, 1990.

363 Around four or five p.m.: Al Kotin, interview with Jack Taylor, in the Jack Taylor tapes, unpublished. In the 1960s, Taylor, curator and assistant director of the Milwaukee Art Museum, did extensive interviews with many New York school painters about the Ninth Street show. The authors are grateful to Reva Shovers, Taylor's close friend, for making available Taylor's extensive collection of interviews.

364 Pollock was celebrated for ripping: Another often repeated and legendary story. Sheehan, interview with the authors.
He would glower into his drink: There are many stories of Pollock's manners when drunk. Joan Ward, multiple interviews with the authors, Aug. 12, 1991, to Apr. 17, 2004.
Once, in the Cedar, Pollock began tormenting Kline: Fielding Dawson, *Franz Kline: An Emotional Memoir* (New York: Pantheon, 1967), 82.

365 At the Cedar, de Kooning and another painter: Florence Rubenfeld, conversations with the authors, 1995–1998.
Elaine believed that it was these parties: Marjorie Luyckx, interview with the authors, June 14, 1994.
After two drinks: Saul Steinberg, interview with the authors, summer 1993.

366 "The marvelous thing was": Steinberg, ibid.
De Kooning once gave a drunken speech: Ibid.
"At the end you don't know": Ibid.

367 The butt of many jokes: Stories about Resnick's imitations circulated widely in the art world. They were often unjustified and an expression of the widespread anxiety created by de Kooning's influence. Pat Passlof, interview with the authors, July 18, 1990.
This crowding toward the individual: Harold Rosenberg, "The Herd of Independent Minds: Has the Avant-Garde Its Own Mass Culture?" *Commentary* (September 1948).
"De Kooning really took a whole generation with him": Clement Greenberg, unpublished interview for *Willem de Kooning*, exhibition catalog (Paris: Centre Georges Pompidou, Musée national d'art moderne, 1984).

368 "I'd see him with his hands behind his back": Robert Frank, in "Letter from New York," reprinted in David Brittain, *Creative Camera: Thirty Years of Writing* (Manchester, England: Manchester University Press, 2000).
"Bill had the attitude": Marca-Relli, interview with the authors.
For years, he invariably referred: Mary Abbott, interviews with the authors, Feb. 5 and Apr. 18, 1992.
In his memoir of the period: John Gruen, *The Party's Over Now* (New York: Viking, 1967), 200.

369 Another time, she went to the Club: Edwin Ruda, interviewed by Michael Chisolm, AAA, Jan. 26, 1988.
"He always seemed to have three women": All quotations attributed to Marisol are from Marisol, interview with the authors, May 15, 1992.
Huntington Hartford II: "The Public Be Damned?" a full-page advertisement that ran in newspapers nationwide in May 1955.

370 During the mid-fifties: See, for example, Serge Guillbaut, *How New York Stole the Idea of Modern Art* (Chicago: University of Chicago Press, 1983). The Museum of Modern Art organized two shows of American modernism in the mid-fifties that were sent to Europe. In 1953–54, "Twelve American Painters and Sculptors" traveled to Paris, Zurich, Dusseldorf, Stockholm, and Helsinki. In 1955–56, "Modern Art in the United States: Selections

from the Collection of the Museum of Modern Art," went to Zurich, Barcelona, Frankfurt, London, Vienna, and Belgrade.

Some remember the cost of the rental: Esteban Vicente, interviews with the authors, May 24, 1990, and Aug. 16, 1991. Elaine de Kooning recalled $200. Interview with Joseph Liss in "Memories of Bonac Painters," *East Hampton Star*, Aug. 18, 1983.

It had very little furniture: Kate Sander, interview with the authors, Sept. 6, 1991.

Elaine described the house: Elaine de Kooning, in Liss, "Memories of Bonac Painters."

371 He and Elaine stayed: Ward, interviews with the authors.

"Lutz had a lot of girlfriends": Ward, ibid.

He disliked the glare at midday: Liss, "Memories of Bonac Painters."

372 Croquet was a favorite: Ludwig Sander, interview with Paul Cummings, AAA, Feb. 1969.

"We got three balls": Vicente, interviews with the authors.

Pollock brought an occasional: Steven Naifeh and Gregory White Smith, *Jackson Pollock: An American Saga* (New York: Clarkson N. Potter, 1989), 732–36. Also Sander, AAA.

Ward said he would join the artists: Ward, interviews with the authors.

"Sensing trouble": Naifeh and Smith, *Jackson Pollock*, 732–36.

373 Not surprisingly, Lee blamed: Sander, AAA.

On those occasions when he did get out: Marca-Relli, interview with the authors.

The Red House, she later told: Elaine de Kooning, in Liss, "Memories of Bonac Painters."

De Kooning was painting: Ward, interviews with the authors.

Elaine and Nancy: Rose Slivka, memorial service for Elaine de Kooning at Cooper Union, New York, Mar. 12, 1989.

According to Joan Ward: Ward, interviews with the authors.

374 "That Saturday, it was very beautiful": Michael Goldberg, interviews with the authors, Apr. 18 and May 8, 1990.

A woman "of considerable girth": Ward, interviews with the authors.

"Three days later": Ibid.

Sidney Janis agreed to advance him $300: Goldberg, interviews with the authors.

One person estimated: Hess recorded the amount as $6,000; Hess, *Willem de Kooning* (New York: Museum of Modern Art, 1968), 74. Lee Eastman, however, by then de Kooning's lawyer, recalled the amount as $4,000; interviews with the authors, Mar. 7 and Sept, 12, 1990. Joop Sanders recalled how angry de Kooning was at Martha Jackson's subsequent sale; multiple interviews with the authors, Oct. 31, 1990, to Mar. 13, 1993.

375 With Elaine's sister, Marjorie: Luyckx, interview with the authors.

She and her son would speak Dutch: Ward, interviews with the authors.

The painter Robert Dash: Dash, interviews with the authors, Oct. 5 and 17, 1991.

376 "She entertained us one entire evening": Sanders, interviews with the authors.

Cornelia also baited her son: Ward, interviews with the authors.

She had strong views: Ibid.

"Most of the time he knew": Ibid.

377 A chic and well-put-together friend: Ibid.

Instead, she lived for a time with Elaine's sister: Martha Bourdrez, interview with the authors, Mar. 31, 1990.

She even complained: Robert Rauschenberg, unpublished interview for *Willem de Kooning*, exhibition catalog, Centre Georges Pompidou.

"She was very intelligent": Sanders, interviews with the authors.

"Bill comes in and is very well dressed": Conrad Fried, interviews with the authors, May 31 and June 1, 1995.

378 After Cornelia returned home: Ward, interviews with the authors.

"The son of a bitch is trying to outlive me": Michael Wright, interview with the authors, Aug. 8, 1993.

"The landscape is": De Kooning to Hess, in Thomas B. Hess, *Willem de Kooning*, 1968, 100.

De Kooning himself referred: "Big Splash," *Time*, May 18, 1959.

De Kooning had a passion for crime stories: Ward, interviews with the authors. Also Elaine de Kooning, in "De Kooning Memories," *Vogue* (December 1983), 352–53, 393–94. Over the years, many acquaintances noticed cheap detective magazines in his studio.

The tough-guy air of film noir: One friend of the Fried family recalled de Kooning speaking of Weegee with great admiration. Anonymous interview with the authors, June 18, 1993.

380 He was struggling to make the deadline: Hess, *Willem de Kooning*, 1968, 50.

Notes

381 Hess wrote that de Kooning "had replaced Picasso": Thomas B. Hess, "Selecting from the Flow of Spring Shows," *ArtNews* (April 1956), 24.
"Poetry is not a turning loose of emotion": T. S. Eliot, *Selected Essays* (London: Faber and Faber, 1932), 21.
He once called Rubens: Nathan Oliveira, interview with the authors, Nov. 20, 1998. Along with Richard Diebenkorn, Oliveira emerged as a leading Bay Area artist in the late 1950s. He got to know de Kooning at that time.

Chapter 26

382 "There is no such thing as being anonymous": De Kooning in Robert Goodnough, ed., "Artists' Sessions at Studio 35" [1950]. In *Modern Artists in America*, ed. Robert Motherwell and Ad Reinhardt (New York: Wittenborn, 1951), 9–69.
The art world talk: Joan Ward, multiple interviews with the authors, Aug. 12, 1991, to April 17, 2004.
"Well, you know": Ibid.
When Ward told de Kooning: Ibid.
383 When labor began: Ward, interviews with the authors.
She checked various possibilities: Ibid.
"Let's just go in for one drink.": Alcopley, interviews with the authors, Apr. 28 and June 6, 1990.
384 The situation was just as troubling: Joan Mitchell, interview with the authors, spring 1991.
"Mrs. de Kooning": Lee Hall, *Elaine and Bill: Portrait of a Marriage* (New York: Harper-Collins, 1993), 174.
385 She had had three abortions: Ward, interviews with the authors.
Elaine later said: Elaine's brother, Conrad Fried, always insisted that Elaine never offered to divorce Bill—quite the opposite, in fact. Fried, interview with the authors.
"Oh . . . Bill and I always wanted a child": Ward, interviews with the authors.
"Well, the baby actually looks sort of like Jackson Pollock": Ibid.
386 She preferred to be a "fairy godmother": Denise Lassaw, remarks at Elaine de Kooning's memorial service at Cooper Union, New York, Mar. 12, 1990. Also, Lee Hall, *Elaine and Bill*, 171.
She would often begin the morning: Ibid., 178.
De Kooning was becoming a binge drinker: Joop Sanders, multiple interviews with the authors, Oct. 31, 1990, to Mar. 13, 1993. Virtually all artists interviewed who went to the Cedar mentioned de Kooning's growing alcoholism.
388 "Bill kept two levels": Conrad Marca-Relli, interview with the authors, May 1, 1991.
One of de Kooning's oldest friends: Milton Resnick and Pat Passlof, interview with the authors, June 6, 1991. At one of the last sessions of the Club, Resnick and Ad Reinhardt denounced certain painters for selling out, strongly implying that de Kooning was an example of this, which eventually provoked a shouting match between Resnick and de Kooning. Edwin Ruda, interview with Michael Chisolm, AAA, Jan. 26, 1988.
The painter Ad Reinhardt: Ad Reinhardt, *Art as Art: The Selected Writings of Ad Reinhardt*, ed. Barbara Rose, *The Documents of 20th Century Art* (New York: Viking, 1975), 4–8.
389 Once when Greenberg was visiting: Florence Rubenfeld, conversations with the authors, 1995–1998.
390 "De Kooning strives for synthesis": Clement Greenberg, *Willem de Kooning Retrospective*, exhibition catalog (Washington: Workshop Center for the Arts, 1953; and Boston: School of the Museum of Fine Arts, 1953).
In the landmark essay of 1955: Clement Greenberg, " 'American-Type' Painting," in Clement Greenberg, *The Collected Essays and Criticism: Affirmations and Refusals*, ed. John O'Brian (Chicago: University of Chicago Press, 1993), 217–36.
392 And some hinted that: This was not a criticism usually advanced against de Kooning in print, but was often brought up in conversation. De Kooning's academic training, interest in mixing paint, and bravura style were often linked to European traditions. The growing pride that developed during the fifties in the peculiarly American qualities of American painting naturally made an academically trained artist from Europe anxious about his place. De Kooning liked to distinguish his work, perhaps somewhat defensively, from the "finished" look created by French painters, saying, "They have a touch that I am glad not to have." De Kooning, "Artists' Sessions."
Greenberg was almost as tough on Pollock: Greenberg, " 'American-Type' Painting."

393 "Bill was painting on the porch": Ward, interviews with the authors.

394 Her arrival came as a shock to Joan: Ward, ibid. The information about the Martha's Vineyard trip comes from these interviews.

395 Jackson's dogs came into my house: Marca-Relli, interview with the authors.

Chapter 27

397 "It's not so much that I'm an American": De Kooning, interview with David Sylvester, "Content Is a Glimpse," *Location* 1 (Spring 1963), 45–53.

In 1957, the Museum of Modern Art: "Picasso: 75th Anniversary," Museum of Modern Art, New York, 1957.

At the same time, MoMA was preparing: "The New American Painting," Museum of Modern Art, New York, 1959.

Sidney Janis began aggressively: Among the artists who joined de Kooning at the Sidney Janis Gallery were Mark Rothko, Robert Motherwell, Franz Kline, Adolph Gottlieb, and Philip Guston.

398 Marca-Relli remembered coming upon: Conrad Marca-Relli, interview with the artists, May 1, 1991.

399 During a panel at the Club: Ibid.

400 Frank O'Hara divided: Joe LeSueur, *Digressions on Some Poems by Frank O'Hara* (New York: Farrar, Straus & Giroux, 2003), 78.

In one famous story: John Gruen, *The Party's Over Now* (New York: Viking, 1967), 219–20.

One woman with whom de Kooning: Shirley Stoler, interview with the authors, Nov. 1, 1994. All Stoler quotes come from this interview.

401 In her book *Elaine and Bill*: Lee Hall, *Elaine and Bill: Portrait of a Marriage* (New York: HarperCollins, 1993), 196–200.

402 Elaine called her "pink mink": Kenneth Koch, interview with the authors, Sept. 7, 1990.

Franz Kline and others preferred "Miss Grand Concourse," according to Florence and Peter Grippe, interview with the authors, July 20, 1992. Kline was referring to a famous highway in the Bronx, implying that Kligman was a flamboyant girl from the boroughs making her way in Manhattan.

"Going with Ruth": Anne Wedgwood Schwertley, interview with the authors, Feb. 15, 1995.

According to one friend: Ibid.

"She really puts lead in my pencil": Koch, interview with the authors.

According to the painter Audrey Flack: Steven Naifeh and Gregory White Smith, *Jackson Pollock: An American Saga* (New York: Clarkson N. Potter, 1989), 776–77.

403 Frank O'Hara famously: Joe LeSueur, *Digressions on Some Poems*, 148; see also Brad Gooch, *City Poet: The Life and Times of Frank O'Hara* (New York: Knopf, 1993).

Kligman had a troubled childhood: Some of the background information about Kligman's life comes from Naifeh and Smith, *Jackson Pollock*, 774–75. Also Ruth Kligman, *Love Affair: A Memoir of Jackson Pollock* (New York: Morrow, 1974), and Ruth Kligman, interview with the authors, June 4, 1993.

404 "Hiya Jackson": Kligman, interview with the authors.

"He looked at me in a certain way": Ibid.

Elaine would describe the beginning of the affair: Marjorie Luyckx, interview with the authors, June 14, 1994.

"We saw each other almost every other night": All subsequent quotations from Kligman are from the June 4, 1993, interview.

405 "I sort of like that": Schwertley, interview with the authors.

406 "He was going away": Joan Ward, multiple interviews with the authors, Aug. 12, 1991, to Apr. 17, 2004.

"Cuba was like being in New Jersey": *Time*, unpublished interview with Welch, May 8, 1959, background for "Big Splash," *Time*, May 18, 1959.

According to Ward, he came back: Ward, interviews with the authors.

"She used to walk back and forth on the beach": Jane Freilicher and Joe Hazan, interview with the authors, June 19, 1991.

De Kooning and Ruth visited: Ibid.

408 What was he supposed to do?: Ibid.

Notes

408 She wrote him regularly: Ibid.

de Kooning invited Elaine to join him: Ibid.

409 Once, when Elaine heard: LeSueur, *Digressions on Some Poems*, 148–49.

He thought the Sistine Chapel: This and subsequent observations by de Kooning about Rome come from an unpublished letter never sent to Ruth Kligman, written during this period. Collection of Joan Ward. © The Willem de Kooning Foundation/Artists Rights Society, New York.

It was a city that would understand: De Kooning, interview with Sylvester, "Content Is a Glimpse," 45–53.

" 'I'm leaving tomorrow' ": Esteban Vicente, interviews with the authors, May 24, 1990, and Aug. 16, 1991.

It was during this period: Ward, interviews with the authors.

410 He and his wife, Harriet, who occasionally wrote: Harriet Janis and Rudi Blesh, *De Kooning* (New York: Grove Press, 1960).

When the Museum of Modern Art approached him: "Big Splash," *Time*, May 18, 1959. Nonetheless, the idea of a major museum show remained in the air, with the poet and critic Frank O'Hara particularly eager to organize one for MoMA.

412 "His clothes started changing": Ward, interviews with the authors.

The gallery was jammed: Details in *Time*, unpublished background file, Welch, May 8, 1959, and in "Big Splash," *Time*.

"No pure abstract geometry": Janis and Blesh, *De Kooning*.

413 "There's no way of astonishing anyone any more": "Big Splash," *Time*.

414 "I told Bill": Ward, interviews with the authors.

Before he left: Records of the land purchase can be found in property deeds, town hall of East Hampton, New York. Unpublished correspondence concerning the purchase is in studio files, The Willem de Kooning Foundation, New York.

According to the Italian artist: Piero Dorazio, interview with the authors, Oct. 19, 1992.

"We drove to the Piazza del Popolo": Plinio de Martiis, interview with the authors, Oct. 21, 1992.

415 "There was this myth": De Martiis, ibid.

"The whole of Rome": Barone Giorgio Franchetti, interview with the authors, Oct. 21, 1992.

According to Drudi, "He was of course invited": Gabriella Drudi, interview with the authors, Oct. 20, 1992.

De Kooning usually had lunch: General details of de Kooning's life in Rome come from Dorazio, Drudi, de Martiis, and Franchetti, in interviews with the authors.

416 "I taught Bill how to drink wine": Dorazio, interview with the authors.

"There was a regular gang": All quotations from Marisol are from Marisol, interview with the authors, May 15, 1992.

He used black enamel paint: Thomas B. Hess, unpublished notes, AAA.

"He was starting with a shape": Drudi, interview with the authors.

"He was not really engaging himself": De Martiis, interview with the authors.

418 "It was four or five in the morning": Drudi, interview with the authors.

Chapter 28

420 "At the end they kept running after me in mobs": De Kooning, in Jan Bart Klaster, "De Kooning gaat door ik schilder mijn binnenste," *Het Parool*, May 11, 1983.

422 In 1959, Hess published: Thomas B. Hess, *Willem de Kooning* (New York: Braziller, 1959), and Harriet Janis and Rudi Blesh, *De Kooning* (New York: Grove Press, 1960).

"I have ... a bigger feeling of freedom": De Kooning, interview with David Sylvester, "Content Is a Glimpse," *Location* 1 (Spring 1963), 45–53.

Once finished, his loft at 831 Broadway: John Russell, "De Kooning: 'I See the Canvas and I Begin,' " *New York Times*, Feb. 5, 1978.

"Where *is* everybody?": Elaine de Kooning in John Gruen, *The Party's Over Now* (New York: Viking, 1967), 220–21.

423 "One time, Elizabeth Taylor": Martin Pajeck, interview with the authors, June 16, 1995.

Once, a European with a sombrero: Mark Stevens, "De Kooning in Bloom," *Newsweek*, Feb. 20, 1978.

423 According to a friend of Dane's: Pepe del Negro, interviews with the authors, Nov. 8 and 20, 1991.

Not long after the phone was installed: Thomas B. Hess, *Willem de Kooning* (New York: Museum of Modern Art, 1968), 102.

424 He called it "erasing the mice": Joan Ward, multiple interviews with the authors, Aug. 12, 1991, to Apr. 17, 2004.

De Kooning objected when: Hess, *Willem de Kooning*, 102.

"New York is a great city": Hansmaarten Tromp, "Willem de Kooning: 'Elke stijl is fraude,' " *De Tijd*, Oct. 21, 1977.

"We felt like supplicants": Anonymous friend of the Fried family, interview with the authors, June 18, 1993.

425 One morning the phone rang: Ibid.

"They were these big": Nathan Oliveira, interview with the authors, Nov. 20, 1998. Oliveira recalled that de Kooning was "a little insecure" around printmaking. Everyone assumed it would take him all day to produce the lithographs, but he was done in half an hour.

But de Kooning, according to Joan: Ward, interviews with the authors.

"I was doing great": Ibid.

Kligman told her friends "Joan's back with the baby": Ibid.

On April 14, 1961, he purchased: Property deeds are in the town hall of East Hampton. Unpublished correspondence about the purchases is in the collection of Joan Ward, shown to the authors courtesy of Joan Ward.

426 "Let's go get a taxi-crab": Mera McAlister, interview with the authors, July 12, 1992.

"I want to learn how to swim": Ibid.

According to the friend, "Lisa took a step back": Tom Ferrara, multiple interviews with the authors from July 8, 1991, to Feb. 16, 1996.

He said to a friend: Anonymous friend of the Frieds, interview with authors.

Lisa herself: Lisa de Kooning, interview with the authors, July 18, 1991, with occasional subsequent conversations, 1991–2004.

427 But then the drinking began: Elizabeth (Betsy) Zogbaum, interview with the authors, Oct. 8, 1990.

De Kooning now began to see Ruth less often: Ward, interviews with the authors.

In late 1961 or 1962, he began an affair: Anonymous friend of the Frieds, interview with the authors.

In early 1964, she begged him: Unpublished letter from Marina Ospina to Willem de Kooning, in de Kooning's studio and correspondence files. The Willem de Kooning Foundation, New York.

Mera McAlister was another pretty girl: All quotations from McAlister and details about her life are from McAlister, interview with the authors.

429 The boy called de Kooning's paintings: Ibid.

A doctor at the hospital: Ibid.

430 "I was in the store": Joop Sanders, multiple interviews with the authors, Oct. 31, 1990, to Mar. 13, 1993.

Once, after a woman hit de Kooning: McAlister, interview with the authors.

In December 1960, a drunken de Kooning: "De Kooning, Sued in Bar Fight, Is Too Busy Painting to Appear," *New York Times*, Oct. 12, 1961.

De Kooning said he merely picked up a glass: untitled article, *New York Post*, Oct. 15, 1961.

Keeping a straight face: *New York Times*, Oct. 12, 1961.

431 "We searched every one of his haunts": del Negro, interviews with the authors.

Rauschenberg once said: Robert Rauschenberg, in "Willem de Kooning, on His Eighty-Fifth Birthday," *Art Journal* (Fall 1989), 232.

"They became very good friends": Esteban Vicente, interviews with the authors, May 24, 1990, and Aug. 16, 1991.

432 "One should always be drunk": Charles Baudelaire, "Get Drunk," in *Paris Spleen* (New York: New Directions, 1947).

"That's my kind of space": Graham Nickson, quoting Mercedes Matter, in conversation with the authors, winter 2002.

"I went to the Cedar": Oliveira, interview with the authors.

Elaine once quipped: Anonymous friend of the Fried family, interview with the authors, July 8, 1992.

433 After doing so, the assistant was about to hang up: Ibid.

Notes

433 She adored the president: Eddie Johnson, a former student and assistant of Elaine's, interview with the authors, Aug. 2, 1994.

434 "Later, Bill came by": Anonymous friend of the Frieds, interview with the authors.
And yet, a vague new idea: Irving Sandler, "Conversation with de Kooning," in "Willem de Kooning, on His Eighty-Fifth Birthday," *Art Journal* (Fall 1989), 216–17.
Relations between de Kooning and Janis: Lee Eastman, interviews with the authors, Mar. 7 and Sept. 12, 1990.

435 Around the time of de Kooning's great gallery success: "Sixteen Americans," Museum of Modern Art, New York, 1959.
Then, in October 1961: "American Abstract Expressionists and Imagists," Solomon R. Guggenheim Museum, New York, 1961.
"Politically, Arnason's exhibition": Florence Rubenfeld, *Clement Greenberg: A Life* (New York: Scribner, 1997), 232.
As reported by the writer Lionel Abel: Lionel Abel, *The Intellectual Follies: A Memoir of the Literary Venture in New York and Paris* (New York: Norton, 1984), 212.
"In actuality what happened": Rubenfeld, *Greenberg*, 232–34.

436 "Every year you have to knock out your opponent": Marca-Relli, interview with the authors, May 1, 1991.
To give the show more weight: "Out of the Picture," *Newsweek*, Mar. 12, 1962.
Hess could always be counted upon: Thomas B. Hess, in "Recent Paintings by Willem de Kooning," Sidney Janis Gallery, Mar. 1962.

437 Even favorably disposed critics such as Dore Ashton: Ashton, "Art," *Arts and Architecture*, May 1962.
"Oh, there's nothing to see": Alcopley, interviews with the authors, Apr. 28 and June 6, 1990.
He had also been seriously ill: Zogbaum, interview with the authors.

438 "It was a bright afternoon": Fielding Dawson, *Franz Kline: An Emotional Memoir* (New York: Pantheon, 1967), 109–11.
The funeral was at St. Bartholomew's: Anne Wedgwood Schwertley, interview with the authors, Feb. 15, 1995.

439 "She looked like a Christmas tree.": Zogbaum, interview with the authors.
De Kooning left very late: Schwertley, interview with the authors.
Eventually, Harold Rosenberg found de Kooning: Jack Kroll, conversation with the authors, 1995.
"He had asked at the local lumber company": Ed Mobley, interview with the authors, Feb. 20, 1996. All quotations from Mobley are from this interview.
Then, in the spring of 1962: Lila Moss, interview with the authors, spring 1996.

440 At Ibram and Ernestine Lassaw's house: Ernestine Lassaw, interview with the authors, Aug. 8, 1991.
De Kooning also dreamed of other qualities: Mobley, interview with the authors.
In September 1962, de Kooning asked: Lee Eastman, interviews with the authors, Mar. 7 and Sept. 12, 1990.
Later that fall, de Kooning paid: Land deeds are in the town hall of East Hampton. Details of the land purchase are in unpublished letters from de Kooning's studio files, shown to the authors, courtesy of Joan Ward.

441 That November, the Sidney Janis Gallery: "The New Realists," Sidney Janis Gallery, New York, Oct. 1962.
De Kooning went to Fifty-seventh Street: Pajeck, interview with the authors.
On December 19, 1962: "Arshile Gorky, 1904–1948," Museum of Modern Art, New York, 1962.

442 The brushstrokes dissolved into light: Scott Burton, "Generation of Light," *ArtNews Annual* (1969), 22, quoted in *Willem de Kooning: Paintings*, exhibition catalog (Washington: National Gallery of Art, 1994), 161.
The palette of yellows, peaches, and whites: McAlister, interview with the authors.
In fact, as the critic and curator Lynne Cooke has suggested: Lynne Cooke, "De Kooning and the Pastoral: The Interrupted Idyll," in *Willem de Kooning, from the Hirshhorn Museum Collection,* exhibition catalog (New York: Rizzoli, 1993), 89–151.
"I'm not a pastoral character": De Kooning, interview with David Sylvester, "Content Is a Glimpse," *Location* 1 (Spring 1963), 45–53.

443 "the hangover years": Marjorie Luyckx, interview with the authors, June 14, 1994.

Chapter 29

447 "I don't want to be new anymore": De Kooning, in "Vanity Fair: The New York Art Scene," *Newsweek* cover story, Jan. 4, 1965.

"Actually I've fallen in love with nature": De Kooning, in an unedited transcript of an interview with George Dickerson, Sept. 3, 1964. Included in Thomas B. Hess papers, AAA.

448 "He liked very poor": Clarence and Dorothy Barnes, interview with the authors, Aug. 6, 1991.

"Snob Hill is really nice": De Kooning, interview with Harold Rosenberg, in Harold Rosenberg, *De Kooning* (New York: Abrams), 48.

In the scrub land: Ibid, 47.

"For a painter like myself": Letter to Joseph and Olga Hirshhorn, May 13, 1965, published in "Artist and Patron: An Exchange of Letters," ed. Judith Zilczer, in Judith Zilczer, *Willem de Kooning, from the Hirshhorn Museum Collection*, exhibition catalog (New York: Rizzoli, 1993), 159. Subsequent correspondence between de Kooning and Hirshhorn is taken from this catalog. This and subsequent letters from de Kooning to Hirshhorn courtesy the Hirshhorn Museum and Sculpture Garden, Smithsonian Institution. All words © The Willem de Kooning Foundation/Artists Rights Society, New York.

According to one friend: Kenneth Koch, interview with the authors, Sept. 7, 1990.

And he had a Dutch workingman's: Joan Ward, multiple interviews with the authors, Aug. 12, 1991, to Apr. 17, 2004.

450 De Kooning later said: Daniel Frasnay, "De Kooning," in *The Artist's World* (New York, 1969), 221–33.

Joop Sanders observed: Joop Sanders, multiple interviews with the authors, Oct. 31, 1990, to Mar. 13, 1993.

Lisa herself said: Lisa de Kooning, interview with the authors, July 18, 1991, with occasional subsequent conversations,1991–2004.

"You're always putting things": Ward, interviews with the authors.

451 Then, a night or so later: Susan Brockman, interviews with the authors, Apr. 24, 1992, and Jan. 14, 1998.

Brockman was an elegant dancer: Ibid.

452 According to de Kooning's old friend: Mary Abbott, interviews with the authors, Feb. 5 and Apr. 7, 1992.

"Bill was there": Unless otherwise noted, information about Brockman's relationship with de Kooning comes from Brockman, interviews with the authors.

"Empathize, don't criticize": Ibid.

454 Lisa would sometimes look: Ward, interviews with the authors.

"I wouldn't say he was madly in love": Ibid.

Around New Year's Day: Ibid.

455 Just how deep de Kooning's feelings ran: Conversation of de Kooning, Harold Rosenberg, and Thomas B. Hess, March 2, 1964 [East Hampton, NY], untranscribed tape recording made by Betty Wolff. Thomas B. Hess papers, AAA.

456 Once, de Kooning, Brockman, and the Lassaws: Brockman, interviews with the authors, and Ibram Lassaw, interviews with the authors, May 23, 1990, and July 2 and 9, 1991.

During this period: Saul Steinberg, interview with the authors, summer 1991.

"It was very upsetting": Rae Ferren, interview with the authors, Sept. 19, 1990.

457 After initially trying: Al Weatherall, interview with the authors, Aug. 26, 1991. All subsequent quotations from Weatherall come from this interview.

He designed the space: De Kooning, interview with Grace Glueck, "A Tenth Street Loft in the Woods," *New York Times*, July 25, 1965.

"I designed it": Ibid.

458 "If he was in East Hampton": Details of Ed Mobley's departure come from Mobley, interview with the authors, Feb. 20, 1996, and interview with Al Weatherall.

459 Another time: Hans Hokanson, interview with the authors, July 22, 1991.

De Kooning gave the discarded windows: Grace Borgenicht, interview with the authors, Mar. 29, 1990.

"Bill was obsessed": Gus Falk, interview with the authors, July 28, 1992.

"The floor was a problem": De Kooning, interview with Hansmaarten Tromp, "Willem de Kooning: 'Elke stijl is fraude,' " *De Tijd*, Oct. 21, 1977.

Accordingly, de Kooning found: Michael Wright, interview with the authors, Aug. 8, 1993.

Notes

See also Avis Berman, "Willem de Kooning: 'I Am Only Halfway Through,' " *ArtNews* 81 (Feb. 1982), 68–73.

459 The basement also contained: Ward, interviews with the authors. Ward spoke specifically of de Kooning's love of the boilers, as did Tom Ferrara, in multiple interviews with the authors from July 8, 1991, to Feb. 16, 1996.

460 According to Jane Freilicher: Jane Freilicher and Joe Hazan, interview with the authors, June 19, 1991.

Once, when his friend Saul Steinberg: Cile Lord Downs, interview with the authors, May 25, 1992.

461 "One time this six-foot": De Kooning, *Newsweek*, unpublished interview with Ann Ray Martin, background file, Nov. 1, 1967.

It was Athos Zacharias: Athos Zacharias, interview with the authors, May 4, 1992.

462 "This house reminds me": De Kooning, unpublished interview with Martin.

"This is to keep alive": No author, "Van verstekeling tot multi-miljonair," *De Telegraaf,* Dec. 9, 1981.

He told still others: Priscilla Morgan, interviews with the authors, Apr. 28, 1992, and Jan. 4, 1995.

Chapter 30

463 "Somebody must bring home the bacon": De Kooning, letter to Joseph and Olga Hirshhorn, Mar. 16, 1965, published in "Artist and Patron: An Exchange of Letters," ed. Judith Zilczer, in Judith Zilczer, *Willem de Kooning, from the Hirshhorn Museum Collection,* exhibition catalog (New York: Rizzoli, 1993), 157. Subsequent correspondence between de Kooning and Hirshhorn cited in this chapter comes from this catalog. Courtesy the Hirshhorn Museum and Sculpture Garden, Smithsonian Institution. All words © The Willem de Kooning Foundation/Artists Rights Society, New York.

"Goethe said that when you're sixty": De Kooning, in an unedited transcript of an interview with George Dickerson, Sept. 3, 1964. Included in Thomas B. Hess papers, AAA.

"There was a heavy atmosphere": Susan Brockman, interviews with the authors, Apr. 24, 1992, and Jan. 14, 1998. Unless otherwise noted, details of Brockman's life with de Kooning come from these interviews.

When the Weatherall brothers: Al Weatherall, interview with the authors, Aug. 26, 1991.

"I am of course looking forward": Letter to Joseph and Olga Hirshhorn, May 13, 1965.

464 At a certain point: Charlotte Willard, "In the Art Galleries," *New York Post Magazine,* Aug. 23, 1964, 44.

He even imagined: Ibid.

465 As de Kooning said at the time: De Kooning, in "Vanity Fair: The New York Art Scene," *Newsweek* cover story, Jan. 4, 1965.

466 "When I came": De Kooning, interview with Harold Rosenberg, in Harold Rosenberg, *De Kooning* (New York: Abrams, 1974), 50.

This new, more physical quality: De Kooning described the exact measurements of his mixture to his old friend Tully Filmus: 1 part safflower oil, 2 parts water, one-half part benzine. Filmus, interviews with the authors, Sept. 17 and Oct. 18, 1991.

Before leaving the city: Leonard Bocour, interviews with the authors, Nov. 30 and Dec. 11, 1992.

When Mary Abbott told him: Mary Abbott, interviews with the authors, Feb. 5 and Apr. 8, 1992. Abbott said that the water had to be heated to make the mixture emulsify properly.

"He'd use teacups": Michael Wright, interview with the authors, Aug. 8, 1993.

467 It was a further, textural effect: Abbott, interviews with the authors.

As de Kooning himself described: Letter to Joseph Hirshhorn, Aug. 4, 1964.

The bicycling became almost a form: Many people noted that de Kooning would be inspired in his painting by things he saw while biking. Specifically, the children of de Kooning's half brother Koos Lassooy recalled that, while they were staying in his studio in the late seventies, he returned from biking and said that he was going to paint things he had seen while biking to Sag Harbor. Interview with the authors, Apr. 1995. In an unedited interview with George Dickerson, de Kooning said, "Now I go on my bicycle down to the beach and search for a new image of the landscape. And I love puddles. When I see a puddle,

I stare into it. Later I don't paint a puddle, but the image it calls up within me. All the images inside me are from nature anyway." Thomas B. Hess papers, AAA.

468 "I said, 'Willem de Kooning' ": Mrs. Henk Hofman, the wife of de Kooning's cousin, interview with the authors, Dec. 1990.

"I have no need": De Kooning, in Dickerson interview.

In fact, de Kooning still sometimes felt: In 1981, de Kooning told a reporter for *De Telegraaf* that, when the Immigration officer asked him during his interview for citizenship, "Have you thought about it enough?" de Kooning answered, "Yes. In your country I'm famous, but in my native country they ignore my paintings." No author, "Van verstekeling tot multi-miljonair," *De Telegraaf*, Dec. 9, 1981.

According to Saul Steinberg: Steinberg, interview with the authors, summer 1993.

469 Ernestine Lassaw: Lassaw, interview with the authors, Aug. 8, 1991.

"We were the only ones": Ibid.

"You go ahead": Ibid.

The article lent both interest and glamour: Harold Rosenberg, "De Kooning," *Vogue* (September 15, 1964), 146–49, 186–87.

Among the modern Medicis: Information on Joseph Hirshhorn comes from many sources, including Hirshhorn, interview with Paul Cummings, AAA, Dec. 16, 1976; Paul Richard, "The Inspired Greed of Joe Hirshhorn," *Washington Post/Potomac*, Sept. 29, 1974, 14–19, 24–26; Vivien Raynor, "4,000 Paintings and 1,500 Sculptures: Joseph Hirshhorn's Mine of Modern Art," *New York Times*, Nov. 27, 1966, 50–55, 60, 64, 69, 72, 77–80; and Emmet John Hughes, "Joe Hirshhorn, the Brooklyn Uranium King," *Fortune*, Feb. 11, 1980.

470 "I've known what it is": Joseph Hirshhorn, in Paul Richard, "Inspired Greed", 14.

He told an interviewer: Ibid.

He went to Gorky's studio: Many details of Hirshhorn's collection come from his interview with Paul Cummings, AAA.

"Those artists were in bad shape": Hirshhorn, AAA.

471 Sometime in 1962: Recollections of Olga Hirshhorn and Hester Diamond, widow of Harold Diamond, to Judith Zilczer, in *Willem de Kooning, from the Hirshhorn Museum Collection*, 151.

After their dinner in Greenwich: Joseph Hirshhorn, *Time*, unpublished background file, Oct. 29, 1964.

According to the lawyer: Lee Eastman, interviews with the authors, Mar. 7 and Sept. 12, 1990.

Abram Lerner, the curator: Unpublished Abram Lerner memoir, delivered by Sidney Lawrence at a Hirshhorn panel marking the opening of the de Kooning retrospective at the museum, Oct. 21, 1993.

Whatever the precise detail: Joop Sanders recalled de Kooning talking happily about Hirshhorn's "right of first view." Sanders, multiple interviews with the authors, Oct. 31, 1990, to Mar. 13, 1993.

472 That October, *Time* called Hirshhorn: *Time*, background file.

"He's been working on a painting": Ibid.

"I feel so much better": Letter to Joseph Hirshhorn, undated, c. Oct. 1964.

Diamond even found: For a discussion of the newspaper "transfers" or "monotypes," as the critic Thomas B. Hess called them, see *Willem de Kooning: Paintings*, exhibition catalog (Washington: National Gallery of Art, 1994), 175.

An assistant recalled carting hundreds: John McMahon, de Kooning's primary assistant from the mid-1960s to the mid-1970s, in panel discussion, the Hirshhorn Museum and Sculpture Garden, Oct. 21, 1993.

"The cost of it is enormous": Letter to Joseph Hirshhorn, May 18, 1964.

473 Over the coming months: Abram Lerner's phrase "inspired greed" was quoted by Paul Richard in his article in the *Washington Post/Potomac*.

According to Lerner: Abram Lerner memoir delivered at the Hirshhorn panel.

Diamond would represent de Kooning: It is unclear exactly what Diamond's role was in Hirshhorn's purchases. He appeared to be representing de Kooning, but he was also a close associate of Joseph Hirshhorn. It is this vagueness that prompted objections from Lee Eastman.

Again and again, de Kooning would tell: Jim Bohary, interviews with the authors, Mar. 14 and Oct. 9, 1991.

474 There could finally be no question: Ward, interviews with the authors.

Notes

475 "I can't get away from the Woman": Douglas Davis, "De Kooning on the Upswing," *Newsweek*, Sept. 4, 1972, 70.

He had first represented de Kooning: Lee Eastman, interviews with the authors, Mar. 7 and Sept. 12, 1990.

"They were innocents": John Eastman, interview with the authors, Mar. 4, 1990, and multiple interviews Feb.–Mar. 2004.

"Through Kootz I met Hans Hofmann": Lee Eastman, interviews with the authors.

Eastman decided to defend de Kooning: Unless otherwise noted, details of the lawsuit come either from interviews with Lee Eastman or interviews conducted with his son, John Eastman, who explained in detail the particulars of the lawsuit. The authors also drew upon Milton Esterow, "Willem de Kooning Files Suit Against Art Dealer," *New York Times*, Mar. 31, 1965, and no author, "Cash Expressionism," *Newsweek*, Apr. 12, 1965.

476 Similarly, he considered Bernard Reis: Reis and his wife Becky had been part of the art scene since the surrealists, with whom they socialized, came to New York; they were also early collectors of the emerging American artists.

In later years, de Kooning would often say: Conrad Fried, interviews with the authors, May 31 and June 1, 1995.

"Before he left": While de Kooning did not routinely write letters, those that he did write often covered five or six pages of legal-size paper.

"I'm not a lecturer": De Kooning, Grace Glueck, "Art Notes," *New York Times*, Feb. 21, 1965.

On the day of the lecture: John and Jodie Eastman, interview with the authors, Mar. 3, 1990.

477 Later, he sent John Eastman: In his letter of apology, de Kooning wrote, "I did behaved [*sic*] terribly irresponcibel [*sic*]. . . . I have an extra selfconscious [*sic*] burden that goes with it, . . . that as an artist I can get away with things" others "cannot, and it makes it worse, and it makes you lose all self respect . . . and it makes one feel like a real louse." Unpublished letter, collection of the Eastmans. © The Willem de Kooning Foundation/Artists Rights Society, New York.

As Lee Eastman put it: Lee Eastman, interviews with the authors.

478 "In this way": Davis, "De Kooning on the Upswing."

"He felt that he was interfering": Mary Abbott, interviews with the authors, Feb. 5 and Apr. 8, 1992.

In the spring of 1965: Susan Brockman, interviews with the authors, Apr. 24, 1992, and Jan. 14, 1998. The further details of their breakup come from these interviews.

479 "I really felt love": Ibid.

That autumn and throughout 1966: Joan Ward, multiple interviews with the authors, Aug. 12, 1991, to Apr. 17, 2004. Unless otherwise noted, the legal details concerning de Kooning's will and efforts at divorce come from Joan Ward and unpublished correspondence in Ward's possession. Shown to the authors courtesy Joan Ward.

480 "He was afraid of divorce": Ibid.

Polier discussed it: Shad Polier, letter to Joan Ward, Mar. 1966. Courtesy of Joan Ward.

After a solitary Christmas: De Kooning kept extensive files throughout the sixties and early seventies of expenses, checks, and business correspondence, with separate accounts devoted to home and studio. Much of the information and dates in this period concerning doctors and hospitalization come from these records, now on file at The Willem de Kooning Foundation, New York.

481 For company, de Kooning turned increasingly: Athos Zacharias, interview with the authors, May 4, 1992.

Born in Kentucky: John McMahon, panel at the Hirshhorn Museum and Sculpture Garden in conjunction with the de Kooning retrospective of 1993–94, Oct. 21, 1993.

According to Michael Wright: Wright, interview with the authors, Aug. 8, 1993. All of the following quotations are from this interview.

482 According to a neighbor: Cile Lord Downs, interview with the authors, May 25, 1992.

Often, said Zacharias: Zacharias, interview with the authors.

483 "He had all of these I call 'em leeches": Al Weatherall, interview with the authors, Aug. 26, 1991.

483 Finally, McMahon came up to her: Molly Barnes, interviews with the authors, May 2 and 14, 1997.

O'Hara and a group of travelers: See Brad Gooch, *City Poet* (New York: Knopf, 1993).

484 De Kooning arrived with a "business-size" checkbook: Joe LeSueur, *Digressions on Some Poems by Frank O'Hara* (New York: Farrar, Straus and Giroux, 2003), 302.

"When I spoke his name": De Kooning, in Gooch, *City Poet*, 463.

"I liked him immediately": Ibid, 453.

"We were very good friends": De Kooning, in Peter Engelsman, "Jongens onder mekaar," *Het Algemeen Handelsblad*, Sept. 21, 1968.

He felt an affinity: De Kooning, *Newsweek*, unpublished interview with Ann Ray Martin, background file Nov. 1, 1967.

Although he emphasized: De Kooning, in L. van Duinhoven, "Willem de Koonings Levenswerk in Stedelijk Museum: 'Mijn kunst is een ouwe hoed,' " *Algemeen Dagblad*, Sept. 18, 1968.

485 "The future lies": Ibid.

When men landed on the moon: Piero Dorazio, interview with the authors, Oct. 19, 1992.

486 Once, when the country-store owner: Clarence and Dorothy Barnes, interview with the authors, Aug. 6, 1991.

487 "I'm 63 now": De Kooning, *Newsweek*, unpublished interview, Ann Ray Martin. Portions of the quote appeared in David L. Shirey, "Don Quixote in Springs," *Newsweek*, Nov. 20, 1967, 80.

The melancholy shadow: *De Kooning: Drawings* (New York: Walker and Company, 1967).

"*Oh*, on that cross": de Kooning to Emilie Kilgore, interviews with the authors, July 24–26, 2003. De Kooning emphasized to Kilgore that what obsessed him was the physical agony of the Crucifixion, not its spiritual dimensions.

Chapter 32

489 "I only want to be happy in an old-fashioned way": De Kooning, letter to Joseph and Olga Hirshhorn, Apr. 12, 1968, published in "Artist and Patron: An Exchange of Letters," ed. Judith Zilczer, in Judith Zilczer, *Willem de Kooning, from the Hirshhorn Museum Collection*, exhibition catalog (New York: Rizzoli, 1993), 164. All subsequent correspondence between de Kooning and Hirshhorn cited in this chapter comes from this catalog. Courtesy the Hirshhorn Museum and Sculpture Garden, Smithsonian Institution. All words © The Willem de Kooning Foundation/Artists Rights Society, New York.

Early in 1967: Grace Glueck was one of the first to break the news, in "Art Notes," *New York Times*, Jan. 29, 1967.

"He was trying to get artists": Joan Mitchell, interview with the authors, spring 1991.

Eastman, never one to mince words: Lee Eastman, interviews with the authors, May 7 and Sept. 12, 1990. All subsequent quotations from Eastman come from these interviews.

490 As the *New York Times* noted: Glueck, "Art Notes."

The antithesis of: Paul Richard, "The Screaming de Koonings," *Washington Post* and *San Francisco Chronicle*, Dec. 3, 1967.

As de Kooning joked: L. van Duinhoven, "Willem de Koonings Levenswerk in Stedelijk Museum: 'Mijn kunst is een ouwe hoed,' " *Algemeen Dagblad*, Sept. 18, 1968.

After several shaky years: Letter to Joseph and Olga Hirshhorn, late 1966.

Hardworking and ambitious: Information on Xavier Fourcade comes mainly from an interview with Fourcade in Laura de Coppet and Alan Jones, *The Art Dealers* (New York: Clarkson N. Potter, 1984), 180–85; a catalog prepared by Sotheby's for the estate sale of Fourcade's art entitled "Contemporary Art from the Estate of Xavier Fourcade: New York, Nov. 4, 1987"; and a phone conversation with Jill Weinberg Adams, who worked with Fourcade at his gallery, July 15, 1992.

"One of those princely Frenchmen": Bob Spring, interview with the authors, June 30, 1995.

In one of his first: Xavier Fourcade, letter to de Kooning, Jan. 19, 1967, in the collection of the artist. Ward kindly granted the authors access to Fourcade's letters.

491 Early on in their relationship: Ibid.

Almost every Sunday: Weinberg Adams, conversation with the authors.

Once, he even threw a pot of paint: Recollection of a bystander in the studio, anonymous, interview with the authors, May 1, 1997.

Notes

492 What was not announced: Fourcade's behind-the-scenes maneuvering with the Whitney is documented in unpublished correspondence between Xavier Fourcade and John Bauer, associate director of the Whitney, collection of the artist, courtesy of Joan Ward.

Together with Lee Eastman: Eric Protter, interview with the authors, Apr. 29, 1992.

Early in 1967: Knoedler inventory, unpublished collection of the artist, courtesy of Joan Ward.

493 At the time: Michael Wright, interview with the authors, Aug. 8, 1993.

"He'd take me upstairs": Ibid.

Abram Lerner once opened one: Unpublished Abram Lerner memoir, read by Sidney Lawrence at a Hirshhorn Museum panel to mark the opening of the 1993 de Kooning retrospective at the museum, Oct. 21, 1993.

He asked Lou Rosenthal: Lou Rosenthal, interview with the authors, Oct. 23, 1991.

In addition to the painter's: Lee Eastman, unpublished letter to Irving Markowitz, Aug. 6, 1965, collection of Joan Ward.

494 That spring: Joan Ward, multiple interviews with the authors, Aug. 12, 1991, to Apr. 17, 2004.

For Lisa herself: Lisa de Kooning, interview with the authors, July 18, 1991, with occasional subsequent conversations, 1991–2004.

"I remember him coming": Ibid. All subsequent quotations from Lisa de Kooning are from these interviews.

Once, when she was in fourth grade: Ward, interviews with the authors.

495 At one point: Ellen Adler, interview with the authors, Feb. 20, 1991.

496 "At that point": Elaine Benson, interview with the authors, Mar. 4, 1990.

497 On August 4: Knoedler inventory, courtesy Joan Ward.

De Kooning had often described: Conrad Fried, interviews with the authors, May 31 and June 1, 1995. Also Tom Ferrara, multiple interviews with the authors, July 8, 1991, to Feb. 16, 1996. See also de Kooning, interview with David Sylvester, "Content Is a Glimpse," *Location* 1 (Spring 1963), 45–53, in which de Kooning says, describing how he loved to drive along highways and see signs: "Most people want to take those signs away—and it would break my heart. You know, all those different big billboards. There are places in Connecticut and New England where they are not allowed to put those signs, I think, and that's nice too, but I love those grotesque signs."

498 When questioned at the time about the suggestiveness: de Kooning, *Newsweek*, unpublished interview with Ann Ray Martin, background file, Nov. 1, 1967.

At a secondhand furniture store: Ward, interviews with the authors.

Chapter 33

500 "You have to change to stay the same": Tom Ferrara, multiple interviews with the authors, July 8, 1991, to Feb. 16, 1996.

On the evening: Richard Shepard, "Knoedler's Opens de Kooning Show," *New York Times*, Nov. 12, 1967.

According to *Time*: "De Kooning's Derring-Do," *Time*, Nov. 17, 1967.

"I don't go to openings": *Newsweek*, unpublished interview with Ann Ray Martin, background file, Nov. 1, 1967.

Two weeks before: Liquor receipt from unpublished studio files, now at The Willem de Kooning Foundation, New York.

The most damning review: Hilton Kramer, "De Kooning's Pompier Expressionism," *New York Times*, Nov. 19, 1967.

501 Irving Sandler: Irving Sandler, "Reviews: New York—Willem de Kooning: Solomon R. Guggenheim Museum," *ArtForum* (Summer 1978), 64.

Dore Ashton, also a strong supporter: Dore Ashton, "New York Commentary: De Kooning at Knoedler," *Studio International* (January 1968), 39.

Paul Richard: Paul Richard, "The Screaming de Koonings," *Washington Post* and *San Francisco Chronicle*, Dec. 3, 1967.

502 During the sixties: Dwight MacDonald, "Masscult and Midcult," *Partisan Review* (Spring 1960), 203–33.

The art historian Robert Rosenblum: Rosenblum, "Carnal Spirits: A Coven of de Kooning's Women," in *Willem de Kooning, Mostly Women: Drawings and Paintings from the John and Kimiko Powers Collection* (New York: Gagosian Gallery, 2000), 71.

503 "It all fits real good": De Kooning to Ferrara, interviews with the authors.

By the end of the year: Knoedler 1967 inventory, unpublished, collection of the artist. Courtesy of Joan Ward.

De Kooning agreed to the plan: Recollection of Eduard de Wilde, told to *Newsweek* reporter Willem Vuur prior to the 1968 retrospective, unpublished file, undated, fall 1968.

Both Elaine and de Kooning: Joop Sanders, multiple interviews with the authors, Oct. 31, 1990, to Mar. 13, 1993.

Finally, de Wilde came: *Newsweek*, Vuur.

504 De Kooning would never admit: Studio records, Dec. 10, 1967.

Once, after listening: Conversation with Christophe de Menil, 1994.

"They used to have": Michael Wright, interview with the authors, Aug. 8, 1993.

505 "I picked him up": Irving Markowitz, interview with the authors, May 26, 1992.

On December 12: Details of the trip preparation come from unpublished studio records now at The Willem de Kooning Foundation, New York, and from a letter from de Kooning to Joseph Hirshhorn, Apr. 12, 1968, published in "Artist and Patron: An Exchange of Letters," ed. Judith Zilczer, in Judith Zilczer, *Willem de Kooning, from the Hirshhorn Museum Collection,* exhibition catalog (New York: Rizzoli, 1993), 164. All subsequent correspondence between de Kooning and Hirshhorn cited in this chapter comes from this catalog. Courtesy the Hirshhorn Museum and Sculpture Garden, Smithsonian Institution. Words © The Willem de Kooning Foundation, Artists Rights Society, New York.

Together with Hess and Fourcade: Details of the trip come primarily from Joan Mitchell. Mitchell was a friend of Fourcade's and exhibited with him. She was also an old friend of de Kooning's. Mitchell, interview with the authors, spring 1991.

506 "And so Xavier and I": Letter to Joseph and Olga Hirshhorn, Dec. 5, 1968.

Sylvester's own view: Recollections of David Sylvester, memorial for de Kooning, Museum of Modern Art, Sept. 24, 1997, unpublished.

"My pictures have been getting bigger": *Newsweek,* background file, David Shirey, for "Don Quixote in Springs," Nov. 20, 1967.

"I'm keeping up": Joan Levy, interview with the authors, June 13, 1995.

The appearance of the cheap curtains: Lisa de Kooning, interviews with the authors, July 18, 1991, with occasional subsequent conversations, 1991–2004.

"I've never had a retrospective": *Newsweek,* background file, Shirey.

507 "I was kind of scared": *Newsweek,* Vuur.

"I think I tried": De Kooning, in Paul Hellman, "De Verloren Zoon Zit Goed," *Algemeen Dagblad,* Dec. 24, 1976.

When his mother and sister: *Newsweek,* Vuur.

Two were at the Stedelijk: Eduard de Wilde, in an article without byline, "Eindelijk barst het beheerste geweld van De Kooning hier los," *Het Vrije Volk,* Sept. 20, 1968. Also *Newsweek,* Vuur.

As one Dutch writer: Ed Wingen, "De Meester Komt Beroemd Terug," *De Telegraaf,* Apr. 13, 1968.

508 "I don't understand": Peter Engelsman, "Jongens onder mekaar," *Het Algemeen Handelsblad,* Sept. 21, 1968.

Because he feared flying: *Newsweek,* background file, Shirey.

He had not invited her: Lisa de Kooning, interview with the authors. *Newsweek,* background file, Vuur, also quoted Fourcade as saying that de Kooning intended to go alone, but after a binge decided to take his family.

"He was very dear": Lisa de Kooning, interview with the authors.

509 At one point: Leo Cohan, in Henry Raymont, "De Kooning Back in Netherlands," *New York Times,* Sept. 20, 1968.

The year before: De Kooning, letter to his sister, Marie van Meurs–de Kooning, Dec. 2, 1967, collection of Antonie Breedveld. Courtesy of Breedveld. © The Willem de Kooning Foundation/Artists Rights Society, New York.

At three-thirty a.m.: Friso Endt, "Royal Dutch Welcome for Prodigal de Kooning," *Life* (Atlantic edition), Oct. 28, 1968, 72.

"It was still very early": *Newsweek,* Vuur.

510 "I knew that Rotterdam": Endt, "Royal Dutch Welcome."

De Kooning was almost as fearful: Once, when his assistant Michael Wright persuaded the painter to go fishing on a boat, de Kooning became seasick and stayed below deck. His only comment was, "I like the light out here." According to Wright, "He was terribly afraid of

the water. He was even scared of going in the tub when he was drunk. He thought he'd slip and fall and drown." Interview with the authors. One time when Lisa was small and threw a fit about getting into a friend's boat, someone suggested that the girl show "more character." De Kooning refused to make her overcome her fears, saying, "Too much character can be bad, too."

510 Also waiting was: Interview with Leendert de Kooning, Feb. 6, 1991; multiple interviews with Joan Ward, Aug. 12, 1991, to Apr. 17, 2004.

511 He wrote his half-brother: De Kooning, letter to his half brother Leendert de Kooning, unpublished, in the possession of the de Kooning family in Holland. Courtesy the de Kooning family. Words © The Willem de Kooning Foundation/Artists Rights Society, New York. "I asked the driver": *Newsweek*, Vuur.
"I was astonished": Ibid. Other details of this sightseeing trip come from *Newsweek*, Vuur.

512 Although de Kooning's arrival: Raymont, "De Kooning."
"When a biographical film": Ibid.
Thomas Hess, who spoke: Thomas B. Hess remarks, reprinted in *De Kooning, January 1968–March 1969*, exhibition catalog (M. Knoedler and Co., Inc., 1969).
"I have never seen": Eduard de Wilde, in "The Native Returns," *Newsweek*, Oct. 7, 1968.
As he told one reporter: De Kooning, in L. van Duinhoven, "Willem de Koonings Levenswerk in Stedelijk Museum: 'Mijn kunst is een ouwe hoed,' " *Algemeen Dogblad*, Sept. 18, 1968.

513 When asked who were the reigning artists: Ibid.
He was unable to say anything: "The Native Returns," *Newsweek*.
According to one reviewer: Charlotte Willard, "De Kooning: The Dutch-born U.S. Master Gathers in the International Honors," *Look*, May 27, 1969, 54–59.
Deliverance came: Details of Marie's meeting with de Kooning come from an interview with the children of Koos Lassooy with the authors, April 1985, and from Willard, *Look*.
"Marie had kind of a husky voice": Joan Ward, interviews with the authors

514 For years, he had helped: Leo Cohan, in Ben Dull, "Willem de Kooning is terug," *Het Parool*, Sept. 18, 1968.
However, the day after the opening: Ken Wilkie, "Willem de Kooning: Portrait of a Modern Master," *Holland Herald* 17 (March 1982), 22–34.
As Koos said later: Ibid.
De Kooning found his mother: De Kooning, in Jan Bart Klaster, "De Kooning gaat door ik schilder mijn binnenste," *Het Parool*, May 11, 1983.
With a kind of head-shaking: Dan Budnik, phone interview with the authors, Jan. 12, 1994.
The same day: Leendert de Kooning, interview with the authors, Feb. 6, 1991.
Two days after the opening: "The Native Returns," *Newsweek*.
After a few days: *Newsweek*, Vuur.

515 "It was like old times": Ibid.
"There was a small bridge": Endt, "Royal Dutch Welcome."
"All those highways": Ibid.
"I really was afraid to come": Raymont, "De Kooning."
Now he began to speak: Endt, "Royal Dutch Welcome."
"How do you like my Dutch?": *Newsweek*, Vuur.

516 "I can't leave my painting": Newsweek, background file, Shirey.
And so, when the day came: Ward, interviews with the authors.
Leendert was surprised: Leendert de Kooning, interview with the authors.
"We would set up": Cile Lord Downs, interview with the authors, May 25, 1992.
Soon afterward: Letter to Joseph and Olga Hirshhorn, Dec. 5, 1968.

517 Writing in the *Times:* Edward Lucie-Smith, "Victim of History," *Times*, Dec. 8, 1968.
In January, Hirshhorn asked: In 1966, after years of being wooed, Hirshhorn promised his massive collection to the Smithsonian, on the Mall in Washington. Work was beginning on the building, designed by Gordon Bunshaft of the firm of Skidmore, Owings and Merrill.
In a letter to Hirshhorn: Letter to Joseph and Olga Hirshhorn, Jan. 1969.

518 Fourcade responded to the failure: Knoedler price list, unpublished, collection of the artist, courtesy of Joan Ward.
It seemed that every magazine: See, for example, Charlotte Willard, "De Kooning: The Dutch-born U.S. Master."
"I didn't want to go": Irving Markowitz, interview with the authors, May 26, 1992.

519 "I got dressed up": Mary Abbott, interviews with the authors, Feb. 5, 1992, and Apr. 8, 1992.
One intelligent, if withering, review: Walter Darby Bannard, "Willem de Kooning's Retrospective at the Museum of Modern Art," *ArtForum* 68 (April 1969), 40–42.
In *ArtNews:* Andrew Forge, "De Kooning in Retrospect," *ArtNews* 68 (March 1969), 44–47, 61–62, 64.

520 *ArtNews,* where Hess was still editor: John Perreault, "The New De Koonings," *ArtNews* 68 (March 1969), 48–49, 68.

521 "I always say": De Kooning, in John Gruen, *The Party's Over Now* (New York: Viking, 1967), 225.

522 "Bring me a small shot of whiskey": Ibid.

Chapter 34

523 "The figure is nothing": De Kooning, in Charlotte Willard, "De Kooning: The Dutch-born U.S. Master Gathers in the International Honors," *Look,* May 27, 1969, 58.
What would you think: Interviews with Priscilla Morgan, Apr. 28, 1992, and Jan. 4, 1995. Many details of the Spoleto Festival, as well as background on de Kooning's Rome trip, come from Morgan.
When a reporter in Amsterdam: *Newsweek,* unpublished file, Willem Vuur, undated, fall 1968.
Once de Kooning agreed: Letter to Joseph and Olga Hirshhorn, May 1, 1969, published in "Artist and Patron: An Exchange of Letters," ed. Judith Zilczer, in Judith Zilczer, *Willem de Kooning, from the Hirshhorn Museum Collection,* exhibition catalog (New York: Rizzoli, 1993), 168. Subsequent correspondence between de Kooning and Hirshhorn cited in this chapter comes from this catalog. Courtesy the Hirshhorn Museum and Sculpture Garden, Smithsonian Institution. Words © The Willem de Kooning Foundation, Artists Rights Society, New York.

524 He was sitting with: Morgan, interviews with the authors.
"I was driving through": Herzl Emanuel, interviews with the authors, Feb. 25 and October 22, 1992. All subsequent quotations come from this interview.

527 De Kooning was also given: Thomas B. Hess papers, AAA.
De Kooning and Brockman got along well: Susan Brockman, interviews with the authors, Apr. 24, 1992, and Jan. 14, 1998.

528 Not long after his return: De Kooning, letter to Herzl Emanuel, unpublished, courtesy of Herzl Emanuel. Words © The Willem de Kooning Foundation/Artists Rights Society, New York.
At the recommendation of Sculpture House: Bob Spring, interview with the authors, June 30, 1995. Information also comes from Roger Anthony at The Willem de Kooning Foundation.
When Christian finally finished: Spring, interview with the authors.

529 Although the Italian trip: John McMahon had his own building business on Long Island, and he could not be on call at the studio twenty-four hours a day. Markowitz, in turn, had grown weary of the constant vigilance required when de Kooning went on a bender and disliked putting him under what amounted to house arrest. "If he got out, we'd go chase him eventually," said Markowitz. "Sometimes the cops would pick him up. Or if he became a problem, they'd call me or somebody else. A couple of times I had to take him to Southampton Hospital." Irving Markowitz, interview with the authors, May 26, 1992.
In his "The Renaissance and Order": A talk delivered at Studio 35 in 1950, reprinted in *trans/formation* 1 (1951), 85–87.
For assistance in planning it: Phone conversation with Kermit Lansner, 1992. Most chronologies erroneously place this trip to Japan in January 1969, as de Kooning himself once recollected it. However, his letter to Joseph and Olga Hirshhorn in February 1970—printed in the Hirshhorn catalog—makes clear that he actually made the trip at the beginning of 1970. This, of course, also coincides with the opening of the World's Fair in Japan in 1970, where Isamu Noguchi was working on a project. The evidence of the lithographs that he began to make later that year, which show a direct connection to Sumi painting, also confirm the timing.
A noted figure in Japan: Bernard Krisher, phone interview, Sept. 14, 1992. Most of the details about de Kooning's trip come from Krisher.

Notes

530 "I think the real purpose": Ibid.
531 He enjoyed his larger-than-life stay: Lee Eastman, interviews with the authors, Mar. 7 and Sept. 12, 1990.
"He was very impressed": Markowitz, interview with the authors.
In April, the English sculptor: Recollection of Xavier Fourcade in Laura de Coppet and Alan Jones, *The Art Dealers* (New York: Clarkson N. Potter, 1984), 180–85.
"He was big": Michael Wright, interview with the authors, Aug. 8, 1993.
532 According to Molly Barnes: Barnes, interviews with the authors, May 2 and May 14, 1997.
533 "We were a terrible bunch of kids": Heidi Raebeck, interviews with the authors, Apr. 6, 1990, and Jan. 26, 1996.
According to the local art dealer: Elaine Benson, interview with the authors, Mar. 4, 1990.
On paper, Buxton seemed ideal: Many details on Buxton come from Joan Levy, who attended Buxton during Lisa de Kooning's time there and at one point roomed with her. Interviews with the authors, Feb. 6 and June 13, 1995.
"It was supposed to be": Ibid.
534 Both also visited: Sidney Simon, interview with the authors, Oct. 19, 1994.
535 Although Hollander encouraged de Kooning: Irvin Hollander and Lanier Graham, *Willem de Kooning, The Printer's Proofs, from the Collection of Irwin Hollander, Master Printer*, exhibition catalog (New York: Salander-O'Reilly Galleries, 1992). Another inducement to make lithographs with Hollander was Fred Genis, a Dutchman working with Hollander.
The first lithographs: Many details on de Kooning's output came from John Ashbery, "Willem de Kooning: A Suite of New Lithographs Translates His Famous Brushstroke into Black and White," *ARTnews Annual* 37 (October 1971), 118–28.

Chapter 35

536 "You made me over": Emilie Kilgore, interviews with the authors, July 24–26, 2003.
After dinner, Kilgore found herself: Ibid. Unless otherwise noted, details on Kilgore's relationship with de Kooning come from these interviews.
539 "By that time I was a little tired": Joan Ward, multiple interviews with the authors, Aug. 12, 1991, to Apr. 17, 2004.
540 When de Kooning received the proofs: Emilie's name can be seen scrawled across "Valentine," a lithograph from de Kooning's 1970 series, in Irvin Hollander and Lanier Graham, *Willem de Kooning, The Printer's Proofs, from the Collection of Irwin Hollander, Master Printer*, exhibition catalog (New York: Salander-O'Reilly Galleries, 1992).
Between 1970 and 1979: Kilgore, interviews with the authors.
541 "The Egyptians named": Letter to Emilie Kilgore, courtesy of Kilgore. Words in this and all subsequent letters cited in this chapter are © The Willem de Kooning Foundation/Artists Rights Society, New York. None of the letters to Kilgore has been published. She kindly read excerpts from them to the authors.
"Darling Mimi": Letter to Kilgore.
543 "There were neighbors nearby": Kilgore, interviews with the authors.
At the artist's request: Bob Spring, interview with the authors, June 30, 1995.
"You use a torch": Ibid.
The English critic: David Sylvester, in *Willem de Kooning Sculpture*, exhibition catalog (New York: Matthew Marks Gallery, 1996), 49.
De Kooning himself liked to quote Brancusi: Kilgore, interview with the authors.
544 So in June 1971: Studio records, unpublished, show that David Christian was on the de Kooning payroll from June 1971 to May 1972, with one additional month in February 1973.
"I wasn't obliged": De Kooning, interview with Judith Wolfe, Mar. 3, 1981, in Judith Wolfe, *Willem de Kooning: Works from 1951–1981*, exhibition catalog (East Hampton, NY: Guild Hall Museum, 1981).
"De Kooning's audacity": Peter Schjeldahl, "De Kooning's Sculpture," in Philip Larson and Peter Schjeldahl, *De Kooning: Drawings/Sculpture*, exhibition catalog (New York: Walker Art Center [Minneapolis] and E. P. Dutton, 1974).
Now he decided to use: Joan Levy, interviews with the authors, Feb. 6 and June 13, 1995. Levy recalled that de Kooning bought many pairs of gloves, with the idea of wearing several pairs at once. So did Xavier Fourcade in Laura de Coppet and Alan Jones, *The Art Dealers* (New York: Clarkson N. Potter, 1984), 180–85, and Bob Spring, interview with the authors. See also Wolfe, *Willem de Kooning: Works from 1951–1981*, 15.

544 Christian proved both imaginative and adept: Short, trim, and dapper—"He was quite a beauty," said Irving Markowitz—Christian had one foot in the world of acting. His girlfriend and eventual wife was Katherine Helmond of the TV show *Who's the Boss?* He liked to refer to Helmond as "my mistress," much to the irritation of Joan Ward. Ward, interviews with the authors.

545 According to Christian: David Christian, telephone interview with Judith Wolfe, Apr. 14, 1981, quoted in *Willem de Kooning: Works from 1951–1981*, 15.
"In some ways": De Kooning, in Stella Rosemarch, "De Kooning on Clay," *Craft Horizons* (December 1972), 34–35.
She returned briefly: Lisa de Kooning, interview with the authors, July 18, 1991, and occasional subsequent conversations, 1991–2004. All subsequent citations of Lisa de Kooning are from these interviews.

546 "Lisa was running around": Heidi Raebeck, interviews with the authors, Apr. 6, 1990, and Jan. 26, 1996.

547 which he dated: Spring, interview with the authors.
De Kooning told his old friend: Joop Sanders, multiple interviews with the authors, Oct. 31, 1990, to Mar. 13, 1993.
And so it seemed propitious: Details of the litigation and settlement come from John Eastman, interviews with the authors, Mar. 4, 1990, and Feb.–Mar. 2004, and with Lee Eastman, Mar. 7 and Sept. 12, 1990.

548 According to the curator: Manuel Gonzalez, interviews with the authors, Dec. 6, 1991, and Feb. 22, 1995.
De Kooning's paintings of the last four years: Ibid.
The critic Robert Hughes: "Slap and Twist," *Time*, Oct. 23, 1972.

549 "Sculpture," said Picasso: Dore Ashton, ed., *Picasso on Art: A Selection of Views* (New York: Da Capo, 1972), 114.

Chapter 36

551 "It seems that a lot of artists, when they get older": De Kooning, from *Sketchbook No. 1: Three Americans*, a film produced and directed by Robert Snyder (1960).
"I love you wherever you are": Letter to Emilie Kilgore, courtesy of Kilgore. Words in this and all subsequent letters quoted in this chapter © The Willem de Kooning Foundation/Artists Rights Society, New York. None of the letters to Kilgore has been published. She kindly read excerpts from them to the authors.
And "classy dames": Mary Abbott, interviews with the authors, Feb. 5 and Apr. 8, 1992.
"Music, all kinds of music": Emilie Kilgore, interviews with the authors, July 24–26, 2003.
Most details of Kilgore's relationship with de Kooning come from Kilgore.

554 During the presidential campaign: "46 L. I. Artists Brush Up for Politics," *New York Times*, Aug. 19, 1972.

555 Often, they would sit in the kitchen: Ruth Nivola, interview with the authors, May 26, 1990.
"Dad kind of liked Herman Cherry": Lisa de Kooning, interview with the authors, July 18, 1991, and occasional subsequent conversations, 1991–2004.
"I like Dalí": De Kooning, in John Russell, "De Kooning: 'I See the Canvas and I Begin,' " *New York Times*, Feb. 5, 1978.

556 Lee Eastman regularly visited: Lee Eastman, interviews with the authors, Mar. 7 and Sept. 12, 1990, and John and Jodie Eastman, interviews with the authors, Mar. 4, 1990, and Feb.–Mar. 2004.
"Bill talked in a stream of consciousness": Lee Eastman, ibid.
Once, when the young critic: Peter Schjeldahl, "Willem de Kooning 1904–1997," *Village Voice*, Apr. 8, 1997.
"I thought he was lonely": Clarence and Dorothy Barnes, interview with the authors, Aug. 6, 1990.

557 Ruth Nivola also saw: Nivola, interview with the authors.
"I think Lisa just called": Heidi Raebeck, interviews with the authors, April 6, 1990, and Jan. 26, 1996.
"We'd talk about": Joan Levy, interviews with the authors, Feb. 6 and June 13, 1995.

558 He wrote to Mimi: Letter to Emilie Kilgore.
In February 1973: Kilgore, interviews with the authors.

Notes

558 In October and November 1973: Ibid.
 In 1976, de Kooning's half brother: Ibid.
 "Santa Emilia": Letter to Emilie Kilgore.
559 In one letter: Letter to Emilie Kilgore.
 "Bill's primary artistic expression": Bob Spring, interview with the authors, June 30, 1995.
 Spring was not the only one to realize that sculpture was at best a sideline for de Kooning.
 His letters to Kilgore, while full of painting talk, never once mentioned sculpture.
 The following year: By then, David Christian was no longer on the payroll. Studio records,
 unpublished.
560 "I was on my bike": Letter to Emilie Kilgore.
 In one letter, he wrote: Ibid.
 "I couldn't miss": De Kooning, interview with Judith Wolfe, Apr. 14, 1981, in Judith Wolfe,
 Willem de Kooning, Works from 1951–1981, exhibition catalog (East Hampton, N.Y.:
 Guild Hall Museum, 1981), 15.
561 He liked to say: Kilgore, interviews with the authors.
562 "He went down": Mary Abbott, interviews with the authors, Feb. 5, 1992, and Apr. 8, 1992.
 According to Tom Ferrara: Tom Ferrara, multiple interviews with the authors, July 8, 1992,
 to Feb. 16, 1996.
 "I've always been crazy about Soutine": De Kooning, in Diane Waldman, *Willem de Koo-
 ning in East Hampton*, exhibition catalog (New York: Solomon R. Guggenheim Museum,
 1978). Originally published in Margaret Statts and Lucas Matthiessen, "The Genetics of
 Art," *Quest '77* (March/April 1977), 70–71.
 When describing his first glimpse: Ibid.
 "Miles Davis *bends* the notes": Kilgore, interviews with the authors.
 "The way I do it": De Kooning, in Wolfe, *Willem de Kooning: Works from 1951–1981*, 16.
 Tom Ferrara also recalled that de Kooning used the term "fitting in."
563 "He said, 'They just poured out' ": Levy, interviews with the authors.
 "I could sustain": De Kooning, in Harold Rosenberg, "The Art World: Woman and Water,"
 New Yorker, Apr. 24, 1978, 132–35.
 "I like a big painting to look small": Interview with Harold Rosenberg, in Harold Rosen-
 berg, *de Kooning* (New York: Abrams, 1974), 43.
564 In his letters: Kilgore, interviews with the authors.
 In the sixties: Perhaps the best overall source for de Kooning's solo and group exhibitions
 through 1983 is *Willem de Kooning*, exhibition catalog (Paris: Centres Georges Pompidou,
 Musée national d'art moderne, 1984). The catalog documents, at a glance, the astonishing
 increase in attention paid to de Kooning as the 1970s progressed.
565 Writing in the *New York Times:* John Russell, "De Kooning's New Frontiers," *New York
 Times*, Oct. 15, 1976.
 He liked to tell people: Many people recounted this story, or variations on it. Like many of
 Elaine de Kooning's amusing stories, de Kooning's anecdotes concealed and revealed in art-
 ful measure.
 According to Elaine Benson: Elaine Benson, interview with the authors, Mar. 4, 1990.
 Before the wedding: John McMahon, talk delivered at the High Museum of Art, Atlanta,
 Oct. 23, 1994. Collection of Joan Ward, provided to the authors courtesy of Joan Ward.
 According to de Kooning's housekeeper: Gertrude Cullem, interview with the authors, Jan.
 19, 1992.
566 But Dixon was also an alcoholic: Irving Markowitz, interview with the authors, May 26,
 1992.
 One Saturday morning: David Porter, interviews with the authors, July 14 and Aug. 1, 1991.
 "They were both at the kitchen table": Ibid.
567 "I'm all right in the meetings": Kilgore, interviews with the authors.
 Elaine had become: Conrad Fried, interviews with the authors, May 31 and June 1, 1995.
 Like Clarence Barnes: Eugene Tiritter, interview with the authors, July 3, 1995.
568 "I genuinely enjoyed him": Ibid.
 "There were the funniest stories": Ward, multiple interviews with the authors, Aug. 12,
 1991 to Apr. 17, 2004.
569 De Kooning himself was aware of some mental slippage: Dan Rice, interview with the
 authors, July 8, 1995.
 Ward said "he did not even feel": Ward, interviews with the authors.
570 He feared death: Kilgore, interview with the authors.

370 In the summer of 1977: Details of Elaine's reemergence in de Kooning's life come primarily from interviews with Lee Eastman, Mar. 7 and Sept. 12, 1990; John Eastman, Mar. 3, 1990, and Feb.–Mar. 2004; Conrad Fried, May 31 and June 1, 1995; and Marjorie Luyckx, June 14, 1994.

When the poet Gregory Corso: De Kooning often spoke about his time in Rome with Gregory Corso. Interview with Bert Schierbeek, in *Willem de Kooning*, exhibition catalog (Amsterdam: Stedelijk Museum, 1968). "I remember the epitaph on Shelley's tomb in Rome," said De Kooning. "I was with Gregory Corso when I saw this—it said something like 'Here lie the remains of an English poet who wrote his name in water.' "

571 "I'm in my element": De Kooning, from *Sketchbook No. 1: Three Americans*.

Chapter 37

575 "That Elaine, she's always the emergency girl": De Kooning, quoted by Joan Ward, multiple interviews with the authors, Aug. 12, 1991 to Apr. 17, 2004.

It seemed miraculous: Information on Elaine's life comes from interviews with, among others, Conrad Fried, May 31 and June 1, 1995; Marjorie Luyckx, June 14, 1994; Jimmy Touchton, a pupil and close friend of Elaine's, July 31, 1991; and the artist Jim Bohary, another close friend of Elaine's, Mar. 14 and Oct. 7, 1991. See also obituary of Elaine de Kooning, *New York Times*, Feb. 2, 1989.

"Part of Elaine": Elaine Benson, interview with the authors, Mar. 4, 1990.

576 In addition to paying: De Kooning checkbook and studio records, unpublished, shown to the authors courtesy of Joan Ward, now at The Willem de Kooning Foundation, New York.

Once, when asking: Ward, interviews with the authors.

To support herself: In addition, Elaine also taught at Carnegie Mellon University, Minneapolis Art Institute, and the Kansas City Art Institute, among others. Information also from Elaine's handwritten resume, provided by Elaine de Kooning to the Archives of American Art, Smithsonian Institution. See also Lee Hall, *Elaine and Bill: Portrait of a Marriage* (New York: HarperCollins, 1993), 231.

"The first thing she told us": Eddie Johnson, interview with the authors, Aug. 2, 1994. All subsequent quotations from Eddie Johnson come from this interview.

One of Elaine's neighbors: Longtime friend of the Frieds, anonymous, interview with the authors, June 18, 1993.

One story she regarded: This story, told and retold by Elaine, was repeated at her memorial service at Cooper Union on Mar. 12, 1989, by Sherman Drexler.

577 Betsy Egan Duhrssen: Duhrssen, interview with the authors, Sept. 19, 1991.

She borrowed regularly: Elaine de Kooning papers, AAA.

One time, the painter Robert Dash: Robert Dash, interviews with the authors, Oct. 5 and 17, 1991.

One person who sensed despair: John Ashbery, speaking at Elaine's memorial, Cooper Union.

Her sister Marjorie: Luyckx, interview with the authors.

578 But in 1969: Studio records show that de Kooning gave Elaine a loan toward the purchase of her house on Alewive Brook Road. Records shown to authors courtesy of Joan Ward.

"She wasn't willing": Jim Bohary, interviews with the authors.

"I always used to think": Jane Freilicher and Joe Hazan, interview with the authors, June 19, 1991.

579 "Believe me": Ward, interviews with the authors.

"I have a thousand close friends": One of Elaine's favorite expressions, repeated by, among others, her longtime friend Rose Slivka, at a talk on Elaine delivered by Slivka at the Studio School, Nov. 18, 1998.

When Kilgore would arrive: Ward, interviews with the authors.

Early on, Elaine and Mimi: Emilie Kilgore, interviews with the authors, July 24–26, 2003.

Given the uncertainty: Luyckx, interview with the authors.

580 De Kooning was still working: List of paintings from the Fourcade Gallery, unpublished Fourcade records, collection of the artist, courtesy of Joan Ward.

Writing in the *New York Times:* John Russell, "I See the Canvas and I Begin," *New York Times*, Feb. 5, 1978.

"I'm crazy about Rubens": De Kooning, *Newsweek*, unpublished interview with Ann Ray Martin, background file, Nov. 1, 1967.

Notes

581 Kramer praised de Kooning's: Hilton Kramer, "De Kooning of East Hampton," *New York Times*, Feb. 10, 1978.

Hughes acknowledged de Kooning's: Robert Hughes, "Softer de Koonings," *Time*, Mar. 6, 1978, 78–79.

The transition to wise old irrelevance: For a complete list of de Kooning's many honors in the 1970s, see the excellent chronology by Judith Zilczer in *Willem de Kooning, from the Hirshhorn Museum Collection*, exhibition catalog (New York: Rizzoli, 1994).

The festivities that marked the opening: Barbara Gamarekian, "Capital Gives All for Art," *New York Times*, May 31, 1978.

She was also irked: Fried, interviews with the authors.

582 He drew up papers: Lee Eastman, interviews with the authors, Mar. 7 and Sept. 12, 1990, and John Eastman, Mar. 4, 1990, and multiple interviews Feb.–Mar., 2004.

But tenure, Elaine said: Fried, interviews with the authors.

He could not bear the thought: Kilgore, interviews with the authors.

"That was their reaction": Rae Ferren, interview with the authors, Sept. 19, 1990.

583 On a Friday: Eugene Tiritter, interview with the authors, July 3, 1995.

"I was separated from Elaine and Bill": Fried, interviews with the authors.

584 Some, like Clarence: Clarence Barnes, interview with the authors, Aug. 6, 1991.

One time, when the writer: Arnold Weinstein, interview with the authors, Sept. 21, 1990.

585 "He was pleased": Tom Ferrara, multiple interviews with the authors, July 8, 1991, to Feb. 16, 1996. All subsequent quotations from Ferrara come from these interviews.

586 De Kooning told: Joan Levy, interview with the authors, Feb. 6 and June 13, 1995.

There was an anchor form: Ibid.

As early as 1974: Conversation with John McMahon at the opening of the Hirshhorn retrospective of de Kooning's art, Oct. 21, 1993.

Molly Barnes, his sometime girlfriend: Molly Barnes, interviews with the authors, May 2 and 14, 1997.

During one particularly bad episode: Curtis Bill Pepper, "The Indomitable de Kooning," *New York Times Magazine*, Nov. 20, 1983, 70.

In 1979, de Kooning wrote his last letter: Kilgore, interviews with the authors.

587 Lisa had left: Lisa de Kooning, interview with the authors, July 18, 1991, with occasional subsequent conversations, 1991–2004.

588 Bill was playing the game: Ward, interviews with the authors.

Chapter 38

589 "Then there is a time in life": De Kooning, from *Sketchbook No. 1: Three Americans*, a film produced and directed by Robert Snyder (1960).

"In a way": De Kooning, in Avis Berman, "Willem de Kooning: I Am Only Halfway Through," *ArtNews* (February 1982) 68–73. All subsequent references come from this article.

"Lately I've been thinking": De Kooning in Amei Wallach, "At 79, de Kooning Seeks Simplicity," *Newsday*, Dec. 4, 1983.

"It was the ethereal thing": Tom Ferrara, multiple interviews with the authors, July 8, 1991, to Feb. 16, 1996.

De Kooning also loved: Emilie Kilgore, interviews with the authors, July 24–26, 2003.

"This conservator came to the studio": Joan Levy, interviews with the authors, Feb. 6 and June 13, 1995. All subsequent quotations from Levy come from these interviews.

590 Once the brush was loaded: Ferrara, interviews with the authors.

"I scoop off what I don't like": Berman, "Willem de Kooning."

591 He still sought visual tension: Richard Shiff, catalog essay, in *Willem de Kooning: Paintings 1983–1984* (New York: Matthew Marks Gallery/Mitchell-Innes & Nash, Jan. 25–Mar. 29, 1997).

According to Conrad Fried: Conrad Fried, interviews with the authors, May 31 and June 1, 1995.

592 The response by the *New York Times*: John Russell, "Lively Competitor to the Old De Koonings," *New York Times*, Apr. 16, 1982.

In 1981, Lisa began to build: Curtis Bill Pepper, "The Indomitable de Kooning," *New York Times Magazine*, Nov. 20, 1983, 86.

593 At Tiritter's recommendation: Joan Ward, multiple interviews with the authors, Aug. 12, 1991, to Apr. 17, 2004.

More ominous still: Marjorie Luyckx, interview with the authors, June 14, 1994.

Alzheimer's-like disease: Dr. Donald Douglas, neurologist, Lenox Hill Hospital, New York, interview with the authors, Dec. 18, 1993.

His eyesight was worsening: Conversation with John McMahon at the opening of the de Kooning exhibition at the National Gallery in Washington, May 8, 1994.

594 A friend of Conrad's was staying: Anonymous friend of the Fried family, interview with the authors, June 18, 1993.

Tom Ferrara and Robert Chapman helped wean: Most of the information about the drugs that de Kooning was taking in the 1980s was provided in interviews with the authors by Joan Ward, Tom Ferrara, or Robert Chapman, July 9 and July 13, 1996.

595 In 1982 he told the writer and art critic: Berman, "Willem de Kooning."

596 She became good friends: Many of Elaine's friends spoke of her friendship with Steve Ross and Courtney Sale Ross; the trip to Positano is described in an interview with Tom Ferrara.

There was even a framed photograph: Lisa de Kooning to her mother, Joan Ward, interview with the authors, July 18, 1991, with occasional subsequent conversations, 1991–2004.

"Paul and Bill are very chummy": Elaine, in Berman, "Willem de Kooning."

At the White House dinner: Kilgore, interviews with the authors.

Aboard the *Rotterdam:* Susan Heller Anderson, "De Kooning Has Meeting with the Queen," *New York Times*, Apr. 25, 1982.

"I'm not difficult": Ibid.

597 "She's pretty cute": Levy, interviews with the authors.

"Before there was Imelda": Denise Lassaw, daughter of Ernestine and Ibram Lassaw, at Elaine's memorial service at Cooper Union, Mar. 12, 1990.

"Kaldis died about a week later": Irma Cavat, interview with the authors, Nov. 25, 1994.

"Some people said": Paul Russotto, interview with the authors, Dec. 9, 1991.

598 One time, after she answered: Ward, interviews with the authors.

Once, he told a friend: Anonymous friend of the Frieds, interview with the authors.

Another article: Joan Tyor Carlson, "Architectural Digest Visits: Willem de Kooning," *Architectural Digest* (Jan. 1982).

Often, he would simply get up: The children of Koos Lassooy noticed that de Kooning appeared to be lost sometimes. Interview with the authors, Apr. 1995.

599 Elaine turned examples: Among those who repeated Elaine's amusing stories were Irma Cavat and Paul Russotto. Curtis Bill Pepper even printed the one about de Kooning being bored on the plane in "The Indomitable de Kooning," *New York Times Magazine.*

Elaine told Emilie: Kilgore, interviews with the authors.

A year or two later, Jane Freilicher: Jane Freilicher and Joe Hazan, interview with the authors, June 19, 1991.

600 According to the neurologist Dr. Donald Douglas: Dr. Douglas, interview with the authors. Now retired, Douglas never treated de Kooning. The authors are grateful for his guidance in understanding dementia.

During a *New York Times:* Confirmed in a conversation with Curtis Bill Pepper, Feb. 6, 1990.

"It got to the point": Robert Chapman, interviews with the authors.

In 1982, the painter: Recounted in Robert Storr, "At Last Light," in *Willem de Kooning: The Late Paintings, the 1980's,* catalog essay (San Francisco Museum of Art and Walker Art Center, 1996), 49.

601 "I am becoming freer": Din Peters, "Willem de Kooning: Paintings, 1960–1982," *Studio International* (August 1983), 4.

De Kooning had once referred: De Kooning, "What Abstract Art Means to Me," a talk given at the Museum of Modern Art, New York, on Feb. 5, 1951, and published in *Museum of Modern Art Bulletin* (Spring 1951).

602 Always known for his difficulty: The figures on de Kooning's output come from Storr, "At Last Light," 51–52.

According to Elaine's assistant: Ibid.

In the usual progression of Alzheimer's-like dementia: Sources on dementia and alcohol-related dementia consulted in the course of researching the disease at the New York Hospital/Cornell Medical Center library in New York were: Alan Jacques, *Understanding Dementia* (Edinburgh, London: Churchill Livingstone, 1988, 1992); Ralph Tarter, Ph.D.,

and David H. Von Thiel, M.D., ed., *Alcohol and the Brain: Chronic Effects* (New York and London: Plenum Medical Book Co., 1985); William E. Kelly, M.D., ed., *Alzheimer's Disease and Related Disorders, Research and Management* (Springfield, Ill.: Charles Thomas, 1984); Howard Gruetzner, *Alzheimer's: A Caregiver's Guide and Sourcebook* (New York: John Wiley & Sons, 1992); and Oliver Sacks, *The Man Who Mistook His Wife for a Hat* (New York: Harper, 1987).

603 In addition to Tom Ferrara: Studio records, unpublished, courtesy of Joan Ward.

604 She asked Ferrara to open tubes: Ferrara, interviews with the authors.

"He stuck with what he was doing": Ibid.

"Certain paintings I don't want to sell": Berman, "Willem de Kooning."

The sale was trumpeted: Rita Reif, "$1.2 Million for a de Kooning," *New York Times*, May 11, 1983.

In 1967, when he had first begun: Knoedler inventory lists, unpublished, collection of the artist, courtesy of Joan Ward.

But by then: Bob Spring, interview with the authors, June 30, 1995. De Kooning's sculpture at Modern Art Foundry was made using the classic Italian system of "lost wax." In this case, a rubber negative mold was first made of the sculpture. Subsequently this rubber mold was used as the basis of the casting process.

"Fourcade and Eastman decided to make some money": Ibid.

605 As the curator: Jorn Merkert, "Stylelessness as Principle: The Painting of Willem de Kooning," in *Willem de Kooning, Drawings, Paintings, Sculpture,* exhibition catalog (New York: Whitney Museum of American Art, in association with Prestel-Verlag, Munich, and W. W. Norton and Company, 1983), 115.

The day before: Ferrara, interviews with the authors.

"A living artist": Anne-Marie Schiro, "Partying for de Kooning," *New York Times*, Dec. 16, 1983.

Both Grace Glueck: Grace Glueck, "De Kooning Retrospective of 60 Years at Whitney," *New York Times*, Dec. 16, 1983; and Robert Hughes, "Painting's Vocabulary Builder," *Time*, Jan. 9, 1984, 62–63.

606 Although the "old cunning": Hughes, "Painting's Vocabulary Builder."

607 Robert Storr observed: Storr, "At Last Light," 39–79.

De Kooning's art: Robert Dash, interviews with the authors, Oct. 5 and 17, 1991.

Chapter 39

608 De Kooning suffered: Joan Ward, multiple interviews with the authors, Aug. 12, 1991, to Apr. 17, 2004. Also Tom Ferrara, multiple interviews with the authors, July 8, 1991, to Feb. 16, 1996.

His housekeeper of twenty years: Gertrude Cullem, interview with the authors, Jan. 19, 1992.

And so began: Robert Storr, "At Last Light," in *Willem de Kooning: The Late Paintings, the 1980's,* exhibition catalog (San Francisco Museum of Art and Walker Art Center, Minneapolis, 1996), 48–49.

609 On those rare occasions: Tom Ferrara, interviews with the authors. All subsequent citations of Ferrara are from these interviews.

"But after he quit drinking": Clarence and Dorothy Barnes, Aug. 6, 1991.

Emilie Kilgore's son: Emilie Kilgore, interviews with the authors, July 24–26, 2003.

Another time: Robert Chapman, interviews with the authors, July 9 and 13, 1996.

610 He appeared, she said, to have no: Kathleen Fisher, interview with the authors, Sept. 24, 1993.

"And all of a sudden": Ibid. All subsequent quotations from Fisher come from this interview.

611 According to Irma Cavat: Irma Cavat, interview with the authors, Nov. 25, 1994.

Based on new research: Although more research remains to be done, much has been written recently about genetic predisposition to develop Alzheimer's-like dementias. At the time of the marriage of de Kooning's father, Leendert, and his mother, it was noted that Leendert's mother could not give her consent to the marriage, which was required by Dutch law, because she was judged mentally incompetent. (Research of Dr. Hanneke Peters; documents of the Rotterdam courthouse contained at the Central State Archive in The Hague.) What's more, de Kooning's half sister, Hendrika (Henny), was judged mentally

incompetent to get married; everyone in the family, according to her brother Leendert, knew that she was "not quite right" mentally. De Kooning's half brother, Leendert, was also suffering from the early stages of an Alzheimer's-like dementia in 1991; his wife alluded to his condition. The authors are indebted to Hendrik van Leeuwen for his follow-up conversations with the family.

She wrote down what he said: Kilgore, interviews with the authors.

612 He created sixty-three paintings: Storr, "At Last Light," 51–52.

613 "We live in the 20th century": Douglas C. McGill, "Triptych Is Focus of Church Debate," *New York Times*, Feb. 25, 1986.

The unfamiliar dimensions: Chapman, interviews with the authors.

614 Seven weeks after it was installed: Ibid.

By 1986 or 1987: Ferrara and Chapman, interviews with the authors.

615 "What you're likely to have": Dr. Donald Douglas, neurologist, Lenox Hill Hospital, New York, interview with the authors, Dec. 18, 1995.

In a painter, for example: Dr. Jeffrey Cummings, quoted in Storr, "At Last Light," 50.

In 1984: Conrad Fried, interviews with the authors, May 31 and June 1, 1995.

616 "I have myself seen": Oliver Sacks, "Letters," *Art and Antiques* (January 1990), 20. Sacks also discusses the ability of artists to function in the face of dementia in the introduction to *The Man Who Mistook His Wife for a Hat* (New York: Harper, 1970), 3–7.

"A person like de Kooning": A recent article in *Neurological Review* further explores artistic creativity and dementia. Bruce L. Miller, M.D., and Craig E. Hou, M.D. "Portraits of Artists: Emergence of Visual Creativity in Dementia," *Neurological Review*, (June 2004), 842–44.

As the year 1986 progressed: On Feb. 17–18, 1995, prior to the show of late de Kooning paintings in San Francisco, a panel of experts was convened at the Judson Art Warehouse in Long Island City to evaluate de Kooning's late paintings. Members of the panel included Gary Garrels, curator of paintings and sculpture at the San Francisco Museum of Modern Art; John Lane, the director of the museum; Robert Storr, curator of painting and sculpture, Museum of Modern Art, New York; John Walsh, the director of the J. Paul Getty Museum, Los Angeles; Kathy Halbreich, director of the Walker Art Center, Minneapolis; Richard Shiff, professor of art, the University of Texas at Austin; and the artist Jasper Johns. Over the course of the two days, they evaluated all of the 1980s paintings that were stored in the warehouse and explored the question of de Kooning's declining abilities. While no unanimous conclusions were reached about works through the middle of the decade, everyone agreed that "the last paintings from 1989 and 1990 were of interest only insofar as they were from the hand of de Kooning" (Gary Garrels, "Three Toads in the Garden: Line, Color and Form," in *Willem de Kooning, the Late Paintings, the 1980s*, 33). Beyond that, some members of the panel thought that a painting-by-painting judgment was required from the mid-1980s on, when de Kooning's control seemed to be slipping; others found considerable visual interest in paintings made as late as 1987 and 1988 (Garrels, 33). Joan Ward provided a complete transcript of the panel. Subsequently a reevaluation of paintings from 1987–8 has taken place. Two paintings from 1987 were shown in *Willem de Kooning in Process*, a show curated by Klaus Kertess for the Museum of Art, Fort Lauderdale, Florida, in 1993. The Matthew Marks Gallery, in conjunction with the Mitchell-Innes & Nash Gallery, mounted a show of de Kooning's 1987 paintings in 2001. And one show devoted solely to work from 1988 was mounted at El Centro José Guerrero in Granada, Spain, in 2001.

Chapter 40

618 "Y'know the moment you really do something": *Newsweek*, unpublished interview with Ann Ray Martin, background file, Nov. 1, 1967.

Few knew that she had already lost a lung: Jimmy Touchton, interview with the authors, July 31, 1991. Touchton said that Elaine hid her illness from most people. Also Betsy Egan Duhrssen, interview with the authors, Sept. 19, 1991.

"It was heartbreaking": Tom Ferrara, multiple interviews with the authors, July 8, 1991, to Feb. 16, 1996.

619 One time, she awakened at five: Kathleen Fisher, interview with the authors, Sept. 24, 1993.

There remained: The conservator Susan Brooks stayed for another year. Chapman continued until 1990. Also present were Kathleen Fisher and a talented artist from Belgium, Katie

Notes

Creegan, who spoke Dutch to de Kooning as his English deserted him. Studio records, unpublished.

619 In the late spring of 1987: Ferrara, interviews with the authors.

"De Kooning was in dreadful shape": John and Jodie Eastman, interview with the authors, Mar. 4, 1990.

620 "I tried to keep": Robert Chapman, interviews with the authors, July 9 and 13, 1996.

Often he'd miss corners: Roger Anthony and Amy Schichtel of The Willem de Kooning Foundation maintain that de Kooning sometimes left bits of primed canvas showing on paintings, especially on small works on paper, on purpose. Elaine de Kooning, among others, felt that de Kooning thought these were "holidays," or overlooked mistakes, when they were in oil paintings.

621 In his 1981 will: John Eastman, interview with authors; and John Silberman, Lisa de Kooning's lawyer, responding to authors' queries, courtesy of Roger and Amy Schichtel at The Willem de Kooning Foundation.

She had borrowed about half a million: John Eastman, interview with the authors, Mar. 4, 1990, and multiple interviews, Feb.–Mar. 2004.

622 At that point: Ibid.

An unconventional deal: The sculptor Philip Pavia brought a lawsuit against de Kooning and Elaine's estate, seeking a total of $3 million in compensation and damages, when he was not paid for casting the alleged de Kooning sculpture. (Carol Vogel, "Inside Art," *New York Times*, July 23, 1993.)

Wasn't she entitled: Elaine de Kooning, in Lee Hall, *Elaine and Bill: Portrait of a Marriage* (New York: HarperCollins, 1993), 301.

623 The firm prepared: Judd Tully, "Court Rules Artist De Kooning 'Incapable,' " *Washington Post*, Aug. 19, 1989.

When Elaine first attempted: Chapman, interviews with the authors.

As his mind floated in and out: Ferrara, interviews with the authors.

According to John Eastman: Eastman, interviews with the authors.

To all but her family: Betsy Egan Duhrssen, interview with the authors.

Conrad Fried: Fried, interviews with the authors, May 31 and June 1, 1995.

The next day: Ibid.

624 Edvard Lieber: Edvard Lieber, speaking at Elaine's memorial service, Cooper Union, New York, Mar. 12, 1989.

On February 11, 1989: Glenn Collins, "Art, Wealth and Filial Duty Ensnarl Dispute over de Kooning's Assets," *New York Times*, June 8, 1989; Judd Tully, "De Kooning and the Battle over His Future," *Washington Post*, July 23, 1989.

625 John Silberman and Lisa: John Eastman, interviews with the authors. Also, John Silberman, authors' query.

As a result, sales plummeted: Collins, "Art, Wealth and Filial Duty."

Clearly something needed to be done: Ibid.

"I could elicit": Ibid.

626 Her past behavior: Ibid.

Lisa had married: Ibid.

"We, whom he has known": Ibid.

At the hearing: Tully, "De Kooning and the Battle."

At the time of Elaine's death: Judd Tully, "De Kooning's Uncertain Legacy," *Art and Auction* (May 1997), 122–23, 163; Carol Vogel, "De Kooning Intrigues Live On," *New York Times*, Oct. 6, 1997.

One weekend, Lisa asked de Kooning's assistants: Chapman, interviews with the authors.

627 "He spent the next week": Ibid.

The first downturn: Ibid.

With no real job: Studio records, courtesy of Joan Ward.

628 Writing of the mini-retrospective: Michael Brenson, "De Kooning: Masterworks from a Master Painter," *New York Times*, Sept. 7, 1990.

The second show: Michael Brenson, "De Kooning's and Dubuffet's Iconoclastic Women," *New York Times*, Dec. 7, 1990.

If the last: Because de Kooning was so prolific in the 1980s, and most works still for sale come from that time, exhibits tend to overemphasize this part of his oeuvre.

It was an exhibit worthy: Paul Richard, "The Eye of the Storm," *Washington Post*, May 8, 1994.

628 In the eyes of many: The critic Peter Schjeldahl, for example, called de Kooning "the last Renaissance painter. Renaissance painting came into its own with Giotto. Now it's over." In Peter Schjeldahl, "Willem de Kooning 1904–1997," *Village Voice*, Apr. 8, 1997.

629 Around 1992: Emilie Kilgore, interviews with the authors, July 24–26, 2003.
 Molly Barnes noted: Molly Barnes, interviews with the authors, May 2 and 14, 1997.
 According to Joan Ward: Joan Ward, multiple interviews with the authors, Aug. 12, 1991, to Apr. 17, 2004.

630 And strange that he would not: De Kooning was cremated. His ashes will eventually be buried on the grounds of the studio.
 "The last few years": Letter to Emilie Kilgore, courtesy of Kilgore © The Willem de Kooning Foundation/Artists Rights Society, New York.

Documentation

Statements by the Artist

De Kooning, Willem. *The Collected Writings of Willem de Kooning.* Ed. George Scrivani. Madras and New York, 1988.

———. In *De Kooning Drawings.* New York, 1967.

———. "A Desperate View." Talk delivered at Subjects of the Artist: A New School, New York, February 18, 1949. Published in Thomas B. Hess, *Willem de Kooning.* New York, 1968.

———. "Letter to the Editor" [on Arshile Gorky]. *ArtNews* 47 (January 1949).

———. "The Renaissance and Order." *Trans/formation* 1 (1951).

———. In "Six Abstractionists Defend Their Art." *New York Times Magazine,* January 21, 1951.

———. "What Abstract Art Means to Me." *Museum of Modern Art Bulletin* 18 (Spring 1951).

Films and Videotapes

Fried, Conrad, and S Again. *De Kooning.* New York, 1984–86.

Leiser, Erwin. *Art Is a Way of Living: Willem de Kooning.* Zurich: Erwin Leiser Filmproduktion, 1984. Film.

———. *De Kooning at Work.* Zurich: Erwin Leiser Filmproduktion, 1979. Film.

———. *Willem de Kooning and the Unexpected.* Zurich: Erwin Leiser Filmproduktion, 1979. Film.

Namuth, Hans, and Paul Falkenberg. *De Kooning at the Modern.* New York: Museum at Large, Ltd., 1969. Film.

———. *Willem de Kooning the Painter.* New York: Museum at Large, 1964. Film.

Signalement. VARA. Dutch Television Network, 1968.

Snyder, Robert. *A Glimpse of de Kooning* (composite of "Talking About Art, New York City, 1960," and "The Act of Painting, East Hampton, Long Island, 1966"). Written by Michael C. Sonnabend. Distributed by Master and Masterworks Productions, 1968. Film.

———. *Sketchbook No. 1: Three Americans, Willem de Kooning, Buckminster Fuller, Igor Stravinsky.* Written by Michael C. Sonnabend. Distributed by Time Inc., 1960. Film.

Zwerin, Charlotte, and Courtney Sale. *De Kooning on de Kooning.* New York: Direct Cinema, Ltd., 1981. Film.

Published Interviews and Articles by Writers Who Interviewed de Kooning

Anderson, Susan Heller. "De Kooning Has Meeting with Queen." *New York Times,* April 25, 1982.

Berman, Avis. "Willem de Kooning: 'I Am Only Halfway Through.' " *ArtNews* 81 (February 1982).

Bibeb, Door. "Willem de Kooning: Ik vind dat alles een mond moet hebben en ik zet de mond waar ik will." *Vrij Nederland* (Amsterdam), October 5, 1968.

Bolten, J. "De Kooning Een Van De Zeer Groten." *Het Parool,* September 25, 1968.

Bourdrez, Martha. "Originality and Greatness in Painting." *The Knickerbocker* (May 1950).

Burckhardt, Rudy. "Long Ago with Willem de Kooning," in "Willem de Kooning, on His 85th Birthday," ed. Bill Berkson and Rackstraw Downes. *Art Journal* (Fall 1989).

Carlson, Joan Tyor. "Architectural Digest Visits: Willem de Kooning." *Architectural Digest* (January 1982).

Davis, Douglas. "De Kooning on the Upswing." *Newsweek,* September 4, 1972.

De Antonio, Emile, and Mitch Tuchman. *Painters Painting.* New York, 1984.

De Hirsch, Storm. "A Talk with de Kooning." *Intro Bulletin* (October 1955).

Dickerson, George. "The Strange Eye and Art of de Kooning." *Saturday Evening Post,* November 21, 1964.

Dull, Ben. "Willem de Kooning is terug." *Het Parool,* September 18, 1968.

690

Engelsman, Peter. "Jongens onder mekaar." *Het Algemeen Handelsblad*, September 21, 1968.
Endt, Friso. "Royal Dutch Welcome for Prodigal de Kooning." *Life*, Atlantic edition, October 28, 1968.
Frasnay, Daniel. "De Kooning." In *The Artist's World*. New York, 1969.
Goodnough, Robert, ed. "Artists' Sessions at Studio 35" [1950]. In *Modern Artists in America*, ed. Robert Motherwell and Ad Reinhardt. New York, 1951.
Glueck, Grace. "A Tenth Street Loft in the Woods." *New York Times*, July 25, 1965.
———. "Art Notes." *New York Times*, February 21, 1965.
Hellman, Paul. "De Verloren Zoon Zit Goed." *Algemeen Dagblad*, December 24, 1976.
Hess, Thomas B. "De Kooning Paints a Picture." *ArtNews* 52 (March 1953).
———. "Is Today's Artist with or against the Past?" *ArtNews* 57 (June 1958).
———. "In de Kooning's Studio." *Vogue* (April 1978).
Holstein, Pieter. "Willem de Koonig: Nederlander wardt beroemdste schilder in verenidgde staten." *Winschoter Courant*, October 19, 1968.
Hunter, Sam. "Je dessine les yeux fermés." *Galerie Jardin des Arts*, Paris, November 1975.
Klaster, Jan Bart. "De Kooning gaat door ik schilder mijn binnenste." *Het Parool*, May 11, 1983.
Liss, Joseph. "Abstraction at Louse Point." *East Hampton Star*, February 25, 1982.
———. "Memories of Bonac Painters." *East Hampton Star*, August 18, 1983.
———. "Willem de Kooning Remembers Mark Rothko." *ArtNews* (January 1979).
Mooradian, Karlen. "Interview with Willem de Kooning, July 19, 1966." *Ararat* 12 (Fall 1971).
Passlof, Pat. "1948," in "Willem de Kooning, on His 85th Birthday," ed. Bill Berkson and Rackstraw Downes. *Art Journal* 48 (Fall 1989).
Pepper, Curtis Bill. "The Indomitable de Kooning," *New York Times Magazine*, November 20, 1983.
Peters, Din. "Willem de Kooning; Paintings, 1960–1982." *Studio International* 196 (August 1983).
Raymont, Henry. "De Kooning Back in Netherlands." *New York Times*, September 20, 1968.
Rodgers, Gaby. "Willem de Kooning: The Artist at 74." *LI: Newsday's Magazine for Long Island*, May 21, 1978.
Rodman, Selden. "Willem de Kooning." In *Conversations with Artists*. 1957.
Rosemarch, Stella. "De Kooning on Clay." *Crafts Horizons* (December 1972).
Rosenberg, Harold. "The Art World: Woman and Water." *The New Yorker*, April 24, 1978.
———. "Interview with Willem de Kooning." *ArtNews* 71 (September 1972). Reprinted in Harold Rosenberg, *de Kooning*. New York, 1974.
Russell, John. "De Kooning: I See the Canvas and I Begin." *New York Times*, February 5, 1978.
Ruyter, Martin. "Een man die op het doek alles kan: Willem de Kooning Expositie in Stedelijk." *Volkskrant*, September, 1968.
Sandler, Irving. "Conversations with de Kooning," in "Willem de Kooning, on His 85th Birthday," ed. Bill Berkson and Rackstraw Downes. *Art Journal* 48 (Fall 1989).
Schierbeek, Bert. Interview in *Willem de Kooning*, exhibition catalog for the de Kooning retrospective at the Stedelijk Museum, Amsterdam, 1968.
Shirey, David L. "Don Quixote in Springs." *Newsweek*, November 20, 1967.
Staats, Margaret, and Lucas Matthiessen. "The Genetics of Art: Willem de Kooning." *Quest* 77 (March/April 1977).
Stevens, Mark. "De Kooning in Bloom." *Newsweek*, February 20, 1978.
Sylvester, David. "Willem de Kooning 1960." In *Interviews with American Artists*. New Haven and London, 2001. First broadcast as "Painting as Self-Discovery." BBC broadcast, December 3, 1960. Excerpts published without interviewer's questions as "Content Is a Glimpse," *Location* (Spring 1963). Excerpts published with questions in "De Kooning's Women." *Sunday Times Magazine* (London), December 8, 1968. Also in "De Kooning's Women." *Ramparts* 7 (April 1969).
Tromp, Hansmaarten. "Willem de Kooning: 'Elke stijl is fraude.' " *De Tijd*, October 21, 1977.
Valliere, James. "De Kooning on Pollock." *Partisan Review* (Autumn 1967).
Van Duinhoven, L. "Willem de Koonings Levenswerk in Stedelijk Museum: 'Mijn kunst is een ouwe hoed.' " *Algemeen Dagblad*, September 18, 1968.
Vivaldi, Cesare. "Un' Intervista con de Kooning." *Italia Domani*, November 29, 1959.
Wallach, Amei. "My Dinners with de Kooning." *Newsday*, April 24, 1984.
———. "At 79, de Kooning Seeks Simplicity." *Newsday*, Dec. 4, 1983.

Documentation

Wilkie, Ken. "Willem de Kooning: Portrait of a Modern Master." *Holland Herald* 17 (March 1982).

Willard, Charlotte. "De Kooning: The Dutch-born U.S. Master Gathers In the International Honors." *Look*, May 27, 1969.

———. "In the Art Galleries." *New York Post Magazine*, August 23, 1964.

Wolfe, Judith. "Van Wim tot Bill de Kooning: Zeven decennia thematiek en vorm." *Jong Holland* 1 (1994).

Yard, Sally. "Willem de Kooning's Men." *Arts Magazine* 56 (December 1981).

———. "Willem de Kooning's Women." *Arts Magazine* 53 (November 1978).

Anonymous

"Big Splash." *Time*, May 18, 1959.

"De Kooning's Derring-Do." *Time*, November 17, 1967.

"De Kooning's Year." *Newsweek*, March 10, 1969.

"The Native Returns." *Newsweek*, October 7, 1968.

"Out of the Picture." *Newsweek*, March 12, 1962.

"Prisoner of the Seraglio." *Time*, February 26, 1965.

"Vanity Fair: The New York Art Scene." *Newsweek*, January 4, 1965.

"Van verstekeling tot multi-miljonair." *De Telegraaf*, December 9, 1981.

"Willem de Kooning: Explosive Images of a Dislodged and Ambiguous World." *Life*, November 16, 1959.

"Willem de Kooning: Geduldig genie." *Volkskrant*, September 28, 1968.

"Willem the Walloper." *Time*, April 30, 1951.

Unpublished Interviews and Conversations with the Authors

Abbott, Mary. Interviews. February 5 and April 7, 1992.

Abel, Lionel. Interview. May 11, 1992.

Adams, Jill Weinberg. Interview. July 15, 1992.

Adler, Ellen. Interview. February 20, 1991.

Alcopley, L. Interviews. April 28 and June 6, 1990.

Anonymous. Friend of Juliet Browner. January 7, 1992.

———. Friend of the Fried family. June 18, 1993.

———. Student of de Kooning at Black Mountain. November 21, 1991.

———. Studio observer. May 1, 1997.

Anthony, Roger. Phone conversation. 1992. Occasional subsequent conversations, 1992–2004.

Appel, Karel. Interview. March 6, 1990.

Ashbery, John. Interview. December 12, 1990.

Auerbach, Ellen. Interview. April 15, 1998.

Baldwin, Willard. Interview. October 28, 1991.

Barnes, Clarence and Dorothy. Interview. August 6, 1991.

Barnes, Molly. Interviews. May 2 and 14, 1997.

Benson, Elaine. Interview. March 4, 1990.

Biala, Janice. Interview. July 27, 1992.

Bocour, Leonard. Interviews. November 30 and December 11, 1992.

Bohary, James. Interviews. March 14 and October 9, 1991.

Borgenicht, Grace. Interview. March 29, 1990.

Bourdrez, Martha. Interview. March 31, 1990.

Braider, Carol. Interview. November 16, 1990.

Breedveld, Antonie. Interview. November 29, 1991.

Brockman, Susan. Interviews. April 24, 1992, and August 2, 1998.

Brooks, Charlotte. Interview. July 16, 1991.

Budnik, Dan. Phone interview. January 12, 1994.

Burckhardt, Rudolph (Rudy). Interviews. March 29, 1990, and October 9, 1991.

Carone, Nicholas. Interviews. March 15 and 21, 1991.

Castelli, Leo. Interview. April 10, 1990.

Cavat, Irma. Interview. November 25, 1994.

Chapman, Robert. Interviews. July 9 and 13, 1996.

Cullem, Gertrude. Interview. January 19, 1992.

Cunningham, Merce. Interview. April 30, 1998.
Dash, Robert. Interviews. October 5 and 17, 1991.
Dehner, Dorothy. Interview. January 8, 1992.
De Kooning, Leendert. Interview. February 6, 1991.
De Kooning, Lisa. Interview. July 18, 1991, with occasional subsequent conversations, 1991–
 2004.
Del Negro, Pepe. Interviews. November 8 and 20, 1991.
De Martiis, Plinio. Interview. October 21, 1992.
De Menil, Christophe. Conversation. 1994.
De Nagy, Tibor. Interview. February 28, 1990.
De Wilde, Eduard. Interview. December 3, 1992.
Dorazio, Piero. Interview. October 19, 1992.
Douglas, Dr. Donald. Interview. December 18, 1995.
Downs, Cile Lord. Interview. May 25, 1992.
Drudi, Gabriella. Interview. October 20, 1992.
Duhrssen, Elizabeth (Betsy) Egan. Interview. September 19, 1991.
D'Vorzon, Berenice. Conversation. 1997.
Eastman, John and Jodie. Interview. March 4, 1990. Multiple interviews with John Eastman,
 February–March 2004.
Eastman, Lee. Interviews. March 7 and September 12, 1990.
Emanuel, Herzl. Interviews. February 25 and October 22, 1992.
Falk, Gus. Interview. July 28, 1992.
Ferrara, Tom. Interviews. July 8 and 22, August 8 and 30, 1991, Memorial Day weekend, May 23,
 and August 28, 1992, January 15, 1993, March 23, 1995, and February 16, 1996.
Ferren, Rae. Interview. September 19, 1990.
Filmus, Tully. Interviews. September 17 and October 18, 1991.
Finkelstein, Louis. Interview. March 14, 1990.
Fisher, Kathleen. Interview. September 24, 1993.
Foss, Cornelia. Interview. September 14, 1990.
Franchetti, Barone Giorgio. Interview. October 21, 1992.
Freilicher, Jane, and Joe Hazan. Interview. June 19, 1991.
Fried, Conrad. Interviews. May 31 and June 1, 1995.
Fried, Conrad, and Marjorie Luyckx. Joint interview. August 2, 1997.
Gendel, Milton. Interview. October 20, 1993.
Gidding, Jan and Monique. Interview. Jan. 31, 1991.
Goldberg, Michael. Interviews. April 18 and May 8, 1990.
Gonzalez, Manuel. Interviews. December 6, 1991, and February 22, 1995.
Gosman, Roberta. Interview. July 11, 1996.
Greenberg, Clement. Interview. Spring 1993.
Grippe, Peter and Florence. Interview. July 20, 1992.
Hague, Raoul. Interview. December 7, 1992.
Hale, Barbara. Interview. September 21, 1990.
Halusic, Virginia (Nini) Diaz. Interview. February 3, 1994.
Held, Al. Conversation. February 21, 1990.
Hendler, Ray. Interview. August 17, 1992.
Herrera, Philip. Interview. December 14, 1990.
Hofman, Mr. and Mrs. Henk. Interview. December 1990.
Hokanson, Hans. Interview. July 22, 1991.
Jacobs, Lewis (Lou). Interview. Summer 1991.
Johnson, Alexia. Phone interview. September 14, 1991.
Johnson, Eddie. Interview. August 2, 1994.
Jonas, Liesl. Interviews. May 21 and October 23, 1991.
Keene, Robert. Interview. July 10, 1996.
Kilgore, Emilie. Interviews. July 24–26, 2003.
Kligman, Ruth. Interview. June 4, 1993.
Koch, Kenneth. Interview. September 7, 1990.
Krisher, Bernard. Phone interview. September 14, 1992.
Kroll, Jack. Conversation. 1995.
Kurz, Diana. Interview. September 23, 1997.

Documentation

Lansner, Kermit and Fay. Conversations. 1992.

Lassaw, Ernestine (with Ibram Lassaw). Interview. August 8, 1991.

Lassaw, Ibram. Interviews. May 23, 1990, and July 2 and 9, 1991.

Lassooy, children of Jacobus, including Cornelia (Cory) Hendrika Maria. Interview. April 1995.

LeSueur, Joe, and Patsy Southgate. Interview with the authors. Summer 1997.

Levy, Joan. Interviews. February 6 and June 13, 1995.

Little, Josephine. Interview. August 6, 1991.

Loew, Mildred. Interview. July 17, 1991.

Luyckx, Marjorie. Interview. June 14, 1994.

Marca-Relli, Conrad. Interview. May 1, 1991.

Marchowsky, Marie. Interview. May 21, 1991.

Margolis, Mr. and Mrs. David. Interview. March 9, 1992.

Margulis, Max. Interviews. March 8 and April 30, 1991.

Marisol. Interview. May 15, 1992.

Markowitz, Irving. Interview. May 26, 1992.

McAlister, Mera. Interview. July 12, 1992.

McMahon, John. Conversations. October 21, 1993, at the opening of the de Kooning exhibition at the Hirshhorn Museum, and May 8, 1994, at the opening of the de Kooning retrospective at the National Gallery.

Mitchell, Joan. Interview. Spring 1991.

Mobley, Ed and Brownie. Interview. February 20, 1996.

Morgan, Priscilla. Interviews. April 28, 1992, and January 4, 1995.

Moss, Lila. Interview. Spring 1996.

Nickson, Graham. Conversation. Winter 2002.

Nivola, Ruth. Interview. May 26, 1990.

Oliveira, Nathan. Interview. November 20, 1998.

Pajeck, Martin. Interview. June 16, 1995.

Passlof, Pat. Interview. July 18, 1990.

Pavia, Philip. Interview. April 9, 1990.

Pepper, Curtis Bill. Conversations. February 6, 1990, and June 1996.

Porter, David. Interviews. July 14 and August 1, 1991.

Potter, Jeffrey. Interview. February 2, 1993.

Protter, Eric. Interview. April 29, 1992.

Raebeck, Heidi. Interviews. April 6, 1990, and January 26, 1996.

Rankine, V. V. Interview. August 13, 1991.

Rauschenberg, Robert. Conversation. September 1997.

Reiner, Bea. Interview. November 1, 1991.

Resnick, Milton, and Pat Passlof. Interview. June 5, 1991.

Reznikoff, Peter. Interview. January 31, 1992.

Rice, Dan. Interview. July 8, 1995.

Rosenthal, Lou. Interview. October 23, 1991.

Rothman, Arthur. Interview. October 21, 1991.

Roussel, Mark and Christine. Interview. May 30, 1995.

Rubenfeld, Florence. Conversations. 1995–1998.

Russotto, Paul. Interview. December 9, 1991.

Sander, Kate. Interview with the authors. September 6, 1991.

Sanders, Joop. Interviews. October 31, 1990, February 15, 1991, April 8, 1992, and March 13, 1993.

Schadee, Nora. Historical Museum of Rotterdam. December 1992.

Schjeldahl, Peter. Conversations. 1997, 2004.

Schloss, Edith. Interview. May 10, 1992.

Schwertley, Anne Wedgwood. Interview. February 15, 1995.

Sheehan, John. Interviews. February 26 and March 5, 1990.

Simon, Sidney. Interview. October 19, 1994.

Smith, Oliver. Phone conversation. Summer 1991.

Solman, Joseph. Interview. May 8 and June 2, 1991.

Spillenger, Ray. Interview. November 21, 1991.

Spring, Bob. Interview. June 30, 1995.

Steinberg, Saul. Interview. Summer 1993.

Sterne, Hedda. Interview. June 18, 1991.

Stewart, Margo. Interview. October 29, 1997.

Stoler, Shirley. Interview. November 1, 1994.
Tiritter, Eugene. Interview. July 3, 1995.
Touchton, Jimmy. Interview. July 31, 1991.
Van Bergen, Mr. R. Interview. December 1992.
Van Wingerden, Mr. Municipal Archives, Rotterdam. Interview. February, 6, 1991.
Vicente, Esteban. Interviews. May 24, 1990, and August 16, 1991.
Vogel, Joseph. Phone interview. October 28, 1991.
Vreeburg, Mr. A. G. M. of the Academie van Beeldende Kunsten en Technische Wetenschappen of Rotterdam. Interview. December 1, 1992.
Ward, Joan. Interviews. August 12, 1991, June 22, 1993, May 3, 1994, April 19, 1995, March 7, 1996, April 30 and May 1, 1997, and April 16–17, 2004.
Weatherall, Al. Interview. August 26, 1991.
Weinstein, Arnold. September 21, 1990.
Wright, Michael. Interview. August 8, 1993.
Young, David. Interviews. October 22 and November 4, 1991.
Zacharias, Athos. Interview. May 4, 1992.
Zogbaum, Elizabeth. Interview. October 8, 1990.

Interviews in the Archives of American Art, Smithsonian Institution

Agostini, Peter. Interview with Colette Roberts. 1968.
Bocour, Leonard. Interview with Paul Cummings. June 8, 1978.
Bolotowsky, Ilya. Interviews with Paul Cummings. March 24 and April 7, 1968.
———. Interview with Ruth Gurin. 1963. From the collection titled "Ruth Gurin Bowman, interviews relating to American abstract artists, 1963–1965" [reels 3418, 4210].
Bluhm, Norman. Interviews with Paul Cummings. October 23 and November 12, 1969 [reel 3196].
Bultman, Fritz. Interview with Irving Sandler. January 6, 1968 [reel 3196].
Cage, John. Interview with Paul Cummings. May 2, 1974 [reel 3196].
Cherry, Herman. Interview with Harlan Phillips. September 1965 [reel 3949].
De Kooning, Willem. Interview with Anne Parsons. 1967. In the Anne Bowen Parsons collection of interviews on art, 1967–1968.
Diller, Burgoyne. Interview with Harlan Phillips. October 2, 1964.
Hague, Raoul. Interview with Joseph Travato. November 4, 1964.
Held, Al. Interviews with Paul Cummings. November 19, 1975, and January 8, 1976.
Hirshhorn, Joseph. Interview with Paul Cummings. December 16, 1976.
Holty, Carl. Interview with Ruth Gurin. April 3, 1964.
Johnson, Buffie. Interviews with Paul Cummings. November 22, 1977, and January 23, 1978.
Marca-Relli, Conrad. Interview with Dorothy Seckler. June 10, 1965.
McNeil, George. Interview with Irving Sandler. January 9, 1968.
Namuth, Hans. Interviews with Paul Cummings. August 12 and September 8, 1971 [reel 3198].
Noguchi, Isamu. Interviews with Paul Cummings. November 7 and December 26, 1973.
Oliveira, Nathan. Interviews with Paul Karlstrom. August 9, 1978, and December 21, 1981.
Ortman, George. Interviews with Richard Brown Baker. September 19 and November 5, 1963.
Packard, Emmy Lou. Interviews with Mary Fuller McChesney. May 11–12, 1964 [reel 3198].
Pavia, Philip. Interview with Bruce Hooten. January 19, 1965.
Porter, Fairfield. Interview with Paul Cummings. June 6, 1968 [reel 4211].
Refregier, Anton. Interview with Joseph Travato. November 5, 1964 [reel 3419].
Rivers, Larry. Interview with Paul Cummings. November 2, 1968 [reel 3949].
Resnick, Milton. Interviews with Cynthia Nadelman. July 13 and October 11, 1988.
Ruda, Edwin. Interview with Michael Chisolm. January 26, 1988.
Sander, Ludwig. Interviews with Paul Cummings. February 4 and 12, 1969 [reel 4779].
Schwabacher, Ethel. Interview by Colette Roberts. 1965. From the collection titled "Colette Roberts, interviews with artists, 1961–1971."
Segal, George. Interview with Paul Cummings. November 26, 1973 [reel 3949].
Tworkov, Jack. Interview with Dorothy Seckler. August 17, 1962.
Vicente, Esteban. Interviews with Elizabeth Frank. November 27 and December 4, 1982.
———. Interview with Irving Sandler. August 26, 1968.
Vogel, Joseph. Interview with Betty Hoag. January 5, 1965.
Zogbaum, Wilfred. Interview with Dorothy Seckler. November 2, 1964.

Documentation

Unpublished Sources

Archives of American Art, Smithsonian Institution

Charlotte Willard Papers. Research notes of an interview with the artist for *Look,* 1969.
De Kooning, Willem and Elaine. Tax records and financial documents from the 1950s. Also a handwritten resume from Elaine from the 1960s.
Pavia, Philip. Records of the Club [reel D176].
Thomas B. Hess Papers. Includes George Dickerson, "Willem de Kooning." Unedited transcript of interview, September 3, 1964, 1–22 [reels 3675–3697, 5028].

Artists' Files, Museums

Metropolitan Museum of Art, New York.
Museum of Modern Art Library, New York.
Solomon R. Guggenheim Museum of Art, New York.
Whitney Museum of American Art, New York.

City Directories and Municipal Archives

East Hampton, New York. Tax records, town hall.
The Hague, Netherlands. Central State Archives. Divorce proceedings, Leendert and Cornelia de Kooning; bankruptcy of Jacobus Lassooy.
Hoboken, New Jersey. City Directory, 1925–26.
New York, New York. Birth certificate, Elaine de Kooning.
New York, New York. City Directory, 1922–23, 1934.
Rotterdam, the Netherlands. Algemeen adresboek der gemeente Rotterdam (address book).
Rotterdam, the Netherlands. Municipal Archives. Willem de Kooning birth certificate.
Schiedam, the Netherlands. Municipal Archives. Marriage records, Leendert de Kooning and Cornelia Nobel.

Unpublished Letters and Correspondence

(All letters by de Kooning copyright The Willem de Kooning Foundation/Artists Rights Society, New York.)
Anthony, Roger. Willem de Kooning Foundation, New York. Envelopes postmarked to addresses where Willem de Kooning lived in the 1930s and 1940s.
Chaet, Bernard. Letters to the authors about de Kooning's teaching at Yale University.
De Kooning, Leendert. Letter to his son. Collection, de Kooning family, Rotterdam.
De Kooning, Willem. Letter to Josef Albers, collection of the Josef and Anni Albers Foundation. (Early draft of letter to Albers, collection of the artist.) Letter to Leendert de Kooning, collection of the de Kooning family. Letter to John Eastman, collection of John Eastman. Letter to Herzl Emanuel, collection of Herzl Emanuel. Multiple letters to Emilie Kilgore, collection of Emilie Kilgore. Unsent letter to Ruth Kligman, collection of the artist. Letter to Marie van Meurs-de Kooning, collection of her family.
Eastman, Lee. Unpublished letters to Joan Ward and Irving Markowitz. Courtesy of Joan Ward.
Fourcade, Xavier. Letters to de Kooning, to Lee Eastman, and inventories of art sales. Collection of the artist, courtesy of Joan Ward.
Ospina, Marina. Letters to de Kooning. Collection of the artist, courtesy of Joan Ward.
Polier, Shad. Legal correspondence relating to de Kooning's will and financial arrangements. Collection of the artist, courtesy of Joan Ward.

Unpublished Interviews

Centre Georges Pompidou, Musée national d'art moderne. Paris, 1984. Background interviews conducted as research for the catalog of de Kooning's 1984 retrospective at the museum:

> Burckhardt, Rudolph
> Castelli, Leo
> Greenberg, Clement
> Janis, Sidney
> Man Ray, Juliet (Juliet Browner)
> Mitchell, Joan
> Rauschenberg, Robert
> Sandler, Irving

Jonas, Bob. Interviews by Judith Wolfe. November 13 and December 4, 1984, and February 19, 1985.

Newsweek. Background file and interview with de Kooning, November 1, 1967, conducted by Ann Ray Martin, portions of which appeared in David L. Shirey, "Don Quixote in Springs," *Newsweek*, November 20, 1967.

———. Background file, undated, David Shirey, for "Don Quixote in Springs," *Newsweek*, November 20, 1967.

———. Background file, "Willem de Kooning retrospective opening in Holland," September 17, 1968, conducted by Ann Ray Martin. Includes interview with Ruth Kligman.

———. Undated background file and interview with de Kooning by *Newsweek* stringer Willem Vuur prior to de Kooning's 1968 retrospective in Amsterdam.

Taylor, Jack. Interviews conducted throughout the 1960s by Jack Taylor, curator and assistant director of the Milwaukee Art Museum, documenting the Ninth Street Show, a decades-long interest of his. Tapes provided courtesy of Taylor's friend Reva Shovers and her husband Philip, executor of Taylor's estate.

> Alcopley, L.
> Bluhm, Norman
> Busa, Peter
> Cavallon, Giorgio
> Cherry, Herman
> Geist, Sidney
> Grillo, John
> Guston, Philip
> Hartigan, Grace
> Holtzman, Harry
> Kotin, Al
> Leslie, Al
> Matter, Mercedes
> McNeil, George
> Resnick, Milton
> Sander, Ludwig
> Stamos, Theodoros
> Tworkov, Jack

Time. Background file, "Bill de Kooning Comes Back," for "Big Splash," a story about de Kooning's 1959 show published May 18, 1959. Includes interview with de Kooning.

———. Background file, "Hirshhorn Buys 13 de Koonings," October 29, 1964, by Leah Gordon. Includes interview with Joseph Hirshhorn. Quotes from this file later appeared in "A Jewel for the Mall," May 20, 1966, a story about the new Hirshhorn Museum planned for Washington, D.C.

———. Background interview file, May 19, 1946, by Saul, with Anton Refregier.

———. Background file, July 8, 1964, by Anne Hollander, entitled "Art Capital Shifts—Paris to New York." Includes interview with Harold Rosenberg.

———. Background file, July 20, 1958, by Welch, entitled "An Analysis of Abstract Expressionism, Its Meaning, the Major Figures." Includes interview with de Kooning.

Transcripts

The Willem de Kooning Foundation, New York. Sally Yard. "Conversations with Willem de Kooning." Transcript of interview, October 14, 1976.

The Willem de Kooning Foundation, New York. Transcripts of "Inner Monologue" (with de Kooning, Michael Sonnabend, and Kenneth Snelson) and "Soirée" (with de Kooning, Sonnabend, Robert Snyder, Harold Rosenberg, Herman Cherry, Thomas B. Hess, and Franz Kline). Both discussions took place in July 1959 and were used in the films produced by Robert Snyder.

Miscellaneous

"The Academy." Yearbook of Erasmus Hall High School. Brooklyn, January 1936.

Albers, Josef, and Anni Albers Foundation. Letter from de Kooning to Albers. The Foundation also has correspondence between Elaine de Kooning and Albers.

Documentation

De Kooning, Elaine. Notes taken by the authors at the memorial service for Elaine at Cooper Union, New York, March 12, 1990.

————. "Personal History of Willem de Kooning, recorded by his wife, Elaine," Unpublished.

De Kooning, Willem. Notes taken by the authors at the memorial service for de Kooning at the Museum of Modern Art, September 24, 1997.

————. Studio records and personal papers, The Willem de Kooning Foundation, New York. De Kooning kept extensive files throughout the 1960s and early 1970s of expenses, checks, and business correspondence, with separate accounts devoted to home and studio.

Herrera, Hayden, "John Graham's *System and Dialectics of Art.*" Unpublished course paper, PhD program, City University of New York, May 1973.

Het onderwijs aan de Academie van Beeldende Kunsten en Technische Wetenschappen te Rotterdam (annual reports, the academy in Rotterdam).

Lerner, Abram. Memoir delivered by Sidney Lawrence at a panel at the Hirshhorn Museum and Sculpture Garden, Smithsonian, October 21, 1993, in conjunction with the opening of the de Kooning retrospective.

McMahon, John. Talk delivered at the High Museum of Art in Atlanta, October 23, 1994. Collection of the artist, courtesy of Joan Ward. McMahon also spoke on a panel at the Hirshhorn Museum and Sculpture Garden in conjunction with the de Kooning retrospective of 1993–94, October 21, 1993.

"The Public Be Damned?" Advertisement paid for by Huntingdon Hartford II that ran nationwide in May 1955.

Shipping records. Public Library Systems, Newport News, Virginia; The Mariners' Museum Research Library, Newport News; and Harbor Master, Rotterdam.

Slivka, Rose. Notes from her talk on Elaine de Kooning. Delivered at the Studio School, New York, November 18, 1998.

Sotheby's catalog, featuring estate sale of Bernard Romein, 1987.

Sylvester, David. Recollections delivered at memorial for de Kooning. Museum of Modern Art, September 24, 1997.

Verheul, J. "De Academie van Beeldende Kunsten en Technische Wetenschappen 1851–1926." Speech delivered on the occasion of the seventy-fifth anniversary of the academy, 1926.

World's Fair, New York, 1939. Publicity handout with biography of Willem de Kooning and description of the Hall of Pharmacy murals, Museum of Modern Art, New York, library.

WPA Publicity release on Anton Refregier. November 7, 1941.

Monographs

Denby, Edwin. *Willem de Kooning.* Madras and New York, 1988.

Gaugh, Harry F. *Willem de Kooning.* New York, 1983.

Hess, Thomas B. *Willem de Kooning.* New York, 1959.

————. *Willem de Kooning.* New York, 1968.

————. *Willem de Kooning Drawings.* Greenwich, Conn., 1972.

Janis, Harriet, and Rudi Blesh. *De Kooning.* New York, 1960.

Lieber, Edvard. *Willem de Kooning: Reflections in the Studio.* New York, 2000.

Rosenberg, Harold. *Willem de Kooning.* New York, 1974.

Sollers, Philippe. *De Kooning, Vite.* Paris, 1988.

Waldman, Diane. *Willem de Kooning.* New York and Washington, 1988.

Wolfe, Judith. *The Young Willem de Kooning: Early Life, Training and Work, 1904–1926.* Diss., City University of New York, 1996.

Yard, Sally. *Willem de Kooning: The First Twenty-Six Years in New York.* Diss., Princeton University, 1980. Published as *Willem de Kooning: The First Twenty-Six Years in New York, 1927–1952.* New York and London, 1986.

————. *Willem de Kooning.* New York, 1997.

Museum Catalogs of de Kooning Solo Exhibitions

Centre Georges Pompidou, Musée national d'art moderne. *Willem de Kooning.* Essays by Robert Rosenblum, Yves Michaud, Louis Marin, Thomas B. Hess, and Claire Stoullig. Paris, 1984.

Guild Hall Museum. *Willem de Kooning: Works from 1951–1981.* Essay by Judith Wolfe. East Hampton, N.Y., 1981.

Hirshhorn Museum and Sculpture Garden. *Willem de Kooning from the Hirshhorn Museum Collection*. Essays by Judith Zilczer and Lynne Cooke. Washington and New York, 1993.

Museum of Art, Carnegie Institute. *Willem de Kooning: Pittsburgh International Series*. Pittsburgh, 1979.

Museum of Art, Fort Lauderdale. *William de Kooning in Process*. Essay by Klaus Kertess. New York, 2000.

Museum of Modern Art. *Willem de Kooning*. Essay by Thomas B. Hess. New York, 1968.

National Gallery of Art. *Willem de Kooning: Paintings*. Essays by David Sylvester and Richard Shiff. Catalog by Marla Prather. Washington, 1994.

San Francisco Museum of Modern Art and Walker Art Center. *Willem de Kooning: The Late Paintings, the 1980s*. Essays by Gary Garrels and Robert Storr. San Francisco, 1995.

School of the Museum of Fine Arts. *Willem de Kooning: 1935–1953*. Essay by Clement Greenberg. (Also at the Workshop Center for the Arts, Washington.) Boston, 1953.

Scottish Arts Council and Arts Council of Great Britain. *The Sculpture of de Kooning with Related Paintings, Drawings, and Lithographs*. Foreword by David Sylvester. Essay by Andrew Forge. Edinburgh and London, 1977.

Smith College Museum of Art. *Willem de Kooning*. Essay by Dore Ashton. Northampton, Mass. 1965.

Solomon R. Guggenheim Museum. *Willem de Kooning in East Hampton*. Essay by Diane Waldman. New York, 1978.

Stedelijk Museum. *The North Atlantic Light*. Essay by Carter Ratcliff. Amsterdam, 1983.

————. *Willem de Kooning*. Essay by Thomas B. Hess. Amsterdam, 1968.

University of Northern Iowa, Gallery of Art. *De Kooning, 1969–1978*. Essays by Jack Cowart and Sanford Sivitz Shaman. Cedar Falls, 1978.

Walker Art Center. *De Kooning: Drawings/Sculpture*. Essays by Philip Larson and Peter Schjeldahl. Minneapolis and New York, 1974.

Whitney Museum of American Art. *Willem de Kooning: Drawings, Paintings, Sculpture*. Essays by Paul Cummings, Jorn Merkert, and Claire Stoullig. New York, 1983.

Gallery Catalogs of de Kooning Shows

Allan Stone Gallery. *Liquefying Cubism*. Essay by Allan Stone. New York, 1994.

Anthony d'Offay Gallery. *Willem de Kooning: Recent Paintings 1983–1986*. Essay by Robert Rosenblum. London, 1986.

C & M Arts. *Willem de Kooning: Selected Paintings and Sculpture, 1964–1973*. Essay by Robert Pincus-Witten. New York, 2000.

————. *Willem de Kooning: Transcending Landscape, Paintings, 1975–1979*. Essay by Jill Weinberg. New York, 1993.

Gagosian Gallery. *Willem de Kooning*. Essay by Henry Geldzahler. New York, 1987.

————. *Willem de Kooning, Mostly Women: Drawings and Paintings from the John and Kimiko Powers Collection*. Essay by Robert Rosenblum. New York, 2000.

M. Knoedler & Co., Inc. *De Kooning: January 1968–March 1969*. Essay by Thomas B. Hess. New York, 1969.

————. *De Kooning: Recent Paintings*. Essay by Thomas B. Hess. New York, 1967.

Matthew Marks Gallery. *Willem de Kooning: Drawings and Sculpture*. Essay by Peter Schjeldahl. New York, 1998.

Matthew Marks Gallery, in collaboration with Mitchell-Innes & Nash. *De Kooning's 1987 Paintings*. Essay by Katy Siegel. New York, 2001.

————. *Willem de Kooning: Paintings 1983–84*. Essay by Richard Shiff. New York, 1997.

————. *Willem de Kooning Sculpture*. With texts by Andrew Forge, David Sylvester, and William Tucker. New York, 1996.

Mitchell-Innes & Nash, in collaboration with Matthew Marks Gallery. *The Artist's Hand: Willem de Kooning Drawings, 1937 to 1954*. Essay by Amy Schichtel. New York, 2002.

————. *Willem de Kooning: Vellums*. Essay by Brenda Richardson. New York, 2001.

Salander-O'Reilly Galleries, Inc. *Willem de Kooning: An Exhibition of Paintings*. Essays by Klaus Kertess and Robert Rosenblum. New York, 1990.

————. *Willem de Kooning, The Printer's Proofs, from the Collection of Irwin Hollander, Master Printer*. Text by Lanier Graham, with contributions by Barry Walker and Dan Budnik. New York, 1992.

Documentation

Sidney Janis Gallery. *An Exhibition by de Kooning Introducing His Sculpture and New Paintings.* New York, 1972.

———. *Recent Paintings by Willem de Kooning.* Essay by Thomas B. Hess. New York, 1962.

Articles on de Kooning

Alloway, Lawrence. "Criticism and Art History." *ArtForum* (January 1975).

Andelman, David. "Belgrade Exhibit Is a Barometer of Decade's Art in East and West." *New York Times*, November 17, 1977.

Arb, Renee. "Spotlight on de Kooning." *ArtNews* 47 (April 1948).

Ashbery, John. "Willem de Kooning: A Suite of New Lithographs Translates His Famous Brushstroke into Black and White." *ArtNews Annual* 37 (October 1971).

Ashton, Dore. "Art." *Arts and Architecture* (December 1955).

———. "Art." *Arts and Architecture* (June 1956).

———. "Art." *Arts and Architecture* (June 1957).

———. "Art." *Arts and Architecture* (July 1959).

———. "Art." *Arts and Architecture* (May 1962).

———. "De Kooning's Verve." *Studio International* (June 1962).

———. "New York Commentary: De Kooning at Knoedler." *Studio International* (January 1968).

———. "Willem de Kooning: Homo Faber." *Arts Magazine* 50 (January 1976).

Bannard, Walter Darby. "Willem de Kooning's Retrospective at the Museum of Modern Art." *ArtForum* (April 1969).

Barr, Alfred. "Gorky, de Kooning, Pollock." *ArtNews* (Summer 1950).

Berkson, Bill, and Rackstraw Downes, eds. *Art Journal* 48 (Fall 1989). "Willem de Kooning on His 85th Birthday," special issue with statements from friends and other artists.

Blok, C. "Willem de Kooning and Henry Moore." *Art International*, December 20, 1968.

Brenson, Michael. "De Kooning and Dubuffet's Iconoclastic Women." *New York Times*, December 7, 1990.

———. "De Kooning: Masterworks from a Master Painter." *New York Times*, September 7, 1990.

Burton, Scott. "Generation of Light." *ArtNews Annual* 35 (1969).

Coates, Robert. "The Art Galleries." *New Yorker*, April 4, 1953.

Collins, Glenn. "Art, Wealth and Filial Duty Ensnarl Dispute over de Kooning's Assets." *New York Times*, June 8, 1989.

Cowart, Jack. "De Kooning Today." *Art International* (Summer 1979).

Creham, Herbert. "Woman Trouble." *Art Digest*, April 15, 1953.

Dalí, Salvador. "De Kooning's 300,000,000th Birthday." *ArtNews* (April 1969).

De Kooning, Elaine. "De Kooning Memories." *Vogue* (December 1983).

Denby, Edwin. "My Friend de Kooning." *ArtNews Annual* 29 (1964).

Devree, Howard. "Master's Drawings: Five Centuries of French Artists' Work at Metropolitan—de Kooning." *New York Times*, March 22, 1953.

Duncan, Carol. "The MoMA's Hot Mamas." *Art Journal* 48 (Summer 1989).

Esterow, Milton. "Willem de Kooning Files Suit Against Art Dealer." *New York Times*, March 31, 1965.

Finkelstein, Louis. "The Light of de Kooning." *ArtNews* (November 1967).

Fitzsimmons, James. "Art." *Art and Architecture* (May 1953).

Forge, Andrew. "De Kooning in Retrospect." *ArtNews* 68 (March 1969).

———. "De Kooning's Women." *Studio International* 176 (December 1968).

Frank, Robert. "Letter from New York." *Creative Camera*. Reprinted in David Brittain. *Creative Camera: Thirty Years of Writing.* Manchester, England, 2000.

Goldwater, Robert. "Masters of the New." *Partisan Review* 29 (Summer 1962).

———. "Reflections on the New York School." *Quadrum* 8 (1960).

Glueck, Grace. "Art Notes." *New York Times*, January 29, 1967.

———. "De Kooning Retrospective of 60 Years at Whitney." *New York Times*, December 16, 1983.

Greenberg, Clement. "Art." *The Nation*, April 24, 1948.

———. "Art." *The Nation*, December 11, 1948.

———. "Letters: Mr. Greenberg Revises." *Art in America* (September/October 1971).

Hess, Thomas B. "Art: Stella Means Star." *New York Magazine*. November 1, 1976.
———. "De Kooning's New Women." *ArtNews* 64 (March 1965).
———. "8 Excellent, 20 Good, 133 Others." *ArtNews* 48 (January 1950).
———. "The Flying Hollander of Easthampton, L.I." *New York*, February 20, 1978.
———. "Pinup and Icon." In *Woman as Sex Object: Studies in Erotic Art, 1730–1970* [*ArtNews Annual* 38], ed. Thomas B. Hess and Linda Nochlin. New York, 1972.
———. "Reviews and Previews." *ArtNews* 58 (May 1959).
———. "Selecting from the Flow of Spring Shows." *ArtNews* 55 (April 1956).
———. "U.S. Painting: Some Recent Directions." *ArtNews Annual* 25 (1956).
———. "The Whitney: Exhibit Abstract." *ArtNews* 47 (December 1948).
Hughes, Robert. "The Painter as Draftsman." *Time*, June 17, 1974.
———. "Painting's Vocabulary Builder." *Time*, January 9, 1984.
———. "Slap and Twist." *Time*, October 23, 1972.
———. "Softer de Koonings." *Time*, March 6, 1978.
Hunter, Sam. "By Groups and Singly." *New York Times*, April 25, 1948.
Kingsley, April. "Willem de Kooning at the Janis Gallery." *ArtForum* (December 1972).
Kramer, Hilton. "A Career Divided." *New York Times*, March 9, 1969.
———. "Art: The Sculptures of Willem de Kooning Shown." *New York Times*, October 13, 1972.
———. "Art: De Kooning of East Hampton." *New York Times*, February 10, 1978.
———. "De Kooning's Pompier Expressionism." *New York Times*. November 19, 1967.
———. "De Kooning Survey Opens at the Modern." *New York Times*, March 5, 1969.
Kuh, Katherine. "The Story of a Picture—or What's a Museum For?" In *The Open Eye: In Pursuit of Art*. New York, 1971. Earlier version appeared in *Saturday Review*, March 29, 1969.
Kuspit, Donald. "The Unveiling of Venus: De Kooning's Melodrama of Vulgarity." *Vanguard* 13 (September 1984).
Lippard, Lucy. "Three Generations of Women: De Kooning's First Retrospective." *Art International* 9 (November 1965).
Louchheim, Aline B. "Conclusion from a Chicago Annual." *New York Times*, October 28, 1951.
Lucie-Smith, Edward. "Victim of History." *Times* (London), December 8, 1968.
Marriott, Celia. "Iconography of de Kooning's *Excavation*." *Bulletin of the Art Institute of Chicago* 69 (January 1975).
McBride, Henry. "Abstract Report for April." *ArtNews* (April 1953).
———. "It's Called Expressionism." *ArtNews* 51 (May 1952).
McGill, Douglas. "Triptych Is Focus of Church Debate." *New York Times*, February 25, 1986.
Mozley, Anita. "De Kooning and His Studio Photographed by Harry Bowden." *Stanford Museum* 8–9 (1978–79).
O'Doherty, Brian. "Willem de Kooning: Fragmentary Notes Towards a Figure." *Art International*, December 20, 1968.
Perrault, John. "De Kooning at the Springs." *New York Magazine*, March 17, 1969.
———. "The New De Koonings." *ArtNews* 68 (March 1969).
Porter, Fairfield. "Art." *The Nation*, June 6, 1959.
———. "Willem de Kooning." *ArtNews* 54 (November 1955).
Ratcliff, Carter. "New York Letter." *Art International* (December 1972).
———. "The Past Undone: Willem de Kooning." *Art in America* 72 (Summer 1984).
———. "Willem de Kooning: New Paintings and Sculpture." *Art International* 19 (December 1975).
Rauschenberg, Robert. "Statement," in "Willem de Kooning, on His Eighty-Fifth Birthday." *Art Journal* 48 (Fall 1989).
Reif, Rita. "Auctions." *New York Times*, April 20, 1979.
———. "$1.2 Million for a de Kooning." *New York Times*, May 11, 1983.
Richard, Paul. "The Screaming de Koonings." *Washington Post* and *San Francisco Chronicle*, December 3, 1967.
———. "The Eye of the Storm." *Washington Post*, May 8, 1994.
Rosand, David. "Proclaiming Flesh." *Times Literary Supplement*, February 17, 1984.
Rose, Barbara. "Art: De Kooning and the Old Masters." *Vogue* (May 1969).
Rosenberg, Harold. "The American Action Painters." *ArtNews* 51 (December 1952).
———. "The Art Galleries: Painting Is a Way of Living." *New Yorker*, February 16, 1963.
———. "De Kooning." *Vogue* (September 1964).
Rosenblum, Robert. "The Fatal Women of Picasso and De Kooning." *ArtNews* 84 (October 1985).

Documentation

Russell, John. "Art: Drawing Reborn in de Kooning's 'Painted Women.'" *New York Times*, September 14, 1974.

———. "De Kooning's Freedom Came Step by Exuberant Step." *New York Times*, February 5, 1984.

———. "De Kooning's New Frontiers." *New York Times*, October 15, 1976.

———. "Gallery View: Two Artists Share the Carnegie International." *New York Times*, November 18, 1979.

———. "Lively Competitor to the Old de Koonings." *New York Times*, April 16, 1982.

Sandler, Irving. "Reviews: New York—Willem de Kooning, Solomon R. Guggenheim Museum." *ArtForum* 16 (Summer 1978).

Schiro, Ann Marie. "Partying for de Kooning." *New York Times*, December 16, 1983.

Schjeldahl, Peter. "De Kooning: Subtle Renewals." *ArtNews* (November 1972).

———. "Willem de Kooning 1904–1997." *The Village Voice*, April 8, 1997.

Shepard, Richard. "Knoedler's Opens de Kooning Show." *New York Times*, November 12, 1967.

Steinberg, Leo. "Month in Review." *Arts Magazine* 30 (November 1955).

Stevens, Mark. "Bravura Brushstroke." *New York*, November 28, 1994.

Storr, Robert. "De Kooning at Fourcade." *Art in America* 74 (February 1986).

Stuckey, Charles F. "Bill de Kooning and Joe Christmas." *Art in America* 68 (March 1980).

Sylvester, David. "Countercurrents." *New Society* (London) 13, January 30, 1969.

Thompson, David. "The End of a Tradition?" *New York Times*, January 19, 1969.

Tillim, Sidney. "In the Galleries." *Arts Magazine* 33 (June 1959).

———. "Month in Review." *Arts Magazine* 36 (May/June 1962).

Tully, Judd. "Court Rules Artist de Kooning 'Incapable.'" *Washington Post*, August 19, 1989.

———. "De Kooning and the Battle Over His Future." *Washington Post*, July 23, 1989.

———. "De Kooning's Uncertain Legacy." *Art and Auction* (May 1997).

Vogel, Carol. "De Kooning Intrigue Lives On." *New York Times*, October 6, 1997.

———. "Inside Art." *New York Times*, July 23, 1993.

Wingen, Ed. "De Meester Komt Beroemd Terug." *De Telegraaf*, April 13, 1968.

Yard, Sally. "The Angel and the Demoiselle—Willem de Kooning's *Black Friday*." *Record of the Art Museum, Princeton University* 50 (1991).

Unsigned Articles

"Big City Dames." *Time*, April 6, 1953.

"Big Splash." *Time*, May 18, 1959.

"Cash Expressionism." *Newsweek*, April 12, 1965.

"Congenial Company." *Art Digest*, January 15, 1942.

"De Kooning's Masterwork." *Time*, March 7, 1969.

"De Kooning, Sued in Bar Fight, Is Too Busy Painting to Appear." *New York Times*, October 12, 1961.

"Eindelijk barst het beheerste geweld van De Kooning hier los." *Het Vrije Volk*, September 20, 1968.

"The Native Returns." *Newsweek*, October 7, 1968.

"Paul and L.I. Pal a Study in Contrast." *New York Post*, February 11, 1982.

"People." Notice of de Kooning being sued in barroom incident. *Time*, April 15, 1966.

Untitled article on bar fight. *New York Post*, October 15, 1961.

"William de Kooning [sic]." *Arts Magazine* 41 (February 1948).

Related Books, Catalogs, Exhibitions and Articles

Abel, Lionel. *The Intellectual Follies: A Memoir of the Literary Venture in New York and Paris.* New York, 1982.

Abstract Expressionism: The Critical Developments. Exhibition catalog. Albright-Knox Gallery. Buffalo and New York, 1987.

Abstract Painting and Sculpture in America. Exhibition Catalog. Museum of Modern Art. New York, 1951.

Alcopley, L. "The Club: Its First Three Years." *Issue, A Journal for Artists.* Reflex Horizons, Ltd., New York, 1985.

Alloway, Lawrence. "Iconography Wreckers and Maenad Hunters." *Art International* (April 1961).

Altshuler, Bruce. *The Avant-Garde Exhibition: New Art in the 20th Century.* New York, 1994.

Amaya, Mario. *Art Nouveau*. New York, 1966.

American Abstract Expressionists and Imagists. Exhibition catalog. Solomon R. Guggenheim Museum. New York, 1961.

American Art at Mid-Century: The Subjects of the Artist. Exhibition catalog, with essays by E. A. Carmean, Eliza Rathbone, and Thomas B. Hess. National Gallery of Art. Washington, 1978.

Arshile Gorky, 1904–1948. Exhibition catalog. Museum of Modern Art. New York, 1962.

Arshile Gorky: A Retrospective: Exhibition catalog by Diane Waldman. Solomon R. Guggenheim Museum. New York, 1981.

Art Nouveau: Art and Design at the Turn of the Century. Exhibition catalog, ed. Peter Selz and Mildred Constantine. Museum of Modern Art. New York, 1960.

Ashton, Dore. *A Fable of Modern Art*. London, 1980.

———. *The New York School: A Cultural Reckoning*. New York, 1972.

———, ed. *Picasso on Art: A Selection of Views*. New York, 1972.

Baldwin, Neal. *Man Ray: An American Artist*. New York, 1988.

Barr, Alfred. *Defining Modern Art: Selected Writings of Alfred H. Barr*. Ed. Irving Sandler and Amy Newman. New York, 1986.

———. "Gorky, De Kooning, Pollock." *ARTnews* (Summer 1950).

Barnett, Catherine. "Man Ray's Juliet." *Art and Antiques* (October 1988).

Barrett, William. *The Truants: Adventures Among the Intellectuals*. Garden City, New York, 1982.

Baudelaire, Charles. *Paris Spleen*. New York, 1947.

Beaton, Cecil. *Cecil Beaton's New York*. London, 1938.

Berman, Avis. "An Interview with Katherine Kuh." *Archives of American Art Journal* 27, 3 (1987).

Boral, Robert. *Turn West on 23rd: A Toast to New York's Old Chelsea*. Garden City, New York, 1965.

Boumard, P. J., and W. H. Bouman. *De groei van de grote Werkstad: Een studie over de bevolking van Rotterdam*. Assen, 1952.

Breslin, James E. B. *Mark Rothko*. Chicago and London, 1993.

Cahalan, Brigid. "Hoboken, a City in Transition." Master's thesis, Queens College, City of New York.

Cash, Stephanie, and David Ebony. Janice Biala obituary. *Art in America* (December 2000).

Coates, Robert. "The Art Galleries." *New Yorker*, December 3, 1949.

———. Reviews of Jackson Pollock shows in the *New Yorker*, May 29 and November 20, 1943.

Cowley, Malcolm. *Exile's Return*. New York, 1934.

Dawson, Fielding. *Franz Kline: An Emotional Memoir*. New York, 1967.

De Branding, 1917–1926. Exhibition catalog. Rotterdam, 1991.

De Coppet, Laura, and Alan Jones. *The Art Dealers*. New York, 1984.

De Kooning, Elaine. *The Spirit of Abstract Expressionism: Selected Writings*. New York, 1994.

Denby, Edwin. "Notes on Nijinsky Photographs." In *Dance Writings*, ed. Robert Crawford and William MacKay. New York, 1986.

Dorfman, Geoffrey, ed. *Out of the Picture: Milton Resnick and the New York School*. New York, 2002.

Eliot, Alexander. "Under the Four Winds" (the Venice Biennale). *Time*, June 28, 1954.

Eliot, T. S. *Selected Essays*. London, 1932.

Feldman, Morton. "Give My Regards to Eighth Street." *Art in America* (March/April 1971).

Foster, Edward Halsey, and Geoffrey W. Clark, eds. *Hoboken: A Collection of Essays*. New York, 1976.

Franz Kline, Black & White, 1950–1961. Exhibition catalog, with essay by David Anfam. Houston, 1994.

Gamarekian, Barbara. "Capital Gives All for Art." *New York Times*, May 31, 1978.

Gaugh, Harry. *The Vital Gesture of Franz Kline*. New York, 1985.

Gooch, Brad. *City Poet*. New York, 1993.

Graham, John. "Autoportrait." *Mulch* (Spring 1972).

———. *System and Dialectics of Art*. Ed. Marcia Epstein Allentuck. Baltimore, 1971.

Greenberg, Clement. "Art." *The Nation*, November 11, 1944.

———. *Art and Culture*. Boston, 1961.

———. *The Collected Essays and Criticism: Affirmations and Refusals*. Ed. John O'Brian. Chicago, 1993.

———. "Marc Chagall, Lyonel Feininger, Jackson Pollock." *The Nation*, November 27, 1943.

Documentation

———. "The Situation at the Moment." *Partisan Review* (January 1948).

Gruen, John. *The Party's Over Now.* New York, 1967.

Gruetzner, Howard. *Alzheimer's: A Caregiver's Guide and Sourcebook.* New York, 1992.

Guilbaut, Serge. *How New York Stole the Idea of Modern Art: Abstract Expressionism, Freedom, and the Cold War.* Chicago, 1983.

Hall, Lee. *Elaine and Bill: Portrait of a Marriage.* New York, 1993.

Hamill, Pete. "Beyond the Vital Gesture." *Art and Antiques* (May 1990).

Harris, Mary Emma. *The Arts at Black Mountain.* Cambridge, 1987.

Heaney, John J. *The Bicentennial Comes to Hoboken.* Hoboken, 1976.

Herrera, Hayden. *Arshile Gorky: His Life and Work.* New York, 2003.

Hess, Thomas B. *Abstract Painting: Background and American Phase.* New York, 1951.

———. "Selecting from the Flow of Spring Shows." *ARTnews* (April 1956), 24.

———. "The Whitney: Exhibit Extract." *ARTnews* 47 (December 1948).

Hoogveld, Carine. *Glas-in-lood in Nederland, 1817–1968.* The Hague, 1989.

Hughes, Emmet John. "Joe Hirshhorn, the Brooklyn Uranium King." *Fortune,* February 11, 1980.

Hughes, Robert. "The Tribal Style." *Time,* October 16, 1978.

Jacques, Alan. *Understanding Dementia.* Edinburgh and London, 1988, 1992.

Kazan, Alfred. *Starting Out in the Thirties.* Boston, 1962.

Kelly, William, MD, ed. *Alzheimer's Disease and Related Disorders, Research and Management.* Springfield, Ill., 1984.

Kingsley, April. *The Turning Point: The Abstract Expressionists and the Transformation of American Art.* New York, 1992.

Kligman, Ruth. *Love Affair: A Memoir of Jackson Pollock.* New York, 1974.

Kline: The Color Abstractions. Exhibition catalog. Phillips Collection, 1979.

Kossman, E. H. "The Low Countries, 1780–1940." In *Oxford History of Modern Europe.* Oxford, 1978.

Kramer, Hilton. "An Era in Art Comes to an End." *New York Times,* July 23, 1978.

———. "A New View of Abstraction." *New York Times,* June 13, 1978.

———. "Art View." *New York Times,* July 23, 1978.

———. "Critics of American Painting." *Arts Magazine* (October 1959).

LeSueur, Joe. *Digressions on Some Poems by Frank O'Hara: A Memoir.* New York, 2003.

Levy, Julien. *Memoir of an Art Gallery.* New York, 1977.

Louchlin, Aline. "Six Abstractionists Defend Their Art." *New York Times Magazine,* January 21, 1951.

Luthmann, J. M. "Inleiding De Bijenkorf in Den Haag." *Wendingen* 7, 11/12 (1925).

MacDonald, Dwight. "Masscult and Midcult." *Partisan Review* (Spring 1960).

Mallin, Judith Young. "Remembering the Faces of Juliet." *Quest* (Summer 1991).

McCarthy, Mary. "Ideas Were the Generative Force of His Life." *New York Times,* May 6, 1979.

McDarragh, Fred W. and Gloria S. *The Artist's World in Pictures: The New York School.* Intro. by Thomas B. Hess. New York, 1988.

McMahon, Audrey. "A General View of the Federal Art Project of the Works Progress Administration." In *New York City WPA Art.* Exhibition catalog. New York, 1997.

Miller, Bruce L., M.D., and Craig E. Hou, M.D. "Portraits of Artists: Emergence of Visual Creativity in Dementia." *Neurological Review,* June 2004.

Mondrian: From Figure to Abstraction. Exhibition catalog. Tokyo, 1997.

Mooradian, Karlen. *Ararat: A Special Issue on Arshile Gorky* (Fall 1971).

Morgenthau, Henry, Quoted in Yuri Babayan. "Amernian History." www.armenianhistory.info.

Motherwell, Robert. *The Collected Writings of Robert Motherwell.* Ed. Stephanie Terenzio. Oxford, 1992.

Motherwell, Robert, and Ad Reinhardt, eds. *Modern Artists in America.* New York, 1951.

The Museum of Modern Art, New York: The History and the Collection, introduction by Sam Hunter. New York, 1984.

Naifeh, Steven, and Gregory White Smith. *Jackson Pollock: An American Saga.* New York, 1989.

Naylor, Gillian. "The Netherlands." In *The Encyclopedia of Decorative Arts, 1890–1940.* Ed. Philippe Garner. London, 1978.

Neugass, Fritz. "New Records for Abstract Art." *Arts Magazine* (February 1965).

The New American Painting. Exhibition catalog. Museum of Modern Art. New York, 1959.

The New Realists. Exhibition catalog. Sidney Janis Gallery. New York, 1962.

Norman, Dorothy. *Encounters: A Memoir.* New York, 1987.

New York City WPA Art. Exhibition catalog, with essays by Audrey McMahon, Emily Genauer, Norman Barr, and Greta Berman. Parsons School of Design. New York, 1977.

Picasso: 75th Anniversary. Exhibition catalog. Museum of Modern Art. New York, 1957.

Polcari, Stephen. *Abstract Expressionism and the Modern Experience.* Cambridge, 1991.

Possibilities 1 (Winter 1947–48). Multiple editors (Robert Motherwell, Harold Rosenberg, Pierre Chareau, and John Cage).

Potter, Jeffrey. *To a Violent Grave: An Oral Biography of Jackson Pollock.* New York, 1985.

Ratcliff, Carter. *The Fate of a Gesture: Jackson Pollock and Postwar American Art.* New York, 1996.

Raynor, Vivian. "4,000 Paintings and 1,500 Sculptures: Joseph Hirshhorn's Mine of Modern Art." *New York Times,* November 27, 1966.

Reinhardt, Ad. "Art as Art: The Selected Writings of Ad Reinhardt." In *The Documents of 20th Century Art,* ed. Barbara Rose. New York, 1975.

Richard, Paul. "The Inspired Greed of Joe Hirshhorn." *Washington Post/Potomac,* September 29, 1974.

Rosenberg, Harold. "The American Action Painters." *ArtNews,* December 1952.

———. *Arshile Gorky: The Man, the Time, the Idea.* New York, 1962.

———. "Art of Bad Conscience." *New Yorker,* December 16, 1967.

———. "The Herd of Independent Minds: Has the Avant-Garde Its Own Mass Culture?" *Commentary* (September 1948).

Ross, Don. "I Buy Art Like Somebody Else Buys Neckties." *New York Herald Tribune,* July 8, 1962.

Rubenfeld, Florence. *Clement Greenberg: A Life.* New York, 1997.

Russell, John. "Harold Rosenberg Is Dead at 72." *New York Times,* July 13, 1978.

———. "Thomas Hess, Art Expert, Dies." *New York Times,* July 14, 1978.

Sacks, Oliver. "Letters." *Art and Antiques* (January 1990).

———. *The Man Who Mistook His Wife for a Hat.* New York, 1987.

Sandler, Irving. *The New York School: The Painters and Sculptors of the Fifties.* New York. 1978.

———. *The Triumph of American Painting: A History of Abstract Expressionism.* New York, 1970.

Schapiro, Meyer. *Modern Art: 19th and 20th Centuries.* New York, 1978.

Seitz, William C. *Abstract Expressionist Painting in America.* Cambridge and London, 1983.

Shap, Marynell. "Man and Wife." *Art Digest,* October 1, 1949.

Sixteen Americans. Exhibition catalog. Museum of Modern Art. New York, 1959.

Smith, Page. *Redeeming the Time: A People's History of the 1920s and the New Deal.* Vol. 8. New York, 1991.

Solomon, Deborah. *Jackson Pollock: A Biography.* New York, 1987.

Soutine. Exhibition catalog. Museum of Modern Art. New York, 1950.

Spender, Matthew. *From a High Place: A Life of Arshile Gorky.* New York, 1999.

Steinberg, Leo. *Encounters with Rauschenberg.* Chicago, 2000.

Sulzberger, C. L. *New History of World War II.* Updated by Stephen Ambrose. New York, 1997.

Surrealism Embodied: The Figure in American Art 1933–1953. Exhibition catalog. Michael Rosenfeld Gallery. New York, 1992.

Tarter, Ralph, PhD, and David H. Von Thiel, MD, editors, *Alcohol and the Brain: Chronic Effects.* New York and London, 1985.

The 30s: Painting in New York. Exhibition catalog, with preface and essay by Patricia Passlof. Poindexter Gallery. New York, 1957.

Vail, Karole P. B. *Peggy Guggenheim, a Celebration.* Published in conjunction with the Guggenheim exhibition "Peggy Guggenheim: A Centennial Celebration." New York, 1999.

Van Oven, Ro. "Japp Gidding." *Elsevier's Geillustreerd Maandschrift* (Elsevier's Illustrated Monthly) 62 (1921).

Young Painters in the U.S. and France. Exhibition catalog. Sidney Janis Gallery. New York, 1950.

Anonymous

"A Jewel for the Mall." *Time,* May 20, 1966.

"A *Life* Round Table on Modern Art." *Life,* October 11, 1948.

"American Abstraction Abroad." *Time,* August 4, 1958.

Chronicle of the Twentieth Century. Mount Kisco, N.Y., 1987.

Documentation

"De winkelweek, Weste Wagenstraat." *Nieuwe Rotterdam Courant*, November 13, 1925.

"Ein Kalender." *Nieuwe Rotterdam Courant*, May 11, 1930.

"46 L. I. Artists Brush Up for Politics." *New York Times*, August 19, 1972.

Gidding, Jaap. Obituary. *Rotterdams Nieuwsblad*, April 26, 1955.

Het Gebouw van de Academie van Beeldende Kunsten en Technische Wetenschappen, van 1 mei 1873 tot 1 September 1935. A history of the academy, contained in the academy archieves.

Het onderwijs aan de Academie van Beeldende Kunsten en Technische Wetenschappen te Rotterdam in 1913. Rotterdam, 1914.

"Jaap Gidding." *Elsevier's Geillustreed Maandschrift.*

"Jackson Pollock: Is He the Greatest Living Painter in the United States?" *Life*, August 8, 1949.

"Kunst en Letteren." *Dordrechtsche Courant*, April 19, 1927.

Macmillan Encyclopedia of Architects. London, 1982.

"The Metropolitan and Modern Art." *Life*, January 15, 1951.

New York Panorama: A Comprehensive View of the Metropolis. Federal Writers' Project of the Works Progress Administration in New York City. New York, 1938.

Sotheby's catalog, "Contemporary Art from the Estate of Xavier Fourcade." November 4, 1987.

Sotheby's catalog, sale of the artwork of Bernard Romein. 1987.

"30 Receive Freedom Medal at the White House." *New York Times*, September 15, 1964.

Three Centuries of Progress: A Brief History of Hoboken, N.J., and Teaneck, N.J., from 1609 to 1940. Published to commemorate the seventy-fifth anniversary of the A. J. Volk Company.

Index

Page numbers in *italics* refer to illustrations.

Index

Index

Index

Index

de Kooning, Willem *(continued)*; Old World values, xiv, 26–7, 103, 104, 138–9, 166, 180, 189, 325–7, 360, 443, 491; oval-egg motif, 78–9, 87, 90; painterly space, 137, 175, 199, 225, 247–50, 419, 562; painting techniques, 24–5, 50, 87, 105, 185–6, 225, 244–6, 249, 295, 322, 324, 380, 419, 465–7, 472, 473, 493, 561–2, 589–91, 601–2, 614, 620; paradoxical sensibility, 41, 89, 108, 137, 140, 174, 188–9, 198–9, 248, 253, 268–71, 295, 338–43, 519, 563–4, 630; in Paris and London (1967), 505–6; pastoral theme, 294, 378, 419, 443, 449–50, 464–6, 485, 497, 498, 503, 518, 560–4, 565, 570–1, 580, 585, 590; philosophy interests, 277–8, 279, 449, 568; physical appearance, xii, 16, 32–3, 48, 53–4, 63, 115, 146–7, 154, 227, 257, 321, 369, 401, 404, 412, 428, 469, 484–5, 518, 536, 542, 551–2, 565, 610; Picasso and, 107–8, 126, 136–40, 174, 175, 219, 250, 311, 354, 381, 397, 471; politics, 83–4, 110–13, 132–3, 164, 484–5, 554; Pollock and, 209, 243–4, 247–8, 253, 285, 292, 335–6, 352, 356–8, 372–3, 385, 393–7, 399–400, 402, 404, 518, 519; as poor businessman, 181–2, 251; popularity with younger artists, 189–91, 308–9, 358–60, 557–8; poverty and malnutrition, 10, 17–19, 24, 31, 49, 54, 132, 135, 176–80, 189, 211–13, 227, 232–3, 244–5, 260, 268–70, 301, 315, 319; premarital relationship with Elaine, 162–6, 175–82, 188–9, 193–4; in Provincetown, 283–5; public persona, 311–12, 397–400, 592–8; Rauschenberg and, 358–60, 431, 455; Red House summer, 370–8, 403; relationship with his daughter, 383, 387, 408, 412, 421, 424–6, *426*, 427, 449, 450, 454, 479, 494–5, 506, 517, 519, 523, 545–6, 554, *557*, 579, 587, 592, 595, 605, 619, 622, 623–8; relationship with his father, 11–13, 48–9, 56, 90, 194, 195, 233–5, 241, 271, 319, 410, 509, 510; relationship with his mother, xii, 10–12, 30–1, 35, 48–9, 57, 74, 119–21, 153, 188, 233, 274, 339, 344, 374–8, 379, 408, 483, 507, 509, 514, *514*, 516; relationship with his sister, 13–14, 31, 33, 34–5, 46, 52, 54, 57, 196, 233, 374, 378, 507, 509, 513–15; reputation in later years, xiii–xiv, 548–9, 595–7, 602–6, 626, 627–8; retreat to the country, 439–43, 447–50; "return to the figure" after *Excavation*, 309–14, 337; reunion with Elaine, and her handling of his affairs, 567, 570, *573*, 575–88, 592–3, 595–8, 603–9, 617, 619, 621–3; reworking habit, 87, 313, 458, 545, 591; rocking chairs, 498–9, *538*, 630; romantic cult of the individual, xiii, xiv, xv, 103, 138,

174, 280, 297, 342, 354–5, 367–8, 381, 518; in Rome, 409–10, 414–18, 420, 523–8, 544; Bernard Romein and, 37–42, 47, 72; Harold Rosenberg and, 223, 334–6, 350–7, 366, 405, 439, 448, 455, 469, 519, 555, 578, 582–3; Rothko and, 147–8, 558; in Rotterdam, 3–33, 35–57, 332; school years, 14–16, 19, 332; sea and, 3, 75, 80, 285, 332, 450, 461, 510, 561; sedatives, 568–9; sexual character, 240, 272, 346, 428, 432; sexual themes, 140, 198–9, 338–43, 419, 464, 485–8, 498, 500–503, 550; short-term memory loss, 569, 583, 586, 593, 602–3, 610; shrewdness, 150, 454, 495; Soutine and, 312–13, 562; Stedelijk retrospective (1968), 503–4, 506, 507, 512–15, 564; studio assistants, 423–4, 433, 481–3, 495, 508, 531–2, 544, 565–6, 580, 585, 592, 598, 600, 603, 609–11, 619–21, 625, 627; success and fame, xii–xiii, 252–3, 265–7, 271, 297, 301, 303–4, 307, 311, 324, 334, 355–60, 363, 374, 381, 387–98, 413–14, 431, 512, 518, 593, 595–7, 605; surrealism and, 78, 173–6, 204, 248, 296, 324, 342; teaching jobs, 256–63, 305–7; telephone hated by, 423–4, 425, 468; television habit, 372, 467, 477, 497, 522, 559, 594, 609, 611, 627; titles of, 251, 282, 380, 606; trip to Holland (1968), 508–16; two-drink stage, 365–8; urban abstraction period, 378–81, 387; violent behavior, 239, 274, 365, 430, 456–7, 504–5, 583, 584; Joan Ward and, 347–50, 371, 377, 382–7, 393, 402, 406, 410–14, 424–7, 447–51, 453–4, 475, 479, 519, 521–3, 527, 532–4, 538–9, 554, 566, 568, 569, 579, 583, 629–30; wedding, 196–7, *197*; "Weegee" style, 378–9; at White House, 468–9, 596, 599; womanizing, xiii, 88, 116–18, 152–3, 273, 346–7, 369, 400–402, 405, 427, 432, 483, 530, 629; "woman" struggle of early 1950s, 309–14, 323–4, 328, 329–31, 336–43, 354; in Woodstock, 85–7, 117–18, 240; work destroyed by, xiv, 76, 141, 178–9, 229, 251; working-class roots, 7–9, 37, 209, 233, 237, 289, 332, 367, 381, 447–8, 471, 524; work routine, 147, 197–8, 213, 228, 267, 294, 311, 322, 332, 368, 420, 467, 495–6, 499, 594, 610; World's Fair mural, 149–50, *150*, 151; World War II and, 168–9, 176, 184, 189–93, 217, 233; WPA mural career, 123–31, 132, 134–5, 151; as Yale visiting "critic," 307–9; youth culture and, 484–5; *see also* de Kooning, Willem, work of

de Kooning, Willem, work of: *Acrobat*, 175; *Asheville*, 263; *Attic*, 282, 293–4, 295, 297; Belgian work, 49–53, 181; *Bill-Lee's*

Index

Index

Index

Index

Index

Index

Index

Illustration Credits

All de Kooning works © The Willem de Kooning Foundation/Artists Rights Society (ARS), New York. In the case of the few unknown photographs, every effort was made to trace their provenance.

Holland

 1 The Rotterdam City Archive.
 7 Fotografic Strauss Rotterdam. Courtesy of Judith Wolfe.
 15 Courtesy of Judith Wolfe.
 21 Courtesy of Jan and Monique Gidding.
 26 The Rotterdam City Archive.
 37 Courtesy of The Allan Stone Gallery, New York.
 39 The Rotterdam City Archive.
 44 The Rotterdam City Archive.
 52 Courtesy of Judith Wolfe.

The Immigrant

 59 © Ellen Auerbach. Courtesy of the Robert Mann Gallery, New York.
 64 Unknown photographer. Reproduced from *Willem de Kooning*, exhibition catalog (Paris: Centre Georges Pompidou, Musée national d'art modern, 1984.)
 83 Courtesy of Liesl Jonas.
 87 Private collection. Photo courtesy of The Willem de Kooning Foundation, New York.
 91 Reproduced from Thomas B. Hess, *Willem de Kooning* (New York: George Braziller, 1959).
 98 Unknown photographer. The Frances Mulhall Achilles Library, Archives, Whitney Museum of American Art, New York.
 114 © 2004 Man Ray Trust/Artists Rights Society (ARS), NY/ADAGP, Paris/Telimage.
 120 Unknown photographer. Reproduced from Curtis Bill Pepper, "The Indomitable de Kooning," *New York Times Magazine*, Nov. 20, 1983.
 146 © 2004 Estate of Rudy Burckhardt/Artists Rights Society (ARS), New York.
 150 Courtesy of the Library of Congress.
 152 Courtesy of The Allan Stone Gallery, New York.
 155 © Ellen Auerbach. Courtesy of the Robert Mann Gallery, New York.
 175 Courtesy of The Metropolitan Museum of Art. From the collection of Thomas B. Hess. Gift of the heirs of Thomas B. Hess, 1984. (1984.613.1).
 181 Courtesy of The Allan Stone Gallery, New York.
 183 Courtesy of Conrad Fried
 184 Courtesy UST.
 188 The Hirshhorn Musem and Sculpture Garden, Smithsonian Institution. Gift of the Joseph Hirshhorn Foundation, 1966.
 197 Courtesy of Marjorie Luyckx.

Recognitions

 201 Harry Bowden. Courtesy of the Charles Campbell Gallery, San Francisco.
 226 Courtesy of the Metropolitan Museum of Art. From the collection of Thomas B. Hess. Gift of the heirs of Thomas B. Hess, 1984/Artists Rights Society.
 228 Harry Bowden. Courtesy of the Charles Campbell Gallery, San Francisco.
 229 Courtesy of the Montana Historical Society. From the Poindexter Collection. (1984.613.1).
 242 Courtesy of The Allan Stone Gallery.
 248 Courtesy of The Museum of Modern Art/Licensed by SCALA/Art Resources, NY/Artists Rights Society.
 256 Courtesy of the North Carolina State Archives.
 260 Hazel Larsen Archer. Courtesy of jan van der donk—rare books, inc.
 281 Courtesy of The Hirshhorn Museum and Sculpture Garden, Smithsonian Institution. Gift of the Joseph H. Hirshhorn Foundation, 1966.

Illustration Credits

Self-Portrait with Imaginary Brother, c. 1938. Private collection. Photo courtesy The Willem de Kooning Foundation, New York.

Seated Woman. Philadelphia Museum of Art. The Albert M. Greenfield and Elizabeth M. Greenfield Collection.

Pink Angels. Courtesy of the Frederick R. Weisman Art Foundation, Los Angeles, California.

Zurich. The Hirshhorn Museum and Sculpture Garden, Smithsonian Institution. The Joseph H. Hirshhorn Bequest, 1981. Photograph Lee Stalsworth.

Black Friday. Princeton University Art Museum. Gift of H. Gates Lloyd, Class of 1923, and Mrs. Lloyd in honor of the Class of 1923.

Excavation. The Art Institute of Chicago. Mr. And Mrs. Frank G. Logan Purchase Prize, gift of Mr. And Mrs. Noah Goldowsky and Edgar Kaufmann, Jr., 1952.1. Reproduction, The Art Institute of Chicago.

Woman I. Copyright [use symbol] The Museum of Modern Art/Licensed by SCALA/Art Resource, NY/Artists Rights Society.

Easter Monday. The Metropolitan Museum of Art. Rogers Fund, 1956 (56.205.2) Photograph copyright [use symbol] 1983 The Metropolitan Museum of Art.

Ruth's Zowie. Courtesy of the Ovitz Family Collection. Photograph by Ellen Page Wilson, courtesy PaceWildenstein.

Pastorale. Courtesy of Mitchell-Innes & Nash Gallery, New York.

Clam Diggers. Courtesy of the Collection of David Geffen, Los Angeles.

Woman, Sag Harbor. The Hirshhorn Museum and Sculpture Garden, Smithsonian Institution. Gift of Joseph H. Hirshhorn, 1966.

The Visit. Tate Gallery, London/Art Resource, NY.

Clamdigger. Whitney Museum of Art, New York. Gift of Mrs. H. Gates Lloyd. 85.51

Whose Name was Writ in Water. Solomon R. Guggenheim Museum, New York, 80.2738.

Untitled V. Albright-Knox Gallery, Buffalo, New York. Gift of Seymour H. Knox, Jr., 1977.

Morning: The Springs, Stedelijk Museum, Amsterdam.

Garden in Delft, 1987. Private collection. Photo courtesy The Willem de Kooning Foundation, New York.

Permissions Acknowledgments

Grateful acknowledgment is made to the following for permission to reprint previously published material.

Harry N. Abrams, Inc.: Excerpts from *De Kooning* by Harold Rosenberg. Reprinted by courtesy of Harry N. Abrams, Inc.

The New York Times Agency: Excerpts from "De Kooning's Pompier Expressionism" by Hilton Kramer, from *The New York Times* (November 11, 1967). Copyright © 1967 by The New York Times Co. Reprinted by permission of The New York Times Agency.

Robert Cornfield Literary Agency: Excerpts from *Willem de Kooning* by Edwin Denby. Copyright © 1965 by Edwin Denby. Reprinted by permission the Robert Cornfield Literary Agency on behalf of the Estate of Edwin Denby.

University of Chicago Press: Excerpts from "Art" by Clement Greenberg, from *The Collected Essays and Criticism: Affirmations and Refusals*, edited by J. O'Brian. Excerpts from "The American Action Painters" by Harold Rosenberg, from *The Tradition of the New*. Reprinted by permission of the University of Chicago Press.

Yale University Press: Excerpts from *Interviews with American Artists* by David Sylvester. Copyright © 2001 by The David Sylvester Literary Trust. Reprinted by permission of Yale University Press.

A Note on the Type

The text of this book was composed in Trump Mediæval. Designed by Professor Georg Trump (1896–1985) in the mid-1950s, Trump Mediæval was cut and cast by the C. E. Weber Type Foundry of Stuttgart, Germany. The roman letter forms are based on classical prototypes, but Professor Trump has imbued them with his own unmistakable style. The italic letter forms, unlike those of so many other typefaces, are closely related to their roman counterparts. The result is a truly contemporary type, notable for both its legibility and its versatility.

Composed by
North Market Street Graphics,
Lancaster, Pennsylvania

Printed and bound by
Berryville Graphics,
Berryville, Virginia

Designed by
Iris Weinstein